THE INTERNATIONAL
ART
MARKETS

Additional material on the development of the art markets in the individual countries covered by this book is available online at:

www.koganpage.com/artmarkets

To access this material, simply use the password: AM48356

THE INTERNATIONAL
ART
MARKETS

The essential guide for collectors
and investors

Consultant Editor
JAMES GOODWIN

KOGAN
PAGE

London and Philadelphia

Publisher's note

Every possible effort has been made to ensure that the information contained in this book is accurate at the time of going to press, and the publishers and authors cannot accept responsibility for any errors or omissions, however caused. No responsibility for loss or damage occasioned to any person acting, or refraining from action, as a result of the material in this publication can be accepted by the editor, the publisher or any of the authors.

First published in Great Britain and the United States in 2008 by Kogan Page Limited
First published in paperback in 2009

120 Pentonville Road
London N1 9JN
United Kingdom
www.koganpage.com

525 South 4th Street, #241
Philadelphia PA 19147
USA

© Kogan Page, James Goodwin and individual contributors, 2008, 2009

ISBN 978 0 7494 5592 7

British Library Cataloguing-in-Publication Data

A CIP record for this book is available from the British Library.

Library of Congress Cataloging-in-Publication Data

The international art markets : the essential guide for collectors and investors / [edited by] James Goodwin. -- 1st ed.
 p. cm.
Includes bibliographical references.
ISBN 978-0-7494-4835-6
1. Art--Economic aspects. 2. Art--Collectors and collecting. 3. Art as an investment. I. Goodwin, James, 1967-
N8600.I57 2008
706.8--dc22
 2008017378

Typeset by Saxon Graphics Ltd, Derby
Printed and bound in India by Replika Press Pvt Ltd

Contents

Contributors

Roxana Azimi was born in 1970 in Teheran (Iran). After studies in visual arts, Roxana completed a PhD in history at the Ecole des Hautes Etudes en Sciences Sociales, France. She then worked for several years at Drouot, where she organized and gave lessons about art. Since 2001, she has written regularly for *Le Journal des Arts*, the *Art Newspaper, Le Monde* and *l'Oeil*. Email: roxana.azimi@wanadoo.fr

Bert Bakker is a freelance financial journalist based in the Netherlands who covers both art markets and capital markets. In 2004 Bakker, himself a keen collector of mid-20th-century design objects, co-wrote *Onschatbare waarde*, a book on financial aspects of art and antiques collecting best translated as 'Priceless'. It is now in its third edition and has become obligatory reading for students of the economic aspects of art history. Email: bertbakk@worldonline.nl

Katia Mindlin Leite Barbosa was born in Rio de Janeiro, Brazil in 1956. She graduated as an architect, and devoted some years to her career before receiving an invitation in 1989 to join Sotheby's as an associate. A former director and current board member of MAM (Museu de Arte Moderna do Rio de Janeiro), she is also committed to other cultural institutions such as Paço Imperial, Fundação Eva Klabin and Fundação Botânica Margaret Mee. Email: sothebysrio@terra.com.br

Godfrey Barker lives in London. His first book, *Vanity Fair: The rich and the price of art since 1850*, is published in 2008. He was arts columnist for *The Daily Telegraph* from 1986 to 1997 and since then has written for *The Evening Standard* (London) and for many newspapers and magazines in the United Kingdom, United States and Germany. He broadcasts for BBC Radio 4 *Front Row* and BBC Radio 3 *Night Waves*, for BBC TV and for the BBC World Service. He gives public lectures on the history of the art market at Sotheby's in London. Email: godfreybarker@aol.com

Adrian Gualdoni Basualdo was born in Buenos Aires in 1941. He specializes in the art market, and writes for several Argentine newspapers and magazines such as *Tiempo Argentino, Clarin* and *Buenos Aires Herald*. Currently he writes for *La Nacion-Revista ADN* and for *Arte al Dia Internacional*. He commissioned the formation of the Museo del Tigre (Buenos Aires) art collection. He is a founding member and director of Consultart/DGB, the first art consultancy firm in Argentina, and also teaches at the Universidad del Salvador, Buenos Aires. Email: mercad@fibertel.com.ar

Diana Boccardo was born in Caracas, Venezuela in 1959. In 1981 she attended the Universidad Central de Venezuela, also in Caracas, where she majored in modern languages. In 1991 Diana joined Sotheby's as the administrator of the Caracas representation, and since 1999 she has worked as an associate of Sotheby's in Venezuela. Email: dboccardo@cantv.net

Elisabeth Bogdan is originally from Canada, and studied historical geography at the University of Toronto. She is currently senior lecturer at Sotheby's Institute of Art, London, where her specialist teaching includes 18th to 20th-century European and American design, decorative art and architectural histories, and art market studies. Email: l.bogdan@sothebysinstitute.com

Dirk Boll studied law in Göttingen and Freiburg, and practised in Hamburg and Brussels, before taking up further studies in art management to continue his career in the art market. He joined Christie's in 1998, and moved to the Zurich office in 2005 to take over the position of managing director in the German-speaking part of Switzerland. In 2007 he was appointed European director. He is also a lecturer at Hamburg University on the subject of art management. Email: DBoll@christies.com

Clemens Bomsdorf, born in 1976, is Nordic correspondent for *Das Kunstmagazin* (Germany) and the *Art Newspaper* (UK) as well as *Financial Times Deutschland* (Germany). He contributes regularly to other publications as well and is one of the commentators at the art blog www.artworldsalon.com, established by Marc Spiegler, now one of the directors of Art Basel. He holds an MSc from Stockholm School of Economics and is based in Copenhagen. Email: bomsdorf@weltreporter.net

Henry Bounameaux studied law and history of the arts at the University of Louvain, before starting (in 1993) an art consultancy office based in Brussels. He is currently president of the Belgian Chamber of Art Experts and is a regular lecturer on the art market (University of Brussels from 2002 to 2007; ENSAV/La Cambre from 2003; ICHEC from 2004). Email: expert@bounameaux.com

Rachel Campbell completed her PhD on risk management in international financial markets at Erasmus University, Rotterdam in 2001. She currently works at the University of Maastricht. Email: campbell.rachel@gmail.com

Byungsik Choi is a professor at Kyunghee University. He is a panel member of the Korean Museum Association, Korean Private Museum Association, Galleries Association of Korea, vice-director of the Development Committee for Korean Art Authentication and commissar of administration of the Korean Art Bank. Email: spacebsc@unitel.co.kr

Sunhee Choi is an art consultant and independent curator. She obtained a postgraduate diploma in history of art at Christie's Education in London, was an intern at the Chinese and Japanese department at Christie's, then worked for two London-based galleries before moving to Paris. She founded ChoiCe Contemporary, an art consulting company, which specializes in Korean contemporary art, and writes for Korean magazines including *Art Price* and *Emotion* and for the *Art Newspaper.* She is a guest lecturer at Dong Kuk University. Her first book on the UK art scene was published in Korea in 2008. Email: sunhee.lefur@gmail.com

Derrick Chong is a senior lecturer in management at Royal Holloway, University of London and consultant lecturer at Sotheby's Institute of Art in London. He read business administration and art history in Canada before completing a PhD at the University of London. He is author of *Arts Management* (2002) and co-editor of *The Art Business* (2008), both published by Routledge. Email: D.Chong@rhul.ac.uk

Brian Curtin was born in Ireland and has been based in Bangkok since 2000. Originally trained as an artist – he holds a PhD in studio art from the University of Bristol – Brian has steadily built a profile as an art critic through writing for magazines such as *Contemporary, Flash Art, Frieze* and Thailand's *Art 4D* and *Fine Art*. He lectures in art history at the Faculty of Architecture of Chulalongkorn University. Email: curtin.brian@gmail.com

Patricia Bueno Delgado was born in Mexico City. She has a degree in economics (Mexico) and a postgraduate qualification in visual culture (UK). She has collaborated on cultural economics publications in Mexico for UBS, the National Council for Culture and Arts (Mexico) and *Trimestre Economico Journal.* Email: patricia.bueno@exalumnos.cide.edu

Iliana Fokianaki is an art critic and independent curator. She studied and lived in London where she read Fine Arts (BA Hons) and completed her MA in Arts Criticism and Management at City University London. She then worked for a London-based gallery for two years. Since 2005 she has been based in Athens where she worked for the Ministry of Culture and the National Gallery of Greece. She is now teaching photography theory and art history and writes for a Sunday newspaper and magazines. She is working on a new project regarding the influence of American art in the Balkans. Email: Ilianafokianaki@gmail.com

Roni Gilat-Baharaff holds a Master's degree in art history from the Courtauld Institute of Art, London. She is managing director of Christie's (Israel) Ltd. Her responsibilities include managing Christie's Tel Aviv office and business development in the region. Roni is an art specialist: her field of expertise is 20th-century art, and Jewish and Israeli art in particular. She is the specialist in charge of Christie's auctions in Israel. Roni is also a member of the board of governors of the Tel Aviv Museum of Art and is on the art advisory board of the Israel Discount Bank corporate collection. Email: rgilat-baharaff@christies.com

Victor Ginsburgh is honorary professor of economics at the Université Libre de Bruxelles, and co-director of the European Center for Advanced Research in Economics and Statistics. He is co-editor (with David Throsby) of the *Handbook of the Economics of Art and Culture* (Amsterdam: Elsevier, 2006), and past president of the International Association for Cultural Economics. Email: vginsbur@ulb.ac.be

Ercilia Gomez Maqueo Y Rojas studied economics and has a Master's degree in mathematics, but her main interest in culture led her to specialize in contemporary art and culture. She was creator and director of the Fundación Cultural Bancomer where she worked from 1988 to 2001. She has edited more than 15 books about Mexican art and was the founder of the Trust for Culture Mex-USA (Fideicomiso para la Cultura Mex-USA) in association with the Rockefeller Foundation and the National Fund for Culture and Arts in Mexico (FONCA). Email: erciliagomez@yahoo.com.mx

James Goodwin, MA, MBA, lectures on the art market at Maastricht University, City University, Kingston University and Christie's Education, London, United Kingdom, where he also specializes in ancient furniture. His research and writing has appeared in the *Economist, Financial Times, Wall Street Journal Europe* and has been broadcast on BBC TV and radio. His ongoing research includes art valuation, creativity and ancient art. Email: arts.research@gmail.com

Lord Gowrie was born in Dublin in 1939. Educated and professionally engaged in England and the United States, he made his home in Ireland until 1983 when he moved to the Welsh Marches. He taught English and American literature at both Harvard and University College London, and in 1972 he exchanged an academic career for business and public life. He has been a company chairman, a Cabinet minister, Chairman of the Arts Council of England and Provost of the Royal College of Art. He is married to the German journalist Adelheid von der Schulenburg and is a fellow of the Royal Society of Literature.

Tim Hazledine is professor and head of the Economics Department of Auckland University in New Zealand. He was educated at the universities of Otago, Canterbury and Warwick (PhD 1978). He lectured at Warwick, Balliol College Oxford, Queen's University Ontario and the University of British Columbia in Vancouver, before returning to New Zealand in 1992. His research focuses mainly on public policy issues. Email: t.hazledine@auckland.ac.nz

Harriet Hedley was born in Johannesburg in 1957. She worked for Christie's as a representative in Johannesburg from 1986 to 2000. In 2000 she started Gilfillan Scott-Berning with Gillian Scott-Berning as a fine and decorative arts consultant. Today she is an independent consultant for Christie's International. She specializes in South African art and has brokered significant private treaty sales of important South African works on behalf of clients. Email: harriet.gsb@mweb.co.za

Kumiko Hirakawa is a partner in Yueshan Yuan, consultants and dealers in Chinese and Japanese classical paintings. Previously she worked at the Ota Memorial Museum of Art in Tokyo and for Christie's Japan as a Japanese art specialist. Email: ysyart@gmail.com

Yvonna Januszewska is a Master's graduate of Kingston University, Surrey. She is currently working at Christie's as a manager in the Business Development Department looking after major European markets, and is also the consultant for Christie's Poland. Email: YJanuszewska@christies.com

Andrea Jungmann studied history of art and art management at the University of Vienna. Since 1989 she has worked at Sotheby's in Vienna, where she was assistant to the managing director. In 1998 she became deputy director, in 1999 head of the Vienna Office, and in 2000 managing director of Sotheby's Austria and Hungary. Since 2004 she has also been a senior director at Sotheby's London. She specializes in Austrian modern art and contemporary art, and teaches on art and the art market at the university in Vienna and other institutions. Email: andrea.jungmann@sothebys.com

Zeynep Kayhan (born 1982) studied art history and comparative literature at Cornell University and is currently pursuing a philosophy degree at European Graduate School. Since 2005 she has been working as a consultant for Christie's. Email: zeynep.kayhan@gmail.com

Ruoh Ling Keong graduated from National University of Singapore with a B.A in History and Political Science. She furthered her studies in France and is conversant in English, Mandarin and French. She joined Christie's Southeast Asian Pictures department in Singapore 2 years after its inception in 1994. Highlights of her career include co-curating the exhibition 'Visions and Enchantment' with the Singapore Art Museum. Email: rkeong@christies.com

Ivana Kodlova studied history of art at Rudolf's Academy in Prague. Since that time she has, with her husband, founded a gallery, Galerie Kodl, in Prague, which specializes in Czech paintings from the first half of the 20th century. Email: martinkodl@galeriekodl.cz

Wojciech Kowalski is professor at the University of Silesia, Katowice, and publishes extensively on cultural property law issues both in Poland and abroad. He is head of the Department of Intellectual and Cultural Property laws. Email: Wojciech.Kowalski@msz.gov.pl

Roman Kräussl studied at the University of Bielefeld, Germany, and at Johann Wolfgang Goethe-University, Frankfurt/Main, Germany. As the head of quantitative research at Cognitrend GmbH, he was closely involved with the financial industry. Currently he is associate professor of finance at VU University Amsterdam and research fellow with the Center for Financial Studies, Frankfurt/Main. His research on the art market deals mostly with investing in art. Email: rkraussl@feweb.vu.nl

Pauliina Laitinen-Laiho (born 1970) has a PhD and is a widely known art specialist in Finnish art markets. She has published non-fiction books on art as an investment, art forgeries and art thefts. She makes art valuations, manages young artists and consults for corporations on art issues. Her ongoing post-doctoral research interest is in pricing art. She also writes an art investment column and makes TV art programmes. In addition she teaches in Finland about art as an investment. Email: pauliina.laiho@nic.fi

William Lawrie is the specialist responsible for Christie's sales of modern and contemporary Arab and Iranian art in Dubai. William joined Christie's Islamic Art Department in London in 2004, and organized the exhibition of Islamic art marking the opening of the Christie's office in Dubai in April 2005. He relocated to Dubai in December 2006 as Christie's first specialist resident in the Middle East. He studied history of art at Edinburgh University, specializing in Islamic art, and graduated with first class honours. Email: wlawrie@christies.com

Birgitte Lie, born in 1972, is producer for the annual Performance Weekend at Kunstbanken Arts Centre (Hamar, Norway), and writes for the art magazine *Billedkunst*. Previously she has been project coordinator for Office for Contemporary Art Norway, as well as coordinator for a postgraduate course for artists for Public Art Norway. She holds an MA in art history from the University of Oslo. Email: bi-lie@online.no

Ruben Lien is the head of sales at Christie's London, and has presided over various successful sales including two very important single-owner collections, the E T Hall Collection of Ming and Qing monochrome porcelains, and Chinese porcelains and enamels from the Alfred Morrison Collection, Fonthill House (both in 2004). A native of Taiwan, he joined Christie's in 2002 after completing an MA in sinology at the School of Oriental and African Studies (SOAS), London. He also holds a postgraduate diploma in Asian art from Christie's Education. Email: rlien@christies.com

João Magalhães works for Mallett & Son Antiques (London). He studied at Sotheby's Institute of London (MA in fine and decorative art), and since 2004 has written on art collecting and market issues for the Lisbon-based magazine *L+Arte*. Email: joaotmagalhaes@googlemail.com

Brook S Mason has covered the international art market and collecting for more than a decade while serving as US correspondent of the *Art Newspaper*. She frequently writes for the *Financial Times* and writes a column on art and design for the online magazine artnet. Email: BMason3570@aol.com

Clare McAndrew is a cultural economist specializing in the fine and decorative art market. Clare completed her PhD in economics at Trinity College Dublin in 2001, where she also lectured and taught economics for four years. She worked for three years as the chief economist at Kusin & Company in the United States, an institutional economic research firm specializing in the art market, and has worked as a consultant on a number of projects for the Arts Council of England, the Arts Council of Ireland and a range of other arts and economic institutions. Since returning to Europe in 2005, she has set up her own art and financial research and consulting firm Arts Economics, and recently completed a book, *The Art Economy: An investor's guide to the art market*, published in 2007 by the Liffey Press. Email: clare@artseconomics.com

Cecilia Miquel has worked in the visual arts in Chile and internationally for more than 15 years. Her beginnings were marked by constant contact with workshops of artists, overseeing their evolution and introducing them to an incipient art market. She has been a representative of Sotheby's since 1999, a platform which gave her opportunity to take part in diverse art courses. In addition to administering the Chilean office, she works on arts sales, searches for new clients and advises collectors. Email: cecilia.miquel@sothebyschile.cl

Sara Mortarotti was born in 1971, and lives and works in Milan. Graduating in economics, she specialized in marketing and communication. She has published numerous articles in prominent Italian newspapers, and she is vice-president of AssiArt, the Italian Art Advisory Association. Email: saramortarotti@yahoo.it

Georgina Pemberton is director and head of Australian paintings, Sotheby's Australia. Georgina joined the company in 2002 as a specialist in Australian 19th and 20th-century paintings, prints, photography and sculpture. Since 2005 she has taken on additional responsibilities as an auctioneer for Sotheby's Australia and for charity auctions, and in August 2005 was selected as a specialist for the Australian *Antiques Roadshow*. Email: Georgina.pemberton@sothebys.com

Claude Piening joined Sotheby's 19th Century European Paintings department in 1996. Working first in New York, he moved back to London in 1999, since when he has specialized in German and Austrian painting and championed eastern European art – notably Polish, Hungarian and Czech painting – on the international market. Email: Claude.Piening@sothebys.com

Lindy Poh, born in Singapore in 1969, is an art curator, writer and lawyer specializing in intellectual property, art and entertainment law. She worked in the Singapore Art Museum from 1996–2000, and is currently a partner in Silver Rue, a Singapore-based art consultancy. Her current appointments include curator for the Singapore Pavilion at the 52nd Venice Biennale 2007, curator for the Ministry of Foreign Affairs (2001–present) and for the Supreme Court of Singapore (2007). Email: silver.rue@pacific.net.sg

Josh Pullan is a strategy analyst for Sotheby's, London. He currently works for the chief operating officer on a range of projects throughout the business. He joined Sotheby's in 2005 in the Corporate Alliances department while completing a Master's in art business from Sotheby's Institute of Art. He has published a number of articles and opinions relating to the financial properties of art. Email: joshpullan@yahoo.com.au

Sergei Reviakin, MPhil, is an art collector who lives and works in London. His particular interest is 20th-century and contemporary Russian art. He is a member of the Russian section of the International Association of Art Critics and Art Historians. Email: sergei@reviakin.com

Iain Robertson is head of art business at Sotheby's Institute of Art. He has written over 100 articles on the arts and is a regular contributor to the *Australian Art Market Report*. He was the Asia correspondent for the *Art Newspaper* for 10 years. He is an advisor to the Asia Art Archive in Hong Kong and a consultant for the emerging New York-based art fund, Meridian. He has written and edited two books on the art market, *Understanding International Art Markets and Management* (2005) and *The Art Business* (2008). Email: iaruk@yahoo.co.uk

Fernando Romero born in Barcelona in 1966. He studied law at the University of Barcelona, and art history, connoisseurship and the art market at Christie's Education in New York, London and Paris. He is also the author of articles and books on the fine and decorative arts, and is currently carrying out an extensive research project on the history of Spanish furniture and its market. He is a member of the Contemporary Arts Council of MoMA, New York, and an advisor to private and corporate collectors. He also runs the Barcelona based Palau Palmerola Art Consulting specialized in expertise and valuations of works of art. Email: polibio@wanadoo.es

Roddy Ropner is currently studying for an MBA at the Chinese University of Hong Kong. Until 2007 he was a director of Christie's Hong Kong. From 1997 to 2000 he was managing director of Christie's Japan, and subsequently held responsibility for offices in the Asia region. His personal interests are in Chinese and Korean art and photography. Email: rjropner@yahoo.com

Katrin Schmitter holds a BSc in communication from the University of Lugano and an MA in arts and heritage from Maastricht University. She has conducted research in the field of African contemporary art and the sub-Saharan art market. Email: katrinschmitter@gmail.com

Sonal Singh holds a Master's in art business from Sotheby's Institute of Art, London, where she specialized in the Indian art market. In addition to her experience in Indian art she has also studied fine art at Central Saint Martins and art history at Christie's Education, London. Sonal is currently based in Mumbai, where she is working with Christie's as a specialist for the Modern and Contemporary Indian Art Department. Email: sonalsinghnaharwar@gmail.com

Kira Sjöberg is a researcher of the art markets, specializing in issues surrounding value and quality construction in art, and is especially interested in researching the art market for women. She is a post-graduate from Sussex University and is currently with Helsinki University working on her PhD. She previously worked at Christie's coordinating among other things the inaugural Nordic art and design sale in 2006. Email: kira@artshortcut.com

Nicole Stava was born in Switzerland in 1981. During her studies in Prague and Geneva she worked for Christie's as a consultant in the Czech Republic and Slovakia. Email: nicole.stava@panstvi-bechyne.cz

Aina Truyols graduated from Ecole du Louvre, Paris, and holds an MA in art history from University College London. She has extensive experience working in various international museums and galleries, and as a junior expert in a Parisian auction house specializing in contemporary art and design. Based in London, she currently works with ArtTactic.com and collaborates with Fine Art Wealth Management. Email: ainatruyols@gmail.com

Vidhyasuri Utami was born in Jakarta in 1974. She obtained a degree in international relations from the Catholic University of Parahyangan and later continued her studies in international relations and philosophy at the University of Indonesia. She currently works as a lecturer at the University of Trisakti (Art Department) and the University of Pelita Harapan (in social and political studies). Email: vidhyasuri@yahoo.com

Calin Valsan is a professor of financial economics at Bishop's University in Lennoxville, Quebec. He holds a PhD in finance from Virginia Polytechnic Institute and State University. He researches the economics of art auctions, economies in transitions, and corporate governance. Email: cvalsan@ubishops.ca

Mary Vavasour is an Auckland-based art consultant and collections manager. She was educated at Auckland University, where she took a BA with a double major in art history and political studies. In 1994 she established and became director and shareholder in Vavasour Godkin, a contemporary dealer gallery in Auckland, and since 1998 she has worked as a consultant and adviser to collectors and institutions. Email: m.vavasour@xtra.co.nz

 Johnni Wong graduated from the National University of Malaysia in 1986 with a degree in social sciences. He worked for UNICEF as a field researcher, before joining the newspaper industry as a journalist. He is currently an editor with Malaysia's leading English daily, *The Star*. He has a keen interest in lifestyle subjects, particularly art, antiquities, architecture and real estate properties. Email: johnni.wong@gmail.com

Foreword

James Goodwin and his authors have assembled and correlated a fascinating 'cabinet of curiosities' in respect of the art market worldwide. Facts and figures; names in and out of fashion; historical and contemporary tendencies; variables to do with the role of museums and governments; the ebb and flow of funds with or against the grain of economic cycles; trade practices; the psychology of investors and collectors – we are given drawer after drawer to rummage through and ponder. Mr Goodwin has, sensibly, avoided the temptation to try to establish laws that govern the behaviour of the art market. Adapting and reacting are what markets do. That which obtains on Monday can look a little frayed by Wednesday and seem altogether irrelevant by the weekend.

A few constants hold, however. Competing for and acquiring artefacts without material value lies deep in our DNA as a species. Others (think of the magpie) may acquire; none trade. 'Grub first, then ethics,' said Brecht. Ethics have to do with culture and so, even when ethically neutral, does art. Some years ago, a painter friend of mine made a portrait of a young man from a poor Anatolian village and gave it to the boy's mother as a gift. When, much later, he returned to the village and asked to see the work, bits of the canvas were proudly displayed patching trousers on most of the family. He was, I believe, wrong to be shocked. Art does not absorb us when we are hungry, or too hot or too cold, or in immediate danger. Famine and global war are the main threats to the art market.

Yet precisely because they have no practical value, works of art have always commanded a steady and sustainable share of surplus wealth. In our time, the last two decades have witnessed an unprecedented surge in the disposable wealth of individuals working in the vanguard of increasingly interdependent global economies. No wonder nearly all kinds of collectible art have risen in real value.

In my career as a private art dealer (in the 1970s) and as London chairman of Sotheby's (in the late years of the last century) I was, from time to time, asked to give advice to new collectors. They often described themselves as new investors. I tried to keep the advice simple and consistent. If you want to invest, seek out individuals of integrity with a proven record of success in one or other sectors of the art market. Back them. If you want to collect, seek out individuals of integrity with proven expertise in the field of art which attracts you. Their experience will modify, refine and strengthen your own taste. At the end of your visit to the theatre, so to speak, you should receive a real-value refund of your ticket, and you will also have enjoyed the show. These are still my views. But as an individual with a parallel experience of working in government and bearing responsibility for publicly funded museums and galleries, I have also had to recognize the effect on prices of a worldwide explosion in museum development, travelling exhibitions, books and filmed documentaries. If the pen is mightier than the

sword, the image is now mightier than the pen. 'Keep an eye on what curators are up to,' I'd counsel. 'Collectors often follow in their wake.' In a few distinguished cases (think of Sir Dennis Mahon), I might have added that it is sometimes the other way about.

Prince Albert expressed an anxiety, more than 150 years ago, that the ability of art to raise the human spirit and extend human sensibility might become polluted by the traffic of trade. And indeed the lustre of gold has always been able to take the shine off what it touches. But Mr Goodwin also concludes that 'while the upper echelons of the market attract the head-lines, the bottom end … is open to everyone with a hundred dollars in their pocket and a love of beauty in their heart.' Amen to that. The £100 I spent as a student in 1960 when I fell for a relatively obscure painter is at present providing me with rainy-day cover of £50,000 or so. Amen to that as well.

Lord Gowrie

Preface

For most of us an interest in the arts begins, unconsciously, at a very young age. Even during this time of discovery, a tendency to depict or record emerges, nurtured by our parents and fuelled by the environment in which we live and the memorable places we may visit. These are experiences which are formalized at school and may be crystallized by our first museum visits. This constant bombardment of our senses develops a view of the world that may not in reality be unique but we certainly perceive it to be our own. From this foundation our tastes emerge, reshaped occasionally by further influences and knowledge. In many cases this culminates in the collection of art and artefacts that remind us of whom we are and who we were.

My own artistic interests were born in my Suffolk childhood in the east of England among friends and relatives possessing carefully chosen fine and decorative art, the sublime craftsmanship of our long-established family furniture-making business, surrounded by the proud architecture of my rural school and the numerous flint-decorated East Anglian churches; all reminding me that art, beauty and money are inextricably linked, even to those willing a higher purpose.

One influence stands out above all because it demonstrated what I consider even now to be an ideal way of living and has greater relevance to this publication. A short cycle ride from where I lived, I was a frequent visitor to a 16th-century hall, the home of childhood friend, the youngest of seven children, and son of the artist Stuart Somerville (1908–1983) and his surviving wife Catherine.

My memories are of their medieval hall, its gothic-shaped oak door, the sound of Beethoven music, a burning fire in winter, a playful King Charles spaniel – a place where you were understood as a child but treated as an adult, surrounded by artworks of the highest quality in an atmosphere that seemed entirely natural; an attitude that opened my mind to an artistic curiosity that has never left me.

In a recent article on British flower painting 1650–1950 in *Antique Collecting* magazine, Stuart's work is put 'on a different plane from even the best of the rest'. As well as this he painted landscapes, still life and the female figures. But as he himself admitted, his flower paintings paid him best: artists need markets, and that is what this book is about.

In the present generation, the Somerville family is headed by John, who was a director of Old Master paintings at Sotheby's during the heydays of the late 1970s and 1980s and is now senior curator of the Lobkowicz Collections in the Czech Republic.

For the inspiration my family, the Somervilles and others have given me over the years, I offer my heartfelt thanks. In particular, I would like to thank my father who has allowed me to return home to complete this book.

Acknowledgements

The list of those to thank for help with this publication is a formidable task because its origins lie in my first art market research seven years ago. For help with these early publications which put me on this path, gratitude goes particularly to John Andrews of the Antique Collectors' Club, Robin Duthy of Art Market Research, Peter Collins of the Westminster Reference Library, Rufus Bird and Robert Copley of Christie's Furniture Department, Christopher Claxton Stevens and Stephen Wild of Norman Adams, Mary Yule of The Art Fund, Malcolm Cossons of *Sotheby's Preview*, Jonathan Reuvid of GMB Publishing, Clare Pardy of AXA Art Insurance, Dr Rachel Campbell of Maastricht University, Ivan MacQuisten of the *Antiques Trade Gazette*, Patrick Lane of the *Economist* and Vanessa Friedman of the *Financial Times*.

For this publication the search for authors was wide and varied. The overall aim to avoid any bias was to keep a balance between the art trade, academia, journalism and related activities. This adds to the book's aim of giving equal treatment to every country in which there is an auction presence. For help with this, thanks are mostly due to Cristina Ruiz, Georgina Adam and Melanie Gerlis of the *Art Newspaper*, Titia Vellenga of TEFAF, Randall Willette of Fine Art Wealth Management, Philip Hoffmann of the Fine Art Fund, Jeremy Eckstein of Sotheby's Institute, Floris Guntenaar of The Cultural Heritage Foundation, Catherine Manson, Matthew Paton and Rhiannon Broomfield plus colleagues at Christie's, Matthew Floris plus colleagues at Sotheby's, and some of the staff at Bonhams. Thanks to them, others were recommended and so on, leading to the final line-up of contributors. Inevitably there are many I may have excluded, for which I apologise. I would also like to thank copy-editors Susan Curran and Chris Carr, and Helen Kogan, Heather Bateman and Ian Hallsworth of Kogan Page for keeping the faith, and their innovative ideas for the success of this publication.

Throughout this time, for direct help with my research I would like to thank the Westminster Reference Library, National Art Library, British Library, Maastricht University, City University, Society of London Art Dealers, LAPADA, BADA, SLAD, AXA Art Insurance, Art Loss Register, the *Art Newspaper*, Artprice.com, Art Sales Index, ArtNet, ArtNews, UN Statistics Division, Keynote and Bureau van Dijk.

For editing the introduction I would like to thank my brother-in-law Jamie Robertson, who has 30 years' experience as an international journalist and presenter on the BBC World Television.

Introduction

James Goodwin

This book is the first of its kind. In 42 country chapters, plus one regional chapter, its aim is to detail the multitude of influences on each country's art market for the benefit of new or existing art collectors and investors.

For new buyers the art market can be a daunting place, and often it does not follow the rules of other more conventional trading arenas. For them this book offers a comprehensive guide to the opportunities on offer. For established collectors it provides an insight into diverse markets they may not have even known existed, let alone explored.

The countries chosen are those represented in the secondary market (see p 6 et seq on 'The workings of the art market') by the three main auction houses, Christie's, Sotheby's and Bonhams. Market share between these three auctioneers is sufficiently high, long-standing and transparent to represent the global art market. The book covers 21 countries from Europe, 12 from Asia and Australasia, five from South America, four from the Middle East and Africa, and two from North America.

Each country has been given equal opportunity to present its art market despite the global market being over 70 per cent weighted by value in the United States (45.9 per cent) and Britain in 2006. Such a level playing field is intended to be non-judgemental. Any of these markets may develop exponentially at any point in the future. This is, after all, an international market where the economic laws of comparative advantage can work to the benefit of those that are seemingly at the bottom of the pile.

Indeed, as other economies develop, it seems likely that the art market will be redistributed more evenly on a larger scale around the world, based on knowledge, wealth, the competing intermediaries who promote and sell art, and above all, artistic talent. However, to achieve these aims further deregulation will be required in many countries. This may be accelerated by competition from emerging art markets. Only in the last year Turkey, where Christie's has just opened an office, was added to the list of country chapters in this book.

That said, the current centres have been built over decades or even centuries on expertise and favourable tax regimes. For example, Sotheby's in New York sells 54 art categories of which nearly half were directly created outside the United States, such as African and Oceanic art, and European furniture.

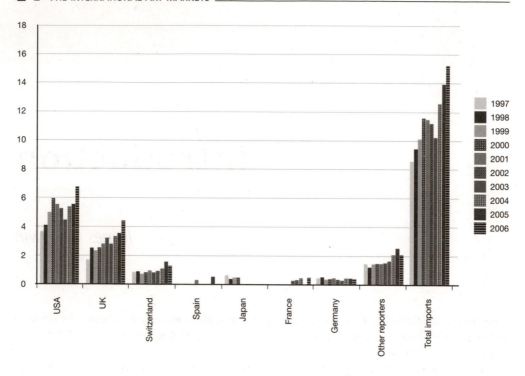

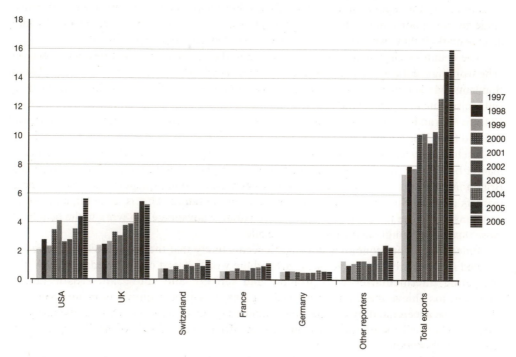

Figure I.1 The international trade in works of art, collectors' pieces and antiques, 1997–2006 (in US$ billion)

Source: United Nations, 2007

In total the book has 58 country authors, chosen from a range of professions. These include auctioneering (20 of the total), academia (16), journalism and art writing (12), art advisory companies (five), museum curating (three) and two art dealers. In all cases the authors were asked to review their art markets thoroughly based on the criteria below, and to avoid any bias in their recommendations because of their business interests. There are short biographies of them on pages xi–xix. Each chapter was edited separately and consistently, for first content then style.

Depending on the information available, each chapter covers the following topics with varying degrees of emphasis, where possible using figures:

■ art history: in terms of international originality and innovation;
■ the art market history to date: including taste, fashion, value, artists, art types, subjects, sales, prices and records;
■ market structure and performance: including auctioneers, dealers, trade associations, museums, exhibitions, fairs, training and education;
■ tax and regulation.

Each of the author's contact details have also been provided, for those interested in further paid consultation. In future the book will be updated as the art market develops to include more country markets, other art types and new information.

With a project of this magnitude, one cannot dismiss the possibility of faults or omissions. From the beginning the biggest challenge was planning the uneven arrival of country chapters, whose content may be slightly out of date by publication. Thankfully, in this case, changes in the art market have been slow even during the current boom. Many of the chapters have been updated since their first submission or just prior to final editing. Much of the information will be new, even to those working in the trade.

In concept, approaching the market geographically rather than stylistically also raised several questions, despite the broader and deeper long-term benefits. For instance, what are the criteria used for placing an artist in a particular country? Should it be based on parenthood, birth, training, the number of productive years spent in one place, subject matter, sales or even death, all of which can be altered by the redrawing of national boundaries? For example, Francis Bacon (1909–1992) had English parents but was born in occupied Ireland; 18th and 19th century Orientalist painters from western cultures worked mainly in the Near East and Far East; Netherlandish painting might refer to art from present-day Belgium or the Netherlands, which were divided by war in the 16th and 17th centuries. The outcome has naturally been to follow the opinion of the art market, which seems to be based on a combination of birthplace first and training second. In reality this conundrum arose only twice, and was easily resolved between authors.

Further limitations include the emphasis on art that is most frequently traded, and the portion of the trade that can be measured. In the first case, most authors refer to the fine or visual arts (painting, drawing, prints, sculpture etc) rather than the decorative arts (ceramics, furniture, glass, jewellery etc). Although exact figures are hard to come by for the decorative arts, their appearance at major art fairs and their trade at auction indicates that they provide less than 30 per cent of the art market's turnover.

What is measurable in the art market is what passes through auctions, which trade less than half of the art market's turnover. Although galleries in the primary market and dealers in the secondary market may be mentioned, their activities, as intermediaries who aim to buy low and sell high, tend to be more secretive and therefore less reliable. I hope future editions of this book will provide more information on all parts of the art trade.

The trading of art

Art, trade and money have always been inextricably and sometimes uncomfortably linked, as well as misunderstood. As long ago as 1519, when Quentin Matsys (1466–1530) painted *The money changer and his wife*, he warned of the changing values in a society increasingly devoted to commerce and finance. Referring to the balance between God and Mammon, there is inscribed on the picture frame a quote from the laws of righteousness in the Book of Leviticus (19:35–36): 'You shall have just balances and just weights.' Whether Matsys's views should be heeded by the modern art investor is for individuals to decide for themselves. But modern buyers will, most likely, have acquired their funds directly or indirectly through some kind of trade.

In many respects the development of the art market is simply the development of a trade in a specific product, which conforms to the theories of international free trade advocated by Adam Smith in the late 18th century and formulated by David Ricardo in the 19th (though Smith regarded artists, as well as lawyers and physicians, as unproductive labour because they did not produce a vendible commodity).

Free trade has been at the centre of the world's growing prosperity since the 1950s. In that period the volume of merchandise trade has risen about 20 times, while as a percentage of national output it has doubled. This has been mirrored by the trade in art. In particular Ricardo's principle that trade competition encourages innovation and product differentiation also applies to artistic creation.

A prime example of the benefits of free trade, which had a direct effect on the arts themselves and then later on the art market, was the opening of Japan in 1858, under American pressure. Most obviously the silk, tea and textile markets thrived as a result, but the encounter between European and Japanese artists also led to the style known as *Japonisme* in the West and the reciprocal imitation of western styles in Japan.

A hundred years later the dramatic growth of the Japanese economy led from the 1960s to Japanese collectors buying western art, particularly French Impressionist and modern art, and resulted in the greatest boom in art market history from 1985–90.

Like any other tradable object, an art work fails to appreciate if its marketplace is restricted. As an author in a book edited by Iain Robertson (who writes on Taiwan in this guide) points out, in the Italian Old Master picture market (14th century to early 19th century), the highest price achieved internationally in 2003 was $28.6 million for an Andrea Mantegna (1431–1506), while in Italy itself, where so many Old Masters originate, the most expensive ever sold was a Giovanni Guercino (1591–1666) for just $976,000. The result of export trade restrictions is an extraordinary quantity of privately, and publicly, owned Italian art in Italy which seldom appears before the public's gaze.

A map of the world showing countries that have developed an individual artistic culture would reveal that works of art grew out of a combination of favourable conditions: a well-established civilization, an atmosphere of liberalism (or at worst enlightened despotism) and a sense of luxury following wealth creation.

While it is debatable whether international artistic style has yet developed from the establishment of a global market, there is a growing and genuine internationalism among buyers, thanks to greater transparency, technology and the opening up of new markets which is more likely to lead to further artistic innovation.

Adding to this process, since 1999, Christie's auction house has published statistics on sales by buyers' origins for top lots. Comparing their Impressionist and modern art sales in New York in 1999 and 2007, there was a notable shift from US and European

buyers (97 per cent to 73 per cent) to other parts of the world (3 per cent to 27 per cent). Buyers' origins for the postwar and contemporary art market are shown in Table I.1.

Table I.1 Buyers' origins for the Christie's postwar and contemporary art market (percentages)

	Auction location	United States	Europe	Asia	Middle East	Other
2000						
Postwar and Contemporary	New York (May)	60	30	2		8
	London (June)	31	65			4
2007						
Postwar and Contemporary	New York (May)	47	19	18		16
	London (June)	27*	62	10	1	

*including Latin America
Source: Christie's, 2007

Art research

Understanding the complexity of the art market has been made easier by the increasing amount of academic research, especially in the fields of art history, economics and sociology. Typically, more research is added during art market upturns, such as have been seen over the last 10 years. A significant number of books and other studies have been added by this book's contributors, and these are mentioned below.

Among art historians there is a surprising amount of consensus about art's good, better or best. Among the first 50 artists to whom scholars have devoted space since the 16th century, one-half have been recognized at all times.

Giorgio Vasari's *Lives of the Artists*, written in the 16th century, was one of the first to encourage viewers and buyers to make qualitative judgements about art, to create a canon of great artists and their great works. Using more sources, in the 18th century Johann Wincklemann's hierarchical system placed art in a wider context.

Today, the most studied and the most sought-after artists are often the same people. They include the familiar names of Pablo Picasso (1881–1973), Albrecht Durer (1471–1528), Peter Paul Rubens (1577–1640), Michelangelo (1475–1564), Leonardo da Vinci (1452–1519), Raphael (1483–1520), Rembrandt (1606–1669), Titian (1485–1576), and Francisco Goya (1746–1828). Their status is reinforced by the 800 institutions with art history departments worldwide which are dominated by western artists and methods of study.

In future, changes to the present order seem likely as more countries join the 10 that have developed their own art history textbooks in the last 25 years. Against this background, a monograph or *catalogue raisonné* can do much to increase the price of a new or neglected artist, as well as confirming the status of the better known.

Art market research mostly builds on Gerald Reitlinger's three-volume study of the London fine and decorative art auction market, *The Economics of Taste 1760–1970*, first published in 1961. There has been much art price research since the mid-1970s. There has been a steady growth in the number of academic papers on the economics of art investment, many of them featured in the *Journal of Cultural Economics* since 1977. Among these pioneers are William Baumol, William Grampp, James Pesando, Victor

Ginsburgh (the Belgium co-author of this volume), Bruno Frey, Guido Candela and William Goetzmann.

Possibly the most influential study during the last decade has been Mei and Moses's paper, 'Art as an investment and the underperformance of masterpieces' (2002), which measured over 8,000 repeat sale prices at auctions in the United States from 1875 to the present. Although it measures less than a tenth of the market, the results since 1952 demonstrate a return from art that is better than bonds but less than equities (see 'The investor', p 18 et seq.), especially under conditions of above-trend inflation and growth.

As a result of this ongoing research, an economic view of the art market is becoming *de rigeur* among the best art market writers. Currently, *The Art Economy* (2007) by Clare McAndrew (who writes on Ireland in this volume) provides the most up-to-date explanation of art, economics and related financial matters, written clearly for both academics and non-experts.

However no one but the aesthetically blind can see art in purely pecuniary terms. Much of the fascination of this book lies in the complex relationship between art's monetary value and its place in society and relationship with individuals.

The workings of the art market

The two levels in the art market are the primary and secondary trade, whose sales ratio tends to be one to three. The primary level deals with art that appears on the market for the first time. Dealers and buyers in the primary market tend to work on low margins and carry little stock, although there can be high rewards for successful artists and their intermediaries, and that in turn attracts others into the market. The secondary market consists of auction houses and dealers, mainly operating internationally and trading in work by established artists, with significant cash and stock.

The art market traditionally begins with the patronage system, whereby a person or organization supports the artist entirely for a period, during which they contract to produce specific works or a specified number of works. Well-established patrons make artists their own by contracting for their entire output in return for a monthly stipend. What pleases patrons depends initially on their own taste and judgement, and later on the judgements of others.

There is a complex relationship between wealth, knowledge, taste and creativity, so how the wealthy and powerful are educated becomes an important determinant of what they will pay artists to produce. A patronage system makes an immediate connection between what the patron wants and understands, and what the artist does. In an efficient patronage system, artists and patrons share conventions and an aesthetic.

However, the interests of the intermediaries who operate distribution systems frequently differ from those of the artists whose work they handle. A dealer will often want to hold a work for years while its value grows, but painters want their work shown, purchased and placed where they benefit from its being discussed. The dealer may also take a more long-term view than the artist. Put another way, the dealer's value needs to be viewed in terms of what artist and collectors can do on their own without a dealer's support.

Self-support obviously provides the greatest aesthetic freedom for artists, and with sufficient independent resources they can create their own distribution system. The growth of the art market liberates artists not only from the patron but also from the tyranny of mainstream taste. The one-person show, often held by almost unknown artists, has become a common sight in most artistic capitals of the world.

However, artists must rationalize their outsider status to become marketable, and distribution therefore has a crucial effect on reputations. This means that when we consider what constitutes great or important art, we will have to keep in mind the way in which distribution systems, with their built-in professional biases, affect opinion.

In the primary market innovative dealers bet on unknown works, and usually specialize in a style or school of art. Their objective is to give the work a public existence and impose it on the market. Dealers' mark-ups can range upwards from 50 per cent of the artist's wholesale price, but they operate within narrower price bands in the secondary market.

Between the dealer and the buyer are the art advisers and agents, roles that have grown up in the last 10 years. These advisers offer an all-encompassing consultancy role, working on commission, but carry no stock. Meanwhile the critics serve as a communications link between artists and the public, with some suggesting that journalists, although they may claim to act as critics, belong more appropriately to the realm of public relations. Critical writing importantly explains what the previous standard was, and shows how the new work is different.

In effect, critics and gallery owners collaborate to promote those artists whose innovations they find attractive. Most changes are therefore minor, and innovators must make a strong argument for a new practice.

Auctions

Auctions are used when markets have neither breadth (numerous buyers and sellers) nor depth (a number of closely related products that can be considered substitutes). Auction houses sell art from a wide range of sectors, in auctions which are mostly open to the public; they also appraise and promote works. They charge commissions to both buyers (buyers' premium on top of the hammer price) and sellers (vendors' commission from the hammer price). Auction price data is one of the few reliable sources of information about the art market. Because of these factors, sale at auction may gain the maximum price for the seller, especially when two or more people are bidding.

The transformation in the secondary art market is largely due to the activities of the two auction houses, Sotheby's (founded in 1744) and Christie's (founded 1766), which competed

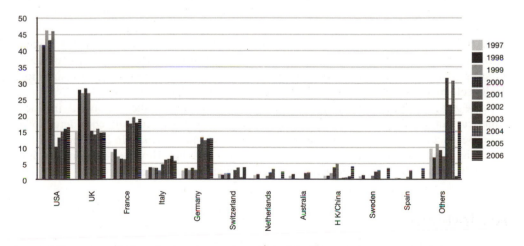

Figure I.2 Worldwide auction turnover and transactions by country, 2002–06 (percentages)
Source: Artprice.com, 2007

for market share throughout the 20th century. Along with the auction house Bonhams (established in 1793) they have almost a third-share in the global auction market. This has been achieved because of their historical reputation, and the process of 'going retail', which began in the late 1950s when the auction houses hired managers to read obituaries and look for estates whose contents might need to be auctioned.

The early 1970s was a period when estimates were first included in the auction catalogues and buyers' names were removed from the price lists. It was also a time when a buyer's premium was introduced to supplement the seller's commission. This charge was increased in 1992, and again recently for lower-priced lots up to $20,000.

Another ongoing development, since the late 1980s, has been for auction houses to provide guarantees and loans, and even to purchase works themselves, to encourage supply, provide publicity and inflate prices. These actions were much criticized because auctioneers are supposed to give unbiased and equal advice to buyers as well as sellers, and there were indeed some spectacular failures (see online material – link at end of chapter).

At a lower price level the market has been filled by the growth in online auctioneering since the mid-1990s. Until recently, the internet was considered less suitable for the auction of larger and more costly art because of the lack of specialist assistance to verify quality and authenticity. Improved technology has changed this. Today, many dealers consult the online auctioneer eBay for price information and to buy ceramics, silver and jewellery. eBay has 248 million registered users in 38 countries and turned over $52 billion in 2006 (a figure that has doubled since 2003). Of the sales, worth $14.4 billion in the third quarter of 2007, collectibles amounted to $2.4 billion, jewellery and watches $1.9 billion, antiques and art $1.2 billion, and coins and stamps $1 billion.

For 1.3 million eBay sellers, the site is their primary or secondary source of income. Typically sales on eBay are made at the beginning of a product lifecycle than in the middle, which is left to traditional retailers. On an annual basis sales on eBay would seem to be a significant proportion of art and collectible sales worldwide, mostly at the lower end of the market.

Art fairs

Key to the promotion of art in both the primary and secondary markets are the art fairs held internationally all year round. The first art fairs date from ancient Greece in the 4th century BC. For both consumers and exhibitors, fairs offer the widest opportunity and most efficient way to view and buy a wide range of art works from the past as well as the present.

Art fairs thrive not only during buoyant economic times but when the market is looking for new artistic direction. They are places where experienced collectors, dealers, museum curators, critics and academics come to exchange ideas and information. As a result most dealers claim to do over a quarter of their business at these fairs.

The *Art Newspaper* lists nearly 150 art fairs worth visiting in the year ahead, in North America, Europe, Russia, China and Japan. The top art fairs are generally considered to be Palm Beach, the Art Show, TEFAF, Art Basel, Frieze and Miami Beach. In 2008 these will be joined by new fairs in London, Dubai, New York and Istanbul. However, most of the fairs tend to be discreet about the volume of trading and other quantifiable activities.

Art indexes

There are three types of art price index measurement – average price, repeat sales regression and hedonic regression – all based on auction prices. The average price method is based on a

basket of art types or artists; repeat sale returns look at paintings sold more than once in the market, and hedonic regression analysis searches for, and quantifies, underlying forces behind art movements (income, inflation etc) or looks at interdependencies between the art and other factors (sale location, provenance etc).

The repeat sales method is now well established as an official measure in the property markets. In the art world, the best known study of art returns using the repeat sales methodology was produced by Professors Mei and Moses in 2002. It found that since 1954, from their measure of less than 10 per cent of the US art market and excluding transaction costs (which can be as much as 30 per cent, shared between buyer and seller), art returned slightly more than the US S&P 500 share index, and far more than US Treasury bonds.

The study further demonstrated that art performed best relative to other investments under conditions of above-trend inflation and growth, and worst under conditions of above-trend inflation and below-trend growth. Based on the Mei and Moses study, in 2005 a Barclays equity/gilt study for the first time since 1956 recommended a portfolio weighting over 10–20 years of 10 per cent in art. In work that I have pioneered, working with Maastricht University, the Mei and Moses study is now being enlarged to include repeat sales at European auctions.

Hedonic regression for the valuation of paintings has its origins as far back as the 18th century, when a similar measure was described as a 'clever way to characterize genius'. Roger de Piles wrote that 'nothing is easier to class than the value of painters by giving them points for composition, colour, facial expression in their portraits, and the means employed, such as drawing, water colours or oils'.

In the late 1970s, Willi Bongard made judgements of contemporary artists by their recognition in permanent collections of museums, one-person and group shows, and by

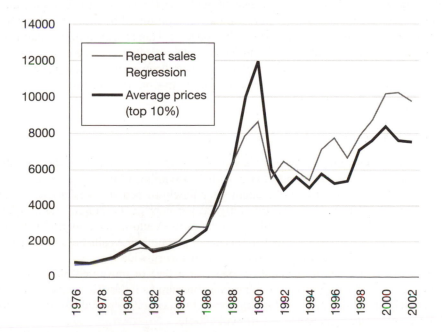

Figure I.3 Fine art price index measurement
Source: Mei and Moses (2002) and Art Market Research, 2007

notices in periodicals and on television. Bongard gave numerical values to his estimates of importance, and measured them against the current price of the artists' works. The results showed that as the estimates of importance increased by 10 per cent, the price increased by 8 per cent. Artists working in all mediums and in styles that were more modern and theoretical received the greatest price rises. In more recent studies of the secondary art market, Victor Ginsburgh (co-author of the Belgium chapter in this volume) discovered that the level of attribution was the key price factor. Today, the cutting edge of research is developing these theories using repeat sales data.

Corporate collections

For centuries it has been the policy of British banks specifically to collect portraits or commission silver, often as a way of decorating their boardrooms or directors' offices. However, most corporate collecting dates from the 20th century, following the example of IBM in the late 1930s and mid-1940s. Its two collections were displayed in New York's World's Art Fair and in San Francisco, later touring North and South America.

However, the 1980s brought a sea change in works being collected and the way they functioned in the business context. By the late 1980s there were more than 1,000 American firms listed as corporate art collectors, often employing full-time curators. By some measures, in 1990 the corporate share of the art market was 50 per cent outside New York and 20–30 per cent in New York. The most active buyers in the United States and the United Kingdom were banks, insurers and real estate companies, followed by manufacturing companies, many of which had started collecting in the 1950s. This was mainly to enhance public image, the working environment and the personal interest of directors, and was encouraged by tax concessions.

With the growth of corporate influence on public-sector exhibitions comes the question of whether scholarship and artistic expression are compromised by these developments – a kind of corporate takeover of public expression and taste. There are examples of public-sector exhibitions being dominated by individual corporate collections, especially in the 1980s. However the arguments are not dissimilar to those over the influence of patronage in general, and will continue for as long as artists require funds to live on while they work.

Museums

Many paintings belonging to museums are never exhibited to the public and are virtually inaccessible to art historians. In most cases, with the exception of the United States, it is estimated that only a quarter or half of a country's publicly owned art stock is ever shown. In 2007 in Britain it has been shown that only 20 per cent of the public sector's 150,000 paintings are on display. In some museums, such as the Victoria and Albert in London, the percentage shown is even less. Moreover, this major part of their wealth does not even appear on the balance sheet for many public-sector museums worldwide.

The solution may lie in the sale or loan (for a fee) of unwanted public-sector art, providing funds for buying other art or improving museum facilities. The cost equation would be further helped by the reduction of storage costs. In this curators would take the intellectual lead, sometimes contrary to prevailing art market taste.

However, it is feared that were a large number of paintings from public collections to be sold, it would cause a crisis of oversupply in the art market, resulting in lower prices and

ironically, less revenue for museums. Instead a slow public sector sale or de-accession has been suggested, when market conditions are favourable and when the sale revenue could be put to better use.

The aim of museums might be to buy art that is 'undervalued' by the market or during a market downturn, with the goal of exhibiting more widely the works that the museum possesses.

In today's booming art market current research suggests that there is a great opportunity to start this process. Following the lead taken by other countries, the process of documenting the 'hidden' paintings in Britain began in 2003 and will be completed by 2012, including availability online. Details of the inventory will include the art work's attribution, date, provenance, dimensions and published references listed by their current location.

Further solutions to cost problems could lie in measures that give museums greater freedom from governmental supervision, taxation on profits from the sale of art works, or other legal restrictions imposed by donors. This would encourage museums to be more enterprising and test new concepts, as well as forcing them to attract more visitors with more flexible opening hours, wider facilities and higher entrance fees. All of this is very familiar to US museums, which have traded in art on a regular basis from at least the 1980s, as well as being long-term beneficiaries of tax-favoured private donations and art loans.

Supply and demand

As in any market the fluctuations in prices for works of art have depended on the extent to which they are available and the degree to which people want to own them. This is particularly challenging because on one hand outstanding objects are by their very nature unique and never available in quantity, while on the other the number of people who are anxious to own them can be very small. Determined collectors must buy not only when they think the price is right, but when an opportunity offers itself.

In the secondary art market, supply benefits from debt, divorce and death. It is said that in an era of political and financial crises art has become a gilt-edged commodity. Today, sales to meet tax bills provide auction houses with the greatest flow of works.

In terms of demand, the crucial factor is value and the relative value of money. As household wealth increases, so do purchases of most types of art, though usually only when a certain threshold of wealth is passed. Some believe that as a country's economy improves and it becomes cash rich, the quality of the art it produces also improves and it becomes recognized internationally.

Reflecting economic growth, currency flows can have an effect on the sale of art. For example, Japanese buying power nearly doubled following the appreciation of the yen after 1985. When translated into yen, many of the already highly priced paintings, especially Impressionist and modern art, appeared as bargains to many Japanese. By 1988, 53 per cent of all worldwide auction sales were to Japan.

Today, the art market reacts ever more quickly to financial shifts into stronger currencies. For instance, the quadrupling of the oil price since 2002 has led to a much more rapid development of the Middle Eastern market, especially in Dubai. In some cases, undervalued currencies can provide arbitrage opportunities, especially for the long-term collector.

Sale location also often adds to value. Today, according to artprice.com, works of art sold in New York and London, in particular works by French Impressionists, sell for more than their equivalent in the other art capitals. Conversely, Europeans have a greater propensity to buy Old Masters than do Americans.

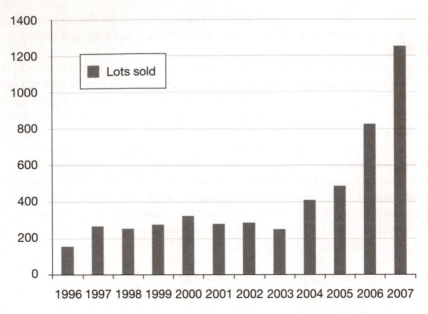

Figure I.4 Number of lots of artworks sold for over $1 million, 1996–2007
Source: Artprice.com, 2008

Value

However imperfect, the market is the only mechanism for putting a monetary figure to art's intangible value at any given moment to any particular person or group of people. When we buy something we tend to believe it is worth the price. Even the French Impressionist painter Pierre-Auguste Renoir (1841–1919) once said, 'There's only one indicator for telling the value of paintings, and that is the sale room.' These events are stimulated by the consensus which adheres to the prevailing social, cultural and economic circumstances at home as well as abroad.

A portion of price will always remain unexplained because of time, taste, place and random elements, because each work has unique qualities and its sale may have unique circumstances. It is therefore impossible to predict with complete accuracy the price of any given object at auction.

The convention in the auction market is to estimate the lower and upper range of prices based on similar objects sold previously. Clare McAndrew proposes a formula whereby the price of art is determined by the characteristics of the artist, the characteristics of the art work and the characteristics of the auction (altogether manifested as the reserve), plus the unexplained auction premium.

Fashion is the most intangible factor of all. In many ways it is dictated by the economic cycle: as one type of art becomes too expensive, another replaces it, and so on in a continuous cycle. The birth and growth of new taste is often the result of some initial unfathomable and illogical shock to the senses from something unexpected which challenges the accepted norm. Often it is decided by a few leaders of public taste who have a talent for influencing others' opinions. If one believes the thoughts of Howard Becker, a mere shock is not enough: an artist has to establish an 'art world' or 'circle of creativity' where he or she is accepted, in order to be successful, socially or financially.

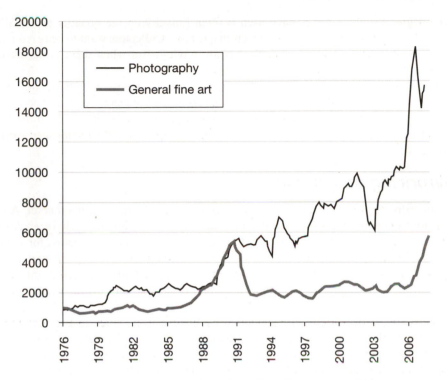

Figure I.5 Photography and fine art, index value of top 10 per cent in US$ real terms, 1976–2006
Source: Art Market Research, 2007

Indeed the value of works by a new artist rise as this 'circle' is created. Prices rise as an artist obtains more exhibitions and prizes, and shows his or her work at more prestigious galleries. The longer an artist continues to sell works at increasing prices, however gradually, the longer their value can be expected to be maintained. Death is of course nearly always beneficial to prices, at least in the short term, because of the inevitable restriction it places on supply.

The intrinsic components in art valuation in decreasing order of importance are materials used, quality, artistic merit, condition, subject matter, size, and the age and place of residence of the artist.

A study described in the *Art Newspaper* showed that the highest prices were gained for works that featured beautiful young women and children, higher social status, sexiness, horses and figures in landscapes, sunny scenes, flowers, calm water, attractive dogs and game birds, as well as bright and bold colours. In particular, Calin Valsan (co-author of the chapter on Canada) found a significant relationship between painting characteristics, especially subject matter, and market valuation in his study of Canadian and US paintings.

A range of market or secondary factors which influence art's intrinsic value include authenticity, attribution, artist's reputation, historical importance/familiarity, provenance, complementary taste/fashion (interior decoration/architecture), sale location and sale inducements.

The accuracy of attributions has changed dramatically thanks to technology, although X-rays, ultraviolet light and microscopes can still only assist connoisseurship, rather than lead

it. The degree to which prices have risen is often linked with the quantity and quality of published supporting material on the objects in question. Collectors want to be reassured that they are really buying what they think they are buying. But when there is no literature, judgement and therefore value are much less certain.

Art market mistakes may be compounded by the vagueness of cataloguing and the tendency to merge academic scholarship with the art trade. For example, it has been claimed there are 8,000 paintings by the French Realist Camille Corot (1796–1875) in the United States alone, which is astonishing considering there are only 3,000 authenticated works by Corot in existence.

Overpricing and bubbles

A major value factor often mentioned by auctioneers is freshness on the market. An item that is not from a private source and that may have appeared comparatively recently on the market will lead to a lower hammer price than one that has been in a collection for a number of years. The cardinal sin is to set the price or reserve too high, meaning the work does not find a buyer, since lowering it is not an option as it signals failure. To lessen this, dealers rely on offering discounts to long-time collectors, or take a work off the market until the public forgets.

The perils of overpricing are supported by historical evidence in the contemporary market that works of art which sell for exorbitant prices during an artist's lifetime often turn out to be poor long-term investments. In particular, prices that increase around the time of artist's death often fall afterwards. Examples in the 19th century include Lawrence Alma Tadema (1836–1912), Claude Monet (1840–1926) and Edgar Dégas (1834–1917). Conversely, it is well known that Vincent Van Gogh (1853–1890) sold only a single painting in his lifetime, yet his work held many art price records throughout the 1980s and 1990s.

However, in the art market it can be hard to find a buyer at any price after bubbles burst. Partly because of this, most collectors have held onto their art for an average of 30 years over the last 125 years. There have been many aristocratic families who have clung to their family heirlooms when all else has vanished.

Nevertheless, what emerges from a study of prices is that a work of art is the best investment over time if the choice of work is directed by pleasure and taste. Indeed, art's appeal may lie in the fact that no amount of sophisticated economic analysis can ever determine something that operates outside the economic framework – changing tastes. But the influences that create value in the marketplace are many and varied.

Value creation

The art market consists of objects which are held to embody an intellectual value and add to our understanding about the world. Financial value is created as much by the importance of the collector and similar collections as by the authentic qualities of the piece itself. The price itself conveys information, affects behaviour and can then distort all other values. Values are therefore very difficult to predict without an expert's knowledge, and even that is fallible.

Buyers are often governed less by intrinsic beauty than by the honour and prestige of possession of a work. Prices come to signal quality or status, and confused buyers see high prices as a guarantee of aesthetic quality. They also make collectors feel secure about acquisitions they have made in the past or intend to make in future.

Dealers and artists therefore have an incentive to ensure scarcity and control supply. If a collector's belief in value is harmed because of a price decrease, the consequences can be dramatic. Dealers therefore prefer to be seen to offer price discounts rather than to succumb to price reductions. They play the multiple roles of gatekeepers, brokers, confidants and patrons of the artists.

The art market is not just an economic but a signifying act: prices, price differences and price changes convey multiple meanings related to the reputation of artists, social status of dealers and quality of the art works. In the end appreciation of art works is dependent on the social context in which they are seen. The difference between the current market price and original acquisition price serves as a status symbol. Prices also establish status hierarchies among artists, and by confirming the rise or decline of artistic movements the price system structures or provides order to the art world historically and geographically.

High prices also structure the relationship of art to the rest of society. A large expensive art work therefore has to carry a considerable amount of cultural language.

Museums overarch this system of collecting as a point of intellectual reference. However, there is a love/hate relationship between museums and collectors because curators exercise crucial control over collections which are necessarily kept separate from the workings of the market, thereby avoiding the corruption which could fatally undermine the whole value system. Museum curators will not give valuations, but by standing at the pinnacle of the authentification process they allow the market to function, and by accepting new kinds of collections they enlarge the canon of accepted and marketable art. Works that enter museums usually remain there because of the rules laid down in bequests. There is no higher position for an art work than for it to become part of a museum display.

One of the main ways in which private and public relationships are blurred in the art market is that trustees of public museums are often wealthy individuals. They may be offered these positions because they have assisted, or it is hoped they will assist, the museum by providing gifts of money or art. In return they understandably look for positions of influence or control.

Like dealers, museum directors and their trustees have interests which may differ from those of artists. The institutions can also exert a conservative effect, leading artists to produce only the kinds of work that institutions are willing to accept. Official public commissions generally go to those practising artists who most clearly represent established values and artistic styles. In this instance, change in artistic direction is caused by artists standing outside this system.

Authenticity

Establishing the authenticity of a work of art is vital. Where prices rise, the incidence of forgery rises too. Publicity around forgeries can be extremely damaging and frightens away would-be art purchasers. Forgeries fall into three categories: deliberate fabrications; replicas, reproductions and copies to deceive; and altered art. There is a real temptation to exaggerate attributions which are less than certain, and some of the best forgeries have even been exhibited as originals.

Penalties for forgeries can be slight compared with the potential profits. Bills of sale including detailed information about the art work may be the best preventive measure prior to stylistic and scientific investigation. Other preventive measures include the art registry established by the art community, especially for living artists.

Despite this, it is difficult for the purchaser to hold an innocent seller liable for a mistake or misrepresentation. Moreover, the threat of time-consuming and costly litigation can make honest experts such as museum curators reluctant to give advice. The result of any enquiry is therefore often based on accumulated opinion, sometimes educated guesses, balanced in the public interest.

Art and tax

Activity in the market has a direct and simple correlation with the tax status of art. The less demanding the tax burden, the greater the art trade, and the higher the tax incentives, the bigger the art donations to the public sector in each country. More valuable art works are shipped to where the conditions of sale are the most advantageous.

Among the main reasons for US dominance in the art market are the low taxes on works of art and a duty-free status for works of art and objects over 100 years old. For instance, transport, insurance and hammer price give the value for import tax purposes. Costs on an imaginary international sale of a Mark Rothko (1903–1970) painting valued at £16.359 million would be marked up differently in Europe and the United States. The United Kingdom would levy 5 per cent import VAT, Switzerland 7.6 per cent, France 5.5 per cent, and the United States would charge a negotiable bond fee or customs merchandise processing fee, starting from $1 per $1,000 up to $4 per $1,000.

In the European Union there is a minimum 5 per cent import VAT rate, with some countries allowed to set higher rates (ie Italy has a rate of 10 per cent). This has been a strong disincentive for collectors who buy works outside the European Union to bring them permanently into the Union. Until 1995 the United Kingdom was the only zero-rated country in the European Union, and when a 2.5 per cent import VAT was introduced, imports fell by 40 per cent. Because of this the United States and Switzerland are set to benefit from more trade.

In addition to this, the artists' resale royalties tax, known as *droit de suite* in the European Union, has been adopted in 47 countries including 11 EU Member States. However, it is not law in Switzerland or the United States, except in California. The law was first codified in France in 1920 to benefit artists' widows after WWI. It enshrines the rights of artists to a percentage share of the earnings from the resale of art works such as original manuscripts, paintings, drawings, prints, sculpture, tapestries, ceramics and photos.

In the European Union this right applies to art works sold up to 70 years after the creator's death, with the payment being made to the artist's family. Today, that includes modern artists such as Henri Matisse (1869–1954) and Pablo Picasso. The rates are on a sliding scale from 5 per cent up to €50,000 to 0.25 per cent above €500,000, to a maximum of €12,500.

Some believe relations between artists and dealers suffer as business is driven abroad. For instance, American dominance over the French in modern and contemporary art may partly be caused by the *droit de suite*. The measure attracted a storm of criticism in the United Kingdom at its introduction in February 2006, and there were specific fears of the damaging effect on the market for art works sold around the £50,000–100,000 mark. However, there is no evidence to date that it has harmed the contemporary art market.

The collector

From its earliest years a child exhibits the instinctive actions of a collector. The Bible would have us believe that Noah was the first collector, and was one of the few to achieve the complete set of anything (male and female animals saved on the ark). Over the centuries art has been amassed for purposes of propaganda, prestige, intellectual enlightenment and sheer pleasure.

The collector's mania embraces the selfish desire to own things for yourself, the altruistic desire to own them for others, and the somewhat crude desire to stop anyone else owning anything you happen to fancy. The taste for collecting is like a game played with utter passion with the dedicated collector, who needs the flair of a hunter, the mentality of a detective, the objectivity of a historian and the natural cunning of a horse dealer.

It involves a permanent conflict between what the eye sees and what it reads, between instinct and scientific research. Collectors can go through spiritual agony at the thought that some object has escaped them, and will deprive themselves materially to prevent its doing so. In the 18th century Catherine the Great of Russia said of her collection, 'It is not so much a love for one solitary thing as a succession of jealousies.'

As a rule, the greater the curiosity, the better the collector. The best collectors have a clear understanding of why they respond to certain kinds of work and can clearly articulate these ideas. It is a general rule that the more resolved the criteria, the greater the credibility of the collector.

Collectors are not just born, they are made, or rather make themselves, by following basic rules. Sometimes the theme of a collection will focus around clusters of artists who belong to the same school, known as vertical collecting. Horizontal collecting in contrast involves the acquisition of a wide range of art without specific focus on any particular artists, medium or theme.

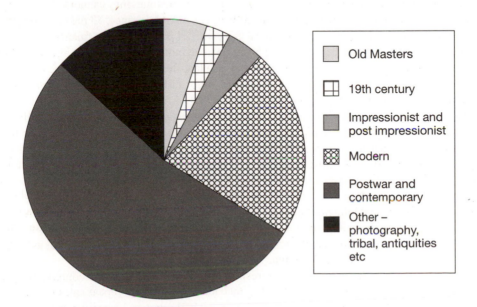

Figure I.6 Top 200 collectors by art type, 2006
Source: ARTnews, 2006

For the wealthiest of collectors, building a collection is inseparable from building up wealth and prestige. Wealthy people have collected art alongside stocks and bonds to prove their own cultural as well as economic standing. Money, it is said, creates taste, although the extravagance of pop stars may not always translate instantly into what, say, the curator of a London gallery would consider tasteful! The billionaire collector Jean Paul Getty believed that 20th-century people could not be transformed into cultured, civilized human beings until they acquired an appreciation and love for art. Such a high ideal did not, however, prevent him from rejecting paintings if their cost per square inch seemed too high.

Collectors have had a lasting impact on the way that art is exhibited and perceived, and even what kind of art is produced. Being in a famous collection gives art works a special aura. Many of the museums founded in the 19th century, especially in the 1870s in America, were built up from donations of private collections mainly for the benefit of the general public. From that time, museums promoted national identification and symbolized a nation's cultural prowess.

In the contemporary art market the collector's influence is broader today than any other time in history. From being a strictly specialist subject catering for a small elite, contemporary art has entered the cultural mainstream. The obsession with consuming the contemporary can be seen as an inevitable product of a high-speed, novelty-seeking and commercially driven era. These collectors secure social status by surrounding themselves not with the art of the past but by supporting radical living artists who, they believe, express the spirit of the times. As a consequence, today's expanded contemporary art world offers more opportunities for collectors of all incomes and inclinations than any other time.

The investor

Like twins it is hard to tell the investor from the collector. Sometimes they cannot tell themselves apart. In a survey of the art-owning public in 2003 by AXA Art Insurance, 73 per cent bought art for enjoyment and only 3 per cent for financial gain, with 24 per cent mixing financial incentives with their collecting. Nevertheless, buying art as a viable individual investment alternative was seen as a practical proposition for 87 per cent, but on a long-term basis.

Art investment is not new. It has come in and out of fashion almost as many times as the economic cycle, which it follows somewhat unpredictably. Louis XIV used to advise his friends to buy modern pictures as an investment. Today, the interest in art investment dates from 1730, when there was a noticeably sharp increase in prices for art works. In the 19th century these trends were accentuated when the daily newspapers started reporting art sale prices regularly.

Over the last 30 years, most economists have perceived art as at worst a lacklustre and risky investment, and at best an excellent one. In the main, the lack of information, heterogeneity, vagaries or excesses of supply, and low or no income, resulting in high transaction costs, low liquidity and long holding periods, prevent art from developing into an investment asset. Furthermore, the capital appreciation has to be much higher than most assets to make up for the cost of acquisition and disposal, valuation and provenance research fees, as well as tax, insurance, conservation and storage.

But at best, the returns on art can be respectable. For example, at the contemporary art auctions in London in June 2006, 44 of the 697 lots measured by repeat sales returned an annual average of 13.14 per cent to their owners after the buyers' premium but excluding other smaller costs, according to research by this author and Dr Rachel Campbell (co-author of the Dutch chapter).

Most of the economic papers on the art market since the 1970s have been dedicated to its risk and return for the purpose of asset diversification. Art price movements are most closely correlated with real estate and commodities, and least with bonds and cash.

However, as part of a diversified portfolio of stocks, art works have proved a good overall investment because they can lower risk while providing higher rates of return over the long run. This was especially the case between emerging art markets and international equities. Moreover, some art, such as Dutch Old Master paintings, has a low correlation with other art, such as French Impressionist paintings.

Added to this an increasing number of companies are accepting art works as collateral against loans because at the very least some works, when carefully selected, tend to hold their value against inflation. Psychologically, art-backed loans also add depth and stability to the art market. Loan rates range from 3 per cent over the prime interest rate to 15 per cent for between 40 to 50 per cent of the estimated value of the work because of the risk involved.

At Sotheby's (in effect, acting as a finance house), the minimum loan is $1million, rising to a total of $3 billion, and loans are mostly used by estates to pay inheritance taxes. Art-backed loans at Citibank, which have been offered since 1979, have doubled in value in the last five years. They are also a practice long offered by Christie's and the Bank of America. Contemporary art accounts for much of the current interest in this field, owing to its greater liquidity, more frequent trades and a growing belief in its long-term value.

Art investment has been given a further boost by the growth in rental income from art in both the private and public sectors. Using American antique furniture as an example, its total return including rent and capital appreciation stood comparison with yields on financial instruments, though this was partly offset by the added costs of insurance and deductions for damage. A recent example is the collector Charles Saatchi's catalogue of 600 works for rent,

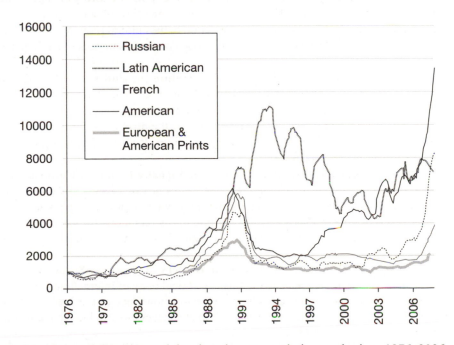

Figure I.7 Sales of emerging and developed country paintings and prints, 1976–2006
Source: Art Market Research

which includes work by many well-known artists. These were offered at a cost of £7,000–20,000 per year for five to 20 works, including special lending packages for exhibitions. It was projected that this might bring in £150,000 a year to defray the costs of running his gallery.

Art and the law

The most valuable items naturally attract (among others) the most unscrupulous of minds. It is no accident that a significant amount of trade in art is at the centre of a web of criminal activity, particularly involving burglars. The present art boom, serious economic problems in less-developed countries and political instability have led to the explosive growth of art crime.

The value of stolen art is estimated at about $5–8 billion a year, and looted objects are thought to reside in several museums. A large proportion of most important collections are uninsurable. Interpol regards international art crime as among the largest of its crime categories, third only after drugs and the illegal arms trade. Money laundering is also intimately connected with art.

Most countries now have legal provision aimed at protecting and preserving their national heritage, based on bilateral and multilateral treaties, which in some cases provide for the extradition of offenders. While the example of the looting of Iraq highlights the deficiencies of international conventions to prevent international traffic in stolen art works, there is an established framework of agreements now in place.

■ **The Protocol to the Hague Convention for the Protection of Cultural Property in the Event of Armed Conflict (1954)**, which incorporates the rules of the 1907 Hague Convention. Signed by 82 states, it gives protection to the cultural properties of any nation from war and in peacetime, and is enforceable based on the assurances of participants via UNESCO.

■ **The UNESCO Convention on the Means of Prohibiting and Preventing the Illicit Import, Export and Transfer or Ownership of Cultural Property (1970)**: this umbrella agreement, signed by over 1,200 countries, covers everything from rare flora and fauna to fossils and works of art, and allows for the recovery of articles not accompanied by documentation from their country of origin. It also includes a provision on illegal export from occupied territories.

■ **The 1995 UNIDROIT Convention on Stolen or Illegally Exported Cultural Objects (1995)**. Signed by more than 20 countries, this allows private owners as well as states to have direct access to the courts of another country where cultural property stolen from their owners is found. It also sets generous time limits on claims for stolen property by signatory states (in effect up to 75 years), and establishes compensation rules for innocent parties involved.

■ **The 1999 International Code of Ethics for Dealers in Cultural Property**. This is a self-regulating measure intended to establish an ethical body of international dealers who will distance themselves from stolen works. Organizations such as the Art Loss Register, which works in cooperation with the art trade, have successfully helped to recover many thousands of art works worldwide.

■ **The 2001 UNESCO Convention on the Protection of the Underwater Cultural Heritage**, designed to help protect history found in shipwrecks and other underwater sites.

A new age and a shift of economic power

Capital has for the last decade moved consistently away from the old centres of North America and Europe. Its destination is diverse, but if the past is any guide, where there is money, and the freedom for individuals and institutions to spend it as they wish, the arts and artists will prosper.

The emerging markets hold much of the potential for the global art market. In 30 years' time it is predicted, based on market exchange rates, that China will be a bigger economy than the United States, which will be followed by India, Japan, Mexico, Russia, Brazil, Germany, Britain and France.

In 2006 there were 9.5 million people globally with assets worth more than US$1 million, representing an 8.5 per cent increase on the previous year, according to the latest Cap Gemini/Merrill Lynch World Wealth Report. The number of ultra high net work individuals (HNWIs, those whose financial assets exceed US$30 million) grew by 11.3 per cent to 94,970 worldwide. Most of these are in Latin America, Africa, the United States and the Middle East.

According to the same survey, HNWIs are willing to allocate 10–20 per cent of their US$32.7 trillion combined wealth (a figure that is expected to rise to US$51.6 trillion by 2011) to alternative investments including 'investments of passion', of which over half would be allocated to art and collectibles.

Because of the doubling of financial wealth in the 21st century and the quest to avoid tax, the top economies by GDP per person are the offshore financial centres (OFCs) of Bermuda (per capita income $70,000 per person), Luxembourg, Equatorial Guinea and UAE. Their GDP per capita is above the USA's $43,500.

The wealth amassed by government-owned sovereign funds in Russia, China, Abu Dhabi, Dubai, Singapore and Norway has now reached $1.5–2.5 trillion. Much of that money is looking for alternative investments, although so far there is little evidence of it finding its way into the global art markets.

The last 10 years

In the 10 years to 2007, the overall art market trend has been the trade divergence between the modern/contemporary art markets and art works over 100 years old, popularly known as antiques. According to world art trade figures, in 1997 the differential was about 4:1 and by 2006 it had risen to around 6:1.

Since 1997 the average price of the top 2 per cent of western fine art in US dollars has risen nearly three times, according to Art Market Research. Allowing for inflation the index of 117,457 art works by 102 artists sold at auction is now 10 per cent above its previous peak set in September 1990. Much of that rise was achieved after October 2005.

Table I.2 Projected growth in GDP (percentage increase over previous year), 2008

EU 27	2.1
Russia and CIS	6.6
Asia and Australasia (excluding Japan)	6.6
North America	2.2
South America	4.5
Middle East and North Africa	5.6
Sub-Saharan Africa	6.3

Source: Economist Intelligence Unit, 2007

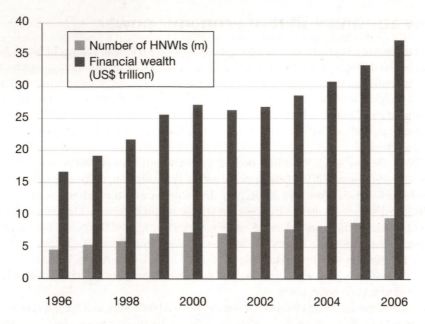

Figure I.8 Number and wealth of high net worth individuals, 1996–2006
Source: CapGemini/Merrill Lynch, 2007.

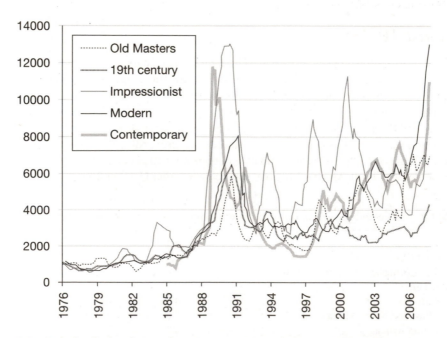

Figure I.9 Painting index (price of top 2 per cent in real terms), 1976–2006
Source: Art Market Research, 2007

A recent survey by artprice.com noted that many art works bought at the height of the boom in 1989–91 were again being offered for sale in 2006. However, it warned that historically the upper end of the market is the most vulnerable market segment, susceptible to dramatic price falls and increasing numbers of unsold works. For the moment though several categories are attracting attention.

Old Masters

Historically, the Old Masters have proved themselves as sound, if staid, investments time and time again. In the last few years the market has remained strong, with many new buyers and a keen interest in excellent provenance. In particular the Americans pay high prices for their own painters of this period.

Domestic art markets have also been opened to international competition, and this has given a boost to the international market for Old Masters. In Spain, where this has happened, the price of paintings has risen especially for Francisco Goya (1746–1828), El Greco (1541–1614), and Bartolome Murillo (1617–1682).

In 2002 Ruben's *Massacre of the innocents* sold for $76.6 million (equivalent to $86 million today). It was the most expensive painting in the world that year, and still at the time of writing holds the record for the most expensive Old Master.

The New York auctions in January 2007 set a record for an Old Master sale, with 14 works sold for more than $1 million and auction records established for Francisco Zurbarán (1598–1664), Joseph Wright of Derby (1734–1797), Bartolommeo Bandinelli (1493–1560) and Pierre-Joseph Redouté (1759–1840). Whether this interest will last is another matter, and some critics describe the market as patchy, unexciting and lacking in quality.

Impressionists

By 2005 the major Impressionist artists were again highly profitable to their buyers, as were a second rung of more minor Impressionists. Notable among them were Monet, Paul Cézanne (1839–1906), Paul Gauguin (1848–1903), van Gogh, Renoir, Georges-Pierre Seurat (1859–1891), Henri Rousseau (1844–1910), Eugène Boudin (1824–1898), Camille Pissarro (1830–1903), Alfred Sisley (1839–1899), Henri Fantin-Latour (1836–1904) and Berthe Morisot (1841–1895) plus Paul Signac (1863–1935), Gustave Caillebotte (1848–1894), Albert Marquet (1875–1947), and Henri Le Sidaner (1862–1939).

Table I.3 Changes in the price of different categories of art over time

Category	Peak	Change from peak[1]	Average price (US$ million)[2]
Old Masters	November 2007	+18 %	1.12
19th century	September 1990	−33 %	0.267
Impressionist	July 1990	−32 %	3.1
Modern	November 2007	+62 %	1.35
Contemporary	January 1989	−7 %	1.82

Notes:
1 Percentage above/below the 1989–91 peak in November 2007.
2 Average price of the segment and section of the art market (ie top 10% of category).
Source: Art Market Research, 2007

However, at a Sotheby's auction of Impressionist and modern art in November 2007 in New York a much-advertised van Gogh failed to reach expectations and went unsold despite guarantees to the owners. Other artists that failed to sell included Sisley and Renoir. The *Art Newspaper* reported that despite strong results overall, the signs are that the extraordinary growth of recent years is cooling.

Modern art

In the 21st century the prices of modern art grew faster than any other genre. In 2006, six modern artists appeared in the top 10 by turnover, representing 19 per cent of the market's value but only 1.25 per cent of transactions, according to artprice.com.

The March 2007 Impressionist and modern painting sales in London were the highest ever recorded. At the November sales in New York there was a record of $33.6 million for a Matisse. The owners of a Lyonel Feininger (1871–1956) and an Amadeo Modigliani (1884–1920), bought less than 10 years ago, more than doubled their investments. But it was the Picasso phenomenon that outperformed even the most optimistic forecasts. In 2000 Picasso broke more records than any other artist, and in 2004/5 season the highest price ever paid for an art work, at $93 million, went to *Garçon à la pipe*.

Postwar and Contemporary artists

During the 21st century the contribution of living artists to auction turnover has doubled to 17.6 per cent of the total, with prices climbing 12.6 per cent, according to artprice.com. Contemporary photography performed particularly well.

At the May 2007 auctions in New York another 100 artist records were added. Notable previous records included David Smith's (1906–1965) *Cubi XXVIII* selling for $21 million in 2005 and Willem de Kooning's (1904–1997) *Untitled XXV* making $27 million in 2006. In 2007 The *Art Newspaper* reported a record sum spent on contemporary art in June, with auction prices averaging over £1 million per lot.

Today, the market continues to grow, especially in the United States and even at the lower end, with prices often paid at the upper end of the estimates. The series of contemporary sales in New York in November 2007 made $883 million, with barely any lots failing to sell and adding artist records for Jeff Koons (b 1955), Richard Prince (b 1958), Lucian Freud (b 1922), and Takashi Murakami (b 1962). The market has, as we have seen, become truly global. Art works that have never before been exposed to an international audience are emerging blinking into the sunlight – the effect has been dramatic for artists and collectors alike.

China

In 2004–05 the Chinese artist Zao Wou-Ki (b 1921) was the first living Asian artist to sell for more than £1 million. Since then Chinese contemporary art sales have exceeded all expectations. By 2006 a quarter of the top 100 contemporary artists by value were Chinese.

Zhang Xiaogang (b 1958), whose painting *Chapter of a new century – birth of the People's Republic of China, 1992* at $3 million achieved the highest price paid for a Chinese contemporary art work, was the second highest priced contemporary artist by sales in the world in 2006.

Sotheby's sale of contemporary Chinese art in Hong Kong on 9 October 2007 brought a house record of $21.9 million. Today, more countries, such as Switzerland and France, are auctioning Chinese contemporary art and more exhibitions are being held in the west, while in China more collections are being displayed, including at government-sponsored museums.

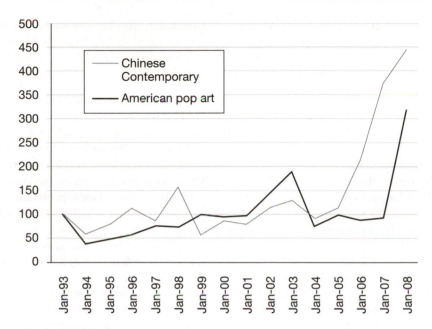

Figure I.10 Prices for Chinese Contemporary and American Pop Art, 1993–2008
Source: Artprice.com, 2008

Hong Kong was traditionally the centre for the Chinese art market. This century has seen Beijing and Shanghai in the ascendancy, with the former having more galleries and artists, while the latter has earned a reputation for being more modern, cosmopolitan and dynamic.

India

The prices of Indian contemporary art have risen by 480 per cent since 1997, especially for works by Francis Souza (1924–2002). A new artistic environment has arisen in India where collectors select works on the basis of their intellectual merit and investment potential.

A number of galleries and organizations have also begun to promote contemporary Indian art outside the auction houses and outside India. In 2006 sales of Indian contemporary art totalled over $3 million, and SH Raza's (b 1922) *Tapovan* was the first to sell for more than $1 million. At Christie's first auction in Dubai in 2006 Indian contemporary art made $6 million and set over eight new artist records.

The Indian art market is thought to be worth $250 million, with Christie's own dedicated sale of Indian modern and contemporary art on 20 September 2007 bringing in a total of $17,811,360. However, in 2007 there have been frequent warnings about oversupply, and the profusion of fakes. In the first nine months of 2007 there was a slowdown in Indian art prices, leading to a 30 per cent fall after a three-year rise of 100 per cent, according to the ET Osian Art Index.

Latin America

In 2005, auctions of Latin American art exceeded $11 million. Most of it was sold to international collectors especially Americans. In May 2006, a new record for a Latin American artist was set with Frida Kahlo's (1907–1954) *Roots* selling for over $5 million, in a two-day sale

which brought in $23 million. The Museum of Modern Art, New York says it is now aiming to buy more Latin American art.

The Sotheby's/Christie's axis

Fine art auction turnover has grown three or fourfold since 1997, to an estimated $6.4 billion in 2006 (52 per cent more than 2005) at 9,200 auctions (9,600 in 2005). The sales ratio of fine to decorative art was approximately 70:30 in 2006. In that year, Christie's and Sotheby's accounted for 46 per cent of the world's fine art auction sales. Christie's worldwide turnover was $4.67 billion, which was a 36 per cent increase on the previous year. This was based on 600 auctions (in the late 1980s Christie's held 1,400 sales per year) in over 80 categories at 16 worldwide locations. Included in the total was $256 million worth of art sold privately.

During 2006 Sotheby's worldwide turnover was $3.66 billion, which was a 36 per cent increase on the previous year. Its sales in the first quarter of 2007 increased 54 per cent to $147.4 million yielding a profit of $24.3 million. This performance was reflected in Sotheby's shares. Since mid-2005 its share price has risen from $15 to over $50 by mid-2007, including a 62 per cent increase in 2007.

For all their dominance of the market Christie's and Sotheby's are not without their problems. The auction houses' practice of offering price guarantees to encourage sellers and to sustain the high prices for the 'best' art works backfired in November 2007 at an Impressionist and modern art sale in New York. Poor results at the sale resulted in a 35 per cent plunge in Sotheby's share price. The guarantee system operates so that the proceeds above an undisclosed price are split 30/70 between the auction house and seller. In 2006 it was estimated that the amount guaranteed by the auction houses increased 51 per cent on the previous year, reaching over $540 million during the May 2007 auctions, mostly for contemporary art. In November the amount guaranteed was three times the previous year's total.

Trading charges have also increased in 2007. The buyer's premium for lower-priced lots was increased by Christie's to 25 per cent in September. This is levied according to national and regional market conditions: up to $20,000 in the United States, £10,000 in the United Kingdom, €5,000 in Europe and HK$150,000 in Hong Kong. The buyer's premium up to $500,000 remains at 20 per cent and 12 per cent above that amount. At Sotheby's the threshold for all consignments is $5,000.

Successful auctions conducted by Christie's in Dubai and Abu Dhabi turned the market's attention to the Gulf States. Dubai supreme ruler Sheikh Mohammed bin Rashid Al Maktoum claims he wants to establish his emirate as a global art centre to rival New York and London. He has sponsored the first international DIFC Gulf Art Fair, while in neighbouring emirate Qatar, no fewer than five museums have been designed by superstar architects and in Abu Dhabi there are plans for four world-class museums.

Table I.4 Percentage breakdown of Christie's sales in 2006

Category	Country of sale
Impressionist and Modern – 26	United States – 45
Post War and Contemporary – 18	UK – 29
Asian art – 9	Hong Kong – 7.5
Jewellery and watches – 8	France – 5
Old Masters – 5	

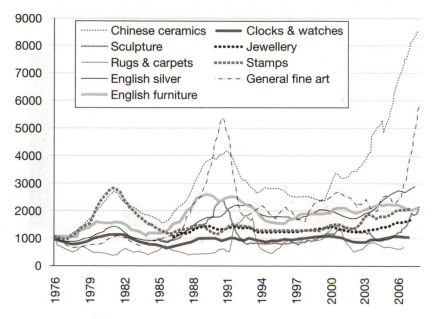

Figure I.11 Auction sales of decorative art and collectables, 1976–2006
Source: Art Market Research 2007

Art fairs

Art fairs are also thriving as they usually do in buoyant economic times, bringing together experienced collectors, dealers, museum curators, critics and academics to exchange ideas and information. The fairs are evenly divided between North America and Europe, with the recent addition of China and Japan. However, the competition between the fairs for exhibitors is high and audience ratings are intense. Hence, most of the better fairs tend to be discreet about the volume of trading and other quantifiable activities.

The oldest existing art fair is the Grosvenor House Art and Antiques Fair, London, which was founded in 1934, and from 1960 Art Cologne was the first fair to concentrate exclusively on modern and contemporary art. In 2007, the three newest major art fairs were in Moscow, Shanghai and Dubai.

To help new buyers in the ever-proliferating art market, another development has been the growth in art advisers and agents, which the *New York Times* first noticed in 1997. These advisers mediate between buyer and seller or artist and buyer, offering an all-encompassing consultancy role working on commission.

Tax and the global art market

Figure I.12 shows the return on capital for the leading UK art market companies by recognized quality and turnover, ranging from £143,000 up to £143 million (approx. $265 million at the exchange rates at the time of writing). The sample includes 37 dealers, five auctioneers, online auctioneers and an art fund.

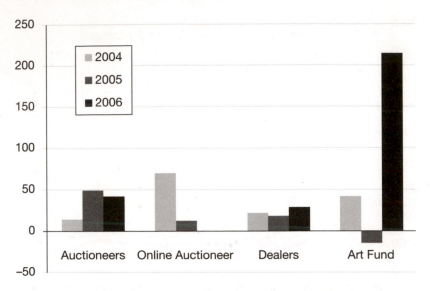

Figure I.12 Return on capital for selected firms in the UK art market, 2004–06
Source: FAME, 2007

Within a global market collectors have become increasingly mindful of where they buy and sell, mainly because of tax. From 1998 to 2001, according to a European Art Fair (TEFAF) survey, the average price of a painting sold in the United Kingdom advanced 54 per cent to $22,039, and was up 75 per cent to $69,736 in the United States, while declining by 39 per cent to $6,761 in the European Union. The reason for the discrepancy is usually tax, and tax changes can have a drastic impact on a country's art market. The *Art Newspaper* found that a typical contemporary work sold from the United States would have no added taxation in that country and Canada, 5 per cent in the United Kingdom and Dubai, and between 5.5 and 10 per cent in Europe, rising to 28 per cent and 29 per cent in Russia and China.

Nevertheless, despite import value added tax and the introduction of the artist's resale royalty, London is now improving as a market centre faster than New York. Figures from Sotheby's and Christie's for all sales in the first six months of 2007 put London at $3 billion, ahead for the first time of the US total of $2.6 billion. This is mostly the result of the strength of the pound, and the increasing number of buyers in Europe, with southern Asians and Russians seeming to prefer to conduct business in London. In the future though it may well matter hardly at all where art is bought and sold, as the market shifts towards the internet.

The internet art market and art funds

The growth of the internet and online auctioneering since 1999 appeals to both dealers and auction houses. Attempts to sell expensive art works online, acting through advisers charging 10–25 per cent of the sale price, have met with success. In 2006, a painting by the Irish artist JB Yeats (1871–1957), sold via eBay for £40,000 ($73,600 at current exchange rates) against an estimate of £12,000. The painting attracted 1,500 hits, according to the *Financial Times*.

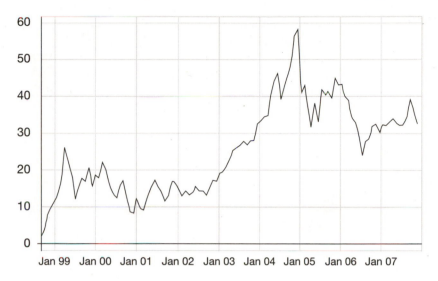

Figure I.13 Share price of eBay Inc from 1999 to November 2007 (US$)
Source: www.hoovers.com, 2007

Mirroring this development and learning from a Sotheby's internet auction failure in 2000/01, in July 2006, Christie's launched its live auction website in New York and London, selling £1.5 million ($2.76 million at current exchange rates) worth of items online in 42 sales, with over 6,700 bids accepted. Items sold included prints, jewellery, silver, clocks, sporting guns, arms and armour, Old Master pictures, sculpture and furniture. More significantly, 25 per cent of the internet bidders were new to Christie's. In Asia in the first half of 2007, Christie's received its highest online bid of $2.6 million.

The concept of art as an investment has reached new levels of sophistication. An article in the *Wall Street Journal Europe* in January 2004 examined price records for a number of artists over the last 15 years, making 'buy', 'sell' or 'hold' recommendations in the way an investment bank would advise share transactions.

In 2004, the UK's Fine Art Fund attracted $30–40 million from 50 mostly foreign investors, especially in Europe, to invest in Old Masters, Impressionist, modern and contemporary art. The aim is to achieve returns of 10–15 per cent a year over 10–13 years. The Fine Art Fund's positive return on capital in the first and the third year especially indicates that more funds may follow. So far there are art funds for Russian, Chinese and Indian art.

Never before have the art market and the world of finance enjoyed so profound a relationship. Many still back away from the spectacle of billionaires paying tens of millions of dollars for works that they feel should speak to the soul rather than take from the bank account. Yet as we have seen, it was ever thus. How different is the man who paid 1,800 guilders for a Hendrik Vroom (1566–1640) in 1610 from the Brazilian businessman who buys a piece of contemporary art for $20 million from a phone on his yacht in the West Indies? It is a difference of degree, rather than attitude. And we should remember that while the upper echelons of the market attract the headlines, the bottom end, which arguably now provides more satisfaction, even happiness, to greater number of people than ever before, is open to everyone with a hundred dollars in their pocket and a love of beauty in their heart.

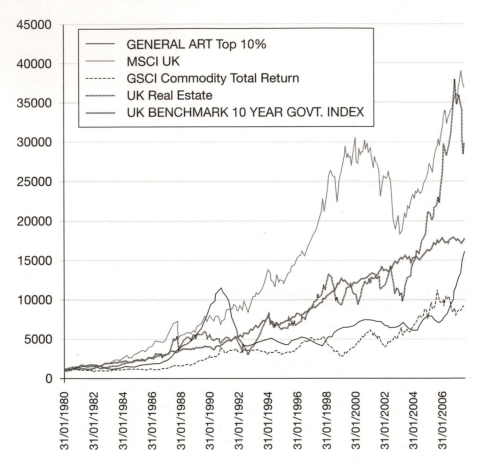

Figure I.14 Art versus investment assets, 1980–2006

Bibliography

Apollo (1990–2006) The art market, regular column, *Apollo*
Art + Auction (1999–2006) Art market, regular column, *Art + Auction*
Artdaily (2005–2007) Website information: www.artdaily.com
Art in America (2002–2006), art market column
Art Investor (2006) Timing, timing, timing, *Art Investor*, February
Art Monthly (2003–2006) Salerooms, regular column, *Art Monthly*
Art News (1988–2007) Art Market, regular column, *Art News*
Art News (2006) The ARTnews 200 top collectors, *Art News,* Summer
Art Newspaper (2006–2007) Art market, *Art Newspaper*, January-December (regular column)
Art Newspaper (2006–2007) The year ahead, *Art Newspaper*, (annual item) December
Art Newspaper (2006) Tax and art, *Art Newspaper*, September
Artprice (2007) Art market trends 2006 [online] www.artprice.com
Art Review (2007) The power 100, *Art Review*, November
Art Sales Index (1987–2006) Hislop's Art Sales Index, Weybridge, Surrey
Art Sales Index (1973–1975) The Art Investment Guide
Becker, H (1984) *Art Worlds*, University of California Press, Berkeley

Bennett, C (1991) *Suffolk Artists 1750–1930*, Image Publications, Suffolk

Buck, L and Dodd, P (1991) *Relative Values*, BBC Books, London

Buck, L and Greer, J (2006) *Owning Art: The contemporary art collector's handbook*, Cultureshock Media, London

Campbell, R (2005) Art as an alternative investment, Working paper, Maastricht University, Netherlands

CapGemini and Merrill Lynch (2007) *World Wealth Report* [online] www.us.capgemini.com/worldwealthreport07/ (accessed 29 March 2008)

Chong, D (2002) *Arts Management*, Routledge, London

Chong, D (2005) Stakeholder relationships in the market for contemporary art, in I Robertson (ed), *Understanding International Art Markets and Management*, Routledge, London

Christie's (1987–2000) Review of the Season, Christie's, London

Christie's (2001–07) Press releases [online] www.christies.com

Courtauld Gallery (1999) *The Value of Art*, Courtauld Gallery, London

Cowen, T (1998) *In Praise of Commercial Culture*, Harvard University Press, Boston, Mass

Crofton, I (1988) *A Dictionary of Art Quotations*, Routledge, London

DuBoff, L and King, C (2006) *Art Law*, Thomson, USA

Economist (2001) *Globalization*, Profile Books, London

Economist (2007) Special report on central banks and the world economy, *Economist*, 20 October

Economist (2007) Special report on offshore finance, *Economist*, 24 February

Economist Intelligence Unit (1979) *Art as an Investment*, Economist Books, London, December

Economist Intelligence Unit (1984) *Art as an Investment*, Economist Books, London, April

Edwards, S (2004) The economics of Latin American art: creativity patterns and rates of return, NBER Working Paper no W10302, National Bureau of Economic Research, Cambridge, Mass

Elkins, J (ed) (2007) *Is Art History Global?* Routledge, London

Elsner, J and Cardinal, R (1994) *The Cultures of Collecting*, Harvard University Press, Boston, Mass

Financial Times (2007) What else can you spend your money on? *Financial Times*, 26 May

Frey, B (2003) *Arts and Economics*, Springer, Berlin

Frey, B and Pommerehne, W (1989) *Muses and Markets: Exploration in the economics of the arts*, Blackwell, Oxford

Galenson, D and Weinberg, B (2001) Creating modern art: the changing careers of painters in France from Impressionism to Cubism, *American Economic Review* **91**(4), pp 1063–71

Ginsburgh, V and Throsby, D (eds) (2006) *Handbook of the Economics of Art and Culture*, Elsevier, Amsterdam

Ginsburgh, V and Weyers, S (2006) *Persistence and Fashion in Art: Italian Renaissance from Vasari to Berenson and beyond,* Poetics, Université Catholique de Louvain, Belgium

Goetzmann, W N (1993) Accounting for taste: art and the financial markets over three centuries, *American Economic Review* **83**(5), pp 1370–76

Graeser, P (1993) Rate of return to investment in American antique furniture, *Southern Economic Journal* **59**(4), pp 817–21

Grampp, W (1989) *Pricing the Priceless,* Basic Books, New York

Grove Dictionary of Art Online [online] www.groveart.com

Heilbrun, J and Gray, C (2001) *The Economics of Art and Culture*, Cambridge University Press, Cambridge

Herbert, J (1990) *Inside Christie's*, Hodder and Stoughton, New York

Herrmann, F (1999) *The English as Collectors*, John Murray, London

Hiraki, T, Ito, A, Spieth, D and Takezawa, N (2003) How did Japanese investments influence international art prices? Working Paper, Graduate School of International Management, International University of Japan

International Directory (2000) Sotheby's Holdings Inc

International Directory (2001) Christie's International plc

Kelly, M (ed) (1998) *The Encyclopaedia of Aesthetics*, Oxford University Press, Oxford

Keynote (2002–06) UK *Antiques and Fine Art Dealers and Auctioneers*, Keynote Reports [online] www.keynote.co.uk

Klamer, A (ed) (1996) *The Value of Culture*, Amsterdam University Press, Netherlands

LAPADA (2005) Membership Survey

Learmount, B (1985) *A History of the Auction*, Barnard & Learmount, Iver, Bucks

Maddison, A (2006) *The World Economy*, OECD, Paris

Mallalieu, H (1984) *How to Buy Pictures*, Phaidon/Christie's, Oxford

McAndrew, C (2007) *The Art Economy*, Liffey Press, Dublin

McAndrew, C (2008) *The International Art Market – A Survey of Europe in a Global Context*, The European Art Foundation, Helvoirt, The Netherlands

McNulty, T (2006) *Art Market Research*, McFarland, Jefferson, NC

Mei, J and Moses, M (2002), Art as an investment and the underperformance of masterpieces, *American Economic Review* **92**(5) (December), pp 1656–68

Mei, J and Moses, M (2005) Vested interest and biased price estimates: evidence from an auction market, *Journal of Finance* (October), pp 2409–35

Minchinton, W (1996) English merchants and the market for art in the long 18th century, in M North (ed), *Economic History and the Arts*, Bohlau, Cologne

Museums Journal (2007) Cultural revolution, *Museums Journal,* October

North, M (1997) *Art and Commerce in the Dutch Golden Age*, Yale University Press, New Haven, Conn

Pearce, S (1995) *On Collecting*, Routledge, London

Pesando, J (1993) Art as an investment: the modern market for modern prints, *American Economic Review* **83**(5), pp 1075–89

Pfister, R (2005) Tax matters, in I Robertson (ed), *Understanding International Art Markets and Management*, Routledge, London

Reitlinger, G (1961 and 1970) *The Economics of Taste 1760–1970*, 3 vols, Holt, Rinehart & Winston/Barrie and Jenkins, New York

Rheims, M (1961) *Art on the Market*, Weidenfeld & Nicolson, London

Robertson, I (ed) (2005) *Understanding International Art Markets and Management*, Routledge, London

Rush, R (1961) *Art as an Investment,* Prentice Hall, New York

Smith, A (1986) *The Wealth of Nations*, Penguin, London

Smith, P (2001) *Cultural Theory*, Blackwell, Oxford

Society of London Art Dealers (2005) Survey of Members [online]

Sotheby's (1974–2001) *Art at Auction*, Sotheby's, London

Sotheby's (2001–06) Press releases [online] www.sothebys.com

Surowiecki, J (2004) *The Wisdom of Crowds,* Little, Brown, New York

Tanner, J (2003) *The Sociology of Art*, Routledge, London

Temple, P (2004) *Superhobby Investing*, Harriman House, Petersfield, Hampshire

Valsan, C (2002) Canadian versus American art: what pays off and why, *Journal of Cultural Economics* 26, pp 203–16

Vasari, G (1985) *Lives of the Artists*, Penguin, London

Velthuis, O (2005) *Talking Prices: Symbolic meanings of prices, constructing the value of contemporary art,* Princeton University Press

Wallace, P (1999) *Agequake*, Nicholas Brealey, London

Watson, P (1992) *From Manet to Manhattan*, Random House, New York

While, A (2003) Locating art worlds: London and the making of Young British Art, *Area* **35**(3), pp 251–63

Wolf, M (2004) *Why Globalization Works*, Yale University Press, New Haven, Conn

Wood, C (1997) *The Great Art Boom 1970–97*, Art Sales Index, Weybridge, Surrey

Wu, C (2002) *Privatizing Culture*, Verso, London

Wullschlager, J (1989) *FT Guide to Alternative Investments,* Financial Times Business Information, December 2007

Sub-Saharan Africa

Katrin Schmitter

Introduction

'African art has it all: beauty, brio, inventiveness, moral gravity, emotional depth, practicality, sensuality and humour. It's hot, cool, high and low, chastening and consoling, endlessly varied, surprising always' (Cotter, 2007). This quote seems like a silver lining, or a dream, washing away problems and hopelessness, giving space to a promising future for art from the Black continent.

Unfortunately the facts seem different, and we cannot just go on by listing prices, statistics or graphs, explaining supply and demand, and enumerating Africa's most popular and most expensive artists. If we do this, we will notice that something seems wrong. And before this leads us to pigeonhole art from Africa as 'Not worth looking at', some background information needs to be given. Why is it that for a long time, art from Africa was not acknowledged as such simply because it was not produced 'for art's sake'? Why does it still encounter difficulties today? It is a fact that the market for African art (especially contemporary art) hardly exists. But it is not sufficient to suggest that the lack of a market is the result of a lack of good artists. It is obvious that Africa has a different background and history than Europe, but to understand how, why and up to what point it is different, it is necessary to go back in time, and analyse certain interactions. It is indeed hardly possible to explain African art in a mere historical context; social, political and cultural interactions are at least as important.

I shall embrace the whole region starting south of the Sahara, also referred to as 'Black Africa', excluding South Africa (which is described in Chapter 33). Even modestly limiting the coverage to this part of the continent, we are still talking about more than 40 countries. Africans often reproach westerners for generalizing and talking of the continent as if it was a single country, but in large part I shall need to do so because it is unfortunately not possible to discuss every single country within the space allowed. African countries are very diverse and in constant development, sometimes at an incredible pace. Those who lump them together frequently also project an artistic unity of 'African style'. I shall talk about art from Africa instead of 'African art', trying to avoid any cultural or stylistic generalizations, and to make some geographic distinctions.

Starting with a brief outline of Africa's history of art, I point out the most important events and changes, investigating Africa's encounters with the west. I then analyse the antique and contemporary sectors, within their specific environment and market. Demographic data and economic information will help to understand the current situation of art, especially contemporary art, in Africa.

Please be aware that due to the enormous diversity of the many countries (and also the various and frequently contradictory theories), this chapter cannot be considered as a complete guide to the topic. It is rather intended to give an introductory glance at art from Africa, inviting further research.

The art market: an abyss between antique and contemporary

Africa's history of art is long, sophisticated, and especially the last 150 years are marked by turmoil. When it comes to its market, we can note that it is very clearly divided in two. On one hand, antique cultural objects possess a very long tradition and enjoy considerable success on the western art market. On the other hand, contemporary art, especially painting, is marked by a 20th century full of changes, and struggles for recognition. 'It is not that contemporary art from Africa has a strong domestic market and suffers from international invisibility, but rather that the domestic market is merely non-existent and does not produce any stimulus for the international market' (Schweizer, interview, 2007). This is a staggering declaration about the future prospects for contemporary art. Later discussion of the interactions and functioning of the art market will make it clear why Schweizer says this.

The antique sector

Here I give a brief outline of the beginnings of collecting African art, and explain the environment of antique art in both Africa and the west. I clarify the factors contributing to the value of a piece of art. Lastly there is a short overview of the most valuable objects.

Collecting

The first time a piece of African art was mentioned in an occidental collection was in the 1580s, when the Duke of Burgundy (Charles the Bold) bought a fetish statue from a Portuguese dealer. Only very few objects were brought back to Europe before the colonial period of the second half of the 19th century. It was after the World Exhibition of 1878 and Africa's colonisation that the Musée d'Ethnographie was inaugurated in the Trocadéro in Paris in 1882. Various collections were then started and ethnographic museums inaugurated, most of them in colonial countries such as France and the United Kingdom. In the United States, the first collections of African art were created in the second half of the 20th century, and generally sprang from the new European artistic movements. In 1911, the first gallery of African art was opened by Paul Guillaume in Paris. After the Second World War, the collection of African objects became quite fashionable, and this brought both the objects and their artists a better image in the eyes of the cultural and social élite of the Western world (Bacquart, 1998: 10–14).

The artistic environment: museums, galleries, art fairs

In both Africa and the west, the ethnographic type of museum and gallery still seems to be the standard way of representing the African heritage. Frequently known as 'national museums', many museums in Africa still have this touch of 'natural history' and museum 'of local history'. In the west, Germany, Switzerland and the United States today have the most ethnographic museums, with a total of 11, eight and six respectively (www.panafrica.ch). This data is probably not complete, though. We also need to be aware that the internet is not yet a widespread and common medium of communication in Africa. Even though they see it as an opportunity to communicate on an international level, smaller organizations and galleries in particular encounter difficulties in installing websites and keeping them updated. Although it is a fact that there are not many galleries with a national or international impact in Africa, it is difficult to evaluate the situation, because of the lack of information.

Around 30 galleries dealing exclusively in antique African art can be found in Europe, mostly in France and Belgium. There are certainly more galleries than this selling African art, but most of them deal in ethnographic items of varying origin, or again do not possess an internet platform. From a total number of 94 galleries of this mixed type identified, only three are located in Africa, one in Togo and two in South Africa. Most are in the United States (37) and France (12) (www.panafrica.ch).

Concerning art fairs, the Brussels Non European Art Fair (BRUNEAF) is probably one of the leading events displaying art from Africa and other places (the last took place in June 2007). The Tribal Art Fair in Amsterdam (held in October 2007), the Parcours des Mondes in Paris (September 2007) and the European Fine Art Fair in Maastricht (March 2008) can possibly be counted as the most important events displaying art from Africa.

Value – what collectors want

As the art market specialist Tom McNulty makes clear, the most important factors that influence the monetary value of a piece of art are the popularity of the style, the artist's reputation, rarity, condition and provenance (McNulty, 2006: 5–13). For each domain of art, those factors may vary, shift in importance or even disappear. When it comes to antique or precolonial art, I would allege that almost all the importance is given to the factors of rarity, condition and provenance. The supply of antique African art is not abundant, which propels prices upwards. Furthermore, the age also plays a significant role, and older pieces generally have a higher value. Besides the pedigree – which may 'double or triple the value of a piece' (Corbey, 2000: 100) – the provenance (who possessed the object before, and not where and by whom it was made) seems to play an increasingly important role for collectors (Fiacco, interview, 2007). The style is significant as well, but not specifically in combination with the artist, who is mostly unknown. Within African art, the style rather refers to a certain ethnic group or tribe. The style increases the monetary value of an object according to the current taste and fashion of western collectors (as is also true in other sectors of art).

At this point, we need to be aware that Africans evaluate objects in a completely different way. For the west, authenticity certainly plays a central role. It is indeed difficult to define what exactly an authentic African piece of art is. Literally, it should include all objects created by African artists, but collectors and conservators in the western world define it in a rather restrictive way, and consider a piece of art as authentic if it has been both created by an African artist and used during tribal rites (Bacquart, 1998: 9). This excludes most modern creations, and art produced for tourists. Both the creators of these works and contemporary Africans have

however an utterly different opinion about the value of objects. 'To their African makers and owners, valuable objects were the ones that possessed visual power and ritual efficacy' (Kasfir, 1999: 104). This last point emphasizes the upsurging difference between cultural and monetary value. (For further details about authenticity, see Levinson, nd.)

Auctions and prices

It was around the 1920s that the first specialized sales of African art took place in Europe (Schweizer, interview, 2007). From then on, auctions of antique cultural objects were organized more frequently. Sotheby's for instance organizes auctions of African and Oceanic art twice a year in New York (in November and May) and Paris (December and June) (www.sothebys.com). Christie's auctions of African and Oceanic art also take place twice a year (June and December) (www.christies.com). On the African continent, auctions and auction houses are scarce. I know of a total of four auction houses, one in Morocco and three in South Africa (www.artvalue.com).

When it comes to the prices, people are frequently looking for 'bargains', explains the German gallery owner Peter Herrmann. This, he says, is an illusion and the wrong attitude. 'Antique African art is a part of human cultural heritage, and it is only fair and natural that high prices must be paid for it.' What is more, there is always the suspicion that a so-called bargain will turn out to be a forgery. Elaborate techniques have been developed to make wooden carvings, for instance, look antique. Dealers and collectors need to be very careful, and a deep knowledge is almost indispensable if you want to start collecting African art.

To give an idea of the prices that can be reached, Table 1.1 lists the 10 most expensive objects sold by Sotheby's in 2006–07. Sotheby's sold African art in eight auctions over this period, mostly in combination with Oceanic and Pre-Columbian art. (Currencies were converted according to exchange rate at the date the items were sold. Christie's was not used as a source because its website does not provide a historical search feature.)

Interestingly, the objects sometimes far exceeded their expected sale price. The Benin head of an Oba (number 1 in the list) had a top estimate of €1.08 million, for example and reached three times that much. The male statue from Nigeria (position 3) did even better, beating the estimated price almost eight times over.

Table 1.1 The 10 most expensive antique African art objects sold by Sotheby's in 2006–07

Rank	Date of sale	Item	Price (€)
1	17 May 2007	Benin head of an Oba, Nigeria, circa 1575–1625	3,505,142
2	5 December 2006	Head-rest, Luba Shankadi, 'Master of the waterfall haircut', Atelier Kinkondja	1,524,000
3	23 June 2006	Male statue, Urhobo, Nigeria	1,132,000
4	23 June 2006	Statue of a prisoner, Bangua, Cameroon	975,200
5	23 June 2006	Bronze panel, Edo, Kingdom of Benin, 16th–18th century, Nigeria	964,000
6	23 June 2006	Fetish statue, Songye, Democratic Republic of Congo	572,000
7	23 June 2006	Reliquary figure	516,000
8	5 December 2006	Maternity, Luluwa, Occidental Kasaï, Democratic Republic of Congo	482,400
9	23 June 2006	Bamana crest (heraldry), Mali	384,000
10	8 June 2007	Mask, Kwélé, Gabon	372,000

Figure 1.1 Benin head of an Oba, Nigeria, circa 1575–1625
Source: Sotheby's

The turnover of African art on the auction market was about US$50 million in 2007. The total auction turnover was US$10–15 billion (Schweizer, interview, 2007), so African art represents only a minute fraction: about 0.5 per cent of total art sales. Frequently African art is not included in statistics about the global art market. The Art Sales Index for example does not include any statistics for African countries, with the exception of South Africa (www.art-sales-index.com).

Furthermore, even though tribal art works sell relatively well, the profit is not a direct benefit for the continent:

> Despite the economic importance of African cultural goods, it is perhaps worth noting that most of the (final) value is created in formal markets in Europe and America, and that it is only the initial informal transactions that directly benefit African countries. African cultural goods can hardly be said to be a major export earner.
>
> (Fongue, 2002: 1342)

It would however be interesting to know how stable the market has been over the last 50 years.

The contemporary sector

The contemporary segment resides within a totally different environment. Even though the developments that painting, for instance, has gone through during the last century are deeply exciting, a market is not settling. Current developments seem to be positive, and artists are being invited to participate at international art fairs and biennales, but it is difficult to say whether a breakthrough will come, when, and who is going to succeed. Hardly any numbers or statistics can be found about the segment, which makes analysis and prediction almost impossible.

Here I provide a brief outline of the emergence of contemporary genres, and some information on prices and artists. A few remarks about the economic and demographic situation will help to explain the background for Africa's contemporary artistic development.

Expectations and economic premises

To understand the emergence and development of contemporary art, it is necessary to strike out a little. Apparently, there is one fundamental difference between pre- and post-colonial arts from Africa: the audience. Kasfir explains that first, art nowadays is no longer made primarily for a local culture, and second, it circulates and resides in geographically much wider circles (1999: 64). Africa is a special case, since the main audience for its contemporary art is international rather than local, and mostly western. And the west has some relatively specific expectations of what art from Africa should look like. 'Westernization' and 'unauthenticity' are probably the two most heard reproaches. Whether they describe it as genuine, authentic or tribal, what people in the art world mean is that African art must be recognizable as such. If not, it is said to be too similar to western art, and hence not authentic. There is a parallel here with the success of antique African art, which is more appreciated and sells better than contemporary work in the west, perhaps in part because it is indeed recognizable as 'authentic'.

Besides those stylistic expectations of the west, the contemporary market is hindered by the effectively nonexistent local market and a few unchangeable economic hurdles. For instance, the culture of the poorest countries is still considered primitive, and their cultural artefacts tend to be less valuable. Furthermore, the environment where art is produced can considerably influence its monetary value. A painting created in Abidjan by an African artist is very likely to have a smaller value than a similar painting created at the same time in New York. In order to obtain an international (competitive) price, the work of art needs to be located within an art market capital. In a regional or local centre, only extremely high local interest and an expanding economy can prevent the price of an artwork from being held flat (Robertson, 2001: 15–16, 243).

Basically, without a flourishing economy, it is hardly possible to create a local market. Without a local market, there is no local interest, no infrastructure and no opportunity for progress and development. Artists have to rely on very few customers and patrons, mostly from the west. Undoubtedly the most flourishing sector is 'tourist' or 'airport' art. It is frequently considered with disdain by experts, but it should however not be undervalued. It is indeed an important way of expression, and another way in which new art forms can develop.

The emergence of new genres

Contrary to what might be thought, contemporary art did not emerge from out of nowhere at the end of colonialism, even though this era tends to be dated from around the 1950s, as is the modern era in Europe (Kasfir, 1999: 13–16). The Nigerian painter Aina Onabolu is frequently named as having marked the beginning of modern art in Africa (Oguibe, 2004: 7). In the first decade of the 20th century she was also responsible for convincing the colonial administration in Lagos to establish an art course in secondary schools (Okeke, 2001: 29). It cannot be denied that colonialism has substantially influenced art developments in Africa, but it is not the case that all the developments that art went through before the colonial period suddenly vanished. Various art forms come from before the colonial period and still endure today. An amalgam of new media, techniques, ideas, patrons and political turmoil also created entirely new art forms. Frequently, traditional elements are mixed with new ones; roots never seem to be forgotten.

Kasfir explains the emergence of those new genres mainly through four social processes: urbanization, the introduction of western technology and material culture, the expansion of

literacy through formal schooling, and the development of an art market under European patronage (Kasfir, 1999: 18). Patronage from the west was indeed significant, and often appeared in the form of workshops, which were found across the entire continent. They were usually run by arts professionals from abroad, and their goal was to set free and generate the artistic powers of Africans to work in their own manner free from western stylistic and commercial influence. The Oshogbo workshop in Nigeria, run by Ulli and Georgina Beier and Susanne Wenger, is probably the most important and well-known one; it is still a vibrant centre for the artistic and cultural scene. The Workshop School of Frank McEwen in Zimbabwe, the Hangar of Pierre Romain-Desfossés in Congo and the Polly Street Centre in Johannesburg also played an important role (Vincent, 2003).

There are basically two categories of places where the widest variety and quantity of new art can be found: cities and those regions that were not too much influenced by pre-colonial image making, such as Senegal, Kenya, Uganda and South Africa. The western and central regions of Africa are quite well known for the production of sculpture. This is why masks and figures are still produced in Nigeria, Côte d'Ivoire, Congo, Mali and Sierra Leone, for either local use or the global market (Kasfir, 1999: 16).

Artistic environment

The development of the artistic environment is undeniably crucial for the evolution of artists. Museums, galleries, exhibitions, customers, audience, patrons and critics form a vital network for the art scene. This scene however depends on a specific social, economic and demographic background, and does not easily develop in most African countries.

In most cases, the problem is that many countries are still busy providing people with food, water and shelter, and do not have the opportunity to encourage cultural awareness. This is very clear from figures of national GDP per head. Somalia and Malawi have the lowest figure, at $600 per head, and Côte d'Ivoire's figure is $1,600, compared with South-Africa's $13,000 and the top global position held by Luxembourg with $71,400 (CIA, 2007). Much the same is true for life expectancy: the lowest 50 positions in international league tables are almost all occupied by African countries, Swaziland bringing up the rear with 32.2 years (CIA, 2007). However we also need to be aware that in some countries wealth is present, but it is very unevenly shared. This does not encourage the cultural awareness either of a wider population, or of artists who frequently work for a single patron whose specific wishes guide their creativity.

Museums

The museum situation in Africa is also not encouraging. Museums are scattered very thinly across the continent, and the ethnographic form that derives from the colonial period remains dominant, both in Africa and in western museums that display African work (Konaté, 2007). Many museums in Africa were founded during the colonial period and have not been changed since. A museum should be not only a source of history and knowledge, but also a source of inspiration for new generations.

There are two possible core reasons for this stagnation: the unfavourable economic situation and the very different meaning a museum has in Africa. Many African countries simply cannot afford to establish or maintain the required infrastructure for museums (Förster, interview, 2007). It could be said that in the west, art is given a brand of quality when it is put

in a museum. This is closely linked to the monetary value of an artist's work, so in the west the museum serves as a positive catalyst for the artist, creating value and power. In Africa however, the meaning of art is still ephemeral and functional. To Africans, objects in a museum lose their value because they are taken out of their context, and hence lose the whole cultural meaning in which the value resides (Haustein, 1996: 22–47).

But gradually, something seems to be changing. In larger cities for instance, inhabitants see themselves, their way of life and era as symbolic of modernity, and are reluctant to identify with the ethnology, explains Till Förster (interview, 2007). Organizations try to make this new movement accessible to the broad population. The International Council of African Museums (AFRICOM) for example supports various projects, and its First Assembly identified three priorities: Intangible Heritage, Professional Development and Continental Networking (africom, 2007). The West African Museums Programme (WAMP) formulated the goal of supporting regional museums and cultural institutions by developing innovative cultural projects which would generate income. This was intended to have a large impact on the local population in terms of education, sensitization and the fight against poverty (www.wamponline.org). Furthermore, the site provides very useful information about its partner museums, which do not always possess a website. Again, though, it is apparent that most museums are historical, ethnographic or military in their focus.

Among others, it is worth citing the national museum in Mali, said to be one of the most dynamic museums on the continent (Andriamirado, 2007). Samuel Sibidé, director of the museum, affirms that it is very important to give visibility to contemporary creations, so as to allow the audience to integrate its current history into a heritage perspective. The population should recognize that (national) identity does not only consist of the past. He further explains that it is still relatively difficult to gain a public for a museum. Förster agrees, and further clarifies that contemporary museums often work in a completely different style. They are not infrequently commercially based, and organize events, theatre or concerts, so to attract locals and make them familiar with the museum. There is often a need for élitist social groups who can intellectually encourage cultural developments (Förster, interview, 2007). The National Gallery of Zimbabwe, which celebrates its 50th anniversary in 2008, is also worth a visit. Providing an excellent website, it seems very progressive about contemporary art (not only from Africa), presenting Zimbabwe's visual heritage and other contemporary art in a promotional but also critical way (www.nationalgallery.co.zw).

Galleries

The situation for galleries dealing in contemporary art does not seem much more promising, whether in the west or in Africa. In the west, customers do not seem to trust the exciting developments contemporary art from Africa is going through, or credit it with any value. In Africa, traditional structures are still very present, and a lack of infrastructure makes progress difficult. At this point it is crucial to mention the role of internet, which is nowadays frequently seen as a great opportunity, especially for artists. It is a way to publicize their work and personality, to reach an audience far away from home, to get in touch with western customers and dealers, and to stay in touch with them. This is why galleries are more and more found online, and sometimes it is even their only way of existence. The Swiss internet platform panafrica (www.panafrica.ch) counts a total number of 37 galleries internationally, of which approximately one-third exist only virtually. Most of them can be found in the United States, Germany and South Africa. The Saatchi Gallery however provides a gallery

guide for 32 different countries and regions, but not for Africa, with the exception of South Africa (Saatchi, 2007). There are certainly more galleries dealing with contemporary art, but due to the still very limited spread of the internet and a lack of information, giving numbers is difficult. It can be said, though, that for instance the Doual'art cultural centre in Cameroon enjoys a lively art scene, as does the Oshogbo workshop in Nigeria. There are various artistic and cultural institutions, such as the Centre of Contemporary Art of Eastern Africa in Nairobi, the Photography Association in Maputo, and the Goethe Institut and Centre Culturel de la langue Française, which contribute to the development of the artistic scene in various countries. However, there is one problem concerning the internet: although it is seen as an excellent opportunity, it is very difficult to obtain the appropriate knowledge, equipment, infrastructure and resources to make efficient use of it. (Most sub-Saharan countries have an internet penetration rate of 1–10 per cent, with a total penetration of 3.6 per cent. African users form only 3 per cent of the total world users.)

Exhibitions and art fairs

Besides museums and galleries, art fairs (and biennales) have gained in weight. They are important hubs and events for artists to meet and show their work. This interaction and exchange of ideas and information, which had long been impossible because of various (often political) reasons, fosters the emergence of an international African art world, and is vital for development and change. Several smaller art festivals exist in many countries, but most of them are not covered by the western press, and more often than not they lack a website. Accordingly, their international visibility is limited (Förster, interview, 2007).

Even though the statistics are not available, observation suggests that artists from Africa are being more and more integrated into large group exhibitions, and get special attention at art fairs or biennales. Starting with only one exhibition in the 1960s, interest in modern art from Africa has grown in the subsequent decades. The 1970s and 1980s were still comparably lean years, with four and seven exhibitions respectively. During the 1990s however, a total of 18 exhibitions took place, most of them in Europe, but for the first time African cities also hosted expositions: the biennales of Johannesburg and Dakar. Since the beginning of the new millennium there have been 12 exhibitions. It is worth noting that the Jean Pigozzi collection was used for several of those exhibitions. (Jean Pigozzi has been one of the most important collectors of African contemporary art for the last 15 years. Curated by André Magnin, the collection contains several thousands of artworks from African autodidacts: see www.caacart.com.)

'The short century', curated by Okwui Enwezor, was one of the first exhibitions to prove that African does not only mean primitive art. A majority of the art exhibited was from during and after the colonial period. It ranged from fine art, photography, architecture, music, theatre and film to fashion (Universes in universe, 2007). Starting in 2001 on the basis of a project of the Villa Stuck museum in Munich, in cooperation with the Haus der Kulturen der Welt in Berlin, it also toured to the Museum of Contemporary Art in Chicago and the PS1 Contemporary Art Center and Museum of Modern Art in New York in 2002. Then came 'Afrika Remix': also one of the most important exhibitions, featuring 75 artists from 23 countries, it started in 2004 in Düsseldorf and toured to London, Paris, Tokyo and Stockholm (www.africaremix.org.uk).

Furthermore, biennales such as Venice, Havana and Istanbul, and art fairs such as Art International Zurich, Art Frankfurt and Art Basel Miami Beach are more and more giving a display place to specific African countries or artists. The Documenta in Kassel was the first

international art fair to engage an African director (Okwui Enwezor) in 2002. Besides being an ideal exchange and information platform for the artists, those events can also encourage discussions between artists and the audience, which is an opportunity to broach the issue of art from Africa in an international environment.

In Africa itself, several art festivals and fairs are worth mentioning. 'Kunstaspekte' for example provides a very informative list of all different kinds of biennales, art fairs, academies, festivals, galleries, institutions and projects. Among the most important fine art fairs we can count the biennales in Dakar, Cairo and Johannesburg, the Photography Biennale in Bamako (Mali) and the Triennale in Luanda. (Within the broader field of the arts, a number of festivals exist around the continent, such as the well-known Fespaco (a film and television festival) in Ouagadougou, Burkina Faso, smaller festivals such as the 'Coco Bulles', a press and comic festival in Abidjan, the Kijani music festival in Kenya and the Chimanimani festival of performing arts in Zimbabwe. Similar minor festivals are also organized in the west, promoting performing arts or film (www.kunstaspekte.de).

Prices, artists and trends

It is disputed whether interest in contemporary art from Africa is increasing or not. Some gallery owners are quite positive and report an increase of sales and interest; others hold the view that these positive developments are a pure illusion, generated by frequent contact with a few like-minded people. Magazines and newspapers now and again talk about 'an upsurge of interest' (Barber, 1987), or even that 'new art from Africa has never been as popular as now' (Mosquero, 1993: 64–66). But the situation does not seem to change. Auctions of contemporary art from Africa do not exist on a regular basis, and only four can be counted since 1990 (sil, nd a). In 2005, the auction house Calmels Cohe organized a sale of contemporary non-occidental art in which several African artists were represented. Sotheby's London auctioned art from the Pigozzi collection in June 1999 for charitable purposes, and the Stephan Welz & Co auction house in Johannesburg collected money for AIDS orphans. In September 2000, Bonhams London had a sale of contemporary African art, but nothing more since then. This suggests that art from Africa has not yet managed to come out of the 'charitable and development aid' drawer.

For my research about prices of artworks, I obtained details of more than 200 artists from across the whole continent of Africa. (I compiled a list of artists based on various collections (Jean Pigozzi, Galerie Peter Herrmann, Galerie Zak, and others) and consulted literature. The choice of the artists was not based on my personal valuation of their work: I looked at those for whom details were available from these sources within a specific timeframe.) Of these artists, only 40.7 per cent are registered in a database, and 31.6 per cent possess auction records (source: www.artprice.com). Table 1.2 lists the artists with the most auction results.

It is interesting to note that those artists whose work appeared most frequently in auctions did not necessarily sell for the highest prices. Table 1.3 details the highest prices received by the works of the 25 best-selling artists.

Conclusion

After this introductory glance at the artistic scene of the African continent, a first deduction can be made: the African art market is not only shaped by matters of quality, taste or aesthetic

Table 1.2 Contemporary African artists with the best auction results

Artist	Country	No of works auctioned	Type of art
Georges Lilanga	Tanzania	113	Painting (89) Sculpture-installation (16) Print (6) Drawing-watercolour (2)
Seydou Keita	Mali	84	Photography
Chéri Samba	Zaire	66	Painting (62) Print (2) Drawing-watercolour (1) Sculpture-installation (1)
Mickaël Bethe-Sélassié	Ethiopia	21	Sculpture-installation (15) Drawing-watercolour (4) Painting (2)
Twin Seven Seven	Nigeria	21	Drawing-watercolour (12) Painting (7) Print (2)
Ben Enwonwu	Nigeria	19	Painting (10) Drawing-watercolour (7) Sculpture (2)
Moké	Zaire	16	Painting
Jean Depara	Angola	12	Photography
Jimoh Buraimoh	Nigeria	12	Drawing-watercolour (10) Painting (2)
Henry Munyaradzi	Zimbabwe	8	Sculpture-installation
Ablade Glover	Ghana	8	Painting

value. It is affected by much more complex issues, originating more than 100 years ago and spinning a web of intercultural, political and historical events. Colonialism indeed played a central role and raised the whole debate about 'African art'. The superiority the west developed towards Africa during colonial administration was decisive not only for the latter's political future, but also for the stylistic development of art. As was suggested earlier, the expectations of the west somehow forced artists from Africa to wear their 'Africanness' like a badge, retrieved within their artistic style. In fact, probably the most decisive change was when Africans discovered the commercial potential of art around 1900. The adaptation to the market that followed, driven by the west, provoked a change of style and cultural attitude towards art. African artists were trying to get familiar with western concepts of arts and aesthetics. However, despite all the endeavours of African artists to get accepted by the west and enter the market, success remained elusive. Economic problems in Africa make progress very difficult. Having become the second largest exporter of visual arts, China is an excellent example of correlation between a flourishing economy and a flourishing art market (artnews-paper, 2007). The local effectively nonexistent market hinders any steps forward in Africa.

There is an immense market gap between the antique and contemporary sectors. Although they have not reached the top position on a global market scale, pre-colonial and antique African art have a settled position and enjoy a relatively high demand. Galleries and museums dealing with ethnographic art are established and objects frequently reach high prices at auction, outpacing their estimates.

Table 1.3 The best prices obtained by the work of 25 contemporary African artists

Name	Auction results	Highest price (€)	Title	Sold by	Date
Mutu Wangechi	7	113,162	*You'll always try to get me*	Christie's New York	17 May 2007
Chéri Samba	66	38,889	*L'espoir fait vivre*	Calmels Cohen	9 June 2005
Seydou Keita	84	10,444	*Untitled*	Christie's New York	24 April 2007
George Lilanga	113	9,555	*Uishi na jirani zako vizuri ili ukipatwa na shida watakusaidia*	Sotheby's London	24 June 1999
Bodys Isek Kingelez	3	9,301	*Kimbembeke Ihunga*	Sotheby's London	24 June 1999
Richard Onyango	5	9,162	*Caution to drivers*	Sotheby's London	24 June 1999
Moké	16	9,025	*Untitled*	Sotheby's London	24 June 1999
Twin Seven Seven	21	8,230	*Untitled*	Sotheby's London	24 June 1999
Agabli Kossi	6	7,706	*Untitled*	Sotheby's London	24 June 1999
Frédéric Bruly Bouarbé	14	6,654	*Connaissance du monde*	Sotheby's London	24 June 1999
Hamed Ouattara	6	6,000	*Untitled*	Boisgirard (SVV)	23 June 2003
Cheik Lédy	2	5,315	*Comme à l'école*	Sotheby's London	24 June 1999
Efiaimbelo	2	5,044	*Aloalo pangalatra omby*	Sotheby's London	24 June 1999
Zinsou	3	5,044	*Untitled*	Sotheby's London	24 June 1999
Jimoh Buraimoh	12	4,933	*The drummer return*	Tajan	26 June 2007
Cyprien Tokoudagba	4	4,518	*Abolissou*	Sotheby's London	24 June 1999
Asiru Olatunde	2	3,169	*The story of Adam and Eve*	Bonhams Chelsea	13 September 2000
Michael Sélassié	21	2,547	*Totem*	Labat & Thierry Scp.	19 February 1990
Ben Enwonwu	19	2,244	*Portrait of a Yoruba girl*	Bonhams London	23 May 2007
Henry Munyaradzi	8	2,000	*Wildlife keeper*	Deburaux et Associés	2 April 2007
Mwenze Kibwanga	7	1,680	*Afrikaans wood*	De Vuyst Belgium	10 March 2007
Ablade Glover	8	1,372	*Orange phase*	Bonhams Chelsea	13 September 2000
Jean Depara	12	1,300	*Femme cow-boy*	Deburaux et Associés	2 April 2007
Aboudramane	3	1,033	*La case camouflée*	Calmels Cohen	9 June 2005
Fernando Alvim	4	900	*Miskito Banda Miskito*	De Vuyst Belgium	14 May 2005

Note: All price information from www.artnet.com, accessed August 2007. Currency converted to euros using the Custom House Currency Converter, provided by artnet.

In the contemporary field, price and auction results make it obvious that the success of for instance Mutu Wangechi and Yinka Shonibare stands in direct correlation with their education, production and exhibition history in the west. Chéri Samba and George Lilanga also enjoy the privileges of the west: the former has had a certain status since *Magiciens de la terre* was shown at the Pompidou Centre in Paris in 1989, and both of them are given the opportunity for various important group and solo exhibitions. However *Magiciens de la terre* was the subject of a lot of controversy and criticism, frequently initiated by Africans, which may have deterred some potential collectors and art lovers. However, such discussions might also incite a dialogue between North and South. The famous exhibition at the Pompidou incited Jean Pigozzi to collect contemporary art, and he is now one of the most important collectors. Patrons and collectors are indeed rare, and the danger rises that only a few artists will gain a reputation (often with a specific style or background according to the taste of the collector) and influence the way African art is perceived, by some kind of aesthetic filtering (but this also happens in other domains of art).

The actual art market somehow still tends to exclude those who are unable to follow the western wage economy. However, whether they are influenced by the west or not (but then, which artist has not been influenced?), the developments art from Africa has gone through are indeed worth a glance. Maybe we should take to heart the saying by Carl Maria von Weber, the German composer, 'Art has no mother country'.

For further information on the development of this particular art market, go to: www.koganpage.com/artmarkets.

Bibliography and sources

Literature

Bacquart, J-B (1998) *L'Art Tribal d'Afrique Noire,* Thames & Hudson, London, pp 9–14

Barber, K (1987) Popular arts in Africa, *African Studies Review* **30**(3) (September), p 1

Bassani, E (2005) Ancient African art for the Africans, pp 26–27 in *Arts of Africa: 7000 years of African art*, Skira editions, Grimaldi Forum, Monaco

Corbey, R (2000) *Tribal Art Traffic: A chronicle of taste, trade and desire in colonial and post-colonial times*, Royal Tropical Institute, Amsterdam, pp 84–100

Fongue, J Ndefo (2002) The market for works of art: the case of African cultural goods, *South African Journal of Economics* (December)

Haustein, L (1996) D*er unerforschte Kontinent: Zeitgenössische Kunst aus Afrika*, pp 2–47 in *Neue Kunst aus Afrika*, exhibition catalogue, Haus der Kulturen der Welt, Berlin

Kasfir, S L (1999) *Contemporary African Art*, Thames & Hudson, London

Kemp, M (2002) *The Oxford History of Western Art*, rev edn, Oxford University Press, Oxford

Luckner, S (2004) Rites sacrés, rites profanes, Zeiggenössische Afrikanische Fotografie, PhD thesis

Magnin, A and Kellein, T (1993) Chéri Samba and Cheïk Ledy, pp 306–8 in P Bianchi (ed), *Kunstforum 122: Afrika – Iwalewa*, Iwalewa House

McNulty, T (2006) *Art Market Research: A guide to methods and sources*, McFarland, Jefferson, NC, pp 5–13

Mosquero, G (1993) Dritte Welt und westliche Kultur, pp 64–66 in P Bianchi (ed), *Kunstforum 122: Afrika – Iwalewa*, Iwalewa House

Oguibe, O (2004) *The Cultural Game*, University of Minnesota Press, Minneapolis, Minn

Okeke, C (2001) Modern African art, pp 25–45 in O Enwezor (ed), *The Short Century: Independence and liberation movements in Africa, 1945–1994 – an introduction* (for the exhibition 'The Short Century', Haus der Kulturen der Welt, Berlin), Prestel, Munich

Paudrat, J-L (2005) The 'discovery' of African arts, p 377 in *Arts of Africa: 7000 years of African art*, Skira editions, Grimaldi Forum, Monaco

Ranking, E (1990) Black artists, white patrons: the cross-cultural art market in rural South Africa, *Africa Insight* **20**(1), p 28

Robertson, I (2001) *Understanding International Art Markets and Management*, Routledge, London, pp 15–16, 243

Steiner, C B (1994) *African Art in Transit*, Cambridge University Press, Cambridge, pp 4–7

Vogel, S and Martin, J-H (1993) Kane Kwei, pp 278–79 in P Bianchi (ed), *Kunstforum 122: Afrika – Iwalewa*, Iwalewa House

Willett, F (2002) *African Art,* Thames & Hudson, London

Websites/online articles

Africa Remix (nd) Africa Remix exhibition information: www.africaremix.org.uk (accessed August 2007)

Andriamirado, Virgine (2007) Interview with Samuel Sibidé, Director of the National Museum in Mali, *Africultures*, 24 July: www.africultures.com (accessed July 2007)

Art Sales Index (nd) 2006 Art market trends: www.art-sales-index.com (accessed August 2007)

Artnet (nd) Data on value and prices of art from African artists: www.artnet.com (accessed August 2007)

Artprice(nd) Data on value and prices of art from African artists: www.artprice.com (accessed August 2007)

Artvalue (nd) Data on value and prices of art from African artists: www.artvalue.com (accessed August 2007)

Bailey, M (2006) China is the world's second largest exporter of art, *Art Newspaper*, 1 February: www.theartnewspaper.com (accessed August 2007)

Cahiers d'études africaines (2003) review of S L Kasfir, 'Cedric Vincent' (in French translation (2000) of Kasfir, 1999): http://etudesafricaines.revues.org/document1551.htm (accessed July 2007)

Capital (nd) List of biennales, art fairs, academies, festivals, galleries, institutions: www.capital.de/guide/kunstkompass/100006894.html (accessed August 2007)

Christie's (nd) Auction data: www.christies.com (accessed August 2007)

CIA (2006) Demographical statistics Africa, data from 2006: https: www.cia.gov/library/publications/the-world-factbook/rankorder/2004rank.html (accessed August 2007)

CIA (2007) Demographical statistics Africa, data from 2007: https://www.cia.gov/library/publications/the-world-factbook/rankorder/2102rank.html (accessed August 2007)

Contemporary African Art (collection of Jean Pigozzi) (nd) www.caacart.com (accessed August 2007)

Cotter, H (2007) Out of Africa: eclectic visions, *New York Times*, 1 June: www.nytimes.com

Drewal, H J (nd) Art and aesthetics in African art, Grove Art, www.groveart.com (accessed May 2007)

International Council of African Museums: www.africom.museum/today/intro.html (accessed August 2007)

Internet World Stats (nd) Statistics of internet usage: www.internetworldstats.com (accessed July 2007)

Konaté, Yacouba (2007) Musées en Afrique: esthétique du désenchantement, *Africultures*, 10 July: www.africultures.com (accessed July 2007)

Kunstaspekte (nd) Rankings of international contemporary artists: www.kunstaspekte.de (accessed August 2007)

Levinson, J (nd) Authenticity in art, http://www.denisdutton.com/authenticity.htm (accessed August 2007)

National Gallery of Zimbabwe (nd) www.nationalgallery.co.zw (accessed August 2007)

Panafrica (nd) Information about museums, exhibitions, galleries of art from Africa: www.panafrica.ch (accessed July 2007)

Saatchi (nd) Index of galleries and dealers worldwide: www.saatchi-gallery.co.uk/dealers_galleries/Gallery/dg_id/1326.html (accessed August 2007)

sil (nd a) Basic reading list about African art: www.sil.si.edu/SILPublications/ModernAfricanArt/maadetail.cfm?subCategory=2000s (accessed August 2007)

sil (nd b) Auction information: www.sil.si.edu/SILPublications/ModernAfricanArt/maadetail.cfm?subCategory=Auctions (accessed August 2007)

Sotheby's (nd) Auction data: www.sothebys.com (accessed August 2007)

Universes in universe (nd) universes-in-universe.de/africa/short-cent/index.htm (accessed in August 2008)

West African Museums Programme: www.wamponline.org (accessed August 2007)

Die Zeit (2007) Malick Sibidé at the Venice Biennale: www.zeit.de/online/2007/24/bg-biennale?9 (accessed August 2007)

Artists' cvs

Ben Enwonwu: http://dubois-paris2006.fas.harvard.edu/biographies.html#BE (accessed August 2007)

Yinka Shonibare: www.yinka-shonibare.co.uk (accessed August 2007)

Mutu Wangechi: www.saatchi-gallery.co.uk/artists/wangechi_mutu_biography.htm (accessed August 2007)

Interviews

Fiacco, A, Gallerie Afrikana, Zürich, interview 27 July 2007

Förster, Till, head of Centre for African Studies, University of Basel, tel. interview 8 August 2007

Schweizer, Heinrich, head department manager African and Oceanic Art, Sotheby's New York, interview 5 June 2007

Argentina

Adrian Gualdoni Basualdo (translated by Jane Brodie)

Introduction

The territory that is now Argentina is located at the southern limit of the American continent. Culturally speaking, its physical distance from western power centres was a negative factor until the end of the 19th century, when economic prosperity based on natural resources made Argentina into one of the most promising nations in the world.

Before Spanish colonization, the original peoples from this area were largely nomads whose artistic expressions consisted of very rudimentary works in ceramic, stone engravings and textiles. They were objects for use, lacking the ornamental richness of the major American civilizations like the Aztec, the Maya and the Inca.

The colonial era, which reached its height from the end of the 18th century to the beginning of the 19th, was also marked by distance from international power centres. While there are some works of religious art from that period – especially architectural, sculptural and pictorial works – they are a far cry from the excellent work produced in, say, Mexico, Peru and Brazil.

When the Spanish Empire – of which what is now Argentina constituted the Viceroyalty of the Rio de La Plata – had been dissolved, the independent local leaders had other priorities. Guaranteeing military independence in order to participate in the concert of nations took years and led to bloodshed. This was followed by a period of domestic conflict whose resolution led to a project for national growth. This project prioritized the mass assimilation of European immigrants, using education and culture as tools for integration and development.

Throughout almost the entire 19th century, the only important art produced in Argentina was made by European artists passing through the country. Now called 'forefathers' of Argentine art, outstanding members of this group include French artists Jean León Palliere, Adolphe d'Hastrel and Robert Quinsac de Monvoisin; Englishmen Emeric Essex Vidal and Richard Adams; Charles Pellegrini from Savoy; German artist Johan Moritz Rugendas; Italian Giuseppe Aguyari, and Swiss artists César Bacle and Adolphe Methfessel. Many of these artists met a growing society's demand for portraits, while also producing work that tackled landscapes, local customs and characters, and the geographical landmarks of the new nation. Generally rendered in oil paint or watercolour, their original work was often reproduced as lithographs by companies in London, Paris and even Buenos Aires, and then sold as albums or

illustrations for travel books, for which there is currently an active market. Most of these foreign artists returned to their home countries, and some of them auctioned off their work in their studios before leaving. Others settled in Argentina permanently.

The market for images from the 19th century, whether original works, graphic pieces or even early photographs, has become significant due to the artistic and historical interest of such work. Numerous collectors in the past such as Antonio Santamarina, Alejo and Alfredo González Garaño (brothers), Elisa Peña, the Fernández Blancos, Dürnhoffer, Bonifacio del Carril, and others have been replaced by new generations of collectors, including Carlos Pedro and Sra Blaquier, Octavio and Claudia Caraballo (brother and sister), Horacio Porcel to name a few. These individuals – as well as others who choose to remain anonymous – fight passionately for the few lots of these ítems that enter the market in the auction houses in Buenos Aires.

The current Argentine art market

Like any other market, the Argentine art market consists of a supply of works produced by contemporary artists as well as works by artists from the past which their owners put on the market again; the demand consists of collectors, investors or users, so to speak, in search of a painting with which to decorate a personal habitat.

Currently, about 100 galleries operate on this market in Buenos Aires. Of them, 20 can be considered and top is Zurbarán, which is certainly the most representative of those dedicated to more traditional Argentine art. In addition to that gallery, we find Van Eyck, Vermeer, Van Riel (the oldest of the currently operating galleries), Francisco Traba and Espacio AG. Among those dedicated to contemporary art, we could mention Ruth Benzacar, Del Infinito, Gradiva, Jorge Mara, Praxis, Sara García Uriburu, Arcimboldo, Loreto Arenas, El Puente, Holz, Zavaleta Lab and others.

The others consist of alternative spaces and cultural institutions, such as the Klemm, Mundo Nuevo and Proa Foundations, with divisions dedicated to visual arts, its exhibition and sales. There are also art galleries, though many fewer, in major cities in the rest of the country. The concentration of the art market in Argentina's capital city is one of its main characteristics.

Many artists sell their work on their own, from their studios or by means of informal circuits. Galleries, institutions and the artists themselves constitute what we might call the market's 'primary segment'; due to its private nature, it is practically impossible to obtain reliable information about its dimension in economic terms. We can, however, affirm that it is extremely dynamic. In Buenos Aires, there are approximately 40 art exhibition openings per week.

The 'secondary segment', or the art audience constituted by art auction houses, can be accurately measured. There are currently nine active top-level art auction houses in the city, four of which deal in Argentine art exclusively, while the other five work with Argentine art, European art, and a broad range of art objects from different eras and places. (Table 2.1 lists these auction houses with their web addresses.) Although the staffs at these establishments initially relied on direct experience, they now have university training that allows them to perform their jobs with an outstanding degree of professionalism.

The two biggest international art auction houses, Christie's and Sotheby's, have offices in Buenos Aires. These are particularly active in the months of May and November, when in New York there are the now traditional auctions of Latin American art, which usually include major works from Argentina.

Table 2.1 Auction houses in Buenos Aires

Dealing in Argentine art exclusively:	
Arroyo	www.galarroyo.com
Banco Ciudad	www.bancociudad.com.ar
VerBo	www.artverbosubastas.com.ar
Indigo	www.indigoarte.com.ar
Dealing in works of art and objects in general:	
Naón	www.naon.com
Sarachaga	www.sarachaga.com.ar
Subastas Roldán	www.subastasroldan.com
Bullrich, Gaona y Wernicke	www.bullrichgaonawernicke.com
Hijos de Martín Sarachaga	www.martinsarachaga.com

Recent changes in policies seek to restrict the flight of certain goods from the country in an attempt to protect the Argentine cultural heritage. Such measures have led to certain bureaucratic and economic obstacles, and as a result there is a smaller presence of Argentine art at these important New York auctions. Currently, the exportation of works of art and art objects in Argentina is subject to a double control. First, it is necessary to obtain an authorization from the Department of Culture, indicating that the departure of the work in question 'does not affect the Nation's Cultural Patrimony'. That report is issued by an advisory committee which meets every 15 days. After an appraisal of the work to be exported, a 5 per cent 'export retention' tax levied on all products that leave the country must be paid. Though not overly burdensome, the process often takes more than a month, and it requires the help of a professional trained in customs procedures. This has discouraged more than one aspiring foreigner from purchasing Argentine art.

Sales volume of Argentine art at auctions

Figure 2.1, which was prepared specifically for this publication with the help of Consultart/dgb, the leading art consulting firm in Buenos Aires, clearly demonstrates the sums of money mobilized by the public segment of the Argentine art market. The chart has taken into account the results of some 50 top-level auctions held throughout the calendar year. The figures in the charts are in millions of dollars, and they evidence crucial factors in the fluctuating Argentine economy. The effects of what was called 'the tequila crisis' are seen in the drop in volume in 1993 and 1994. The positive effects of the early stage of President Menen's neoliberal economic policy are evident in the growth from 1995 to 1999. The consequent exhaustion of this model, and its attendant recession, are seen in the sudden fall in the year 2000 and subsequent years. The current economic boom is clear in the current volumes ($13.5 million in 2006 – second only to 1999, when the volume was $15.5 million).

Obviously, these figures are not so impressive compared with the major capitals of the art world. To read them accurately requires at least moderate knowledge of Argentina, its economy and its insertion in the global market.

The average number of works sold at top-level auction houses annually is estimated to be 4,000, approximately 80 per cent of which are paintings (oil, acrylic, tempera, watercolour, pastel), 15 per cent graphic work (different types of prints) and only 5 per cent sculpture (bronze, marble, stone, terracotta, cement and plaster).

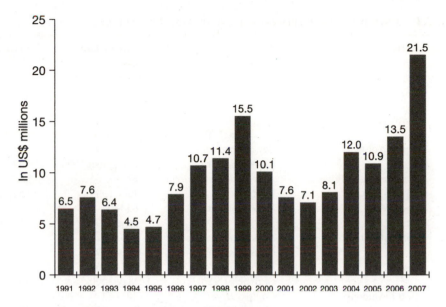

Figure 2.1 Argentine art sales at auctions, 1991–2006
Source: CONSULTART/dgb

The 10 most expensive works of Argentine art on the market

At the top of the list are three large paintings by Antonio Berni (1905–1981), which, though sold at auctions of Latin American art in New York, were purchased by public art collections in Argentina. *Ramona espera* (Ramona waits) is currently at the Museo de Arte Latinoamericano de Buenos Aires (MALBA-Colección Costantini), and *La gallina ciega* (The blind hen) will form part of the permanent collection of the future Fundación Fortabat museum. Both institutions are located in Buenos Aires. Next on the list are two paintings by Prilidiano Pueyrredón, perhaps the first Argentine-born painter (1823–1870); these works are currently in important Argentine private collections specializing in 19th century art.

Next on the list is an important painting by Emilio Pettoruti, the man who introduced Cubism to Argentina. His work was widely scorned in the first exhibition he held in Buenos Aires in 1924. Years later, his art is among the most valuable Argentine art on the market. It holds a privileged place in museums and private collections in Argentina and abroad.

Next come two more works by Antonio Berni. *La fogata de San Juan* (San Juan bonfire) was purchased by a Latin American collection and *Chelsea Hotel* is on display at the afore-mentioned MALBA museum, a quality venue that also houses *Prueba de nuevo* (Test again) by Jorge de la Vega (1930–1971) and *La canción del pueblo* (The people's song), by Pettoruti, which brings our list to a close. In the next places on this brief list are Fernando Fader, Xul Solar, Lino Enea Spilimbergo, Benito Quinquela Martín, Cesáreo B de Quirós and other, now deceased masters, as well as the contemporary artist Guillermo Kuitca, who currently draws the highest values. Additional highly valued contemporary artists are Guillermo Roux, Julio Le Parc, Antonio Seguí and Rómulo Macció.

Table 2.2 The top ten auction prices obtained for Argentine paintings

Rank	Artist	Title Venue	Dimensions Date	Price US$
1	Berni, Antonio	*Ramona espera* Sotheby's (NY)	200×300 November 1997	717,500
2	Berni, Antonio	*La gallina ciega* Christie's (NY)	160×200 November 1997	607,500
3	Berni, Antonio	*Los emigrantes* Christie's (NY)	300×189 November 1996	552,500
4	Pueyrredon, Prilidiano	*Apartando en el corral* Naón	62×81 June 1999	551,530
5	Pueyrredon, Prilidiano	*Los capataces* Naón	63×80 June 1999	515,660
6	Pettoruti, Emilio	*El morocho maula* Christie's (NY)	160×62 May 1998	497,500
7	Berni, Antonio	*La fogata de San Juan* Christie's (NY)	155×236 May 2000	468,000
8	Berni, Antonio	*Chelsea Hotel* Christie's (NY)	201×63 June 1999	442,500
9	De la Vega, Jorge	*Prueba de nuevo* Sotherby's (NY)	130×200 May 2001	335,750
10	Pettoruti, Emilio	*La canción del pueblo* Saráchaga	74×64 September 1993	324,220

Source: CONSULTART/dgb

Conclusion

This brief summary of the Argentine art market shows that it is an active environment where work by Argentine artists is widely appreciated. Fundamental to this market is the necessarily small segment of the population with disposable income to spend on art. Extreme fluctuations in the Argentine economy, as well as the country's great social mobility, are largely responsible for the relative flexibility of the art market in Argentina compared with more firmly structured societies. In Argentina, owning a work of art is considered a striking visible symbol not only of the wealth of its owner, but also of their cultural level. And this is something that artists, art dealers and auctioneers use to their advantage.

Bearing in mind the size of the Argentine art market, its future will most certainly be conditioned by its possible insertion into the international art scene. The lifting of restrictions on exports and a greater presence at major venues such as biennales and art fairs in major centres require a firm conviction from a government which, for now, does not seem overly interested in supporting Argentine art so that it can obtain a stronger position internationally. The isolation which, for economic reasons, is experienced by most Argentine artists conspires against an appropriate relationship between the quality of their work and the prices it currently draws.

For further information on the development of this particular art market, go to:
www.koganpage.com/artmarkets.

Australia

Georgina Pemberton and Josh Pullan

I come from the land down under

The total value of art works sold at auction in Australia in 2006 was AU$104.9 million (US$79.4 million). This is a particularly impressive figure when compared with total sales of AU$20.2 million (US$15.2 million) only 15 years earlier (Furphy, nd). However, when placed in the context of international art sales, a single picture, such as Picasso's *Dora Maar au chat* (which sold for AU$126.3 million (US$95.2 million) in May 2006), soon dwarfs these results. Immediately it is apparent that the Australian market marches to a different tune.

This chapter provides an overview for those who are unfamiliar with the Australian art market, and exposes readers to the essential players, its dynamics and history. It is intended that it will give readers the flavour of the Australian market and potentially develop their appetite for further information. A significant portion of the quantitative numerical analysis is based upon sources that are readily available to the public, while the qualitative data has been captured via a series of interviews with key figures in the art market and a survey of some of Australian's leading art galleries.

The first section of this chapter briefly reviews the history of Australian and Aboriginal art and the relative values and trends of each market. (It should be noted that the term 'Australian art' is used only as a method of distinguishing indigenous and non-indigenous art works. All references to the 'Australian art market' should be understood as meaning the Australian art market in its entirety, including both Aboriginal art and Australian art.) An examination of the distribution networks (auction houses, galleries and dealers) and tastemakers (museums, publications and prizes) is undertaken in the second section to familiarize potential buyers with the dynamics of the market. The third section briefly explores the regulatory environment in which the market operates, and the chapter concludes with a discussion of the characteristics of typical buyers.

A segmented market: Australian and Aboriginal art

John Lewin's *Fish catch and Dawes Point, Sydney Harbour c.1813* is widely regarded as the first known Australian oil painting (Allen, 1997: 20). In contrast, the oldest art work by an indigenous artist is thought to be a rock painting dating back approximately 50,000 years (Caruana, 2003: 7). These divergent art histories partially explain the complexity of the Australian market. Although international art is traded in Australia, this area has remained relatively static over the past 20 years, and for the purposes of this chapter will be largely ignored.

In order to develop a better understanding of each market, it is useful to briefly explore the main movements and historical events in each sector.

Australian art

As a young nation, Australia's art history is relatively short (excluding Aboriginal art which is discussed in detail below). The first images relating to Australia began to appear on maps in the 16th and 17th centuries, however it was not until Australia's settlement by migrants that draftspeople documenting the flora and fauna of the new colony produced what could be considered the first art works in Australia. As professional artists arrived, paintings began to depict an expanding colony which was taming the Australian landscape in order to woo potential settlers. By the 1830s, artists such as John Glover and Eugène von Guérard began to present a romantic vision of the Australian landscape, capturing the raw beauty and grandeur of the bush. Even at this formative stage of Australia's art history, artists were drawn to the theme of the landscape, and this remains one of Australian art's most enduring themes.

Towards the end of the 19th century Australia's first great art movement was gathering momentum. A group of Melbourne painters (Charles Conder, Frederick McCubbin, Tom Roberts and Arthur Streeton), known as the Heidelberg School, were Australia's Impressionists, and they mastered the *plein air* technique, capturing the changing light and atmosphere of the Australian bush in their rapidly created compositions. The concept of rural work within the landscape was also a key theme for this group, and it conveyed the feelings of confidence and growth that the new nation was experiencing at the time. However, as Australia descended into a depression in the mid-1890s, the ideals of the Heidelberg School diverged from reality and the art works began to express the pessimism felt by the nation. By the end of the 1800s, the nationalist sentiments captured by the art works had disappeared and the movement came to an end.

As some of the earliest proponents of Australia art, the Heidelberg and early colonial artists have enjoyed immense popularity in the Australian art market. Many of them, such as John Glover and Frederick McCubbin, have commanded prices in excess of AU$1 million (US$750,000) for a number of years. The difficulty in assessing the performance of this group of artists is that the majority of their significant art works are now held in museum collections and are therefore unlikely to reappear on the market.

In the post-First World War and Second World War era, Australia entered a period of instability in its art history, with dissent between conservative, modernist and avant-garde camps. Amongst these splintered ideologies, a group of artists known as the Angry Penguins developed their own vision of modernism. The key artists, Sidney Nolan, Albert Tucker and Arthur Boyd, arguably produced some of the most strikingly original art works in Australian art history, of which Sidney Nolan's *The camp* is an excellent example. The composition was executed by Nolan in 1946 and is one of the first art works in his famous Ned Kelly series.

Like Nolan, Russell Drysdale was struck by the outback. Commissioned by the *Sydney Morning Herald* in 1944 to record the drought-stricken landscape, Drysdale's images of ghost towns and pubs, with their complement of elongated figures of stockmen, station hands and half-caste families, are now iconic images of this era.

Abstract art enjoyed a sustained period of popularity between the mid-1950s and early 1970s. For example, Fred Williams sought out landscapes that seemed unexceptional to the casual viewer and created a new vision of rich colour, subtle texture and powerful abstract form that captured what is now thought of as the 'real Australian landscape'. The Antipodeans (Charles Blackman, Arthur and David Boyd, John Brack, Robert Dickerson, John Perceval and Clifton Pugh) attempted to reassert the importance of figurative painting. Modern artists from this period are currently dominating the top end of the market. For example in April 2006, John Brack's depiction of the urban landscape in *The bar* achieved AU$3.1 million (US$2.4 million): at the time, the highest price ever paid at auction for an Australian art work. At the time of writing, this record had been surpassed by two other art works in 2007: another Brack, *The old time,* which Sotheby's sold for AU$3.4 million (US$2.7 million) in May 2007, and Brett Whiteley's *The Olgas for Ernest Giles* which achieved AU$3.5 million (US$2.8 million) at Deutscher Menzies' June 2007 auction and now holds the record as the most expensive Australian art work sold at auction. Whiteley is well known for his sumptuous azure blue Sydney Harbour paintings and lyrical style. He was a prolific artist and the only one to have won all the major Australian art prizes (Archibald, Wynne, Sulman and McCaughey) within two years of each other.

The 1980s were an era when installation art, video art, sculpture and performance art rose to prominence. Because of the temporary nature of many of these art works, some most enduring art works surviving this period are by sculptors such as Robert Klippel, who is currently enjoying a spate of auction successes including the highest price achieved at auction for a work of sculpture (AU$507,800, US$382,474) in 2006. Postmodernism was also in vogue in this period, and artists such as Rosalie Gascoigne and Lindy Lee employed the post-modern tropes of repetition of image to dazzling effect.

In more recent years, Australia's contemporary artists have remained focused on conservative subject matter. The themes of work and position relative to the landscape are still readily recognizable in many art works. William Robinson's multiple perspective rainforest landscapes, Tim Storrier's burning embers of gumtrees and star-studded skies and John Olsen's aptitude at capturing the native wildlife flourishing, pulsing and growing in the landscape have struck a chord with collectors domestically. Interestingly, artists who have opted for controversial subject matters such as Patricia Piccinini's grotesque creatures and Bill Henson's dark, sexual fantasy worlds have been met with international acclaim.

Aboriginal art

History

Just as the history of Australian art relates to European settlement and Australia's development as a nation, the history of Aboriginal art is also closely linked to the arrival of Aboriginal people and their relationship with the land.

The Aboriginal people first arrived in northern Australia and gradually dispersed throughout the continent. Over time, a number of diverse clans developed in different regions, each with their own distinct cultures, environment, stories and artistic practices. This segmentation is still readily recognizable today, and broadly speaking, the artistic styles can

be grouped into the geographical region from which they originate. The three primary regions – the desert, the Kimberley and Arnhem Land – are briefly explored below.

Before we do this, it is important to acknowledge that it was only within the last century that Aboriginal art works began to gain widespread recognition as works of art, rather than primarily ethnographic objects. Therefore although the history of Aboriginal art extends far beyond the past century, this chapter will only examine it relative to its position in the Australian art market. Indeed the first international exhibition of traditional Aboriginal art works only took place in 1941, and since then the international and domestic appreciation of Aboriginal art has developed at a rapid pace. The opening of Musée du quai Branly in Paris in 2006, which features the works of eight Aboriginal artists covering the ceiling, walls and façade of one of the main buildings, is a testimony to the growing popularity of the category.

Regions and styles

The communities in the central and western desert arguably produce some of the most recognizable Aboriginal art works. The use of dots and common symbols to represent a variety of objects or actions are characteristic of most desert artists, such as Clifford Possum Tjapaltjarri and Emily Kame Kngwarreye. These two artists in particular have enjoyed success on an international scale, and Clifford Possum's composition *Warlugulong* became the most expensive Aboriginal art work to be sold at auction when it achieved AU$2.4 million (US$1.9 million) at Sotheby's July 2007 sale.

Arnhem Land produces a diverse range of artistic styles that reflect the variety of natural habitats in the region. 'X-ray' style paintings (where the anatomical features of the subject are visible) are a trademark of the region. However not all artists employ this technique, with those around Limmen Bight (such as Ginger Riley Munduwalawala) opting for vivid colours and figurative painting in their compositions. The last couple of years have seen increased interest in traditional sculpture from Melville Island and compositions on bark.

In contrast to the bolder colours used in many of the desert art works, Kimberley artists such as Rover Thomas [Joolama] and Queenie McKenzie generally employ a restrained palette using traditional ochre colours. The composition of many of the art works is characterized by large blocks of solid colour that convey the power of the story. The top end of the Aboriginal art market is almost exclusively dominated by Rover Thomas, who holds record prices for four out of the top 10 most expensive Aboriginal art works ever sold at auction. His 1991 composition, *All that big rain coming down the top side*, sold to the National Gallery of Australia in 2001 for AU$778,750 (US$403,579), and had been the most expensive Aboriginal art work sold at auction for approximately five years until that record was broken in 2007.

Although great variety exists in the style and medium of Aboriginal art works, the majority are primarily based upon stories from the 'Dreamtime', a period when according to Aboriginal lore, supernatural beings shaped the universe and laws that govern it. Because of the deeply spiritual content of these stories, Aboriginal art was primarily used for ceremonial purposes and was largely temporary in nature, being painted on the bodies of participants or drawn in the sand in some regions. This functional aspect of the art meant that some ceremonies were only able to be performed or observed by specific members of a clan. Because Aboriginal art works are now publicly and permanently displayed on canvas or bark, artists have created innovative techniques to mask the privileged aspects of stories, such as the dot techniques employed by many desert artists.

Another unique feature of some Aboriginal art is an absence of predetermined orientation. Many art works are produced by artists working on the ground, and it is often the arrangement of symbols in the composition relative to each other that convey meaning, rather than the orientation from which they are viewed.

Ethical issues

In recent years, the Aboriginal art market has been the subject of controversy. Instances of dealers offering artists alcohol, drugs, cash and cars in exchange for art works produced outside the artist's Community Art Centre arrangement have come to light. In other cases, artists were placed in appalling conditions and forced to paint large volumes of art works before they were allowed to return home. In response, the Federal Government announced the launch of an official inquiry into the industry's practices and ultimate sustainability in August 2006.

Urban Aboriginal art

An interesting fusion of Aboriginal and Australian art is expressed in the compositions of artists such as Lin Onus, Julie Dowling and Tracey Moffatt. These artists incorporate traditional elements or experiences from their Aboriginal heritage and express it in a non-traditional form, such as photography or figurative paintings incorporating indigenous symbols. The popularity of this style has gathered momentum, and it is likely this will remain a burgeoning sector of the Australian art market.

Financial indicators and performance

As is the case in all art markets, information inefficiencies make it impossible to state with certainty the total value of the art market. The most reliable information available is obtained via auction results, which can then be extrapolated to provide an indication of trends experienced in the market in general.

John Furphy's *Australian Art Sales Digest* is the most comprehensive source of Australian art auction results, and as Figure 3.1 demonstrates, the value of Australian art auction sales has increased steadily since 1990. At the time of writing, the year to date results for 2007 indicated another year of sustained growth in sales.

Turning to the relative importance of the three segments of the Australian market, Figure 3.2 illustrates that a significant alteration in the market share between sectors has occurred. Aboriginal art increased its market share from 2 per cent in 1988 to commanding 14 per cent of the total value of the market in 2006, while interest in international art has slightly waned during the same period. (Because these figures are based solely on auction sales it is likely that they largely understate the total market share of Aboriginal art sold by galleries and dealers, because only a handful of auction houses hold sales dedicated exclusively to Aboriginal art.) As Justin Miller, chairman of Sotheby's Australia, notes:

In recent years there has been an exponential growth in the Aboriginal art market and Sotheby's has remained the clear leader in this segment of the Australian art business. Aboriginal art now represents almost 25 per cent of Sotheby's business in Australia.

(Author interview)

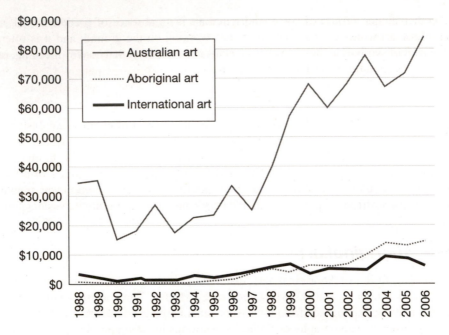

Figure 3.1 Value of the Australian art market sector, 1988–2006

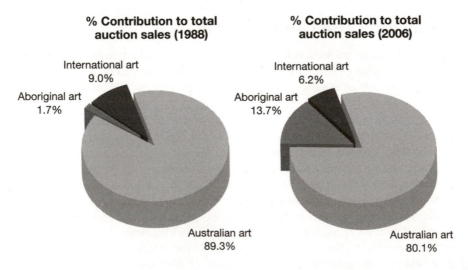

Figure 3.2 Australian market share of Australian, Aboriginal and international art, 1988 and 2006

Although the performance of individual artists, record prices or sales volumes may make good headlines, they alone are not indicative of the performance of the broader market. Art indices can provide guidance in this area, and Roger Dedman's *Australian Art Market Movements Handbook* (to be published by Deutscher Menzies under the new title *Australian*

Art Market Index in 2007) is widely regarded as the most authoritative indicator of Australian art market performance.

Based upon the period 1975–1995, when the last major troughs in performance occurred, Dedman's study suggests a long-term real rate of return of approximately 4.7 per cent pa (Dedman, 2004: 22). Having said this, the rate of return in the short term would be considerably higher than this, as Dedman notes:

> The market has been consistently improving for a number of years now. 2004 and 2005 saw increases of approximately 10 per cent and 15 per cent respectively and I would predict that 2006 will also see an increase somewhere in the region of 10 per cent.

> (Author interview)

In this sense, the Australian art market has enjoyed a comparable period of growth to that experienced by the other major international markets over the same period.

The players

Distribution networks

The main participants in the Australian art market interact in a similar way to those in the major international markets. However, from a practical point of view, it is useful to briefly examine who these players are and where they are based. (Sydney and Melbourne will be the main focus of discussion in this section, due to the parameters discussed.) This is not to say that important players do not exist in other auction houses.

Auction houses

Currently there are approximately 30 auction houses in Australia which regularly conduct auctions of fine art. The businesses themselves range from large international corporations with salesrooms in multiple cities, to small family-owned operations that service relatively niche markets.

Historically the competition between Sotheby's and Christie's had been strong in the Australian market. However in the past 5–10 years strong competition from local auction houses has caused a significant reshuffle of the market. In 1998 a locally owned auction house, Deutscher Menzies, established a foothold in the market through aggressive deal-making, concerted marketing efforts and an auction calendar that departed from the traditional Sotheby's–Christie's schedule. By the end of 2002, after only five years in operation, Deutscher Menzies stole the number two market share position from Christie's, and on 14 March 2006 Christie's announced the closure of its Australian salerooms, stating that 'resources should be reallocated to support other areas of increased potential growth in the global marketplace' (Christie's, 2006). Since then another restructuring has occurred, and Deutscher Menzies' executive director, Chris Deutscher, departed and established a new firm known as Deutscher and Hackett.

The auction house landscape in Australia continues to develop and there are currently eight significant players: Bonhams and Goodman, Deutscher and Hackett, Deutscher Menzies, Joel Fine Art, Lawson Menzies, Moss Green, Shaprio's and Sotheby's. Moss Green, Joels Fine Art and Deutscher and Hackett are particularly interesting business models as they

have positioned themselves as both auction houses and private dealers who conduct selling exhibitions for artists.

Dealers and galleries

Art dealers and galleries are in abundant supply in Australia, with approximately 800 in operation around the nation (Meakin and Reid, 2005). In some cities a distinct pattern of clustering can be observed, with an extraordinarily large number of dealers or galleries all operating within one suburb or street. For example, the Sydney suburbs of Paddington and Woollahra are densely populated with galleries and dealers, as are Melbourne's Flinders Lane and the surrounding suburbs of Richmond and Armadale. Although no list is exhaustive, the galleries and dealers included in Table 3.1 are some of Australia's best, and should provide a starting point for those seeking further information.

Aboriginal Community Art Centres

A unique feature of the Australian art market is the existence of Aboriginal Community Art Centres which operate out of the various Aboriginal communities. Their primary role is to assist artists in their community with all aspects of the production and sale process. This includes

Table 3.1 Some Australian art galleries and dealers

Australian Capital Territory
Solander Gallery
Queensland
Andrew Baker Art Dealer
Jan Murphy Gallery
Philip Bacon Galleries
Victoria
Charles Nodrum Gallery
Christine Abrahams Gallery
Gallery Gabrielle Pizzi
Lauraine Diggins Fine Art
Niagara Galleries
Tolarno Galleries
Vivien Anderson Gallery
New South Wales
Annandale Galleries
Christopher Day Gallery
Eva Bruer Art Dealer
Gould Galleries
Kaliman Gallery
Martin Browne Fine Art
Michael Reid
Rex Irwin Art Dealer
Stills Gallery
Northern Territory
Gallery Gondwana
Western Australia
Greenhill Galleries
Lister Calder

supplying artists with paint and canvases, dealing with intellectual property issues, negotiating the sale of art works to commercial galleries and dealers, and ultimately distributing the sale proceeds. In addition to these functions, one of the great legacies of the Community Art Centres has been the application of unique stock numbers to all art works produced by their artists, and this has partially helped to address the problems with forged art works.

Marketing and placement

In some aspects the marketing activities of the various players in the distribution networks are strikingly similar. For example, the survey of Australia's leading art galleries and dealers conducted for this chapter revealed that approximately 85 per cent of respondents had participated in at least one domestic art fair within the last 12–18 months. The Melbourne Art Fair ranked most popular with respondents, followed by Art Sydney & Art Melbourne and the Australian Antiques and Fine Art Fair. Interestingly only a fraction of respondents had participated in major international art fairs such as Frieze Art Fair, Art Basel and Art Cologne.

Examination of the survey results contained in Table 3.2 demonstrates a wide variety of marketing strategies employed by galleries and dealers. Traditional print-based advertising media such as magazines, newspapers and mailshots still dominate marketing activities, and only 38.5 per cent of respondents employed online promotion in addition to their own website. Given that Australia has the highest percentage of internet users per capita anywhere in the world, with approximately 70.1 per cent of the population connected (ABS, nd), it will be interesting to see whether galleries and dealers adjust their marketing strategies in the future as the demand for online advertising steadily increases.

Tastemakers

Museums

Each Australian state capital city has its own state art gallery, most of which were created in relatively quick succession following the foundation of the National Gallery of Victoria in 1861. Although blockbuster international art exhibitions such as the National Gallery of Victoria's 'Picasso: love and war' have enjoyed widespread success, Australians' interests rest primarily with domestic artists. Indeed the top three most attended exhibitions at Australian museums in 2005 were all exhibiting the work of exclusively Australian artists.

Table 3.2 Marketing activities of respondents, Australia

Marketing activity	Percentage of respondents
Magazine	69.2
Television	7.7
Mailshot	61.5
Online	38.5
Radio	2.3
Art fair	84.6
Newspaper	61.5
Newsletter	30.8

Source: authors' survey

Many of Australia's major artists have art works held in international collections. A few examples include Fred Williams (Tate and MOMA), Peter Booth (MOMA), Roy de Maistre (Tate), Russell Drysdale (Tate and MOMA) and Sidney Nolan (Tate and MOMA). However it is Aboriginal art that has largely attracted the interest of international institutional collections such as the Musée du quai Branly (Paris), the British Museum (London) and Staatliches Museum für Volkerkunde (Munich).

Critics and publications

Because international art market publications have tended to focus upon European and American markets, Australian art critics, academics and market commentators have developed a wealth of art periodicals that cater to the domestic market. Important periodicals include: *Art + Australia, Australian Art Collector, Australian Art Market Report, Art Almanac* and *Art Monthly.* Two national newspapers, *The Australian* and *Australian Financial Review*, also have excellent weekly columns that comment on the art market. The Bibliography lists books recommended for those interested in gaining a more detailed understanding of the Australian art market.

Turning to freely available electronic sources, ArtNet (www.art.net.au), an online portal to commercial galleries, dealers and art-related services, is a welcome addition. The site currently provides listings for over 450 galleries and dealers, and displays highlights from their current exhibitions. It also maintains a fully searchable section of nearly 200 art services, including art consultants, framing and hanging specialists and art valuers.

Prizes

Several art prizes exist in Australia, and usually offer prize money or some form of scholarship programme. Arguably the most controversial is the Archibald Prize, which is awarded to the best portrait painting. Over the past few decades, several winners of the Archibald have found themselves embroiled in lengthy legal disputes over the prize. Perhaps most famous was William Dobell's 1944 portrait, *Joshua Smith*, where it was contended that the composition was a caricature and therefore not a portrait within the terms of the prize. More recently, Craig Ruddy's charcoal portrait of *David Gulpilil* was also the subject of a dispute, where it was argued that it constituted a drawing, again falling outside the scope of the prize. Ultimately both cases were dismissed by the courts.

Other major national art prizes include the:

- Doug Moran National Portrait Prize (best portrait);
- Fleurieu Peninsula Art Prize (best landscape);
- Photographic Portrait Prize (best photographic portrait);
- Sulman Prize (best subject or genre painting or mural project);
- Telstra National Aboriginal and Torres Strait Islander Art Award (most outstanding indigenous art work);
- Wynne Prize (best landscape painting).

Promotion of Australian art

Primarily the Australia Council for the Arts is responsible for the government funding and promotion of the Australian art market both domestically and abroad. It currently issues 1,700 arts-related grants per year and has been the driving force behind Australian artists' presence at the Venice Biennale since 1954.

A recent example of government promotion of the arts is Austrade's Art Portfolio project in the United States in 2006. This initiative involved promoting a group of 36 predominantly mid-career Australian artists by sending a portfolio of their collective art works to interested American galleries with the aim of securing gallery representation in the United States. Joel Newman, business development manager for Austrade in Los Angeles, enthused:

> The response has been overwhelming …. I think generally the artists' compositions are different to art work being produced by US artists, which can be a competitive advantage. Australian artists often use landscapes as subject matter, which can be foreign to buyers in major art markets. But the US is a vast market and every artist can find their niche.

(Author interview)

Artbank is another highly successful government initiative which has been operational since 1980. Artbank involves the rental of a portfolio of predominantly contemporary Australian and Aboriginal artists to a range of clients including large corporations, overseas embassies and also private individuals. There are more than 9,000 art works in the portfolio, and rental ranges from AU$110 (US$83) to AU$5,500 (US$4,135) per art work per annum. During 2006 and 2007, an exhibition entitled 'Artbank: Celebrating 25 years of Australian art' is touring Australia, and will showcase some of the collection's important art works.

The regulatory environment

The regulatory environment in which the Australian art market operates is relatively similar to that experienced in other countries around the world. However there are some unique features which are worth exploring below.

Transaction costs

At the time of writing, the buyer's premium associated with purchasing an art work at auction from Sotheby's and Deutscher Menzies was set at a flat rate of 20 per cent of the hammer price. This differs from the sliding scale used by the major auction houses in New York and London, and can perhaps be explained by the comparatively low average lot value of most works of Australian art. The seller's commission is generally around 10 per cent. A federal tax known as goods and services tax (GST) is levied on the amount of buyer's premium and seller's commission at a rate of 10 per cent.

Taxation

In addition to any GST, capital gains taxation may be applicable upon the sale of art works that are less than 100 years old. However the taxation framework is not all bad news in Australia. Since 1999, Australians have been able to place art into a specific type of superannuation (pension) scheme known as a self-managed superannuation fund (SMSF). Under this structure, members of the SMSF are able to display art works owned by the SMSF in their residences subject to certain conditions, and enjoy considerable taxation concessions on contributions to the fund and any income produced by or capital gains accrued by the assets of the fund. Interestingly, the British government had been contemplating permitting art

investment in a similar pension structure known as a self-invested personal pension (SIPP) until 2005 when the concept was abandoned.

Export restrictions

The Protection of Moveable Cultural Heritage Act (1986) and Wildlife and Protection Act (1982) are the two key pieces of legislation restricting the export of art works. Under the former, art works require an export permit where they meet various criteria. As a general rule, paintings with a value in excess of AU$250,000 (US$188,000) which are more than 30 years old will require a permit. However for paintings by Aboriginal artists, the thresholds are considerably lower, with a permit being required for paintings that are more than 20 years old and are worth more than AU$10,000 (US$7,500).

The Wildlife and Protection Act requires buyers of animal material such as ivory and tortoiseshell to obtain an export permit, prior to shipping goods from the country.

Buyer characteristics

At the time of writing, the Australian economy was thriving. In part, the favourable economic conditions can be attributed to the significant volume of raw and agricultural materials being exported to China. Corresponding with the prosperous financial climate in Australia, the number of high net worth individuals in Australia has grown from 146,000 to 161,000 between 2005 and 2006 (CapGemini/Merrill Lynch, 2007). The impact of newly created wealth is clearly perceptible in the Australian art market. Auction houses in particular have noted the transition from a small group of well-known regular buyers to an influx of new faces, including hedge fund managers, entrepreneurs and financiers who are particularly interested in contemporary art. The result is that competition for most desirable art works is fierce, and in many cases public institutions are no longer able to compete with the budgets of private collectors.

Typical collector profile

Building the profile of a typical art purchaser is fraught with difficulties; however an analysis of the survey results conducted for this chapter revealed some interesting trends. Galleries and dealers who sell Aboriginal art have a significantly higher percentage of international clients (approximately 16.1 per cent) than those who sold exclusively non-indigenous Australian artists (approximately 4.2 per cent). With the exception of Aboriginal art, the vast majority of purchasers of Australian art live predominantly in Australia or are Australians living abroad. This is perhaps unsurprising given the geographic isolation of Australia from the rest of the world. International galleries and dealers are less likely to actively cultivate Australian collectors at home due to the considerable time and expense involved in travelling to the region. Conversely, Australian artists are predominantly promoted domestically for the same geographical and financial reasons.

The age brackets in which Australians purchase art are well defined, as illustrated in Figure 3.3. Evidently as purchasers age, they acquire the financial means and knowledge required to purchase art works and ultimately their interest peaks and gradually tapers off as their priorities change focus.

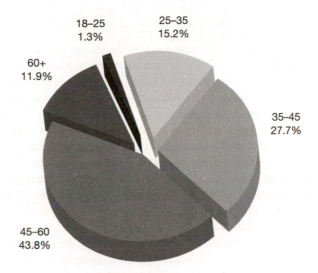

Figure 3.3 Average age of Australian art buyers

Corporate collections

Corporate art collections remain popular in Australia, with some of the nation's largest corporations, such as Wesfarmers, Macquarie Bank, ANZ Banking Group and Australian Capital Equity, continuing to build significant collections. However, the last five years have seen the sale of a handful of blue-chip corporate collections, such as the Fosters Group, BHP, John Fairfax Holdings and Coles Myer. Reasons for these sales have varied from taking advantage of strong selling market conditions, to demonstrating fiscal responsibility to shareholders, to releasing the necessary capital to refocus the collection on contemporary art works that better reflect the values of the company. The new collections being created, such as Deutsche Bank's, are largely commission-based and are often intended to complement the architectural design of the building. Companies are also using the proceeds raised from the sales to support the artistic community through philanthropic gifts. A recent example of this was the sale of the Qantas Collection by Sotheby's which ultimately funded the Qantas Art & Travel Scholarship, a state and territory-based prize which will support Australian artists into the future.

Art investment schemes

Although there are a vast range of businesses, dealers and consultants who are eager to 'actively manage' an art investor's portfolio of art works, it appears that the concept of a collective investment scheme where buyers have fractional ownership in a portfolio of paintings is yet to become viable in Australia.

Conclusion

The Australian art market offers a diverse range of artistic styles and media for interested collectors to explore. From early colonial or bark paintings, to sculpture and video art, there is a wealth of talent in every sector. Part of the challenge for Australian art is expanding its reach to an international audience, and we hope this chapter has provided readers with the resources to further develop their interests.

Those who are considering Australian art from an investment perspective should be mindful of the unique properties of art as an asset class. Arguably the specific risk of holding Australian art is greater than that experienced in many other art markets. This is primarily due to the relatively small marketplace, predominantly domestic buyer demographic and resultant low liquidity of Australian art works. However the outlook for the Australian art market remains healthy, as Chris Deutscher notes:

> The depth of buyers in Australia is far greater than 1989; perhaps 10 times as many buyers now operate in the market. Many are wealthy young new collectors prepared to spend AU$100,000 on each acquisition. There is also a large amount of investment purchasing currently occurring, so even if the market were to fall, it would be supported by opportunistic purchasers.
>
> (Author interview)

Therefore those investors willing to accept the higher risk associated with the market may reap significant financial rewards, especially as the market for Aboriginal art becomes increasingly international.

For further information on the development of this particular art market, go to: www.koganpage.com/artmarkets.

Bibliography

Allen, C (1997) *Art in Australia: From colonization to postmodernism*, Thames & Hudson, London

Australian Bureau of Statistics (ABS) (nd) Statistics[online]www.abs.gov.au

Capgemini/Merrill Lynch (2007) *World Wealth Report 2007*, Capgemini/Merrill Lynch

Caruana, W (2003) *Aboriginal Art*, Thames & Hudson, London

Christie's (2006) Christie's Australia reverts to representative office, press release, 14 March

Dedman, R (2004) *Australian Art Market Movements Handbook*, Christie's Australia, Melbourne

Furphy, J (nd) *Australian Art Sales Digest* [online] www.aasd.com.au

McCulloch, S (2001) *Contemporary Aboriginal Art*

McCulloch, A, McCulloch, S and McCulloch Childs, E (2006) *The New McCulloch's Encyclopaedia of Australian Art*

Meakin, L and Reid, M (2005) *Reid's Guide to Australian Art Galleries*

Reid, M (2004) *How to Buy and Sell Art*

Smith, B and Smith, T (2003) *Australian Painting 1788–2000*

4

Austria

Andrea Jungmann and Claude Piening

Short history

Austria has always been seen as a country of culture and art. Over centuries Austrian noble and imperial families supported artists at their courts and put together the most famous art collections. Today, the most important of these can be found in Austrian museums such as the Kunsthistorisches Museum in Vienna, whose collection is founded on the activities of Erzherzog Leopold Wilhelm, who acquired 1,400 pictures by famous painters including Titian, Veronese, Rubens and Van Dyck during his governorship in the Netherlands in the mid-17th century. Another is the collection of the Albertina with its 50,000 drawings and a million prints, which was founded by the Herzog Albert von Sachsen-Teschen (1738–1822). Not everything went to museums, and much – including the Harrach collection, now in Schloss Rohrau in Lower Austria, and the Esterhazy Collection in Schloss Esterhazy in Eisenstadt, Burgenland – remained in private hands. For a long time Old Master paintings dominated the Austrian art market, and they still play an important role. The Old Master paintings auctions at the Dorotheum in Vienna serve an international clientele and have accounted for a major share of the auction house's turnover since its beginning.

While art patronage before 1850 was dominated by the Austrian aristocracy, the turn of the century saw an increasing number of bourgeois collectors. The Biedermeier era in the first half of the 19th century promoted art which was accessible to everyone. Day-to-day life and well-known views of Austria's cities emerged as the main subjects of the artists of that time. The middle class was prospering and started to decorate its apartments with works by Rudolf von Alt or Friedrich von Amerling. The end of the 19th and the beginning of the 20th century saw the rise of industrialists, many of them Jewish, acting as patrons of the arts and assembling astonishing art collections. Most of them collected Vienna secessionist artists, the avant-garde of the time. Families like Bloch-Bauer, Zuckerkandl, Steiner and Lederer all lived with paintings by Gustav Klimt, Egon Schiele and furniture by Hoffmann or Moser. They were often the artists' patrons, knew them personally, and invited them to 'salons' to discuss art and politics to promote their living. Transactions between artists and collectors were mainly done on a private and direct basis. Unlike in other European countries there was an almost complete absence of art dealers (artists like Van Gogh or Monet would not have

been as successful without a gallery which supported and promoted their art), nor was there any government aid to help young avant-garde artists. This resulted in the foundation of artist associations like the Künstlerhaus, the Secession and the Wiener Werkstätte around 1900, which organized regular selling exhibitions for their members and thus helped to establish contacts between potential buyers and collectors.

This status quo came to a sudden end in 1938 when the Nazis confiscated many of these art collections and the owners were forced to flee. The collections were looted, torn apart, and sold for the benefit of the regime. The events of that time were a shock to the art market in Austria. An art market which had been internationally known and acknowledged became regional and secondary. A few dealers profited from looted art but the buyers, often themselves Jewish, either died in concentration camps or fled the country to start new lives in the United States, Canada or England. The art of collecting seemed to have died.

Nevertheless, a number of individuals started collecting in the immediate aftermath of the war. Rudolf Leopold was one of them: drawn by the work of Schiele in 1947, he refrained from buying his first car in favour of his first work by Schiele. This period from 1945 to 1960 was a difficult time for the art trade. Dealers struggled to find buyers in Austria for the art they had in part acquired through the war years while collaborating with the Nazi regime. Artists struggled to find a means to express themselves in a new way, while working hard to rebuild a country completely destroyed by the war, and without access to art movements in other countries or the financial means to travel. This was at a time when in America the abstract expressionists were making their first appearance and Pollock was painting his first abstract canvases. However, although it took a little longer, Austria's own revolutionary avant-garde movement, called Viennese Actionism, finally emerged between 1962 and 1968.

Auction houses in Austria

The history of auctions in Austria started on 14 March 1707 when Emperor Joseph I founded the Versatz- und Fragamt to regulate the credit business and to invite Austrians to pawn items legally in return for loans. Every item was accepted as long as it had some value, be it a watch, porcelain or even a fur coat or chair. If the loan was not repaid the property was sent for auction. In 1923 the institution was renamed the Dorotheum, and it remained state-owned until 2001, when it was bought out by a group of young investors who have since successfully run it privately.

A period of prosperity from 1901 to 1914 ended suddenly with the outbreak of the First World War. After 1918 the Dorotheum saw consignments mainly from the former Imperial family and the high aristocracy, and from 1938 to 1945 it was used by the Nazi regime to sell art collections looted from Jewish citizens. Around 1980 the international auction houses Sotheby's and Christie's discovered the Austrian art market, and established representative offices in Vienna. Around the same time two small auction houses in Vienna held successful, though low-value sales: Hassfurther, which still exists and achieves record prices for Austrian 19th and 20th century art, and Alt-Wien, which closed in the early 1990s. In 1993 competition on the Austrian auction market was intensified when a consortium of dealers, lawyers and auctioneers founded the Wiener Kunstauktionen, today called Im Kinsky.

The Dorotheum holds around 600 sales per year and employs 400 members of staff (worldwide), 70 of these as experts. It has offices in Milan and Prague, and representative offices in Düsseldorf, Zagreb, Brussels, Munich and Tokyo. Im Kinsky has around 20 employees, all in Vienna.

Table 4.1 Turnover of the Dorotheum and Im Kinsky in € million, 2001, 2004 and 2005

	2001	2004	2005
Dorotheum	70	77	85
Im Kinsky	10	12.8	19

The Austrian art market

Herchenröder (2000) estimated that works of art from Austria worth €22 million were sold on the international auction market in 1997. Since then this sum might have grown another 30 per cent. Herchenröder does not clarify whether this sum is based on estimates or hammer prices achieved at auctions.

The Austrian contribution to the international art market is in fact very high in relation to the population: Austria generally contributes between 0.7 per cent and 1.5 per cent to the worldwide turnover of paintings, in 1999/2000 amounting to €20.7 million. This is rank 11 in the Art-Sales-Statistics. Art worth €175.5 million was sold in 1998, ranking Austria fifth in Europe after the United Kingdom, France, Germany and Switzerland, and ahead of the Netherlands and Italy (source: MTIC estimates).

Traditionally Austria has been dominated by a dealer market, with 900 businesses in 1998 and 2,100 employees (ranking the country fourth in Europe, according to MTIC estimates). (See Table 4.2.) This is equivalent to every Austrian spending more than €2 on art that year, more than double the German level, but still a negligible sum. Of course not every Austrian buys art, as buying art was and still is limited to a small élite.

Between 1990 and 1997 works by Austrian artists worth circa €225 million were sold worldwide. Over the same period some €128 million of paintings in general (not only by Austrian artists) were sold in Austria. This shows that the largest turnover for works by Austrian artists is outside Austria.

Export law and restitution

The export law in Austria which stems from 1918 is quite strict. Up to 2,000 works of art including furniture, antiques, books, manuscripts, silver and metal carvings and even stamps (for more information see www.bda.at) were generally forbidden from leaving the country without an export licence by the department for monumental care. Every single item, no matter what medium, age or value, had to have an export licence before crossing the border. In 2000 the law was changed and value limits were introduced. Anything above these limits (for paintings older than 50 years €150,000) still needs an export licence, as do items below

Table 4.2 Art sales turnover for various countries, 2001/02 season

Country	Turnover (£ sterling)	Number of sales	Average value (£ sterling)
Austria	11,447,074	3,201	3,576
USA	712,825,515	19,908	35,806
UK	526,532,975	30,016	17,542
France	118,300,502	19,226	6,153

the limits that are considered important to Austria's cultural heritage. This means that oil paintings by artists like Gustav Klimt and Egon Schiele are very often not allowed to leave the country. The only way at the moment that these receive an export licence is if they have been restored to a previous owner by an Austrian museum. (See Table 4.3 and Figure 4.1.)

The restitution law came into being in 1998 after two works by Schiele from the Leopold Collection were confiscated during an exhibition in the MOMA in New York. The law advises museums to research any property which came to their collection between 1938 and 1945. As early as 2000 the large Rothschild collection with mainly Old Master paintings from the Kunsthistorisches Museum was returned to the rightful owner and sold at auction at Christie's in London. Many other restitutions followed, and all in all over 6,000 objects were restored, some of them important and expensive paintings by Gustav Klimt or Egon Schiele,

Table 4.3 Location of Egon Schiele paintings

Type of location	In numbers	In percent
private collection	186	56
foreign institution (museum/gallery)	21	6
domestic institution (museum/gallery)	83	25
Leopold Museum	37	11
Österr. Galerie, Vienna	14	4
NÖ Landesmuseum Wien	7	2
Historisches Museum der Stadt Wien	6	2
Stiftsmuseum Klosterneuburg	4	1
Neue Galerie der Stadt Linz	4	1
Neue Galerie am Landesmuseum Joanneum Graz	4	1
Albertina	3	1
OÖ Landesmuseum Linz	2	1
Galerie Würthle	1	0
Tiroler Landesmuseum Ferdinandeum Innsbruck	1	0
present whereabouts unknown/destroyed	44	13
Total	**334**	**100**

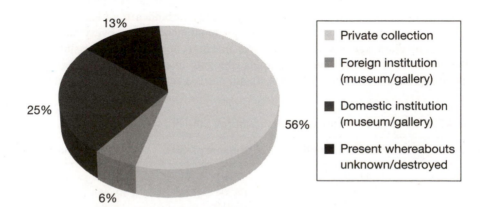

Figure 4.1 Location of Egon Schiele paintings

others complete libraries of not very high commercial value. Research is ongoing and the museums are still in the process of checking their archives and looking for heirs. In October 2006 items in the Austrian state and Viennese museums with doubtful provenance were published on www.kunstrestitution.at, a website founded by the Österreichisches Nationalfond together with the relevant institutions, to establish whether or not they are subject to restitution and also to find possible heirs.

Collecting fields

At the time of writing, the art market in general has reached levels last seen during the boom of the late 1980s. This is also true of prices being paid for 19th-century Austrian art (in November 2005 a work by Ferdinand George Waldmüller (1793–1865) achieved $1.3 million at the Dorotheum in Vienna, the highest price for the artist since the world record price of $2.2 million established in London in 1989), the marked difference being that the market has become more selective, with top examples by key artists like those mentioned achieving record prices, and second-tier painters of lesser quality proving more challenging to sell. With the appearance of ever more scholarly literature, researched auction catalogues and art advisory services, increasingly savvy and discerning buyers are outstripping supply, a trend which is set to continue, at auction, in the trade, and at private treaty level, locally and internationally.

Underlying this general trend, however, there are marked differences in the perception of, and market for, 19th-century Austrian art in Austria and outside Austria, in other words between the domestic market and the international one. These differences are linked to taste, culture and buying power. On the whole, the local market in Austria for Austrian art is a lot broader than the international market, in terms of the range of artists sold and of subject matter. The majority of Austrian painters, beyond the seminal names outlined above, have a local following, either because their reputation has not grown beyond Austria's borders, or – and more importantly – because the subjects of their work are of specific local interest or taste. Examples are views of lesser-known Austrian towns, portraits of local personalities or royals, and historical scenes relating to very specific events in Austrian history. This pool of local artists makes up a robust middle market in Austria, attracting private, trade and institutional buyers alike. Works by these artists, while growing steadily, are not seeing the dramatic gains in value enjoyed by the top, internationally recognized names.

The international market in London and New York for 19th-century Austrian art is much more selective, and restricted largely to the 'blue chip' names in Austrian art history such as those discussed above, whose reputation has spread across Europe and beyond. Clearly one of the main reasons for their popularity abroad is their reputation at home, based on their perceived quality and contributions to artistic life. But beyond this, it is the universal appeal of their subjects and the decorative qualities of their works that hold international appeal. Waldmüller's timeless alpine landscapes, staffed by happy peasant families, Gauermann's dramatic hunting and wildlife scenes, Rudolf von Alt's (1812–1905) unmistakeable Vienna panoramas, and Olga Wisinger-Florian's (1844–1926) colourful landscapes and still lifes all have one thing in common: while often quintessentially Austrian, they embody qualities that collectors around the world can relate to. Indeed, hitherto less well-known Austrian names have recently emerged on the international market by virtue of their painterly quality and subject matter. One example is Pauline Koudelka-Schmerling's (1806–1840) still-life paintings. In 2002 a pair of paintings sold to a British collector at Sotheby's London for

£59,750 ($120,000), setting a new world record. With regard to the Austrian Orientalists, there is also strong interest from buyers in the Middle East.

Naturally, works by these artists attract strong interest and achieve high prices locally in Austria, but as a result of international interest from some of the world's wealthiest collectors and institutions, who gravitate towards the centres of the world art market, London and New York, many world auction records for Austrian artists have been achieved in these two cities. The fact that the world record auction prices for Waldmüller, Alt, Moritz von Schwind (1804–1871), Hans Makart (1840–1884), Ludwig Deutsch (1855–1935), Wilhelm List (1864–1918), and the painters of Venice Eugen von Blaas (1843–1931) and Franz Richard Unterberger (1838–1902) among others have all been achieved at Sotheby's and Christie's in London and New York since 1989 is testimony to the truly international demand for this segment of Austrian art.

From 2000 to date, Sotheby's alone has sold some 150 19th-century Austrian works, for a total of $14,000,000, in its salerooms in London and New York. This lot-to-value ratio, with an average lot value of $100,000, is a clear indicator of the selectiveness of the international market compared with the local market in Austria.

Analysis of the make-up of the buyers in this field clearly confirms the popularity of Austrian art among international buyers. Over 85 per cent of the lots by volume and 88 per cent by value sold in London and New York since 2000 were bought by non-Austrian buyers based in the United States, the United Kingdom, Germany, Switzerland, Italy, Greece, France, Asia and the Middle East.

Overall, 59 per cent of buyers were private collectors, 39 per cent were dealers, and 1.5 per cent museums. However, of the Austrian buyers, who spent a total of $1.6 million, 68 per cent of the lots by volume and 71 per cent by value were secured by dealers, indicating the traditional dominance of dealer intermediaries in Austria.

20th-century Austrian art

Three artists are at the heart of the Secession, the Viennese Art Nouveau movement, founded in 1897: Gustav Klimt, Egon Schiele and Koloman Moser, who all died young in 1918, but all three produced a large volume of works during their short careers.

The most expensive artist of the three is Gustav Klimt (1862–1918), whose Austrian landscapes account for the highest prices of all his work: the world auction record of $29.1 million was paid for a landscape on canvas, *Landhaus am Attersee*, on 5 November 2003 at Sotheby's New York. Klimt's other records in the past 20 years were £13.2 million paid for *Schloss Kammer am Attersee II* (1909) on 9 October 1997 at Sotheby's London and *Litzlberger Keller am Attersee* (1915–16), which fetched $13.4 million (£8.2 million).

Since 1997 works by Gustav Klimt have gained 62 per cent in value. Only a few paintings come up for auction; the finest pieces are to be seen in museums, and this fact makes it hard to easily establish benchmark prices for Klimt oil paintings. Only in September 2006 the world's most expensive painting was sold privately to Ronald Lauder and his Neue Galerie in New York, for a reported $135 million: a Klimt famous golden portrait of *Adele Bloch-Bauer I* from 1907. Otherwise the Klimt market primarily consists of works on paper, which constitute 85 per cent of the Klimts sold at auction (about 50 each year). The prices range between $15–30,000 for a good drawing, but the lesser-quality works are very hard to sell, and 44 per cent of the drawings offered in 2002 went unsold. Austria and Germany are naturally the two other large markets for Klimt, offering 39 per cent of lots between them and specializing in cheaper works on paper.

Egon Schiele (1890–1918) was the youngest of the three famous Secessionists, but he produced about 3,200 works in his short life span. Schiele is the second most expensive Austrian artist: and the artist's index rose 65 per cent between 1997 and 2005 and continues to rise. Works by Schiele come up for auction on a regular basis, of which 60 per cent are drawings and watercolours, usually sold for between €60,000 for a pencil drawing and more than €200,000 for a watercolour. Schiele's drawing *Selbstporträt als Heiliger Sebastian* (1914) fetched $2.25 million in November 2005, three times Sotheby's high estimate and establishing the world auction record for a pencil drawing by this artist. According to Artprice data, the price of his works on paper doubled between 1998 and 2004, with nearly 50 of these pieces auctioned every year.

His paintings are of course more expensive, not least because they are much rarer: in fact over the last 20 years less than 50 oil paintings have come up for sale, with 31 of them offered since 1990, and in 2004 not a single Schiele painting came to auction. His world auction record painting was *Krumauer Landschaft (Stadt und Fluss)* from 1916, which achieved £12.6 million at Sotheby's in London in June 2003.

Koloman or 'Kolo' Moser (1868–1918) is less well known, and the market for his work is therefore more restricted. Fewer than 20 pieces come up for auction each year. In April 2005, *Ditha's SCVRZ* (1912), a small drawing auctioned by Palais Dorotheum, fetched €800, while his small oil painting *Paisaje* was sold by the Ansorena auction house for only €1,500. In February 2006 Sotheby's London sold the monumental painting *Kampf der Titanen* for an exceptional £153,600.

Contemporary art

The avant-garde movement of Viennese Actionism with its main protagonists Hermann Nitsch (b 1938), Günther Brus (b 1938), Rudolf Schwarzkogler (1940–1969) and Otto Mühl (b 1925) marked the beginning of an Austrian contemporary art scene in the 1960s. Their expressive and sometimes violent, definitely shocking performances were a cry for freedom and revolution. In the tradition of the Fluxus and Happening movements they aimed to break radically with prevailing aesthetic conventions and challenge social conventions.

The exhibition 'La peinture comme crime' at the Louvre (from 19 October 2001 to 14 January 2002) provided the official international recognition of the Viennese Actionist scene, followed shortly after by Charles Saatchi's purchases of works by Hermann Nitsch for his collection. Saatchi's taste can make reputations, and being chosen for his collection tends to boost an artist's results at auction. This was true for the Young British artists, and more recently for the main protagonist of Viennese actionism, Nitsch, whom Saatchi showed in 2005 at the Saatchi gallery in London's County Hall as part of the Triumph of Painting show. Nitsch's prices gained nearly 60 per cent over the next three years but are still affordable internationally and below the prices he achieves in Austria. His most expensive work sold at auction was at Im Kinsky in November 1995: *Schüttbild* from 1962, which went for $12,873.

The Austrian market for contemporary art has gained momentum over the last 10 years, resulting in a growing number of new galleries opening up and a lively art scene, concentrating on mainly young Austrian artists but increasingly also showing international artists in the Viennese galleries. Over the last few years three streets and their surroundings have established themselves as 'art centres': the galleries around the Seilerstätte, the Schleifmühlgasse and the Eschenbachgasse create a lively scene for new buyers coming on to the market. A lot of the art shown is sold to non-Austrian buyers, especially that by internationally recognized

artists. There are only a few Austrian collectors who buy internationally as well, like Karl-Heinz Essl, who opened his own museum in Klosterneuburg, near Vienna, in 1999 to be able to show not only his collection but also stage exhibitions reflecting the international trends on the art market (in 2006 for example the Leipzig school and Contemporary Chinese art).

Since 2005 the Vienna Art Fair has been held annually in April, with the aim of establishing Vienna as a market place for international, Austrian and also Eastern European art. Galleries from London, Paris, Budapest, Prague, Warsaw and Moscow present their art together with Austrian galleries from all over the country.

With the enlivenment of the Viennese art scene the chances for Austrian living artists to succeed internationally have grown. Ten years ago only about five Austrian galleries were present at international art fairs. Nowadays 15 to 20 can be present at once. At the Arco 2006 in Madrid, Spain, Austria was the guest country and 22 galleries took part in the fair. This activity enables Austrian artists to be present internationally and gain recognition worldwide. A major part of sales at galleries goes to international collectors. Artists like Erwin Wurm, Peter Kogler, Franz West and Gelitin (both represented by the Gagosian Gallery), and Muntean and Rosenblum have their admirers all over the world.

More and more very young artists are following in their footsteps. Most of them are educated at the two art universities, Universität für Angewandte Kunst and Akademie der Bildenden Künste. The universities offer exhibitions of their students at the end of each study year, which are very well visited, and more and more collectors can discover artists there. Among the young artists who are already starting an international career are Esther Stocker (b 1974) (abstract paintings, photographs and installations, whose work is conceptually dominated and reduced to black and white), Michael Kienzer (b 1962) (installations which broach the issues of space, time, surface and compression), Anna Jermolaewa (b 1970) (videos and photographs whose subjects are the structures of society, the relationship between human beings and the power a state or society puts on the individual) and Gregor Zivic (b 1965) (whose photographs give an insight in the strange and secretive world of his alter ego).

Sources of further information

The two art universities also offer the best libraries on anything to do with art, together with the institute for history of art at the main Viennese university. Of magazines, *Parnass* covers arts, antiques and culture; *Spike* concentrates on Austrian and international contemporary art; and *Eicon* concentrates on Austrian and international photography. The daily newspapers *Die Presse* and *Der Standard* offer special art market pages once a week. There is also a web magazine: www.artmagazine.cc

For further information on the development of this particular art market, go to: www.koganpage.com/artmarkets.

Reference

Herchenröder, C (2000) *Kunstmärkte im Wandel. Vom Jahrzehnt des Umbruchs in die Gegenwart*, Wirtschaft und Finanzen, Düsseldorf

Belgium

Henry Bounameaux and Victor Ginsburgh

Introduction

Belgian art history really begins after 1830, a time at which Belgium became independent from its many successive occupiers (Spain, Austria, France and the Netherlands). During the 15th century, Brussels (with Hugo van der Goes, Rogier van der Weyden), Louvain (Dirk Bouts) and Bruges (Jan van Eyck, Hans Memling, Gerard David) were burgeoning art centres, although later on Bruges started to decline because the Zwyn which gave Bruges access to the North Sea silted up, and merchants, and the artists who followed them, slowly moved to Antwerp in the late 15th and early 16th centuries. At that time Antwerp became one of the largest art centres in Europe, and altar paintings that were almost factory-built were exported as far away as South America. (See de Marchi and Van Miegroet (2006) for a recent short economic and historic survey.)

The so-called Golden 17th century is associated with names such as Pieter-Paul Rubens, Anthony Van Dyck and Jacob Jordaens, some of whom were simultaneously artists and dealers. This is also the century during which Pieter Brueghel the Younger and David Teniers II excelled in rural landscapes and scenes.

A few artists from the Romantic period (Louis Gallait, Gustaaf Wappers, Nicaise de Keyser, Henri Leys) became internationally known, and were bought by famous collectors in the mid-19th century, but are almost completely forgotten nowadays. The Antwerp Academy was renowned all over Europe, and contributed to the spread of historical genre paintings, and some artists (Eugene Verboeckhoven in particular) were known for their animal scenes. With the exception of Alfred Stevens, celebrated in France during the Second Empire, Belgian realism hardly made an impression internationally. This changed in 1883, the year during which James Ensor, Fernand Khnopff and Theo Van Rysselberghe founded the Groupe des XX, which attracted the European avant-garde (Georges Seurat and Vincent van Gogh among others) to Brussels. This important movement influenced artistic life in Belgium during a whole decade.

Although Belgium was influenced by international currents such as fauvism (with Ferdinand Schirren and Rik Wouters among others) and expressionism (essentially in Flanders, with Gustave de Smet and Constant Permeke), it is clearly surrealism and René Magritte and to a lesser degree, Paul Delvaux who became essential during the 1950s. The

late 1960s and the early 1970s were important years, with exhibitions at Wide White Space in Antwerp and MTL in Brussels showing conceptual avant-garde artists, led by Marcel Broodthaers and Panamarenko. More recently, Luc Tuymans became the most expensive living Belgian artist.

Decorative arts are represented by tapestries made in Tournai, Brussels and Oudenaerde, furniture from Liege, china from Tournai and Art Nouveau craftworks (Gustave Serrurier-Bovy, Henri Van de Velde) during the end of the 19th century.

The Belgian art market

Contemporary art: galleries and fairs

Contemporary art galleries are located predominantly in Brussels and Antwerp, and to some extent in Ghent. Among the best galleries in Brussels, Xavier Hufkens (with works by Louise Bourgeois, John Chamberlain, Anthony Gormley, Roni Horn, Robert Ryman, Erwin Wurm), Rodolphe Janssens (Balthasar Burkhard, Philip Lorca-diCorcia, Stephen Shore) and Greta Meert (John Baldessari, Robert Barry, Sol LeWitt, Robert Mangold, Thomas Struth) deserve mention.These are all regular participants at ArtBasel. In 2006 the fair also invited two newer galleries, Jan Mot and Catherine Bastide. In Antwerp, most galleries are located close to the museum of contemporary art (MuHKA). It is worth singling out Micheline Szwajcer (with works by Stanley Brown, Angela Buloch, On Kawara, Tobias Rehberger, Lawrence Weiner) and Zeno X (Stan Douglas, Marlene Dumas, Luc Tuymans).

The ArtBrussels fair takes place every year in April. It is, after Cologne, the second oldest contemporary art fair in the world. Although it was redesigned after being bought by an event-organizing company, the fair continues to invite galleries that show younger artists than in other fairs. In 2006, 168 galleries from 20 countries attracted 26,000 visitors.

The secondary market: auctioneers, dealers, and fairs

There exist many, but relatively small, salesrooms in Brussels and Flanders, and only a few in Wallonia. Most of them are affiliated with the Chambre Royale Belgo-Luxembourgeoise des Salles de Ventes aux Enchères, formed in 1936. Considerable activity takes place in Brussels, where the largest salesroom (Salle des Ventes au Palais des Beaux-Arts; later renamed Servarts SA) was acquired in June 2006 by Pierre Bergé & Associés, a Paris auctioneer, which we can hope will create some synergies between Paris and Brussels. Other salesrooms are Horta, Vanderkindere and Galerie Moderne in Brussels and Bernaerts, Campo, Vlaamse Kaii and Campo and Campo in Antwerp. Auctioneers mainly trade Belgian art and regional furniture. In 2005, the three most expensive pieces sold were a work by Paul Delvaux (on 6 December at the Beaux-Arts in Brussels for €570,000), a canvas by Jean Le Mayeur from his Bali period (on 28 November at Amberes, Antwerp for €320,000) and a pair of paintings by Sébastien Vranckx (on 29 November at the Beaux-Arts in Brussels for €180,000).

Important Belgian collections have often to be disposed of to pay for inheritance taxes. As a consequence, international salesrooms have offices in Belgium. Both Christie's and Sotheby's have large representations in Brussels, from where works are sent to Amsterdam, as far as the middle market is concerned, or to more international markets such as London and New York. Luxembourg has also been used to avoid resale rights (*droit de suite*). In 1994 a painting by James Ensor was sold to a Belgian collector for €200,000. The painting was

stored in Luxembourg (no resale rights at the time), but Belgian potential buyers could make offers in Belgium and the painting was shown on a television screen in a Belgian salesroom.

Antique dealers are scattered throughout Belgium, but again the most renowned are located in Brussels and Antwerp. They are regrouped within the Chambre Royale Belge des Antiquaires de Belgique, formed in 1919. This association organizes every year (in January) an important antique fair, the Foire des Antiquaires de Belgique. In 2006 it attracted 120 dealers from eight countries. The organizers have the intention of opening the fair to a larger number of foreign dealers.

As a former colonial country, it comes as no surprise that Belgium (Brussels in particular) has a central role in dealing and collecting not only African, but also Oceanic and Pre-Columbian art. Since 1983, some 50 dealers have organized open days (the so-called Brussels Non European Art Fair, BRUNEAF). This fair has been open to foreign dealers since 1996, and is organized at the same time as the Brussels Antique Fair (BAAF) and the Brussels Oriental Art Fair (BOAF). Two other fairs are held in Brussels. The recent (2004) salon Grands Antiquaires gathers some 30 participants, both Belgian and foreigners. Eurantica, which is 25 years old, addresses the middle market and mainly visited by amateurs, most of which are living in Belgium.

Collectors and collections

Belgians are known as contemporary art collectors, who buy both in Belgium and in other countries, and do not miss any of the great international events. They are characterized by their very reserved attitude, and hardly show their (sometimes very important) collections, which are often sold after the death of the collector. The Vanthournout heirs, for example, sold a large part of Roger Vanthournout's collection (which included works by Francis Bacon, Tom Wesselman, Carl Andre and Gerhard Richter) at Sotheby's in November 2006. There also exist a few other collections: Belgian painters from the late 19th century and the first half of the 20th century, Tournai china, silverware, African and Pre-Columbian art (in 2006, the important Janssen collection of Pre-Columbian art was donated to the Flemish Community in lieu of inheritance taxes).

A few large firms also collect, but since fiscal rules do not allow the writing-off of art works, the collections depend on the goodwill of executive officers or owners. The Dexia Bank (former Crédit Communal) owns probably the largest collection of Belgian art, with a few incursions into Old Masters. The ING Bank (former Banque de Bruxelles-Lambert) has concentrated on contemporary art, following the tradition initiated by one of its former owners, Baron Leon Lambert. More recently, the Group Lhoist has assembled an impressive collection of contemporary art and photographs.

Collectors are also almost the only ones who buy art, since museums can afford very little and only from time to time. They merely concentrate on exhibitions. In Wallonia, the MAC'S (at the Grand Hornu mining site) shows well-known artists (Bernd and Hilla Becher and Anish Kapoor, among others) while BPS22 (in Charleroi) specializes in younger artists. Since Brussels hosts no real contemporary art museum, it is on the new (December 2006) Wiels art centre that all hopes are concentrated. In Flanders, three institutions are worth citing. In Ghent, the Smak museum hosts art created after the Second World War, as well as very well-attended exhibitions. Close to Ghent, in Deurle, the Dhont-Daenens museum invites contemporary artists to show their works. In Antwerp, the MuHKA is the other Flemish pole in contemporary art.

Culture and cultural policies are decentralized, and the federal government is responsible for a very small number of important institutions, in particular, the Musées Royaux des

Beaux-Arts de Belgique and the Musées Royaux d'Art et d'Histoire, both in Brussels. Since financial means are very limited, additions to these collections are very rare. The situation is somewhat better in the Flemish community, which recently could afford to buy (in London!) a masterpiece by Panamarenko, the *Prova car*.

Belgian artists on international markets

Celebrated Old Masters such as Brueghel and Rubens are of course sold on international markets, but quite surprisingly, this is also the case for more contemporary artists. Ginsburgh and Mertens (1994) show that among the 50 most expensive Belgian painters (selected on the basis of their average price between 1962 and 1992), 30 are sold more often on international markets than in Belgium. This is obviously so for René Magritte, Paul Delvaux, James Ensor, Fernand Khnopff and Pierre Alechinsky, but it is true also for Jules Schmalzigaug, Theo Van Rysselberghe, Edward and Gérard Portielje, Jean-Baptiste Madou, Georges Lemmen, Willy Finch, Félicien Rops, Alfred Stevens, Eugène Verboeckhoven and many others. It is hard to assess whether these are bought by Belgian or international collectors. One of the versions of *L'empire des lumières* by Magritte fetched $11.5 million at Christie's New York in 2002. Some contemporary painters such as Luc Tuymans are very successful.

Legal issues and taxation

A reduced 6 per cent value added tax (VAT) is levied on imports. No VAT is due on sales between individuals. The normal 21 per cent rate on the total price is applicable to transactions by professionals, although they may opt to apply the rate on their margin only, in which case the professional buyer cannot recoup the VAT. Artists are allowed to charge a reduced 6 per cent VAT when they sell directly to a gallery or to a private collector.

There exists no wealth tax in Belgium, and capital gains by individuals on occasional sales are not taxed. Donations to recognized cultural institutions are tax deductible, though they cannot exceed 10 per cent of the donor's income, and are subject to an upper limit of €320,000; donations by firms cannot exceed 5 per cent of profits, and are subject to an upper limit of €500,000. Donations between individuals under authentic deeds are taxed (at 3 to 7 per cent, according to the family ties). Donations without deed (*don manuel*) are subject to the condition that the donor is still alive three years after the gift. For inheritance taxes, the cultural property of the deceased person is valued. The rates are different in the three Belgian regions (Brussels, Flanders, Wallonia), and depend on the family ties between survivors and the deceased. The scale increase with total value. Although a law allowing acceptance of works in lieu of tax was drafted 10 years ago, it took some time to get it working. (Note that the Flemish government recently (October 2006) accepted the Pre-Columbian Janssen collection in lieu of tax.) Transfers to cultural institutions by the deceased are subject to taxes.

Droit de suite applies to all acts of resale involving professionals (and not only to auctions). It is levied on the price of all works resold, up to 70 years after the artist's death. The rate reduces as the value of the work increases (4 per cent for works under €50,000, 3 per cent on the part between €50,001 and €200,000, etc). In general, the rules follow the EU Directive, which is not yet fully integrated into Belgian law.

More details on legal issues can be found in Lambrecht (2006).

For further information on the development of this particular art market, go to:
www.koganpage.com/artmarkets.

Bibliography

Bounameaux, H and De Baere, B (2006) *Contemporary Art in Belgium 2007*, Best of Publishing, Brussels

De Marchi, N and J. Van Miegroet (2006) The history of art markets, in V Ginsburgh and D Throsby (eds), *Handbook of the Economics of Art and Culture*, Elsevier, Amsterdam

Ginsburgh, V and Mertens, S (1994) Le peinture belge moderne et contemporaine: evolution des prix dans les salles de ventes internationales, 1962–1992, *Bulletin du Crédit Communal*, 190, pp 57–80

Ginsburgh, V and Mertens, S (1995) La peinture belge et la situation des salles de ventes belges face à la concurrence internationale, *Reflets et Perspectives de la Vie Economique*, 34, pp 187–208

Lambrecht, L (2006) Tax and art: Belgium, *Art Newspaper*, 172 (September), pp 7–8

Brazil

Katia Mindlin Leite Barbosa

Market activity in Brazil is not as widely monitored as in the United States or Europe, where auction results are released and databanks enable in-depth research. Since most transactions evolve around Brazilian art, which has limited circulation abroad and undisclosed results locally, there is a great deal of subjectivity. Therefore anyone who intends to venture into this uncharted territory will benefit from some background knowledge on the arts in Brazil, both institutional and commercial, with an indication of the main players.

The current art market in Rio de Janeiro and São Paulo

The art market in Brazil has evolved greatly in the last few decades but assessments of its performance remain subjective. Many factors contribute to the lack of accurate data regarding market activities, including confidentiality and tax issues. Unlike the main art centres where auction results are available to the general public, in Brazil no auction house releases these magic numbers (although James Lisboa, auctioneer in São Paulo, provides individual lot results to Art Price). Bolsa de Arte, a local auction house based in Rio de Janeiro, publishes in its website 'quotes' with a waiver that states, 'The values indicated refer to the last bid without implying that the lot mentioned was effectively sold.' Considering there are a number of active auction houses, this data is hardly sufficient for a reliable analysis.

Attending the sales in order to obtain price information is frequently a frustrating experience as one cannot always determine whether a lot has been sold; it is not standard practice for auctioneers to announce whether an item has 'bought in' or has remained unsold. In my attempt to gauge the annual turnover in art transactions, I have talked to a number of dealers and auctioneers, and most estimates (all of which came with disclaimers) are that Brazilian auctions and art galleries turn over US$30–40 million, with one or two more optimistic projections. Most important deals are made privately and these numbers are impossible to track.

Artists who influence the market

There follows a short briefing on the most relevant artists and the market trends for the major art categories.

Old Masters

Brazil cannot boast important Old Master painters, except indirectly: the artists Frans Post (1612–1680) and Albert Eckhout (1610–1665) joined Mauricio de Nassau's Dutch mission to Brazil in the 17th century. Post's paintings have increased greatly in value in the last 15 years, and from six-digit figures now achieve seven-digit results. However the artist's current record at auction of US$4,512,500 for *View of the town and homestead of Frederik in Paraiba, Brazil* dated 1638, was obtained not locally but at Sotheby's New York in 1997. Post's etchings illustrate Gaspar Barlaeus's *Rerum per Octenium in Brasilia*, printed in Amsterdam in 1647 and considered one of the most important books of Braziliana.

19th century and academic paintings

Upon the arrival of the Portuguese royal family in 1808, immigration restrictions were lifted, encouraging the incursion of scientists, botanists, zoologists, naturalists and painters. These various scientific and artistic expeditions resulted in a significant outpouring of drawings, watercolours, engravings and oil paintings. Landscape, fauna, flora, physiognomy and local habits were duly recorded by the artists who had been enticed to Brazil. These works are today highly valued and are the subject of a few important collections.

Among many expeditions the most notorious was the French Mission mentioned earlier, and the foremost name was that of Jean-Baptiste Debret (1768–1848). Around 1825, he executed a series of etchings of human types, local customs and landscapes. Later, back in Paris, he published *Voyage Pittoresque et Historique au Brésil*, illustrated with lithographs based on his earlier studies in Brazil.

The Austrian Mission of 1817, which preceded the arrival of the Archduchess Dona Leopoldina, who was to marry Don Pedro I, included the zoologist Johann-Baptiste von Spix (1781–1826) and the botanist Carl Friedrich Philipp von Martius (1794–1868), who published *Flora Brasilienses* and other important titles after he returned to Germany. Another participant painter, Thomas Ender (1793–1875), was the author of *Viagens ao Brasil*, comprising 796 images depicting rural and urban landscapes, everyday scenes, utensils and portraits, all painted between 1817 and 1818.

The Langsdorff Expedition, led by Heinrich von Langsdorff, the Russian general council to Brazil, lasted from 1821 to 1829 and covered over 17,000 km from Rio de Janeiro to the Amazon, via Minas Gerais, São Paulo and Mato Grosso.

Painters Hércules Florence, Johann Moritz Rugendas and Adrien Taunay were retained for the expedition, and faced all sorts of obstacles including the death of Taunay by drowning. Many members were victims of tropical fevers, including the baron who became insane as a consequence.

In spite of this melancholic outcome, the drawings and watercolours of the artists, especially Rugendas', attracted great interest. Back in Europe in 1825, Rugendas worked on the publication of his *Voyage Pittoresque dans le Brésil* published in German (1827) and French (1935). Together with Debret's book mentioned above, these are considered the two most important works of 19th century Braziliana. Rugendas visited Brazil again in 1845 and was invited to participate in the General Exhibition of Fine Arts.

There are also artists who travelled to Brazil on their own account and whose paintings are highly considered.

The arrival in Brazil in the late 1870s of the German artist Johann Georg Grimm (1846–1887) had a great impact on local artists. Grimm became a teacher at Academia de Belas Artes and challenged tradition by encouraging his students to paint from the direct observation of nature. The Grimm Group met on a regular basis in 1882 and 1883, depicting the beaches and suburbs of Niterói, located across the bay of Rio de Janeiro. It included Antônio Parreiras (1860–1937), Garcia y Vasquez (c1859–1912), França Júnior (1838–1890), Francisco Ribeiro (c1855–c1900), Joan Batista Castagneto (1851–1900), Hipólito Boaventura Caron (1862–1892) and the German painter Thomas Driendl (1849–1916).

British influence in Brazil was extremely significant in the political and economic spheres. The Royal family sailed to Brazil protected by an English fleet. When the independence of Brazil, declared in 1822, was threatened by Portuguese resistance, Don Pedro I sought British know-how to assemble a defensive Brazilian navy, naming Lord Cochrane as first supreme commander.

The ensuing peace treaty with Portugal was conditional on Brazil paying an indemnity to the crown and absorbing the outstanding debt towards England. This required a heavy loan from the British to the new nation, and British influence as a result further increased.

By the middle of the 19th century, imports were completely dependent on England. The British also controlled banking, railways and electric utilities, as well as ocean-going shipping.

The many British travellers of the time, such as Henry Chamberlain, Maria Graham, William Gore Ouseley, Emeric Essex Vidal and Henry Koster, rendered their impressions and constitute an important source of information. Other European artists in Brazil during the 19th century and now sought by collectors are (by date of arrival or recorded activity in Brazil) Abraham Louis Buvelot (1840), Edward Hildebrandt (1844), Nicolau Antonio Facchinetti (1849), François-Auguste Biard (1858), Henri Nicolau Vinet (1866) and Castagneto (1875).

Among the native 19th-century painters significant names are Agostinho José da Mota (1824–1878), Vitor Meirelles (1832–1903), Benedito Calixto (1853–1927), Henrique Bernardelli (1857–1936), Belmiro de Almeida (1858–1935), João Batista da Costa (1865–1926) and Artur Timóteo da Costa (1882–1923).

When it comes to Impressionist art the name of Eliseu Visconti (1866–1944) rises above all others. He also explored symbolism and pointillism, and ventured into industrial and graphic design, with works in ceramics, textiles and lighting influenced by the Art Nouveau movement.

He was initially commissioned by the mayor to decorate the stage curtain of the Theatro Municipal do Rio de Janeiro, a smaller-scale version of the Opera de Paris. This was one of his most allegorical works; he then painted the ceilings and later the foyer. His important paintings sell for more than US$300,000.

Modern art

The first gusts of modern art were felt when Anita Malfatti (1889–1964), returning from Europe, exhibited a series of fauvist paintings in 1917. It aroused violent criticism but inspired artists and poets, and led to the Semana de Arte Moderna, held in February 1922 at the Theatro Municipal de São Paulo.

Candido Portinari (1903–1962) was the first artist to obtain recognition abroad. The enthusiasm of Nelson Rockefeller was an essential factor and ensured commissions such as one for the UN building. Other foreign collectors such as Helena Rubenstein also helped to promote his name outside Brazil. He is considered by many as the most important Brazilian

modernist artist, although this title is disputed by the supporters of Emiliano di Cavalcanti (1897–1976), who had a prolific and long-lasting career. He was a master in the 1930s, 1940s and 1950s, and works from this period can fetch in the low seven digits, but the quality of his works in the later years became uneven and the values achieved at sale are in consequence appreciably lower. Other major modernists are Segall, Rego Monteiro, Brecheret, Bandeira, Guignard, Ismael Nery, Pancetti and Milton Dacosta.

It is important to note that quite a few important Brazilian artists spent time abroad, especially in Europe, so from time to time works surface at minor international sales that are not properly identified, offering a good investment opportunity for the savvy scavenger.

Two more artists worthy of mention are Alfredo Volpi and Maria Martins. Volpi (1896–1988), who started his life as a wall painter, after distancing himself from his initial figurative language, adopted an abstract style where houses, windows, roofs, masts and little flags, evocative of a traditional Brazilian folk festival, São João, were incorporated in his paintings as mere elements of geometric compositions concerned only with line, colour and form. Martins (1894–1973) was a surrealist artist and one of the rare woman sculptors in Brazil. As a wife of a Brazilian ambassador she lived in Paris and Washington. She had a studio in New York and was friends with artists such as Mondrian (with whom she exhibited in New York), Lipchitz, Breton and especially Duchamp with whom she sustained a secret love affair. Her work remained in the shadows for many years but has resurfaced in the last two decades through the initiative of Jean Boghici, who has organized exhibits in Brazil and abroad together with André Emmerich, and has promoted her work in international art fairs such as FIAC. Martins has become a sort of cult name, with a recently published biography, and many of the important modernist collections include her work.

None of these modernist artists had the benefit of a market-oriented strategy such as occurs today, and with some exceptions their work still sells best within the country. This is also true for Iberê Camargo, the last modernist to survive (1914–1994), whose work is extremely valued in Brazil but is rarely seen in the foreign market. This is bound to change through the work in progress developed by the Fundação Iberê Camargo.

Exceptionally, works by Brazilian artists attain meaningful results at international sales. Such was the case for two lots by Portinari offered in the November 2005 season: *Swing* (1959) carried an estimate of $150/200,000 and was sold at Sotheby's for $940,000; *Tocador de Trombeta* (1958) with an estimate of $300/400,000 was sold at Christie's for $721,000. Di Cavalcanti's *Mulher deitada com peixes e frutas* (1956) sold in November 2000 for $886,000 (within the estimated range). Another significant result was an impressive work on paper by Candido Portinari, *Kite flyers*, sold at Sotheby's in May 2006 for $144,000 against an estimate of $20/30,000.

Official results achieved at international auctions are extremely important for the growth of the market as they are publicized, create awareness and set parameters for foreign collectors. But unfortunately it is rare to see top-quality Brazilian art circulating abroad. Brazilian sellers are not sufficiently confident on how the international market will respond and mostly prefer to negotiate locally. Although the top results in Brazil are still achieved by modernist works, the values would improve further if these had sustained circulation abroad. This phenomena is perceptible with contemporary art, where international success translates into higher local quotes.

Contemporary art

A market-oriented strategy is fairly recent in Brazil but has proven to be efficient. Many dealers have been willing to invest in the artists they represent on a longer-term basis. As a

result a number of Brazilian artists are now exhibited abroad either at galleries or fairs; efforts are made to include their works in important institutional or private collections and to ensure the publication of specific bibliographies. This has resulted in greater visibility and stronger sales. A handful of Brazilian contemporary works have been sold at auction at prices comparable to those of the modernist masters. Names include Sergio Camargo, Lygia Clark, Hélio Oiticica, Mira Schendel, Antonio Dias, Beatriz Milhazes, Tunga, Ernesto Neto, Adriana Varejão, Cildo Meireles and Waltércio Caldas. Vic Muniz, whose work crosses over to photography, is in great demand, featuring in international sales with strong results. Other names from photography are Miguel do Rio Branco, Mario Cravo Neto, Orlando Brito, Evandro Teixeira, Walter Firmo, Cristiano Mascaro and Luiz Braga.

Trends

In the recent years the market has matured and collectors have become more demanding and knowledgeable. As prices rise and art also becomes an investment, quality should be the first criterion, whatever the period or medium of choice, for this will ensure liquidity and profit.

The category that achieves highest sale totals today is Brazilian modern art, where the leading artists can reach the lower seven-digit range. There is however a large spread between the prices for the best and worse examples of each artist, as seen with Di Cavalcanti's work. For emblematic works of art, prices will definitely rise significantly as buying pressure increases. The universe of Brazilian masters is not a large one; there are perhaps up to 30 truly big names, and as a consequence, only a limited number of paintings are available. This quantity factor will help ensure a stable level of demand even for lesser examples of Modern Art's top names. Art production of the 20th century in Brazil bears very recognizable characteristics, making this asset an effective status symbol.

Also on the rise are modern works on paper. Adequate framing procedures that prevent foxing and discoloration are encouraging previously reluctant collectors to invest in this medium. For a fraction of what a canvas might cost, one can purchase an excellent example of modernist work.

But there is no doubt that contemporary art is gaining market share. This is the result of broader exposure in a global market and the use of an artistic vocabulary that bridges cultural differences. As such, it should consistently retain its value. It is still affordable and is a promising area for investment.

Photography, until recently restricted to specific niches, is consolidating its importance, with a growing number of collectors and exhibitors. At a slower pace, video art is beginning to be negotiated within the local market. These are two additional segments with strong growth potential. As I write this chapter, photography and video art are being showcased simultaneously in seven different galleries in Rio de Janeiro.

There is an opposite trend for 19th century paintings: in the 1970s they were valued significantly more than modern art. Today the prices have dropped perhaps 40 to 50 per cent, except for iconographic and topographical paintings which remain prized items. Some dealers foresee in this category, now affordable, an investment opportunity. However contrary to their modern peers, the majority of the academic painters came from a culture which did not promote great originality, so the quality criterion becomes even more imperative in this area.

As happens elsewhere, there are some artists in Brazil who have enjoyed a strong market in the past but have fallen out of favour. For example works by Enrico Bianco, a disciple of

Portinari and Teruz, were highly valued in the 1970s but in the recent years their prices have dropped over 50 per cent.

Contacts and institutions

Knowledge of the main dealers, auctioneers, collectors, fairs and institutions will be useful for those wishing to venture in the Brazilian art market.

Dealers

In Rio the dealers includes Jean Boghici, Mauricio Pontual, Max Perlingeiro (Pinakotheke Cultural), Luís Sève (Galeria de Arte Ipanema), Liecil and Neide de Oliveira (Galeria Athena), Ronie Mesquita and Gustavo Rebello (Estúdio Guanabara), Mercedes Viegas, Silvia Cintra, Laura Marsiaj, Ricardo Rego (Lurixs), Heloisa do Amaral Peixoto (HAP Galeria de Arte) and Ralph Camargo.

In São Paulo some of the main dealers are Peter Cohn (Dan Galeria), Benjamin and Gugu Steiner, Brenno and Isaac Krasilchik (A Ponte), Reinaldo Renot, Thomas Cohn, Raquel Arnaud (Gabinete de Arte Raquel Arnaud), Luisa Strina, Marcia Fortes & Alessandra D'Aloia (Galeria Fortes Vilaça), Jones Bergamin, who in Rio owns the auction house, Bolsa de Arte, Luciana Brito e Fábio Cimino (Brito Cimino Arte Contemporânea), Marília Razuk, Berenice Arvani, Mônica Filgueiras, André Millan (Galeria Millan Antonio), Max Perlingeiro, Nara Roesler, Oscar Cruz and Maria Cruz (Galeria Baró Cruz), and Ricardo Trevisan (Galeria Triângulo).

Most of these galleries offer similar terms: selling commission ranges from 20 to 33 per cent in a sliding scale according to value. This commission can reach 50 per cent for artists represented by the gallery.

The introductory commission is normally 10 per cent.

Auction houses

Fine art auctions are not restricted to one specific period as the comparatively small volume of art available makes it impossible to assemble sales in exclusive categories. On average over 90 per cent of the property offered at auction is by Brazilian artists, with some occasional European Old Masters or 19th-century paintings and more rarely, foreign Impressionist, Modern or Contemporary artists.

The fact that the bulk of art negotiated is Brazilian has a direct impact on the sale totals and the overall numbers in the art market. Since there are very few Brazilian artists that fetch seven digits, a successful night can yield something between $1–3 million. Among the artists above the $1 million threshold are Tarsila do Amaral, Portinari, Di Cavalcanti, Segall, Guignard, Rego Monteiro and Brecheret.

For a foreign audience patience is recommended: the auctioneers rarely impose increments that are proportional to the value of a lot, so a dispute between bidders can linger far beyond the average minute per lot.

The main auction houses in Rio de Janeiro include:

∎ Bolsa de Arte, owned by Jones Bergamin, holds three or four sales a year. Auctions have average presale estimates ranging from $1,500,000–3 million and a selling rate of 65 to 70 per cent. It is the only auction house to release information on results online.

- Soraia Cals, whose auction catalogues also serve an educational purpose with the inclusion of critical essays, holds two or three sales a year.
- Evandro Carneiro, former owner of Bolsa de Arte, a long-standing auctioneer and a successful sculptor himself, chose as a strategy to cater for a middle-range market, and promotes an average of four fine arts sales a year. The sales always include two or three more significant lots so as to ensure the participation of major clients. They offer excellent opportunities for anyone who is building up a collection of Brazilian art.

Auction houses in São Paulo include:

- Aloísio Cravo holds three sales a year with presale estimates of an average $1–2 million per sale.
- James Lisboa holds three or four sales a year. He posts individual artists' results on Artprice but the overall totals of his sales are not available. Nevertheless this is promising news. If other auction houses and dealers follow this example, in a few years we will have objective numbers on which to gauge the art market.

The remaining auction houses hold general sales in which fine art is also included, such as those promoted by Dagmar Saboya, Roberto Haddad, Leone, and Ernani and Dutra. The main auction houses have a standard seller's commission of 20 per cent but as elsewhere, this is negotiable pending the volume of consignment. The buyer pays a 5 per cent fee on hammer price which represents the auctioneer's commission.

Art fairs

Art fairs have the merit of grouping together a number of active galleries and a diverse inventory which appeals not only to established collectors but also to the larger public, offering an instant update into the latest trends along with the appreciation of important masters. As an event, fairs attract press coverage and promote the exchange of ideas, adding visibility to art production and revitalizing the market. The top fairs are currently held in São Paulo.

Salão de Artes e Antiguidades, recently renamed Salão de Arte, has been held at Hebraica, the Jewish club of São Paulo, for the last 10 years and in 2006 presented its 13th edition. Every year one social institution is chosen to benefit from the full proceeds of tickets sold. It has close to 70 exhibitors, including a few international guests, showcasing art works, antique furniture and rare objects from Brazil's most important galleries, antiquaries and jewellers, covering an area of 3,000 sq metres. It is a good opportunity to gauge the market and establish contacts. In 2005 9,000 visitors attended the fair.

SP Arte is the only Brazilian fair devoted exclusively to modern and contemporary art. It is held in the premises of the Biennial of São Paulo, an emblematic space for the arts. Its first edition was held in 2005 under the supervision of Fernanda Feitosa, with the participation of 41 galleries, including one from Uruguay. In 2006 the number of participants rose to 50 including six foreign galleries (from Germany, Argentina, Chile, Spain, Portugal and Uruguay) and the area expanded to 5,500 square metres. The 2007 edition was held from 18–22 April at the same location.

The feedback from galleries is very positive and considerable business is concluded in the aftermath of the fair. There are no official numbers of sale volume but unofficial estimates point to $5–10 million. An objective number for the total value insured is also unavailable as dealers purchase individual coverage.

Non-commercial art events also have an impact on the art market. The single most important art event in Brazil is the São Paulo International Biennial (Bienal de São Paulo). The first biennial was held in 1951, coordinated by Ciccillo Matarazzo with his wife Yolanda Penteado, who travelled abroad to recruit international delegations. It took place in a ballroom at the Trianon Plaza, where the Museu de Arte de São Paulo subsequently arose. Its success led to a search for a permanent address. For the new location, Oscar Niemeyer designed three pavilions, raised in record time, at Parque Ibirapuera, where in 1953 the second biennial was opened to the public. This was one of the most important editions, with a total area of 24,000 square metres, 33 countries represented, and 3,374 works displayed including 51 works by Picasso, one of which was *Guernica* – a triumph for Yolanda, who personally negotiated its inclusion.

Throughout the years the biennial has played an essential educational role, allowing the Brazilian public to view ground-breaking works of art. At a time when travelling and communication were still restricted this was the primary source of information.

The Panorama /MAM-SP exhibition has been held since 1969 at the São Paulo Museum of Modern Art (MAM) and is one of the most traditional in the country's visual arts calendar. The Mercosul Biennial, which has taken place since 1997, also contributes to the dynamic of the art markets of Rio and São Paulo, in spite of taking place in Porto Alegre.

Institutes and cultural centres

The busy fine arts schedule of local institutes and cultural centres complements museum activity and benefits the market, educating and expanding the potential client base. In Rio de Janeiro, I should mention Centro Cultural do Banco do Brasil, Centro Cultural dos Correios, Centro Cultural da Caixa Econômica, Centro Cultural da Light, Centro Cultural Telemar, Instituto Moreira Salles, Fundação Castro Maya. In São Paulo there are Itaú Cultural, Centro Universitário Maria Antônia, Instituto Tomie Ohtake, Centro Cultural Banco do Brasil, Instituto Moreira Salles and Espaço Cultural BM&F.

Legal and regulatory aspects of the local art market

Art-related legal cases are extremely rare as parties prefer to settle privately. Where international magazines such as *Art and Auction* devote a monthly column to art related legal issues, in Brazil there is little jurisprudence on this field.

In authenticity issues, expertise is mostly available for Brazilian artists or subject matter, as foreign works do not have sufficient circulation in the local market. Therefore when purchasing works of art by international artists, more caution is recommended. But it should be noted that the reputable professionals tend to consult experts abroad whenever a significant work by a European or North American artist goes on the block.

Experts or committees officially accepted as leading authorities on one particular artist, and which play such an important role in the international market, are limited to a few examples: Portinari is the only Brazilian artist whose work has been compiled into a formal CR featuring close to 5,000 works. The Projeto Portinari can be visited at its website, http://www.portinari.org.br. Di Cavalcanti's work is presently being catalogued by his daughter with the aim of publishing a future CR. Owners of works by the artist are invited to contact Elisabeth di Cavalcanti at: mailto:elisabethdicavalcanti@superigcom.br.

An estimated 70 per cent of Alfredo Volpi's work has been catalogued and the *catalogue raisonné* of prints by Iberê Camargo has been released. Sergio Camargo's *oeuvre* is also being catalogued under the supervision of Raquel Arnaud.

For other artists such as Tarsila do Amaral, Di Cavalcanti and Bonadei, similar publications are under way. Also relevant to our art history is the recently published *catalogue raisonné* for Frans Post.

When a doubtful or fake work of art surfaces the word might spread out, but rarely are effective measures taken. The few instances where the most knowledgeable and serious dealers have stood up to condemn a work of art yielded such legal hassle that these champions of a healthy market now abstain from voicing their opinions publicly, and the most reliable professionals will only volunteer a private, unofficial opinion. There is no law specifically concerning art forgeries, which fall under Article 171 of the Brazilian Penal Code, related to fraud. When in doubt as to the authenticity of a particular work, provenance can be paramount as well as the reputation of the dealer involved.

In Rio there is only one official legal consultant, João Carlos Lopes dos Santos, who has published a *Manual do Mercado de Arte* with guidelines for newcomers to the market.

Existing legislation ruling the art market also includes:

■ Lei do Leiloeiro (Law for the Auctioneer);
■ Lei do Direito Autoral (Law for Copyright);
■ Lei de Sequência: (Droit de Succession) the Estate of Alfredo Volpi has filed a claim to 'droit de succession', rejected by the court in its first ruling.

Export and import

In addition there are relevant laws concerning the export and import of works of art. No work of art can be exported without a licence granted by the Institute for National Artistic and Historical Heritage (IPHAN) so as to prevent undue export of cultural heritage produced in Brazil or abroad up to the end of the Monarchic period in 1889. Further to this, there is a complex bureaucratic procedure handled by agents with power of attorney, which includes registration at the Federal Revenue and Customs Administration. Taxes apply upon import and are cumulative, adding up to roughly 35 per cent, and breaking down as follows:

■ industrial products tax/imposto de importação 4 per cent;
■ merchandise circulation tax (ICMS) 18 per cent;
■ PIS 1.65 per cent;
■ Cofins 7.60 per cent.

The prohibitive import taxes also apply to Brazilian art returning to the country. This prompted general discussion when a Brazilian collector, after acquiring a Guignard *Still life with flowers* for a record price in New York, chose to leave the painting in New York to signal his protest. To address this incoherence, a law project exempting all Brazilian art from the 18 per cent taxation was submitted by Senator Edson Lobão. It has been approved by the Senate, but awaits ratification from the Congress. One should hope that under a reviewed sensible taxation regime, more Brazilian cultural goods will find their way back home.

Settlement for commercial transactions must be made through the Brazilian banking system and evidence of compliance with trade legislation is required.

Conclusion

Brazil, a country with 190 million inhabitants, boasts the world's largest hydro reserves and biodiversity, generous mineral resources, extensive lands for agriculture and a favourable climate.

In October 2006, Luís Inácio Lula da Silva, was re-elected. Once feared as a radical, he has shown moderation in office. Consequently, the macroeconomic outlook is optimistic as the country continues to enjoy a sound balance of payments coupled with strong currency and lower country risk. Inflation, the worst threat in the past, is under control. International public debt is no longer an issue and targeted income support has been implemented with the 'Bolsa Família'. To address problems such as prohibitive interest rates; internal public debt, taxes representing 37 per cent of GDP; the negative impact of a strong currency on exports, deficient infrastructure and excessive social security costs, the government issued a new set of measures called PAC Programa de Aceleração de Crescimento, but its results are not yet measurable.

Therefore, although Brazil is far from China's and Russia's 7–8 per cent growth in GDP, it is on the right path to achieve slow but steady economic growth ranging from 3.5 to 5 per cent for the next few years. Sustained confidence in economic policies will positively impact the art market, making it an attractive investment opportunity for future gains.

For further information on the development of this particular art market, go to:
www.koganpage.com/artmarkets.

Bibliography

Berger, P (1990) *Pinturas e Pintores do Rio Antigo,* Kosmos Editora
Bertolini, S (ed) (1987) *A Presença Britânica no Brasil*, Editora Pau Brasil
Fioravante, C (2001) *O Marchand como curador,* Casa das Rosas
Morais, F (1995) *Cronologia das Artes Plásticas do Rio de Janeiro*, Topbooks
SP Feira Internacional de arte moderna e comtemporanea de São Paulo (2006) Catálogo (catalogue)

Websites

Itaú Cultural
Projeto Portinari
Trópico
Pitoresco
Guia das Artes
Mapa das Artes
Investarte
http://p.php.uol.com.br/tropico/html/textos/2564,1.shl
Arte brasileira: real e ficção
Por Aracy Amaral
Historiadora comenta o artigo 'Mercado de arte: global e desigual', sobre a produção artística do Brasil
 no mundo

Canada

Calin Valsan, Derrick Chong and Elisabeth Bogdan

Introduction

Canada, as a nation state founded in 1867, has been shaped by several forces which also help to understand the market for art in Canada. First, English-French duality (the country is officially bilingual) is a response to the country's colonial past. Toronto and Montreal have cultivated different artists and art markets. Second, the geographic expanse of Canada means that the country is made up of regions: Atlantic (Newfoundland, including Labrador, New Brunswick, Prince Edward Island, and Nova Scotia), Quebec, Ontario, Prairies (Manitoba, Saskatchewan, and Alberta) and the North (Nunavut, the Yukon, and Northwest Territories), and West Coast (British Columbia). Political and economic power has focused on the triangle of Ottawa-Toronto-Montreal, with pockets of affluence having emerged in Vancouver and Calgary. Third, Canada's proximity to the United States (a country that is 10 times larger by population), including a shared border (approximately three-quarters of Canadians live within 200 miles of the border), has meant that the United States is a point of reference: Canada (as nation brand) seeks points of parity with the United States and points of difference. Fourth, multiculturalism has accelerated in the largest Canadian cities such that there has been a radical change in the ethnic and racial composition since the 1960s. Related to this has been greater self-determination by indigenous (or aboriginal) people (First Nations, Inuit and Métis). This adds a new dimension to the conventional English-French duality.

Few Canadian artists, whether living or dead, have reputations outside Canada. This is one reason to explain the limited appeal for Canadian art outside the domestic market. There is a narrow consumer base, even for the Group of Seven, with a very high proportion of Canadian art buyers being Canadians. Individual Canadian artists have broken into the international context. In the post-Second World War period, Jean-Paul Riopelle (1923–2002) was touted as Canada's first international artist. Others like Jack Bush, Michael Snow and General Idea have also developed international reputations.

The so-called Vancouver School of photo-conceptualists ('led' by Jeff Wall and including Ken Lum, Dan Graham and Stan Douglas) is important in that it represents the first Canadian group, as opposed to individual artists, to develop an international following who are known as being Canadian.

Sources of data

Dealers

The Art Dealers Association of Canada (est 1966) is the key trade association, with about 75 members, with Toronto, Montreal and Vancouver being the key cities. Some major commercial galleries participating at the Toronto International Art Fair (est 2000), the key contemporary art fair in Canada, or the Toronto Alternative Art Fair International are not members of the ADAC.

Historical Canadian art is where secondary market players in Canada excel. Leading galleries include Loch (Winnipeg, Toronto and Calgary), Walter Klinkhoff (Montreal), Rod Green's Masters (Calgary), Uno Langmann (Vancouver), Art Emporium (Vancouver), Claude Lafitte (Montreal), Jean-Pierre Valentin (Montreal), Roberts (Toronto) and Mayberry (Winnipeg). Dealers like David Loch, Eric and Alan Klinkhoff, and Rod Green along with art consultants like Christopher Varley, grandson of the Group of Seven member, also represent clients at auction.

There are limited secondary market players for non-Canadian works, although the key gallerists like Miriam Shiell and Corkin Shopland (both Toronto) and Landau (Montreal) are internationally competitive. Landau is often the sole Canadian representative at Maastricht's Tefaf, including works by Riopelle.

Primary market dealers deal mainly with Canadian artists. Few have the economic resources to participate at the leading modern and contemporary art fairs such as Art Basel (and Art Basel Miami Beach), the Armory Show in New York, or London's Frieze Art Fair. Of course, there are notable exceptions like Corkin Shopland, Susan Hobbs and Catriona Jeffries. Spin-offs or parallel fairs (such as Scope, Volta, Liste and Pulse) have boosted Canadian representation, with artists represented including Tracey Lawrence, Artcore/Fabrice Marcolini, Angell, Christopher Cutts, Nicholas Metivier and Pierre-François Ouellette.

No Canadian gallerist has operations outside Canada. Some have multiple showrooms in Canada: Douglas Udell (Edmonton, Vancouver and Calgary), Monte Clark (Vancouver and Toronto), and Bau-Xi (Vancouver and Toronto). In Toronto, long-established galleries (opened between the late 1950s and mid-1980s) include Walter Moos, Mira Godard, Jane Corkin, Odon Wagner, Wynick/Tuck, Miriam Shiell, Olga Korper, Sandra Ainsley (primarily works in glass) and Christopher Cutts. Some newer gallerists, outside the ADAC membership, have developed high profiles: Susan Hobbs (Ian Carr-Harris, Robin Collyer, Liz Magor, Colette Whiten, Robert Wiens and Shirley Wiitasalo), Artcore/Fabrice Marcolini (Max Streicher), Pari Nadimi (Rebecca Belmore), Jessica Bradley, Paul Petro and Nicholas Metivier. Key gallerists in Montreal include René Blouin (Geneviève Cadieux, Pascal Grandmaison and Nicolas Baier), a long-standing figure in the contemporary art scene, and a younger player, Pierre-François Ouellett (Luc Courchesne). Vancouver has some of the most ambitious gallerists like Catriona Jeffries (Brian Jungen, Geoffrey Framer, Germaine Koh and Ian Wallace), Tracey Lawrence (Tim Lee, Althea Thauberger and Brandon Thiessen), and Equinox (Joanne Tod and Etienne Zack). TrépanierBaer, based in Calgary, was established in 1992 by Yves Trépanier and Kevin Baer.

The Department of Indian Affairs and Northern Development recognizes the official mark of the 'igloo design identifying Canadian Eskimo art' as being important in the marketplace for authenticating Inuit sculpture. The Arctic Co-operatives Ltd serves as an umbrella organization of 36 cooperatives in the distribution network of Inuit works of art to dealers (Feheley, Toronto; Elca London, Montreal; Inuit Gallery of Vancouver). Inuit art is prominent, with sculpture, prints, drawings and wall hangings.

Auctioneers

The auction trade in Canada focuses on Canadian art produced well before 1960. The recent consolidation amongst the five key auction houses in Canada has resulted in three groups offering Canadian art at public auctions twice per year (in May/June and November/December): Heffel, Sotheby's Important Canadian Art in association with Ritchies, and Joyner Waddington's Canadian Fine Art compete head-to-head. Paintings by Tom Thomson (1877–1917) and the Group of Seven, Emily Carr (1871–1945), Riopelle, David Milne (1882–1953) and James Wilson Morrice (1865–1924) represent the most prized artists. An auction catalogue sale exceeding $10 million is considered very successful, with works auctioned for over $1 million being newsworthy in the national Canadian press.

Heffel bills itself as 'Canada's national auction house', based on its four geographically dispersed offices, located in Vancouver, Toronto, Ottawa and Montreal. This is a considerable achievement from its origins (est 1978) as a commercial gallery in Vancouver. Sotheby's in association with Ritchies is a partnership between the two auction houses. Sotheby's Canada (in Toronto) has two roles: it is responsible for the sale of Canadian art, and it assists Canadian clients in bringing art to auction in Europe, Asia and North America. Established in 1967, with offices in Toronto and Montreal, Ritchies holds 20 auctions per year. Joyner Waddington's is the result of a merger in 2002 between Waddington's – billed as 'Canada's auction house since 1850' – and Joyner Fine Art, established in 1985 by Geoffrey Joyner (who is credited with developing the auction market for Canadian art from his time at Sotheby's starting in 1968).

Waddington's holds 125 auctions per year, and has a very strong reputation for Inuit art sales. Note that the other two international auctioneers, Christie's and Bonhams, do not conduct auctions in Canada. (Although, at the time of going to press Bonhams announced an inaugural Canadian sale in Toronto for June 2008.) Smaller auctioneers operate (from east to west): Tim Issac (St John), Empire (Montreal), Walker's (Ottawa), Dominion (Calgary), Galvin (Calgary), Hodgins (Calgary), Levis (Calgary), Lando (Edmonton), Westbridge (Vancouver), Lunds (Victoria) and Kilshaws's (Victoria)

Public art museums

The National Gallery of Canada (NGC, Ottawa), the Art Gallery of Ontario (AGO, Toronto) and the Montreal Museum of Fine Art (MMFA, Musée des beaux-arts de Montréal) are the key public art museums in Canada. Whereas the NGC offers a good representation of art production in Canada, the English-French divide is noticeable in the collections of the AGO and MMFA. The AGO is strong on Group of Seven, a group of artists of secondary importance at the MMFA; on the other hand, the Automatistes (such as Paul-Emile Borduas (1905–1960), Alfred Pellan (1906–1988) and Riopelle) and JW Morrice (see Cloutier, 1985) are more at home at the MMFA. Along with the NGC and the AGO, the McMichael Canadian Art Collection, just north of Toronto (in Kleinburg), is another (and arguable the best) place to view works by the Group of Seven. Aboriginal art is represented at the big three (NGC, AGO and MMFA) and at the Royal Ontario Museum (Toronto), the Canadian Museum of Civilization (Gatineau) and the McCord Museum (Montreal). Smaller collecting institutions include the Vancouver Art Gallery (for Emily Carr and Vancouver School artists), the Winnipeg Art Gallery, the Musée d'art contemporain de Montréal, and the Art Gallery of Alberta (formerly the Edmonton Art Gallery).

Venues for contemporary art exhibitions exist in Toronto (Power Plant, Art Gallery of York University and Museum of Contemporary Canadian Art) and environs (Oakville

Galleries and Oshawa's Robert McLaughlin Gallery), Montreal (Centre internationale d'art contemporain de Montréal, which established the Biennale de Montréal in 1998), Vancouver (Contemporary Art Gallery, and Morris and Helen Belkin Art Gallery at the University of British Columbia), and smaller cities like Winnipeg (Plug In), Calgary (Art Gallery of Calgary), Saskatoon (Mendel Art Gallery) and Lethbridge (Southern Alberta Art Gallery).

Artist-run centres

Canada was at the forefront in establishing artist-run centres (ARCs) in the late 1960s and early 1970s through the public agency support of the Canada Council. Unlike commercial galleries, ARCs do not emphasize sales. Toronto (YYZ, Art Metropole, Mercer Union, Gallery 44, Gallery TPW and A Space), Montreal (Graff, Articule, Optica, Circa, Dazibao, Ateliers and Le Centrale), and Vancouver (Western Front) are the main cities.

Other institutions

The visual arts section of the Canada Council celebrates successful artists. The Sobey Art Award (est 2002 and awarded every two years, with a cash prize of $50,000) is likened to the UK Turner Prize: it is Canada's pre-eminent prize for a Canadian artist 39 years old or younger who has shown their work in a public or commercial art gallery in Canada in the previous 18 months. The inaugural winner was Vancouver's Brian Jungen. The RBC (Royal Bank of Canada) Canadian Painting Competition (est 1999) is another award; Etienne Zack is a recent winner.

Market data

Heffel has been the auctioneer most aggressive in exploiting online possibilities, including a subscription-service database of auction sales in Canada. This is akin to Artnet or Artprice with a Canadian slant. Westbridge (2002) published an investor's guide to the Canadian art market with 17 'indices' (including the Automatistes, the Beaver Hall Group, the Group of Seven and Painters Eleven). According to Westbridge's composite index, the annual rate of return was 9.5 per cent from 1977 to 2002. Since this index is not investable, it does not reflect actual returns in the art market. These measures offer a rather historical insight into general market trends. Note this is not a proxy for the actual price a work would have achieved at auction or with a dealer; rather, the average price movement for an artist's or group's works over a given period is presented. Limited transactions – such as low volume trading at auction – and the exclusion of sales conducted by dealers cause distortions. Moreover, it is very difficult to obtain repeated sales data, which is necessary as works of art, even by the same artist, are not interchangeable. Hodgson and Vorkink (2004), using AY Jackson as a dummy variable, examine various factors including painter identity on auction prices; they cite an annual average return of 8.5 per cent based on a portfolio of the most popular painters.

Auction sales in Canada total $50–60 million. The average price per painting during the 2004/05 auction season (including premium paid by buyers) was $8,000, with 68 paintings selling for more than $100,000 (Westbridge, 2006). Valsan (2002) argues that the style of Canadian artists, not least of all landscape painting to define national identity, has resulted in Canadian painters gaining less international market recognition than their American counterparts.

Auction results

The Canadian auction market rests on about 50 artists, accounting for three-quarters of total sales. Lawren Harris (1885–1970), Emily Carr and Jean-Paul Riopelle are significant, representing about one-quarter of total sales (Westbridge, 2006). Most works by Tom Thomson, who died early, are in public collections, thus few Thomsons appear on the market. Other core artists outside the Group of Seven include Cornelius Krieghoff (1815–1872), Milne, Morrice and Maurice Galbraith Cullen (1866–1934). Goodridge Roberts (1904–1974) and Horatio Walker (1858–1938) also feature on a regular basis. (See Table 7.1.)

To gain a better understanding of the Top 10 list it is instructive to mention the collecting taste of Lord Kenneth Thomson, media baron and Canada's richest man, who died in 2006. In 2002 Thomson announced the donation of his art collection of 2,000 works (estimated to be worth $300 million) to the Art Gallery of Ontario: highlights include Peter Paul Rubens, *Massacre of the innocents*; Paul Kane, *Scenes in the Northwest*, which is at the top of the Canadian auction market, and Lawren Harris, *Baffin Island*. Thomson's Canadian art collection started in the 1940s with Krieghoff, and 200 works by the artist were amassed; Kane was another pre-Confederation artist in the collection. Collecting in the Group of Seven and Tom Thomson started in 1970 through Toronto dealer G Blair Laing (d 1986) and more recently with Winnipeg-based David Loch: 300 works were collected. Milne represented another artist valued by Thomson, with 182 works. Other artists included Morrice, Borduas and Riopelle.

Paul Kane

Very few works of Kane (1810–1871) appear at auction: only the two listed in Table 7.1 were sold, according to Artnet, which helps to account for the high prices.

Lawren Harris

Harris has four works in the Top 10 and leads the Canadian auction 'total accumulated sales' list. Harris was extremely innovative, with stylistic changes over the course of a long career; moreover, he is important in art history owing to his support of other artists such as Tom Thomson and Emily Carr. Painting trips with Group of Seven members to Algoma from the end of the First World War to 1921 resulted in representational landscapes associated with the Group. His interest in theosophy started in the 1920s, and is noticeable in paintings from the north shore of Lake Superior (1921–24), the Rocky Mountains (1924–29), and the Arctic (1930–33). In 1934 Harris moved to the United States (described as a transitional period in some auction catalogues), and returned to Canada in 1940, when he settled in Vancouver. 'Only in his last great mystical paintings of 1967–68 did he once again return to geometric forms, although these are painted with the unusual "feathered" strokes, and glow with the white light of pure spirit' (Reid, 1973: 276). Harris's works are popular with collectors and expensive.

Emily Carr

Carr's career is divided into three parts: 1889–1910 (student and other early work including sketches of First Nations villages before her departure for France); 1910–12 (period in France and works of 1912 when she returned to Canada and applied her new way of seeing to First Nations themes); and 1928–42 (the long period of her steady mature production, including massive totem and green deep forest paintings).

Table 7.1 Top Canadian paintings sold at auction (as of Spring 2007 sales)

Artist	Title and dimensions (inches)	Auctioneer and date	Sale price (including buyer's premium) and estimate (low/high excluding buyer's premium)
Paul Kane	*Scene in the Northwest* (1845/46) 20×31	Sotheby's/Ritchies 25 February 2002	$5,062,500 $450,000/550,000
Lawren Harris	*Pine tree and red house, winter, city painting III* (1924) 32×38	Heffel 23 May 2007	2,875,000 $800,000/1,200,000
Lawren Harris	*Baffin Island* 40×50	Joyner's 29 May 2001	$2,427,500 $600,000/700,000
Paul Kane	*Portrait of Maungwudaus* (1846) 30×25	Levis 1 December 2002	$2,420,000 $2,800,000/3,000,000
Jean-Paul Riopelle	*Untitled* (1955) 78×138	Sotheby's (New York) 3 May 1989	US$1,540,000 (=C$1,832,600) US$250,000/300,000
Lawren Harris	*Mount Lefroy* (1929) 12×15	Heffel 25 May 2006	$1,667,500 $200,000/250,000
Jean-Paul Riopelle	*Il etait une fois une ville* (1954–55)	Heffel 24 November 2006	$1,667,500 $750,000/950,000
James Wilson Morrice	*Effet de neige* 26×32	Sotheby's/Ritchies 18 November 2003	$1,622,500 $250,000/350,000
Lawren Harris	*Winter in the northern woods* (1915) 55×73	Sotheby's/Ritchies 31 May 2004	$1,575,500 $1,000,000/1,500,000
Maurice Cullen	*The Bird Shop, St Lawrence Street* (1920) 24×32	Heffel 24 November 2005	$1,495,000 $250,000/300,000
Jean-Paul Riopelle	*Composition* (1951) 51×64	Christie's (London) 27 June 2002	£633,650 (=C$1,485,000) £100,000/150,000
Lawren Harris	*Algoma Hill* 46×54	Sotheby's/Ritchies 21 November 2005	$1,382,500 $800,000/1,200,000

Note: See Heffel (heffel.com), Sotheby's/Ritchies (sothebys.com or ritchies.com), and Joyner Waddington's (joyner.ca) for recent catalogues and sales results

Source: Westbridge (2006); updated using Artnet, Artprice, and Art Sales Index

Jean-Paul Riopelle

Riopelle had a long career as an artist. Yet works during the 1950s, following his move to Paris in 1948, represent his finest. They are the most valued by collectors.

Cornelius Krieghoff

Krieghoff's strong and long-standing popularity with private collectors has lessened his art historical significance, though Dennis Reid (1999) has attempted to redress this lack of critical acclaim. Walter Klinkhoff (Montreal) is a good dealer for paintings by Krieghoff.

David Milne

Milne 'was a great painter, but it remains to be seen if he will be re-claimed as an American artist, and I am going to regret it if he is priced out of the Canadian market', according to Varley (2004). Milne's Top 20 on Artnet are over $100,000, with oil on canvas paintings from 1914–30 as key, though there are several watercolours (from the same period). Mira Godard (Toronto) is a good dealer for works by Milne.

Jack Bush (1909–1977)

Bush is at the $100,000 mark. The early 1960s were marked by Bush's first 'sash' paintings; and the switch to acrylic paints in 1965 added a new luminosity to his colour. Miriam Shiell (Toronto) is a good dealer for paintings by Bush.

Michael Snow (b 1929) has critical reputation as an experimental film-maker since the 1970s. Yet there is a great deal of demand by private collectors for his 'walking woman' works of 1961–67. Jeff Wall (b 1946) is one of Canada's successful living artists. He has gained international exposure through the long-standing dealer representation of Marian Goodman (New York and Paris). On the other hand, Joanne Tod (b 1953), the star of Mark Cheetham's examination of trends in Canadian art, published in 1991, has not progressed outside Canada.

Conclusion

A consensus has developed around the key artists valued by the market – a list of about 50 artists as featured in standard histories with Thomson's donation to the AGO as an indicator of private taste – with the Group of Seven and 'associates' leading the pack. Six auctions per year in Canada cover the core market sales, and a handful of key secondary dealers are based in several Canadian cities. At the same time, contemporary Canadian art has made international inroads. The path forged by Vancouver's Jeff Wall since the 1980s is one that artists a generation younger, such as Brian Jungen, have adopted. Likewise, younger gallerists are recognizing the importance of developing relationships outside Canada.

Acknowledgements

Derrick Chong would like to recognize the financial support of the Faculty Research Program grant 2006/07 from Foreign Affairs Canada (International Council for Canadian Studies file number 605–1-2006/07).

For further information on the development of this particular art market, go to:
www.koganpage.com/artmarkets.

Bibliography

Bradley, J and Johnstone, L (eds) (1994) *Sightlines: Reading contemporary Canadian art*, Artexte, Montreal

Cheetham, M (1991) *Remembering Postmodernism: Trends in recent Canadian art*, Oxford University Press, Toronto

Cloutier, N (1985) *James Wilson Morrice 1865–1924*, Montreal Museum of Fine Arts, Montreal

Harper, R J (1966) *Painting in Canada: A history*, University of Toronto Press, Toronto

Hill, C (1975) *Canadian Paintings of the Thirties*, National Gallery of Canada, Ottawa

Hill, C, Lamoureux, J and Thom, I (2006) *Emily Carr: New perspectives on a Canadian icon*, Douglas and McIntyre, Vancouver, National Gallery of Canada, Ottawa and Vancouver Art Gallery, Vancouver

Hodgson, D and Vorkink, K (2004) Asset pricing theory and the valuation of Canadian paintings, *Canadian Journal of Economics*, **37**(3), pp 629–55

Hubbard, R H (1967) *Three Hundred Years of Canadian Art: An exhibition arranged in celebration of the centenary of Canada*, National Gallery of Canada, Ottawa

Jackson, A Y (1958) *A Painter's Country: The biography of AY Jackson*, Irwin Clarke, Toronto

Mellen, P (1978) *Landmarks of Canadian Art*, McClelland and Stewart, Toronto

Murray, J (1998) *Canadian Art in the Twentieth Century*, Dundurn Press, Toronto

Reid, D (1970) *The Group of Seven*, National Gallery of Canada, Ottawa

Reid, D (1973) *A Concise History of Canadian Painting*, Oxford University Press, Toronto

Reid, D (1979) *Our Country Canada; Being an account of the national aspirations of the principal landscape artist in Montreal and Toronto 1860–1890*, National Gallery of Canada, Ottawa

Reid, D (1988) *A Concise History of Canadian Painting*, 2nd edn, Oxford University Press, Toronto

Reid, D (1999) *Krieghoff: Images of Canada*, Douglas and McIntyre, Vancouver

Rhodes, R (2001) *A First Book of Canadian Art*, Owl Books, Toronto

Shadbolt, D (1971) *Emily Carr: A centennial exhibition celebrating the one hundredth anniversary of her birth*, Vancouver Art Gallery, Vancouver

Silcox, D (1996) *Painting Place: The life and work of David B Milne*, University of Toronto Press, Toronto

Silcox, D (2003) *The Group of Seven and Tom Thomson*, Firefly Books, Toronto

Town, H and Silcox, D (1977) *A Celebration of the Paintings of Tom Thomson*, McClelland and Stewart, Toronto

Valsan, C (2002) Canadian versus American art: what pays off and why, *Journal of Cultural Economics*, 26, pp 203–16

Varley, C (2004) The development of the modern market for historical Canadian art, manuscript

Westbridge, A (2002) *Made in Canada: An investor's guide to the Canadian art market*, Westbridge Publications, Vancouver

Westbridge, A (2006) *Canadian Art Sales Index*, Westbridge Publications, Vancouver

Wilkin, K (ed) (1984) *Jack Bush*, McClelland and Stewart, Toronto

Chile

Cecilia Miquel (translated by Georgina Fleming)

Introduction

In terms of a cultural framework, Chile relies on a National Council of Culture and Arts, an organization created at cabinet level in September 2003, which has started to establish national parameters for cultural policies. So far its impact is informal, especially in the arts market. To date, there is no clarity on the legal area or the scope of the visual arts, nor are there any cultural taxes on the visual arts. There is only legal regulation for the import and export of art works.

This has led to a gradual overcrowding and high degree of informality in the development of the art market. Art is being converted more and more into an economic commodity, to the extent that some artists feel motivated to produce works that cater to commercial criteria rather than to creative ones. The result is that collectors acquire works of art as investments rather than acquiring works out of passion. Nevertheless, this field is still very much reserved for a national élite. (This consists typically of people with high income, more than 50 years old, with traditional ancestry. There is another group of some immigrants from the beginning of the 20th century.)

The market for Latin American art started its rise in Chile in the 1980s following the continuous expansion in the volume of Chilean art works on the international market (although few Chilean artists have been present in international auctions). The end of the 1990s marks the period from which contemporary artists incorporated themselves in the international market in an autonomous way, ceasing to be seen as Latin American artists and instead being valued as individuals. In this field, globalization can be seen as an opportunity to provide new perspectives on creation and distribution, plus there are increasing amounts of money and widening taste.

Nevertheless, the movement of the market in Chile is determined by the financial value of the works of art and by fashion – the market tends to be very informal. Value is determined by newspapers, cultural centres and exhibitions in the commercial galley areas in Santiago.

The point of view of the artist

Since the late 1980s, but particularly over the last 15 years, artistic expression has been expanding and increasing in impact. A new generation of more experimental artists has emerged in Chile, although this has received little publicity. The same can be said for the new critique and new writing.

An important issue is the generation of artists graduating from university in the previous three years. We are talking about young adults who are unemployed, who do not have any connections with galleries, whose financial support relies heavily on the Fondart (Fondo Nacional de las Artes) or on personal resources and funds, and whose 'products' have not been assimilated into the market. They are therefore practically unknown as artists. A mass of at least 250 young artists are looking to fit into the Chilean market. This number is increasing with the expansion of new art schools, which have grown to 15 or 16 across the country, and from which 300 students graduate each year. A recent study of the pay of those graduating in different subjects in Chile showed that arts graduates today earn the least.

Today's artist is subject to a frame of mind in which fame matters more than importance. 'It amazes me that so many young adults' only objective is to exhibit, disregarding the subsequent outcome and the subsequent effect on the public', says Oscar Gacitúa (1953), an outstanding Chilean sculptor. This message refers to the fact that many schools have abandoned the great masters, have stopped looking and learning about the past, and are producing students who cannot draw well and who do little studying in school (something also attributed to the students' lack of interest). In other words, there is a complete abandonment of the origins of the visual arts.

Despite this tendency, the market benefits from private firms buying paintings to decorate their offices or sculptures to install in building entrances. This has helped produce very important works of art in the country, and ensures there are sculptures in public urban spaces. There is a direct relationship between art galleries and artists, and the burnishing of corporate image through art.

The importance of management

There are various segments of the Chilean art market:

■ International auction houses. Sotheby's and Christie's representatives in Chile provide a regulatory mechanism: they set the worldwide reference prices for works from artists with an existing reputation, and satisfy collectors.

■ National and international art gallery directors and art fairs. Most of the sales take place between the same galleries, which invest in artists who are becoming established. Many take on artists and position them in international fairs such as the Bienal de Sao Paulo, Arco (Madrid), Basel (Miami) and ArteBA (Buenos Aires). The sector includes national galleries such as Isabel Aninat, Animal and Marlborough.

■ Independents. This sector consists of dealers, collectors, artist representatives, auction houses and art collectors, among others. In the past few years the buying sector has enlarged to include influential young adults who acquire paintings as investments or as ornaments. This is a broadly local market, served by galleries like Arte Espacio, La Sala, Afa gallery, Florencia Loewenthal, Francisco Stuardo, Matucana 100 and Gabriela Mistral.

■ The experimental sector. This is the market that has been generated by artists in search of new venues, some of which are increasing in reputation (with emerging neighbourhoods and galleries). The internet provides an interesting window of opportunity for hundreds of artists whose careers are in formation or with an experimental nature. Examples are Die Ecke, Taschi and the Metropolitana gallery.

New art venues in Santiago

The art market is concentrated in Santiago. The 1990s saw a growing avant-garde scene, with a proliferation of galleries coinciding with the disappearance of the Bellavista art circuit. The decade gave rise to the first art business district in the Alonso de Córdova area, with Nueva Costanera, now devoted to commercial art with its strategic gallery nights. The past few years have seen a new dynamic of visual culture in the Museo de Artes Visuales area, the recently restored MAC, the Galería Bech and Sala Gasco in the city centre, and the Centro Cultural Matucana 100 rounding off the circuit. Today, galleries redirect their programmes, and new spaces enliven areas of the city that were previously devoid of culture, like Quinta Normal, Ñuñoa and Providencia. Examples are Galería VALA (Vanguardias Latinoamericanas), AtlanticTransArt, Die Ecke y Di End, Galería AFA, Sala Amigos del Arte and Galería Stuart.

Consumption statistics

The Consejo Nacional de la Cultura (National Council of Culture and Art) and the Instituto Nacional de Estadísticas (National Institute of Statistics) produced a document *Encuesta sobre Consumo Cultural y Uso del Tiempo Libre* (Survey on cultural consumption and the use of spare time) in 2004. In August 2005 a study of the national character was published. In this study a notable increase was observed in attendance at cultural activities, museums and art galleries, and recreational activities such as theatres, concerts, recitals, ballets, cinemas, sport shows and literary movements. The results indicate that from 2000–02 to 2004–05 there was an increase of around 40 per cent in attendance at cultural shows. Visits to state museums shot up to 1,668,442, the most requested museum being the Nacional de Bellas Artes with 673,132 annual visits.

Two organizations annually carry out a national consumption survey for art: Bank Santander and the Corporación Cultural Amigos del Arte (Cultural Corporation for Friends of Art). This alliance questions collectors, intermediaries and experts in the art market who appraise portfolios. Two portfolios are measured: one of traditional art (19th century and beginning of the 20th century), and the other of contemporary art (mid-20th century onwards). This initiative was created in 1990, under the direction of Roberto Méndez, director of Amigos del Arte. The process has been in function since 1993, so there are now more than 10 years of measurements.

There has been a drop in demand for traditional Chilean painting. This drop started in the year 2001 as the result of a change in the buyers' profiles and of the scarce number of market operators generally. Those buying traditional Chilean painting tend to be over 50 years old, and the majority of these buyers have little interest in updating their collections. Museums and institutions have minimal budgets, if any, for acquisitions. Since 2002, the value of Chilean paintings sold has dropped by 5.8 per cent. Out of the 17 important galleries of the country between 1996 and 2000, only 12 are left, while there are no more than four auction houses still in business. The market became saturated and many operations closed down.

Good artists such as Pedro Lira (1846–1912), Arturo Pacheco Altamirano (1903–1978), Pedro Subercaseaux (1880–1956) and Benito Rebolledo (1881–1964) worked in Chile at the start of the 20th century. Today, these painters have high value within Chile, but not necessarily high values at the international market, so their work tends to appear only at local sales.

The arrival of Christie's and Sotheby's (which has had a presence in Chile for over nine years) has helped give real authenticity to works of art (including not only painting but furniture, jewellery and other objets d'art). They provide much information on the previously unknown or uncertain origin of works: in Chile there exist few experts who can certify the value and origin of art works.

The surveys have indicated that in the past few years there has been a great interest in contemporary art. This sells best at prices ranging from $500–3,000.

Some Chilean artists that have made their careers in other countries include Jorge Tacla (b 1958), Francisco Corcuera (b 1944), Alfredo Jarr (b 1956), Guillermo Muñoz Vera (b 1956), Gonzalo Cienfuegos (b 1949) and Fransica Sutil (b 1952).

Summary

The main reasons for changes in the art market, which has undergone many developments, have been:

- the increasing number of works that artists sell directly from their studies and through artists' associations;
- new creators who graduate year after year from university art courses (lowering prices and increasing artistic standards);
- the representation of companies such as Christie's and Sotheby's, which have modified people's view on art because national buyers can now more easily and frequently acquire works of art from international artists;
- the tendency for Chilean artists to sell their works in other countries like Spain, England, Mexico, Germany and the United States.

As a business, art works in a very informal way because of the distributed location of art works, sales from small shops and sponsorships from companies. Galleries in Chile take an average of 35 per cent commission on the sale of a painting, and the independent market takes an average of 15 to 20 per cent commission.

Trading in art in Chile can be profitable, but there are some conditions: it is necessary to know the market, know the artist, know how to deal with the press and have determination and credibility. It is estimated that every year this market brings in US$60 million to Chile, but it is hard to be precise because the art market is so informal (the real figure could be triple this estimate).

In conclusion, the art market in Chile is slowly growing. There is a demographic reason, in the increase in population and life expectancy. It is also specifically due to the creation of new audiences that line up for the openings of new museums (MAVI, Ralli, MAC, and Centro Cultural Palacio La Moneda, among others), which have transformed urban areas into cultural centres (Quinta Normal, the boom of private galleries in the Alonso de Córdova neighbourhood, as well as more remote areas).

The boom is also due to increases in construction, of everything from working-class homes to luxury apartments, and, finally, the creation of new art universities sponsored by famous Chilean artists.

The link between technology and art remains weak in Chile. In the mid-1990s the term 'net art' was coined, in which works were done by and for the net. In Chile this is a primary technique, and various national artists have created their own websites. In 2001, Fondart (a public fund for artists) assigned resources for a new grants category called 'art in internet'. Only 13 artists applied for the grants, of which three ended up winning.

Acknowledgements

The author is grateful to Georgina Fleming for translating this chapter, and to Dalia Haymann, cultural manager and Sotheby's Chile assistant and to Cecilia Miquel, representative of Sotheby's Chile, for their advice and assistance with translation.

For further information on the development of this particular art market, go to: www.koganpage.com/artmarkets.

China

Ruben Lien

Introduction

2007 was an explosive year for Chinese contemporary art (Christie's and Sotheby's contemporary art sales totalled HK$488,612,800 in the first half of the year), much like the works of one of its most prodigious artists, Cai Guoqiang (b 1957), leaving trailblazing marks on the wide canvas of today's rapidly expanding art market. The allegory is made more poignant by the fact that it was the Chinese who invented gunpowder around the 9th century, although using it to make works of art was probably the furthest thing from the minds of the Daoist alchemists who stumbled upon it. Its true potential was only realized when it was brought to the west, where it was turned into a lethal weapon. Western traders used it to open the doors of China, and this indirectly resulted in the end of the Qing dynasty (1644–1911). Many of the Imperial court's most precious works of art found their way to the west in this period, sometimes by trade, but often also by force.

The ensuing years were tumultuous to say the least, and after the two Great Wars and the civil war between the Nationalists and the Communists, the latter succeeded in laying its claim to China in 1949, and thus began a period of disastrous economic policies and heritage obliteration. It was not until Deng Xiaoping's reforms in the 1980s that China started to show its true potential and became a formidable market force. As its economic power gathers pace, so does its art market. It is not only the contemporary art that is producing enviable results. 2007 has been a bumper year for Chinese art in all categories: record prices are being achieved for pieces ranging from archaic bronzes dated to 1,100 BC to Imperial porcelain bowls made in the Qianlong period (1736–95). The Chinese art market is making the Great Leap Forward, much to Mao Zedong's dismay for sure if he could be here to witness it, as his motherland makes her transition into a capitalist superpower.

The Chinese economy has been growing at an average of around 9 per cent per annum officially for the past 20 years. It is reported that China now has over 300,000 millionaires, 27,000 of whom are worth more than RMB50 million (excluding overseas property), while the average wage in China is still around RMB25. The art market has a geared effect on the economy and it is not surprising that we are seeing the increasing interest the very wealthy are showing for fine works of art. The new-found wealth in China has created a class of collectors

who are buying art for the prestige, or as an expression of their recent liberty to connect with China's history and heritage, but in many cases art is also perceived as a lucrative investment. Works of art are also often given as gifts, either with great fanfare for maximum publicity, or as clandestine gestures to facilitate behind-the-door business dealings.

These collectors are mostly entrepreneurs who have made their money from China's many booming manufacturing industries. Their collecting pattern shows the characteristics of new collectors, preferring pieces that are ostentatious and decorative. They are also keen to leave their mark, and an interesting phenomenon in China now is the creation of many private museums, much like what happened in Japan in the 1980s. It is reported that China had more than 2,000 museums in 2006, up from 830 a decade ago. One of the most active amongst them is the Poly Museum, set up in 1999 by a government-backed group, which has been a very strong buyer in the market. In 2000 it purchased three bronze fountain heads which were taken by the British troops in the ransacking of the Summer Palace in 1860, from Christie's and Sotheby's Hong Kong for over HK$25 million. The Poly Group now operates its own auction company.

It is not only the Chinese that are interested in Chinese art. Many of China's periphery economies are benefiting from her economic growth, such as Hong Kong, Korea, Indonesia, Singapore, Japan and Taiwan, all of which share some cultural or racial affiliation with China. Hong Kong's economy is tied inextricably with China, but at the same time faces stiff competition from Shanghai, especially if China's currency finally becomes fully convertible. At the moment, however, Hong Kong is performing very strongly, and many of the most important collectors of Chinese art are from Hong Kong.

Despite the political tension and ambiguity surrounding the cross-strait relationship between Taiwan and China, Taiwan is responsible for more than US$200 billion of investment in China, around half of the total of China's foreign direct investment. The rise of the Taiwanese economy in the 1980s was one of the main driving forces of the Chinese art market alongside the Japanese, and some of the most important collections of Chinese art, not to mention the world-class National Palace Museum collection, are to be found in Taiwan. As the Japanese largely retreated from the market since the recession at the beginning of the 1990s, the boom of the Chinese economy has ensured that the Taiwanese remain influential in the market.

The first international auction house to set up salerooms in Hong Kong was Sotheby's in 1973. Christie's followed suit in 1986, and Hong Kong quickly took over from London and New York to become the principal centre of the Chinese art market. In 2006 the combined sale total of Christie's and Sotheby's was over HK$36 billion, a growth of over four times since 2002 (see Table 9.1).

Bonhams has just set up its office in Hong Kong and had its first sales in spring 2007. Although its first attempt in tapping into the Hong Kong market has not been a great success – the three sales it held made a total of only HK$40 million – it remains to be seen whether it will find its own niche amidst stiff competition from the two bigger houses.

Table 9.1 Christie's Hong Kong sale totals 2002–06 (in US$)

2002	82,558,000
2003	84,397,000
2004	170,820,000
2005	235,080,000
2006	335,893,000

Since the Communist authorities legalized the private art market in 1992, almost 2,000 local auctioneers have set up business, many short-lived from mismanagement. After a decade of competition between Shanghai and Beijing, the latter emerged as the main auction centre, with two of the most reputable auction houses now operating in China, China Guardian and Hanhai. Although the People's Republic of China (PRC) theoretically opened its doors to foreign competition in 2004 in order to fulfil its obligations as a member of the World Trade Organization in 2001, government regulations in effect exclude outsiders. It is also illegal to export any antiques more than 200 years old from China, unless one can prove that the item had been imported previously. Regulations are somewhat lacking in the auction business, and auction results have been known to be untrustworthy at times. It is difficult to take money out of China as the currency RMB is still not fully convertible. Until things change for the better, it is generally wise for foreign collectors to avoid buying or selling art in the Chinese auction market. This chapter will therefore concentrate on the art market in Hong Kong and Chinese art sold in other international locations.

The art market by sector

When perusing an auction catalogue of Chinese art for, say, Sotheby's or Christie's, one is invariably struck by the range of objects, media, artistic styles and the time span it covers. After all, it would be the equivalent of having an auction catalogue of 'European art', since China covers a larger area than Europe and has a much longer history, not to mention an unbroken artistic tradition. To cover this hugely complex and wide-reaching market is a mammoth task not possible in the scope of the present chapter. I shall therefore attempt a brief overview of each of the main categories, to provide a general outlook of the market.

Although in recent years the market for modern and contemporary art has expanded very rapidly, it is works from antiquity that have been the foundation of the market and have historically been the focus of collectors. Collectors of antiquities face a serious problem today from the overwhelming amount of high-quality forgeries that have flooded the market. Made-in-Shenzhen Louis Vuitton bags and Rolex watches aside, the act of imitation can be interpreted at many levels in Chinese culture, in many instances with positive connotations.

Archaism, for example, is an honourable aesthetic tradition which pays tribute to the achievement of the past by imitation. Sometimes porcelain pieces are marked with reign marks of a previous era, not with the intent to deceive, but as a tribute or an allusion to the glory associated with wares produced in that era. However, in most of these instances the perpetrator does not intend to deceive, therefore it is not difficult to differentiate between the imitated and the imitating. With the modern technological advancement and ease of access to information, the forgers in China today have become extremely competent in their craft. Provenance has therefore become a very important issue in the buying and selling of antiquities, and many collectors are turning away from the antique market to modern and contemporary art, which has far fewer authenticity issues. Rarity, quality and condition are, as a general rule, three of the other most important considerations in collecting antique works of art. Pieces that have satisfied these four criteria generally can withstand the test of time and change of taste.

Although in recent years the Chinese antique market has been dominated by the rapid growth in popularity of Ming and Qing Imperial pieces, it is interesting to note that many of the most expensive Chinese works of art ever sold fall outside this category. In particular there are two areas that draw attention, archaic bronzes from the Shang (1600–1100 BCE) and Zhou (1100–256 BCE) dynasties, and blue and white vessels from the Yuan dynasty (1279–1368).

The market for Tang pottery pieces has declined since 1990 because of the continuing excavation in China which flooded the market with materials, and the lack of interest from new Chinese collectors. Since these pieces were made to accompany burials, their inauspicious association with the dead is a great inhibiting factor for the Chinese. These pottery pieces were mainly collected in the West and by the Japanese prior to the 1990s, and by the Americans today after the Japanese and the Europeans have dropped out of the market. In 2001 Christie's New York sold a bronze wine vessel, *fanglei*, from circa 1100 BCE for US$9,246,000.

Although archaic bronze vessels were also found in burials, their primary purpose was to be used in rituals, in which wine or food were contained to be offered to Heaven and the spirits. They were astounding for both their technological achievement and the mystical quality of their appearance. The highly ornate and complex designs are imbued with meanings, some of which are still not fully appreciated today. They were expensive items to produce and required a highly organized labour force, hence they were also symbols of power and status. Many of these bronze vessels bear inscriptions which are important and invaluable records to the study of Chinese history. The collecting and preservation of these archaic vessels has a long tradition in China, and many of them were recorded in Imperial collection inventories. However, this is an area where we see particular strong buying from western collectors at the very top end. The *fanglei* mentioned above, for example, was sold to an anonymous European private collector. Since all archaic bronze pieces came from excavation at some point, it is particularly important for them to have a solid provenance. It is also worth noting that the market is extremely selective, and pieces at the top spectrum can sell for a fortune while pieces in the lower end struggle to attract much interest.

The record for the most expensive Chinese work of art is today held by the van Hemert jar, a 14th century Yuan blue and white jar depicting a narrative scene, sold by Christie's London for a staggering £15,688,000, making it also the most expensive Asian work of art ever sold at auction. This jar was brought back to Europe in the first quarter of the 20th century and had remained in the van Hemert family until it was sold. This jar in effect is one of the finest early blue and white porcelains ever made. The market for Yuan blue and white, like that for the archaic bronzes, is very selective and extremely competitive at the top level, but with a wider audience perhaps than the archaic bronze market. Although good-quality Yuan blue and white pieces have always been sought after, it was not until the sale of a blue and white flask from the F Gordon Morrill Collection by Doyle New York in 2003, and the van Hemert jar in 2005, that the prices for these pieces really took off. The Morrill flask, painted with a dragon and the only such example now in private hands, sold for US$5,831,500 and was again bought by a European private collector.

Ceramics have a long history of being treasured and collected as works of art, and Song (960–1279) ceramics for many collectors are the epitome of refined taste. Their elegant, simple form and decoration, coupled with a subtle, mainly monochrome glaze, give a restrained appearance very different from the more ornate works of the subsequent dynasties. Connoisseurs in the west traditionally had high esteem for these pieces, and in the auctions of Chinese art in London before the 1970s, Song ceramics commanded at least equal, if not much higher prices than their Ming and Qing counterparts. Japanese collectors and to an extent some Taiwanese collectors also have a particular fondness for Song ceramics. Not surprisingly, at the height of their purchasing power in the 1980s, the market for Song ceramics was very strong. In recent years, however, the market has dropped quite significantly for some categories, especially in the mid to lower market. Good quality Song pieces with good provenance still achieve high prices, but their appreciation in value is nowhere near the meteoric rise of

Ming and Qing porcelains in recent years. Some categories do particularly well, such as *guan*, *ge*, Jun and Ding wares, which are sometimes associated with the court and which produced some pieces of very fine quality. There are very few genuine *guan* and *ge* wares in existence, so whenever a good example comes up, it normally receives much attention.

The market that has been the most significant and has seen the biggest financial returns for collectors of antiquities for the last decade is undoubtedly the so-called 'Imperial art'. The term 'Imperial art' used to denote quite specifically those works of art that were commissioned by the Emperor and made under the supervision of the court artists or workshops, mainly in the Ming and Qing dynasties. However its definition is nowadays much more general, referring to all works of art intended to be used in the Imperial court or palaces, or those sent as tribute pieces to the court from other regions.

Although the term has long been used by collectors, it was not until 1999 when Christie's Hong Kong inaugurated its first Imperial sale that this new direction in art collecting and marketing really gained momentum. A new generation of collectors, mainly of Chinese origin, are now collecting specifically in this category. Anything that is associated with the court, be it porcelain, jade, lacquer, enamel, painting or furniture, has in a short period of time gained much stature and value. Amongst the myriad mediums in this category, porcelain is still without question the most revered and popular. Ming and Qing Imperial porcelains, especially those from the 15th and 18th centuries, headline most of the major auctions in Hong Kong and China. Record prices are constantly being achieved, a testament to the enduring popularity of these fine works of art.

In 2004 Bonhams and Butterfields San Francisco sold an underglaze copper-red dish from the Hungwu period (1368–98) for US$5,726,250; two years later, Christie's Hong Kong sold the most expensive Ming porcelain ever at auction, a pear-shaped vase also in underglaze copper-red from the same period for HK$78,520,000. Throughout the 1970s and 1980s, early Ming blue and whites were the stars of any auctions of Chinese art; in the 1990s however, we saw a gradual shift towards the more ornate and colourful 18th-century pieces, and the stagnation of the more run-of-the-mill early Ming blue and white specimens. The prices for dishes and bowls that are fairly standard have not moved much in the last five years. However, fine and rare pieces still fetch high prices, and recently a blue and white brushwasher decorated with dragons from the Yongle period was sold by Christie's Hong Kong for HK$40,943,750 in 2004, becoming the most expensive Ming blue and white porcelain ever sold, up from HK$16,520,000 when Sotheby's sold it in 1997.

Although 16th and 17th-century porcelains traditionally have been regarded as inferior in quality to those from the 15th and 18th centuries, they play a vital role in the development of styles and techniques for later porcelains. With the proliferation of over-glaze enamels, more colourful and complex decorations appeared on ceramics of the Ming period, especially in the 16th century. In 2000 Sotheby's Hong Kong sold a polychrome enamelled porcelain jar painted with fish from the Jiajing period (1522–1566) for HK$44,044,750, making it the most expensive Chinese porcelain piece ever sold at the time.

Qing Imperial porcelains have been the real stars of the show since the end of the 1990s. Under the auspices of the Kangxi (1662–1722), Yongzheng (1723–35) and Qianlong (1736–95) emperors, porcelain production in the Imperial kilns at Jingdezheng reached its zenith. A myriad of styles and techniques emerged, incorporating not only the existing traditions that had been passed down by previous generations, but also the western influences that had arrived with trade and the missionaries. The Chinese empire was at its height in both its military and economic might, and this is well reflected in the quality and quantity of fine works of art being made in this period. Traditionally they were not regarded as true collector's items

but only curiosities, inferior to the classic Song ceramics or early Ming pieces. However the market has gone through a rapid change, especially since 2000, with the existing mega-rich collectors from Hong Kong and Taiwan competing against each other and with the emerging entrepreneurs from China, who are drawn to the fine quality and ostentatious style of these pieces. Although the top end of the market is still dominated by Hong Kong and Taiwanese collectors with some competitive buying from a few western collectors, the voracious appetite of the new buyers from China has pushed up prices for the middle and lower end of the market. The demand for good 18th-century 'mark and period' pieces (porcelain that bear the reign mark indicating its true age) has far outstripped the supply and they are disappearing rapidly from the market. Nowadays even good Jjiaqing (1796–1820) and Daoguang (1821–50) pieces, previously much neglected, are becoming hotly contested properties.

It is not only porcelains that are performing very strongly. Other categories under the 'Imperial' umbrella such as jade, enamel on metal, Buddhist art, lacquer, textiles, furniture, paintings or scholar's objects (paraphernalia for a scholar's desk) are also going through a period of renaissance. Recently the market for both gilt-bronze Buddhist sculptures and jade carvings received a strong boost from the sale of the collections of two renowned dealers in their respective field, Jules Speelman and Alan Hartman. The Speelman collection of Imperial Ming gilt-bronzes at Sotheby's Hong Kong in 2006 totalled HK$324,344,000 with only 14 lots in the sale, including a Yongle Buddha which sold for HK$116,600,000 to a Chinese buyer, making it the most expensive non-porcelain Chinese work of art ever sold at auction. The first part of the Hartman Collection of jade carvings in Christie's Hong Kong 2006 totalled HK$116,051,999, with two top pieces selling over HK$10 million. A set of seven jade archer's rings that used to belong to the Qianlong emperor fetched HK$47,360,000 at Sotheby's Hong Kong in 2007; when it first appeared at Christie's Hong Kong in 1997 it only sold for HK$4,970,000. The most expensive Chinese painting ever sold at auction, also by Christie's Paris in 2005 for €6,060,000, is a scroll made in the Imperial workshop to commemorate a banquet at the end of a military campaign under the Qianlong emperor. For a painting specialist it is a meticulously executed documentary rather devoid of artistic merit. However for a collector of Imperial art, an American financier in this case, its association with the court and its lavish style made it the perfect addition to his collection.

As the old Chinese proverb goes, 'When the tune is high, few can sing along'. Classical Chinese calligraphy and painting, specifically landscape painting, have traditionally been held in the highest regard by the cultured class. They encapsulate the essence of history, literature, philology and philosophy, difficult subjects themselves, to say the least. To truly appreciate classical Chinese calligraphy and painting takes time and patience, and their qualities are perhaps not so immediately apparent to many collectors. That is why, contrary to their high status amongst the myriad art forms produced in China, the market for these pieces is somewhat more limited than one might imagine. For example, in November 2006 the total for Christie's classical Chinese calligraphy and paintings sale was HK$44,002,000, dwarfed in comparison by the HK$540,753,199 achieved by the Chinese works of art sales in the same season, and the growth in this area has also been moderate compared to others.

The contemporary art market

Wu Guanzhong (b 1919) and Zao Wou-ki (Zhao Wuji, b 1921) are two living stalwarts on the modern art market. Both studied in Lin Fengmian's school and went to France around the same time; their paths diverged significantly afterwards. Zao stayed in France and continued

his career on the international art scene with much critical acclaim and success, while Wu returned to China where after a short teaching career he was sent to the countryside for re-education during the Cultural Revolution, and did not pick up his brushes again until 1977.

Zao's abstract oils emanate a dynamic energy by introducing elements of the traditional aesthetic into the mystical spaces of his canvasses. The inspiration for his abstract works was drawn from traditional Chinese landscapes, using graceful, almost calligraphic lines to create a poetic atmosphere. Wu's works, on the other hand, uses nature itself as a source of abstract beauty, the elements of which are hidden within the landscape to create a unique impression-istic style. Both their works are now selling for high prices on the market. Zao's *14. 12. 59* sold for HK$29,440,000 at Christie's Hong Kong in 2007, and a Wu landscape sold for close to RMB38 million in Hanhai in 2006.

Christie's inaugurated its first Asian contemporary art sale in Hong Kong in November 2005, and after two years, its total has grown from HK$35 million for the first sale to HK$275 million for the last offering in the spring of 2007. Sotheby's, on the other hand, has positioned its Asian contemporary art market in New York, with similarly successful results. Its recent 2007 spring sale achieved US$25,348,600. The market for Chinese contemporary art is truly international, and western buying accounts for at least 30 per cent of the current market. With this rapid expansion in such a short period, some people question the longevity and sustain-ability of the market. Nevertheless, it seems unstoppable.

Shanghai has just had its first international contemporary art fair, SH Contemporary, organized by ex-Art Basel director Lorenzo A Rudolph and the Swiss dealer Pierre Huber, with more than 100 exhibitors from all over the world. It is designed to put Shanghai on the map of the international contemporary art fair circuit. In Beijing the Ulenses, a Belgian couple who are one of the most important collectors of contemporary Chinese art, are selling their collection of JMW Turner (1775–1851) to fund the Ullens Centre, a gallery and exhi-bition space that they are planning to build to showcase contemporary art. It will open its doors in 798 Space in the Dashanzi district in northeast Beijing, a once-derelict industrial site now transformed into the cutting-edge hub of contemporary art.

It is true that many new-generation artists' works have only recently appeared on the international auction market, and it is difficult to predict within such a short period whether they can withstand the test of time. Sotheby's New York sold a painting by Leng Jun (b 1963), whose work has never before been offered at an auction outside China, for US$1,216,000 in March 2007. Many artists' works have also been increasing in value at an astonishing rate. Christie's spring sale was 95 per cent sold by lot, and indicates that the market is still very strong and has a fearsome appetite. Works from artists like Cai Guoqiang (b 1957), Yue Minjun (b 1962), Zhang Xiaogang (b 1958), and Zeng Fanzhi (b 1964) are setting new records every year. These artists were mostly born in the 1950s, and experienced China's transition from the command economy of the 1960s and 1970s to the reformed, quasi-capi-talist market economy of the modern day. They developed a keen interest in political subjects as well as a growing but critical curiosity about ideas from western cultures. In a unique envi-ronment where the traditional coexists with the avant-garde, these artists focused their attention on the 'China question'. It is in this environment that the contemporary Chinese artists developed their own inimitable flavour, reappraising their vast cultural heritage to create their own interpretation of the modern society and visual language.

For example, *Tiananmen Square* by Zhang Xiaogang sold at Christie's Hong Kong in 2007 for HK$18,040,000. Zhang is famous for his surrealist family portraits based on old photographs of the Cultural Revolution era. *Tiananmen Square* is painted in bluish grey with the infamous gate accentuated in yellow. The painting is devoid of human life, but with faint

lines of bright red at the foreground hinting at the 1989 massacre. Zhang's works are perhaps the most sought-after amongst Chinese living artists, and another painting, *Bloodline: three comrades*, fetched US$2,112,000 at Sotheby's New York this year. The prices for his works have doubled in the last three or four years.

Like Zhang, Yue Minjun is currently one of the most popular artists. His paintings and sculptures of trademark laughing faces repeated endlessly create a sense of eerie positivity that reflects modern society's desire to imitate idols, and a certain helplessness about the current social environment. His *Portrait of the artist and his friends* was sold for HK$20,480,000 in Christie's Hong Kong in 2007, setting a world record for his work.

Cai Guoqiang is perhaps the most well-known Chinese artist on the international contemporary art scene. His large-scale gunpowder projects in various locations such as museum entrances or the sites of landmarks have won him acclaim from all over the world, including a Golden Lion from the Venice Biennale. Christie's Hong Kong sold his *Drawing for man, eagle and eye in the sky: eagles watching man-kite* for HK$6,952,000 in 2005, setting a world record for his work.

Conclusion

With the coming of the Olympics, China is going through a period of frantic construction and PR offensive. 2008 is shaping up to be the year of China, and Chinese art will certainly be under the spotlight. Despite occasional warnings that the Chinese economy is overheating, and evidences of social disquiet among the people at the bottom of the social ladder, many people believe China's economy will keep performing miracles. In any case the Chinese art market has never been stronger. If the last 10 years is anything to go by, there are great prospects ahead. If the Chinese currency eventually becomes fully convertible and is revalued, and China opens its door to let in more foreign competition, it will have a major impact worldwide, and propel the domestic market on to the international centre stage.

For further information on the development of this particular art market, go to: www.koganpage.com/artmarkets.

Czech Republic

Nicole Stava and Ivana Kodlova

Profile of the Czech art market

There was at first great interest on the part of domestic collectors in works of Czech cubism, especially by the artist Emil Filla (1882–1953) (the price record on the Czech market is CZK7.3 million without auction surcharge, paid in 2000) and Bohumil Kubišta (1884–1918) (record CZK4.8 million from 2000). (€1 = approx CZK 29.) This demand continues but an increased level of interest is now appearing in Czech surrealism and imaginative art, such as works by Jindrich Štýrský (1899–1942) (record CZK8.6 million from 2006), Toyen (1902–1980) (record CZK3.15 million from 2002) and Josef Šíma (1891–1971) (record CZK6.7 million from 2004) and in classic abstract works by artists such as František Kupka (1871–1957) (record CZK 13.4 million from spring 2007). Of the painters influenced by cubism and expressionism, the greatest interest is in Josef Capek (1887–1945) (price record CZK9.3 million in 2006).

The limits of the financial possibilities of Czech collectors today are around CZK10 to 15 million. The clientele is relatively numerous and consists mainly of new Czech and Moravian businesspeople. Interest in the Czech market is also reflected by the world professional public. In 2006, for instance, the prestigious Pelican History of Art series published *Art, Design, and Architecture in Central Europe 1890–1920* by Elizabeth Clegg, in which the majority of Czech expressionist and cubist artists are represented.

Another stimulant for the Czech market was the auction in Paris of André Breton's estate in 2003 (by CalmelsCohen), which significantly helped the market evaluation of Czech artists. Toyen's (Breton's girlfriend's) 1943 painting *I wish you good health* was sold for €170,000 (CZK5.3 million), which is a new record for a painting by this important Czech surrealist painter. Success for Czech artists was also recorded by Sotheby's London, where paintings and drawings by Czech cubists from the collection of Milan Heidenreich were sold on 19 March 1997 for £500,000, and for example a Emil Filla made £56,500.

In general, interest is seen in works from the classic Czech avant-garde period and in classics of Czech modern art. Older works of art are sold to a lesser extent in the Czech Republic, partly because of the very strict Conservation Act, which practically crippled the market for works of religious art, to which special conditions apply for both export and

domestic sales. The ban on the export of sacred works also concerns copies from the 19th century and even applies to works that have a very low artistic value, where the iconography relates to Christianity. Through this measure, which has applied since 1994, the Czech Republic wants to restrict the theft of furnishings from churches in the regions. On the contrary, the restriction does not apply to works of modern art. In 2007 Sotheby's London sold *Torso of a walking woman* (1914) by the German avant-garde artist Wilhelm Lehmbruck, from the famous Tugendhat Villa of Mies van der Rohe in Brno. The export permit was approved by the Czech Ministry of Culture even though the villa is on the UNESCO World Heritage list.

Apart from domestic collectors in Prague, foreign clients also purchase works of art, and a relatively strong group is made up of Russians who buy classic works of Russian art from private collections in the Czech Republic (the records are for an Ivan Ivanovic Šiškin (CZK7.5 million in 2006) and Konstantin A Korovin (CZK4.75 million, 2005)). There is still a relatively low level of interest on the Czech market for classic Czech photography, such as work by Josef Sudek and František Drtikol, who are more successful on the global market than in Prague, and glass art: work from the Lötz glass works is known throughout the world and sells well. There is also less interest in contemporary studio glass (new glass), but the classics of this art such as Stanislav Libenský, René Roubícek and Václav Cigler sell well. The renown of these artists abroad is, however, greater than in the Czech Republic. In general it may be said that there is still not much interest in applied and decorative art in the Czech Republic among the richest collectors. The exceptions are curiosities, such as the furniture designed by Cubist architects. Very high-quality works in private Czech and Moravian collections are the works of the Viennese Jugendstil and modern art (these include quality series from the Wiener Werkstätten, whose founder Josef Hoffmann came from Moravia). In 2005 the Dorotheum auction house sold an armchair used by the Viennese architect Adolf Loos in the interior of the Müller Villa in Prague for CZK750,000.

The market for contemporary art in the Czech Republic

The market for contemporary art in the Czech Republic has just begun to become established over the past 15 years. Because it was not possible to build on tradition in this sector, contemporary art galleries came and went. The MXM Gallery was the most important in the early stages, established in 1990, but it closed down in 2002. Another important gallery that has shut down was the Behemot Gallery. It is true that the causes were different – MXM for example could not offer young artists a sufficient level of service and marketing to persuade them not to sell their work directly from their studios – but this reflected the fact that nobody in the Czech Republic knew how to operate a gallery. The first, and still the only truly professional, gallery is the Jirí Švestka Gallery, established in 1996. This gallery regularly participates in international trade fairs, for example in Basel, Cologne, Turin and New York, where it presents works predominantly by young Czech artists.

The best picture of the provinciality and continuing unrefined nature of the Czech contemporary art market is the Art Prague trade fair, held annually since 2000 in May in the Mánes Exhibition Hall in Prague. The variety and quality of the work on offer has however improved significantly in recent years. With the growth in interest by foreign collectors and galleries in young Czechs, more and more domestic collectors are beginning to take an interest in them. Another reason is the enormous growth in prices in a more or less closed market for classic modern art, which sometimes leads collectors to change their focus to contemporary art. The

number of good galleries which have a differing market strategy is on the increase and it really is just a question of time until the Czech market reaches the international level.

The current auction market in the Czech Republic

After the fall of the communist regime in autumn 1989, the art market in the Czech Republic was influenced in part by free enterprise, which relatively quickly created a wider range of fairly wealthy clients, and in part by the restitution laws, on the basis of which works of art from state collections that had been confiscated by the Nazis and/or the communists were returned to their original owners. Especially valuable collections came from the National Gallery in Prague and the Moravian Gallery in Brno. This especially concerned collections from the assets of Jindrich Waldes (classics of modern art) and Richard Morawetz (Old Masters). Some of the works were bought back by the state and some ended up on the open market, as did the large collection of paintings and drawings by František Kupka from the assets of the Waldes family.

Because relatively strict export laws apply in the Czech Republic, most of these works had to be sold in the country, which was one of the reasons for the establishment of around 10 auction houses in Prague (1.2 million inhabitants), which make a relatively good living even with a small domestic market (of 10 million). Auctions are held practically every weekend in Prague from February to June and from September to December, and the turnover fluctuates around the level of CZK10–20 million per auction. Auction activities in Prague are also handled by many classic galleries. International auction houses such as Christie's, Sotheby's and the Dorotheum are represented in the Czech Republic, exporting Czech and international art found in the Czech Republic to the global auction market.

2006 was an international record breaking year for the Czech art market. Collectors spent over CZK390 million on fine art and antiquities, which is a 40 per cent rise on 2005, which in turn showed a growth of only 4.5 per cent from 2004 (see Figure 10.1) (all statistics in this section from *Art and Antiques*).

Overall the number of art works sold did not really grow, but the average prices increased dramatically. In 2006 over 500 works were sold over the CZK100,000 level, which is 150 more than in 2005, and 44 paintings, one sculpture and one antique wardrobe made over

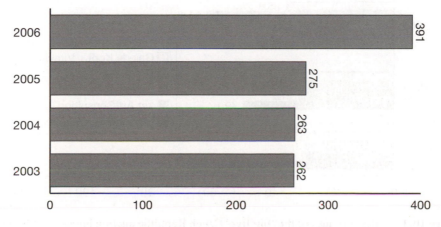

Figure 10.1 Sales revenues of all Czech auction houses (CZK million)

CZK1 million. In 2005 only 28 paintings made over CZK1 million. To express the growth in prices another way, in 2005 the top 10 lots made CZK41 million, and in 2006 they made CZK21 million more (see Figure 10.2).

Even though today there are about 15 auction houses and galleries which regularly hold auctions, there are only a few top runners, the so-called 'big five'. These are Gallerie Art Praha, the Dorotheum, 1st Art Consulting Brno-Praha, Galerie Kodl which holds auctions together with Galerie Vltavin, and Meissner & Neumann (see Figure 10.3). A newcomer that deserves mention is the Art CZ company, now called WozArt, which deals only with Czech contemporary art.

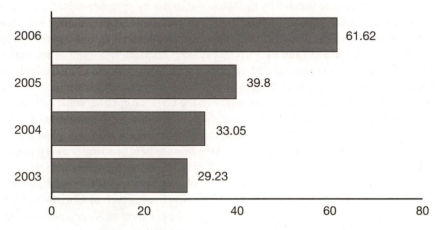

Figure 10.2 Sum needed to purchase the top 10 auction lots in the Czech Republic, 2003–06 (CZK million)

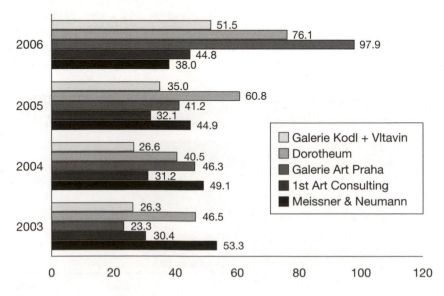

Figure 10.3 Sales revenues of the 'big five' Czech Republic auction houses, 2003–06 (CZK million)

Table 10.1 The most expensive pictures sold at auctions in the Czech Republic, 1990–2007

Rank	Painter	Title of work	Auction house	Price (CZK million)*	Year
1	František Kupka	Elevation IV Serie C II	Art Consulting Brno-Prague	22.1	2007
2	František Kupka	Abstract composition	Art Consulting Brno-Prague	13.4	2007
3	Jindrich Štyrský	Krajina v oblacich (Landscape in the clouds)	Galerie Kodl	10.25	2007
4	Josef Capek	Koupel (Foot bath)	Galerie Art Praha	9.3	2006
5	Jindrich Štryský	Cirkus Simonette (Circus Simonette)	Galerie Art Praha	8.6	2006
6	Ivan Ivanovic Šiškin	Pred zrcadlem (In front of the mirror)	Galerie Pictura	7.5	2006
7	Emil Filla	Zlaté rybicky (Goldfish by the window)	Galerie Kodl	7.3	2000
8	Antonín Procházka	Kopretiny (Daisies), 1922	Galerie Art Praha	7.1	2006
9	Josef Šíma	ML (Vejce, Rovnováha ci MZ) (Egg, balance or MZ)	Art Consulting Brno-Prague	6.7	2004
10	Josef Šíma	Portrét Zuzky Zgurisky (Portrait of Zuzka Zgurishka)	Pictura	5.85	2005

* Price reached in the hall (the buyer must also pay an auction charge which is calculated at various levels, most frequently from 15 to 20 percent).

Important addresses

Art Consulting Brno-Praha
Dum umení
Malinovského nám 2
Tel/fax +420 542 214 789
brno@acb.cz
www.acb.cz

Christie's Czech Republic
Nicole Marie Therese Stava
Zamek 1, 391 65 Bechyne
Tel +420 724 008980
nstava@christies.com
www.christies.com

Dorotheum spol sro
Ovocný trh 580/2
110 00 Prague 1
Tel: +420 224 216 699
klient.servis@dorotheum.cz
www.dorotheum.cz

Galerie Jiri Svestka
Biskupsky dvur 6
110 00 Prague 1
Tel +420 222 311 092
gallery@jirisvestka.com
www.jirisvestka.com

Galerie Kodl
Vitezna 11
150 00 Prague 5
Tel +420 251 512 728
galerie@galeriekodl.cz
www.galeriekodl.cz

Galerie Vltavin
Masarykovo nábreží 36
110 00 Praha 1
Tel +420 224 933 960
Fax +420 224 934 608

Meissner & Neumann
Ing Jan Neumann
jednatel spolecnosti
Jugoslavskych partyzanu 20
160 00 Prague 6
Tel/Fax +420 233 342 293, +420 233 343 194
info@aukce-neumann.cz
www.aukce-neumann.cz

Sotheby's Czech Republic
Filip Marco
Pod Homolkou 22
150 00 Prague 5
Tel +420 2 2423 7298
filip.marco@sothebys.com
www.sothebys.com

For further information on the development of this particular art market, go to:
www.koganpage.com/artmarkets.

Denmark and Iceland

Kira Sjöberg

Denmark constitutes a connecting link between the European mainland and Scandinavia, and has approximately 5.5 million inhabitants. Iceland has had a cultural influence mostly through Scandinavian, and specifically Danish and other European associations, but also through good connections to the United States. The geographical position of both countries has had a strong effect on not only the culture but also on the art produced. Denmark, whose art history has been influenced by many often maritime connections, still possesses its own distinctive style. As Denmark ruled over much of Scandinavia after the 9th century AD, a common Nordic culture developed. Iceland was largely isolated historically, but in the modern day it has had regular artistic influence due to its relationships especially with Denmark, but also elsewhere.

Denmark and Iceland are discussed together in this chapter because of these historic artistic links. During Iceland's time under Danish rule, artists often travelled to study in the country's academies and used Denmark as a foundation for their artistic learning and development. The aim of this chapter is hence to give an international bird's eye viewpoint on these two markets, their relationship to each other and the art market in general. It cannot go into depth, but is aimed more at those interested in beginning to collect Danish or Icelandic art.

The art market

Pricewise the market is interesting, as it is not quite yet inflationary, but both national as well as international collectors are starting to slowly recognize the monetary value in Danish art partly due to the increase of international visibility and sales. In 2006 Sotheby's sold a Vilhem Hammershøi (1864–1916) interior for £590,400 (approx. $1.2 million), against a pre-sale estimate of £200–300,000 (approx $400–600,000) setting the standard high (shareholder, 2007). Christie's also had two Hammershøis in its inaugural Nordic Art and Design sale the following October, and sold both of them close to the £300,000 ($600,000) mark, with one almost doubling its pre-sale estimate and both going to an American private buyer (Bødker, 2006). The 2007 sales continued this tradition, with the extremely successful Sotheby's sale which realized a total of £6.4 million ($12 million), a top result for a sale in this category ever at Sotheby's (artdaily, 2007; Sotheby's, 2007a, b). Christie's sale was not quite as successful

as it made a total £2.5 million ($5 million) with the top lot being a Hammershøi selling for £550,000 ($1.1 million) (Christie's, 2007a, b).

In the mid-1990s and towards the end of the decade the market for Scandinavian art along with Danish art started rising again, and the 19th-century Danish school, for instance, became popular again in the United Kingdom, after having been introduced in the 1980s and gone through the late 1980s inflation and early 1990s crash. The prices first started rising in the sales of the Kunsthallen and Bruun Rasmussen in Copenhagen, but had a turn upwards elsewhere as well (Moncrieff, 1996).

An example of modern Danish art is the CoBrA artist Asger Jorn's *Untitled* which sold for £366,400 ($740,000) to a Nordic gallery in 2006 (Bødker, 2006). Another artist represented in the Nordic sale 2006 and Scandinavian sale of 2007 was Per Kirkeby, whose work was sold for £54,000 ($108,000) in 2006 and £50,000 ($100,000) in 2007 when Sotheby's decided to incorporate postwar and contemporary art in its historically more traditional Scandinavian sale. This was perhaps after a market re-evaluation as a consequence of Christie's inaugural Nordic art and design sale.

Olafur Eliasson (b 1967) was represented in the 2006 Nordic art and design sale with the sixth edition of his famous glacier series, a set of 42 photographic images of the Icelandic landscape, which went to a private collector for £142,400, establishing a world auction record for the artist which is not a difficult task considering the lack of Icelandic artists on the international auction market in the past. There seems however to be a somewhat changing attitude on the international market to new markets due to possibly a change in collector profiles, which in this case is showing in for instance two pieces by the Icelandic Svavar Gudnason which both doubled their pre-sale estimates in the Nordic art and design sale of 2007, selling for £32,000 ($64,000) and £55,000 ($110,000). The Danish/Norwegian artist pair Elmgren & Dragset is yet another example of contemporary Nordic artists reaching the auction market. On the modern side, Franciska Clausen (1899–1986) was represented in the 2006 Christie's sale with a work called *Contrastes des formes*, painted in 1927, when she lived with Léger in Paris. The piece had a high pre-sale estimate at £250–350,000 for an internationally relatively unknown artist, and remained unsold (Christie's, 2006, pp 50–52).

Fine art is however not the only strength on the Danish market. There are several designers who are highly appreciated by the international design community and whose work has a monetary value which derives partly from this stamp of world fame. Danish designer and architect Verner Panton (1926–1998) is often represented in the marketplace, and two of his chairs, the prototype free swinger chair and the s-chair, were both up for sale in the 2007 Nordic sale hosted by Christie's, with pre-sale estimates of £7–9,000 and £5–7,000 respectively, with the s-chair doubling its pre-sale estimate to make £13,000 ($26,000). As Brook Mason writes, 'Panton is now on a roll, with his futuristic furniture and lighting designs from the 1960s and 1970s scoring record prices both in auction houses and galleries' (2005, pp 64, 66–7).

Another example is Arne Jacobsen (1902–1971), again an architect and designer whose perhaps best-known pieces – which also have the highest market value of his work – are three types of chair: the Ant, the Egg and the Swan. These became some of the most distinctive shapes of the 20th century. Cara Greenberg wrote:

Many of his mid-century designs have been in continuous production, and others have been reintroduced periodically. This has tended to hold prices down for vintage pieces, while new models generally cost more. Serious collectors can still get bargains on vintage Jacobsen, which usually fetches prices in the middle to high four figures.

(Greenberg, 2002)

This has changed in the last four to five years, and the development of prices for the Egg chair, for instance, has been evident. In the Nordic sale of 2006 a leather Egg chair made £30,000, five times more than its presale estimate. In the Nordic sale of 2007 a pair of black leather chairs made £25,000 ($50,000). In Denmark these chairs are more readily available, and prices there do not always reach the same levels. It must however be remembered that these chairs sold by Christie's have clearly had a distinctive historical provenance, which arguably has affected the rise in price, together with the popularity of the pieces as collectors' items.

In addition to furniture, silver designs by Georg Jensen (1866–1935) have been enthused over by collectors and art market specialists for the past century. Founded on arts and crafts principles which sought to make handcrafted works available to the general public, Jensen had a Copenhagen workshop in which the production of jewellery and domestic wares for a middle-class clientele was the focus. Jensen and the painter/designer Johan Rohde collaborated and developed the hallmarks that have since defined Jensen silver. The company's reputation has never faded, and its silverwares and jewellery from all periods are highly collectable (Greenberg, 2004).

Historical patronage

Patrons as well as artists remained largely anonymous from the introduction of Christianity until the Reformation (1536). After the Reformation there was an increase in individual commissions, with artists being attracted to the court. Melchior Lorck (c1527–1583) was a court painter (1580–83) to Frederick II, and was under royal patronage to travel for four years. Frederick's successor, Christian IV, asserted his position through the visual arts by encouraging depictions of Classical mythology and an image of Denmark as a strong Christian nation (Harboe, 2007).

The Rosenkrantz family who had lived near Aarhus since at least the 16th century were famous patrons and collectors. Many private individuals who were prominent in the Renaissance and Baroque periods were patrons of arts as well. National artists were often preferred, and in general the works are anonymous and only a few names are known. Nonetheless there is one place, the small provincial town of Ribe, a centre for trade with northern Germany and the Netherlands, where artistic production and patronage is well documented. Six painters were active in Ribe before the 1660s, including a Dutch emigrant, Jakob Adriansz van Meulengracht (d 1664). The paintings on the cathedral's altarpiece (1597) are attributed to Lauritz Andersen Riber (d 1637), who also worked in Tønder, Kolding, Randers and Århus. Of the royal family in the 18th century, both Christian VI and Frederick V showed an active interest in the arts:

> Through the court and the power of the monarchy new French trends reached the country, and although there were a number of Danish court artists such as Lambert van Haven, the majority were foreigners, engaged by royalty and the nobility. The traders in for instance tea the Asiatisk Kompagni (Danish East India Company) sponsored one of Danish art's most expensive projects, the statue of Frederick V (completed 1771; Copenhagen, Amalienborg) by the French sculptor Jacques-François-Joseph Saly. In 1754 Frederick V ... founded the Kongelige Danske Kunstakademi (Royal Danish Academy of Fine Arts), Copenhagen.

> (Harboe, 2007)

At the beginning of the 19th century art came to be oriented to private buyers, probably due to a shift in the economy and source of wealth, because of industrialization. In 1825 the Kunstforening (Art Society) was founded to buy and exhibit art. It supported the Eckersberg School (Harboe, 2007). The most significant single patron in the late 19th century was the brewer Carl Jacobsen, who was a major sponsor of art and architectural projects to make art more accessible to a larger public (Harboe, 2007). As Harboe writes, 'From 1910 the Ny Carlsbergfond, also established by Jacobsen, became the major private patron in Danish art' (2007). Other contemporary collectors and patrons included Heinrich Hirschsprung, who was the most prominent sponsor of the artist Peder Krøyer's travels to Italy, and Mads Rasmussen in Fåborg, who started a collection of contemporary works by artists in Fyn. His collection now forms a museum. Carl Jacobsen's example of patronage was continued by Knud W Jensen, who is famous for involving architects with artists in his Louisiana Museum of Art in Humleb'k (founded 1958). One major development in this area came in approximately 1964 when the state again became a significant patron through the Statens Kunstfond (the State Art Fund), which is responsible for large public art schemes, gives grants to artists and provides financial and other aid to museums and galleries (Harboe, 2007). A large number of art societies also represent a form of decentralized patronage in Danish art.

Foreign patronage is of course also common, particularly among those with local links through emigration and an interest in family history and ancestral culture. The United States has a vast number of citizens with Scandinavian roots, and the most notable known private collection is Ambassador John L Loeb Jr's (Loeb, 2005). In the United Kingdom the National Art Collections Fund (now renamed the Art Fund) supports galleries and museums to purchase art works, and has for instance assisted the Pier Arts Centre in Stromness, Orkney, to acquire a work by Olafur Eliasson called *The colour spectrum series*. An *Interior* by Vilhelm Hammershøi from 1899 was presented to the Tate in 1926 as a gift in memory of Leonard Borwick by his friends through the Art Fund. The piece is currently on a long-term loan to the National Gallery in London (Art Fund, 2007).

The businessman Vilhelm Hansen (1868–1936) had a major collection of French impressionist paintings and older Danish art which he donated to the state in 1952, forming the Ordrupgaardsamlingen in Charlottenlund. Another collector, Lars Ulrich from the band Metallica, was much discussed in the media where some estimates of the value of his collection reached DKK110 million ($20 million) in 2002; he later sold his pieces on the London market and had artists such as Asger Jorn in his collection (Bødker, 2002).

On the corporate collection side, the Danske Bank (Danish Bank) has an art society which was founded as a membership organisation and holds one of the larger collections in Denmark (Danske Bank, 2007). In addition Nordea Bank buys art locally in the countries it is located in (according to the Merita Art Foundation). There are several other societies within the country, but public information on corporate collections is hard to come by.

Auctions and galleries

Auctions are a popular form of selling and buying in Denmark, but not as much in Iceland. Among the centres are Copenhagen, Aarhus and Veijle in Denmark, and Reykjavik in Iceland. In Denmark Bruun Rasmussen (one of the top 10 auction houses on a global level, with representation in for example Sweden) is the major actor in the marketplace. Established in 1948 in Copenhagen, it has been holding auctions for nearly 60 years, and values art for businesses, private collectors and public authorities as well as individuals. Other famous

auction houses are Høiland Auktioner and Auktionshuset (both competitors to Bruun Rasmussen but ones that specialize more in collectibles) (www.auktionshuset.com; www.thauctions.com). There is an interesting online auction called Kunst Auktion Online which concentrates on modern art with a website however in Danish only for now. (http://kunstauktiononline.dk/). In Iceland Art Gallery Fold, a contemporary art site with three spaces holding several exhibitions a year, has held auctions four times yearly since at least 1999, selling mostly Icelandic art (www.absolutearts.com).

The market is currently very upward trending, not quite inflationary as in the late 1980s, but it has been steadily growing since the mid to late 1990s as has been the case with other Nordic countries. There are several auctions yearly, mostly during the autumn and spring seasons. As in Sweden, the Danish auction calendar is busy as auctions are a common way of selling both highly valuable art and items of lesser value. The international auction houses, Sotheby's and Christie's, show activity on these markets with their local representation.

Galleries in Denmark

Many Danish non-commercial art galleries were established by popular initiative through art associations, museum associations or local authorities, so there are both private and governmental galleries. Examples are the Kunstmuseum in Århus (founded 1854), Randers Kunstmuseum (1887), Nordjyllands Kunstmuseum (1877), Ålborg and Fyns Kunstmuseum (1885), and Odense, which are among the older provincial museums. The art galleries in Herning, Holstebro, Silkeborg, Esbjerg, Tønder, Kolding (Trapholt) and Sorø, among other towns, contain varied collections of mostly modern Danish art, although several galleries also have international collections (including Århus, Randers, Ålborg, Herning and Silkeborg). Two art galleries with particular local affinities are Skagens Museum (founded 1908), with works by the artists who settled there from the 1870s, and the Museum for Fynsk Malerkunst (founded 1910) in Fåborg, dedicated to the Fyn painters from the end of the 19th and start of the 20th century (www.kunstonline.dk).

Modern commercial galleries are easily found on the link on kunstonline, a Danish information site, as all the major ones located in Denmark are there. There is an estimated 200 galleries in the country out of which approximately 20 are very active nationally and internationally. Some of them include Copenhagen Art Gallery, representing Danish and other European contemporary artists, Galerie Mikael Andersen which also hosts a range of Danish and international contemporary art, Galleri Nicolai Wallner, Galleri Faurschou, Kunsthallen Nikolaj, Galleria Signe Vad and Peter Lav Photo Gallery. All are located in Copenhagen (www.kunstonline.dk). In London a gallery called Nordic Artworks represents an increasing amount of contemporary Nordic artists and is also interested in developing its artist portfolio further (www.nordicartworks.com).

Galleries in Iceland

The art gallery and market scene in Iceland has not been very active, and artists have tended to market their own works (Proppe, nd). CIA is a very informative site on contemporary movements in Icelandic art, with exhibition calendars and other useful information. Gallerí Hlemmur is a not-for-profit artist-run space which opened in 1999 and exhibits emerging Icelandic contemporary artists. Galleri 18, founded in 1995, again promotes works by

emerging artists. Others are Gallerí Skuggi, Galleri Saevars Karls, Gerðuberg Cultural Center, the Graphic Society Art Galleri, 101 Gallery, Kling & Bang Gallerí and 02 Gallery. Icelandic artists have a trade union (www.sim.is) to support their rights, and it seems very much that the market is held by the artists.

The Nordic House in Reykjavík opened in 1968 as a Nordic cultural centre. Its main goal is to serve as a link between Iceland and the other Nordic countries. Numerous exhibitions of Nordic art are held in the gallery yearly.

Art awards

There are two Nordic-wide art awards, the Carnegie Art Award and Ars Fennica (see also Chapter 36, p 303). The Carnegie is a biennial prize founded in 1998 to support upcoming artists in the Nordic countries. It is one of the largest art prizes in the world, presenting awards of SEK1 million, 600,000 and 400,000 ($145,000, 87,000 and 58,000 as of April 2007) to three participating artists, and a scholarship of SEK100,000 (US$14,500) to a young artist. In 2006 115 candidates were nominated and the jury short-listed 21 to take part in the contestant exhibition prior to announcing the winners. The first, second and third prizes were won respectively by Karin Mamma Andersson from Sweden, Eggert Pétursson from Iceland and Petra Lindholm from Finland; the scholarship went to the Swedish Sirous Namazi. These awards not only allow the winners to invest time in their work, they also bring media attention and can lead to higher prices for work.

The 2008 award drew 143 nominations, with 26 shortlisted artists. The Danish and Icelandic shortlistees were Thordis Aðalsteinsdó ttir (IS), Anette H Flensburg (DEN), Ellen Hyllemose (DEN), Jesper Just (DEN), Ferdinand Ahm Krag (DEN), John Kørner (DEN), Fie Norsker (DEN), Allan Otte (DEN), Kirstine Roepstorff (DEN) and Thór Vigfússon (IS). The first, second and third prizes were won respectively by the Swedish artist Torsten Andersson, the Danish Jesper Just and the Danish John Kørner. All the three artists participated in an extensive touring exhibition around the Nordic countries in late 2007 and 2008 (www.carnegieaward.com).

The Finland-based foundation Ars Fennica award is given yearly to one artist from the Nordic or Baltic region. The selection committee varies yearly and the final selection is made by an international expert – in 2007 Glenn Scott Wright from Victoria Miro, a London based gallery, acted as the visiting specialist. The prize is currently €34,000 (approx $45,000) and the winning artist has an exhibition as well as a catalogue produced. Icelanders Hrein Friðfinnson (b 1943) and Georg Gudni (b 1961) and Danish Tal R have been nominated for the award in the past (www.arsfennica.fi). Tal R to give an example on price development has been estimated to have increased close to 1,400 per cent in the past four to five years (www.finin.dk). The 2007 winner was the Finnish-born Markus Kåhre. There are of course several festivals of arts and smaller local fairs and awards (see contact information below).

Taxation

Culture in Denmark is taxed on broadly the same basis as other sectors, but the government has agreed special schemes to support Danes working in the cultural sector, as it often involves somewhat random income. Artists with a maximum income of DKK539,000 ($98,000) per year can choose to 'store' the amount for up to approximately 10 years, to be

taxed at a later stage. This does not apply to performing artists (Act no 1062 of 17 December 2002). Prizes from competitions with an external selection/nominations committee are tax exempt. A 2004 Act (no 1389) lets companies invest in art and culture without sponsoring restrictions. This means in practical terms that when a company buys an art work, up to 25 per cent of its price can be deducted for tax benefits. Foundations have similar regulations. This act has benefited the cultural life enormously with an increase in for instance corporate collecting together with the state established system which allows working galleries help in transportation costs of up to 40 per cent to aid participation in important fairs. The Danish rate of VAT on cultural services and goods is 25 per cent (www.culturalpolicies.net).

Conclusion

Denmark and Iceland have perhaps the most developed and active markets in Scandinavia in terms of international reach. On the contemporary side Eliasson definitely leads the sales figures, and earlier artists such as Jorn, Kjarval and Hammershøi are well known nationally and increasingly known internationally.

Contemporary arts from Iceland especially have fast made their way on to the world map of art history. Mark Poltimore, chairman of Sotheby's, suggests that art will become increasingly popular on the international market (interview, 2007). The market is active and busy and will perhaps continue to grow alongside the general economy.

Arguably the relatively low prices for Danish and Icelandic contemporary art means it is not a particularly risky longer term investment even if the international and national market would deflate somewhat. With the possible exception of Eliasson, who according to ArtTactic's market confidence report ranked fifth in the May 2007 rating of the top 10 contemporary artists on the market. Of course, the aesthetic and conceptual factors of the art from these countries also needs to be taken into account, particularly if buying art for artistic value is among a collector's main interests.

For further information on the development of this particular art market, go to: www.koganpage.com/artmarkets.

Bibliography and contact information

Bibliography

Abilgaard, H (2007) Danish art: after 1840, Grove Art Online [online] www.groveart.com (accessed 12 May 2007)

Art & Antiques (2005) Great Dane, *Art & Antiques*, **28**(10) (October), pp 64, 66–7

Bødker, K (2002) Pæne London-priser for Jorn, *Børsen*, 1 May

Bødker, K (2006) Dansk Kunst topper i London, *Børsen*, 2 November

Bøggild Johannsen, B (2007) Danish art: before c. 1540, Grove Art Online [online] www.groveart.com (accessed 12 May 2007)

Christie's (2006) Catalogue for Nordic Art and Design sale, 31 October

Christie's (2007a) Catalogue for Nordic Art and Design sale, 26 June

Christie's (2007b) Press release, Nordic Art and Design, 26 June [online] www.christies.com (accessed 12 May 2007)

Copenhagen Post (2000) Developing the business of culture, 22 November

Glancey, J (2006) Tate Modern 2: the epic sequel, 26 July [online] http://arts.guardian.co.uk/news/story/0,,1830048,00.html

Greenberg, C (2002) Arne Jacobsen: making a mark and a market, *Art & Auction*, **24**(6) (June), pp 128–37

Greenberg, C (2004) Mark of distinction, *Art & Auction*, **26**(10) (April), pp 84–89

Harboe, J (2007) Danish art: patronage, Grove Art Online [online] www.groveart.com (accessed 12 May 2007)

In-depth Arts News (1999) Icelandic art auction, 19 September

Kofod-Hansen, E (2007) Danish art: before c. 1540, Grove Art Online [online] www.groveart.com (accessed 12 May 2007)

Kusk, G (2007) Danish art: an introduction, Grove Art Online [online] www.groveart.com (accessed 12 May 2007)

Loeb Jr, J L (2005) *The Danish Art Collection*, New York

Moncrieff, E (1996) Danish schools are rising again, *Art Newspaper* 7 (October), p 40

Proppe, J (nd) A market to match the art, *Icelandic Art News*

Skerritt J (2006) Icelandic heritage comes alive in duo's artistry, *Winnipeg Free Press*, 15 February

Sotheby's (2007a) Catalogue for the Scandinavian sale, 27 June 2007

Sotheby's (2007b) Auction results for the Scandinavian sale, 27 June 2007, London [online] www.sothebys.com

Statens Museum for Kunst (1993) *Leger og Norden*, exhibition catalogue, Statens Museum for Kunst, Copenhagen, 22 April–20 June 1993

Tate Modern (2003) The Unilever Series: Olafur Eliasson, press release, 1 July

Interviews

Sophie Hawkins, head of Nordic Art and Design sale, Christie's, 15 January 2006
Jonathan Horwich, UK chairman, Christie's, 15 August 2006
Alexandra McMorrow, Head of 19th Century European Art, Christie's, 6th December 2006
Lord Poltimore, Sotheby's chairman, UK & Scandinavia, 19 February 2007

Websites

http://artguide.dk/
http://en.wikipedia.org/wiki/Artists_of_Iceland
http://jenssoendergaard.dk/welcome.htm
http://www.absolutearts.com
http://www.art.is/
http://artguide.dk/
http://www.artdaily.org/section/lastweek/index.asp?int_sec=11&int_new=20776&int_modo=2
http://www.artsmia.org/mirror-of-nature/the-artists.cfm?lng=0&artist=philipsen
http://artnews.is/issue008/index.htm
http://foreninger.danskebank.dk/kunstforside (accessed 10 July 2007)
http://www.arsfennica.fi/ (accessed 13 April 2007)
21http://www.artnews.is/issue012/012_venhist.htm
http://www.artnode.org/index_frame.html.
http://www.auktionshuset.com (accessed 1 April 2007)
http://www.bruun-rasmussen.dk/vfs/articles/1.1/about/index.html (accessed 1 April 2007)
http://www.carnegieartaward.com (accessed 12 April 2007)
http://www.cia.is/info/1.html
http://www.culturalpolicies.net/web/denmark.php?aid=515
http://www.danisharts.info/ (Danish Arts Agency)
http://www.galleriskuggi.is http://www.gerduberg.is (English site http://www.gerduberg.is/displayer.asp?cat_id=21)

http://www.guldalder.dk/show.asp?id=219
http://www.hlemmur.is
http://icelandreview.com/icelandreview/search/news/Default.asp?ew_0_a_id=277693
http://www.i8.is
http://www.jvs.is/02gallery.htm
http://www.kunstdk.dk/uk/uk_index.html
http://www.kunsthallennikolaj.dk/en/
http://www.kunstonline.dk/diverse/gallerier/ (accessed 19 May 2007)
http://www.kunstonline.dk/diverse/museer/ (accessed 19 May 2007)
http://www.kunstonline.dk/diverse/sammenslutninger/
http://www.listasafn.is/?expand=0–116&i=116&root=1
http://www.museums.dk/denmark.html
http://www.nordicartworks.com (accessed 10 May 2007)
http://www.nordice.is
http://www.randburg.com/is/fold/
www.saevarkarl.is
http://www.shareholder.com/bid/downloads/news/20060613–200404.pdf
http://www.sim.is/Index/English/SIM/ (accessed 20 May 2007)
http://www.tate.org.uk/about/pressoffice/pressreleases/olafureliasson_07–03.htm
http://www.thauctions.com/Default.aspx (accessed 1 August 2007)
http://this.is/klingogbang/
http://uk.brandts.dk/wm139951
http://www.um.dk/Publikationer/UM/English/Denmark/kap4/4–2.asp#4–2-4

Finland

Pauliina Laitinen-Laiho

Finnish art markets today

Nowadays the culture of collecting art has a low profile in Finland, but not as low as in the 1990s. However investing in art and record prices are again very favourable subjects for the media and among investors. Collectors, at least the owners of older art, rarely give interviews. Many of them are scared of thieves and envious people. This means that collectors do not affect the values of art works. Instead of the collectors the curators, critics and gallery owners are the real valuers. In Finland contemporary art is what people are increasingly interested in, and it sells. Art investors have noticed that high quality and reasonable prices are good alternatives for making investments in arts.

Finnish art markets are very western-like in levels of development and effectiveness, as in other EU countries. Art markets are concentrated in Helsinki. The most important galleries are located in Helsinki, but some good ones also exist in southern Finland in Tampere, and in Turku and Oulu, which is the most northerly big city before Lapland.

The art market can be divided approximately into three sections: galleries, art dealers and auctions. There are two kinds of galleries in the Finnish art market: the financially supported ones owned by art unions and privately owned commercial galleries. Both galleries work in very similar ways and the gallery system is very hierarchical. The best commercial galleries work as gatekeepers for quality art for the art world, media and collectors. These are galleries such as Galerie Anhava, Galerie Forsblom, Galleria Krista Mikkola, Galleria Heino and Galleria Uusitalo. These galleries try to get a lot of respect for themselves and their artists. If an artist is talented, they need an exhibition in Helsinki. There are also a few commercial galleries in Helsinki, like Galerie Anhava and Galerie Forsblom, that have good international contacts and represent their artists at the foreign art fairs in Basel, Berlin and Frankfurt.

In Finland there are two big auction houses: Bukowski and Hagelstam, which were both established in the late 1970s. In the 1980s there were more auctions, but the economic downturn of the 1990s caused their major competitors to shut down. Bukowski and Hagelstam have retained their reputation as the places where the most interesting art is on sale. The openings of auction exhibitions also act as society parties. Auction specialists and

managers are influential people in the Finnish art market. The duopoly between these auction houses is similar to the competition between Sotheby's and Christie's, but milder. It is quite common in Finland for people to do the buying and selling in auctions themselves and they mostly do not use much art consultants, even though this is getting more common all the time.

There are two kinds of art dealers in Finland, dealers with a fixed shop and dealers without a fixed place. If the dealer has a good reputation (for example in dealing with forgeries) he or she usually has good collector clients. Many dealers buy and sell antiques or artworks, the estates of deceased persons. The best works they usually sell through big auctions because auction houses get a lot of interest from the media.

The prices of artworks

Art dealers often use auctioned prices as an example for pricing. Sales of auctions show what is hot and what is not. Some recent research in contemporary art (by this author, as yet unpublished) has shown that when Finland joined the euro the prices got higher. When young artists sell their artworks in galleries, their gender does not matter in pricing, except that young female artists tend to raise their prices more for larger works. For established older artists the difference grows; in other words established artists raise their price more for larger works than do young artists. Older male artists are the only ones who clearly ask for higher prices from large works: for example if an older established male artist sells privately a painting measuring 210×160 cm, he is likely to ask double the price that an established female artist would ask. Also female artists' work is more expensive in galleries at the beginning of their career, but when artists are established, works by male artists cost more. One reason might be the old myth in art markets that male painters make the most expensive art. However this is changing in Finland – and Helene Schjerfbeck's art is the most expensive in the country. In the 1980s the value of both old and contemporary female artists grew a lot, and prices got much higher. The same value judgement is still on. Usually when a young artist gets into the commercial gallery system their prices immediately double.

Investing in art through Finnish auctions

Statistics show that the art markets of Finland show economic fluctuations lasting about seven years. This means that artists whose work has recently achieved price records can perhaps not be expected to break those records until the beginning of 2010. The economic fluctuations in art markets are unique in a way, because the logic is so complicated: it seems to involve a mixture of feelings, cultural tradition and status (compared for example with stock markets). Arguably these economic fluctuations of art markets are good for art investors, because they offer the possibility of better profits. The years before an economic upturn are very important for making investments in visual arts. Artists with a good reputation among collectors and media tend to achieve record prices during economic booms. However this does not mean that art is always a good investment. In the economic downturn the correction to the prices is also strong, and only the best-quality art works maintain their value.

The fluctuations are a tough test for art investments, and the more fluctuations objects have gone through, the better investment they are likely to prove. This is true of Finnish painters such as Helene Schjerfbeck (1862–1946), Eero Järnefelt (1863–1937), Albert

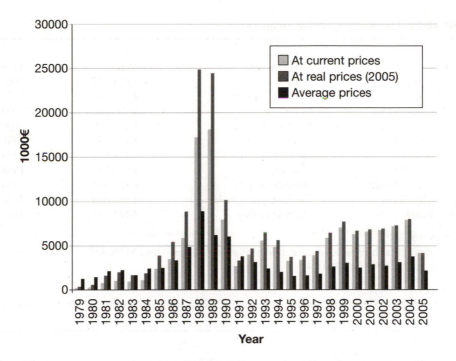

Figure 12.1 Investing in art in Finland (Finnish auctioned art)
Source: *Taidepörssi*

Edelfelt (1854–1905), Akseli Gallen-Kallela (1865–1931) and Elin Danielson-Gambogi (1861–1919). The value of these artists' work is well proven, and the price level of even their less good paintings has remained stable. Their paintings tend to be worth €50,000–500,000.

All the most expensive Finnish paintings date from the Golden era of the late 19th and early 20th century. For example if a modern good-quality painting from a famous artist costs €2,000, the same kind of contemporary painting is likely to cost €5,000 and a Golden era painting €400,000. The most beloved subjects are very patriotic ones, like forests, cultivated grounds, agriculture and workers in the countryside, or the works show characters of a Finnish nature or mentality. All the naturalist paintings by Helene Schjerfbeck show a female posing, which was a typical subject for this artist. All paintings by Albert Edelfelt are in a national romantic mode: they are regarded as the best of Finnish history paintings.

Ferdinand von Wright's bird painting *Metso soitimella* is probably the most famous painting in Finland. Sheds are famous subjects in Finland, for artists Eero Nelimarkka (1891–1977), Onni Oja (1909–2004) and Juhani Palmu (b 1944). Interior views of country houses like Veikko Vionoja are loved in Finland, and so are subjects such as the forest in winter or summer. For example *The snow junipers* by Pekka Halonen (1865–1933) (a winter forest view) was auctioned at Bukowski in 2001 for €41,200.

In 2005 and 2006 Finnish art markets and especially auctions were quite passive and waiting, and there were not record prices for Finnish art. Analysts warned people who invested to be careful because of the anticipated economic downturn. Recently people have had more money to spend – for example a lot of bank loans have been taken out to buy apartments. The art markets have also become more active, and especially new artists and cheaper

Table 12.1 The most expensive Finnish art

Classical art:

Artist	Title of work	Price	Year
Helene Schjerfbeck	*My mother*	€874,577	2001
Albert Edelfelt	*The boys at play*	€500,000	2007
Helene Schjerfbeck	*Hjördis*	€500,000	2002
Helene Schjerfbeck	*The Brogan string*	€437,289	2000
Albert Edelfelt	*Needlewomen*	€437,289	1999
Albert Edelfelt	*The strawberries*	€428,879	1998
Helene Schjerfbeck	*Mourning*	€370,013	1988
Ferdinand von Wright	*Metso Soitimella*	€319,557	1988
Helene Schjerfbeck	*The beauty of Tammisaari*	€310,000	2002
Albert Edelfelt	*The boys at play*	€302,738	1988

Contemporary art:
Juhani Linnovaara (b 1934) *Kathedral*, sold in 1989 at Bukowski for FM390,000 (€65,600) and *Monarch*, sold in 1999 for €20,000.

Sculpture:
Walter Runeberg (1838–1920), *Bacchus and Amor* (1870), marble. Auctioned in 1996 by Hagelstam for €85,000.

good-quality art were interesting the paying audience more and more towards the end of 2006. The prices of some very interesting new artists have rocketed.

The effect of an artist's death on prices was shown in 2006 for work by the talented painter Ilkka Lammi (1976–2000) who died very young. Just before Lammi died he won the important prize of Young Artist of the Year in Salmela. In spring 2000 paintings by Lammi cost €500; by the autumn they cost €10,000. All his paintings soon vanished from the art markets, bought by private collectors and art dealers. In May 2006 Bukowski auctioned his *A woman from Paris* for €77,000. Two other paintings made double their estimated prices. It is expected that the prices of Lammi's paintings will continue their dynamic development, and in spring 2007 the price level in auctions seemed established at around €40,000.

In Finland there has been a lot of Russian art, and the 21st-century Russian art boom has also affected Finnish sales. Many Russian dealers bought old Russian art from Finnish auctions: for example Petr Vereshagin's work was auctioned for €580,000 and Ivan Aivazovski's for €500,000. At the end of the 1980s Sotheby's and Christie's began to hold auctions dedicated to Scandinavian art. When the economic downturn came Christie's stopped the auctions, but continued to auction Finnish art in separate auctions. Sotheby's started to hold Scandinavian auctions once a year. Since June 1999 Sotheby's has auctioned Nordic art worth a total of £18 million. In October 2006 Christie's resumed auctions of Nordic art and offered a great deal of Finnish art and design. Now the specialists in Christie's have noticed that international interest has focused more on Scandinavian art and design.

At the moment it seems that art is a growing investment area in Finland. Buying and selling habits are also good. In Finland art buyers are private people, companies and funds. There is probably the highest proportion of museums per inhabitant in Finland of any country, so there are a lot of museums where art can be found. Museums are either private or owned by a state or town. Art can also be found in many galleries and art boutiques. Buying and selling art online is very rare.

In Finland there are many art schools at different levels. The most famous are the Academy of Fine Arts and University of Art and Design in Helsinki, Lahti University of Applied Sciences Institute of Design, Satakunta University of Applied Sciences and the Faculty of Fine Arts in Kankaanpää. These days there are a lot of young artists graduating, and public opinion has been that maybe too many people are training as artists. Artists' earnings tend to be less than the medium salary. Still at the same time the quality of Finnish contemporary art is higher than ever since the Golden era, thanks to education and internationalization.

In contemporary art it is appreciated in Finland that artists should get scholarships from the state or other recognition. It is also important that artists belong to artist unions, and exhibit regularly, both at home and abroad. The Young Artist of the Year is one of the most important prizes in Finland, as is the Carnegie prize. The Finnish Cultural Foundation is one of the most significant scholarship funds in Finland. The main Finnish media that cover art include the art magazine *Taide*, the main newspaper *Helsingin Sanomat*, national television channels and the women's magazine *Gloria*. The only important source of auctioned art and prices is *Taidepörssi*, which has been issued since 1979, but unfortunately the last edition was in 2003.

Finnish contemporary art is nowadays highly ranked in international exhibitions of avant-garde art, for example installations, video art and photography. Sculpture is also rising in favour these days. Finnish contemporary paintings above all are of very high quality, although one weakness in the contemporary art market until now has been its failure to differentiate the very best painters and create brands for them.

Many Finnish art investors have said that investing in art gives a return of one to ten. One is buying costs and the rest are profits. Finnish art markets are developing all the time, but slowly. Efficient foreign investors have the opportunity to make good investments in Finnish art works. Usually foreign investors notice good investments first and the locals realize it too late, or they do not appreciate the art before somebody else does.

In Finland there are no art funds that are known in international art markets. One reason is legislation. In Finland it is possible to bargain with art dealers more than for example in Great Britain, because in Finland sales are not so efficient and the market is not based on quick selling. The season also affects the availability of art to buy or sell and its location.

According to the Finnish tax laws, sales profit from the art works is taxable income. It is the taxpayers' duty to report this income, but since there are no control systems the only check on reporting is random inspections by tax authorities. In 2003 contemporary art became subject to VAT, with the rate of 8 per cent if the artist sells the work directly. Art works sold by galleries are subject to 22 per cent VAT. In Finland art collectors cannot offset art donations against their tax liabilities.

Some Finnish artists and art categories

Sculptors

Kain Tapper (1930–2004), Eila Hiltunen (1922–2003), Laila Pullinen (b 1933).

Contemporary art

Samuli Heimonen, Leena Luostarinen (b 1949), Marjatta Tapiola (b 1951), Nanna Susi (b 1967), Pasi Tammi (b 1971), Rafael Wardi (b 1928), Juhani Linnovaara (b 1934), Mari Sunna (b 1972) and Nina Roos (b 1956). Cheap in auctions.

Contemporary photography

This is internationally much appreciated, especially artists Eija-Liisa Ahtila (b 1959), Ola Kolehmainen (b 1964) and Esko Männikkö (b 1959).

Design

Finnish design is valuable and prices have risen in recent years.

Finnish old art

In monthly auctions there can be found cheap works on paper from the most appreciated artists, for example aquarelles and graphics.

Prints

Esko Railo (b 1961), Outi Heiskanen (b 1937) and Inari Krohn (b 1945). The prices are very low and there is no big difference in prices whether the prints are made by established or young artists.

Foreign prints

Foreign prints are auctioned in Finland very cheaply, even under €2,000. Prints by Pablo Picasso might rise as high as €6,000. A Serge Poliakoff print from 1972 was auctioned at Bukowski for €1,900. Prints from Marc Chagall cost about €12,000 in a gallery. Finnish people are interested especially in prints by Joan Miro, Andy Warhol, Vassili Kandinsky, Tapies and Léger. Their prints sell in Finland for about €5–10,000.

Icons

Icons do not interest Lutheran Finns much, so they are cheap. In Finland there is not a good retail market for icons and it keeps the prices low. Many tourists find this out and buy icons during their journey. The prices are at least half those in central Europe. In Estonia too icons are more expensive than in Finland.

Provocative art

Kalervo Palsa (1947–1987), Jani Leinonen (b 1978) and Teemu Mäki (b 1967).

Art sale institutions in Finland

Galleries

Galerie Anhava, Galerie Forsblom, Galleria Krista Mikkola, Galleria Heino, Galleria Uusitalo, Galerie Aspis, Gallery Piipo & Kalhama.

Auctions

Bukowski Oy, Hagelstam Oy.

Art dealers

Art Clipper, Sesanne Oy, Art Partners.

Important summer exhibitions

Taidekeskus Salmela, Mäntyharju.
Taidekeskus Retretti, Punkaharju.
Mäntän kuvataideviikot, Mänttä.
Fiskars, Pohjan kunta.

Table 12.2 Data from Finnish art markets, 2001

Sales (€ million):	
Auction	17.78
Dealer	21.73
Total	39.51
Number of businesses:	
Auction	4
Dealer	67
Total	71
Number of employed:	
Auction	53
Dealer	128
Total	181
Average nominal fine art price in 2001: €3,007	
Total imports, exports and net exports of paintings in 1999 (€ million):	
Imports	0.70
Exports	0.92
Net exports	0.22

Source: Kusin & Company (2002) and The European Art Market in 2002

For further information on the development of this particular art market, go to: www.koganpage.com/artmarkets.

France

Roxana Azimi

History

It is an established fact that France, along with Italy, produced some of the brightest artistic talents in Europe. What is less well known though, is that a fairly well-organized art market existed as early as the 18th century. Public auctions were already being held in the 16th century, but sales catalogues only appeared during the Age of Enlightenment. Records of the time reveal the popularity of Dutch and Flemish paintings, as well as the decorative arts. The fascination with French furniture and its followers was such that German cabinetmakers like Adam Weisweiler and David Roentgen set up workshops in Paris.

The Revolution of 1789 transformed society, increasing in some ways the independence of craftspeople. The appearance of industrial fairs in the 19th century put them in direct touch with the public, without help from the dealers. But the monarchs and aristocrats of the Ancien Regime were replaced by a bourgeoisie of tradespeople. Although he had little personal interest in art, Emperor Napoleon Bonaparte understood its strategic and political value, in particular for the influence of his Empire beyond its borders.

England in particular was home to many Francophile customers, such as the Marquis of Hertford. At the dawn of the 19th century, Paris had no equivalent to England's 'great arbiter of good taste', King George IV. Collection mania only rose to fever pitch in the middle of the 19th century, thanks to a number of essential personalities such as the Duke of Aumale, the son of King Louis-Philippe, and towards the end of the century Monsieur Choquet, one of the first to buy Impressionist works. In the 18th century Paris had attracted the great cabinet-makers, and then as now the French capital was a magnet for avant-garde movements. Impressionism, cubism and surrealism were all able to flourish there, despite the conservatism of French collectors. That was of little importance, given the close attention the Americans were paying to Paris.

As the dealer Paul Durand-Ruel recalls, half of the works by his Impressionist protégés belonged to American collectors. They were also besotted with Picasso and Matisse, thanks mainly to the influence of Gertrude Stein, whose salons were legendary. Alfred Barnes bought works by Cézanne and Chaïm Soutine, the touchstones of his Foundation. All eyes turned to Paris because the city was home to leading dealers such as Ambroise Vollard,

Georges Petit, Henri Kahnweiler, Paul Guillaume Paul and Leonce Rosenberg and, for older art, the Wildenstein dynasty.

The Second World War, however, was a turning point, in aesthetics as well as politics. Although a figure like Arshile Gorky drew a link between American abstract expressionism and surrealism, the leading lights of the New York school were determined to shake free of all European – and especially French – heritage.

While, during the 1950s, France clung to lyrical abstraction and the United States stirred up its aesthetic revolution, the market itself rested on its laurels. It is worth noting that during this decade, the turnover made by French auctioneer Etienne Ader alone was comparable with the amounts made by Christie's and Sotheby's put together. Another turning point came in 1964 when the American artist Robert Rauschenberg plucked the prize at the Venice Biennale from under the nose of the French Roger Bissière. At the same time, Sotheby's, then a British company, stole a march on French auction houses by acquiring the New York firm Parke-Bernett. Sotheby's annual turnover rose from £13 million in 1963–64 to £21.4 million in 1965–66. The phenomenon continued apace from one year to the next, especially since, while the number of American clients grew constantly, the number of French clients was rapidly shrinking as tax pressures increased. Today, according to Christie's France's figures, France represents 13 per cent of the global market for all artistic categories combined. The globalization of the art buyers has a clear impact on the French market, since in some sales foreigners represent 40 to 60 per cent of the buyers. In spite of a doomed economic situation, France keeps progressing, but not at the same pace as other countries.

The end of France's dominant position is largely a result of major tax disadvantages. Sellers must pay capital gains tax of 4.5 per cent on the sale of art works. Then there is import VAT of 5 per cent, the bugbear of the Syndicat National des Antiquaires (National Union of Antiques Dealers) and the Comité des Galeries d'Art (CGA, Committee of Art Galleries). Next comes the *droit de suite*, a variation of copyright, created in 1920, and payable to artists throughout their lifetime and for 70 years after their death. A European directive has now extended this copyright across the European Union, using a staggered system from 4 to 0.25 per cent. It is still hard to measure the impact of this harmonization on the French share in Europe, since Great Britain enjoys a moratorium until 2010. This new measure has, however introduced a cap of €25,000, reducing the negative impact on the market. On the other hand, the directive has extended the application of the *droit de suite* to art galleries, which were previously exempted. Furthermore, French collectors are still concerned that works of art may one day be included in the base for calculations of the French wealth tax (ISF), as is already the case for jewellery.

The main players in the market

The French market underwent a fundamental change in July 2000. The new millennium marked the end of the monopoly of French auctioneers, a privilege dating back to an Edict by Henri II in 1556. Although the Le Chapelier Act of 1791 had brought an end to corporatism, one guild had survived: the guild of auctioneers. Until 2000, the Paris firm Drouot had orchestrated 100 auctioneers, who nevertheless ran their business independently, via their own practice. There were some 450 of them across France. It took fierce lobbying by Sotheby's to achieve a reluctant reform. On 29 November 2001, Sotheby's became the first foreign company to wield the auctioneer's hammer in France, at the sale of the second set of Belgian Charles Hayoit's collection of books. The result of €3,960,000 was amazing, and encouraging since no items remained unsold.

The new law changed the status of auction houses, which were no longer official ministerial representatives but private companies. And, as businesses, they decided to increase the level of fees levied on buyers from 10 per cent to 20 or even 24 per cent. At the same time, in an increasingly competitive environment, buyers' fees fell, at least for major collections. However that had no effect on the buying craze observed for about two years. New commercial weapons also began warily to emerge, such as zero fees or retrocession of part of the buyer's fees to the vendor. The new law also introduced a supervisory body, the Conseil des Ventes Volontaires (Voluntary Auctions Council) which gives (or withdraws) its approval to Sociétés des Ventes Volontaires (SVV) (voluntary auction companies). Many, however, question its effectiveness. Today, there are 81 SVVs in Paris and 300 across France. Five years after a reform of auctions that could have destroyed it, Drouot is still at the helm, without having undergone the overhaul that it had so often promised. It has succeeded in attracting some of the most prestigious sales of recent years, including writer André Breton's workshop in 2003 (€46 million) and Pierre and Claude Vérité's collection of African art in 2006 (€43 million). But how long will this 'miracle' last without a complete rethink and a clear strategy? Few people would bet on a long-term future for this structure.

2003, however, saw a shake-up in the ranking of the auction houses. Christie's, the property of collector François Pinault, who also owns the Piasa auction house, took the number one spot, which it still holds today. Sotheby's, which had fought to open up the market, still lags behind, with a policy based more on export, although the new chairman in Paris plans to develop more auctions. Exports are also the key focus for Bonhams and Phillips, both of which opened offices in France in 2005. Bonhams organized its first car sale in February in Paris, but does not plan to conduct more auctions there.

The new landscape is defined not so much by new players as new partnerships. Artcurial, owned by the aircraft manufacturing family Dassault, was born in 2001 of the then previously individual auctioneers, Francis Briest, Hervé Poulain and Rémi Lefur. François Tajan left the family firm to join them in 2005, while Rémi Le Fur withdrew from the quartet in 2007 and opened a new auction house together with designer Pierre Cardin. The Tajan auction house, created some 30 years ago by auctioneer Jacques Tajan and acquired for a time by luxury group LVMH, has belonged since 2004 to businesswoman Rodica Seward. A new firm, Bergé & Associés, was created in 2002, owned by businessman Pierre Bergé.

The reform also reduced the importance of the Monaco market. Until then, Sotheby's and Christie's had been holding their prestige sales there since 1975 and 1985 respectively, as they were not allowed to wield the hammer in France. In the boom years, Sotheby's posted a turnover of €60 million (1990), holding around a dozen auctions a year. In 1999 the company held only around two sessions a year, with a turnover of €13 million. For Christie's, the yearly figure varied between €2 and €5 million. Cold-shouldered by the Anglo-Saxons, Monaco is still a strategic location for Artcurial and Tajan. The latter holds its most lucrative jewellery sales and less successful modern painting sales there. Artcurial has been striving for success in the Principality since 2006.

Two distinct types of auction house exist today, those with both national and international reach and those which remain local. Some firms have developed foreign bureaux. Bergé & Associés holds jewellery sales in Geneva and has acquired Art Home in Belgium. Drouot has ventured across the Atlantic to Canada, but still it is hard to understand its strategy.

As well as the auction houses, art galleries and antique dealers are also major players on the market. The Syndicat National des Antiquaires (SNA) (National Union of Antique Dealers) has over 400 members, while the Syndicat National du Commerce de l'Antiquité et de l'Occasion (SNCAO) (National Union of Antique and Second-hand Trading) boasts nearly

2,000 members. The CGA brings together 180 contemporary and modern art galleries. In 2005, it commissioned a survey of galleries. The results showed that the average turnover for contemporary art galleries is €487,053. According to the survey, the average turnover for all art galleries taken as a whole actually flirts with €797,878. That figure should be offset by the fact that 41 per cent of the galleries surveyed did not answer that particular question. Although they may not be exhaustive, the results of the survey shed new light on the economic weight of galleries compared with auction houses. The CGA puts the figure at €640 million, nearly five times the turnover from auctions in 2004 in the modern and contemporary art segment. Finally, a new player has moved into the existing market. Artprice, a valuation database, launched a website for adverts in 2005. A year later, it boasted nearly 270,000 adverts with an average price of €11,540.

The buyers

In France, culture is government business. The New Deal, introduced in 1980, sparked the creation of many artistic organizations outside Paris, such as the Fonds Régionaux d'Art Contemporain (FRAC) (regional contemporary art funds), but this type of state interventionism turned out to be a double-edged sword. It perpetrates an image of artists and galleries still heavily dependent on state subsidies, but the truth is a long way from the stereotype. French art galleries in fact do 66 per cent of their business with private French individuals. But this business involves often small amounts of money.

The results of the survey commissioned by the CGA in 2005 revealed that purchases by museums and public art centres represent only 6 per cent of turnover as a whole, and 11 per cent for galleries involved with edgy contemporary art. These low figures reflect the higher numbers of private collectors and the concomitant decrease in public purchase loans. The €3.9 million from the FRAC, added to the €3.1 million from the du Fond National d'Art Contemporain (FNAC) (National Contemporary Art Fund), are a long way from being enough to finance all art galleries! With the exception of François Pinault, Bernard Arnault and the very discreet Marcel Brient, France has no megacollectors capable of rivalling the size of American wallets. It has, however, a whole host of highly active small and medium collectors, some of whom are organized as the Association pour la Diffusion de l'Art Français (ADIAF) (Association for the Dissemination of French Art).

Since 1921, the museums have a right of pre-emption, allowing them to purchase a piece at the price offered by the highest bidder at public auctions. That right is implemented for works considered as necessary to be retained in public museums by intervening once the auctioneer has accepted the last bid. Furthermore, the state can prevent any work considered to be a national treasure from leaving the country. In that case, it has three years to acquire the painting, or issue a certificate of free circulation. The Museum Act of 4 January 2002 allows companies to buy works of art for national museums in return for a tax exemption of between 40 and 90 per cent depending on the method used. In 2003 the patronage of the PGA Holding company, France's biggest car retailer, allowed the Louvre to acquire *Divertissements champêtres*, an ensemble of nine decorative panels by Jean-Baptiste Oudry (c 1720–23) worth €3.5 million. In 2004, 130 drawings from the Juan de Bestégui collection, worth €11.33 million, became part of national museum collections thanks to the patronage of Carrefour. This transaction was made possible by Sotheby's, which acted as intermediary, first being required to sell the drawings at auction. The number of national treasures acquired through corporate patronage has tripled since the law came into force.

French specialities

The French market has two star disciplines: the primitive arts and decorative arts of the 20th century. The former benefited from the effect of the Musée du Quai Branly in 2006, which had the market on tenterhooks as it impatiently awaited the inauguration. Regular high-quality auctions of African art such as the Pierre Harter and Jean-Claude Bellier collections, and more recently the Hubert Goldet, René Gaffé and Vérité collections, along with the presence in Paris of major dealers like Alain de Monbrison Bernard Dulon and Ratton-Hourdé led Christie's and Sotheby's to step up their presence in Paris in this field. In 2006, the turnover of Sotheby's African art department in Paris, at around €13.7 million, outstripped that of the New York office by €5 million. In the same way, British dealer Lance Entwistle switched his primitive art business to Paris from London. Following figures by the Conseil des Ventes Volontaires, this field has progressed by 241 per cent in 2006, thanks to the Vérité sale.

Another jewel in the French crown, the Art Deco market, was built up in the 1970s, under the leadership of gallery owners like Bob and Cheska Vallois and Félix Marcilhac. The Jacques Doucet auction in 1972 was the beginning of a dramatic rise in prices which reached its apogee in 1999 with the sale of lawyer Pierre Hebey's collection. In a strange paradox, France dominated in fields where the big dealers were mainly Parisian, but where the clients were foreign and often American! However, the situation is becoming more balanced. The Fang mask sold for €5 million as part of the Vérité collection has remained in France. In the same way, the Vallois gallery has noted that, while 80 per cent of its clients have long been Americans, the proportion of Europeans has been increasing over the last two years.

The scarcity of Art Deco pieces has given a boost to 1950s work, symbolized by designers Jean Prouvé and Charlotte Perriand. Defended as early as 1956 by Steph Simon, 1950s furniture came back into fashion at the end of the 1970s, championed by several prospective dealers. Since 1998, prices have been multiplied by three or even five for exceptional pieces of furniture. While the principal designers and promoters are French, the majority of the clients are American.

Older paintings remain the speciality of London or New York, with Sotheby's exporting works worth €40 million there in 2005. In fact, France controlled only 6.5 per cent of this market in 2005. Furthermore, most of the big dealers on this market are based in London. Paris however is market leader in drawings, not so much in terms of auctions, which rarely offer many masterpieces, but more because of the Salon du Dessin. This tiny fair brings together 30 top-level art galleries every year. High-quality 18th-century furniture, often considered a truly French speciality, is in fact more often sold at London and New York auctions, although it is true that there had previously been some memorable sales at Drouot. The Wildenstein collection was sent to London, while antique dealer Maurice Ségoura's collection and Ariane Dandois's inventory were exported from Paris to be sold in New York in 2006 and 2007. Nevertheless Paris, and especially the Faubourg Saint-Honoré, is home to the main dealers in 18th-century pieces. But the profession suffers from a lack of new blood, and the heirs are often deficient and unable to continue in the tradition of their forefathers, with a few exceptions such as Hervé Aaron and Nicolas and Alexis Kugel. There is also a lack of new collectors. Another endemic problem in this segment is the scarcity of supply. Although the auctions are full of bourgeois furniture, such as 'tombeau' chest of drawers or 'Cabriolet' armchairs, this is of little interest to collectors who are looking for highly structured or unconventional pieces. Furthermore, at the Biennale des Antiquaires, which, along with the TEFAF in Maastricht is the most important antiques fair, the 18th century is increasingly giving ground to the 20th century.

Generally criticized for lagging behind on the contemporary art market, France took benefit of the success of auctions in New York. In 2007, turnover from contemporary art for Artcurial (€33.2 million), Christie's (€41 million) and Sotheby's (€31.4 million) was consistent. In December 2007, Sotheby's sold a *Portrait of Muriel Belcher* by Francis Bacon for €13.6 million. But let there be no illusion! The annual turnover of Artcurial itself remains less than that of a single morning sale at Christie's in New York on November 14th ($51.1 million). According to Artprice, France had a market share of only 4 per cent in this segment in 2006, which is less than new markets such as Hong Kong! What is more, fewer transactions take place at Fiac Fair compared with Art Basel and Art Basel Miami. According to most exhibitors, collectors hesitate to buy pieces priced over a certain level. A major change was yet noticed in 2006, with a surprising amount of transactions, few of them however exceeding €500,000. Nonetheless, an important gallery such as Lelong boasted little more than a €1 million result.

Even though many like to portray Paris as the capital of photography, the market itself flies the Star Spangled Banner. According to Artprice, France's turnover in this segment fell by 46 per cent from 2003 to 2004. In 2007, France had a market share of only 8.1 per cent. But at the same time, the Paris Photo fair, created 10 years ago, remains the reference for photography: 70 per cent of its participants come from abroad and many clients are international. Even though certain participants report that sales are at a less high level than in America, the number of prestigious collectors who make the pilgrimage every year is enough to attract the American galleries.

France also means niche markets. For six years now, devotion to the Emperor Napoleon Bonaparte has been working miracles at auctions. Napoleon-mania is in fact cyclical, with a peak occurring every 30 years. After an ultra-calm period in the 1980s came the hysteria which began in 1998–99. Jean-Pierre Osenat, an auctioneer in Fontainebleau, was one of the first to herald this lucrative Napoleon-mania. Chief among the objects of desire are personal effects. A shirt was sold in Fontainebleau in March 2002 for €74,300! A love letter to Josephine even went for FF650,000 (€99,091) at a Briest sale. This romantic piece of prose now belongs to Bill Gates, a self-confessed admirer of the Emperor. In the field of vintage cars, France seems to be a good market, since Bonhams staged a sale successfully in February, although Christie's decided to shut down that department in 2007. The most expensive object sold in France in 2004 was a Bentley Speed Six car, which went under the hammer at Christie's for €4.2 million in June. In 2003, the record went to a Mercedes sold by Artcurial. But according to the Auction Council's figures, turnover from vintage cars fell to €3.4 million in 2005. Rare books too remain a French speciality, with many records set over recent years in France, not to mention the marathon sale of bookseller Pierre Berès' library in 2006 (€14.2 million).

Exports

But the greatest of all French specialities must be – exports. This outflow of heritage is nothing new. While Cardinal Mazarin was a major importer of Italian paintings in the 17th century, the writer Denis Diderot was an immense exporter of French works, sending carriages full of paintings to St Petersburg for the Empress Catherine II. In its own way, the French Revolution accelerated this trend. The Château de Versailles in 1793 auctioned off over 17,000 lots, many of which went abroad. British bidders were the main beneficiaries of these revolutionary auctions. Indeed today, Versailles houses only 10 per cent of the volume

of the furniture held before the Revolution! According to the Observatoire des Mouvements Internationaux d'Oeuvres d'Art (Observatory of International Flow of Works of Art), the value of exports stood at €689 million in 2005, or twice the value of imports. This figure does not differentiate, however, between works purchased in France by foreigners and those sent abroad for sale. Sotheby's exported €150 million in 2007, while Bonhams sent to London €13 million worth. Christie's annual exports outstrip its French turnover by 60 per cent. Ninety to 100 per cent of the major paintings it collects in Paris move abroad, mainly to New York. According to the Observatory of International Flow of Works of Art, the United States imports €340 million worth of works of art from France. That's no surprise.

The gulf between the economic and political climate and the art market has never been wider in France than in the last two years. All the indicators pointed to a lack of competitiveness, a flagging industrial sector, investments heading offshore, and a significant brain drain. Indeed, France failed to match the growth posted across the Euro zone in 2006, particularly in comparison with its neighbour and rival, Germany, where the economy was again on the upturn. But even in this context, the art market was in excellent health, with French collectors playing an important role in the upswing. Chief among their spending sprees were Art Paris and the International Contemporary Art Fair (Fiac). This high level of activity is really not surprising, given that private French individuals account for 66 per cent of the revenues of French galleries.

Yet spending power in France has clearly not kept pace with the rise in the United States or emerging countries. Furthermore, fiscal pressure has increased in France over the last five years, and the spectre of including works of art in the calculation of the French wealth tax, ISF, is uppermost in many minds. It is difficult to put a figure on the number of affluent taxpayers leaving France for this very reason every year. As the tax authorities refuse to publish this information, the only available source is a study carried out by the Finance Ministry at the end of the 1990s. According to the rapporteur to the National Assembly on the Budget, Gilles Carrez, the report estimated that one very wealthy individual (worth at least €10 million) left France for fiscal reasons every day, or 365 every year. So the real lifeline for the French market is the globalization of buyers. In 2007, 60 per cent of bids at Sotheby's were made by foreigners. The buoyancy of the French market is therefore based on short-term rather than structural factors. As long as the global economy remains healthy, the French art market will, in turn, be fighting fit.

For further information on the development of this particular art market, go to: www.koganpage.com/artmarkets.

Germany

Roman Kräussl

This chapter discusses various aspects of the German art market. The first section analyses the specific characteristics of collecting and dealing as it takes place in Germany. It therefore provides a more detailed account of galleries, auction houses and art fairs, as well as a short overview of museums and exhibitions, and a brief history of German patronage. The second section discusses the position of the German art market in the international market, and analyses transactions and sales turnover data. It also evaluates the recent market performance of different styles and individual artists. Finally, this chapter closes with a discussion of whether art might serve as an alternative asset class, with a special focus on the first German art fund.

Collecting and dealing

The German art market is very different from other European art markets because of the country's federalist system. Germany hosts many art centres that help enhance regional diversity. Whereas in other countries a centralized art market allows a single leading institution to control trade, in Germany the diverse collection of museums with varying structures and styles express their influence and ideas. In terms of the sheer number of galleries, art fairs and public art institutions, Germany follows a close second behind the United States. Measured per capita, Germany actually contains the most art institutions in the world (see www.artfacts.net). Publications such as *ART – Das Kunstmagazin* (www.art-magazin.de), *ARTinvestor* (www.artinvestor.de) and *Artnet* (www.artnet.com) provide interested readers with frequent updates about recent auctions, art fairs and exhibitions.

Art galleries and auction houses

Most art galleries remain concentrated in the centres of German art dealing: Munich, Berlin, Cologne and Düsseldorf. Auction houses are more widely dispersed and numerous, as indicated in Table 14.1. These houses organize several sales, mostly in spring and autumn.

The most prestigious works appear for sale at the most famous galleries: Kunsthaus Lempertz in Cologne, Villa Grisebach in Berlin, Ketterer Kunst in Munich and Hauswedell &

Table 14.1 Auction houses in Germany

Name	Location	Website
Auktionshaus Arnold	Frankfurt/Main	www.auktionshaus-arnold.de
Galerie Bassenge	Berlin	www.bassenge.com
Bolland & Marotz	Bremen	www.bolland-marotz.de
Kunst- und Auktionshaus Döbritz	Frankfurt/Main	www.doebritz.de
Auktionshaus Dr. Jürgen Fischer	Heilbronn	www.auctions-fischer.de
Villa Grisebach Auktionen GmbH	Berlin	www.villa-grisebach.de
Hartung & Hartung KG	Munich	www.hartung-hartung.com
Hauswedell & Nolte	Hamburg	www.hauswedell-nolte.de
Karl & Faber	Munich	www.karlundfaber.de
Auktionshaus Karrenbauer	Konstanz	www.karrenbauer.de
Kunst & Auktionshaus Kastern	Hannover	www.kastern.de
Ketterer Kunst	Munich, Hamburg	www.kettererkunst.de
Antiquariat Klittich–Pfankuch	Braunschweig	www.klittich-pfankuch.de
Kunsthaus Lempertz	Cologne, Berlin	www.lempertz.com
Auktionshaus Metz	Heidelberg	www.metz-auktion.de
Nagel Auktionen	Stuttgart	www.auction.de
Kunstauktionshaus Neumeister	Munich	www.neumeister.com
Auktionshaus Ursula Nusser	Munich	www.nusser-auktionen.de
Quittenbaum Kunstauktionen	Munich	www.quittenbaum.de
Reiss & Sohn	Königstein	www.reiss-sohn.de
Rippon Boswell & Co.	Wiesbaden	www.rippon-boswell-wiesbaden.de
Kunstauktionen Hugo Ruef	Munich	www.ruef-auktion.de
Kunstauktionshaus Schloss Ahlden	Ahlden	www.schloss-ahlden.de
Leo Spik	Berlin	www.leo-spik.de
VAN HAM Kunstauktionen	Cologne	www.van-ham.com
Winterberg Auktionen	Heidelberg	www.winterberg-kunst.de
Auktionshaus Michael Zeller	Lindau	www.zeller.de
Auktionshaus von Zengen	Bonn	www.zengen.de

Nolte in Hamburg. Unlike other countries, no single location maintains a monopoly over the market. This highly regionalized structure produces lively competition among German auction houses, which may explain why the German representatives of Christie's and Sotheby's play only a minor role. With 29 per cent of the overall auction market, Berlin holds the most prestigious sales position.

Art fairs

Galleries bear the standard for tradition, but they also complain of fewer and fewer visitors. In contrast, art fairs welcome a readily increasing number of enthusiasts; seemingly, collectors prefer trendy art fairs to stuffy old galleries. Many gallery owners have responded to this trend by participating in the fairs themselves. Therefore, many art fairs run throughout the year; Table 14.2 lists the 10 major German art fairs.

Art Cologne, Germany's leading art fair, was established in 1967 by 18 progressive galleries as Europe's first fair for modern art. Instrumental in bringing together geographically separated dealers and galleries, the fair offered the first competitive overview of the international art market. For six days each spring, Art Cologne brings together more than

Table 14.2 Art fairs in Germany

Name	Location	Date	Website
Art Karlsruhe	Karlsruhe	Spring	www.art-karlsruhe.de
Fine Art Fair Frankfurt	Frankfurt/Main	Spring	www.artfrankfurt.de
Art Cologne	Cologne	Spring	www.artcologne.de
dc duesseldorf contemporary	Düsseldorf	Spring	www.dc-fair.de
ART Bodensee	Dornbirn	Summer	www.artbodensee.info
Preview Berlin	Berlin	Autumn	www.previewberlin.de
art forum berlin	Berlin	Autumn	www.art-forum-berlin.de
Kunst-Messe München	Munich	Autumn	www.kunstmessemuenchen.de
Cologne Fine Art	Cologne	Autumn	www.cologne-fine-art.de
Art.Fair 21	Cologne	Autumn	www.art-fair.de

250 leading dealers of different countries to showcase the very best of the international contemporary art market.

Although Cologne has had a history of being the contemporary art capital of Germany, since German reunification there has been a steady decline of artistic life in Cologne. Since the early 1990s Berlin has moved up to become the German cultural centre again, which also has to do with the lower cost of living and the freshness of its contemporary art.

Museums and exhibitions

An initiative by Arnold Bode (1900–1977) in Kassel in 1955 held particular importance for German artists during the postwar period. In mounting an exhibition that would display international developments in contemporary art, which he called Documenta, he attempted to mend the broken threat of modernism and reacquaint artists, as well as the German public, with forms of art that had been prohibited during the Nazi years. He also aimed to bring new impulses to the German cultural landscape by exposing it to international developments. Bode's concept for the Documenta held that it should take place every five years, which would allow distinctive new forms of art to emerge during the intervening years. This model persists to the present day. Although international in tone, the Documenta has always contained significant German accents.

In the past decade, museums in Germany have also developed an interesting marketing concept. The Lange Nacht der Museen (Long night of the museums), cultural events organized by multiple museums and cultural institutions, keeps establishments open late into the night. Since the first Lange Nacht der Museen in Berlin in 1997, the number of participating institutions and exhibitions has risen from 12 to 125. A common entrance pass allows visitors to visit all the art spots and access public transportation to reach them. The popularity of the concept has led to expansion of these nights to more than 120 German cities, as well as other European cities including Amsterdam, Paris and Zurich.

Patronage and droit de suite

Since the end of the Second World War, Germany has maintained a system of governmental, industrial, and private patronage. State patronage is decentralized since each state of the Federal Republic determines its own cultural affairs. Industry supports young German artists through foundations such as the Kulturkreis im Bundesverband der Deutschen Industrie. Some

companies have their own cultural budgets for funding exhibitions and also for collecting art. In the last 20 years it has become increasingly popular for commercial banks to invest in culture as well; a common example is Deutsche Bank and its Guggenheim Foundation.

In Germany, art associations also play a vital role as non-commercial forums for contemporary artists that have not yet become established. These art associations often give unknown artists their first chance to exhibit their work. More than 200 of these art associations form the network Arbeitsgemeinschaft deutscher Kunstvereine (AdKV, see also www.kunstvereine.com).

Germany is one of the countries that signed the *droit de suite*. The implementation of these resale royalties in Article 26 of the German Authors Rights Law of 1965 guarantees the rights of artists to receive a percentage of the revenue from the resale of their works in the art market. This right is inalienable, thus the artist cannot transfer it to another person or institution during its lifetime. After the artist's death their right is transferred to their heirs for up to 70 years. The law covers all sales by German artists in Germany plus works sold by foreign artists living in Germany on the basis of reciprocity. The basis for assessing the royalty is the sales revenue, that is, the gross sales price without deductions such as commission fees or other costs to the seller. On this price the royalty is charged at the standard rate of 5 per cent for every artwork that sells for more than €51. The payments due to *droit de suite* are collected directly: the seller subtracts the royalty from the sales price and passes it to the artist or their representative.

Investing in German art

A global view

Germany holds a rather unique position in the art market. In recent years, Germany has remained steadily in fourth place in terms of number of transactions, behind France, the United States and the United Kingdom. Sales volumes for 2006 also remained virtually unchanged (some 25,000 lots sold). Figure 14.1, which includes recent data from Artprice, reveals that in 2006, Germany was responsible for approximately 12.7 per cent of the global art auction market.

However, what clearly distinguishes the German art market is the presence and influence of multiple works of art. A far higher proportion of prints and photographs sells in Germany than in other markets: although they represent just less than 22 per cent of worldwide transactions, they are 42 per cent of the market in Germany. As Figure14.2 indicates, according to Artprice, sales turnover for the German art market in 2006 was just 2.9 per cent of the global figure.

During 2006, the average lot price in Germany was $4,000 – 10 times lower than in the United States. That 95 per cent of the works sold in Germany change hands for less than $10,000 mirrors the structure of the German art market.

Performance of different styles and individual artists

Although many observers view the German contemporary market as particularly buoyant, these works still constitute just 5 per cent of volume sales, while contemporary art works account for almost 7 per cent of the worldwide art market. Paradoxically, some German contemporary artists remain extremely sought after; for example, Anselm Kiefer (b 1945) and Sigmar Polke (b 1941) already have sold works for over $500,000 and number among the 20 most expensive artists born after 1940. The work of the Cologne contemporary artist Martin Kippenberger (1953–1997), whose individual Artprice index has progressed by more than 250 per cent in the past five years, is also subject to high speculation. For example, a series of

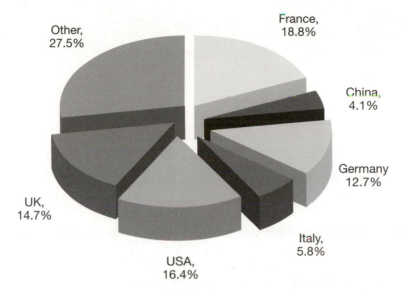

Figure 14.1 Global number of transactions, 2006

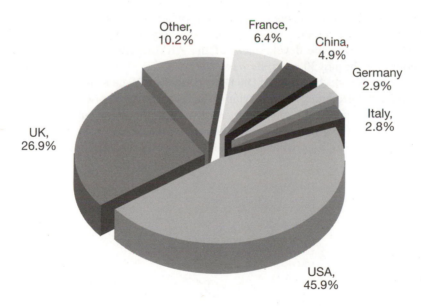

Figure 14.2 Global sales turnover, 2006

four paintings entitled *Frau mit viel Zeit* sold for $140,000 in February 2003 and then for $706,000 in October 2006. Figure 14.3 reveals the development of the ArtMarketResearch index of German 20th-century painting during the past 30 years.

Figure 14.3 also indicates that in the late 1980s, the German art market flourished, largely because the economic boom of the times created a young audience for art that could

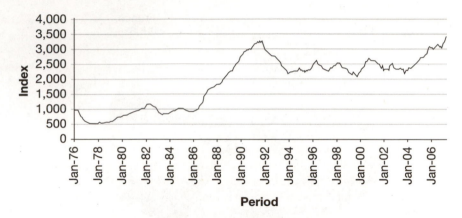

Figure 14.3 ArtMarketResearch index for German 20th-century painting, 1976–2006

pay practically any price. This condition initially pushed up the prices for emotionally charged works by the painters of the Junge Wilde group to astronomical heights, but as the art market crashed in the early 1990s, these prices fell back down again.

Furthermore, in terms of the recent performance of German contemporary art, the artists' best pieces no longer appear solely in Berlin, Munich or Cologne but rather show up in London and New York, where they fetch top prices. But although contemporary art is more popular in other countries, modern works sell very well in Germany as elsewhere, as Figure 14.4 depicting the development of the ArtMarketResearch index for German Expressionists in the past 30 years, shows.

The prices of works by artists of Die Brücke and Der Blaue Reiter have been spiralling upwards since the beginning of this century. The recent surge in prices also stems from the increasingly short supply of Expressionist works. Thus, the artists currently generating the greatest turnover at international auction houses include Emil Nolde (1867–1956), Max Pechstein (1881–1955), Karl Schmidt-Rottluff (1884–1976) and Erich Heckel (1883–1970).

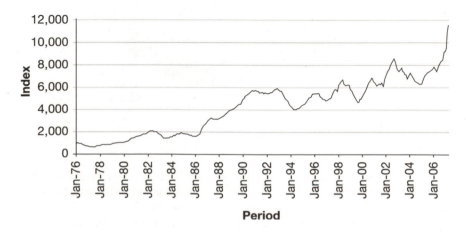

Figure 14.4 ArtMarketResearch index for German expressionists, 1976–2006

Also in recent years, international collectors have eagerly snatched up works by German photographers. Commanding the highest prices, Andreas Gursky's (b 1955) works sell primarily in the US and UK markets and regularly earn prices of more than $1,000,00 for his master works. The Artprice index on Thomas Ruff (b 1958), another icon of the contemporary photography market, increased by more than 500 per cent in the past 10 years.

Modern collectors in New York and London evince significant interest in works by young German artists (YGAs) of the Neue Leipziger Schule. During the last years, numerous international gallery owners and art exhibitors have made substantial efforts to promote these labels on the international art market, which are now paying off. For instance, Neo Rauch (b 1960) can hardly keep up with demand; his art works seldom sell at auctions for less than $100,000. Top collectors face waiting lists of longer than a year to obtain one of the eastern German artist's melancholic interpretations of socialist themes, and in the secondary market, their prices have risen vertiginously. In 2004, a new painting by Tim Eitel (b 1971) or Matthias Weischer (b 1973) cost about $20,000; at a Christie's auction in late 2005, a Weischer fetched $370,000, and an Eitel brought in $212,000.

Besides this significant upward trend in prices paid for German modern and contemporary artists, German 19th-century painting is undergoing a rapid rise in value. Art works by early German romantics such as Caspar David Friedrich (1774–1840) and Philipp Otto Runge (1777–1810) have meanwhile become very rare, and when they do come to the market fetch top prices. This has turned collectors in recent years towards art works that have been undervalued for many years, for example, the paintings by Otto Scholderer (1834–1902) and Carl Rottmann (1797–1850), who was the most important representative of heroic landscape painting. Art works by Carl Spitzweg (1808–1885) are also still consistently selling well. It seems like a hunger for beautiful paintings is awakening again. Moreover, German art has lost its post-Second World War stigma and becomes highly recognized and collectible again.

Art as an alternative asset class?

Highly volatile equity markets have prompted investors' ongoing searches for alternative asset classes to fulfil their needs to uphold returns without taking on too much risk. Moreover, increasing globalization has diminished the impact of diversifying portfolios across borders. These recent developments have greatly increased the popularity of hedge, private equity, real estate and art funds, along with other alternative investments. Nonetheless, the question remains whether financial motives justify the popularity of these investment alternatives or whether art works should be kept and valued merely for their aesthetic return. (A recent paper evaluates whether art might be a serious alternative to current standard asset classes, such as equities and bonds. That article, as well as additional research on art as an alternative investment class, appears at www.art-finance.com.)

In November 2006, Art Estate received final approval from the German Federal Supervisory Authority for Financial Services to publish the sales brochures of its first art fund. Investors in the Art Estate Kunstfonds 01 will participate in developing 25 works by internationally acknowledged contemporary artists for a duration of approximately 15 years. With its investment strategy, Art Estate is banking on a mixed portfolio of works by selected German and American artists, bought already by the investment company. The artworks include offerings by Baselitz, Lüpertz, Penck, Polke, and Richter, as well as Robert Rauschenberg (b 1925), James Rosenquist (b 1933-), Frank Stella (b 1936), Andy Warhol (1928–1987) and Tom Wesselmann (1931–2004).

For further information on the development of this particular art market, go to:
www.koganpage.com/artmarkets.

Bibliography

Literature

Adam, P (1992) *Art of the Third Reich,* Harry N Abrams, New York

Barron, S (1991) *'Degenerate Art': The fate of the avant-garde in Nazi Germany,* Harry N Abrams, New York

Droste, M (2006) *Bauhaus*, Taschen-Verlag, Cologne

Honour, H and Fleming, J (2005) *The World History of Art*, Prentice Hall, Upper Saddle River, NJ

Hopfengart, C (2000) *Der Blaue Reiter*, DuMont, Cologne

Janson, H W and Janson, A F (2004) *History of Art: The eastern tradition,* Prentice Hall, Upper Saddle River, NJ

Klotz, H (2000) *Geschichte der deutschen Kunst, Band 3: Neuzeit und Moderne 1750–2000*, Beck-Verlag, Munich

Kräussl, R and Schellart, E (2007) Hedonic pricing of artworks: evidence from German paintings, working paper, VU University Amsterdam [online] http://papers.ssrn.com/sol3/papers.cfm?abstract_id=968198 (accessed 18 March 2008)

Lehmann-Haupt, H (1973) *Art Under a Dictatorship*, Oxford University Press, New York

Lenman, R (1997) *Artists and Society in Germany, 1850–1914*, Manchester University Press, New York

Michalski, S (1994) *New Objectivity*, Taschen-Verlag, Cologne

Mullins, C (2006) *Painting People: Figure painting today*, DAP, New York

Richter, H (1965) *Dada: Art and anti-art*, Thames and Hudson, London

Rosenthal, M (2005) *Joseph Beuys: Actions, vitrines, environments*, Tate, London

Stockstadt, M, Cateforis, D and Addiss, S (2002) *Art History,* Abrams, New York

Websites

ART – Das Kunstmagazin at www.art-magazin.de

Art Estate at www.artestate.com

ArtFacts at www.artfacts.net

Art-Finance at www.art-finance.com

ARTinvestor at www.artinvestor.de

Artnet at www.artnet.com

ArtMarketResearch at www.artmarketresearch.com

ArtPrice at www.artprice.com

Arbeitsgemeinschaft deutscher Kunstvereine at www.kunstvereine.com

Greece

Iliana Fokianaki

It is very difficult to examine Greek art, trying to pinpoint a moment where it begun to flourish, since it is inextricably linked with the evolution of the ancient Greek culture more than 4,000 years ago. Art in Greece has been an expression of the everyday and a necessary companion to its civilization. However, there have been many groundbreaking evolutions in Greek culture and art in particular, since Aristotle's writings, in which the word art (*tehni*, which at times referred to technique) entailed different meanings than the contemporary definitions of the word.

Regarding 19th century art, most artists of the 19th century are seen in the Greek art sales in London and sometimes New York, with sale prices rising exceedingly in the last five years. Safe investing definitely applies to these so-called blue chips of the Greek art market. Analytically, first of all there is no risk in investing in the first major artists of the neo-hellenic art, such as Nikiforos Lytras (1832–1904),who sells for roughly £200,000–1,000,000, with London sales since 2005 having risen and with three examples of a 500 per cent higher sale than the estimate, as well as Nikolaos Gysis (1842–1901) (last Sotheby's sale sold works for double their higher estimate). These are followed by Georgios Iakovides (1853–1932), Theodoros Vryzakis (c 1814–1878) (a work at Sotheby's London sale of 10 May 2007 with a higher estimate of £150,000 sold for £500,000, Périclès Pantazis (1849–1884) and Konstantinos Volanakis (1837–1907), as seen by the sales in Sotheby's London on 10 May 2007.

The beginning of the 20th century established the influences of modernism and there are excellent examples of artists such as George Maleas (1879–1928), Michalis Economou (1888–1933) and Spyros Papaloukas (1892–1957), with most prominent being Costantinos Parthenis (1878/79–1967), a truly exceptional artist.

Entering the 1920s the first galleries in Athens were established with an active programme until the Second World War, when most of them closed. Artists are Nikos Hadjikiriakos-Ghika (1906–1994) the representative of cubism in Greece, Georgios Bouzianis (1885–1959) with his fierce expressionist works, Nikos Eggonopoulos (1910–1985) the surrealist of the group, Jannis Moralis (b 1916) with his classical approach to cubism (in his early works) and the wonderful Jannis Tsarouhis (1910–1989), who balanced between his love for the work of Matisse, Byzantium and Greek ancient and folk influences such as the naïf painter Theofilos (1871–1934).

The 1950s was a decade where timidly but steadily Greek art began to pick up with art trends abroad. In 1950 Greece had its first participation at the Venice Biennial and at the Sao Paolo Biennial in 1951. Many artists worked abroad such as Thanasis Tsingos (1914–1965) with his intense expressionist canvases of flowers and Giannis Spyropoulos (1912–1990) who won the UNESCO award at the Venice Biennale in 1960, as well as other artists, especially Moralis who evolved his style and became one of the most admired Greek painters of the period. (He still remains very popular among Greek audiences. His one-man show in Zoumboulakis Galleries in February 2007 was a huge success.) The 1960s was a politically charged period for Greece, mainly because of the imposition of the military dictatorship, commonly known as the *junta* (1967–1974). The '60s generation' included Vlassis Kaniaris (b 1928), Nikos Kessanlis (1930–2004), Danil (b 1924), Jannis Gaitis (1923–1984) and Kostas Tsoklis (b 1930), artists who left for Europe (mainly Italy and France) and remained abroad because of the dictatorship. Furthermore, artists who were slightly younger but with a more 'academic' style were very popular within the domestic art market, such as Dimitris Mytaras (b 1934), Alekos Fasianos (b 1935), Chronis Botsoglou (b 1941) and Giannis Psychopedis (b 1945).

During the same period four artists left Greece and had successful careers. These were Lucas Samaras (b 1936), Chrysa (b 1933), Takis (Vasilakis) (b 1925) and Jannis Kounellis (b 1936). The two most famous Greek (or in Samaras's case, Greek-born) artists are Samaras and Kounellis. Their work is in the collections of the Tate, MOMA, Guggenheim and MCA Los Angeles.

Galleries

The majority of contemporary art galleries are in Athens, with a few in Thessaloniki. The most established galleries in Athens, with highly acclaimed artists, are the following:

■ Xippas Gallery with showrooms in Paris and Athens, with Chuck Close (US, 1940), Ian Davenport (UK, 1966), Vera Lutter (DE, 1960), Martin Maloney (UK, 1961), Vik Muniz (BR, 1961) as well as the Greeks Apostolos Georgiou (1952), Panos Kokkinias (1965) and Lucas Samaras.

■ Bernier/Eliades is also one of the strongest galleries with a highly acclaimed stable of international artists: Haluk Akakce (TR, 1970), John Baldessari (US, 1931), Delia Brown (US, 1969), Tony Cragg (UK, 1949), Gilbert and George (UK, 1943 and 1942), Cameron Jamie (US, 1969), Richard Long (US, 1945), Bruce Nauman (US, 1941), Tony Oursler (US, 1957), Daniel Richter (DE, 1962), Ed Ruscha (US, 1937), Thomas Shutte (DE, 1954) and Greeks Nikos Navridis (1958) and George Hadjimichalis (1954), who were seen at the 51st Venice Biennial.

■ Rebecca Camhi, currently relocating, has an international group of well-known artists such as Rita Ackerman (HU, 1968), Nobuyoshi Araki (JP, 1940), Sylvie Fleury (CH, 1961), Nan Goldin (US, 1953), Karen Kilimnik (US, 1955), Tracy Moffat (AS, 1960), Julian Opie (UK, 1958) and others; artists that have works in museum collections such as MOMA NY and the Tate, and from Greece Nikos Alexiou (who represented Greece at the 52nd Venice Biennial), Andreas Angelidakis (1968), Angelo Plessas (1974), Kostantin Kakanias and Takis.

■ Eleni Koroneou gallery is also an important player representing artists that have exhibited widely in museum and public spaces and have been included in important international

exhibitions such as the Venice Biennale, Documenta and Istanbul Biennale, such as Larry Clark (US, 1943), George Condo (US, 1957), Gregory Crewdson (US, 1962), Thomas Helbig (DE, 1967), Axel Hütte (DE, 1951), Les Rogers (US, 1966), Dieter Roth (DE, 1930–1998), Michael Schmidt (DE, 1945) and Christopher Wool (US, 1955). Greek artists include Alexandros Georgiou (1972), winner of the 1st DESTE prize, and Eftihis Patsourakis (1970).

■ Ileana Tounta Contemporary Art Centre exhibits both international and domestic artists. Artists include Hilde Aagaard (NO, 1958), Per Barclay (NO, 1955), Maria Friberg (SE, 1966), Joao Onofre (PT, 1976), Pedro Cabrita Reis (PT, 1956), and Greeks Dimitris Foutris (1972) shortlisted for the DESTE prize in 2005, Maria Ikonomopoulou (1961), Thodoros and Costas Varotsos (1955).

■ Antonopoulou Art has Greek modern and contemporaries (Alexis Akrithakis, Lida Papakostandinou, Alexandros Psychoulis, Zafos Xagoraris).

■ Zoumboulakis Gallery has a mixture of established and modern Greek masters (Jannis Moralis, Chronis Botsoglou, Jannis Psychopedis).

All galleries mentioned above participate in international art fairs regularly (Art Brussels, Vienna Art Fair, Art Basel etc).

There are several new 'young' galleries with a very active presence in Athens and the international art scene, such as "The Breeder", which is undoubtedly the gallery with the most energetic profile in the global art market. With both international and Greek artists, an entry at the first Frieze Art Fair in 2003 and participations at the Armory in New York, Vienna ArtFair, Art Forum Berlin, Liste 06, Art Brussels – in all of which it presented very interesting displays – it has formed a stable of artists who exhibit in galleries abroad and participate in many group exhibitions in museums and institutions in Europe and the United States such as Manifesta 02, ICA London, Gem Museum, Kunsthalle Wien and the Stedelijk Museum. Artists include Markus Amm (DE, 1969), Mark Bijl (NL, 1970), Scott Myles (US, 1975), Mindy Shapero (US, 1974) and Greeks Athanasios Argianas (1976), Ilias Papailiakis (1970), Jannis Varelas (1977) and Vangelis Vlahos (1971). The Greek artists mentioned have participations in museum and gallery exhibitions internationally (such as Vlahos's group show at the Stiedjelik Museum in September 2006 and Argianas's recent two-man show at Max Wigram in London). The Apartment gallery hosts a mixture of international and Greek artists. Artists include: Nina Bovasso (US, 1965), Delia Brown (US, 1969), Jonathan Callan (UK, 1961), Maria Finn (SE, 1963), Nina Saunders (DK, 1958), Daniel Sturgis (UK, 1966), Larry Sultan (US, 1946), and greek-born Effie Paleologou and Nike Savvas (AU, 1964).

Batagianni Gallery is also supporting young Greek artists (Christina Calbari (1975), Dimitris Tzamouranis (1967), Vangelis Gokas (1969) and Filippos Tsitsopoulos (1966) seen at the Austrian biennial in 2006, together with a selection of international Rainer Splitt (1963) and Jimmie Durham (1940). Gazon Rouge has a stable of young Greek contemporaries. Young artists with an active presence abroad are Diamantis Sotiropoulos (1978) with his current participation at two group exhibitions at: 'New Acquisitions of Deutsche Bank, 1997–2007', at the Deutsche Guggenheim, and 'Myth – matrix of the world', at Upstairs Berlin, and Eleni Kamma (1973) with her participation at the last Istanbul Biennial and Yorgos Sapountzis (1976).

Lastly, Vamiali's hosts exhibitions of mostly international artists such as Uta Barth (DE, 1958), Diann Bauer (US), Matt Franks (UK, 1970), Liam Gillick (UK, 1964), Mark Hutchinson (UK, 1966), Janice Kerbel (US, 1966), Alexandra Mir (PL, 1967), Ian Monroe (US, 1972), Katy Moran (UK, 1975), Seb Patane (IT, 1970), Greeks and Loukia Alavanou (1978) nominee of this year's DESTE awards.

Thessaloniki is the only other city with commercial galleries, Kalfayan Gallery (which has two more galleries in Athens as well) being the only active presence with participation in fairs all over Europe as well as Dubai with a stable of modern Greeks (Nelly's, Gaitis, Tsingos, Chrysa) as well as contemporaries such as Edouardo Sacaillan (or Eduard Sacajan) and Kostantin Kakanias. Other galleries are TinT and Zina Athanasiadou, but unfortunately they do not participate in art fairs abroad. However, their yearly group shows with young contemporaries are promising.

Fairs/biennials

In the summer of 2007, Athens had much more to offer than the usual sightseeing and ancient marvels. On 30 May Art Athina, the only Greek art fair, relaunched with a new profile, aiming to attract many international collectors. September brought the inauguration of the first Athens Biennial under the title 'Destroy Athens' curated by Xenia Kalpaktsoglou, director of DESTE Foundation, Poka-Yio, artist and Augustine Zenakos, journalist at the V*ima* newspaper, and mainly sponsored by Deutsche Bank. 'Destroy Athens' was the main exhibition. The biennial was planned to 'be a narrative exhibition that can be "read" in various ways by several groups of audiences' (*Athens Voice*, 2007) and for the purposes of its narrative nature, it was set up according to temporary interventions made by the Italian architect team Gruppo A 12. It was held in Technopolis in the Gazi area of Athens, with three smaller projects nearby ('How to endure' curated by art critic Tom Morton, 'Young Athenians' curated by the head of the School of Fine Arts, Edinburgh University, Neil Mulholland, and a video projections programme by German artist Florian Wust). The title 'suggests an attempt to challenge the ways in which identities and behaviours are determined by stereotypical traditions' (Marinos, 2007). The Athens Biennial was also part of the programme Tres Bienn, which brought together three biennials of contemporary art that all took place in autumn 2007: the Athens, Istanbul and Lyons biennials. The initiative illustrated the willingness for collaboration that developed between these three events: exchange of artists and artistic projects, development of cultural interchange, joint communication and visibility strategies. Thessaloniki hosted its first biennial in late May 2007 under the title Heterotopias, with curators Jan-Erik Lundstrom, Catherine David and Maria Tsantsanoglou, and several parallel projects happening in the city.

Auctioneers

Christie's has a Greek office in Athens, and holds auctions of Greek contemporary and modern art occasionally in Athens and Thessaloniki. Its London office holds Greek art sales twice a year. The same is true for Sotheby's London offices, with sales at either Bond Street or Olympia. Lastly, Bonhams holds one or two Greek sales per year: the sale on 15 May 2007 fetched more than £3.87 million and broke many records, such as the highest price for a living artist with lot 122, Yiannis Moralis's *Composition* (1965) (high-end estimate of £180,000, hammer price £490,400). The London sales usually fetch more than the estimates. There are a few examples of internationally acclaimed contemporary Greek artists (including Lucas Samaras (b 1936), (Vassilakis) Takis (b 1925), Jannis Kounellis (b 1936) and Chrysa (Vergi) who appear in international sales apart from Greek ones: typically in Munich, Paris, Italy and the United States.

There is one Greek auction house, Vergos, which deals mostly with 18th–20th-century works by Greek artists and holds between two and five sales annually, which are usually very

successful. Vergos Auctions started with sales in books, rare documents and engravings, and during the last 10 years has hosted 19th and 20th-century art auctions due to their success abroad. Mihalarias Art has also held auctions of 19th and 20th-century artists since 1987 but with not much activity recently. Buying preferences do not differ between Greek and overseas auctions when it comes to 19th-century artists, but on modern and contemporary works there is a slightly more conservative taste within Greece, and a preference for pictorial or expressionist works. In my opinion Greeks tend to buy aesthetically easier to like works by artists such as Dimitris Mytaras (b 1934), Alekos Fasianos and Yannis Tsarouhis (1910–1989).

Collectors and collections

Greek tycoons have always been avid art collectors over the years, and have supported artists (Greeks and international) even during difficult times such as the economic depression of the 1920s in the United States and the World Wars. Many Greek art collectors live abroad, especially in the United Kingdom. The Goulandris and Niarchos families are examples of collectors that support the international art scene apart from the Greek. However, when looking at the Greek art market and its players, apart from three to five collectors with their own collections that have been turned into museums (see below) most of the middle class in Greece have little interest in art. There are several reasons, but I think it is mostly because an interest in art is not instilled into children, since art history and European art are only taught at private schools. This creates an economic problem for artists living in Greece, since the vast majority of people with an income that would allow them to buy art on a moderate scale are not really part of the market. Lastly, the economy in Greece in general has been difficult since the introduction of the euro, and is recently facing troubles with fines and sanctions from the European community, which leads to art and its market being considered by the government as a luxury.

As a result galleries tend to depend on major collectors, who are not many. It has always been the upper classes that took an interest in investing in art, mostly due to their social status and travel. The auctioneers in Athens profit mostly from sales by artists of the 19th and early 20th century, since they are the safest investment. There are few risks involved in buying a Gyzis, Lytras or a Volanakis painting (as shown from their prices rocketing, in the analysis above).

Greeks are not very well trained in art buying and there are few if any professional art consultants, so arguably potential buyers do not yet feel very confident in buying work from contemporary young artists who seem to do well abroad. Nor are they very familiar with it: many Greek collectors, when they talk about Greek contemporary art, are actually referring to Greek modern art (art of the 1960s). This lack of information, the education gap and the lack of investment (mostly public but also private) are the main reasons that Greek contemporary art is not well known within its own borders, let alone promoted abroad. As critic and curator Katerina Gregos put it, 'I often hear the rather uncomfortable – for me – question, "So, is there really contemporary art in Greece?"' (Gregos, Pappa and Zaharopoulos, 2004).

Dakis Joannou, founder of the DESTE foundation in Athens, established in 1983, has however supported and promoted contemporary art in Greece and Greek contemporary art abroad. He is a megacollector on an international scale, appearing in the top 20 of *Art Review*'s power list for the last five years, and has a vast and interesting collection including work by Kutlug Ataman, Matthew Barney, Vanessa Beecroft, Maurizio Cattelan, Rineke Dijkstra, Fischli & Weiss, Gilbert & George, Douglas Gordon, Andreas Gursky, William Kentridge, Martin Kippenberger, Jeff Koons, Paul McCarthy, Shirin Neshat, Noble & Webster, Chris Ofili,

Gabriel Orozco, Charles Ray, Pipilotti Rist, Cindy Sherman, Wolfgang Tillmans, Kara Walker and Gillian Wearing, together with a Greek contemporary collection.

DESTE is a non-profit foundation which showcases contemporary art exhibitions curated by the likes of Dan Cameron, Ali Subotnick, Maurizio Cattelan and Massimiliano Gioni, Jeffrey Deitch, Katerina Gregos and Marina Fokidis. From its inception, DESTE has mounted several shows in Greece and abroad. There have been many presentations of the collection over the years with two particularly notable ones, Everything that's interesting is new (1996) and Monument to now (2004). The 1996 show caused quite a stir in Athens and led to a new-found interest in art and many galleries in the city. To further support its mission, the foundation inaugurated the DESTE Prize in 1999, awarded biannually to a Greek artist. Artists nominated for the 2007 award were Loukia Alavanou (winner), Nikos Arvanitis, Savvas Christodoulides, Socrates Fatouros, Jannis Grigoriadis and Eleni Kamma.

Leonidas Beltsios supports mostly young Greek artists, and recently organized a huge exhibition of contemporary Greek art together with some works from the 1960s and 1970s generation, in his hometown Trikala (see www.beltsioscollection.gr). One very big collection of modern and contemporary Greek art is the Emfietzoglou Collection, with more than 600 works from the 19th–21st centuries, including works by Gysis, Parthenis, Bouzianis, Maleas, Kounellis and Takis. The J F Costopoulos Foundation holds the very important Alpha Bank collection, with an equally large selection of artists from the 19th century to contemporary. It collaborates regularly with state museums and hosts exhibitions, as well as funding numerous art projects and initiatives. Other collections include the Portalakis Collection, Athens, the Averof Collection in Metsovo, the I Katsigras Collection in Larissa, the Pieridis Collection in Athens and the Kostas Ioannidis Collection.

Public collections and museums

Representative works of all 19th century and early 20th century artists up to the 1960s are held at the National Gallery, which holds more than 15,000 works of Greek art and is considered to be a treasury of Greek art from the meta-Byzantine period until the '80s. Apart from purchasing a few important works by El Greco, and a smaller collection of works that were given to the Greek state as a token of appreciation for the Greek resistance during the Second World War by a group of artists such as Pablo Picasso, Francis Picabia, Henri Matisse and Pierre Bonnard, the National Gallery does not hold a large collection of European works. The National Gallery has been united with the Alexandros Soutzos Museum and the Koutlides Collection, and regularly organizes exhibitions of international and Greek artists: for example in April 2007 the Athens–Paris exhibition featured work by Paul Cezanne, Picasso, Nikolaos Gyzis, Constantine Parthenis and Konstantinos Maleas.

The National Museum of Contemporary Art (EMST) was founded in 2000 and aims to fulfil a true vision, reinforced by its director, Anna Kafetsi. Unfortunately as yet it has no building, since due to bureaucracy and reluctance from the government to immediately clear funds, the former FIX Factory on Sygrou Avenue in Athens is yet to be completed. It holds a collection with artists such as Marina Abramovic, Vito Acconci, Kutlug Ataman, Linda Benglis, Nan Goldin, Dan Graham, Mona Hatoum, Gary Hill, Rebecca Horn, Vlassis Kaniaris, Nikos Kessanlis, Jannis Kounellis, George Lazongas, Nikos Navrides, Shirin Neshat, Dennis Oppenheim, Nam June Paik, Walid Raad & the Atlas Group, Pipilotti Rist, Martha Rosler, Lucas Samaras, Carolee Schneemann, Tomas Struth and Bill Viola. Unfortunately, like other Greek museums EMST has a limited budget for buying works of art. There are very few donors

and benefactors, but these include the I Costopoulos Foundation, the Niarchos Foundation and Alpha Bank, as well as the Attiko Metro company in Athens. Finally, the Benaki Museum in Athens, with its second new building at Pireos Street, has a large programme and hosts contemporary, modern, architecture and other very interesting exhibitions.

Other museums include the State Museum of Contemporary Art in Thessaloniki, which also holds the Costakis collection of Russian avant-garde, and hosted the first Thessaloniki biennial. The Photography Museum in Thessaloniki hosts the Photosynkyria, an international photography exhibition that recently transformed into a biennial event, and the Macedonian Museum of Contemporary Art has a new programme by recently appointed artistic director Denys Zaharopoulos. In Crete there is the Rethymnon Centre for Contemporary Art.

Cultural policies are very much centralized: museums, collections and art centres depend on the Ministry of Culture for financial aid, and due to the limited funds big museums in Athens and Thessaloniki are the ones that usually benefit. Other funders are the National Bank, ERT (the state television and radio station) and the Alexandros Onassis Foundation. Efforts have been made since 2000 to decentralize the art centres and public galleries in Greece, and there have been indeed many interesting new galleries and centres created, but many of them, such as the Larissa Art Centre, have unfortunately been closed down by the current government.

Legal issues and taxation

Unfortunately Greece is not very up to date with legislation regarding artefacts, so it is not very collector-friendly. Donations and art sponsorships are not encouraged by special taxation schemes, although the Ministry of Culture has recently proposed a new law for the restitution of taxes referring to donations and sponsorships. Companies, which could give great amounts of money to endorse, sponsor or donate art exhibitions and events, are limited to donating money to art institutions mainly for publicity reasons.

Wealth and inheritance tax

There is a difference between Greece and other countries in the EU: for purchases of any movable objects (not land or a house) that exceed the amount of €5,000 the tax office is allowed to enquire how the buyer obtained the money. This applies only to individuals and not companies.

Works of art are taxable for inheritance purposes, and are included in the estate of the deceased. The tax office usually asks for help from a state art institution (such as the National Gallery) to evaluate the value of the work. The rates of taxation depend on the family ties between the deceased and the persons that accept the inheritance.

VAT

VAT on art works and artefacts is as follows (*Art Newspaper*, 2007):

■ 9 per cent for works of art that are considered unique: paintings, drawings, watercolours, sculptures that are carved and that are assembled (not casts), which have been bought from a gallery that acts as an intermediary between artist and buyer.
■ 19 per cent for sculptures – even if they are of a small edition – original prints, limited editions, photographs, DVD works, video works and installations; this rate is charged for works that are bought from the stock of a gallerist and not during a current exhibition.

■ 19 per cent for all sales of works by artists that are no longer alive. This applies to the seller's commission (which in Greece is around 15 per cent for auction houses but usually 50 per cent for galleries). When a gallery or a company buys a work but not straight from an artist, then there is a purchase agreement form to which is applied not the usual 9 per cent or 19 per cent but 3 per cent VAT plus a 20 per cent revenue/tax stamp on the VAT, which amounts to a 3.6 per cent of the sale price. There is no VAT on a sale between two individuals.

Import/export tax

There is taxation for all artefacts and art works imported from countries outside the European Union and intended to remain permanently in Greece. In general, paintings, drawings, sculptures (in limited edition or not) are subject to a 9 per cent tax, whereas new media works are subject to 19 per cent. There is no export tax in Greece.

Intellectual property rights/copyright

The Greek law 2121 of 1993 referring to IPR charges 5 per cent for reselling works of an artist without as yet setting an irreducible minimum and also without offering a sliding scale.

Acknowledgements

I would like to thank the staff at the Library of the National Gallery in Athens, for their valuable help, guidance and patience.

For further information on the development of this particular art market, go to: www.koganpage.com/artmarkets.

Bibliography

Art Newspaper (2007) Greek version, no 155, March
Athens Voice (2007) Interview with Augustine Zenakos, co-curator of Destroy Athens, 20 April, p 26
Gregos, K, Pappa, S and Zaharopoulos, D (2004) *Breakthrough! Greece 2004: Contemporary perspectives in the visual arts*, catalogue of the ARCO exhibition, Madrid
Kathimerini (2005) Epta Imeres supplement, 13 March 2005
Marinos, C (2007) An island of creativity: Athens art scene in Grigoteit, A (ed) Affinities, Deutsch Bank Collection, exh cat 28.4–24.6.2007, Deutsche Guggenheim, Frankfurt, p 209–21
Skaltsa, M (1989) *Art Galleries in Greece, Athens Thessaloniki 1920–1988*, Apopsi Editions, Athens
Misirli, N (1993) *Greek Painting 18th–19th Century, National Gallery – Alexandros Soutzos Museum*, Adam Editions, Athens
National Gallery – Alexandros Soutzos Museum, Municipal Gallery of Patras (1995)
Greek Painting: The 30's generation, January
National Gallery – Alexandros Soutzos Museum, Corfu Department, (1996) *Greek Painting: The 30's generation after the war*, July–December

India

Sonal Singh

The growth of the art market in India

From as early as the mid-1960s, work by select Indian artists began appearing intermittently at international auctions. (Some of this was work by artists such as Francis Newton Souza (1924–2002), S H Raza (b 1922), M F Husain (b 1915) and Ram Kumar (b 1924), which had been bought by collectors in England and France at the time that the artists were living there.) The first sale of modern and contemporary Indian art was held in 1988, and was of works from the collection of India's largest media group, the Times of India. This sale was held in New Delhi and was auctioneered by Sotheby's. Four years later, in 1992, Sotheby's organized a sale of its own in Delhi. Disappointed by the lack of turnout and high rate of lots being bought in, it was only in 1995 that annual auctions featuring Indian contemporary art were started by Christie's and Sotheby's. These sales were held in London.

The sale of the Chester and Davida Herwitz collection by Sotheby's on 5 December 2000 in New York is often regarded as the first auction to put Indian art in the spotlight. This was the third sale of the Herwitzes' collection and included 193 lots of Indian art, bringing in a total of $1,383,000, with an average of $7,166 per lot. (The other two sales were held in 1995 and 1997; auction results source: www.sothebys.com sale NY7563). The year 2000 was also important for the history of this market for another reason as it marked the launch of India's two main indigenous auction houses, Saffronart, an online auction house and Osian's, both based in Mumbai (erstwhile Bombay). Prior to this, most sales of art held within India were through private transactions with galleries or in some cases with the artists directly. This meant that all centres for contemporary Indian art in India had a strong and established gallery system.

The two cities leading the market were New Delhi and Mumbai. Here galleries such as Vadehra, Dhoomimal and Kumar Art Gallery in Delhi, and Chemould and Pundole in Mumbai, had been in operation from as early as 1936 and had a small yet loyal following of buyers. However, artists did not have to deal through any one gallery in particular. Rather, artists were free to sell to any dealer they chose. The idea of a gallery exclusively representing an artist did not exist.

Buyers for art at auction were mainly non-resident Indians (NRIs), and resident Indians were not seen buying at international sales. In 1999 Indian auctions were shifted to New York. Indian art was often also included at the Southeast Asian pictures and 20th century Indian pictures sales held by Christie's in a few other cities that have a strong NRI base, such as Singapore and Hong Kong.

The art market today

Since 2000, there has been a noticeable shift within the Indian art market, not just in terms of sales but also in terms of visibility, as Indian artists have begun to be included in a number of seminal international exhibitions at museums, art fairs and biennales. Indian artists have been shown in museums over a wide geographical area, such as the Tate Modern (London), Asian Art Museum (San Francisco) and the Ecole de Beaux Arts (Paris). Indian art is also being featured at biennales such as those held in Venice, Moscow and Sao Paulo. This has sparked interest from a broader global audience, with many of the high-priced pieces being bought by foreign buyers. Yet international buyers still account for approximately only 15–20 per cent of all sales. The main shift that has occurred has been between the NRIs and resident Indians, as a large proportion of buyers are now resident Indians and the number of collectors within India has continued to increase substantially every year.

Amrita Jhaveri in *A Guide to 101 Modern and Contemporary Indian Artists* (2005) states that 'Those defining Indian art today do not share a common style or medium: painting and · sculpture exist alongside installation, photography and video, performance and web-based art.' This is only true of the creators and is not a reflection of the predominant market trend, as most dealers find a fair amount of similarity in tastes where buying art is concerned, with a large number of buyers following the few taste-making collectors. Buyers have repeatedly shown a bias towards painting, while sculpture and other media have not been able to capture their attention. As the profile of buyers changes to a younger, international and fashion-conscious group, there has been a notable shift in tastes in favour of artists addressing contemporary issues, such as Atul Dodiya (b 1959), N S Harsha (b 1969) and Jitish Kallat (b 1974), and those working in the style of photorealism, including Subodh Gupta (b 1964) and Shibu Natesan (b 1966).

There is a small section of the buyers that continue to collect work by the Old Masters. These include artists that come under the banner of 'National art treasures': Abanindranath Tagore (1871–1951), Gaganendranath Tagore (1867–1938), Rabindranath Tagore (1861–1941), Jamini Roy (1887–1972), Sailoz Mukherjee (1908–1960), Nandalal Bose (1882–1996), Amrita Shergill (1913–1941), Hemen Mazumdar (1894–1948) and Raja Ravi Verma (1848–1906). However, there is little overlap between these buyers and those buying contemporary art. In each instance, it is still painting that leads in preference, regardless of the period and artist.

Galleries

As the market has grown, galleries have become more aware of their rights where artists are concerned, and most contemporary artists are now represented by a single gallery/dealer in a city. While this has allowed for the establishing of a single pricing system for works by the artists, it is however still rare for an artist to be exclusively represented by a gallery, and the more popular the artist is, the more galleries they are likely to have. For example Subodh

Gupta (b 1964), an artist working out of Delhi, is represented by Nature Morte in Delhi, Bodhi Art in Mumbai and Singapore, Jack Shainman in New York, in SITU in Paris and Art & Public in Geneva.

As artists are often represented by a number of galleries, competition between these galleries/dealers to ultimately gain exclusivity is very high. Thus, galleries have opened spaces in more then one city in an attempt to provide their artists with maximum visibility. Yet most galleries are historically linked to a particular city, such as Chemould, Sakshi and Pundole in Mumbai, Gallerie 88 and CIMA in Kolkata, Sumukha and Ske in Bangalore, and Vadehra and Nature Morte in New Delhi. The newest entrant to the whole gallery system is Bodhi Art, which in a span of two years has opened four spaces in Mumbai, New Delhi, New York and Singapore, and has come to establish itself as one of the most significant advocates of Indian art today.

Recently, the gallery system experienced a few jolts as international players have begun to notice the work of Indian artists. One of the most active international galleries is the Berkeley Square Gallery in London. Other dealers include the Grosvenor Gallery (London), Galerie Müller and Plate in Germany, Enrico Navarra in France and Arrario in China. Seeing this international interest, artists are increasingly keen that local galleries exhibit their work abroad. As a result, many Indian galleries have formed partnerships with these international galleries, such as Berkeley Square with Saffronart and the Grosvenor Gallery with Vadehra Art. This has facilitated a check on the pricing of works by foreign galleries, and has kept prices within the same range as those for works sold in India.

Another factor forcing a change within the established gallery system in India is the impact that galleries like Bodhi Art have made in the past few years by drastically changing the old standards. Changes have been made at every stage of the functioning of a gallery, beginning with the basics of display and design for exhibitions and publications. A new level of professionalism has been introduced into their relationships with artists, buyers, museums, curators and critics. Works made by their represented artists are now being documented and archived, and galleries have begun to hold regular talks, presentations and discussions on the subject. This is perhaps only natural, and as the buyer's base of the galleries expands to international collectors, galleries in India will continue to model themselves on their counterparts in New York or London.

Art fairs, biennales and triennials

An area that has seen a slow but increasing presence of Indian contemporary art is international art fairs and biennales. Its limitation and slowness are partly due to the financial limitations of galleries, and also because most members on the selection committees are not familiar with Indian art. It is not uncommon for the committees to dictate the names of the artists they would like to see exhibited, and galleries are accepted only by promising to exhibit one or more artists from the select handful of very well-known names.

Public art and public patronage of art are not common phenomena in India, and this may be because the government tends to lean towards encouraging handicrafts. There is essentially one museum for modern and contemporary art: the National Gallery of Modern Art (NGMA). It has two branches in Mumbai and New Delhi (with a third opening in Bangalore shortly); however it is tightly controlled by the government and tends to favour retrospectives of senior artists. While the museum does have a good collection of contemporary art, the public has yet to see any involvement by the NGMA in organizing and curating shows of it.

India has held a triennial of international art in New Delhi since 1968. However, it has led to general dissatisfaction as the artists shown are usually those with state sponsorship, and thus not considered an accurate representation of the prevailing art scene in their country. To counter these criticisms, a Delhi-based group proposed to hold the first Delhi Biennale in early 2008, in a new wing of the NGMA, New Delhi. The group consists of artists and critics including Vivan Sundaram, Geeta Kapur, Gayatri Sinha, Pooja Sood and Jyotendra Jain.

In 2005 Peter Nagy, founder of Nature Morte in Delhi, along with two other independent curators – Gordon Knox (director, Montalvo Arts Centre, California) and Julie Evans (a New York-based artist) – exhibited work by Indian artists at the Venice Biennale. Although India does have a long-standing agreement to participate more actively in Italy's cultural events, this was the first time that there had been a presence of Indian art at the Biennale. The display was not an official pavilion sponsored by the Government of India, but ran parallel to the Biennale at the refectory of the former Convent SS Cosma & Damiano. Work included paintings, videos and installations by very well-established contemporary artists such as Atul Dodiya (b 1959), Ranbir Kaleka (b 1953) and Nataraj Sharma (b 1958).

Auctions

Until recently, international auctions of modern and contemporary Indian art were dominated by an older group of artists, and included those who had played an active part in the Indian art scene before 1965. In the past few years however, auctions have begun to cover a larger range of artists and to include the work of a younger and more widely dispersed group. There are a number of reasons, most obviously the change in buyer demographics to a younger more adventurous group who are willing to diversify their portfolios.

While the art scene in India has a growing base of young artists, only a handful have managed to capture the interests of international museums, art critics and buyers. This group includes Atul Dodiya, Anju Dodiya (b 1964), Subodh Gupta, Jitish Kallat (b 1974), N S Harsha (b 1969), T V Santhosh, Surendran Nair (b 1956), Nataraj Sharma, Bharti Kher (b 1969), Jagannath Panda (b 1970) and A Balasubramniam (b 1971).

Market performance

As in the case of all markets, it is difficult to estimate the net worth of the Indian art market as a large percentage of sales made are through galleries and private sales. Media quotes have ranged between $175 million and $440 million, yet these are not supported by any evidence. A better understanding of the growth in the market for Indian contemporary art is apparent from auction results of this sector in the past few years.

In the first half of 2006 alone, there were over 10 auctions held by Sotheby's, Christie's, Bonhams, Saffronart and Osian's that featured modern and contemporary Indian art. Sotheby's, Christie's and Saffronart held seven auctions between them, bringing in over $45 million in sales, with an average lot price just under $65,000. Indian art has usually been included in two of Sotheby's and Christie's annual sales; since 2005 it has featured on a more regular basis.

The March 2006 sales held in New York by Sotheby's and Christie's brought in $12,171,200 and $15,627,080, respectively with more than 13 lots going for over $500,000.

Saffronart's auction in May 2006 brought in $12,868,000, with 91 per cent of lots selling above their high estimate. This has not always been the trend: as recently as May 2005, Saffronart's auction fetched $3,700,160, averaging just over $25,000 per lot, compared with $86,000 per lot a year later. This is also true for Sotheby's and Christie's: in 2004 their total sales value for modern and contemporary Indian art was $1,917,500 and $2,276,000 respectively.

Such significant price increases have not gone unnoticed, and have received a tremendous amount of attention from the press, buyers and inevitably investors. The sector has received a fair amount of attention from not just the domestic media but also the international press, including *Newsweek,* the *Economist,* the *Financial Times* and the *New York Times*. The Indian press has fuelled the belief amongst its readers that it can be profitable to invest in art, and in 2006 and 2007 a number of funds sprung up that invest purely in contemporary art, started by art galleries such as Sakshi in Mumbai, auction houses – both Saffronart and Osian's – and even national banks including Kotak and ICICI.

The immediate future

While there has been a swift expansion of the market over a relatively short period of time, there has also been an increasing degree of speculation, which makes one question the sustainability of the market. However, it is unlikely that prices for Indian art will fall as the buyers' base has continued to grow simultaneously. One of the main reasons is the rapidly expanding middle class in India who are looking to attain social and cultural status and who will continue to demand art, especially that of younger artists whose work they can relate to. Another factor is that the international buyer's base has also increased and in comparison with contemporary artists from the west and even China, work by Indian artists is relatively undervalued. An example of this was the Christie's auction of Asian contemporary art in May 2006. While the work of Indian artists averaged $44,000 per lot, the average lot price for Chinese art was $110,000.

Essentially regarded as immature, the Indian art market is also very opaque. Saffronart has become one of the leading auction houses for Indian contemporary art, resulting in partial visibility of some of the transactions in the market. While the media hold the key to creating awareness amongst the public on the status of the art market, they have unfortunately played a negative role by only focusing on those lots that have achieved record prices. Further, the media has also glorified the possibilities of art investment, and in many ways have validated speculation within the market.

As the market grows and matures, we can expect the obvious bias it has had until now for paintings to lessen, and it is likely that the discerning buyer will become more receptive to other media such as photography, prints, new media and sculpture. Photography and sculpture have begun to create a presence, with works of photographers N Pushpamala (b 1956) and Dayanita Singh (b 1961) and sculptors Subodh Gupta, Sudarshan Shetty (b 1961) and Valson Kolleri (b 1953) exhibited frequently. International museums and galleries have always shown a greater interest in the genres of sculpture, installation and photography, and the majority of exhibitions of Indian art abroad have showcased work from these areas.

The area where the market may face a setback is educating new buyers. There is very little documentation on the work created by artists and little government support in terms of museums, public art, biennales and so on. Galleries have already begun to narrow this gap, and will continue to play an important role in the creation of awareness and understanding of the sector – acting like quasi-institutions by publishing books, holding educational discussions and lectures, and often supporting public art projects.

For further information on the development of this particular art market, go to: www.koganpage.com/artmarkets.

Select bibliography

Dalmia, Y (1997) *Indian Contemporary Art: Post independence*, Vadehra Art Gallery, New Delhi

Dalmia, Y (ed) (2002) *Contemporary Indian Art: Other realities*, J J Bhabha, Mumbai

Jhaveri, A (2005) *A Guide to 101 Modern and Contemporary Indian Artists*, India Book House, Mumbai

Kapur, G (1978) *Contemporary Indian Artists*, Vikas, New Delhi

Kapur, G (2000) *When Was Modernism: Essays on contemporary cultural practice in India*, Tulika, New Delhi

Kapur, G, Padamsee, A and Bartholomew, R (1982) *Contemporary Indian Art: An exhibition of the Festival of India*, Royal Academy of Arts, London

Mitter, P (1994) *Art and Nationalism in Colonial India, 1850–1922,* Cambridge University Press, Cambridge

Nagy, P, Knox, G and Pijnappel, J (2005) *Icon: Indian contemporary*, Montavlo Arts Centre, Bose Pacia, New York

Reddy, S (2003) *Nri's Worth 300 Billion,* Terry College of Business, University of Georgia, 6 October

Sheikh, G (ed) (1997) *Contemporary Art in Baroda*, Tulika, New Delhi

Sokolowski, T W, Patel, G and Herwitz, D A (1985) *Contemporary Indian Art – From the Chester and Davida Herwitz Family Collection*, Grey Art Gallery & Study Centre, New York

Tate Modern (2001) Century City: Art and culture in the modern metropolis [online] http://www.tate.org.uk/modern/exhibitions/centurycity

Tuli, N (1998) *The Flamed Mosaic: Indian contemporary painting*, Abrams, New York

Wechsler, J, Gaur, U, Dalmia, Y, Cohen, A L, Keehn, T, Reddy, H, Reddy, S and Tak, M (2002) *India: Contemporary art from north eastern private collections*, Jane Voorheers Zimmerli Art Museum, New Brunswick

Websites

www.artcylcopedia.com
www.artprice.com
www.bankofengland.co.uk
www.bonhams.com
www.christies.com
www.indianartnews.com
www.osians.com
www.rbi.org.in
www.saffronart.com
www.sothebys.com

Indonesia

Vidhyasuri Utami

Over the years, the appreciation of Indonesian art is growing. Indonesian art works that once were a souvenir from the east during the Dutch colonial era – both Indo-European works of Dutch artists who depicted Indonesian scenes and landscape, and Balinese traditional paintings – have become collectable items for art enthusiasts and collectors alike. In 1990, Glerum Auctioneers saw the potential for a specialized auction in Indonesian art, and held one in the Netherlands. The response was promising. Glerum continued to do so during the 1990s, and later entered the south-east Asian market in 1996 – partnered by Bonhams – with an auction in Singapore.

In 2000, Glerum joined the local Larasati auction house and has worked with it ever since. Christie's (1994) and Sotheby's (1996) entered the specialized auction field of south-east Asian art in Singapore in the mid-1990s, while Christie's Amsterdam set up a specialized auction of Indonesian art (offering a number of lots featuring Indonesian art works, textile and antiques) in the 1990s. Various important Indonesian painters also entered the auction scene. The pioneer of Indonesian art, Raden Saleh (1807–1880), the father of Indonesian modern art S Sudjojono (1914–1986) and the prominent Abbas Alibasyah (b 1928), whose work shown in the prestigious Sao Paulo Biennale in 1963 was auctioned by Glerum in Singapore, 1999, were among the featured artists in specialized auctions.

The phenomenon was then followed by local auction houses, which have mushroomed since 2000. Nowadays there are at least five auction houses (Larasati, Borobudur, Masterpiece, Cempaka and Sidharta's Auctioneers) that regularly hold at least two auctions per year in and outside the country. In 2006, the Indonesian market witnessed at least 20 auctions featuring Indonesian art works in and outside the country. Larasati, the oldest surviving auction house on the local art scene, has shown consistency in conducting auctions throughout the years. A new trend that is worth mentioning is the sale of 'affordable art'. Works targeted at below IDR50 million, sold through the newly established Sidharta's Auctioneers, have gained attention especially from new collectors of Indonesian art.

Several categories of art works are auctioned. Probably the oldest category is Indo-European art: that is, Dutch or other foreign artists depicting Indonesia around the start of the 20th century. The artists include Jacob Dooijewaard (1876–1969), Wynand Otto Jan Nieuwenkamp, C L Dake (1886–1946), Gerard Adolf Peters, Adrien Le Mayeur de Mepres

(1880–1958), W G Hofker (1902–1982), Rudolf Bonnet (1895–1978), Walter Spies (1895–1942) and Arie Smit (b 1916). Raden Saleh is also sold with this group. Second is the Balinese school, for which demand seems to rise and fall: it includes a variety ranging from the classical Kamasan to the newer generation of Balinese traditional art, including the Pita Maha artists and their disciples. A special auction of this category (the Pre-war Balinese modernists: 1928–1942) was held by Christie's Singapore in September 2001, generating a total of S$607,005 (US$38,193). Another specialized auction for Balinese lots was held in July 2006 by Larasati in Bali, making up to IDR4,024,568,000 (S$7,610,124).

The third category is modern and contemporary Indonesian art: names such as S Sudjojono, Affandi (1907–1990), Lee Man Fong (1913–1988, actually a Singaporean citizen), and Hendra Gunawan (1918–1983). (Lee Man Fong also edited the book *Lukisan-Lukisan dan Patung Koleksi Presiden Sukarno dari Republik Indonesia* (Paintings and Statues from the Collection of President Soekarno), a basic reference for Indonesian art.) Newer Indonesian art works were hived off from this category in the late 1990s, with sales of contemporary Indonesian art by Christie's and Sotheby's. This newer generation of Indonesian art includes the first three generations of graduates from Yogyakarta Art School (established in 1950). Two prominent names that generated high appreciation are Srihadi Soedarsono (b 1931) and Sunaryo (b 1943). This changing period in Indonesian art grew in significance as the postmodernism discourse 'invaded' Indonesian art, as shown in the featured works of the Jakarta Biennale XI in 1998. It exemplifies the flexibility of the art market toward the growing trend of discourse in the Indonesian art scene.

Table 17.1 shows the top prices gained for Indonesian art up to and including 2006. The top prices in Indonesian art are dominated by Indo-European works. Thus this category is the blue chip of Indonesian art, with highest values and a stable price throughout the years. Names such as Adrian-Jean Le Mayeur, Rudolf Bonnet and Raden Saleh dominate the list, while Hendra Gunawan and Affandi are among the highest priced Indonesian modern artists.

Raden Saleh's works were amongst the highest priced at both Christie's and Sotheby's. For example *A night eruption of the Merapi Volcano on Java* was auctioned by Christie's Singapore in 1994 for NLG360,000 (IDR1,924,379,310 at current conversion rates: 1 NLG = 5,345.50 IDR) (Van Donk, 1996: 166). It was resold by Christie's Hong Kong in November 2006 for HK$2,136,000 (IDR2,563,000,000). The price record for Raden Saleh goes to his *Deer hunter* (1848) which sold for S$3,083,750 (IDR17,932,006,250) in Christie's March 1996 auction.

Adrian-Jean Le Mayeur de Mepres also sells consistently: his *Terrace affording a view of the sea with Pollok under an umbrella and several figures* went up to HK$14,402,760,000 in 2006, while his *Ni Pollok* was valued at IDR2,300,000,000 in Larasati's auction in 2001. Le Mayeur's sought-after works usually come from his Balinese period and feature his wife, Ni Pollok, as model. Work by Rudolf Bonnet, founder of Pita Maha, an association for Balinese painters in 1930, made HK$4,879,750 (IDR 5,767,864,500) in Christie's October 2004 auction.

Hendra Gunawan's *Women at a waterfall* went for S$245,750 (IDR1,429,036,250) in Sotheby's October 1996 auction, *Penjual Ikan* for S$480,000 (IDR2,776,800) in Larasati's 2003 auction, and *Reclining nude* for HK$2,248,000 (IDR2,657,136,000) in Christie's 2006 auction. Affandi was also a frequent entry in the price charts. In Christie's April 2004 auction, four of his works took HK$ 3,268,900 (IDR3,863,839,800), generating 9.24 per cent of the auction total (for 100 lots). *Minum Tuak* went for S$406,400 (IDR2,363,216,000) in Sotheby's April 2004 auction in Singapore, while *Kuda-kudaan* sold for S$380,000 (IDR2,209,700,000) in Larasati's 2005 auction in Singapore.

Table 17.1 Top prices for Indonesian art, as of 2006

Rank	Artist	Title of work	Sold by	Date
1	Adrian-Jean Le Mayeur	*Terrace affording a view of the sea with Pollok under an umbrella and several figures*	Christie's Hong Kong	May 2006
2	Lee Man Fong	*Bali life*	Borobudur Jakarta	February 2006
3	S. Sudjojono	*Pura Kembarn*	Christie's Hong Kong	November 2006
4	Adrian-Jean Le Mayeur	*Four maidens*	Sotheby's Singapore	October 2006
5	Lee Man Fong	*Feeding the chicken*	Christie's Hong Kong	November 2006
6	S. Sudjojono	*Indestructible desert*	Christie's Hong Kong	May 2006
7	Adrian-Jean Le Mayeur	*Two Tahitian beauties*	Christie's	May 2006
8	S. Sudjojono	*Tempat Mandi di Pinggir Laut*	Borobudur Jakarta	December 2006
9	Raden Saleh	*The eruption of Mount Merapi at night*	Christie's Hong Kong	November 1996
10	Raden Saleh	*Merapi and Merbabu*	Christie's Hong Kong	May 2006

Indo-European art

Several artists' works gained significant appreciation in and outside the country, including those of German painter Walter Spies. *Rehlandschaft in Djembarana* sold for S$1,549,550 (IDR) in Sotheby's April 2001 auction, while *Die Landschaft und ihre Kinder* made HK$8,874,100 in Christie's October 2002 auction. The fact that his works rarely come to market make them a sought-after item. Miguel Covarrubias (1904–1957, a painter of Balinese themes), Isaac Israels (1865–1934), WG Hofker and Theo Meier (1908–1982) are also important artists in this section.

Indonesian modern art

A key role here is played by S Sudjojono, once referred to as the first Indonesian cartoonist by Sukarno. The value of his works has appreciated although works from the important period of 1950–60 rarely surface at auction; most sales are of post-1970s works. His price record is for *Pura Kembarn* (HK$3,700,000 (IDR4,445,000,000): see Table 17.1). Illustrator-cum-journalist Sudjana Kerton (1922–1994) documented the history of Indonesia – in its early period, including the 1949 Dutch recognition of Indonesian sover-eignty – in his sketches. In Sotheby's April 2004 auction *Sisingaan,* describing a traditional Sundanese celebration, went for S$406,400 (IDR2,363,216,000). Lee Man Fong's works are sought-after and often resold. *Three Horses* was sold for S$260,280 (IDR1,513,528,200) in Sotheby's April 2004 auction, and resold by Borobudur in September 2006 auction in Jakarta for S$302,800 (IDR1,755,000,000).

The Balinese school

Paintings by the traditional Balinese school entered the international art market long before there were specialized auctions of Indonesian art. During the early 20th century, they were sold mainly as tourist souvenirs. Patrons in the early 20th century – such as Rudolf Bonnet, the Neuhaus brothers, Gregory Bateson and Margaret Mead – ensured Balinese paintings entered the international art market. These works also featured in the first decade of specialized auctions (the 1990s), with names such as Anak Agung Meregeg (1908–2000), I Ketut Djodjol (b 1940) and Ida Bagus Kembeng (1897–1954).

The classical style of Balinese paintings is called Kamasan, and is often found in temples depicting the ritual function of art in Bali. This style is used to illustrate the two Hindu scripts, the *Mahabharata* and the *Ramayana*, and various folk stories – for instance *malat panji* and *calon arang* – appeared in this style. The same technique and themes are still used today.

The Batuan style, also found in Bali, is often considered as a further development of Kamasan style. It uses the traditional technique of *sigar mangsi* (black and white sketches) and colouring. This style usually depicts a more eerie atmosphere (*tenget* as Balinese called it) in paintings showing Balinese folk stories or daily scenes.

Painters such as Rudolf Bonnet and Walter Spies introduced the western aesthetic to Balinese painters, and this led to secular themes on Balinese canvases. However village scenery, market life and similar subjects still predominate. This is known as Ubud style. Batuan and Ubud-style works have received notable appreciation while the classical Kamasan style has not yet met with the same approval.

Indonesian contemporary art

Of more modern works, Srihadi Soedarsono's *Purnama di atas Borobudur* sold for IDR1,000 million in Larasati's March 2003 auction. Sunaryo's *Stagen Merah* made S$312,000 (IDR1,814,280,000) in Sotheby's in October 2005. Sagita (b 1957), Heri Dono (b 1960), Dede Eri Supria (b 1956), I Nyoman Masriadi (b 1973), Agus Suwage (b 1959), Mangu Putra (b 1963), Rudi Mantofani (b 1973), Handiwirman (b 1975), and Putu Sutawijaya (b 1971) are also contemporary artists whose work sold well. I Nyoman Masriadi's *Weekend* was sold for HK$168,000 in Christie's May 2005 auction. Agus r Suwage's *Luxurious blue* made HK$96,000 in Christie's November 2005 auction. Mangu Putra's *Tatapan Mata Komang* made S$13,200 in Sotheby's Singapore October 2005 auction.

Other Indonesian artists of note include the leading female artist of the 1940s, Emiria Soenassa, whose works appeared in a special section of Sidharta's Modern Art auction in December 2005, Agus and Otto Djaja (1916–2002), the decorative-style painter Kartono Yudhokusumo (1924–1957), Henk Ngantung (1921–1991), Itji Tarmizi (1935–2001), Nasjah Djamin (1924–1997), Oesman Effendi (1919–1985), Zaini and Ahmad Sadali (1924–1987). Mochtar (1938–1986), a Bandung school sculptor/painter, emerged as a leading figure when his *Fun in the sun* made IDR850 million (against an estimate of IDR80–110 million) in Larasati's December 2004 auction.

Contemporary artists also worth mentioning are Made Wianta (b 1946), Ay Tjoe Christine (b 1973), Dadang Christanto (b 1957), Koeboe Serawan (b 1961) and Eko Nugroho (b 1977); their works are starting to attract significant attention in and outside the country.

Other contemporary artists sell more through exhibitions rather than auctions. Names seemingly off the auction radar though equally interesting to observe are FX Harsono (b 1948, a leader of the first generation of Indonesian contemporary art in the 1970s), Dolorosa Sinaga (b 1952, a mentor of Indonesian sculptors, whose works are internationally known and collected), Sigit Santoso (b 1964, from a new school of Indonesian surrealism in the 1990s), Yani Mariani (b 1955, an established sculptor whose feminine signature style stands out from other sculptors of her generation), Awan Simatupang (b 1970, famous for his dreamy-like sculptural forms) and Hanafi, whose latest 'maturing' abstract works have drawn a lot of attention from critics and collectors. The works of two older sculptors, Sidharta Soegijo (1932–2006, also a painter) and Rita Widagdo (b 1938, the pioneer of abstract sculpture in the Bandung School) would also be a valuable addition to any collection of Indonesian art.

For further information on the development of this particular art market, go to:
www.koganpage.com/artmarkets.

Reference

Van Donk, R (1996) *Paradise Framed: A guide to Indonesian paintings, drawings, water-colours, lithographs and woodcuts,* 2nd edition.

Ireland

Clare McAndrew

The Irish art trade

The Irish art market is relatively small, accounting for just over 2 per cent of the EU turnover and a little less than 1 per cent of international share of auction and dealer turnover. There are over 200 businesses currently trading in the Irish art market. The three largest art auction houses, located in Dublin, are Adam's, DeVeres and Whyte's, which account for over 90 per cent of Irish art auction sales. Some larger auction houses such as Sotheby's and Christie's hold sales of Irish art but these are carried out exclusively in their UK auction rooms. The remaining 10 per cent of sales are conducted through a number of smaller regional houses that hold art auctions throughout the year, although often on a more irregular basis. The 'big three' houses predominantly sell Irish art, and the bulk of sales are in the modern and contemporary sectors. Although there are no official figures, it is estimated that there are somewhere in the region of 160 art dealers or galleries throughout Ireland.

The only publicly available information on the art market in Ireland is from auction houses, as dealers conduct private sales and are extremely reluctant to reveal information on prices. Although the exact breakdown of dealer versus auction sales in Ireland is not known because of the privately held dealers' sector, using the international breakdown of 50:50 would put an estimate of total art sales in Ireland topping €70 million in 2006. Most experts in the Irish art trade would agree that dealers account for a larger share, closer to 70 per cent, meaning that this estimate is probably at the low end. Adding in smaller auction sales in Cork, Galway and other regional centres, and with the higher dealer to auction ratio, the market for Irish art could be worth in excess of €90 million.

In 2006, the Irish art market had one of its best years ever. Sales were up substantially on previous years' totals, and there were many record prices for Irish artists at auction, particularly in the contemporary sector. The standard case where older works of deceased Irish artists net both the highest total sales turnover and highest individual prices was turned around during the year, with five living artists in the top 20, and two of those achieving the highest ranking positions overall. Based on the auction results of the 'big three' Irish auction houses, the value of sales at auction totalled just over €35 million, with over 6,200 works hammered down throughout the year.

The average price of works of art brought to auction in 2006 was approximately €5,670; however, many auction lots were far from the mean. The average is likely to be dragged up by a small number of high-end sales. These can raise the average despite the fact that around 81 per cent of sales that year were €5,000 or less and nearly half of the total lots (46 per cent) went for €1,000 or less. The highest-priced painting sold in Ireland in 2006 was a work by Louis Le Brocquy (b 1916) entitled *Sick tinker child* which sold at Adam's December auction for €820,000, around €20,000 over the high estimate. The highest price paid for an Irish artist during the year was €1.18 million for *The honeymoon* by Sir John Lavery (1856–1941) at Christie's Tenth anniversary Irish sale in May.

Table 18.1 summarizes some of the key features of the art auction market in Ireland from 2001 to 2006. It appears that the market started to pick up considerably in 2004, after a relatively poor year in 2003, fuelled by both increasing supply and strong demand, with the value of sales increasing 39 per cent and the average price up 21 per cent to €7,155. Sales shot up in 2005, increasing nearly 60 per cent in terms of value, and this momentum continued in 2006 with an even greater year-on-year increase of 62 per cent. While average prices were stable in 2005, they dropped slightly in 2006 with record total sales figures driven by both a doubling of the volume of works brought to auction, alongside a substantial number of high-end transactions. Irish art auctions remain relatively inexpensive compared with some international counterparts.

Table 18.2 shows the breakdown of sales by each of the auction houses in 2006. Adam's had the highest market share for the year, in terms of both value and volume, with nearly €20 million in total sales. A large portion of that total came from the December sale of Important Irish art, which not only achieved records for the year for individual artists such as Le Brocquy, but with 176 works brought under hammer the final sale total, minus fees, reached just under €6 million, well in excess of the previous record total sale for an Irish auction of €3.75 million achieved at Whyte's earlier in the year. Only around 10 per cent of the works brought to auction remained unsold, but given that many of these buy-ins may have been sold after the auction, the total could be even higher. This record sale combined with other strong sales during the year gave Adam's the highest market share, and also put it within the top sphere of auction houses within the United Kingdom, alongside the UK operations of such giants as Sotheby's, Christie's and Bonhams. If the present rate of growth continues, driven by a consistent flow of high-quality works coming on to the supply-driven market, the Irish auction art market will begin to make an increasing impression in international league tables.

In the Irish market, in 2005, the top price overall was for a work by Jack Butler Yeats (1871–1957). His *A blackbird bathing in Tír na nóg* sold at DeVeres' November 2005 auction

Table 18.1 Summary of Irish art auction sales, 2001–06

Year	Number of transactions	Value of sales	Average price	Top price
2001	2831	€14,936,321	€5,276	€825,500
2002	2137	€13,940,440	€6,523	€620,000
2003	1646	€9,762,120	€5,931	€300,000
2004	1896	€13,557,895	€7,155	€390,000
2005	3026	€21,632,570	€7,149	€820,000
2006*	6203	€35,172,600	€5,670	€820,000

*2006 measured as 5 December 2005 to 5 December 2006

Table 18.2 Irish art auction sales 2006

	Total sales	Average price	Lots sold	Market share
Adam's	€19,636,040	€5,281	3,718	56%
Whyte's	€9,855,560	€6,387	1,543	28%
DeVeres	€5,681,000	€6,031	942	16%
Total	€35,172,600	€5,900	6,203	100%*

* These figures relate to the largest three houses only, so the 100 per cent share of their combined turnover is over 90 per cent of the total Irish auction market.

for €820,000, some €120,000 over the high estimate, and the highest price ever paid for Yeats at auction in Ireland. In 2006, however, Adam's sale of Important Irish art on 5 December earned LeBrocquy the top position for *Sick tinker child* (see above). (Two more of Le Brocquy's oil paintings, *Image of W B Yeats* and *Fantail pigeons*, sold at the same sale for €310,000 and €280,000 respectively, the latter being four times its high estimated value.) Le Brocquy celebrated his 90th birthday in 2006 with a special exhibition of his *Portrait heads* in the National Gallery.

Born in Dublin, Le Brocquy's paintings frequently sell at auction for six-figure sums. He has also sold individual paintings for over €1 million on international auction markets. In 2000, *Travelling woman with a newspaper* sold for £1.1 million (then €1.7 million) at Sotheby's in London. A spokesperson for the auction house commented:

> In these days the £1 million barrier is increasingly seen as the surest test of an artist's international importance and it is a very rare event for a living painter to break it. Le Brocquy's achievement marks him out as one of the painters, like Freud and Hockney, who will come to symbolize this age.

Le Brocquy sold paintings worth nearly €3.7 million at auction in 2006, making him by far the highest selling and earning artist in the country. This does not include sales through galleries, which for most living artists represent a much greater outlet. Le Brocquy's agent in Dublin is the Taylor Gallery, which upholds the usual dealer discretion when it comes to revealing sales figures, but again using the international benchmark, it is reasonable to estimate that he sold over €7 million in 2006.

As shown in Table 18.3, the second highest seller at auction for 2006 in Ireland was another contemporary artist, Sean Scully (b 1945). Although still classified as an Irish artist due to his Dublin roots, Scully has lived most of his life in New York, studying art in the United Kingdom and then at Harvard. Scully, who was nominated for the Turner Prize in 1989 and 1993, sold nearly €3.2 million at auction during the year, but only 9 per cent of these sales took place through the Irish houses. His highest-priced lot for the year sold in New York, when Sotheby's hammered down his oil painting, *Wall of light mountain* for nearly €630,000. Scully sells the most abroad of all of the artists in the Irish Top 20, although the highest overall lot sold for the year was also overseas (Sir John Lavery's *The honeymoon*).

Another interesting entry in the list is Patrick Leonard (1918–2005), who sold just under €1 million worth of paintings during the year. This was primarily a supply-driven mass of sales, with around 65 per cent of this total coming from just one auction, a studio sale by the

Table 18.3 The Top 10 Irish artists at auction in 2006

Artist*	Total sales	Artist's highest lot	No of lots	% sales in Ireland
Louis le Brocquy	*€3,689,449*	*€820,000*	*67*	*70%*
Sean Scully	*€3,196,372*	*€629,360*	*37*	*9%*
John Lavery	€2,994,627	€1,184,058	24	16%
Jack B Yeats	€2,692,035	€700,000	51	76%
Paul Henry	€2,484,289	€306,978	28	63%
Daniel O'Neill	€1,652,232	€170,000	33	74%
Patrick Leonard	€964,990	€40,000	287	100%
Walter F Osbourne	€903,456	€400,000	16	92%
Mark O'Neill	*€835,440*	*€22,000*	*212*	*100%*
Norah McGuiness	€833,953	€210,000	33	98%

Note: Living artists in italics

artist's widow through Adam's in April. With 287 lots at auction (and nearly 200 from this sale), the artist's average price per painting was in the region of €3,500.

Table 18.4 shows the top 10 living artists. While the top two spots remain unchanged, the third highest seller is Mark O'Neill (b 1963), who also ranked ninth overall for total sales. Adam's conducted a rare primary sale of O'Neill's works this year at auction, selling a total of €577,840 in just over 180 lots at one sale, which amounted to nearly 70 per cent of his annual total. David Britton, director of business development at Adam's, commented that the practice of selling new works directly from the artist remains relatively rare at auction houses in Ireland, primarily as it can be difficult to find artists who have enough fresh work to auction. However, this is something they intend to pursue, with at least two sales of this nature planned for 2007. The presence of resale royalties on the resales of works of art by living artists undoubtedly has also encouraged this practice. The Irish government was forced to implement the EU Directive on Resale Royalties for artists, and this was partially passed into Irish law on 13 June, giving royalties to living artists in Ireland every time their works are resold via a public sale at an auction or gallery.

Table 18.4 Top-selling living artists at auction in 2006

Artist	Total value	Highest lot
Louis le Brocquy	€3,689,449	€820,000
Sean Scully	€3,196,372	€629,360
Mark O'Neill	€835,440	€22,000
Kenneth Webb	€496,452	€60,000
Basil Blackshaw	€389,596	€82,071
John Kingerlee	€325,568	€101,400
William Crozier	€244,500	€52,227
John Shinnors	€187,405	€37,305
Donald Teskey	€148,700	€50,000
Martin Mooney	€125,425	€32,000
Peter Collis	€124,894	€12,500

The Irish taxation system

In Ireland, under the Taxes Consolidation Act (TCA) of 1997, there is an exemption from any capital gains taxes that arise on the sale of certain works of art that have been exhibited publicly for 10 years or more. The works must be valued above €31,740 (by the Revenue) and be displayed in an approved gallery or museum for the period. For the purposes of the relief, exemptable works of art are referred to as 'heritage items', which can mean any kind of cultural item including any archaeological item, archive, book, estate record, manuscript and painting, and any collection of cultural items that are considered appropriate for donation to the national collections.

Section 1003 of the Act provides that those who donate such heritage items can also credit the value of those items against certain tax liabilities including income tax, corporation tax, capital gains tax, gift tax and inheritance tax. In order to obtain the tax credit, the item must be donated for no financial (or other associated) consideration other than the tax credit itself. (In other words the donor cannot receive any direct or indirect payment from the purchasing institution.)

The tests applied in order to determine whether a heritage item or collection of heritage items is appropriate for donation to the approved bodies are:

- The heritage item must be an outstanding example of the type of item involved, pre-eminent in its class, whose export from the state would constitute a diminution of Ireland's accumulated cultural heritage, or whose import into the state would constitute a significant enhancement of the accumulated cultural heritage of Ireland, and must be suitable for acquisition by the approved bodies.
- The open market value of the heritage item or collection of heritage items must be at least €150,000 and, in the case of a collection, at least one item in the collection must have a minimum value of €50,000. The aggregate open market value of all heritage items donated in a calendar year must not exceed €6 million.

 These items may only be donated to an approved body as provided for under the legislation, which includes:
 - National Archives;
 - National Gallery of Ireland;
 - National Museum of Ireland;
 - National Library of Ireland;
 - Irish Museum of Modern Art.

In 2006 there were seven paintings (and one historical artefact) accepted in lieu of taxes, which were valued at just over €6 million, up from €5.5 million in 2005. Since 1995, items worth nearly €37 million have been accepted in lieu of taxes in Ireland, including works by Francis Bacon, Yeats, Le Brocquy and Roderic O'Connor.

Besides the list above, the Dublin City Gallery (the Hugh Lane) and some other art institutions are registered charities and therefore can also take advantage of tax relief for donations to them. A list of the charities authorized under the Scheme of Tax Relief for Donations to Eligible Charities and Other Approved Bodies under the terms of Section 848A of the TCA is available from the Revenue's website (at www.revenue.ie). In order to qualify for the relief, the minimum donation made to any one eligible charity or approved body in a year is €250, and it must not confer any benefit on the donor or any person connected with the donor. If there is no association between the donor and the charity or approved body to which the

donation is made, there is no maximum qualifying donation. If there is an association between the individual and the charity, a maximum of 10 per cent of the individual's total income can attract tax relief. According to the Revenue, 'associated with' implies being an officer, director, employee or member of the institution.

It is important to note that the tax treatment of the donations differs whether the donor is a PAYE worker (an employee) or a self-employed person or company. Self-assessed individuals and companies can simply claim a tax deduction on their tax return. PAYE workers, on the other hand, are treated as making the donation net of tax, and the museum or gallery then reclaims the tax paid from Revenue. In other words, the institution rather than the individual gets the relief in this case. For example, a PAYE taxpayer who pays tax at 42 per cent makes a donation to the National Gallery of Ireland (NGI) of €500. The value of the donation is actually €862: €500 plus €362 (€362 is the tax already paid by the donor, which is reclaimed by the NGI from the Revenue).

The artist's exemption

Apart from incentives for donations and public exhibition of works of art, another tax-related exemption that affects the Irish art market, and indirectly investment within it, is the Irish artist's tax exemption. Ireland maintains a unique exemption for artists from income taxes, introduced in 1969 by the former Taoiseach Charles Haughey, when he was serving as the Minister of Finance. The exemption grants tax-exempt status to self-employed creative artists – that is, composers, writers and visual artists. The exemption was initially introduced in the 1969 Finance Act and applies to all creative artists who qualify for residency, as defined by the Revenue. Under Section 195 of the TCA, the Revenue is empowered to make a determination that certain artistic works are original and creative works generally recognized as having artistic merit. Accordingly, any earnings derived from sales or copyright fees from such works are exempt from income tax from the year in which the claim is made. The only tax to come out of this income is PRSI at the rate of 3 per cent. If artists earn income from any other sources, such as teaching, it is taxed the same as other Irish citizens at the appropriate rate. The exemption also does not apply to VAT, which artists must register for and charge on all sales if their income is over €51,000 (at a rate of 13.5 per cent).

In order to qualify for the exemption, it is not necessary for a work to have both artistic and cultural merit; the presence of either is sufficient. The categories of works accepted for the exemption come under one of the following: a book, a play, a musical composition, a painting or like picture, or a sculpture. From 2002 to 2006, visual artists have been the largest group taking advantage of the exemption, with around 1,135 painters and sculptors (plus around 230 musicians and 640 authors or playwrights).

The artist must also be 'living in Ireland' to qualify for the scheme, although the exemption applies to all income earned in Ireland (whether it comes from domestic or overseas sources). The Revenue defines this as resident, or ordinarily resident and domiciled, in the state and not resident elsewhere. The two tests for determining residence, introduced by the Finance Act of 1994 are if the individual spends 183 days or more in the state in the tax year; and if the individual spends 280 days in the state, combining the number of days spent in the state in that tax year and in the preceding tax year.

The common test applied is that the artist is in residence in Ireland for at least six months and shows signs of living there, such as owning a home permanently ready for their occupancy. This feature of the incentive has been criticized as running contrary to its intentions. The exemption was designed in part to support low-income struggling artists, whereas in

practice it encouraged already famous authors, musicians and other artists to set up a base in Ireland to avail themselves of the incentive, often actually living elsewhere much of the time. In the first seven years of the introduction of the exemption, for example, half of those bene-fiting from it were not Irish. Although some of these criticisms are valid, many of the most highly successful artists, by the very nature of their professions, are 'naturally' internationally mobile, and hence are forced because of career commitments to spend a considerable amount of time away from their 'home base'. From an economic net benefit perspective, the ancillary benefits and external revenues that are generated for others by these artists 'living' in Ireland should also be considered in any aggregate critical evaluation, even if these were not the primary intentions of the original legislation.

Another related criticism that has some validity has been that the incentive also offers most to artists who are already commercially successful, as they sell more works and earn more copyright income, when these are arguably the artists who need it the least. This also implies that those possibly most able to pay for public welfare through taxation avoid doing so, leaving the rest of the economy (locally and regionally) to pay the difference. Again, this criticism can be applied in part to a number of other tax incentives in Ireland, which have been designed intentionally or otherwise to reduce the tax burden for in practice often the wealthiest investors.

In light of some of these issues and, more importantly, the cost to the Exchequer, a cap was introduced on the exemption in the Budget of 2006. Now only income of up to €250,000 per annum falls under the exemption, with earnings over that threshold subject to full income taxes. In 2001, the estimated cost of the exemption was €36.8 million but this dropped to €22.6 million for 2003 (the latest year for which figures are available in 2007). Although this is still a substantial sum, put in context, of all the tax forgone to the state in that year as a result of all the various tax relief schemes, the artists' exemption represented just 0.15 per cent.

Based again on the most current statistics, the Revenue calculate that 694 artists, or over half those claiming the exemption, had incomes of less than €10,000, and 34 per cent of those were below €5,000. A total of 456 artists claimed exemption on incomes between €10,000 and €50,000, meaning most artists (87 per cent) earn less than €50,000. A further 114 artists claimed exemption on incomes of between €50,000 and €200,000, which is a substantial salary, especially if tax-free. Only 59 artists or the top 5 per cent claimed exemption against income above €200,000, which means relatively few artists are likely to exceed the new threshold for the exemption. The total income of those highest-earning 5 per cent of artists previously exempted from tax was over €56 million. The total income exempted for tax by those 1,264 artists who earned under €200,000 was just over €23 million, while those 694 artists who earned under €10,000 totalled just €2.7 million in income that year.

On the positive side, the tax exemption continues to encourage artists to remain first in their profession, and second within Ireland – both of which help to augment the local supply of art in the market (particularly through galleries). A problem with the exemption, however, is that while it significantly assists the financial viability of many middle- and higher-income artists, a large portion of emerging artists do not earn enough from their artistic careers to benefit substantially from it. For the substantial number of artists earning under €10,000 per annum, for example, after basic tax credits are applied, very little income tax may be due, lessening the exemption's beneficial impact. In these cases introducing greater tax-free) subsidies, or other direct funding for artists could be more beneficial than indirect tax-based support.

Ireland and droit de suite

Many countries, including Ireland, missed the 1 January 2006 deadline by either not partially or fully implementing the legislation. After an unexplained six-month delay, the lack of implementation of the Directive in Ireland was the subject of a successful legal challenge by Irish artist Robert Ballagh. Ballagh brought proceedings against the Irish state claiming redress for lost revenue under the principle of state liability. The government managed to minimize the effects of the court finding in favour of the artist by introducing new regulations transposing the Directive ahead of the 30 June hearing date that was set for the case. The new regulations, the European Communities (Artists Resale Right Regulations) SI No 312 of 2006, came into effect on 13 June 2006, and were to be fully implemented in 2007. The system currently in place in Ireland is therefore a maximum royalty of 4 per cent, and for now it only applies to works over €3,000 by living artists, although this may be reduced to €1,000 when the law is fully implemented.

Ireland was one of the original Member States that never had the *droit de suite* levy in place. During the 1990s when the Directive was first proposed, Ireland alongside the Netherlands fully supported the British government's attempts to dissuade the European Commission from proceeding with imposing legislation. In spite of this opposition, the Commission was persuaded to introduce a harmonizing Directive on the grounds of a perceived distortion of the internal art market, which was approved by the European Parliament at its first reading in 1997. The Commission accepted some of the Parliament's amendments and these became the subject of detailed debate at the official and ministerial council level.

The British government vigorously opposed the Directive in subsequent rounds of debates as the single member state with the most at stake, with by far the largest art market in Europe and the second largest internationally. Agreement could not be reached concerning the Directive under the German and Finnish presidencies in 1999, due to the opposition of the United Kingdom, Ireland, Austria, the Netherlands and Luxembourg, as well as support from other external international allies sympathetic to the concerns raised. In May 2000, a compromise was reached unanimously.

Despite the legislation being passed into Irish law in 2006, there are still a number of controversial issues related to the threshold, when the right will be introduced for heirs, and how the levy will continue to be collected.

The case against lowering the threshold appears to dominate, according to the estimates above, and again provides an example of how some government intervention and legislation with the best intentions can actually promote adverse effects. With regard to the second point, there will undoubtedly be a concerted struggle by the art trade, especially in the United Kingdom, to fight against the introduction of royalties for heirs, for fear of the significantly negative impact this could have on the major art markets within Europe. A crucial point in the Irish case is that any imposition of aspects over and above what occurs in the United Kingdom will simply lead to a diversion of sales to the larger market. If the allowed derogation is not imposed for heirs until 2012, for example, Ireland will almost certainly lose a significant amount of its trade to the United Kingdom. Many sales of top Irish artists are already taking place in London, and these higher-priced works will certainly be sold in the United Kingdom if there is any chance of arbitrage between national art markets.

If the Irish auction data is analysed in greater detail, it also shows that, if extended to heirs, nearly one quarter of the *droit de suite* collected would have gone to the estates of just two deceased Irish artists (Jack Yeats and Paul Henry) (McAndrew, 2006. Using the sample

year of 2004, this study showed that a total of €356,696 could have been collected as *droit de suite* for artists and their heirs using a threshold of €3,000, 74 per cent of which would be due to heirs). The only living artist with any significant share of *droit de suite* would have been Louis le Brocquy with around 5 per cent, with any other living artists having less than 1 per cent shares.

A key argument made against the levy in the first place was that, in practice, it will do little to help living artists and the bulk of the royalty will be paid to, in many cases, the already wealthy heirs of relatively famous artists. Research carried out by the European Fine Art Fair (TEFAF) in 2005 into the market for eligible sales proved that on an EU-wide level if introduced across the board, heirs would certainly be the main beneficiaries (Kusin and McAndrew, 2005). In the study, the data showed that if *droit de suite* had been collected in a sample year on all eligible transactions in the European Union (for dead and living artists), heirs of deceased artists would have received 81 per cent of the levy, as opposed to only 19 per cent due to living artists.

For further information on the development of this particular art market, go to: www.koganpage.com/artmarkets.

References

Kusin, D and McAndrew, C (2005) *The Modern and Contemporary Art Market,* TEFAF, Helvoirt

McAndrew (2006) *Droit de Suite and the Irish Art Market*, IAVI, Dublin

Israel

Roni Gilat-Baharaff

History and background

One can discuss Israeli art – art created in Israel – beginning in 1906, with the establishment of the first Bezalel School in Jerusalem. However, the State of Israel was only declared in 1948. This conundrum is a result of unique historical facts, and the upheaval in traditional Jewish life in Europe in the 19th century and in the first part of the 20th century.

In the 19th century, vast changes took place in the traditional life of Jewish communities, with the age of emancipation in Europe, and the enlightenment movement (Haskala) which called for Jews to become more assimilated into their countries of residence. Jews began to create graven images, forbidden by centuries of tradition, which limited artistic efforts to the field of decorative arts and Judaica items.

Prominent among the first Jewish European artists who painted Jewish subjects were artists such as Daniel Moritz Oppenheim (1800–1882), Maurycy Gottlieb (1856–1879) and Isidor Kaufmann (1853–1921), who made Vienna his home. With the rise of the Zionist ideals and movement in Europe, and the subsequent waves of Jewish immigrants leaving Europe to inhabit Palestine, the issue of professional occupation and making a living became important for these immigrants.

The 1920s are considered a pinnacle of artistic achievements in Israeli art. The best-known artist of this pioneering period was Reuven Rubin (1893–1974), a native of Rumania who came to Palestine in 1912 and enrolled in the Bezalel School. He was disenchanted with the limited scope of the art world in Palestine and returned to Europe in 1913. Rubin came back to Israel in 1922 and after a brief sojourn in Jerusalem settled in Tel Aviv. In his paintings of landscapes of the period, Rubin painted an ideal world of coexistence between Jews and Arabs, and harmony with nature.

Rubin's paintings of Israeli landscapes are sought after by collectors and have made some of the highest prices ever achieved on the Israeli art market. Naïve shapes and bold colours characterized the painting style of this period. Among other artists active during this period in Israel, who worked in a similar style, are Yoel Tene (1889–1973), Nachum Gutman (1898–1980), Moshe Mokady (1902–1975) and Sionnah Tagger (1900–1988).

The 1930s were characterized by foreign influences penetrating the local art scene. If the artists of Bezalel and of the 1920s tried to create a local style and depict local subjects, the 1930s saw an influx of European ideas into Israel. During the 1930s local artists travelled to Europe to study art, mainly in Paris, the eternal art capital of the pre-Second World War art world. The lure of Paris for the Israeli artists was no different than for their European counterparts. The active art scene and the important museums were a welcome change from the provincial Palestine. Another source of influence on art created in Israel during the 1930s were the German Jews arriving in Palestine after 1933.

With the rise to power of the National Socialist Party in Germany, Jewish artists, some of whom were also left-wing activists, were forced to flee to Palestine. Painters, sculptors, literary figures, and most importantly architects trained at the Bauhaus school, flocked to Palestine. Modernist architecture made its mark on the rapidly developing country, with international-style apartment buildings erected in Tel Aviv and Jerusalem. German immigrants brought paintings by Jewish German artists with them, and a rich urban culture, deeply appreciative of the arts.

Best known among the new immigrant artists was Mordecai (Bronstein) Ardon (1896–1992), a Bauhaus pupil. During the 1930s he painted few modernist landscapes of Israel.

After the Second World War Israel was a traumatized country. In 1948 the State of Israel was declared and the British Mandate ended. Holocaust survivors came to Israel. The local artists wanted to create a new and modern art, keeping in step with international trends, and thus the New Horizons group began its voyage towards abstraction. Leading artists such as Moshe Castel (1909–1991), Joseph Zaritsky (1891–1985), Yehezkel Streichman (1906–1993), Arie Aroch (1908–1974) and Yohanan Simon (1905–1976) worked to create a modern international language as stated in the group's manifesto. This modernism was inevitably a slow progress to non-representational art.

The members of this group are considered the founding fathers of contemporary Israeli art. Paintings, especially large non-representational canvases by Joseph Zaritsky and Yehezkel Streichman of the 1950s and 1960s, are highly sought after by collectors, and achieve strong results at auction. The artists were influenced by their desire to create a modernist art, following closely non-representational ideas, common in Europe at this time.

The 1980s and 1990s saw the rise of contemporary international-style art, with prominent international exhibitions and collections exhibited in the main museums. In the 1990s photography became a leading contemporary medium. Performance art, video art and installation art became important in the local art scene. The political realities continued to play an important role as a leading subject. Israeli artists became well-known figures on the international scene, with artists such as Avigdor Arikha (b 1929) and Michal Rovner (b 1957) represented by international galleries and having museum shows abroad.

The new millennium dawned on Israel with international art more important than ever. Alongside local artists working and succeeding abroad, international artists such as Wolfgang Tillmans (b 1968) and Rineke Dijkstra (b 1959) have visited and worked in Israel in recent years. International contemporary art exhibitions are popular in museums and private galleries. Both the Israel Museum in Jerusalem and the Tel Aviv Museum of Art now exhibit important classical and cutting-edge international art on a regular basis. New technology and the web make the international art world closer and more immediate for artists and collectors.

Political upheaval and reaction to the realities of everyday life have a strong influence on the local art market, and this feature is perhaps what makes it unique. During the period of the second Intifada, in the early 2000s, there was a decline in the local art market. Another phenomenon is the strong results achieved at auction for works with a soldier motif: for

example *Untitled* from a series of photographs by Israeli photographer Adi Nes (b 1966), executed in 1999, depicts soldiers seated in Last Supper-like format. This photograph sold very successfully at auction, setting one of the main price records for Israeli art, especially rare for a young artist.

The market characteristics

Unique characteristics of the Israeli art market are its newness and youth. There is limited local trade in old objects, Old Master paintings or decorative arts. There is some trade in antiquities, but not usually on an international level. Other artifacts sold on the local market are Judaica objects and manuscripts.

Historically, residents arrived in Israel either in the aftermath of the Second World War or prior to the 1930s. Many of these immigrants came empty-handed wishing to fulfil a Zionist ideal; others came as destitute refugees. A few wealthy families arrived with their collections, such as the Schocken family, famous owners of department stores in pre-war Germany. Many of the international art collections presently in Israel were formed during the1960s, 1970s and 1980s. Some collections are on display in museums, such as the Sarah and Moshe Mayer collection at the Tel Aviv Museum.

As a result, the art market is mainly concerned with Israeli art and international art of the 19th and 20th centuries. International Jewish artists of the 19th century mentioned previously such as Isidor Kaufmann, Maurycy Gottlieb and Jozef Israels (1824–1911) are sold locally. Among 20th-century artists whose works are sold on the local market are the Jewish artists of the inter-war Ecole de Paris, namely Marc Chagall (1887–1985), Moise Kisling (1891–1953), Jules Pascin (1885–1930), Chana Orloff (1888–1968) and Mané-Katz (1894–1962), to name but a few. These artists are also sold in Europe and the United States on a regular basis.

In the new millennium, collectors are willing to pay record prices for seminal Israeli works of art which are scarce. For historical reasons, icons of Israeli art, important paintings of the 1920s by Rubin, landscapes by Ardon, large abstract canvases by Zaritsky and other treasures were purchased by visiting Jewish collectors from Europe and the United States, rather than by local patrons, and exported. The country was poor in its early days, and residents were either trying to get by or were investing in local industries and building the foundations of the country. A limited number of collectors had available funds for art purchases in the formative years of Israeli art.

With the rising values for Israeli art, international collectors who purchased these paintings upon visiting Israel in the 1960s and 1970s are now offering them back on the local market. These works are presently achieving extremely strong auction prices.

The dark expressive taste of the 1930s, and the influence of Jewish artists such as Chaim Soutine (1893–1943), Michel Kikoine (1892–1968) and Pinchus Kremegne (1890–1981), had a powerful impact on collecting tastes in Israel up until the 1990s. The local market, in keeping with international trends, is now showing an interest in younger Israeli art, in new media, mainly photography, and in international contemporary art.

How to buy and sell in Israel – historical facts

The first organized efforts to sell Israeli art abroad were the Bezalel travelling exhibitions in the early Bezalel period. Historically, Israeli art was mainly sold to foreign visitors to Israel,

or by galleries and the artists themselves to collectors in Israel and abroad. Some early seminal paintings were bought or given as gifts to local collectors and to family members. International art brought to Israel by new immigrants was sold by placing ads in the local newspapers or through select galleries.

Some of the established galleries are still active, and some have long since disappeared. Most were family-owned businesses. Among important established names were the Katz Gallery, Steiglitz Gallery, Chemrinski Gallery, Hadassah Klachkin Gallery in Tel Aviv, Goldman Gallery in Haifa and Safrai Gallery in Jerusalem. These galleries dealt (and some still deal) in Israeli art and European art, selling paintings by traditional European artists from Jewish origins such as Jozef Israels, paintings by the artists of the school of Paris and Israeli art.

The artists of the New Horizons group were mainly represented by Sam Dubiner's Israel Gallery, which aimed to bring modern selling methods into the Israeli art market. This was the first time where a group of artists with a shared ideology were represented by a gallery dedicated to their work.

Some of the more established galleries presently operate as younger, more contemporary spaces. Rosenfeld Gallery, established in 1952 as a framing shop, specialized in Jewish and classical Israeli art and now exhibits cutting-edge young artists. Bineth Gallery, established in 1962 also dealt in prints, and now deals in classical and contemporary Israeli art. Engel Gallery in Jerusalem and Tel Aviv represents established artists alongside young artists. The Gordon Gallery was established in 1966, and used to lead the market with important auctions of Israeli art until 2001. The gallery now is run by the younger generation of the family and specializes in contemporary Israeli art. Other established noteworthy galleries which show work by established and younger artists in Tel Aviv include the Givon Gallery, Stern Gallery and Nelly Aman Gallery.

Historically, Israeli artists were sold abroad with galleries exhibiting and representing their work. Karl Flinker sold Moshe Castel's work in Paris; Dalzell Hatfield Gallery, Los Angeles handled Rubin's work; the O'Hana Gallery in London sold Mané-Katz and Reuven Rubin. Denis Renee, Paris showed Marcel Janco and Yaacov Agam. Bertha Urdang Gallery in New York represented several of the Israeli conceptual artists in the 1970s and onwards. Marlborough Gallery represented Modercai Ardon, and still represents Avigdor Arikha and Israel Hershberg.

Corporate patronage was established in Israeli early on. The Workers Union, the Histadrut, funded the efforts of artists and in return was paid in art. The Histadrut's collection was sold in 1996, via the Ben Ami auction house.

The best-known corporate collection of Israeli art was assembled by the Israeli Phoenix Assurance Company. Originally a family-owned business, run by Joseph Hackmey, it was committed to collecting local art and managed to assemble the most comprehensive collection of Israeli art in the country over a period of 20 years beginning in the late 1980s. Another corporate collection committed to young Israeli art is ORS. The Doron Sebbag Art Collection is a mainly international contemporary art collection with a strong commitment to young Israeli artists. Paintings from both collections can be seen on display at the company's headquarters, and extensive exhibitions from these collections were held at the Tel Aviv Museum of Art.

Buyers

Israel is an international market, with buyers and sellers active from many countries – the United States, Europe and others – buying international art sold locally and Israeli art. Israeli

buyers are active in markets abroad. The Israeli art market and auction results are still greatly influenced by international buyers. Foreign visitors still have considerable access to funds, and avidly collect Israeli art. Some of the strong results achieved in Israel and outside for Israeli art were for art works purchased by collectors residing outside the country.

Tax and regulations

VAT at 15.5 per cent is charged on art sales on purchases in galleries, the buyer's premium at auction and on art imports. Thus art imported from outside the country becomes more expensive to the Israeli buyers, rather than foreign buyers who choose to export their purchases.

As in most countries, there are export regulations for various artifacts. Some items require special export permits, mainly in the fields of antiquities and Judaica. The export of such artifacts is regulated by the Israeli Antiquities authority. Other export/import restrictions affecting the art world include rare materials and endangered species which are regulated by the Israel Nature and National Parks Protection Authority.

The art trade structure

The established trade in Israel is conducted via galleries, auction houses and intermediaries.

Galleries

The majority of the active art galleries are located in the Tel Aviv area. Most of the galleries deal in Israeli art, some sell traditional art and some offer cutting-edge art; the latter category in keeping with international trends is very active nowadays.

Alon Segev Gallery and Sommer Contemporary Art, both established in 2000, exhibit classical contemporary and cutting-edge Israeli contemporary art, alongside international contemporary artists. Noga Gallery in Tel Aviv exhibits young and established contemporary Israeli artists, as do Givon Gallery, Dvir Gallery, Braverman Projects and the Chelouche Gallery. These galleries are active in international fairs and promote Israeli art abroad. They also feature among their exhibitions both established and new international artists.

Auctions

The first auction house active in Israel was Gordon Gallery, founded as an art gallery in 1966. It held two auctions a year in Tel Aviv from 1979 to 2001. These auctions were followed closely by local collectors, most of whom bought on a regular basis. The sales featured international art and established Israeli art, as well as prints.

Sotheby's entered the local market in 1985 and began holding regular sales in Israel in 1988, offering Judaica and 19th and 20th-century art. In 2004 the Jucaica, Israeli and international art sales were moved from Tel Aviv to New York. The sales held in Israel included international and Israeli art as well as Judaica and a few theme sales. The sales in New York have indicated a strong market for Israeli art and especially important results for Israeli art from the 1950s to the present day. The sale totals indicate an increase in volume, with a 2006 sale total of $6 million.

Christie's was established in Israel in 1986 and began holding sales locally in 1994. The sales are held on an annual basis usually in April, and feature important 19th and 20th-century

international and Israeli art. During the past 14 years of sales some of the strongest prices for Israeli art were achieved in Tel Aviv for more established artists, as mentioned below, as well as for younger Israeli art. With the present market trend and its contemporary flavour, record prices are achieved every season for present-day Israeli artists. In 2008, the Israeli 19th and 20th century art sale totalled $6.7 million. Christie's Israel holds the all-time auction record price for an Israeli art work at auction, for Mordecai Ardon's 1963 masterpiece *Timepecker*.

Among local auction houses currently active in Tel Aviv is Matza, established in 1975, which holds two sales a year specializing in 19th and 20th-century international, Eastern European art and Israeli art. Montefiore is a younger establishment that offers mainly local contemporary art. Tiroche, established in 1992, offers modern and contemporary art as well as being the only auction house in Israel that deals with decorative arts, Judaica and carpets. Hammersite is an online auctioneer active in Israel. Established in 2000, it auctions international and Israeli art on a regular basis.

Museums

The Israel Museum, located in Jerusalem, is a wide-ranging institution with collections covering archaeology, the Shrine of the Book (home to the Dead Sea Scrolls), Judaica, tribal art, Impressionist art, international contemporary art, Israeli art, European period rooms and much more. The museum was established in 1965 and it now encompasses the core art collection which was part of the Bezalel School.

The Tel Aviv Museum of Art was founded in 1932 by Meir Dizengoff, first mayor of Tel Aviv. It was established in its present location in 1971 and is now a main attraction in the centre of Tel Aviv with collections ranging from Old Master paintings to modern and contemporary art. The museum is presently very active in exhibiting modern and contemporary Israeli art.

The Herzliya Museum, established in 1965 with an additional wing added in 2000, is a younger institution which exhibits contemporary Israeli and international art, specializing in video and new media. Other active art museums are the Ramat Gan Museum, Ein Harod Museum, Haifa Museum, Petah Tikva Museum and the Open Museum in Tefen. In total there are over 200 active museums in Israel.

Recent and important art market results

The market for important Israeli art is extremely strong presently, more so than ever before. The market went through a quiet period, influenced by regional politics, from 2002 to 2004. The present strength of the market was detectable from 2005, and 2006 was a landmark year, with ground-breaking prices achieved for seminal Israeli works of art.

Mordecai Ardon's *Timepecker* (1963) was sold at Christie's Tel Aviv by the estate of the late industrialist and entrepreneur Benno Gitter. Estimated between $200–300,000, it sold for a record $643,200. Thus Ardon was established as the highest-priced Israeli artist. It seems that the Israeli market is undergoing a shift from a more traditional overall taste which focused on the style of the school of Paris and sentimental Israeli landscapes of the pioneering period, the 1920s, to a more contemporary taste.

Other strong auction results were achieved in 2006 for paintings by Reuven Rubin. In New York the third highest auction result ($419,200) for the artist was achieved for a 1920s painting, *Jerusalem with Mount Scopus*. In Tel Aviv in 2006 a later Rubin, a panorama of the old city *The heavenly Jerusalem*, from the estate of Claire Vogelman, New York, sold for

$441,600. This was the first time that a mature period painting by Rubin sold above the $250,000 mark. Buyers in these sales included Israeli and international collectors.

The record two results for paintings by Zaritsky were achieved in 2005 with a large canvas *Tzuba*, sold online by Hammersite for $184,000, and another large abstract painting selling in New York for $180,000.

Other important results were achieved in 2005–2006 for modernist artists, including Michael Gross (1920–2004), a minimalist artist whose 1968 landscape, *A wall in Mea She'arim*, sold for a record $204,000 in 2006 in New York.

Important results were achieved for younger artists in sales in Tel Aviv and New York in 2006 and 2007. These include an impressive auction result for a photograph by the New York-based Israeli artist Michal Rovner, *Overhang no 4*, which made $45,600 in Tel Aviv. In March 2007 Adi Nes's *Untitled* sold in New York for a staggering $264,000. This is a record price for the artist and for any Israeli contemporary work of art.

Market trends

The highest results at auction are still achieved by Ardon and Rubin. Ardon's market has been stable for many years, with an early painting executed in the 1930s, *Kidron Valley*, sold by the Metropolitan Museum of Art at Christie's Tel Aviv in 1995 for a then record of $249,000, the benchmark for the Ardon market up to 2003. Between 2003 and 2006 Ardon's work made records every season. Important paintings by Ardon are rare on the market, and therefore competition for seminal works is fierce. Between 2003 and 2007 auction records for Ardon were broken every season peaking in 2006. In 2007 *Salute to morning*, an impressive 1961 composition, sold for $348,000, the second highest auction result for this artist.

Rubin is possibly the most dominant artist on the Israeli market, being prolific; there is a wide choice of works every season in varying price ranges. Watercolours and works on paper are offered on a regular basis and sell typically up to $20,000. Early 1920s paintings by Rubin are the most sought after by collectors. The highest price paid for an early Rubin is $623,400 for *Old Sycamore Trees*, sold at Christies Tel Aviv in 2008. The sale at Christie's Tel Aviv in 2006 of a mature painting for $441,500 marked a change in this market, and indicates an interest in important works, not only early ones. This market trend was reaffirmed in 2007 at Christie's Tel Aviv auction with a 1939 *Jerusalem seen from Mount Scopus* selling for $408,000.

The Israeli market has matured over the last decade. In early days it was dominated by the Jewish artists of the Ecole de Paris. In the late 1990s the interest in purchasing early Israeli art depicting pioneering days of the 1920s in their naïve bright colours led the market. Today the market is strong for quality works by various artists, and is actively seeking to buy seminal painting of all periods. Among them seminal works of the New Horizons group, minimalist Israeli artists, local contemporary art and more.

In the 1990s the market was led by strong results for the artists of the Ecole de Paris, while prices for Israeli art were considerably lower. As the international market became stronger for international artists who used to feature regularly in sales in Israel such as Chagall and Soutine, the Israeli market turns to look into its history and selects Israeli art as the main theme for sales. The strong results achieved and large sums that are being spent on the international markets legitimize investments in local art.

For further information on the development of this particular art market, go to:
www.koganpage.com/artmarkets.

Italy

Sara Mortarotti

The Italian art market

Analysing the history of the Italian art market, the most important hammer price of the recent past is attributed to the Mannerist painter Jacopo Carrucci called Pontormo (1494–c1556): on 31 May 1989 Christie's New York auctioned his portrait of *Duke Cosimo I de Medici*, oil on canvas, for US$35.2 million. Today from an economic point of view, Venetian art, especially Vedutism, has the largest number of top lots. Without any doubt Canaletto is the most quoted Italian artist in the world. On 7 July 2005 Sotheby's London auctioned *Venice, the Grand Canal, looking north-east from Palazzo Balbi to the Rialto Bridge*, oil on canvas, for £18.6 million (valuation £6–8 million). Certainly it represents the record for any Italian artist's auction in the world.

Another Italian artist well known in the international art market is Amedeo Modigliani. On 4 November 2004 Sotheby's New York registered his record with *Jeanne Hebuterne (devant une porte)*, 1919, oil on canvas, auctioned at $31,368,000 (estimate $20–30 million). But in recent years Italian modern and contemporary art are also starting to capture the interest and enthusiasm of private collectors and institutions worldwide, and this is currently an area of market growth. This is furthermore confirmed by the fact that, since 1999, Christie's and Sotheby's have organized a special sale in London exclusively dedicated to 20th-century Italian art. '20th-century Italian art is increasingly sought after on the international market and yet is still enticingly undervalued,' said Olivier Camu, international director of Christie's London (Sotheby's, 2006). This is because the Italian sale is usually a launchpad for these artists. Many of them reach their auction record during the Italian sales. For example, Pino Pascali's two records have been both reached during the Italian sales, and they are much higher than the usual prices of his works (*Cannone Semovente*, Christie's London, October 2003 for £1,573,250, and *Cannone Bella Ciao,* Christie's London, October 2005 for £1,352,000).

The first Sotheby's Italian sale in October 1999 made £5.2 million with 44 lots; the October 2005 sale reached £9.7 million with 56 lots, 98.6 per cent sold and 11 auction world records. Among 20th-century Italian art movements, conceptual art is the one that reached the best results in recent times: on 9 May 2006 Christie's New York sold an oil painting (*Coupure*) by Lucio Fontana for $ 2.7 million (estimate $1.2–1.8 million) as well as a canvas (*Achrome*) by Piero Manzoni for $1.9 million (estimate $0.8–1.2 million).

The market in Italy

According to the Nomisma Report for 2005, the Italian art market recorded a global turnover of about €500 million, with a 5 per cent increase over the previous year. Between the late 1990s and the early 2000s, the estimated value of Italian families' possessions increased about 75 per cent. This is because of the selling of financial assets (equities) in order to invest in more wealthy segments such as noble metals, luxury products, hedge funds and notably art. Between 1993 and 2002 Italian investments in real assets grew as follows: 48 per cent in real estate, 16 per cent in investments on enterprises and 129 per cent for value objects.

The key players in the Italian market are private collectors, representing 37.1 per cent of the customer base. They are followed by art dealers, galleries and auction houses with 23.8 per cent. The number of speculators and investors who buy art is about 16.6 per cent of all the buyers. It will be apparent from these statistics that institutions are only marginal buyers in the Italian art market: they form only 6 per cent of the customers of galleries, auction houses and antique dealers. Of this 6 per cent, 2 per cent are foundations and 4 per cent are museums. It should be noted that because of its internal characteristics, including Italian legislation, a huge part of the art market in Italy is not declared, meaning that transactions do not always follow legal requirements.

Generally speaking Milan and Rome are the centres of the Italian art trade. In particular, Milan is the main market for modern and contemporary art while Rome leads for antique art. Painting is always the most important category of the Italian art market, in 2005 representing 40 per cent of the global turnover. Sculpture, representing 30 per cent, is becoming more and more relevant and captures the interest of private collectors and institutions. The remaining 30 per cent is decorative arts and photography.

Painting also reaches highest level in terms of money paid for a single artwork (see Figures 20.1 and 20.2). The average price paid for a painting is €26,702, 0.9 per cent more than in 2004.

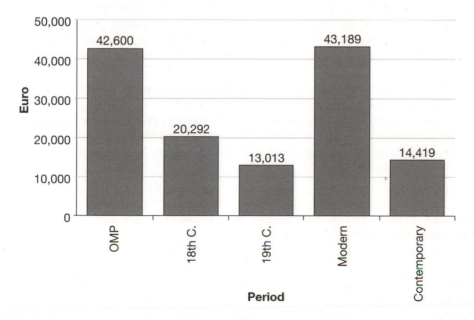

Figure 20.1 Average price for paintings of different periods in Italy
Sources: LCBA, Nomisma 2005

In particular, Old Masters and modern paintings are the most appreciated periods, with an average price paid for a painting equal to €42,600 and €43,189 respectively (this considering only art works sold in Italy).

Contemporary painting's segment grew 4.9 per cent over previous year, showing the extraordinary interest of the Italian market in contemporary art. Another important phenomenon is the increasing attention given to photography (+0.8 per cent over 2004), a wealthy segment completely neglected a few years ago.

Structure of the market

Auction houses

In Italy the creation of companies organizing professional auction sales is quite new. The most important Italian auction house is Finarte, founded in Milan in 1959. Together with the foreign-owned Sotheby's (founded in Florence in 1969) and Christie's (founded in Rome in 1958), they represent 80 per cent of the national auction market. The Italian auction market is historically characterized by a big number of small players spread across the territory. These small auction houses tend to be well known in their local area but very weak at national level. When Sotheby's and Christie's entered the Italian auction market, thanks to their big dimension and international prestige, it was extremely easy for them to gain the leadership. Finarte is the only Italian auction house able to compete with them.

Among small auction houses with a local market and/or a focus on a particular art category, the most renowned are Porro in Milan, Farsetti, founded in Prato near Florence and now also in Milan and Cortina, and Pandolfini in Florence.

About 30 per cent of the global art turnover in Italy is done by the auction houses (source: Censis). In 2005 on the whole they achieved about €150 million of turnover, 12 per cent more than the previous year. We can explain this very positive trend by the boom in modern and contemporary art as well as the selling of some important private collections. In the first half-year of 2006 some Italian modern artists obtained important results at Italian auctions:

■ Umberto Boccioni, *Portrait of Doctor Tian* (1907), oil on canvas. Sold at Christie's Milan on 23 May 2006 for €1,205,100 (estimate €700–900,000).
■ Giorgio De Chirico, *Le mendiant des Thermopyles* (1929), oil on canvas. Sold at Christie's Milan on 23 May 2006 for €1,086,000 (estimate €600–900,000).
■ Alberto Burri, *Black, white and sack* (1954), mixed media. Sold at Farsetti Arte Prato on 27 May 2006 for €1,029,000.

Table 20.1 Turnover of the main Italian auction houses in the first half of 2006 for modern and contemporary art sales (€ million)

	2006	2005	%
Sotheby's	10.044	7.629	+31.6
Finarte	9.342	8.070	+15.7
Christie's	8.918	10.152	−12.1

Source: *Il Giornale dell'Arte*

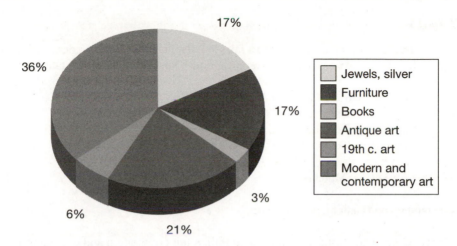

Figure 20.2 Turnover by category for Sotherby's Italy, Christie's Italy and Finarte, first half 2006
Source: *Il Giornale dell'Arte*

Considering in particular Sotheby's, Christie's and Finarte, their turnover in the first half of 2006 by category is shown in Figure 20.2.

Galleries

In Italy there are more than 3,000 modern and contemporary art galleries and about 1,500 antique dealers. About 10 per cent of the operators are concentrated in Milan which is by far the most prosperous market. The major galleries are joined in four different associations:

- ANAG – Associazione Nazionale Antiquari e Galleristi (National Association of Antique Dealers and Galleries).
- ANGAMC – Associazione Nazionale Gallerie di Arte Moderna e Contemporanea (National Association of Modern and Contemporary Art Galleries). It includes 200 operators and has also the task of controlling the authenticity of art works.
- AAI – Associazione Antiquari d'Italia (Association of Italian Antique Dealers). It includes 171 dealers and publishes the *Gazzetta Antiquaria*, a free magazine coming out twice a year distributed with *Il Giornale dell'Arte* (25,000 copies).
- FIMA – Federazione Italiana Mercanti d'Arte (Italian Federation of Art Dealers). It unifies 30 associations and 1,068 operators. It operates in the international contest especially with the Minister of Art and Culture and the military force of carabinieri for the safeguard of the cultural patrimony.

Among the most important modern and contemporary art galleries are Cardi, Blu, Gianferrari, Tega, Stein, Giò Marconi, Invernizzi and Guastalla in Milan, Tornabuoni in Florence, Mazzoleni in Turin, De Crescenzo & Viesti in Rome, Contini in Venice, Artiaco and Lia Rumma in Naples, and Minini in Brescia.

Art fairs

During the last few years the number of art fairs in Italy, in particular of modern and contemporary art, has increased considerably. Among antiques fairs the most authoritative are:

- Mostra Biennale dell'Antiquariato, Florence;
- Collezionismo a Palazzo Venezia, Rome;
- Milano Internazionale Antiquariato, Milan;
- Padova Antiquaria, Padua;
- Mercante in Fiera, Parme;
- Modena Antiquaria, Modena.

Among modern and contemporary art fairs:

- MiArt, Milan. One of the most important Italian fairs of modern and contemporary art. In 2006 it had 249 exhibitors, more than 11,000 sq m of exhibition space and more than 32,000 visitors.
- ArteFiera, Bologna. Held in January, this is an international appointment with modern and contemporary art. In 2006, its 30th edition, the fair boasted 25,000 sq m of exhibition space and 250 exhibiting galleries (35 per cent from abroad).
- Artissima, Turin. Held in November, this is the Italian fair dedicated only to contemporary and cutting-edge art. As well as museums, foundations, cultural institutions, magazines and art editors it includes more than 150 galleries.
- ArtVerona, Verona (October): the first edition was held in 2005 and counted 142 exhibitors and 18,000 visitors. In 2006 the exhibition space increased and the number of exhibitors reached 200 galleries.

The attendance of Italian galleries at the best-regarded international art fairs is becoming significant, as is the number of foreign galleries hosted by Italian fairs (see Table 20.2).

Table 20.2 Attendance of Italian galleries at art fairs in 2005

Fair	Country	Total galleries	Total Italian galleries
Arte Fiera	Italy	209	141
Miart	Italy	192	165
Artissima	Italy	152	78
Arco	Spain	287	17
The Armory show	USA	162	8
Art Brussels	Belgium	132	19
Art Basel	Switzerland	272	13
Art Forum Berlin	Germany	119	1
Frieze Art Fair	UK	160	9
Fiac	France	235	14
Art Cologne	Germany	292	9
Art Basel Miami	USA	155	4

Source: Associazione Nazionale Gallerie Arte Moderna e Contemporanea (ANGAMC)

Art and cultural demand

During the last few years, Italians' art and culture consumption increased in every area. Some interesting figures collected by Doxa in 2003 support this assumption:

■ 47 per cent of Italian adults have visited a museum or an artistic monument at least once in the last three years.
■ 41 per cent of Italian adults have visited an exhibition at least once in the last three years.
■ The number of exhibition and museum visitors has increased more than 10 per cent.
■ Most Italian people think that private companies' contributions in support of art and culture are necessary and deserving.

Istat research has shown that cultural tourism in Italy is increasing, with 81,388,134 attendances in 2004 (up 5.6 per cent on 2003). The 192 Italian public museums were visited in 2004 by 10,529,866 persons (up 3.8 per cent on 2003). In 2005 the 30 most important Italian museums registered a 3 per cent increase in the number of visitors compared with the previous year. The most visited museum was the Vatican Museum with 3,822,234 attendances. The most appreciated cultural facilities show Italian art: compared with 2004, in 2005 the visitors of Italian art museums increased by 4.9 per cent (see Table 20.3).

Art collectors can be categorized as follows.

Modern and contemporary art collectors

These tend to be individuals aged between 30 and 40, rich but sometimes without too much 'pedigree' and with a recent fortune. They really love contemporary art and consider it as a status symbol as well as an instrument to diversify their assets. They usually visit more popular and publicized galleries and art fairs. Because in many cases they are not connoisseurs of the art world, they usually turn to professionals for their investments.

Antique art collectors

These are often but not always individuals of advanced age. They belong to rich families and they own big collections which have increased over the generations. They are cultured,

Table 20.3 Italy's top 10 most visited museums in 2005

Cultural site	Locations	% increase 2004–05
Vatican Museums	Vatican City	+10.6
Pompeii excavations	Pompei	+3.6
Ducal Palace	Venice	+7.2
Santa Croce complex	Florence	+6.2
Uffizi Gallery	Florence	−6.1
Aquarium of Genoa	Genoa	−6.9
Accademia Gallery	Florence	+0.4
Central Museum of Risorgimento	Rome	−3.5
National Museum Castel Sant'Angelo	Rome	+14.4
Zoological Garden Bioparco	Rome	+13.9

Source: Touring Club Italiano

conservative and do not want to risk much, so they usually choose to invest in the best-established artists, who are shown in the biggest museums or galleries.

The ecletics

Very curious and wealthy individuals, young and less young, who choose not to concentrate on a single art period. They usually buy art for passion and have the taste to collect it. They know the market and they don't despise speculative purchases.

Italian collectors like to be anonymous and prefer not to appear directly. In Italy the sense of privacy is very strong. Today collectors are more mature, especially in the middle part of the market. In particular, in the 1980s people used to buy almost everything hoping for a revaluation in the short period. It was an improvized way to collect art, just a sort of 'bite and run', and it was not the result of love for art. This contributed to the crisis of the 1990s.

Among the younger Italian collectors there is a general interest in contemporary photography. Photography, which is easiest to understand and has relatively low prices, is becoming the key to enter contemporary art and to approach more complicated art forms. Another interesting phenomenon that has developed recently is that Italians are interested more and more in collecting antique books and first editions.

A study of the Agnelli Foundation suggested that 51 per cent of art purchases in Italy have an economic purpose, but none of the big collectors will ever admit this.

Art market legislation

Italian legislation on the art market did not change much for some years. An important legal revision in 2004, promoted by Minister Urbani, led to what is known as Urbani's Code. This code did not bring major changes to the previous laws, but organized them in a unique structure.

Tax

The Italian tax legislation is very propitious for investments in art. In fact, the Italian state does not apply any tax on any kind of income obtained by the selling of art objects. Nor does the ownership of an art work incur any tax. The ownership of art works does not appear in individual tax returns. Companies (only if they keep the art works in their offices) can deduct the whole cost paid for the art works with a fiscal saving of 35 per cent in five years' time. In addition, the Italian state does not apply any tax on the capital gain from the selling of art works by private individuals.

Notification

Notification is an act of the Italian law with the objective of protecting the national artistic patrimony. According to the law, the Ministry of Cultural Property has the authority to notify art works of particular cultural value created more than 50 years ago or by dead artists. If a privately owned artwork has been notified, the state has the right of pre-emption in the case of sale, and the work can leave Italy only temporarily and with formal authorization. In addition, if the state receives a request to export a work of art that has not been notified, it can always notify it and assert the right of coercive buying.

It is obvious that, although this law correctly protects the huge Italian cultural patrimony, it considerably reduces the market for Italian art masterpieces. In consequence of this law, many Italian collectors prefer to buy important art works abroad and never bring them into Italy, in order to be able to resell them whenever they want at the best price the market allows. On the contrary, notification increases the value of medium-quality art works.

In consequence of this law, in order to protect the Italian cultural patrimony, a special corps of 120,000 carabinieri (military police) was set up in 1969, to counter the spread of criminal action to the detriment of the nation's cultural patrimony. It works to safeguard and protect the national cultural heritage, under the direction of the Minister for Cultural Property. It is part of an international network, operating with foreign countries' forces.

This special corps, located in Rome, has the following main tasks:

- recovery of works of art illicitly removed or exported from Italy;
- pursuing violations to the rules which regulate counterfeiting;
- control of commercial activities (exhibitions, dealers, galleries, auction houses, and other operators in the art market);
- carrying out archaeological site inspections using helicopters, motorboats and horseback patrols;
- cooperation with the Archaeological Submarine Unit of the Ministry for Cultural Property;
- international activity.

VAT

In Italy VAT – applied on the sale of a product – is equal to 20 per cent if the art work is sold by professional companies, that is to say galleries and dealers. On the contrary if the seller is a private person VAT is not applied, and it is 10 per cent if the seller is directly the artist or their heirs.

Obviously, compared with other countries, the rate applied to transactions through galleries is very high. As a matter of fact a lot of Italian collectors prefer to buy from foreign galleries in order to save amounts of money which are in some cases huge. In addition, this high VAT inevitably encourages illegal (not declared) transactions. At present all dealers' associations are carrying on a battle to adjust Italian VAT to the same rate as most other countries.

Droit de suite

The *droit de suite* is the right for artists and their heirs to receive a proportion of the price obtained from the sale of the original artists' works, but only after the first sale done by the artist and if an art professional is involved in the sale. There is no payment if:

- the price is less than €3,000;
- the seller bought the art work less than three years previously and the resale price is less than €10,000 euros;
- the sale does not involve any art professionals.

In Italy the *droit de suite* has been applied since February 2006 following these rates :

- 4 per cent to €50,000;
- 3 per cent from €50–200,000;

- 1 per cent from €200–350,000;
- 0.5 per cent from €350–500,000;
- 0.25 per cent above €500,000.

Tax on gifts

Since October 2001 there has been no Italian tax on gifts of artworks to blood relatives. For gifts to other persons if the value of the artwork exceeds €180,759.91, a 3 per cent tax is applied.

Companies and institutions can deduct from their taxable income donations to the state or other cultural institutions. Individuals can deduct from their taxable income 19 per cent of the donations in money or value of items donated to state or other cultural institutions. It is also possible to give cultural objects to the state in lieu of taxes.

Tax on imports and exports

The Italian state applies 20 per cent VAT to the purchase price of art works bought in the European Union and imported to Italy. This import tax has to be paid by the buyer. For the importation of art works from countries outside the European Union, the VAT applied is 10 per cent and there are also customs duties. No taxes are applied for the import of art works donated to public institutions from countries outside the European Union. No taxes are applied on the export of art works.

Death duties

Since October 2001 there have been no death duties, making the transfer of art works and entire collections from generation to generation very easy.

For further information on the development of this particular art market, go to: www.koganpage.com/artmarkets.

Reference

Sotheby's (2006) The Italian sale, press release, 1 September, http://www.christies.com/presscenter/pdf/09012006/105238.pdf

Japan

Roddy Ropner and Kumiko Hirakawa

Introduction

This chapter provides a survey of the art market in Tokyo from its modern origins to the present. Information for this chapter was gathered from collectors, dealers and curators in Japan and others involved in the Japanese art market.

The art market

The Japanese economy and the 'bubble'

Japan is the world's second largest economy in terms of gross domestic product (GDP) (US\$4.6 trillion in 2005: source *Economist*) behind the United States (US\$12.5 trillion in 2005). The GDP per capita is US\$35,800 (2005). Tokyo has a population of 12.4 million which represents about 10 per cent of Japan's total population. It is home to the nation's Diet and the financial capital of the country.

No survey of the art market would be complete without mention of the 'bubble economy' which took place in Japan in the late 1980s. Fuelled by rising stock and land prices and easy credit from banks, the domestic and international art markets were pushed to new highs by Japanese collectors and speculators. At the time it was estimated that the Japanese accounted for 30 per cent of sales at Christie's and Sotheby's, and some commentators estimated that Japanese buying accounted for up to 50 per cent of the international art market total. The most celebrated case is that of Ryohei Saito, the chair of Daishowa Paper Manufacturing who, in two evenings in London in 1990, at Christie's and Sotheby's respectively bought Van Gogh's *Portrait of Dr Gachet* for US\$86.5 million and Renoir's *Le moulin de la galette* for US\$78.1 million. It tends to be forgotten now but the Japanese also spent heavily at the auctions in other areas including Chinese, Japanese and European decorative arts, buying both quality and quantity with seemingly limitless funds.

The fact that Japanese collectors accounted for 30 per cent of the art market was not necessarily a problem in itself. After all American collectors accounted for similar volumes.

It was the speed with which they appeared and the abruptness with which they left that rocked the market. As the Nikkei rose to its record high of 39,000 in December 1989 and Tokyo land prices soared, the Bank of Japan intervened to quell the overheated markets. Interest rates rose from 2.5 per cent to 6 per cent between 1989 and 1990. Debtors could no longer repay their loans or sell the works they had purchased. Buying activity from collectors, speculators and dealers ground to a dramatic halt in late 1990. Calculations of the total amount spent on art during this period are impossible to verify but estimates run to billions of dollars, and the international market for impressionist paintings did not recover to the same levels for more than 10 years, while the domestic market has yet to recover.

The origins of the art market in modern Japan

There is, however, a long tradition of collecting art in Japan that is not motivated by investment and short-term profit. Various private museums incorporate the collections of wealthy entrepreneurs and industrialists. Generally speaking the modern art market started after the restoration of the Meiji Emperor in 1868 and with the disappearance of the feudal system. With the break-up of the ruling classes the existing patterns of the domestic art market were interrupted. Many found it hard to adjust to the new social system and many were forced to sell off their collections. Furthermore as the country modernized and tried to learn from the west, many saw their collections of Japanese art as curios from the feudal past that they were trying put behind them. Art dealers organized closed auctions to disperse the collections, and sold these treasures on to the newly-rich industrialists such as railway owners and textile producers. Hara Sankei, a textile merchant, was one such. Nezu Kaichiro, founder of Tobu Railway, was another. His collection is exhibited at the Nezu Museum of Art in Tokyo. One of the consequences of this burst of activity in the market was the founding of the Tokyo Bijutsu Club in 1906.

About this time the fashion for collecting Japanese art developed in the west. The series of World expos such as the Vienna expo in 1873 and the Paris expo in 1903 played a role in introducing a generation of collectors in Europe and America to new forms of Japanese art. The government helped to open new markets for artists and craftspeople by supporting and encouraging them to export works of art. At the same time their export was a vital way for the Japanese government to obtain foreign currency. The contemporary crafts of the Meiji included such wares as Satsuma vases, cloisonné, ivory carvings, and bronze vases with fine and realistic details often produced by highly skilled sword-fitting craftsmen who could no longer continue their traditional trade. All these were produced for export in vast quantities.

Later there was also a significant international trade in Japanese antiques. Collectors such as Ernest Fenellosa (1853–1908) and Charles Freer (1871 –1940) had an appreciation for the domestic arts of Japan, and during this period were able to form first-rate collections. These can now be seen in the Boston Museum of Fine Arts and the Freer Gallery in Washington respectively. Between 1892 and 1921 there were 85 Japanese companies including art dealers and trading companies involved in the international trade of art, such as Yamanaka Shokai with branches in Europe, the United States and even in China. In time this trade gave rise to the fear that important works of art were disappearing overseas, and eventually led the government to enact laws to prevent their export. Two further events, the Great Kanto Earthquake of 1923 and the Second World War, resulted in further disbursement of antiques as owners were forced to sell their collections.

The Tokyo Bijutsu Club and the Art Fair Tokyo

A distinguishing feature of the Tokyo art market is the established and extensive network of dealers centred on the Tokyo Art Dealers Association with its home at the Tokyo Bijutsu Club in Shinbashi in central Tokyo. In February 2006 the Tokyo Bijutsu Club celebrated its 100th anniversary with an exhibition, *The grand heritage: a tradition of beauty*. Just a few months later in August, the Art Fair Tokyo took place at the Tokyo International Forum. These two events reveal much of what is happening in the Tokyo art market, and one can also discern the traditions that have guided the market and the direction that it may now be taking.

There are currently approximately 500 members of the Association. According to Uragami Mitsuru, a director of the Bijutsu Club, of the active dealers approximately 60 per cent are involved with antiques and 40 per cent with modern art. Dealers can become members after completing several years training with an existing member or by introduction and recommendation from existing members. Various groups within the Association hold regular auctions at the Club. These are not open to the public but are a means for the dealers to buy and sell works to each other. Each year there are as many as 275 auctions organized by 33 different groups. The Tokyo Art Dealers Association also holds selling exhibitions open to the public, such as the Tobi Art Fair held in October each year, with booths run by nearly 100 dealers. Most dealers also have their own galleries located throughout Tokyo, and many can also be found in Ginza, Kyobashi, Nihonbashi, Roppongi, Azabu and Aoyama.

The 100th anniversary exhibition included Chinese and Korean and ceramics, Chinese paintings, Japanese calligraphy, paintings, screens, lacquer, tea ceremony wares, yoga and modern brush paintings (*shinga*). In the exhibition were several works designated as National Treasures and Important Cultural Properties. The exhibition was not simply meant to celebrate an illustrious history but was also intended to inspire new collectors by showing works of the highest order. It ran for three weeks, was featured on national television and attracted some 65,000 visitors.

The ability of the Tokyo Art Dealers Association to attract so many important works is testimony to their influence. The term National Treasure was first used in 1897 with the enforcement of the Old Shrines and Temples Law. Under the Law for the Protection of National Treasures enacted in 1927 many works were registered and their export prohibited. The law was later refined and a further classification of works carried out in 1950. Broadly speaking such works may not be exported 'except for special necessity from the view point of cultural exchange' and then only with the approval of the Agency for Cultural Affairs. Such works only leave the country on loan for important exhibitions. Even the movement and transfer of ownership of National Treasures within Japan is subject to restrictions. The advantage of this classification is that it helps in the preservation, research and restoration of items deemed to be of cultural importance to Japan. (In the fields of fine and applied arts, there are approximately 9,700 items in total designated under this law, of which 830 have the higher classification of National Treasure. Of the total it is reported that 8,745 are works made in Japan, 841 were made in China, 96 are from Korea and 16 from the west (Japanese Government Policies in Education, Science, and Culture 1993, Ch. 3).

The Art Fair Tokyo, now in its fourth year, was conceived with the ambitious aim to 'change the situation and open the art market'. The hope is to create a fair that will rival the big names such as Basel and Miami. It mixes antique and contemporary works, and encourages foreign participation. In 2008 there will be more than 100 exhibitors, including contemporary art galleries, those exhibiting modern art and Japanese paintings, and a number of antiques galleries. There will also be seven galleries from overseas. In 2007 the fair attracted 32,000

visitors in three days. Sales figures are reported as being in excess of US$10 million but it seems that many of those who attended were more interested in viewing than buying. However the fair is a genuine and well-intentioned attempt to create a new stage to entice new collectors into the market. Another hope is to introduce collectors to the many contemporary Japanese artists who have been overlooked in favour of their better-known counterparts in Europe, the United States and more recently China. By adding a mix of antiques to the show, the organizers hoped to encourage visitors to take a fresh look at these works as well.

Department stores and auction houses

A unique feature of the Tokyo art market is the department stores which for many years have also played a key role in promoting and selling art. Their position may also be juxtaposed with that of the Japanese auction houses which are a relatively new phenomenon, with several starting up in the early 1990s.

The first department store to sell works of art was the Mitsukoshi in Nihonbashi in 1906. Many others followed suit. They have always handled contemporary art such as *Nihonga*, *Yoga*, metalware, sculptures, ceramics, lacquer and occasionally they have also dealt in impressionist and modern western paintings. The department stores are estimated to be the biggest art retailers in Japan. Salespeople known as *gaisho* visit customers and promote the works of art alongside other items found in the stores. Some department stores have art departments as well as a 'culture development' department, sometimes with a theatre and art exhibition space similar to a museum. These are used to entertain customers and provide an air of sophistication. As Wu Chin-Tao has noted (2004):

> In Japanese consumer culture … it has for decades been established practice for shopping to go hand in hand with art. Since the beginning of the twentieth century department stores in Japan have set up exhibition spaces within their premises as an extra attraction to entice customers across their thresholds.

Unlike dealers or auction houses the department stores use the power of their brand name more than in-house experts to promote their sales. They have two sources for the works they sell. One is directly from the artists and the other is through art dealers. In the former case the store may take 40–50 per cent of any sales. In the latter case they may take 25–30 per cent. In some cases the dealers sell their works at the department stores but do not necessarily use their own gallery names but rather act as 'employees' of the department store. In Tokyo alone there are 26 companies and 93 stores registered with the Japan Department Stores Association. The major stores with art departments are Mitsukoshi, Takashimaya, Daimaru, Isetan, Matsuzakaya, Matsuya, Seibu, Wako, Tobu and Tokyu.

The position of the art departments at stores is less prominent today than it was in the past, and some of the more famous museums such as the Seibu Museum of Art at the Seibu Saison department store have now closed. Yet the department stores still organize important exhibitions and selling shows. They continue to play a significant role in promoting contemporary artists and crafts.

Several domestic auction houses were established in the 1980s and 1990s. The largest of these is Shinwa Art Auction Company, which was funded in 1989 and publicly listed in 2005. In 2005 it claimed a 33 per cent share of the market with total sales of JPY 8,366 million. Sales for 2007 were close to JPY 6,445,565,000 or US$66 million approximately (US$1 – JPY 116). Shinwa mainly sells Japanese brush paintings, modern Japanese oil paintings and Japanese

ceramics, with a number of other categories. The top-selling Japanese work of art in 2006 was a Nihonga painting *Rinsen* by Higashiyama Kaii (1908–1999) which sold for JP72,000,000 or US$620,000 approximately. The highest price ever achieved was JPY7,731 million in December 2000 for *Portrait of Reiko* by Kishida Ryusei (1891–1929). Kishida studied under Kuroda and exhibited at the Bunten.

There are nine main auction companies in Japan including AJC, Est-Ouest and Mallett Japan Auction. Their audience is largely made up of domestic collectors. However in a development that mirrors a global trend recently Shinwa, along with other auction houses, introduced Contemporary Art auctions which include works by Chinese, Korean and western artists. These have proved extremely popular and have attracted interest from overseas buyers. As in other markets some collectors like the open style of auctions, and they continue to gain in popularity in Japan and make inroads into sectors of the market that were once dominated by department stores and dealers. It should be noted, however, that many of the auction houses, Shinwa included, were established by groups of dealers in the first place.

At the time of writing a new world record price for a Japanese work has just been created, not in Japan but at Christie's in New York in March 2008. A wood sculpture from the Kamakura period (1190s) and attributed to Unkei sold for $14,377,000 (including buyer's premium). There is no little irony in the fact that the successful bidder was the Mitsukoshi department store bidding on behalf of a client. Impressive as this record sounds it is worth noting that the previous overseas auction record price was set as long ago as 1992, when a Kakiemon elephant sold for £700,000 at Christie's in London. It is tempting to compare this with auctions of Chinese art, where numerous record prices are set and broken with each season. In 2005 a Chinese blue and white jar from the Yuan dynasty made £15.7 million. This tripled the previous record set at Christie's in New York in 2001 of US$9.2 million for an archaic Chinese bronze wine vessel.

When the Manno Museum of Art in Osaka sold part of its collection of Japanese and Chinese works in 2001 it chose to sell overseas, with a selection of Japanese works of art being sold at Christie's in London. There was a clear recognition that many of the more active collectors for Japanese works of art are now outside Japan and based in Europe and America.

Collecting postwar and contemporary art

Since the war, private collectors have bought works by artists active in the 1950s and 1960s such as Shiraga Kazuo (b 1924), Motonaga Sadamasa (b 1922), Takamatsu Jiro (b 1936), Nakanishi Natsuyuki (b 1935) and Akasegawa Genpei (b 1936). Overseas the Rockefeller Foundation also started to acquire Japanese contemporary art. In the 1970s the Japanese government founded the National Modern Art Museum in Tokyo and also local museums in each prefecture. In the early to mid-1980s, as the economy developed, the government continued to build municipal museums around the country. For over two decades these museums bought and exhibited local artists' works. In the early 1990s after the economy collapsed these activities stopped. From the late 1990s a few artists such as Murakami Takashi (b 1963) and Nara Yoshitomo (b 1959) were introduced to the international market through biennales, overseas auction houses and a handful of galleries exhibiting overseas. However the successful results abroad were seldom emulated at home. From the beginning overseas private buyers of Japanese contemporary art have outnumbered those in Japan. The percentage varies depending on the gallery and artist but it is reported that 50–80 per cent of sales are to foreign clients. Furthermore, according to Tabata Yoshio of Tokyo Gallery 50 per cent of the trading has been done through the internet since the late 1990s.

In a recent development a number of galleries including Tomio Koyama, Taka Ishii, Hiromi Yoshii, Miyake Fine Art, Shugoarts, Magic Room, Zenshi and Kido Press all moved to a new complex in Kiyosumi in eastern Tokyo near the Museum of Contemporary Art Tokyo on the far side of the Sumida River. The hope is that there will be sufficient critical mass to generate further interest in the field. Most of the other galleries are spread across Tokyo. Major galleries include Gallery Koyanagi and Tokyo Gallery in Ginza and Mizuma Art Gallery in Meguro. Takashi Murakami established KaiKai KiKi in 2001 to support and develop younger artists. It holds the Geisai art event in the spring and autumn each year to introduce art enthusiasts and collectors to artists and their work. Taking up this theme in April 2008 28 galleries from Japan and overseas will take part in the inaugural "101 Tokyo Contemporary Art Fair". Their aim is to "infuse new life" into Tokyo's contemporary art scene by exhibiting new and up-and-coming artists from Japan and abroad. Indeed it seems that the combination of activities including fairs, dealers' shows, auctions and museum exhibitions is succeeding in focusing attention on Japanese art once again.

Museums

According to the National Museum Association there were more than 80 art museums in Tokyo at the end of the fiscal year 2004 including public and private institutions (Tokyo Statistical Year Book 2003). That Japan is a nation of art lovers can be attested by the number of museums and the attendance records for exhibitions.

The Tokyo National Museum (TNM) located in Ueno Park was founded in 1872. It contains more than 110,000 objects from Japan and other Asian countries including 88 National Treasures and 610 Important Cultural Art Objects. According to the *Art Newspaper*'s annual survey published in March 2006 the Hokusai exhibition held at TNM was attended by 9,436 visitors per day (332,000 in total), the highest number of any exhibition in the world that year. The second placed exhibition, also held at TNM, was *The National Treasures of Toshodaiji Temple*, with 8,678 visitors a day.

One of the more recently opened museums is the Mori Art Museum (MAM). MAM's mission states:

> With an open attitude toward contemporary art and culture the Mori art museum sets the standard for a new kind of public institution. The museum aims to inspire visitors by showing art in new ways and frameworks through an accessible programme of exhibitions, public events and research projects that provide an international platform for emerging and established designers and artists throughout Japan, Asia and the world.

The inaugural show, *Happiness, a survival guide for art and life*, attracted 720,000 visitors. A retrospective of photographer Sugimoto Hiroshi's work in 2006 attracted 520,000 visitors. MAM is part of Roppongi Hills, a vast development of shops and restaurants, residential towers and offices that is a city within a city. MAM sits atop all this, reminiscent of the cultural halls in department stores. MAM does not have yet a major permanent collection but its location on the 53rd floor of Roppongi Hills Mori Tower with breathtaking views of Tokyo and the innovative exhibitions have managed to attract crowds and comment in equal measure.

Between these two extremes there are many superb collections in private museums in Tokyo. The following is a small selection of the finest whose collections include Japanese art, and the year they were opened to the public. The Nezu Institute of Fine Art (founded in 1940)

includes paintings, calligraphy, sculpture, ceramics, lacquer and metalwork. Suntory Museum of Art (1961) includes lacquer, ceramics, glass, costumes, masks, paintings and prints. The Idemitsu Museum of Arts (1966) includes Japanese paintings, calligraphy, and ceramics. The Hara Museum of Contemporary Art (1979) includes modern and contemporary Japanese art. The Toguri Museum of Art (1987) founded by Toguri Tohru houses a fine collection of Japanese ceramics.

For further information on the development of this particular art market, go to: www.koganpage.com/artmarkets.

Media and references

References

Wu, C T (2004) Tokyo's high-art emporia, *New Left Review*, 27 (May-June)
Tokyo Statistical Year Book (2003) Education and culture, Tokyo Statistical Year Book [online] http://www.toukei.metro.tokyo.jp (accessed 19 March 2008)

Internet

www.tokyoartbeat.com lists details of over 500 venues in Tokyo
www.rogermc.blogs.com by independent curator Roger MacDonald has reports on contemporary art and events in Tokyo and other locations he has visited

Magazines

There are relatively few magazines devoted to the arts and fewer still available in English. A sample of what is available:

ART IT, a quarterly bilingual magazine with articles on contemporary art in Japan and Asia.
Art Asia Pacific includes news and reviews of contemporary art in Japan. Its annual almanac includes a detailed review and art related statistics.
Asian Art News also includes news and reviews of contemporary art in Japan.
Arts of Asia and *Orientations* each include articles on Japanese art.

Acknowledgements

We would like to thank the following for their assistance in the preparation of this article:

Mr Tajima Mitsuru, London Gallery, Tokyo
Mr Uragami Mitusuru, Uragami Sokyudo, Tokyo
Mr Tabata Yoshio, Tokyo Gallery, Tokyo
Mr Inoue Yukichi, Inoue Oriental Art, Tokyo
Mr Inami Kenichi, Japan Sword Company, Tokyo
Ms Nagase Mami, Christie's Japan, Tokyo
Mr Imaizumi Yoshii, Togeisha Co Ltd, Tokyo
Dr Shane McCausland, Chester Beatty Library, Dublin
Mr Raymond Sun, Yue Shan Yuan, Hong Kong.

Malaysia

Johnni Wong

Malaysia is categorized as a 'developing nation'. It has an estimated population of 27 million, and is a multiracial and multicultural country with three main races, Malays, Chinese and Indians.

Geographically it is divided into two distinct parts. Peninsular Malaysia is separated from the eastern states of Sarawak and Sabah on Borneo island by the South China Sea. On the peninsula, Putrajaya is the newly created administrative capital for the Federal Government. Malaysia's capital city, Kuala Lumpur, was founded in 1857 and remains the seat of parliament, as well as the commercial and financial capital of the country.

The artists

Just the mention of a proposed list of the country's top 10 artists will invoke heated debate. Such a list is, naturally, fluid due to the dynamic forces of any market structure. Serious art buyers categorize Malaysian artists under three distinct 'generations':

- first generation: pioneer artists (mostly deceased);
- second generation: overseas-trained artists of the 1960s (now in their 60s and 70s);
- third generation: the latest 'stars' in their 30s, 40s and 50s.

Works of pioneer artists do come up for sale from time to time, but due to the nature of the work, condition and quality, as well as the poor medium used, the prices for their art in the secondary market is not very high. For instance, 1940s and 1950s watercolours by Yong Mun Sen (1896–1962) are still available for between RM20,000–30,000 (about US$5,700–8,600) and his oils for about RM40,000 (about US$11,400). In comparison, the enamel and acrylic works respectively of Latiff Mohidin (b 1983) and Syed Ahmad Jamal (b 1929) (two of the current top three artists) already sell for RM250,000 (US$71,000) or more. Ibrahim Hussein's acrylics are reputed to have been sold for more than RM1 million (about US$286,000) – a remarkable sum by local standards. At Sotheby's April 2007 auction in Singapore, an Ibrahim Hussein painting set the Malaysian record when it fetched S$102,000 including premium.

But the most recent auction by Christie's Hong Kong in November 2007 astonished Malaysian collectors when the works of newer contemporary artists such as Ahmad Zakii Anwar (b 1955) (HK$223,500/US$29,055 and HK$427,500/US$55,575) and Jailani Abu Hassan (b 1963) (HK$391,500/US$50,895) fetched several times their previous record prices. For instance, the price for Jailani's work equalled that of Latiff's iconic work from his Pago-Pago series. It is interesting to note that the works of younger contemporary artists are already outperforming many of Malaysia's senior artists in international auctions.

The top 10 living artists in Malaysia

This list is based on a poll of the leading art galleries, artists and serious art collectors. The ranking is based on their age and does not necessarily reflect their artistic merit in their respective 'generations'. Nevertheless, the senior artists in the second generation generally enjoy greater prestige than those in the third generation. But recent art auctions have shown that international buyers aren't concerned about who is more senior at the local level.

Second generation

- Syed Ahmad Jamal (b 1929)
- Ibrahim Hussein (b. 1936)
- Latiff Mohidin (b 1941)
- Jolly Koh (b 1941).

Third generation

- Yusof Ghani (b 1950)
- Ahmad Zakii Anwar (b 1955)
- Chang Fee-Ming (b 1959)
- Jailani Abu Hassan (b 1963)
- Bayu Utomo Radjikin (b 1969)
- Chong Siew-Ying (b 1969).

The government's role

Malaysian art as a valued commodity received an important boost with the setting up of the National Art Gallery. As a British colony, Malaysia got its independence in 1957. And soon after – in the throes of nationalism – programmes that pursue all things that symbolize a modern nation were instituted. There was need for a Parliament House, international airport, National Stadium, National Museum, Dewan Bahasa & Pustaka (the Institute of Language and Literature) and of course, a National Art Gallery.

The National Art Gallery was established in 1958 under the patronage of Malaysia's first Prime Minister Tunku Abdul Rahman. It started out with 'four donated art works'. The permanent collection has purportedly grown to more than 2,500 works. Prior to the establishment of the National Art Gallery – which gave a sense of focus and national mission to develop the art scene – the local 'trade' in paintings was merely a pretty picture market. There were, of course, early 'art galleries' in Kuala Lumpur in the 1960s and 1970s, but the 'art market' was not developed simply because of the lack of a significant number of collectors. The affluent middle-class had not as yet developed. And in the 1960s, the memory of the

Second World War as well as the communist insurgency (the Emergency, 1948–60) was still fresh in the minds of the people. After the Second World War and the subsequent slump in commodity prices in the 1950s, the wealth and influence of many of the elite families diminished considerably.

By the 1960s, with the return of foreign-trained artists like Syed Ahmad Jamal, Ibrahim Hussein, Latiff Mohidin and Jolly Koh, the development of Malaysian art really began and hence, the local art market. Among the early collectors of Malaysian modern art were the National Art Gallery trustees themselves, like former ambassador and lawyer Ms P G Lim and lawyer-corporate chief Kamarul Ariffin, who were educated in London.

The 1960s and 1970s can be considered the infant years of the art market. Many trained artists of that period held full-time jobs such as art teachers to support themselves. The luckier ones got themselves appointed as an artist-in-residence at universities and institutions with such a programme. Government institutions such as the National Art Gallery and MARA College (a technical institute) where art was formally taught, tended to support the careers of budding Malay artists, lecturers and curators.

Policies such as the New Economic Policy (1971–90) and later, the National Development Policy in 1991, were part of an affirmative action plan in socio-economic restructuring. Aimed at uplifting the well-being of the Malays, who are termed 'Bumiputera' or 'son of the soil'. For example, generous scholarships were given to Malays to pursue higher education overseas. Thus, the senior artists of Malaysia who currently command the highest prices are Malays such as Ibrahim Hussein, Abdul Latiff Mohidin and Syed Ahmad Jamal. But this is not to say that their works are not without merit, nor are they solely supported by government institutions. In fact, some of the biggest buyers of their works are Chinese collectors.

This notion of Malaysia's top-rated artists can be traced to the active support of institutions like Bank Negara (National Bank), Malaysia Airlines, Tenaga Nasional Berhad (formerly National Electricity Board), Malayan Banking Berhad, Oriental Bank and other prestigious bodies that bought their art at a period when there was no real market.

Dr Mahathir Mohammad

The arrival of Dr Mahathir Mohammad as Malaysia's 4th prime minister from 1981 to 2003 marked an era of rapid modernization and prosperity. The 1980s till the mid-1990s was a period of conspicuous consumption, with modern five-star hotels as well as nouveau riche homes sprouting throughout the country. A new generation of wealthy Malaysians emerged and Malaysian art became a convenient symbol of prestige, wealth and sophistication.

Art institutions

One of the legacies of Dr Mahathir's 22 years as Malaysian prime minister is the Petronas Twin Towers. 'Petronas' is short for Petroliam Nasional Berhad, the government-owned oil and gas company founded in 1974. The corporation is vested with the entire oil and gas resources in Malaysia. Petronas is ranked among Fortune Global 500's largest corporations in the world. Below the twin towers is the Suria KLCC mall, and the Dewan Filharmonik Petronas (DFP), home of the Malaysian Philharmonic Orchestra. Within the mall is the Galeri Petronas. This art gallery was established in 1993 and moved to Suria KLCC in 1998.

According to its curator, Anurendra Jegadeva or J Anu, as he is better known, the gallery grew out of the National Art Gallery's lack of exhibition space but quickly became an art institution in its own right. The former journalist and active artist states:

As a corporate gallery we do much more than acquisitions and showing our own collection – in curating exhibitions either in-house or with guest curators/writers/ artists. We are committed to the development and preservation of the fine arts in Malaysia through the provision of a working venue for exhibitions and educational programmes as well as direct support for the members of the art fraternity.

In terms of art works and artists chosen for the gallery, the policy is to look at a broad cross-section of artists and media and categories to fulfil Petronas's objective of bringing art in all its forms and contexts to a broader Malaysian public, 'but our new emphasis will be on contemporary practice', says Anu.

Auction houses

From the mid-1990s till the present, the role played by international auction houses in Hong Kong and Singapore – namely, Christie's and Sotheby's – in promoting South-east Asian paintings including Malaysian contemporary art is hugely important. They created the market for South-east Asian paintings.

According to Christie's South-east Asian art department head Keong Rouh-Ling, Malaysian paintings were sold at the first Christie's sale of South-east Asian paintings on 27 March 1994 in Singapore. There were 14 works offered during this first sale and 36 per cent of lots were sold or five paintings in total, including the works of Siew Hock Meng (b 1942), Yeh Chi Wei (1915–1981) and Latiff Mohidin. The most expensive painting sold was a Latiff Mohidin, *Malam Merah* (Red night) for S$57,500. Says Keong:

> The criteria in selecting all our paintings across all the different departments is the same. We look for works which are already established in the primary market, those works by artists who have already made a name for themselves, have a following of collectors and whose works are not readily available in the market. We always strive to seek the most unique and outstanding pieces from these artists, and where the quality and condition are in our opinion at their highest.

However, Philippine and Indonesian artists dominate Christie's current catalogue, with fewer Malaysian and Thai.

> The main reason for this imbalance in representation is because there is still not enough regional awareness and appreciation for both Malaysian and Thai works outside of their respective countries. And even within one's own country, and particularly with Malaysia, we find that the culture of promoting and collecting works from one's own country is not as strong as in the Philippines or Indonesia at this time. So without more local support of artists and their work, it is very difficult to gain awareness for them not only in the region, but on an international scale.

Art dealers

While the number of local buyers of Malaysian art is fairly small, the number of professional art dealers is even smaller. There are about a dozen private art galleries in Kuala Lumpur

where the major art exhibitions are held. Of those galleries, only three offer buyers and artists a semblance of professional services.

Valentine Willie Fine Art (VWFA)

VWFA was founded in 1996 by lawyer and art collector Valentine Willie. According to VWFA managing director Beverly Yong, the gallery relocated to bigger premises in Bangsar in 1997. 'The objective is to represent the best of modern and contemporary South-east Asian art – from the historically important to the cutting-edge,' says Yong, a partner in the business:

> We carry a range of works, local and regional, mostly contemporary but also works by second-generation Malaysian artists, and even pioneer artists. We even represent different 'generations' of artists, from young emerging artists to senior artists. We limit ourselves to what we think is good, interesting, valid, exciting, and we like to be able to provide a broad picture of what the region has to offer.

VWFA stages 14–16 exhibitions a year in the main gallery, and in 2007 it had a parallel programme of eight exhibitions in its 'project room'. Artists exhibiting regularly at VWFA often have a pricing guideline set by the market. Art prices are based on the 'experience and feel of the market' of the gallery directors.

Wei-Ling Gallery

Artist and gallery director Lim Wei-Ling and her husband Yohan Rajan initially set up the Townhouse Gallery in 2002 as her studio and a place to showcase her own art works. Soon, other artists wanted to use her space to exhibit their works. In 2005 the couple relocated their gallery, renamed Wei-Ling Gallery, to Brickfields in Kuala Lumpur. 'In our first year, we had two shows; second year, five; third year, eight; and in our 4th year, a record 12! Many serious artists were in dire need of an alternative space to show their works,' says Lim.

As the Malaysian art market is a 'very small one', the gallery targets 'anyone/everyone' who is interested in looking at art. The gallery shows and represents contemporary Malaysian art and artists. Most of the 25 artists that Lim represents are exclusive to her gallery. Wei-Ling Gallery holds 12 exhibitions a year. Lim thinks the art market is definitely growing. And she reckons there are 'up to 20 serious collectors' in Malaysia and that she is in touch with '80 per cent' of them.

NN Gallery

NN Gallery was established in 1996 by the brother-and-sister team of Syed Nabil Syed Nahar and Sharifah Nor Akmar. Their gallery is a purpose-built space designed by the owners. They target 'everyone with an interest to collect' art and they exhibit 'eclectic' works. 'We represent over 100 artists,' says Sharifah Nor, 'We don't represent any one artist exclusively.' The gallery stages one exhibition a month.

The collectors

One of the most vocal critics of the local art scene is lawyer-collector Pakhruddin Sulaiman. He and his wife Fatimah, also a lawyer, have been collecting art since the mid-1990s. 'Our

collection was spurred on by the feeling that some of the best works were being bought by Singapore in its effort to create South-east Asia's art centre, and nobody – including our National Art Gallery – was doing anything about it, at the time,' states Pakhruddin (Wong, 2005a). That was more than 10 years ago and by now, their collection has outgrown their 279 sq m (3,000 sq ft) home in Kuala Lumpur. Most of their collection of over 1,000 art works – including sculptures – are stored and displayed at their private gallery, Ruang Pemula (RuPe), located below Pakhruddin's law firm. They also have over 15,000 books, nearly 2,500 of which are on art and design.

The core of their art collection revolves around artists Amron Omar, Mad Anuar Ismail, Ahmad Zakii Anwar, Juhari Said, Wong Hoy Cheong, Yusof Majid, Jailani Abu Hassan, Raja Shahriman, Zulkifli Yusof, Muthalib, Nadia Bamadhaj, Paiman, Sharmiza and the quartet – Bayu Utomo Radjikin, Ahmad Fuad Osman, Ahmad Shukri and Hamid Shoib – from the Matahati group of artists. The works by more senior artists include Redza Piyadasa, Syed Ahmad Jamal, Jolly Koh, Khalil Ibrahim, Tajudin Ismail and Yusof Ghani.

Pakhruddin was a trustee of the National Art Gallery and has turned into its harshest critic:

> I think one of the Gallery's biggest failures to date is in not producing a group of profes-
> sional curators who can stand on their own and stand out, who can curate shows, write
> proper catalogues, to promote and disseminate information on Malaysian art.
>
> (quoted in Ooi and Tan, 2007)

What particularly galls Pakhruddin is the way art works are acquired by the National Art Gallery on an 'ad hoc' basis, without a proper system for vetting the works.

Another top private collector is London-trained plastic surgeon Steve Wong. In 1985 when he was building his house in Kuala Lumpur, he went on a 'slight splurge' to decorate it with art. Then in 1998 when he moved into his new 465 sq m (5,000 sq ft) office, he bought more art. 'And from then on, I didn't stop buying,' he declares (Wong, 2005c).

Dr Wong confesses to being guided by what he likes. His main collection is focused on the art of Ahmad Zakii Anwar, with about 100 works. He also favours Chang Fee Ming, Jailani Abu Hassan, Ahmad Shukri, Chong Siew Ying, Anum and Wong Hoy Cheong. His collection now includes the works of Latiff Mohidin, Jolly Koh, Yeoh Jin Leng, Redza Piyadasa, Dzukifli Buyong, Yusof Ghani, Tajuddin Ismail, Norma Abbas, Amron Omar, Ismail Latiff, Yusof Majid, Raja Shahriman, Abdul Muthalib and Kow Leong Kiang.

Conclusion

Top Malaysian art is relatively underpriced compared to the best in the South-east Asian market, and more so in the Asian context, where contemporary art from India and China are breaking world records. While the works of pioneer and contemporary artists in Malaysia have yet to achieve the kind of record prices set by their Indonesian counterparts, the coming years may see a change in the value of their works. Already, a couple of notable third-generation artists are seeing their works sold at international auctions at increasingly higher prices than at home. Malaysian art is one of the few undiscovered gems still available in the Asian art market at relatively affordable prices.

For further information on the development of this particular art market, go to:
www.koganpage.com/artmarkets.

Selected bibliography

Hsu, M (1999) *A Brief History of Malayan Art,* English trans by Lai Chee Kien, Millenium Books, Singapore

Koh, J (2006) *Jolly Koh @ Art Salon & XOAS*, 27 September to 7 November 2006 exhibition catalogue, Art Salon, Malaysia

Ooi, A and Tan, J (2007) State of the art, *Off the Edge* (January), p 34

Piyadasa, R (1983) *Modern Artists of Malaysia*, Dewan Bahasa dan Pustaka, Malaysia

Piyadasa, R (1986) Modern art activity in Asia. Paper presented at the Art Symposium, Third Asian Art Biennale Bangladesh, Dhaka, April

Wong, J (2005a) Bitten by the art bug, Special, *The Star,* 27 April

Wong, J (2005b) Selling the big picture, BizWeek, *The Star*, 28 May

Wong, J (2005c) A cut above art collection, BizWeek, *The Star*, 10 October

Wong, J (2006) South-east Asian art poised for a boom, *Sunday Star*, 28 May

Mexico

Patricia Bueno Delgado and Ercilia Gomez Maqueo Y Rojas

The importance of 20th-century Mexican art

Art plays an essential role in defining the identity of any country. Mexico is one of the richest countries in cultural diversity and paradoxically one of the least studied by art critics and other cultural specialists. The analysis and study of the Mexican art market began relatively recently, from around the 1950s, when works of art were more frequently displayed in public spaces and art galleries became formal selling establishments.

However, it was not until the end of the 1970s that the market gained worldwide importance and the work of national artists was first sold at international auctions in New York (Sotheby's 1977, Christie's 1981). From then on there has been an increasing presence of Mexican art in international collections, as well as an increase in transactions inside and outside the country. As an example, the total auction value for Latin American art work in 2002 was estimated at close to US$28 million. Approximately 30 per cent of this figure corresponds to Mexican art work (source of data: Sotheby's and Christie's Latin American art catalogues), which ranks Mexico as the absolute leader in Latin America. Recently, Mexico has increased its share at international auctions. In November 2007, 55 per cent of total Latin American sales at Sotheby's were of work by Mexican artists, while at Christie's Mexican works represented 45 per cent of sales. This shows not only that Mexican artists are present in the greatest numbers at international auctions, but also that their works reach the highest prices. Frida Kahlo's (1907–1954) painting *Roots* sold for $5.6 million at Christie's in 2007, Diego Rivera's (1886–1957) painting *Vendedora de flores* sold for $2.8 million in 2006, and Rufino Tamayo's (1899–1991) mural *America* sold for $2.6 million at Christies in 1993.

Mexican art is deeply rooted within 20th-century Mexican history and is not a recent phenomenon. The importance of Mexican artists worldwide is due not only to the high prices reached at international auctions, but to the prestige and influence achieved by artists who worked in Mexico in the first half of the last century, among them Kahlo, Tamayo and the so-called 'Great three' of the Mexican school of painting: Rivera, José Clemente-Orozco (1883–1949) and David Alfaro-Siqueiros (1896–1974). The 'Great three' were the leaders of the Mexican muralist movement, designed in theory to create awareness for national values

among the masses. They were linked to what was, or was supposed to be, the 'national essence'. Although each artist expressed himself according to his individual style, most of their themes were related to the class struggle, the Mexican revolution (which started in November 1910 in the state of Puebla), scenes from the Spanish conquest and the power of the Catholic Church during the colonial era. They were also devoted to idyllically expressing the customs, myths, rituals and traditional festivities of the country and its people, geography, landscape, ethnic groups and the pre-Hispanic past.

Fleeing from the Second World War and the Spanish Civil War between 1939 and 1942, several European intellectuals and artists arrived in Mexico. They had an important and significant influence in the scene. Among them were three important visual artists born in Europe, but who decided to stay permanently in Mexico: Remedios Varo (1908–1963), born in Spain, Leonora Carrington, born (1917) in England, and Alice Rahon (1904–1987), born in France. Together with other artists also living in Mexico such as Gunther Gerszo (1915–2000) and Katy Horna (1912–2000), they created the surrealist group in Mexico. Varo and Carrington were close friends who shared their lives and ideas. Today, both are very famous and their work is highly valued in international markets. Leonora Carrington is still alive and just turned 90. She still lives in the same house in Mexico that she first arrived at over 65 years ago.

The work of these artists has reached record prices at international auctions: Varo's *Exploring the Orinoco river source* was sold at Christie's in 2007 for $1,273,000 and Carrington's *The bath* sold for $541,000 at Sotheby's in 2007. The prices of their works continue to rise, although only a few works reach the market, making any assessment more difficult.

Kahlo was Rivera's wife, and today is considered a symbol of Mexican culture and an ambassador for Mexican art around the globe. She achieved world fame because of not only her works, but also her eccentric, intense and tragic life. Unlike Rivera, Kahlo was only moderately valued by the intellectuals of her time. André Breton was perhaps the only critic interested in her work. Her first individual exhibitions took place in New York in 1938 and Paris in 1939. During her lifetime she only had one great collector in Mexico, Eduardo Morillo-Safa. He owned some of her most important and meaningful paintings, such as *Henry Ford Hospital* (1932), *A few small nips* (1935) and *The broken column* (1944).This collection later passed to Dolores Olmedo and today is on display in her museum, located in the former hacienda La Noria in Xochimilco. Other significant collections of Kahlo's work are in the Jacques and Natasha Gelman collection (currently at the Muros museum in Cuernavaca) and the Modern Art Museum in Mexico, which has her masterpiece, *The two Fridas* (1939) and five other paintings.

Kahlo earned the first place in price terms of all Latin American painters when Sotheby's sold her self-portrait *Time flies* (1929) in July 2001 for a then record $4.6 million (over $5 million including commission). The sale of *Roots* (see above) put her second in the worldwide female rankings to Georgia O'Keeffe, whose *Calla lilies with red anemone* made $6.2 million at Christie's in May 2007. Her fame was promoted by a detailed study by the American historian Hayden Herrera, published in the early 1980s, and her work has been shown in the most important museums around the world.

Mexican art has been present in important private collections in the United States and Europe since the beginning of the 20th century, thanks to painter José María Velasco (1840–1912). His works can reach over $1 million. Table 23.1 lists other high-priced auction sales of Mexican artists' work.

Table 23.1 Highest prices achieved at auction by Mexican artists

Artist	Auction price (US$)	Date of sale
Frida Kahlo	5,616,000	24 May 2006
Alfredo Ramos Martinez	4,072,000	31 May 2007
Diego Rivera	2,800,000	17 May 1995
Rufino Tamayo	2,350,000	17 May 1993
José María Velasco	2,200,000	18 November 1991
Remedios Varo	1,273,000	19 November 2007
José Clemente Orozco	1,042,000	10 June 2004
Gunther Gerzso	625,800	21 November 2006
Francisco Toledo	622,400	31 May 2007
Angel Zárraga	556,000	3 May 2000
Leonora Carrington	541,000	19 November 2007
María Izquierdo	497,000	23 November 1999
Pedro Coronel	307,200	25 May 2005
Joaquín Clausell	300,000	15 November 1995
David Alfaro Siqueiros	240,000	31 May 2007
Dr. Atl (Gerardo Murillo)	185,000	17 May 1993
Jesús Guerrero Galván	181,000	20 November 2007
Raúl Anguiano	156,000	25 May 2005
Rafael Coronel	150,000	18 May 1994
Carlos Mérida	144,000	15 November 2005

Sources: http://www.sothebys.com, http://www.christies.com/, http://www.findartinfo.com/, http://www.artnet.com/

The current art market

In order to analyse the current art market, we researched art prices in Mexico for the last 20 years of the 20th century using qualitative data about artists. We then estimated an art price index, which we called IPAR Bueno/Maqueo, and compared the Mexican art market with other financial and artistic markets in Mexico and abroad.

We selected 35 artists for study, based on the following criteria:

■ contemporary artists (currently alive and working) working in Mexico or Mexicans living abroad;
■ artists practising all the trends and plastic languages in vogue (painting, sculpture, installation, object art, photography, video and performance art);
■ professional artists with a recognized career;
■ artists with work in museums and/or professional galleries, both national and international;
■ young artists with an expanding market, but also with awards and critical recognition;
■ representing the following market features:
 – participation in international markets;
 – recognized career and excellent opinion from critics, but a narrow market composed of experts and specialists;
 – a very wide market and insignificant critical review.

Performance art was then excluded since there was not enough price data available; in Mexico it is not fully integrated to the market, unlike in more developed locations like the United States. The IPAR Bueno/Maqueo does not take into account artists with falling prices because of a lack of information. Such artists do not influence the general trend of the index since their market is reduced and insignificant. The price index also does not include 'late accomplished' artists (Kahlo, Rivera, Tamayo, etc) or living artists in their maturity period such as Manuel Felguérez, Francisco Toledo, José Luis Cuevas or Rafael Coronel.

Because of the lack of similar studies in Mexico, and of systematized price records, this research was based on information provided by the artists and direct sales data. In this way we created a Mexican contemporary art prices database and later the IPAR Bueno/Maqueo index (see Figure 23.1).

All the indices studied showed an unstable behaviour over the period analysed as a result of the complex economic situation. However, art is the only index that showed a considerable recovery during 2000, when it enjoyed a 53 per cent increase. (The return on other financial assets topped at 18 per cent, while the Dow Jones and gold prices both reported losses.) The return on Mexican contemporary art investments for 2005 was 15 per cent; this represents a decrease from the preceding year, but prices remain high compared with all other financial assets with the exception of the Bolsa de Valores (IPC – the Mexican stock market). Art is the only investment that did not produce a negative return throughout the study period, while all others showed considerable losses, especially gold (1996) and the IPC (1995 and 1998).

The research showed that the accrued return on art investments tends to increase and is higher than the returns produced by other financial instruments such as gold and housing. This is despite the fact that the stock exchange produced high returns in certain years, although its performance was highly volatile until 2002. A 16-year investment on the Mexican stock exchange would have produced a return of 1,671 per cent compared with 1,731 per cent produced by investments in art. All other financial assets, such as gold and housing, tend to be more stable, or have very low returns. Thus, according to the historic trends, it is highly probable that art market prices will continue to rise during the next few years.

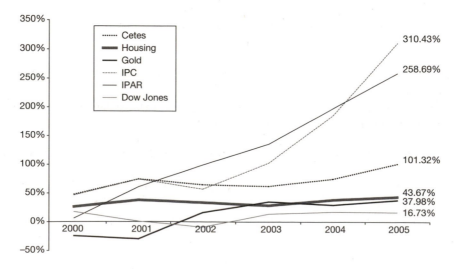

Figure 23.1 Annual accumulated yields from different investments, 2000–05

Such results seem to indicate that art is a very profitable investment. However, it must be noted that the Mexican contemporary art market has some flaws compared with other markets, which must be taken into account when investing in this field:

■ It is an imperfect market without insufficiently reliable information about prices available to the general public.
■ The pricing on works of art does not consider the same variables used to set prices for other kinds of goods and services, as it does not take into account costs or production volumes. It is a highly volatile market where perception is more important than hard facts, and to make things worse, it is not easy to tell between art of good and bad quality. In Mexico, the greater number of sales usually take place through intermediaries such as art dealers, galleries and auction houses. Private agreements between buyers and intermediaries do not guarantee a balanced price level, and there may be over- or under-valuation as prices are never made public.
■ The Mexican art market is a very small and low-liquidity market with few collectors and buyers. Not everyone can produce and sell works of art since it is a market that requires experienced and knowledgeable professionals like those working in professional galleries.
■ Given the nature of works of art, collectors keep them for longer periods than they would keep other financial assets, which limits supply.
■ Works of art are non-fungible and non-exchangeable goods, which means they cannot be replaced by other works even by the same artist. In addition, they require care: maintenance, documentation, conservation and insurance, which imply additional costs for the buyer.
■ Art investment works efficiently as a protection against inflation, economic crises or sudden changes in economic policies, unlike what has happened with gold since 1989, where investors received a very low return. Besides, art is a time-tested investment as it does not present the volatility observed in other financial assets.
■ Another complex aspect of this market is the difficulty of determining investment risk. The value of the works is based on subjective elements and extraneous circumstances like fashion or the valuation of specialized critics, so it is hard to determine the risk level of any particular work. The greatest risk lies in buying poor-quality art or fakes, hence proper counselling is crucial to avoid a bad investment or purchasing at inflated prices because of a lack of adequate information. Every investment implies a risk. Reducing risk levels means having as much information as possible and having specialized advice before taking decisions.
■ Lastly, it is as in any other field: young artists have greater returns in the short term, but also represent a greater risk because it is not certain that they will remain marketable. Conversely, mature artists provide a greater guarantee because of their length of time in the market, although over time the return is not as high as that from work by younger artists.

There are other factors that provide greater certainty about the work's value and must be considered when making an art investment. In addition to pricing information, the artist's history, career and critical appraisals, it is important to answer the following questions when buying art primarily as an investment:

■ How profitable can it be compared with conventional financial instruments?
■ What techniques or expressive languages are currently most valued in the market?
■ What is the influence of specialized criticism on the valuation of the works in the market?

■ What kinds of artists have greater long-term profitability and which have a greater short-term one?

■ What are the changes in fashion or in taste of consumers?

Artists' pricing grows at different paces, depending on factors like fashion, the guidelines established by specialists and, most importantly, the type of work produced. Our research determined that only five artists (Gabriel Orozco, Francis Alys, Julio Galán, Sergio Hernández and Javier Marín), that is to say only 5 per cent of the artists considered, are market leaders in Mexico. They have a significant influence because they not only reach the highest price levels, they also have a high sales volume and are in growing demand. Of the five, the undisputable battering ram of the Mexican contemporary art market is Gabriel Orozco (b 1962), who alone can significantly raise any rating in which he participates. It is also important to consider that the market does not fully take into account the opinions of Mexican art critics: the prices of some artists unrecognized by the critics, like Oaxaca painter Sergio Hernández, grow faster and reach higher levels than those of recognized artists.

Trends

The art market in Mexico is clearly characterized by a lack of liquidity, caused in great measure by the small size of the market. Another distinguishing feature of today's market (not only in Mexico but in all countries with active markets) is the proliferation and overlapping of the participants' roles. Recently there have been new kinds of sales routes, and the traditional ones have had to adapt their operating procedures. The old model of artist/gallery/collector has become obsolete, and particularly in Mexico there is a great diversity of art work suppliers. For example:

■ Some collectors are successful dealers whose interest in treasuring and keeping works of art has changed by buying and selling.

■ Artists now sell directly, both from their studios (a widespread practice) and from spectacular galleries (and similar institutions) set up by themselves where only their work is sold.

■ Professional dealers do not always have a display space.

■ Curators, critics and museographers sell works of art.

■ Some commercial galleries sell works of the worst quality.

■ Charity events where auctions are not conducted by professionals represent a very lucrative niche.

In the face of such market exuberance, professional galleries (which in the entire Mexican territory number barely 20) have been forced to look for new horizons in international markets, mainly through fairs and exhibitions abroad which will undoubtedly help promote art in Mexico. The ideal intermediary for this is one who (as in any other market) has the greatest amount of information organized and systematized for easy and dependable consultation about many different variables, which range from the artist's biography to historical market pricing records.

Taxes are a very important issue, which studies on art rarely take into account. There are many gaps and deficiencies in the applicable laws in Mexico, which can cause participants to use unofficial channels and fail to declare sales. The lack of understanding from the authorities, both fiscal and cultural, strongly restricts market expansion because it discourages the

recording and documenting of art sales. Documented sales are subject to 15 per cent VAT, which buyers must pay and which cannot be set off against income.

National heritage laws (in this case the General Law for the Protection of Archaeological, Artistic, and Historical Areas and Monuments enacted in Mexico City in 1972) also tend to distort the market. Works of art by some great artists like Kahlo, Rivera, Tamayo, Orozco, David Alfaro Siqueiros, Saturnino Herrán and María Izquierdo can only be sold within the country. This affects the price levels that can be reached. The lack of visionary cultural legislation to promote Mexican art nationally and worldwide severely affects any attempts to document both sales and production. This is a very complex and sensitive issue: there needs to be a thorough study to show the authorities the benefits from adequately regulating this field, making it clear that art does not behave like other industrialized or handmade goods.

In conclusion, it can be said that according to Art Price information (www.artprice.com), annual sales of art worldwide have seen sustained price increases during the five years to 2007, and although it seems incredible, all forecasts suggest that this trend will be maintained over the next five years. The arguments that sustain these forecasts are:

■ The market is expanding. Nowadays, the art market is among the most dynamic in the economy, and is growing vigorously since an increasing number of young entrepreneurs and financial agents are buying art. This situation is showing its effects on the Mexican market and other Latin American countries which traditionally have not enjoyed market expansion. However the most impressive is the Chinese art market, which forced international auction houses to install branches in Beijing and begin operations immediately thanks to an extraordinary growth during the past four years.

■ There is a global market. Art markets have traditionally had a vibrant activity in New York, London and other European cities like Berlin. Because of this, the most powerful collectors came from these cities. Nowadays, the most notorious collectors come from all over the world: for example Bernardo Paz, Brazil's metal mogul; C I Kim, the Korean commerce magnate; Venezuela's Cisneros family; and in Mexico's particular case, Eugenio López. This young entrepreneur from Jumex has fostered through his philanthropic foundation an important contemporary art museum which hosts the Jumex Collection of international art works. Today a Mexican collector can buy art in China and a Chinese collector can buy art in Mexico, while not long ago the art market was mostly a local phenomenon.

■ Lastly, art has become a new asset in investment portfolios, with art market returns often higher than those achieved by bonds and other financial assets as reported by S&P 500 and Dow Jones indexes.

These factors justify a claim that the art market is growing and is unlikely to collapse, at least in the medium term. Investing in art not only offers the opportunity of building wealth, it also represents an exciting and fun activity that enriches multiple aspects of a person's life. Mexican art opens a world of possibilities, not only because of its discourse and creative proposals, but also because of its great economic value and growth potential in international markets.

For further information on the development of this particular art market, go to: www.koganpage.com/artmarkets.

The Middle East and North Africa

William Lawrie

The contemporary art scene in the Middle East is developing at a rapid pace. Since the summer of 2006 art in the Middle East and the art of the region have seen profound changes. In May, Word into art, the critically acclaimed exhibition at the British Museum in London, coincided with the first sale of Christie's Dubai, the first successful international auction to be held in the region. Together these helped to bring Arab and Iranian contemporary art to the attention of the international art community. They were followed soon after by the announcement of the first branch of the Guggenheim Museum to be built in the Middle East, designed by the world-class architect Frank Gehry, a branch of the Louvre, designed by Jean Nouvel, and an auditorium designed by the celebrated Iraqi architect Zaha Hadid. All of these are to be built in Abu Dhabi's Sadiyyat Island, which has been earmarked in its entirety as a centre for the arts. The second half of 2006 saw a flurry of activity in the galleries in the Middle East, especially in Dubai, with new galleries opening, more exhibitions, greater attendance and a greater volume of sales.

The beginning of 2007 saw the second round of Christie's auctions. The results of the second art auction showed that the unexpectedly strong prices achieved at the first sale were sustainable, especially for the new category of Arab and Iranian contemporary art. At the beginning of March, less than six weeks later, the first art fair of international standards came to the Middle East in the form of the DIFC Gulf Art Fair. Funded by the Dubai International Financial Centre (DIFC), alongside the exhibition space in a conference centre, this comprised installations and art works throughout the city. Forty galleries from around the world participated, mainly from Europe and the United States, but also from the Far East, India, the Middle East and North Africa. The estimated 9,000 visitors that attended included international curators, gallerists and art observers on the one hand, and on the other, residents of the Gulf States, especially of the United Arab Emirates (UAE), many of them with a new interest in buying art. These trends have accelerated in the second half of 2007 and in early 2008, with a growing number of new galleries and collectors in the region. The major auction houses have all now included Arab and Iranian

contemporary art in their auctions, and the region now has two annual international contemporary art fairs: Art Dubai in March (the rebranded DIFC Gulf Art Fair) and in November, ArtParis Abu Dhabi.

Categories of art

In the Middle East and North Africa (MENA) there are collectors for contemporary art, Orientalist paintings (19th and 20th century), Islamic art, jewellery and some kinds of European furniture, especially 19th-century. Contemporary art is the best publicized, and comprises Arab and Iranian art (there is a large expatriate Arab community in the Gulf from around the Arab world in addition to the Gulf Cooperation Council (GCC) nationals), Indian and Pakistani art (there is also a large business community from the Subcontinent) and to a lesser extent western art for which there are a growing number of collectors.

Galleries

The geographical distribution of the commercial gallery scene for modern and contemporary art in the MENA can be broadly divided into four areas. First, many of the old cultural centres of the Levant, such as Beirut in Lebanon, Cairo in Egypt, and Damascus in Syria, have galleries which are generally specialized in the art of that country, both recent and 20th century. Second is North Africa, especially Morocco and Tunisia (where the conditions are similar to the Levant). The third sector is the Arabian peninsula: the Gulf States of the UAE, Kuwait, Bahrain and Oman, and also Saudi Arabia, which generally exhibit recent art from around the MENA region; and the fourth is Iran, where the galleries show almost exclusively Iranian art. The price range for works of art from galleries in each of these regions is typically from US$2,000–50,000.

The Levant

Lebanon

In Beirut, contemporary galleries of note include Janine Rubeiz (with works by contemporary Lebanese artists, participant at ArtParis Abu Dhabi), Sfeir-Semler (a branch of the Hamburg gallery, and the only Lebanese participant at the first DIFC Gulf Art Fair, and also in the second fair, rebranded Art Dubai) which shows cutting-edge works from international and Middle Eastern artists, Fadi Mogabgab for contemporary Middle Eastern art, Alice Mogabgab for international contemporary art, and Agial (participant at ArtParis Abu Dhabi and Art Dubai), which specializes in 20th-century modern art from around the Arab world and contemporary Arab art.

Egypt

Cairo has several commercial contemporary art galleries and one of the more creative art scenes in the Middle East. Townhouse Gallery, Masrhribiyya and Espace Karim Francis in the Downtown district show contemporary and cutting-edge work, Zamalek and Safar Khan in the upmarket neighbourhood of Zamalek specialize in modern and contemporary Egyptian art.

Syria

In Damascus there are the well-established Atassi (a participant in the DIFC Gulf Art Fair and Art Dubai) Mustafa Ali's studio and Kozah in the Old City. Ayyam, which opened at the beginning of 2007 in one of the affluent suburbs, is perhaps the most active at the moment, and about to open a branch in Dubai (a participant in ArtParis Abu Dhabi and at the Haughton fair in Dubai); while Art House is an old mill converted into a boutique hotel with a gallery.

Jordan

There are a few small galleries in Amman which specialize in Jordanian and Iraqi art, thanks to the large Iraqi population that has recently moved into Jordan. An arts centre called Darat Al-Funun (the Khalid Shoman Foundation) holds exhibitions and symposia for Arab and international artists.

North Africa

Tunisia

The galleries are centred in Tunis and its surrounding areas. These include Galerie Essaadi in Carthage, the Galeries Cherif Fine Arts and Ammar Farhat in Sidi Bou Said, and Espace Mille-Feuille in La Marsa. Two of them, El Marsa and Le Violin Bleu, were participants in the first DIFC Gulf Art Fair and in Art Dubai. El Marsa also participated in the ArtParis Abu Dhabi fair.

Morocco

The art market is more diffused in Morocco than in other Arab countries, including markets for several categories of collectables, such as Orientalist paintings, Islamic art, carpets and antiques as well as contemporary art. The contemporary art galleries are found mainly in Casablanca but there are also some in Marrakesh, Rabat, Tangier and Fes. In Casablanca, contemporary art galleries include Alif Ba, Athar, Charfi, Espace Wafa Bank, Nadar, Al-Manar and Meltem. In Marrakesh there is Noir sur blanc and Rê, in Rabat, Bab el Rouah and Marsam, in Tangier, Delacroix, and in Fes, the Orientalist Gallery.

The Gulf and Saudi Arabia

United Arab Emirates

Dubai is the centre of the art market in the Gulf and is fast overtaking Beirut as a cultural hub of the Middle East, not least because of the current political situation in Lebanon. There are a growing number of contemporary art galleries and at the moment much of the international attention is on this city. Two of the longest-established galleries are Green Art and Majlis, which exhibits Arab and international art. Newer galleries such as the Third Line (contemporary Middle Eastern, particularly strong in Iranian art, participant at DIFC Gulf Art Fair, ArtParis Abu Dhabi and Art Dubai), B21 (contemporary Middle Eastern, participant at ArtParis Abu Dhabi and Art Dubai), Art Space (mainly Arab art, participant at Art Dubai), XVA (Middle Eastern art, organizer of the Creek Art Fair) often have cultural programmes to complement their exhibition schedules. Contemporary Indian art is shown at Bagash (participant at Art Dubai). These have been joined in recent months by Meem (Middle Eastern art with an Islamic focus), Ave Gallery (contemporary Iranian) and Red Gallery (East Asian).

For a long time, the Abu Dhabi Cultural Foundation in the centre of the city was the only venue in the UAE capital to present exhibitions by prominent Arab artists, and it does so throughout the year. There are few commercial galleries in Abu Dhabi, but surely this will soon change. The first two to open were Ghaf and Qibab, and others are planned. Exhibitions are often held in the lavish Emirates Palace Hotel.

Kuwait

The two well-established galleries here are Al-Sultan and Dar Al-Funoon. Both show work by contemporary Arab artists. Kuwait has had a small but strong art scene for several decades.

Bahrain

The relaxed atmosphere of the capital, Manama, has attracted a gallery scene which, while less busy than Dubai, is quite vibrant by the standards of its neighbours. The two most notable galleries are Albareh (participant at ArtParis Abu Dhabi and Art Dubai) and Al-Riwaq, both exhibiting mainly Arab art.

Qatar

Although the national collection of modern Arab art is almost certainly one of the most comprehensive in the region, the capital Doha currently lacks a commercial gallery. Exhibitions take place in various temporary venues. At least two of the Dubai galleries are about to open branches here within the next year.

Oman

The gallery of note is Beit Munza (participant in ArtParis Abu Dhabi).

Saudi Arabia

Contemporary art in Saudi Arabia is centred on Jeddah, the most relaxed of its cities. Worth mentioning are Roshan and Rida galleries. Riyadh, the capital, now has a gallery, the newly opened Hewar, which looks to be increasingly active. Al-Mansouria is a notable institution in Saudi Arabia.

Iran

Despite, or perhaps because of, the restrictions which related to art in Iranian society, the contemporary art scene is flourishing, alongside the film industry. There are many galleries in Tehran and a few in Isfahan. These are spread out around the city and there are several of note, including the Tehran Gallery, Seyhoun, Mah, Homa, Assar and Silk Road (for photography, participant at ArtParis Abu Dhabi and Art Dubai). Ave, the sister of the Dubai gallery, shows cutting-edge work.

Iraq

The political situation in Iraq has forced many Iraqi artists to relocate. Accordingly, Iraqi art can be found in neighbouring countries such as Syria, Jordan and in the Gulf.

Local auctions

There have been a number of auctions of Orientalist and contemporary pictures in Beirut over the last ten years. These have been largely discontinued following the events of summer 2006. The Moroccan auction house MarocAuction at Galerie Athar in Casablanca holds several sales a year, with categories including posters, arms and armour, objets d'art, Moroccan and orientalist paintings, Islamic art and carpets. The Moroccan auction house Compagnie Marocaine des Oeuvres et Objets d'Arts (CMOOA) held its first sale of Arab and Iranian contemporary art on 29 March 2008.

International auctions

Christie's Dubai holds two auctions a year, one in spring and one in autumn. Since March 2007, the other major international auction houses have announced their plans for the region. Sotheby's has an office in Abu Dhabi, and held a sale of Modern and contemporary Arab and Iranian art in London on 23 October 2007. In April 2007, Bonhams announced that it was to open a Dubai office in partnership with the Dubai-based Al-Tajir family, and held its first auction in Dubai on 3 March 2008, which was very successful.

Museums

Notwithstanding the high-profile designs for museums and cultural centres in the Gulf, both announced and in preparation, public access to high-quality works of art in museums remains restricted. Currently there are relatively few major non-commercial exhibitions, but these are growing in number as interest grows and funding becomes available. In 2008 Dubai has seen the British Museum exhibition, Word into art, and a selection of high-quality works from the JP Morgan Chase collection of contemporary art be exhibited in DIFC, while Abu Dhabi has hosted a major show of Islamic art from the Nasser D Khalili Collection in the Emirates Palace.

Few Middle Eastern countries hold permanent national collections of contemporary art from the Middle East and Islamic world. Those of note in the Arab world include the Jordan National Gallery of Fine Art in Amman, the Museum of Egyptian Modern Art in Cairo, the National Museum in Damascus (with a small section of modern Syrian art), the National Museum of Contemporary Art in Rabat and the Omar Benjelloun Foundation in Marrakesh (both in Morocco), and the Museum of Modern Arab Art in Qatar (soon to be rehoused in larger premises). 2007 saw the opening of the Museum of Modern and Contemporary Art in Algiers.

In Egypt there are also a number of smaller museums showing the work of specific artists, notably the Mahmoud Said Museum, the Museum of Adham and Seif Wanly, the Museum of Modern Art, all in Alexandria, and in Cairo, the Mahmoud Khalil Museum (with a fine collection of paintings by Western impressionist and modern artists). In Iran, the Tehran Museum of Contemporary Art holds a permanent collection of Iranian modern art as well as one of the world's great collections of Western post-impressionist, modern and contemporary art. This museum was supported by the former Empress of Iran, Farah Diba, a great patron of the arts. Last year a new museum opened, the Imam Ali, for contemporary work influenced by traditional Islamic art.

The older museums are unlikely to continue to acquire art in great quantities due to limited funding, although the newer ones in the Gulf, on much higher budgets, will continue

to enlarge their collections. The governments of several Gulf States, such as the UAE, Qatar and Kuwait, have recognized the value of investing in museums in terms of national prestige and the benefits of cultural tourism. Within the next few years, Qatar will open its Islamic Art Museum and Kuwait will reopen its National Museum. As the countries of the Middle East develop their collections, enabling the public to educate itself better about regional and international art, we should expect to see an increased number of potential collectors.

Biennials

The Sharjah Biennial, held in the spring, is a showcase of Middle Eastern and international contemporary art. It has been running since 1993, and until recently the only large-scale international event in the Gulf. In Egypt, the Cairo Biennial is held at the Gezira Opera House complex in the centre of the city.

Fairs

The DIFC Gulf Art Fair in March 2007, held at the Madinat Jumeirah hotel, generated a lot of favourable publicity, catching the attention of the global media and art market alike. The galleries with the greatest number of sales were those from the Arab world and India, although the western galleries made more sales than expected. The second fair, rebranded Art Dubai, held in March 2008, also at Madinat Jumeirah, was almost twice the size, with 70 galleries included, and had a greater focus on Middle Eastern contemporary art, whilst at the same time attracting a large number of international galleries. Again it included public art projects around the city. Held at the same time as Art Dubai in the historical area of Bastakiyya by the Creek in Dubai is the fringe fair, the Creek Art Fair. Organized by XVA gallery, this includes local and regional galleries and exhibits by individual artists. In February 2008 the first Haughton's Art and Antiques fair was held at the same venue as Art Dubai, the Madinat Jumeirah.

November 2007 saw the inaugural ArtParis Abu Dhabi, the first fair in Abu Dhabi, held at the Emirates Palace Hotel and including Western and Middle Eastern and North African galleries.

Collectors and collections

Collectors of Arab contemporary art mostly comprise those in the Levant and North Africa, with collections drawn from that country or from its immediate neighbours, and a number of dedicated collectors in the Gulf, either expatriates or Gulf nationals. The first group has in some cases collected over a period of decades, whereas the second group includes those who have more recently started collecting, a number of them of Western origin. Residents of Gulf countries often collect several different categories, and there are the beginnings of a crossover between collectors of Arab, Iranian and Indian art. Many of the collectors of Iranian contemporary art are based in Iran, but there are collectors among the large expatriate Iranian communities in the Arab Gulf States, Paris, London and in the United States.

Local media coverage

Since 2006 the regional art market has caught the imagination of the local media. More important exhibitions are mentioned in the dailies of the respective countries, and those that take place in the UAE are often featured in listings and society magazines. Events in 2007 in the Gulf attracted the attention of the international press, and a long feature in the *Art Newspaper*. This trend has continued during 2008.

Currently there are two outstanding periodicals on Middle Eastern art, *Canvas* and *Bidoun*. Both are available at news stands and in galleries throughout the region and further afield. *Canvas* discusses many of the prominent artists on the market and includes with each issue a comprehensive listings guide of events both within the Middle East and globally that relate to Middle Eastern Art. *Bidoun* focuses more on cutting-edge contemporary Middle Eastern art.

Legal issues and taxation

Purchasers of objects imported into the UAE, collected or shipped within the GCC (Gulf Cooperation Council, including Saudi Arabia, UAE, Kuwait, Qatar, Bahrain and Oman) are subject to 5 per cent import duty on the total price, levied at the time of collection. *Droit de suite* does not apply in the UAE.

The other countries in the region each have their own regulations which should be checked carefully prior to importing or exporting works of art.

Prognosis

Although a fledgling art market, there is a lot of potential in the Middle East, and especially within the Gulf, where there is a diverse range of nationalities, a concentration of capital and an increasing level of cultural sophistication linked to rapid development. The recent events in Dubai and elsewhere have linked the disparate strands of the Middle Eastern contemporary market and have seen the emergence of a unified art market. There is a growing contingent of collectors who are purchasing Arab and Iranian art for investment purposes, following what has become a growing trend in the global contemporary art market. Some observers have noted similarities in the emergence and growth of the Arab and Iranian art market and the Indian and Chinese before it. These trends will no doubt be bolstered by the increased participation of the international auction houses and art fairs in the region.

For further information on the development of this particular art market, go to:
www.koganpage.com/artmarkets.

The Netherlands

Bert Bakker and Rachel Campbell

Dutch art internationally: prominence thanks to fertile soil

Although prominent for the size of the Dutch population, the Netherlands is a small player in the international art markets. The United States and the United Kingdom dominate worldwide sales, with the Netherlands falling behind France, Germany and Italy in the prices reached for global sales. The Netherlands was not even mentioned as a sales location in the Artprice trend reports of recent years.

Artists with Dutch origins however more than make up for the lack of market share, with a 6 per cent significant share of the global top 50 of artists ranked by auction turnover during 2006. The abstract expressionist painter Willem de Kooning (1904–1997), Rotterdam born, was the best-selling Dutch-born artist in 2006, ranking globally at fourth place, with US$107 million turnover at auction, behind Picasso, Warhol and Klimt. Vincent van Gogh (1853–1890), having only just remained in the top 50 at 49 in 2005, took 13th place with $52 million at auction in 2006. Third in the Dutch rankings was Kees van Dongen (1877–1968), taking place 23 in the top 50 ranked artists by auction turnover, with $34 million sold at auction in 2006. Average prices for de Kooning and Van Dongen have risen substantially over recent years.

The general trend for Dutch art compared with the global art markets is reflected in Figure 25.1, constructed using data from Art Market Research.

Average prices for the top 100 Dutch artists are shown next to the general art index, which constitutes the world's top 100 artists. Both indices start in 1976 at 1000, showing that the prices for Dutch art have been generally lower than the global art market as a whole. The enormous prices reached during the boom in the market during the 1990s were not attained to such a striking effect for Dutch painting; hence the drop thereafter was less dramatic than for the global art market. Prices have therefore tended to rise again at a steadier rate over the past 25 years.

2007 has seen a dramatic rise in prices on the market for artists with Dutch origins. The index constructed with the top 100 Dutch artists in 1976 does not include and therefore account for subsequently popular artists such as Kees van Dongen and Willem de Kooning, whose works as we have seen are currently reaching extremely high prices. This will only serve to underemphasize the value for the Dutch index at present.

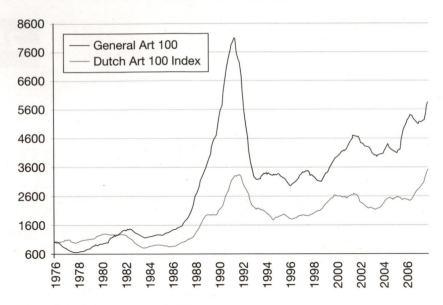

Figure 25.1 Dutch art prices, 1976–2006
Data source: Art Market Research

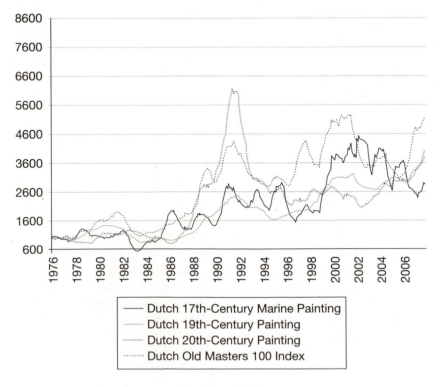

Figure 25.2 Prices for Dutch art sectors, 1976–2006
Data source: Art Market Research

Breaking down the Dutch market into the various sectors – 17th-century marine painting, 19th century, 20th century and Old Masters for the Dutch market – enables us to see which sector of the Dutch market has outperformed the others. It can be seen from Figure 25.2 that the Dutch Old Masters' prices have remained the top sector for art price performance. Prices for Dutch marine painting have been quite volatile, resulting in greater price risk in this sector, and at present lie below the other sectors in the market. Marine paintings appear to have fallen from fashion from 2002 to 2006 relative to other types of Dutch painting. During this period we can also see a general upward trend in prices for both 19th and 20th-century Dutch paintings, slightly behind the staggering price increase for Dutch Old Masters during this period.

The Cobra movement for art is tracked (see Figure 25.3) by taking average art sales prices from the following artist members: Pierre Alechinsky, Karel Appel, Corneille, Lucebert, and the Danes Egill Jacobsen, Asger Jorn, and Carl-Henning Pedersen, from 1976 to 2005. From 1975 the price for art of the Cobra movement followed the general art market quite closely, although the extremely high prices of impressionist art were not reached during the 1990s boom. In the last 10 years prices deteriorated relative to the general art index, but they have made an astonished comeback in the 2000s. Compared with other major sectors in the art market, the Cobra movement has done extremely well, with average annual returns of over 7 per cent over the five years to 2006, even accounting for a fall in the first three years of

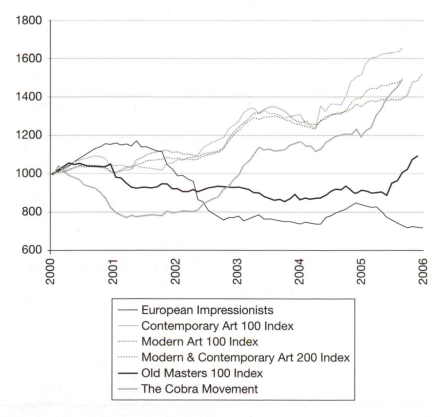

Figure 25.3 Art market research sector indices

Data source: Art Market Research

the decade. Since 2000 returns have been in line with the especially hot markets for modern and contemporary art, and from 2004 to 2006 returns averaged a staggering 15.5 per cent.

Dutch contemporary artists in the international market

In terms of international fame, Dutch contemporaries as a collective do not quite stand up to the standards set by their 17th-century forebears. But some do play a part in the contemporary art market hype that is currently going on. The work of a handful of young Dutch artists is bought by devoted collectors from all over the world.

Two of them do photography. Inez van Lamsweerde (b 1963) is a fashion photographer, whose pictures are bought as stand-alone autonomous works of art. Rineke Dijkstra (b 1959) made her reputation shooting adolescent girls on desolate Eastern European beaches. Like painter Marlene Dumas (b 1953), she is a master at showing human vulnerability. Dumas in fact has been so hot in the international art markets, and has in recent years been so much sought after, that at auction her works are being sold in the multi-million bracket. In 2005 her painting *The teacher* (1987) fetched over $3.3 million, the highest price ever for a piece of art by a living female artist. A sad detail for chauvinists is that Dumas is not Dutch at all. All her working life she has spent in the Dutch capital and she has been teaching at the prominent Amsterdam art school De Ateliers for many years, but Dumas in fact is South African.

Michael Raedecker (b 1963) and Aernout Mik (b 1962) are two more up and coming stars still in their 40s. Raedecker, a painter, was nominated for the Turner Prize in 2000, and exhibited by London art mogul Charles Saatchi, thus quickly outgrowing the slightly parochial Dutch art scene. Mik made his mark as a sculptor and a video and installation artist.

Atelier van Lieshout is another name that must be mentioned. Joep van Lieshout (b 1963) heads a group of 20 to 30 junior artists who execute impressive installations to his design and sculptures often made of monochrome synthetic materials. Functions of the human body (that is, faeces) are among his fascinations.

Maybe not contemporary in the strictest sense, but fitting in the postwar modern bracket is Jan Dibbets (b 1941), who starred internationally from the 1960s to the 1980s, when he experimented with so-called 'perspective corrections': compositions of shifting photographs of church vaults, cupolas and landscapes.

The best known Dutch artist of the north-west European 1950s Cobra movement was Karel Appel. From the late 1950s onward Appel exhibited and worked in Paris and New York. In 2005 he died in Zurich.

Sculptor and printmaker Jan Schoonhoven (1914–1994) started producing his typical oeuvre, grid-shaped white paper-covered 'reliefs', only when he was over 40. These objects, refinedly playing with light and shadow, started capturing the eyes of international museums in the 1960s, and from then on those of collectors from Holland and beyond.

Dutch design

In contrast with the fairly modest presence of Dutch contemporary art in the international arena, Dutch contemporary designers have become extremely visible and successful since the mid-1990s, maybe even more so outside the Netherlands than within. Prominent names are designer collectives such as MOOOI and DROOG, and the design platform Frozen Fountain. Individual designers such as Tejo Remy (b 1960), Maarten Baas (b 1978), Marcel

Wanders (b 1963), Claudy Jongstra (b 1963), Jurgen Bey (b 1965) and Hella Jongerius (b 1963) have become design deities, in part due to the fact that the appreciation of design objects made in small editions is on an equal footing with autonomous art, and they are therefore becoming equally collectable.

The Dutch markets for global art today

Holland has a long history as a trading centre, and this still remains for the art market. The Netherlands hosts one of the world's leading art and antique fairs, the European Fine Art Fair (TEFAF), the result of a merger of Antiquairs International in Valkenburg (just east of Maastricht) and the Pictura Fine Art Fair in 1985. In March every year over 215 of the most eminent international dealers from 15 countries flock to the Maastricht Fair, in the southern province of Limburg, for just under two weeks. With only 18 per cent of the exhibitors being Dutch, and 10 per cent of the exhibitors coming from outside Europe, the fair has an extremely international, rather than just European feel. Originally the fair built its reputation on Dutch and Flemish masters, but it has grown to cover Italian, Spanish, French, German and English Old Master paintings. Over the last few years TEFAF has also become an increasingly important venue for modern and contemporary art. More than 40 prestigious modern art dealers from nine countries exhibit in Maastricht, showing one of the greatest displays of 20th-century European and American art. Although named for fine art the fair has an increasing reputation for French, English and Italian furniture, Classical antiquities and Egyptian works of art as well as Asian, African, Oceanic and South American objects, with a more global feel than the fair's name denotes. On offer are around 20,000 works of art with a total value between €0.5 and €1 billion. With an average price of €25,000 it is a tall order for the majority of the 84,000 visitors.

The Netherlands's second art fair, whose name is also uncharacteristic of the style of art on show, is pAn Amsterdam in the Dutch capital, which is extremely Dutch in flavour. Of just over 100 exhibitors from the Netherlands, Flanders and Germany, over 85 per cent are Dutch. Attendance figures are also very high, at over 30,000 annually, and growing, showing a strong national interest in art.

Interest in global art on a national level is underlined by the fact that the Netherlands boosts an enormous number of museums for the size of the population. Some of these museums are dedicated to famous Dutch artists, such as the Van Gogh Museum and the Rembrandt House in Amsterdam, or to art influenced by particular Dutch art movements, such as the Cobra Museum in Amstelveen, and the Mondriaan House in Amersfoort.

Local Dutch art and art markets

For art collectors touring the Netherlands it is tempting to believe that after their visit to the Rijksmuseum and the Van Gogh Museum in Amsterdam they can take a stroll along the canals and, money presumed no object, pick up a splendid little Dutch Old Master at a local art gallery, or maybe a Van Gogh or a Mondrian overlooked by others. Sadly, the Netherlands is an unlikely place to find art at that level. London and New York are the marketplaces for the best of Dutch classic art, with the exception of the TEFAF art fair of course. But then, TEFAF is the international art market epitomized. So what could a collector typically expect to find in the art galleries and auction houses of Amsterdam and The Hague? (Rotterdam plays a rather modest role.)

Of course in the Amsterdam Nieuwe Spiegelstraat and adjacent Prinsengracht area or The Hague's Dennenweg you will probably find the occasional Rembrandt etching, or a 17th-century still life with flowers or birds. And there certainly is an ample choice of Dutch *haute époque* and Baroque furniture, and decorative items like Delft vases, saucers and tiles, and silver, bronze and tin objects. They will possibly even be at quite reasonable prices, since antiques in general have grown somewhat out of fashion amongst under-50 collectors. The 18th century was not very productive in terms of autonomous art, but so much more in – again – antiques and decorative arts. Dutch varieties of the Louis styles are quite abundant and are generally offered at modest prices.

Surprises are more likely to be found in art and objects of less mature age. The 19th century for example is quite appealing, even if it is true that Dutch artists were not among the inventors of impressionism – possibly with the exception of J B Jongkind (1819–1891), who was connected to the Barbizon school of painters after he left for France in 1846. Neither did the Netherlands produce precursors of the romantic movement, like the German Caspar David Friedrich (1774–1840). And medieval revival styles such as practised by the British pre-Raphaelites John Everett Millais (1829–1896) and Dante Gabriel Rossetti (1828–1882), did not branch out to Holland until the last decades of the 19th century. But the Netherlands did develop their own, very Dutch-rooted romantic styles.

Winter landscapes with skaters drinking chocolate under grey and orange skies have been, and still are, a very popular genre. Artists who worked proficiently in this style were A Schelfhout (1787–1870), J J Spohler (1811–1866), B C Koekkoek (1803–1862) and C Leickert (1806–1907). Art historians have long maintained that these nostalgic pictures verged on the kitsch, but popular demand, both domestic and from abroad, has always been strong and recently prices have shot up to levels only seen internationally. For example a painting by Koekkoek sold at auction for an extraordinary €1.4 million, and price tags of €300–400,000 for romantic school paintings are no longer exceptional for other local artists of that period.

Roughly the same applies to an equally Dutch genre: views of streets in the historical towns of Holland. Master of this style was no doubt Cornelis Springer (1817–1891), whose *View of the streets of Enkhuizen* made over €1 million at auction in 2006. And a work by the female painter Henriette Ronner-Knip (1821–1909) who specialized in painting cats and kittens – until recently considered too sentimental to be taken seriously – can today cost well over €300,000.

In comparison, prices of the traditionally more highly regarded Dutch impressionists actually seem reasonable. For works by J B Jongkind, and Josef Israels (1824–1911), top prices can hover around the €500,000 mark, but generally sell for less. The same goes for the later Hague school painters like J H Weissenbruch (1824–1903), Jacob (1838–1899) and Willem Maris (1844–1910) and Isaac Israels (1865–1934), or an impressionist like G H Breitner (1857–1923), whose early photography-inspired paintings have a nice Amsterdam flavour.

Van Gogh (1853–1890) was active in the 1870s in Brabant, but his dark early Dutch work is considered less interesting than what he made in his more colourful and mature French period. Interestingly Van Gogh was never part of any school or movement of Dutch artists.

In the beginning of the 20th century the Netherlands was however one of the breeding grounds for the gradual move towards abstract painting. Around 1910 Piet Mondriaan (1872–1944) was experimenting with cubism and the reduction of a painting to vertical and horizontal lines and primary colours. Before that however he worked in a symbolistic style alongside artists like Jan Toorop (1858–1928), less well known internationally. In the 1910s both artists met in the sea resort and artists' colony of Domburg, where Mondriaan would later conceive his ground-breaking work *Pier and ocean.*

Mondrian's abstract painting had a decorative arts counterpart in furniture designed by the De Stijl architect Gerrit Rietveld (1888–1964). The De Stijl movement was also connected to Walter Gropius's (1883–1969) Bauhaus. The market for 1920s to 1950s Rietveld furniture (often unique or almost unique pieces and very expensive) is still partly Netherlands-based.

Among *fin de siècle* painters, Toorop, who went through several stylistic phases, is still among the most highly regarded. A portrait of a lady done in the pointillist/lumist way in 1900 was sold to the Rijksmuseum for over €800,000 in 2005.

Fauvism, another early 20th-century movement, developed a relatively strong foothold in Holland. Dutch born Kees van Dongen was one of the best-known representatives of the school. Jan Sluijters (1881–1957) and Leo Gestel (1881–1941) have embodied the expressive colourful style in the local market, and today both show up in auction quite frequently. Prices can go as high as €200–300,000, but mostly remain within the €20–50,000 range.

In the 1920s Kirchner's (1880–1938) expressionism had Dutch offspring in a Groningen-based group of artists called De Ploeg. Hendrik Werkman (1882–1945), Johan Dijkstra (1896–1978), Jan Altink (1885–1971) and Jan Wiegers (1891–1959) were some of the important names. De Ploeg is little known outside the Netherlands and consequently prices, in the €10–30,000 range, tend to be modest.

The years between the great wars also saw some artists with kindred minds to surrealist De Chirico (1888–1978), now indicated as magical realists, the most prominent names being Pyke Koch (1901–1991), Jan Mankes (1889–1920), Wim Schuhmacher (1894–1986) and Carel Willink (1900–1983).

During the inter-war period in the field of decorative arts Holland also gave birth to a fascinating variety of the art deco style, called the Amsterdamse school. Designer-architects Michel De Klerk (1884–1923) and Piet Kramer (1881–1923) drew dreamlike, grotesquely shaped houses but also chairs, tables, sideboards and lamps, often executed in rich combinations of tropical and vernacular woods. Sculptors typically connected to the Amsterdam school were John Raedecker (1885–1956) and Hildo Krop (1884–1970). For some reason this rather un-Dutch style (in the sense that it contradicts the typical Calvinistic preference for frugality) has generally been neglected by other than Dutch buyers, meaning that prices have remained somewhat below their French or American contemporaries. Though not typically connected to the Amsterdam school, a famous designer of decorative glass was Andries Copier (1901–1991). H P Berlage (1856–1934) was a very prolific designer and architect, initially working in the arts and crafts tradition and later in a Frank Lloyd Wright-inspired modernist style.

The post-Second World War era is probably best described by dividing it in two: the first 25 years after 1945, when the country was recovering from the war, and the period thereafter when wealth and welfare rose to levels not seen before. In the first quarter-century the community of artists was small, but relatively successful, Cobra being an internationally visible movement. After 1970 the opposite was the case. Higher incomes and generous government grants allowed thousands of baby boomers and following cohorts to start off in life as artists, but precious few came to national, let alone international, renown.

Apart from Cobra, interesting local artists born before, but mainly active after, the Second World War are Armando (b 1929), Gerrit Benner (1897–1981), Ad Dekkers (1938–1974), Jef Diederen (b 1920), Daan van Golden (b 1936), Ger Lataster (b 1920), Jan Roeland (b 1935), Sierk Schröder (1903–2002), Carel Visser (b 1928) (a sculptor) and Co Westerik (b 1924). It is however hard to pinpoint a common denominator in the work of these artists.

This last observation seems even more true for the generation born during or after the war. Some of them are mainly known in the Netherlands and well represented in museums

such as Stedelijk Museum Amsterdam, Van Abbe, Bonnefanten and Boymans Van Beuningen, but they have the potential to attract (more) interest from foreign collectors. Examples are Eric Andriesse (1957–1993), Philip Akkerman (b 1957), Rob Birza (b 1962), René Daniels (b 1950), Ger van Elk (b 1941), Kees de Goede (b 1954), Fons Haagman (b 1948) Jeroen Henneman (b 1943), Erik van Lieshout (b 1968), Marc Mulders (b 1958), Avery Preesman (b 1968), Marien Schouten (b 1956), Han Schuil (b 1958), Toon Verhoef (b 1946) and Robert Zandvliet (b 1970). (Artists under 30 are not included here.)

One final point to be mentioned is that the current hype in contemporary art collecting, such as seen in the United States, the United Kingdom, Germany, Italy and other countries, simply has not manifested itself in the Netherlands. Prices under €10,000 are still normal for any postwar work of art. Price tags over €50,000 are highly exceptional. Still, this says very little about the art itself and a lot about the prevailing local art-collecting traditions.

The role of the government in the art scene: public and private spending on the arts

Although the Dutch government is the largest patron for public art and culture, the Netherlands channels a smaller proportion of its GDP through its public agencies for the arts than other countries (see Arts Council, 1998). Less money is spent on the arts because a lower proportion of arts spending is managed at the public level. Much as in the United States the arts are left to private initiatives. This appears to work effectively with a society dedicated to the arts.

During the 1960s when the ideological pillars of Dutch society began to fall, government policy changed and subsidized quality in the arts, providing for example local facilities for the arts. The government continued to fund high-quality art within a budget, and introduced financial incentives for institutions acting privately within the free market. Today the Dutch government has outsourced cultural policy in the Netherlands to the Raad voor Cultuur and the Mondrian Foundation, thus distancing itself from making value judgements, but with decisions still being made in the public rather than the private domain.

The current government policy towards the arts is to reduce the bureaucracy in supporting arts and culture, to achieve a greater connection and interaction in cultural lifestyles, and to further promote the cultural element in society. However, according to the Dutch Ministry of Foreign Affairs on Dutch cultural policy from 1999–2003, public expenditure for culture in general has risen by almost a third. It also reports that spending on museums has increased by more than a quarter and funding for the performing arts more than doubled. Since 2004 these increases have been curtailed.

For further information on the development of this particular art market, go to: www.koganpage.com/artmarkets.

Reference

Arts Council (1998) International data on public spending on the arts in eleven countries, research report 13 (March), Arts Council of England, Policy Research and Planning Department.

New Zealand

Tim Hazledine and Mary Vavasour with Lisa Gotlieb

This chapter consists of two main sections: the first is an account of the functioning of the primary and secondary art markets, and the second reports some statistical analysis of prices received at auction by leading NZ painters.

The structure of the art market in New Zealand

Nearly all NZ-made art is bought by New Zealanders – living at home or expatriate – and most but not all art bought by New Zealanders is locally produced. That is, there is very little export market for NZ art, but over the years, a stock of imported art has found its way into the country, and from time to time, on to the market. However, it is unusual to find major overseas paintings or sculptures in the local catalogues. This does not mean that such works are not owned by New Zealanders, but rather that these are taken out of the country, most often to London, for resale. In recent times, in the primary dealer market, a few galleries (such as the Jensen Gallery) are showing international artists. However, they have not come on to the auction market as yet.

So the focus of the market, and of this section, is on works of art made and sold in New Zealand. The primary market operates largely through dealers, in the usual way, and the secondary market is shared between dealers and auction houses. We shall examine the workings of both.

Auctions

The five art auctioneers are Webb's, Dunbar Sloane, International Art Centre, Cordy's, and newcomer Art+Object that opened in 2007. Webb's (www.webbs.co.nz), in Auckland, is generally agreed to be the market leader. It holds auctions of major paintings and other works of art four times a year, usually in April, June, September and December. Dunbar Sloane (www.dunbarsloane.co.nz) dominates militaria, Maori and Pacific artefacts in Auckland, and art sales in Wellington. Three auctions are held yearly in each city dependent on when stock

comes in. The International Art Centre (www.internationalartcentre.co.nz) holds six auctions a year in Auckland, also dependent on stock availability, with more of an emphasis on historical artwork. Cordy's (www.cordys.co.nz) focuses on antiques and general sales. Art+Object (www.artandobject.co.nz) focuses on art, modern design and applied art. It is fair to say that works of the highest quality, if not sold privately or through one of the leading primary dealers, are likely to be consigned to Webb's; perhaps to Dunbar Sloane, if the seller is Wellington-based.

According to data prepared by Webb's, the NZ art auction market had an annual turnover in the $5–7 million range from 1995 to 1999, then jumped to $11.4 million in 2000, peaked at $19.3 million in 2003 and has since fallen back somewhat. (Figures are in NZ dollars unless otherwise indicated. At time of writing NZ$1 = US$0.78 and €0.50. Inflation in New Zealand over this period has been fairly steady at 2–3 per cent per year, so a doubling in nominal turnover over 10 years represents, in real terms, approximately a 70 per cent increase.)

In 2003, 4,222 lots were sold, at an average price of $4,571. In 2004 more lots came on the market, but the price achieved on sales dropped quite sharply, to just $3,404. However the 2004 fall in price does not appear to have been driven primarily by the higher end of the market, although prices there have eased since 2005. Just five artists accounted for 32 per cent of sales, by total value, in the two years 2003–04 – Ralph Hotere (b 1931) (11 per cent), Colin McCahon (1919–1987) (9 per cent), Frances Hodgkins (1869–1947), (5 per cent), Bill Hammond (b 1947) (4 per cent), and Michael Smither (b 1939) (3 per cent). Since then the Hotere market has fallen back, and the long-term leader in sales value is undoubtedly McCahon, whose painting *Let be Let be* (1959) set an NZ auction price record in 1995, selling for $712,000 (hammer price), and selling again a couple of years later for AUS$1.1 million through a commercial dealer gallery. The National Museum Te Papa in 2003 paid privately $2.75 million (+GST) for McCahon's *Beach walk* (1973) – a painting which had been first purchased for $25,000. Many of McCahon's paintings have sold through the commercial dealers for $1million upwards.

On the list of the 10 highest price auction painting sales of the 1995–2004 period, McCahon takes first, second and seventh place; third is Hodgkins, fourth Gordon Walters (1919–1995), fifth C F Goldie (19870–1947), sixth and eighth Hotere; ninth the historical painter LJ Steele (1843–1918), and tenth Hammond's *Whistlers mothers, sticks and stones* which fetched $240,000 in 2003.

The auction houses add a buyer's premium and subtract a seller's premium from the sale price. These premia are set at 12.5 per cent, plus goods and services tax (GST) at 12.5 per cent on the value of the premium. GST is the tax on valued added applied almost universally in New Zealand (the only exceptions are housing rentals and mortgages). As a value added tax, it is not applied to the sale price of a second-hand item such as a painting being resold on the secondary market, only to the cost of the transaction – the dealer margin or the auction house premia. New paintings are subject to GST if the artist is 'registered', this being a requirement for all businesses with turnover of more than $40,000/year. Of course, the artist can claim back the GST included on materials and other costs of production, such as studio rental. Thus, a painting which sold at auction at a hammer price of $100,000 would end up costing the purchaser $114,000, and yielding the seller a net price of around $90,000. The buyer's premium is normally fixed, while the seller's premium is approximately 10 per cent but a certain amount of negotiation may sometimes go on with respect to this premium, if, for example, the work is a significant piece which will add prestige and interest to the auction list, or if it is to be featured on the cover of the catalogue.

Prices are set in the usual manner, as the result of what economists call a first-price English auction, in which the highest bidder when the gavel falls pays the highest-price bid.

If the highest bid is below but not too far below the reserve there may be some to and fro-ing the next day, mediated by the auction house, to attempt to find a mutually satisfactory price. Reserves are not normally formally announced in advance, but can usually be taken to be the lower end of the range of 'estimates' given for a work in the auction catalogue.

Dealers

The dealer market is of course much harder to quantify than auctions, because data on sales and turnover are not publicly available. Even estimating the number of dealers is problematic, because, unlike art auction houses, which must operate at a certain scale or not at all (to offer regular sales, produce catalogues, etc), there is no sharp objective demarcation line to be drawn separating 'serious' dealers from the chocolate box merchants and picture framers selling 'fine art' on the side. Webb's data suggests that there are approximately 40–50 dealer galleries of significance, and we can provide a somewhat shorter list in an appendix available from the authors. In terms of the secondary market, the most important 'blue chip' dealer is probably Gow Langsford in Auckland, where the Ferner Gallery also has a presence. In the South Island the leading players are Fisher Galleries and Milford Galleries. Fisher Galleries has begun an online art auction service, but the internet does not appear to have become a serious site for the sale or purchase of NZ art.

It is estimated that these 40–50 dealer galleries have an annual turnover upwards of $45 million, with the top 10 accounting for $20 million-plus of this. Apart, of course, from their crucial role in bringing new artists and the new work of established artists on to the market, dealers perform a stabilizing role relative to the auction houses in the secondary market.

The most established primary dealer is Peter McLeavey (Wellington), who has been a pioneer, making a significant contribution to the public acceptance of the new work of McCahon, Hammond, Walters, Milan Mrkusich (b 1925), Robinson, Smither, Michael Illingworth (1932–1988), Richard Killeen (b 1946) and others. A mid-generation dealer in Wellington is Hamish McKay, who shows a good mix of Australian and New Zealand artists. Brooke Gifford Gallery is a well-established dealer in the South Island showing all the senior and mid career artists from the North such as Killeen and Hammond.

Gow Langsford also shows new work by John Pule (b 1962), Sarah Hughes (b 1971), Shane Cotton (b 1964) and Judy Millar (b 1957), and represents the estate of Allen Maddox (1948–2000) and Tony Fomison (1939–1990). It also shows a few international artists such as Bernard Venet and Tony Cragg, as well as contemporary Chinese art.

Sue Crockford Gallery represents the Gordon Walters estate as well as representing Hotere and Mrkusich. Younger, high-profile artists such as Peter Robinson (runner-up for the Walters prize) and John Reynolds (b 1956) are also represented, with some international artists and prominent photographers such as Laurence Aberhart (b 1949).

Recent arrivals are the Michael Lett Gallery, whose key artist is Michael Parekowhai (b 1968), and Starkwhite Gallery, which show 'et al' (Walters prize winner, 2004 and participant at the Venice Biennale, 2005) and also focuses on photography and emerging artists. Newcomers include the Anna Miles Gallery, Two Rooms and Roger Williams Contemporary.

Of the younger generation of dealers, the emerging leaders are, in Auckland, Andrew Jensen, Ivan Anthony and Vavasour Godkin. Jensen Gallery represents both New Zealand and international artists, such as the leading New Zealand abstract artist Stephen Bambury (b 1951) and the Scottish abstract painter Callum Innes, who has a high profile here. Ivan Anthony represents photographers and sculptors as well as painters. His stable includes the well respected mid-career artists Killeen and Hammond, as well as younger local stars such

as Andrew McLeod (b 1976), Yvonne Todd (b 1973) – winner of the Walters Prize (fashioned on the Turner Prize) – Rohan Wealleans (b 1977) (Wallace Prize winner), and Frances Upritchard (b 1976) (Walters Prize winner). Vavasour Godkin is a mid-generation dealer which has launched the careers of many young emerging abstract artists. The gallery represents the well-respected senior artists Geoff Thornley (b 1942) and Andrew Drummond (b 1951), as well as young artists such as Noel Ivanoff (b 1963). Anna Bibby Gallery shows artists such as Elizabeth Thompson (b 1955) as well as younger artists.

FHE Gallery and Masterworks deal in glass works, with Ann Robinson (b 1944) being the dominant figure. Robinson has a strong primary and secondary market and also shows internationally. FHE Gallery is known for its artefacts from the Pacific rim as well as ethnological objects from the Oceania.

Dealer margins vary, but a typical figure in New Zealand is 40 per cent – that is, the sale price is split 60:40 between artist and dealer. Thus the mark-up is less than in, for example, New York, where a 50:50 split is customary. Attempts to haggle on the price of a new work are not likely to be successful, and may be counter-productive. Certain important private collectors and public museums/galleries may be offered, as a matter of course, a 10 per cent discount. The secondary market operates somewhat differently. Probably most, or in some dealers' cases all, the works are sold on consignment from their current owner, with the initial promise (or forecast) of the owner netting an agreed sum. The dealer may or may not commit to the maximum sum they will ask for the work.

Art consultants

The profession of 'art consultant' is even harder to delineate than that of 'art dealer', being a designation assumed at will by persons of widely varying expertise and professionalism, including some whose principal occupation is actually interior decoration. In New Zealand there is a very small number of fully professional art consultants, competent to assist serious private and corporate collectors in the accession and de-accession of high-quality works of art. Such consultants will not just guide their clients to quality artists, but will have the expertise to limit their attention to only the best, or at least, very good examples of the work of those artists (which of course are not always the biggest or most expensive). The consultant will be aware of the suitability of the work as part of the client's present and future collection, and will advise on the optimal arrangement and hanging of the collection in the client's home or offices. The best consultants will have good relationships with all dealers which will be of value to the consultant's clients; for example in getting early access to important works before their availability is made known to the wider market. A particularly valuable service that a skilled consultant can perform is to bid at auction for a client.

Art buyers

The buying side of the NZ art market is predominantly made up by private collectors and art institutions. There is also some corporate collecting, by, for example, large law firms, businesses and upmarket hotels. Any work of major artistic or historical interest is likely to attract some institutional interest. Controversially, New Zealand no longer has a national gallery. This was closed in 1998 and replaced with a museum, Te Papa, in Wellington, which originally had no permanent art exhibition space at all. The fine national collection is stored in a warehouse.

Fortunately this collection continues to be added to, as do the collections of the leading regional public art galleries.

Prices listed or quoted at dealers will be inclusive of such GST as they are liable for. The auction buyer's premium of 12.5 per cent has GST at 12.5 per cent added to it, so that overall it adds 14.06 per cent to the hammer or negotiated sale price. There is no capital gains tax (nor estate tax) in New Zealand, but frequent buying and selling of art – as with any other asset, such as property or shares – will likely attract the attention of the Inland Revenue (the taxation office), which may after investigation determine that the 'collector' is in fact really acting as a professional trader, in which case all the profits from these trades are likely to be assessed for income tax at the maximum rate of 39 per cent.

Recent prices and trends in the NZ art market

In this final section we report and analyse the performance at auction of 14 major NZ artists, over the period 2000–06. Our data are culled from the catalogues of the major auctioneer, Webb's, in Auckland, and have been checked with Webb's in cases of doubt or ambiguity. The catalogue for each of the four sales held each year gives data on the works to be sold, along with prices received at the previous sale. These prices include sales negotiated after the auction. A comprehensive source of price data from all Australian and New Zealand art auctions is available from Australian art auction records online (www.artrecord.com) and Australian art sales digest (www.aasd.com.au).

The 14 artists include the five identified as accounting for nearly one-third of total auction sales: McCahon, Hotere, Hammond, Hodgkins and Smither. We included five other artists of major historical and artistic significance: Goldie, Rita Angus (1908–1970), Mrkusich, Pat Hanly (1932–2004) and Walters. We also looked for the late NZ expatriate artist Rosalie Gascoigne (1917–1999), whose work is increasingly valued in Australia, where she lived, but found only two examples going through Webb's. She has a stronger presence in the secondary dealer market. Then we added three important 'mid-career' artists: Bambury, Cotton and Killeen. The last three choices were to an extent arbitrary in that there are a number of other well-established active artists who could with equal justification have been included, and would have been in a more comprehensive analysis. This list would include (but not be limited to) Don Binney (b 1930) and Pule.

Note that there are some significant names who, for a variety of reasons, are not well represented in auction sales. Their work tends to be sold through dealers or in private transactions, such as the international Scottish-based artist Callum Innes.

Table 26.1 summarizes the data. It is notable that the average price achieved by Goldie is almost the same as McCahon, at more than $126,000, though McCahon's highest sales have been reached through dealer transactions. The low volume and price of Rita Angus sales simply reflects the fact that important works by this artist are by now rarely seen at auction – there have, however, been reports of sales through dealers at prices exceeding $200,000. The tiny presence of Rosalie Gascoigne in the Webb's sales sheets is likely to change, and certainly does not reflect the increasingly strong Australian market for this attractive artist.

The fairly low sales percentages achieved by Hotere and McCahon probably represent an induced supply effect – when major works by these artists are seen to sell for high prices this entices on to the market other examples from their large oeuvre. Some of these works are not in good condition, and some are simply not very good or interesting paintings, and with unrealistic reserves fail to sell. The canny collector of course does not buy on name alone, but buys only good works with good names, for both aesthetic and long-term investment satisfaction.

Table 26.1 Paintings offered at Webb's auction sales, 2000–06

Artist	No works offered	No sold	% sold	Average price	Total value of sales
Angus	21	15	71.4	$24,156	$362,340
Bambury	12	10	83.3	$9,200	$92,000
Cotton	26	21	80.8	$24,091	$505,911
Gascoigne	2	2	50.0	$130,000	$260,000
Goldie	15	11	73.3	$126,500	$1,391,500
Hammond	46	33	71.7	$60,974	$2,012,142
Hanly	27	17	63.0	$48,694	$827,798
Hodgkins	26	15	57.7	$87,594	$1,313,910
Hotere	55	38	69.1	$76,641	$2,912,358
Killeen	16	15	93.8	$20,633	$309,495
McCahon	62	42	67.7	$126,744	$5,323,248
Mrkusich	25	16	64.0	$39,031	$624,496
Smither	47	28	59.6	$35,575	$961,000
Walters	13	7	53.8	$62,333	$436,331

Our sample size of 268 successful sales is large enough to support more intensive statistical analysis. We used the data from the catalogues to produce what economists call an econometric model, to 'explain' differences in sale prices in terms of certain objective or subjective criteria. Of course we can never expect to totally explain quantitatively the myriad of factors that must determine the result of each and every work taken to auction. However, it may be surprising just how well quite simple objectively measurable variables can perform in a statistical model. The model that uses the variables listed in Table 26.2 explains or accounts for nearly 72 per cent of the variation in auction prices across this sample of 268 sales. (That is, the 'R-squared' of the econometric equation is 0.719. The 'adjusted R-squared' is 0.693, and the Durbin-Watson statistic, which is informative though not strictly appropriate here, is 1.96.)

Discussing the results as summarized in Table 26.2, we see first that size matters for paintings (as nearly all these works of art are). *Ceteris paribus*, a work measuring, say, 80×60 cm (4,800 sq cm) would be expected to fetch 40 per cent more at Webb's than a work of 60×40 or 2,400 sq cm. A work we judged to be 'important' – of which there were 19 in this sample – would, holding other things equal, sell at a premium of 201 per cent – that is, three times the price of other paintings by the same artist. And if the medium is oil or similar, the likely premium over watercolour or gouache is 59 per cent.

The other variables are of two types: one controls for the year of the auction, the other for the identity of the artist, in each case relative to some arbitrarily chosen reference year or artist, because these measures are relative, not absolute. In the case of the year in which the sale was held, we take the first year, 2000, as our point of reference. Doing so highlights the substantial jump in prices that occurred after 2000. The price level shifted up 38 per cent in 2001 and a further 41 percentage points in 2002 (= 79–38); it had doubled by the year 2003, peaking around this year or the next, but since falling back.

The increase in prices is plausibly linked to the strong economic performance of the NZ economy since 1999, which in particular benefited upper-income groups. The recent fall-back is more of a puzzle, because growth has continued, and other assets – notably the share market and residential property – have continued to show strong value appreciation. We suggest that the auction market (though not necessarily the dealer market) may have suffered from a loss of buyer confidence following a fall – possibly a 'correction' – in prices achieved for works by

Table 26.2 Results of econometric model of NZ art auction prices

Determining factor	% effect on price	
Size	+40%	Effect on price of a doubling in area of painting
Important	+201%	Effect on price if painting is judged to be 'important'
Oil	+59%	Effect on price if painting is oil (or similar, eg tempora)
2001	+38%	Prices in 2001 compared with 2000, other things equal
2002	+79%	Prices in 2002 compared with 2000, other things equal
2003	+107%	Prices in 2003 compared with 2000, other things equal
2004	+112%	Prices in 2004 compared with 2000, other things equal
2005	+87%	Prices in 2005 compared with 2000, other things equal
2006	+61%	Prices in 2006 compared with 2000, other things equal
Angus	42%	Price of a painting by Angus, compared with McCahon
Bambury	8%	Price of a painting by Bambury, compared with McCahon
Cotton	17%	Price of a painting by Cotton, compared with McCahon
Gascoigne	76%	Price of a painting by Gascoigne, compared with McCahon
Goldie	141%	Price of a painting by Goldie, compared with McCahon
Hammond	33%	Price of a painting by Hammond, compared with McCahon
Hanly	31%	Price of a painting by Hanly, compared with McCahon
Hodgkins	93%	Price of a painting by Hodgkins, compared with McCahon
Hotere	39%	Price of a painting by Hotere, compared with McCahon
Killeen	9%	Price of a painting by Killeen, compared with McCahon
Mrkusich	27%	Price of a painting by Mrkusich, compared with McCahon
Smither	14%	Price of a painting by Smither, compared with McCahon
Walters	37%	Price of a painting by Walters, compared with McCahon

the two artists revealed by Table 26.1 to have been quantitatively the most important in terms of total sales value – McCahon and (especially) Hotere.

Turning to the results for individual artists, our reference point here is Colin McCahon, meaning simply that the numbers shown on Table 26.2 tell us whether each other painter tended to get a higher or lower price at auction than McCahon, other things such as painting size held similar. The statistical analysis reveals that there are recognizable groupings of artists in the market. There is a group of five senior blue-chip artists whose realized auction prices, adjusting for size and other factors, are around 30 per cent of the price of a McCahon: Hammond, Hanly, Hotere, Mrkusich and Walters. Statistically, Angus might appear also to be in this group, but she is from an older generation and we have noted that by now very few of her major paintings come up for auction.

Then there are the three notable younger painters we chose for the sample – Bambury, Cotton and Killeen – all of whose prices are at this stage still well below those achieved by the Hotere cohort, as are the prices paid for the mid-career artist Smither. Gascoigne's prices are high, but we have only two observations of sales. Comfortably ahead in the price stakes are the great classics of the NZ market: Hodgkins, Goldie and McCahon himself. The higher figure for Goldie in Table 26.2 contrasts with Table 26.1, which showed that the average prices achieved by Goldie and McCahon were about the same. The difference is due to Goldie's paintings tending to be rather smaller than McCahon's.

For further information on the development of this particular art market, go to:
www.koganpage.com/artmarkets.

Norway

Clemens Bomsdorf and Birgitte Lie

It is hard to find another country whose art market is as highly dominated by one artist as Norway – and that artist is, of course, Edvard Munch. He tops the list of auction results in his homeland and represents a large share of the Norwegian auction houses' turnover. A famous Munch put up for sale abroad always attracts attention and money (see for example the Olsen sale at Sotheby's: Bomsdorf, 2006). The media coverage linked to the robbery and the recovery of the paintings *The Scream* and *Madonna* between 2004 and 2006 led to further increased interest. Munch has influenced many Norwegian and foreign artists. References to his work are plenty, *The Scream* probably being the one most often referred to. (For example AK Dolven, Andy Warhol, Mikkel McAlinden, Bjarne Melgaard, Jasper Johns and Tracy Emin refer to Munch; see also the exhibitions Munch revisited (2005 in Dortmund, Germany) and Skrikets ekko/echoes of the scream, 2001 in Oslo; http://www.munch.museum.no/ekko.) Nevertheless, the art history of Norway starts before Munch and does not end in 1944, the year of his death. In this chapter, an insight into the market for Norwegian art is given. The most important auction market players dealing with the big traditional names are presented, while the galleries mentioned focus on contemporary art as this mirrors the market.

Exhibitions and education

There are several regular exhibitions in Norway. Among them are the Annual autumn exhibition (Kunstnernes Hus, Oslo), the Festival exhibition (Bergen Kunsthall, Bergen), the Performance Weekend (Kunstbanken Arts Centre, Hamar), Momentum: Nordic Festival for Contemporary Art (Biennial, Moss), LIAF: Lofoten International Art Festival (Biennial, Svolvær), the UKS Biennial (Unge Kunstneres Samfund/Young Artists Society, Oslo), Biennial South (Sørlandet Art Museum, Kristiansand), the Drawing Biennial (Tegnerforbundet, Oslo), the Sculpture Biennial (Association of Norwegian Sculptors, Oslo) and the Barents Art Triennial (organized by Pikene på broen, Kirkenes and the Barents region).

The Oslo National Academy of the Arts, Bergen National Academy of the Arts and Trondheim Academy of Fine Art are the major art schools. They have annual graduation exhibitions. Recently, Tromso Academy of Fine Art was established.

The market and market conditions

With less than 5 million inhabitants and a long tradition as a poor farming and fishing nation, art for a long time played a comparatively small role in Norway. However, in recent years the market has caught up. Thanks to its oil, which was found in the 1970s, ranked by GDP per capita measured in PPP, Norway nowadays belongs to the group of the richest nations in the world. People more and more spend their money on art.

Since 1948 according to law a fee of 3 per cent has to be paid for any sale of visual art in Norway. Assuming that everybody sticks to this law, it is relatively easy to estimate the size and growth of the Norwegian art market. From 1996 to 2005 the sum collected based on that law grew by almost 90 per cent from NK9.2 million to 17.2 million (NK = Norwegian crowns). For 2007 the sum was expected to be approx. NK20 million. The import and export of art from Norway in the period 1996–2004 had a very unsteady development, although the trend is clearly showing that exports grew faster than imports (source: UNESCO).

Based on these figures, the Norwegian art market in 2005 had a volume of almost NK575 million (approx US$85 million or €72 million) and the 2006 estimates gave a market volume of approx NK665 million (US$105 million, €80 million). This included all visual art sold in Norway during that year. Hence, works by foreigners, but sold in Norway are included, while works made by Norwegians but sold outside Norway are not included. Oslo and its surroundings make up more than 60 per cent of the art market, and 85 per cent of the volume was generated through sales by galleries, dealers or auction houses. In certain cases they do not have to pay any tax on the sale apart from the 3 per cent. According to Norwegian law art works can be sold without adding value added tax if the sale is arranged by the artist personally or through an intermediary such as a gallery in the name of the artist. In any other case VAT of 25 per cent is added to the sales price. Originally only paintings, drawings, sculptures and the like counted as art works in the sense of that law. In 2004 artistic photography was added. Since then if the work is from an edition of less than 30 no VAT has to be added. Private persons and companies can usually not reduce their taxes by buying art. If a company can prove that the value of a work decreases after buying it, it can reduce the tax by depreciation as is possible with other goods as well.

Art publications

There is not a large market for Norwegian publications specializing in art. The main ones are *Billedkunst* (visual art), *Tekstilkunst* (textile art), *Kunsthåndverk* (crafts), *NUMER* (drawing and illustration), *Kunstårboka* (Norwegian Art Yearbook), *Kunst og Kuttar* (the oldest periodical for art history in Norway) and *Hot Rod* (pop culture and contemporary art). However, recently two new publications were launched. In winter 2007 *Kunstmagasinet* was sold for the first time and in autumn 2006 *Kunstjournalen B-post* was launched; the latter is published once a year, *Kunstmagasinet* four times a year. In general, people are left to use English-language magazines such as *Art Review, Frieze, Artforum* and the *Art Newspaper* or German ones like *art* as their sources of information. (Although fewer people study German nowadays, it is still a common language and many can at least read it.) However, daily newspapers cover the art scene and the market quite extensively. Most articles can be found in the daily papers *Aftenposten, Dagens Næringsliv*, a financial paper, and *Klassekampen*. The weekly *Morgenbladet* also publishes reviews, and from time to time curators or artists exchange views in it. Even the yellow papers *Dagbladet* and *Verdens Gang* can be used as a source for the latest developments on the market.

In September 2005 they published a list of Norway's most important artists after Munch. Although one might doubt the usefulness of such a ranking, it is uncommon to find it in a yellow press paper (see http://www.vg.no/pub/vgart.hbs?artid=107628). The auction houses have their own marketing publications, which are printed several times a year.

Auction houses, dealers and galleries

Due to the transparency of Norwegian companies the situation of the Norwegian players in the art market is also relatively clear. In addition, the small size of the art market makes it easy to keep track of their situation. The auction houses Blomqvist and Grev Wedels Plass Auksjoner (GWPA), which are both dealers as well, have the major share of the market for classical Norwegian art sold in Norway. In addition since 2002 there has been a newcomer FineArt, with online auctions of mainly cheaper works at www.fineart.no. Kaare Berntsen, which does not auction, but deals in arts and antiques, is also active in that segment. In 2004 the turnover of Blomqvist (including antiques) was almost NK16 million while GWPA reached nearly NK6 million. Berntsen made much more, but the figure is not comparable as it is not only based on fee income. (For Norwegian public companies, turnover and other data can be found in the Brønnøysundregistrene; see www.brreg.no.) All three focus on Norwegian art, and Munch represents a great share of their turnover.

While GWPA publishes its auction results online extensively and in detail, Blomqvist is more careful about disclosing figures and Berntsen does not do so at all. As a result most information given here is from GWPA. As Sotheby's and Christie's have representatives in Norway, but do not hold auctions there, their role cannot as easily be expressed in financial figures. However, for both the Nordic market is of growing importance. Christie's held its first Nordic art and design sale on 31 October 2006, but of the 85 lots sold, only nine were works by Norwegians. The artists were Frank Brunner (b 1971), Munch, Bjarne Melgaard (b 1967), Mikkel McAlinden (b 1963), Mari Slaattelid (b 1960) and Frits Thaulow (1847–1906), as well as the designer duo Arne Korsmo (1900–1968) and Grete Prytz (b 1917). Sotheby's in spring 2006 held the biggest Munch sale ever when selling parts of the Olsen collection – eight paintings were auctioned for almost £17 million (approx €25 million, US$33 million). Comparing that figure with the data about the annual turnover of the Norwegian auction houses shows that Sotheby's was at least temporarily much more important in dealing in Norwegian art.

Regarding Munch, GWPA has a clear emphasis on his graphic works. Since 2000 GWPA has held an auction solely of Munch every autumn. In November 2007 one version of the *Vampyr* was sold for almost NK12 million. In total 35 (out of 36) works were sold for more than NK55 million, almost 10 times as much as the year before. In 2006 Blomqvist auctioned the woodcut *Two people, the lonely* (1899, printed 1917) for NK8.1 million (€1 million, US$1.3 million). This was a record for a graphic by Munch. GWPA's director Hans Elgheim is expecting a further price increase, not least due to the media coverage of the robbery and the recovery of the two Munch paintings. Martin Biehl, who was managing director at Blomqvist until the beginning of 2007, agrees. (He was replaced by Blomqvist's owner Knut Forsberg.) According to Elgheim, nowadays more than half of the lots at GWPA are sold to outside Norway, mainly the United States and Germany, while most of the paintings sold are from Norwegian collectors.

Munch's *Madonna* graphic, sold in 2005, was only the second most expensive work GWPA ever sold: *Bridal procession over the Hardanger fjord* by Adolph Tidemand

(1814–1876) and Hans Gude (1825–1903) tops the list. It went for NK5.1 million in 2002. Four more works by Tidemand are on GWPA's top 10 list of auction results, together with another Gude, one by I C Dahl (1788–1857), one by Ludvig Karsten (1876–1926), and one by Jahn Ekenaes (1847–1920), the lowest-priced at NK1.6 million, sold in 1999. Regarding turnover by artist, Munch tops the list with NK25 million, followed by Tidemand (NK17.6 million) and Gude (NK13.6 million). Foreign collectors buying classical Norwegian art almost solely buy Munch and to certain extent also Dahl, Elgheim says.

The foreign buyers bidding for non-contemporary Norwegian art, mainly Munch, are mostly from Germany and the United States: in both countries there are a couple of very wealthy Munch collectors. They buy in Norway through auctions at GWPA and Blomqvist as well as from the dealer Berntsen or from foreign dealers such as Faurschou in Copenhagen.

The market for contemporary Norwegian art is also highly dominated by a small group of players. The galleries K and Riis are the more established ones, while Christian Dam, Fotogalleriet, Standard and MGM are relative newcomers, but nevertheless also highly respected by international collectors. (Although Blomqvist from time to time also sells works by for example Odd Nerdrum (b 1944), it is not included here, as classical art is its focus.) Wang, also a well-established name, had to close down after running a deficit in the years 2003 to 2005, but its director Erik Steen reopened a new place under his own name in 2006. In addition to these galleries the art dealer Peder Lund works for private persons as well as companies (Norsk Hydro and Telenor). He often cooperates with Riis gallery. The legal firm Formuesforvaltning provides consultancy to customers buying art.

For K Norwegian art probably plays the smallest role in relation to its whole business, as it also shows well-established foreign artists as Albert Oehlen, Thomas Demand, Andreas Gursky and Sigmar Polke. K represents the Norwegian artists Mikkel McAlinden (b 1963), Kjell Bjørgeengen (b 1951) and Anne-Karin Furunes (b 1961). Riis on the other hand is the big player, and for several decades has been the most established one, focusing on Norwegian artists such as Tom Sandberg (b 1953), Jan Groth (b 1938) and Sverre Wyller (b 1953). Mainly younger names can be found at the others mentioned above.

Standard is the one with perhaps the brightest future of the younger galleries. It was founded by Eivind Furnesvik, who previously ran Fotogalleriet. Standard managed to establish itself as the gallery for younger Norwegian and international artists (born in the 1970s), a group which has not really been promoted before. Furnesvik says the business is going surprisingly well. According to him, over the last couple of years the interest of collectors in contemporary Norwegian art has been growing strongly, but despite its wealth

Table 27.1 Results of GWPA's Munch auctions

Auction date	No of pieces sold (NK million)	Total turnover	Highest lot	Price of highest lot (NK million)
27 November 2007	35	56.64	*Vampyr II*	11.8
28 November 2006	18	5.58	*Madonna*	2.20
29 November 2005	19	8.64	*Madonna*	5.0
29 November 2004	20	1.62	*Birgitte III*	0.30
19 November 2003	17	1.51	*Det syke barn I*	0.30
21 November 2002	16	1.69	*Brosjen*	0.55
27 November 2001	33	3.97	*Det syke barn I*	0.40
14 November 2000	29	4.91	*Mannshode i kvinnehår*	0.68

Norway is not a country where collectors buy on a huge scale. The reason for this is also that income distribution is relatively equal and only a small number of very wealthy people exist. But the average income is much higher than in other countries. So far, Norwegians have had a tendency to spend their money on boats and holiday houses, but the interest for buying art is definitely increasing, although it will still be far from the level seen in Berlin, Cologne, Paris and New York. The small Oslo gallery scene was joined in the beginning of 2007 by Randi Thommessen's Lautum, which aims to position itself somewhere between Standard's approach with emerging artists and Riis's in dealing with more established ones.

Collectors

In Norway two groups of collectors coexist, those focusing on classical and those focusing on contemporary art. Both groups tend to have a home bias, and over-represent works by artists from their own country. While Standard's Furnesvik, who claims to have most of the big collectors of contemporary art as clients, is convinced that the two groups are really separate, Blomqvist's former director Martin Biehl says he now sees collectors of classical works also buying contemporary art (interview in Norwegian daily *Dagbladet,* 26 June 2006). Only time will tell whether this is only a temporary phenomenon at Blomqvists or whether it will last.

Regarding contemporary art, the number of collectors is almost as limited as the number of galleries. Only around 20 regularly spend more than NK100,000 on art a year, says Furnesvik. Even though most of those spend a lot more, one cannot speak of a big collector scene. The most important figure is probably Hans-Rasmus Astrup, whose collection is behind the Astrup-Fearnley museum, which opened in 1993 and will be moving to new premises by 2012 at the latest. He bought works by artists such as Damien Hirst at a relatively early stage. By acquiring international art on a big scale and showing it in Oslo, Astrup helped to draw attention to art. According to Furnesvik, it is only because of him that a small scene of collectors focussing on Norwegian art could develop. Besides Astrup, Rolf Hoff, who owns an advertising company, Jack Helgesen, owner of a sex shop chain, the publisher Erling Kagge and investor Christen Sveaas are important persons on the list of Norwegian collectors. Some big Norwegian companies also collect art. The bank Nordea has a large and important collection of Norwegian and international contemporary art. The Henie Onstad Art Centre in Oslo has recently exhibited the collections of the banks DnB NOR and Nordea, and the private collection of Pontus Hultén (www.hok.no). The collection of the partly state-owned energy company Norsk Hydro is also very interesting for the Norwegian art market, as it solely acquires Norwegian art.

Table 27.2 2005 turnover of Norwegian galleries

Name	Turnover (NK million)
K (Galleri K and Galleri K-Art)	36.3
Brandstrup	10.5
Riis	4.2
Standard	3.5–4 (est.)
Fotogalleriet	1.6

Source: Brønnøysundregistrene; Standard: estimation. No figures available for other galleries

Visual arts

The earliest Norwegian artists still playing a part in today's art market worked in the 19th century. From today's perspective the landscape painter Johan Christian Dahl (1788–1857) is one of the most important. Others include Johannes Flintoe (1787–1870), Thomas Fearnley (1802–1842) and Peder Balke (1804–1887). Since most Norwegian artists were educated abroad they are described by schools named after the city in which they were located. The most important painters of the Düsseldorf school were Adolph Tidemand (1814–1876), Hans Gude (1825–1903), Carl Sundt-Hansen (1841–1907) and Lars Hertevig (1830–1902) among others. Adolph Tidemand and Hans Gude painted one of Norway's most important art works *Bridal procession over the Hardanger fjord* (1848) in collaboration. The generation of the 1870s has been called the golden age in Norwegian art history. Among the major painters of the Munich school were Eilif Peterssen (1852–1928), Harriet Backer (1845–1932), Erik Werenskiold (1855–1838), Theodor Kittelsen (1857–1914) and Christian Krohg (1852–1925).

Decorative arts

Norway has a long tradition of applied arts, dating back as far as even the Viking ages (c 800–1050). Works from that time and the centuries thereafter are exhibited at the Museum of Decorative Arts and Design (Kunstindustrimuseet) which is part of the National Museum of Art, Architecture and Design (Nasjonalmuseet for kunst, arkitektur og design). The official market for decorative arts from Norway has up to now been dominated by works from more recent years, mainly from the Renaissance period (c 1550–1650).

Norway is particularly famous for its rose painting. It was popular during the rococo period (c 1760–1790) and is a mixture of elements from baroque, regency, rococo and Chinese motives, which form a new style. It has no relation to nature's natural forms, and is abstract, ornamental and two-dimensional. The central area of the Norwegian rose painting is Telemark and Hallingdal (Berg, 1993). The style has some regional differences, and among the decorated objects are chests, cabinets, shrines and beer bowls. Some of the artists also made wall decorations, and some of them were woodcarvers as well as painters. Among the predominant Norwegian rose painters are Peder Aadnes (1739–1792), Kittil Rygg (c 1727–1809), Truge Olson Gunhildsgard (c 1699–c 1770), Tomas Luraas (1799–1886), who developed a personal and characteristic style with strong black contours, Olav Hansson (c 1750–1820), Herbrand Sata (1753–1830) and his sons, Nils (1785–1873) and Embrik Bæra (1788–1876). These last developed their own personal style called the Halling style, and quite a few of their objects are still to be found on the market.

Glassworks and weaving also played an important role in Norwegian history of decorative arts. Objects from the Herrebøe faience factory (ceramics) and Nøstetangen glassworks are considered precious valuables. Herrebøe faience factory (1758–1772) produced a lot of objects with characteristic blue decoration and rococo ornaments (Rostad and Tschudi-Madsen, 1998).

A dominant player in the Norwegian market for decorative arts and antiques is Kaare Berntsen, who is also an art dealer. He arranges three big sales annually. Blomqvist also plays a part in that market.

Together with Denmark, Finland, Iceland and Sweden, Norway has managed to position itself as a design nation. An important event in establishing the brand of Scandinavian design after the Second World War was Frederik Lunning's Lunning Prize (1951–70). He was director of the Danish design company Georg Jensen in New York, and marketed

Scandinavian design in the United States. The Lunning Prize was awarded to two outstanding Scandinavian designers each year, and the prize was significant in establishing the concept and the profile of Scandinavian design domestically and abroad. Among the best known Norwegian recipients are Grete Prytz Kittelsen, Tias Eckhoff and Erik Pløen. In the 1960s Nordic governments supported exhibitions touring internationally and helped to establish the myth of Scandinavian design. (Interestingly around 40 years later the Nordic countries again organized a touring exhibition of Scandinavian design beyond the myth, which helped to carry on the myth.) The Norwegian Design Council was founded in 1963. As a partnership between the Norwegian Export Council and the Federation of Norwegian Industries it was clearly meant to support the economic importance of Norwegian design.

Acknowledgements

This chapter is based on publicly accessible information as well as interviews and background talks done in the last couple of years. We want to thank especially Martin Biehl, Hans Elgheim, Eivind Furnesvik and Rolf Hoff for contributing their knowledge.

For further information on the development of this particular art market, go to: www.koganpage.com/artmarkets.

Bibliography

Berg, K (1993) *Norges Malerkunst*, Vols 1 and 2, Gyldendal, Oslo

Bomsdorf, C (2006) Largest ever Munch sale has controversial past: Olsen Collection to be auctioned at Sotheby's contains work confiscated by Nazis, *Art Newspaper*, 166 (February), p 41

Brønnøysundregistrene [online] www.brreg.no

Børja, M (2006) Vi kjøper kunst for millioner, interview with Martin Biehl, *Dagbladet*, 26 June [online] http://www.dagbladet.no/kultur/2006/06/23/469737.html (accessed 29 March 2008)

Emblem, T, Libæk, I, Stenersen, O and Syvertsen, T (1997) *Norge 2*, Cappelen, Oslo

Museum für Kunst und Kulturgeschichte (2005) Munch revisited, exhibition, Dortmund, 30 January–1 May [online] http://www.kunst-und-kultur.de/Museumsdatenbank/show/show_ausstellung.php/12059/ (accessed 29 March 2008)

Rostad, B and Tschudi-Madsen, T (1998) *Norske antikviteter: Fra bygd og by*, H Aschehoug, Oslo

Skrikets Ekko (2001) Munch-museet 17 June–30 September [online] http://www.munch.museum.no/ekko (accessed 29 March 2008)

Thorkildsen, Å (2006) Scandinavian Design, fra 1930-årene til ca 1960, Drammens Museum, March [online] http://www.drammens.museum.no/docs/TOT_Scandinavian_design.htm

VG (2005) Norges 60 viktigste kunstnere, 21 September [online] http://www.vg.no/pub/vgart.hbs?artid=107628 (accessed 29 March 2008)

The Philippines

Ruoh Ling Keong

The art market

Fernando Cueto Amorsolo (1892–1972) was amongst the first Filipino artists to be included in a Christie's south-east Asian art auction, in March 1996 in Singapore. *The market place*, an oil on canvas from 1939, had a pre-sale estimate of S$15–20,000, and sold for S$245,750. This first price set a pattern for other Amorsolo pieces over the next three seasons. These works were mainly sourced from the second generation of the original collectors, who were mostly American and occasionally European expatriates in the Philippines in the first half of the 20th century, and mostly depicted classic pastoral scenes of the country.

In any art market, the golden rule of supply and demand prevails. By October 1999, despite there being only one oil by the artist in the sale, a deliberate effort on the part of the auction house to concentrate on quality and not quantity, the hammer price of *A lady by the cooking fire* fell within the pre-sale estimate of S$50–70,000. The bidding was calm and reserved, unlike the excited mood just three years before. Local dealers and galleries in Manila were beginning to feel the effects of a transparent market where art prices are largely dictated by the forces of demand and supply, and the days of dealers pricing an art work independently without considering the mechanics of the secondary market were noticeably over. The auction market made a few facts apparent. First, there was no lack of works by Amorsolo outside the Philippines, and second, good prices are only commanded by his best works. His later works, generally considered to be those post-1965, often went unsold or sold for very modest prices.

Critics of the Filipino sections in the auctions of 1996–99 made perhaps justifiable comments on the small selection of work, which they felt was not representative of the country's rich artistic heritage. Indeed, it consisted mainly of works by Amorsolo, with an occasional Vicente Manansala (1910–1981), Hernando R Ocampo (1911–1978) and Fabian de la Rosa (1869–1937).

A quick summary of the Filipino art movement should lead to an appreciation of this gross under-representation. The Filipino artists stand out amongst their south-east Asian peers because of their distinctive flavour of flamboyance and diversity. With the country's long-standing history of Spanish colonization, mingled with a diverse and pluralistic native

community, Filipino art contains a unique artistic expression that has a definite Latino spirit. It is this curious mix of colonial culture and an ingenious creativity that gives the Filipino art form its complexity and uniqueness. This was put into context by John Clark:

> I will take the Philippines as a case of the complexity of mediation of Euramerican styles within a colonial culture. Complicating historical features include the length of the Spanish occupation of the Philippines since its 'discovery' in 1521 and 'settlement' in 1565 with only partial Hispanicization of the population; the establishment of plantation agriculture and a distinctive aristocratic culture of those called illustrados; the opening of Manila to trade in all foreign goods after 1795; … and the revolutionary nationalism that brought about the expulsion of Spain in the first successful anti-colonial struggle in Asia in 1898 and was then subjected to the neocolonialism of the American Commonwealth period. All of these features of Philippines history make it an important site for understanding the relation between a generalized colonial background and the transfer of European academy practice. Perhaps more importantly, there is a long history of assimilation of European artforms and techniques for religious purposes from the 1550s to 1790s.
>
> (Clark, 1998: 54)

This long period of nurturing and grounding resulted in mature art forms with a mature audience, as Clark again explains:

> Art discourses and particular artworks do not achieve the complexity and fulfilment that Philippines painting was to reach in the late 19th century without a very strong bedrock of sensibility, a history of disciplined execution in many domains of art practice, and an audience ready to appreciate it. The sixty-year lead time from the 1820s to the 1880s between the work of Damian Domingo (1790s–1820s) and that of Juan Luna (1857–1899) and Simon Flores y de la Rosa (1839–1904) shows the kind of momentum required in an art culture to move from simple transfer of skills to transformation within a complete discourse. It also indicates the level of local training and over several generations, the amount of talent that must be assembled, mobilized and trained in order to allow the kind of leap that takes place in the 1880s, on a level and with an intensity not found anywhere else in Asia at that time.
>
> (Clark, 1998: 56)

There is a clear lineal and cohesive development of art from the 19th century through to the 21st century. If Juan Luna and Felix Resurreccion Hidalgo (1853–1899) represent the highest levels of achievement in Filipino academism while epitomizing colonial art in the Philippines, then de la Rosa and Amorsolo can be considered the masters of genre, who dominated the Filipino art scene during the first half of the 20th century, and thereby provided the crucial link in the development from academism to modernism. An examination of the works left behind by these two artists provides a good understanding of the rich heritage enjoyed by the Filipino modernists, who were active from the 1950s onwards, and whose ideals were pronounced by Victoria Edades (1895–1985):

> To find pleasure in the visible qualities of even the commonest objects of everyday life, to use colour structurally, to investigate every department of our environment which we

directly experience; and to blend and integrate all of our impressions with our Oriental heritage and our traditional Christian culture, these are the profound lessons with which the great Modern Art movement is inspiring our progressive artists.

(Edades, 1948)

The progressive art movement soon blossomed into a period of multi-pluralism, and the artists dabbled with a range of styles, from neo-realism to cubism, resulting in the creation of some of the most interesting cubist works by Manansala and, much later, Ang Kiu Kok (1931–2005).

Contemporary Filipino artists share this rich heritage with the colonial artists and the modernists but nevertheless take a bold leap into the complexity of present issues, resulting in works that are both edgy and relevant. It would be superficial to categorize such contemporary works as in a specific style or genre, as their richness and diversity defy convenient definitions.

A number of factors contributed to the selection for the auction market from the mid-1990s to 2000 remaining small and selective in spite of this wealth of opportunity. It was a time when collectors in the home market rarely looked beyond its known artists, and it was also a slow period for the Filipino art market generally. With less sensational prices made in the auction market, there was less of a desire to sell works, and hence the sourcing of Filipino works for auction was particularly challenging.

However it was very much a market with sophistication, astute minds and deep pockets. In September 1999, Christie's offered a very rare tempera work of Anita Magsaysay-Ho (b 1914), the only female artist of the 13 modernists of the progressive movement. Sourced from Australia, *In the market place* depicted a group of women busily entangled in conversation, in sober shades but highlighted with the sporadic smears and splashes of orange, red and yellow. With their almond-shaped eyes and angular faces, the work brilliantly presents the best characteristics of the artist, commonly known as the 'female Amorsolo'.

This early work was important to the career of the artist, few of whose works ever came on to the market. It was also the first time a Filipino artist's work had made the front cover of a south-east Asian sale catalogue. It had a pre-sale estimate of a mere S$18–25,000, in a highly 'friendly' range, but attracted bidders beyond the Philippines. The painting sold for S$669,250 to an institution in Manila.

The significance of this sale cannot be over-emphasized. The work helped to win respect for the auction house from key collectors. It was also the first work to expand the 'vocabulary range' of the south-east Asian auctions, which had until then been dominated by Indonesian artists. However it was not until April 2001, when Christie's presented a private collection of a distinguished Filipino family, that the south-east Asian market in general began to realize the importance of a number of Filipino artists. For the domestic market, this auction had great significance. The collection consisted of only five pieces, but they were works by modernist artists which rarely came to market. Works by Manansala and Magsaysay-Ho were offered alongside younger artists such as Federico Alcuaz (b 1932). Manansala's nostalgic *Luksong Tinik* was the cover piece for the season. The collection realized $293,425 against an estimate of $100,000.

From this point, the auctioning of Filipino works has gone from strength to strength – not without its own dramatic moments, such as the offering of Luna's *Parisian life* by Christie's Hong Kong in October 2002. The work depicts the novelist and national hero Dr Jose Rizal, the physician Ariston Bautista Lin (the original owner of the work) and Luna himself in a Parisian café. The playful, relaxed mood of Parisian life does not give the slightest hint of the tumultuous happenings to come in the artist's life, or of the heroic roles that all three men

would take in the revolution in the Philippines (1896–98). The rarity of the work and the historical importance of the three personalities sparked off a furore in the Philippines. Claims were made on the painting by various groups, and controversy was created over the issue of a 'possible' national treasure being sold on foreign soil; and, a prospect much more scandalous, that potentially it could be bought by a non-Filipino. The painting was sold to the Filippine's GSIS at Christie's in Hong Kong for HK$6,674,100 (US$867,633), a record that is yet to be challenged in the Filipino section.

Christie's south-east Asian auction was relocated from Singapore to Hong Kong in 2002. Amorsolo's *Portrait of Fernanda de Jesus* graced the cover in the inaugural auction in April 2002. Hong Kong is becoming the forum for the best Asian arts and thus a gathering of the most relevant collectors. Filipino and other south-east Asian art was exhibited in the same venue as classical Chinese paintings, modern Chinese paintings and 20th-century Chinese art.

In May 2007, almost 100 per cent of the contemporary section sold, with many of the works being knocked down for values many times higher than pre-sale estimates. It included works of Filipino artists such as Ramon Orlina (b 1944), Gabriel Barredo (b 1957), Geraldine Javier (b 1970), Nona Garcia (b 1978) and Wire Tuazon (b 1973). The prices achieved for these works are less significant than the bidders for them – collectors from Taiwan, India, Hong Kong, mainland China, Europe and America, who viewed and appreciated the art works as contemporary works rather than as works of Filipino artists.

While the works of Amorsolo are still a regular feature of any south-east Asian auction, the gradual inclusion of many young and emerging artists is taking the Filipino art market to the next level, where Filipino talents can be appreciated by the international art community at large.

For further information on the development of this particular art market, go to: www.koganpage.com/artmarkets.

References

Clark, J (1998) *Modern Asian Art,* Craftsman House, Australia
Edades, V (1948) Liberating ourselves from academism, *This Week*, 19 September

Poland

Yvonna Januszewska and Wojciech Kowalski

Introduction

Poland's advantageous geographical location, on Central Europe's crossroads between west and east as well as north and south, and its wide access to the Baltic Sea, gave it a chance to be a place for exchange of ideas, fashions, skills and goods on an international scale. For these reasons it has always played a pivotal cultural role, and been an art centre and market important to the whole continent. It has been open to the cultural worth of other nations, adopted them and thus enriched itself. However, at the same time its position often tempted its neighbours, mainly Germany and Russia, and was a major cause of permanent wars and upheavals.

Auctioneers, dealers and modern art galleries

Auctioneers

The auction process as a method of selling art has not had a long tradition in Poland. The first book auction organized on fully professional and commercial basis was held in 1988, and the first art auction in the spring of the following year. Currently, auctions are the main field of activity for such firms as Rempex, Agra, Ostoya, Polswissart, Desa-Unicum and Desa. They are based mainly in Warsaw but they operate all over the country. All of them have their own conditions of business modelled on international standards. Art sales, offering normally up to 100–150 items, are held often in the top Warsaw hotels, usually with 100–300 members of the public attending, although only 20–30 people really bid, having prepaid for a gage (*wadium*). When an auction house executes bids on behalf of the buyer, the gage rate can equal 10 per cent of the estimated price.

The auction house charges seller and buyer commissions on every successful sale, usually between 5 and 10 per cent of the hammer price. This rate can be negotiated. The sum the buyer pays is free from any charges. VAT is only paid by the auction house on its profit. Normally, auction houses guarantee that the works of art to be auctioned are authentic and consistent with their catalogue description. If not, the buyer has the right to give the work

back within a certain number of days, usually no more than one month, and to claim back the money paid for it, provided that the claim is substantiated with credible expertise. It is possible to bid by phone.

Up to now only Rempex has run online auctions. All the auction houses mentioned above have regular customers and a national acquisition network. The works for sale are advertised in catalogues which are prepared to a good editorial level and distributed to potential buyers, with a considerable number of copies, usually exceeding 1,000. Finally it should be also mentioned that because of the lack of items to sell and the frequency of auctions, auction houses deal in antiques when there is no auction taking place. Of the items exhibited in the galleries only the best are usually put in an auction, and if unsold they are returned to the display.

Judging from auction results, buyers in Poland hold works by local masters in the highest esteem. In the list of the 100 top sales there are only two works by foreign artists. *Danzatrice col dito al mento*, a sculpture by Antonio Canova, sold in 2005 for around US$410,000, and a David II Teniers typical picture sold in 2003 for around $130,000. Price records for Polish paintings (all set in 2000) include Henryk Siemiradzki's (1843–1902) *Rozbitek* for around $710,000, Jacek Malczewski's (1858–1929) *Polonia* for $530,000, Eugene Zak's (1884–1926) *Musician* for $460,000, Aleksander Gierymski's (1850–1901) *Linden street* for $430,000 and Wladyslaw Czachórski's (1850–1911) *The first roses* also for $430,000. The paintings of the Polish 19th and 20th-century masters reach record prices on the Polish market.

Antique dealers and modern art galleries

Generally speaking, the sales practice in the art market after 1945 was based on the principle of private sales contracted between parties directly involved. Professional art dealers had a fairly limited role as this kind of commerce was monopolized by one state-owned enterprise, which even at the time of its greatest prosperity could only act from about 20 shops located in major Polish cities. Radical changes in the art market structure occurred at the turn of 1989–90, following the political and economic transformations. There is no official data on the number of currently active antique dealers and modern art galleries, but it certainly reaches several hundred. Their interests are represented in principle by the Art and Antique Dealers Association of Poland, a member of CINOA, although this organization has only about 100 members.

There are also art and antique fairs organized twice a year, in June in Krakow and in December in Warsaw. The art market has its own magazines, including *Art & Business* which is published in both Polish and English versions. Other magazines include *Antyki* and *Sztuka.pl – Gazeta Antykwaryczna*.

Collections and collectors

When describing collections and collectors it is necessary to underline again that Poland was raped and pillaged of its national heritage in the course of numerous wars in the 17th and 18th centuries and national uprisings in the 19th century, not to mention particularly the disastrous World Wars of the 20th century. All these events had and still have a negative impact on collecting, severely limiting the chance to build really important museum and private collections. A country that once had a national collection of enviable magnitude has one currently made up of but a few works of art of international importance, for example Leonardo da

Vinci's *The lady with an ermine* (1485) and some Rembrandt paintings. For these reasons it is important to remember that good Polish collections were based mainly on purchases made abroad. Interestingly, in the 19th century the import process made it possible to enrich collections with foreign masters' works, while today it is often the only way to buy works of Polish art. Additionally, now and in the foreseeable future, restitution will play a great part in the reclamation of Polish heritage for the nation: works should be restored to both public and private collections.

Public collections and museums

Because Poland was not a separate nation from the end of the 18th century until the end of the First World War, the process of the establishment of public museums in Poland was different from Western European models. In the spirit of the time, Poland's last king, Stanislaw August Poniatowski, who reigned in the second half of the 18th century, had intended to transform his rich collections into a Museum Polonicum, open to the public. The plan was thwarted, however, as Poland lost independence. The country's new foreign rulers (Russian in the east, Prussian in the west and Austrian in the south) were not interested in founding public museums, and determinedly impeded any such initiatives, particularly those undertaken in Warsaw. The dissolution of the Museum of the Warsaw Society of the Friends of Sciences, and of the Museum of the University of Warsaw by the Russian authorities after their suppression in the 1830–31 uprising are examples of what took place.

A gap was thus created, to be filled in part by private museums established by wealthy landowners, such as the foundations of Izabela Czartoryska at Pulawy (1809–31) and the Dzialyñski family at Kórnik (1845–60). Their foundations, however, were also unfavourably viewed by the political authorities, which at that time represented foreign powers not interested in fuelling the Polish national spirit. It is for these reasons that the first public Polish national museum was set up abroad, at Rapperswil, Switzerland, in 1869. It was not until 1883 that the first National Museum could be founded on Polish soil, in Krakow, where the Austrian authorities were pursuing a liberal policy, more favourable to this kind of initiative.

Despite the heavy losses, there are now about 500 museums in Poland. The biggest is the National Museum in Kraków, which has around 780,000 objects in its collections, ranging from antiquity to modern art. The second biggest is the National Museum in Warsaw, with 720,000 items and a similar variety of collections. Last but not least we should not forget about 17,000 churches and other religious buildings, which preserved their artistic contents and are normally open to the public.

Collectors

Due to the nature of Polish history private collections have mainly been put together recently, and today only a few older collections remain. Out of 22,000 palaces and historic country mansions before the Second World War, only a very small number were saved and are still in private hands. The Polish middle classes have been enlightened to contemporary art and are no longer hanging paintings by Wojciech Kossak (1857–1942) and other 19th-century Polish artists on their walls. Figurative art is of particular interest to the Polish people. Now not only rich businesspeople buy art, so do more and more 'yuppies'.

This last group are not buying the paintings of Malczewski, Wlasimil Hofman (1881–1970) or Kossak. In their houses they hang the paintings of contemporary artists – even artists freshly out of art school, like Monika Szwed (b 1978) who graduated from the

Poznan Art Academy only a few years ago. When her first exhibition was organized by Jan Michalski in the Zderzak Gallery in Krakow all her works sold. The prices of young Polish artists' works depend on whether the interest is local or international. For instance the works of Wilhelm Sasnal (b 1972), Martta Weg (b 1978) and Kai Soleckiej, contemporary abstract art which is sold internationally, demand higher prices. In new large apartments there is more room, and for instance people can put in whole instillations.

From 1990–97 in auctions the works of Jacek Malczewski, Wlasimil Hofman, Wojciech Kossak and Jerzy Kossak were the most prominent. From 1998–2000 the most popular paintings were those by Alfons Karpinski (1875–1961) and Theodor Axentowicz (1859–1938). From 2000–04 the leading artist became Jerzy Nowosielski (b 1923), thanks to a major exhibition of his works organised by the dealer Andrzej Starmach in Krakow. The fact that from the year 2000 contemporary art has been gaining momentum in Polish auctions is evidence that the market is similar to the western markets, as was said by Marek Lengiewicz, chairman of Rempex.

The present market differs from the pre-war market, as it is far narrower. The taste of the best traditional clients – the middle classes – has not changed much, as they still like art appropriate to their age. Before the Second World War they collected mainly modernist and impressionist works. In the 1920s and 1930s they collected futurist and formist works, the most popular artists of the time being Waclaw Borowski (1886–1954), Eugene Zak (1860–1923), Tadeusz Makowski (1882–1932), Leopold Gottlieb (1883–1934) and Henryk Kuna (1879–1945).

Before the war many aristocrats were patrons of the arts. During the 1920s and 1930s many works of art were ordered by the national patron, which had a direct influence on price and the launch of new names. The first national orders were works of art exhibited in the world exhibitions held in Paris. The government wanted to promote Poland through art, and therefore presented artists who were mainly futurists, whose works were then bought by corporations and institutions. At present there are no patrons like Izrael Poznanski, who was lucky enough to collect wonderful impressionist paintings and Polish artists like the Gierymscy brothers, Wladyslaw Podkowinski (1866–1895) and Henryk Rodakowski (1823–1894).

The richest man in Poland now, Jan Kulczyk, or rather his wife Grazyna, has completely different taste from the millionaire from Lodz. She said, 'Once I used to concentrate on the second half of the 20th century but now I prefer young art, for instance video art. I also collect photographs; my latest acquisition was the work of a young photographer Maciej Osika.' Apart from young artists Kulczyk likes Tadeusz Kantor (1915–1990).

Among the 100 richest Poles the top collection is held by the Bienkowscy brothers who have at least 50 works by Henryk Stazewski (1894–1988). Dariusz and Krysztof Bienkowscy, businessmen from Lodz, have many paintings by Wojciech Fangor (b 1922), as well as works by Jadwiga Maziarska, Waclaw Szpakowski, Jan Berdyszak, Stefan Gierowski, Ryszard Winiarski, Koja Kamoja, Jurgen Blum-Kwiatkowski, Marian Bogusz, Zbigniew Dlubiak, Zbigniew Gostomski and Kajetan Sosnowski.

In Poland 10 per cent of the art is bought by companies and state-owned institutions and 90 per cent by private individuals. This means that first, Polish people are enriching themselves, and second, there is more desire for art. Polish taste is becoming more stable, which means an auction house is seldom able to influence the buying public, unlike even 10 years ago. Recently an attempt was made to triple the value of the art of the late Zdzislaw Beksinski (1929–2005). Unfortunately even though the auction house tried to steer the

market, no buyers were found, as the young cannot afford such high prices. Today the prices of expressionist works retain the highest value but they are difficult to find in Polish auction houses.

Polish artists on the international market

As Agnieszka Widacka from the National Museum in Krakow commented in her article regarding the new rulings about the protection of National Artefacts, all written permissions for export are granted for a specific time, on official forms. They should always be handed back to the issuing body and be re-applied for each time a repeat export is required. The care and attention of the conservation body acting to prevent illegal export covers both great works of value and more minor artefacts.

In practical terms, for the export control procedure the age of the object is still a deciding factor. Objects produced more than 55 years ago are subject to control: those who want to take such items abroad must have written permission to do so. The ultimate deciding authority in this matter is the Minister of Culture and National Heritage. For newer objects it is enough to have a certificate stating that export permission is not needed. A similar certificate is also necessary when a particular object is old but not a National Artefact. However the definition of this is very broad, and it is difficult to interpret it uniformly across the whole country. Certainly, industrial products or amateur works of art will not be classified as National Artefacts but the lack of clear and sharp criteria may result in disappointing decisions, although unsuccessful applicants for permission or certification can always make use of the administrative procedure to fight for a final verdict which satisfies them.

This complicated and at times time-consuming procedure puts off honest individuals from taking the official route of obtaining written permission, and the relative ease and minimal punishments encourage illegal acts bypassing the authorities. The development of internet transactions is easing the illegal activities with regard to artefacts leaving the country. The negative and unquestionable side of these rigorous rulings is that the Polish art market is developing in a state of isolation. The prices of 19th-century Polish works of art in world markets are far lower than in Poland. For example, Henryk Siemiradzki is renowned in Poland but a painting of his was sold in London in 2006 for only £2,640.

The national antique market has been based on the same works over the last 50 years, and stands apart from the international market. This closed market and the lack of contact with Europe and the world markets have had a negative influence on prices in Poland. The prices obtained for Polish works of art do not reflect the quality of the art. Paintings from the 19th and the beginning of the 20th century often do not adequately reflect the prices realized.

On the other hand many Polish artists have not achieved international status because of the lack of competent advertising and exhibiting. Because of this situation Polish art is being pushed to the extremities of the international market. Poland is losing international recognition and acclaim. Concentrating efforts on protecting artefacts of minimal monetary value allows the world to be ignorant of the high class of Polish culture. Until now the rule was, 'Dura lex sed lex' – see and be seen. It is probably this fact that has made ministers work again on new guidelines, which will probably change the law and may ease the process of organizing the import and export of works of art. For this the Polish art market is desperate and waiting in anticipation.

For further information on the development of this particular art market, go to: www.koganpage.com/artmarkets.

Bibliography

Boldok, S (2004) *Malastwo polskie XIX I XX wieku,* Antiquarius sp Zoo, Krakow

Ostrowski, L K (1999) *Masters of Polish Painting,* Kluszczynski, Krakow

Osrodek Ochrony Zbiorow Publicznych (2001) *Catalogue of Losses: Valuable, priceless/lost,* Pagina sp Zoo, Warsaw

Magazines

Antyki, bi-monthly

Art & Business, monthly

Sztuka.pl – Gazeta Antykwaryczna, monthly

Portugal

João Magalhães, translated by Nancy Dantas

The art market in Portugal is difficult to discuss. From an economic point of view, data for analysis remains significantly under researched. Auction houses refused to disclose the total number of their sales (with the exception of Cabral Moncada Leilões). It is also significant that in the study *The European Art Market in 2002* (Kusin and Company, 2002) where the figures related to total sales from auctions and dealers, as well as the number of companies and jobs in this area were revealed, Portugal and Greece were the only countries with no data. Art Sales Index reveals very limited data and the INE (National Statistics Institute) studies in cultural area are vague and of no major use to this analysis. There are no academic studies in this matter and dealers associations have also failed to produce financial studies or disclose their associates' activities. The state's greater regulation of activity, the promotion of research by professional associations and growing academic interest in the impact of collecting and investing in art on the national economy should help reverse a situation that has surprisingly had little to no effect on the existence of this lively and growing market.

This chapter will reflect upon the current commercial activity of art in Portugal mostly from a qualitative perspective. To this effect, the agents, their characteristics and how they operate are described in order to determine how the market emerged, what the current situation is and how it will possibly evolve in the future.

Taste and trends

Taste in Portugal, much like artistic creation, is traditionally conservative and nationalist, and like in any other peripheral region, tends to absorb international trends somewhat belatedly. Models of taste are socially established and mimetic behaviour prolongs them indeterminately, sometimes over several generations. An example of this can be found in the collection of entrepreneur António Champalimaud (1918–2004), sold at Christie's London in 2005. It demonstrates how the French taste inherited from the Marquis of Foz (1849–1917) was still present, even after the revolution of 1974. The sale was a huge success, making a total of €43.7 million.

The decorative arts soon became the driving force behind art and the national market. Inside palaces, homes and churches – such as S Francisco Church in Porto and the Palace of

Santo Antão do Tojal in Lisbon – Portuguese art found a space of expression, with *talha* (gilded carved wood), *azulejo* (tiles) and sumptuous decorative pieces. To this effect, between the end of the 17th century and late 18th century, improved craftsmanship, access to international models, the abundance of high-quality material and relative socio-economic stability combined, increased the production of furniture, silverware and ceramics, which characterize one of the richest periods in the history of Portuguese art. The Museu Nacional de Arte Antiga (National Museum of Art) is perfect for studying these different areas at their best in a single place.

The 17th century is most likely to be the period where Portuguese furniture best achieved a distinctive national identity, with the employment of characteristic techniques and definition of typical embellishments and typologies. The *bufete* (centre table), the *cadeira de couro lavrado* (chairs with embossed leather), and the *contador* (a cabinet on a stand) with singular ripple cuttings are types that best define this period. Due to their heavy appearance, and sometimes because of the difficulty involved in dating these pieces, current buyers do not pay a lot of attention to this material. This is to the benefit of certain connoisseurs; in fact, it is quite common to find American dealers hunting down this type of furniture, which has developed a large following in the United States, attracted by their decorative qualities.

The 18th century in Portugal, in turn, was marked by the grandiose notions of the absolute monarchy of King Dom João V. With Brazilian hardwood, furniture became richer in ornamentation. The *mesa de encostar* (console table with drawers) and the *cómoda (*chest of drawers) are emblematic of this century. France and England were the main sources of inspiration, crossing regularly in their paths of influence. The extension of this sumptuousness steered the way towards the creation of high-quality furniture in the reign of Dom José (1750–77), a period which has set a number of record auction prices.

Thanks to the significant flow of pieces on to the market and social change, this furniture, which traditionally graced the houses of the Portuguese aristocracy, was adopted in the 1980s to accent the interiors of the newborn economic élites.

Regarded for many years as one of the safest investment areas – due to the undeniable quality of most furniture, the existence of a sustained supply and indigenous nature of the pieces – the auction prices of furniture have fallen quite significantly (see Table 30.1). This is not only a reflection of the economic crisis that has befallen the country, but is a consequence of the lack of major pieces on the market and younger audiences' disinterest in larger, ostentatious pieces.

Portuguese silverwork seems to have evolved following a similar pattern, the 17th century being representative of profound local features. During the 18th century, there was an increase in production, with direct influences coming from the French baroque and rococo and English neoclassicism. The 19th century, a period without personality, was marked by the prolongation or recovery of old styles. Non-religious items that have survived from the 16th century are rare, of extraordinary quality and usually reflect not only the influences of the Discoveries but also of Renaissance values from Italy or Northern Europe, and are thus highly valued.

In spite of these external influences, silverwork retains a profound national mark. Silver maintains its solid market of collectors and, holding an intrinsic value, is still viewed as important.

Portuguese ceramics is an area with a significant number of collectors. The range finds expression in faience of the 17th century, which was highly influenced by Chinese porcelain, and in the industrialization of production in the 18th century in Porto and Lisbon, led by the Real Fábrica do Rato, as well as in decorative earthenware from Caldas da Rainha, developed in the 19th century, with caricaturist Rafael Bordalo Pinheiro as the genre's figurehead. Over

Table 30.1 Record sales at auction of Portuguese furniture

Date	Auction house	Item	Price
1990–99			
April 1997	PCV	Chest of drawers, D José, 18th century, rosewood	€264,500
May 1991	PCV	Writing chair, D José, 18th century, rosewood	€254,500
May 1991	PCV	Four-top table, D José, 18th century, rosewood with inlays	€249,500
April 1997	PCV	Four-top table, D José, 18th century, rosewood with inlays	€180,000
May 1991	PCV	Bureau, D José, 18th century, rosewood	€105,000
2000–06			
March 2004	LN	Chest of drawers with oratory, gilt and japanned, late 18th century	€420,000
May 2005	PCV	Pair of side tables, D José, 18th century, rosewood	€200,000
May 2000	PCV	Bureau, D José, 18th century, rosewood	€150,000
May 2005	PCV	Writing chair, D José, 18th century, rosewood	€85,000
May 2005	PCV	Set of six chairs, D José, 18th century, rosewood	€60,000

PCV: Palácio do Correio Velho.
LN: Leiria e Nascimento.

For all tables in this chapter: Sources: Cabral Moncada Leilões (CML), Leiria e Nascimento (LN) e Palácio do Correio Velho (PCV). Prices do not include buyer's premium or tax.

the past 20 years, the sale of important ceramic collections, like the António Capucho (2005), the Maldonaldo de Freitas (1996) and the José Abecassis (1996) collections, have taken place at the Palácio do Correio Velho.

Within the field of porcelain, production by the Vista Alegre factory (founded in 1824), has been the object of several collections, whether functionalist or artistic-decorative in accent. Annual auctions comprised solely of Vista Alegre items have been held since 1997 thanks to the efforts of the factory itself and the Cabral Moncada auction house.

One of the outcomes of the encounter between cultures promoted by Portuguese traders and missionaries is a set of extremely diverse pieces that have attracted European audiences since the beginning of the 16th century. Ranging from exquisite objects produced for the Renaissance *wunderkammern* through to more functional items, production to reach the ports of Lisbon captivated not only foreign, as expected, but local audiences, to become a part of the Portuguese household. These items – brought from the Azores, China, Brazil, Japan, Sri Lanka, India and so on – continue to draw the interest of Portuguese audiences to this day, and the field presents a unique group of buyers and connoisseurs who have bolstered the value of these items in Portugal. Although these items have captivated the interest of collectors since the 19th century, collectors re-embraced the appeal and potential of this art produced during the Portuguese maritime expansion after the ' XVII Exposição de Arte, Ciência e Cultura' in 1983.

Owing to its diversity and quality, Indo-Portuguese ivory represents another area of consistent investment. A combination of unique Indian craftsmanship and Christian motifs, these creations possess a market of loyal collectors. The naturalist quality of the intricate carvings from Sri Lanka is highly sought after, although most creations derive from the region of Goa, capital of the Portuguese Asian territories after 1510. Rarer is the eburnean production from China.

Indian furniture made for the Portuguese market from the second half of the 16th century has a strong following nowadays. Smaller or larger *contadores* (cabinets) are

Table 30.2 Record sales at auction – Indo-Portuguese ivory, 1996–2006

Date	Auction house	Item	Price
October 2001	LN	Good Shepherd, Indo-Portuguese sculpture, 17th century, ivory	€150,000
May 1997	CML	Calvary, Indo-Portuguese sculpture group, 17th century, ivory and wood	€105,000
October 2000	CML	Crucifixion, Indo-Portuguese sculpture, 17th century, ivory	€60,000
May 1998	PCV	Crucifixion, Indo-Portuguese sculpture, ivory	€40,000
May 2002	PCV	Good Shepherd, Indo-Portuguese sculpture, 17th century, ivory	€40,000
March 2003	PCV	Plaque with Christian scenes, Sri-Lanka, ivory	€40,000

CML: Cabral Moncada Leilões.
LN: Leiria e Nascimento.
PCV: Palácio do Correio Velho.

Table 30.3 Record sales at auction – Indo-Portuguese furniture, 1996–2006

Date	Auction house	Item	Price
November 2006	CML	Casket, Indo-Portuguese, 16th century, tortoiseshell and silver mounts	€125,000
March 2000	CML	Cabinet, Indo-Portuguese, 17th century, with coat-of-arms, teak and ebony with ivory inlays	€80,000
May 1999	CML	Cabinet, Indo-Portuguese (Gujarat), early 17th century, teak, ebony with ivory inlays	€70,000
July 2003	PCV	Cabinet, Indo-Portuguese with Mughal influence, 17th century, Indian rosewood, teak, ebony and ivory	€60,000
May 2005	PCV	Cabinet with single side-hung door, Indo-Portuguese, 17th century, Indian rosewood, teak, ebony and ivory	€60,000
May 2004	PCV	Table, Indo-Portuguese, 17th century, Indian rosewood, teak, ebony and ivory	€57,000

PCV: Palácio do Correio Velho.
CML: Cabral Moncada Leilões.

considered emblematic of this voluminous period of production, which ranges from items in teak or Indian rosewood to other more embellished samples with ivory inlays or tortoise-shell veneers.

Indian manufacture for the Portuguese market essentially derives from the regions of Gujarat, Goa and Sri Lanka. Rarer, and thus greatly sought after, jewels, textiles and *objets d'art* – like the production of Gujarati mother-of-pearl – are highly appreciated and right from first being imported until today have always found a broad European clientele.

The passage of the Portuguese through Japan also left its mark. Avid collectors hunt this art, collectively termed Namban (meaning 'barbarians of the south') – a name used by the Japanese for the Portuguese. These objects combine traditional style and techniques, such as lacquer, with European shapes and sometimes representations of Christian or western motifs.

Brazilian art should be considered an extension of the metropolis. Its major difference, the excess of ornamentation, is not always obvious but has been, as a collector's rule of thumb, dismissed in relation to items of Portuguese origin.

The Portuguese were the first to commercialize porcelain in Europe almost immediately after the first encounter with the Empire of China in 1516. Ever since, and through the permanent trading settlement in Macao, Chinese export porcelain has had a privileged role in the Portuguese household and is one of the main vectors of collecting in Portugal. Before the revolution in 1974, the Portuguese had an important role in the international market, largely projecting the prices of Chinese porcelain wares. This political uprising had severe repercussions. Today, and after some changes in deeply rooted social preferences, prices in Portugal are almost the same as in the international arena, and the high prices paid in the middle and lower markets have scaled down. With this change in behaviour, collectors look mostly for pieces in mint condition and with Portuguese armorial bearings. These items stir the interest of quite a significant group of collectors.

Portuguese ceramic tile art (*azulejaria*) constitutes an interesting case in the Portuguese market. Large decorative panels of the 17th and 18th centuries move the market of this national art. One of the downsides of this collectible, apart from its scarcity, is the difficulty of maintenance and relocation, although some items find immediate buyers in foreign collectors. Locally, entrepreneur José Berardo is currently building what will be one of the most representative collections of Portuguese *azulejos*.

Religious art, which has always been a part of Portuguese life and collecting, is currently experiencing a less fortuitous period. The extinction of religious orders in 1834 and the plundering of churches throughout the 20th century flooded the market with religious items. The 17th and 18th centuries represent abundant periods of production and have a strong presence in the market. Today, only superior items, often associated with schools or craftspeople such as António Ferreira and Machado de Castro, are more easily sold.

But the business that moves the most money, apart from modern and contemporary, is undeniably naturalist painting of the end of the 19th century and beginning of the 20th century. Initiated in 1870 by the painters Marques de Oliveira (1853–1927) and Silva Porto

Table 30.4 Record sales at auction – Chinese porcelain, 1996–2006

Date	Auction house	Item	Price
November 2003	LN	Five-piece garniture, Chinese porcelain, Famille Rose, Yongzheng period	€250,000
November 2003	LN	Pair of dogs, Chinese porcelain, Famille Rose, Qianlong period	€150,000
March 2004	LN	Pair of vases with cover, Chinese porcelain, Famille Rose, Yongzheng period	€150,000
February 2004	PCV	Miniature tureen with dish (sauce-boat) with Portuguese royal coat of arms, Chinese porcelain, Qianlong period, c 1775	€120,000
October 2001	LN	Pair of vases with cover, Chinese porcelain, Famille Rose, Yongzheng period	€80,000
February 2004	PCV	Falcons, pair of boxes, Chinese porcelain, Qianlong period, 1750–70	€80,000

LN: Leiria e Nascimento.
PCV: Palácio do Correio Velho.

(1850–1893), this movement stretched throughout successive generations of artists up until the mid-20th century, marking Portuguese preferences to this day.

With variable quality, not always reflected by sales prices, Alfredo Keil (1850–1907), Artur Loureiro (1853–1932), Sousa Pinto (1856–1939), João Vaz (1859–1931), Carlos Reis (1863–1940) and Aurélia de Sousa (1865–1922) are some of the artists with continued collector demand.

José Malhoa (1855–1933) is one of Portugal's best-loved painters. A national phenomenon of no real genius, Malhoa has admirably maintained his commercial prestige. The highest bid offered in Portugal for one of his registered works was €220,000, although this price does not show his real market potential since his more significant works are predominantly bought and sold in private deals.

The singular Columbano Bordalo Pinheiro (1857–1929) is one of the greatest painters of his generation. Columbano set a record with his painting *O Serão*, acquired by entrepreneur and collector João Pereira Coutinho for a record €310,000.

In spite of the continued presence of naturalists in Portuguese life, Portuguese art developed during the first decades of the 20th century with the appearance of some interesting figures. Amadeo de Souza-Cardoso (1887–1918), a close friend of Modigliani and the

Table 30.5 Record sales at auction – painting pre-1945, 1996–2006

Date	Auction house	Artist	Work	Price
May 2004	PCV	Columbano Bordalo Pinheiro	*Serão*	€310,000
October 2002	LN	José Malhoa	*O Besuga*, 1920	€280,000
February 1998	PCV	Souza Pinto	*O Amuado*	€220,000
December 2000	PCV	José Malhôa	*Adelaide, Personagem de O Fado*	€210,000
October 1999	PCV	Amadeu Souza Cardoso	*Composição com instrumento musical*	€205,000
May 2000	LN	Mário Eloy	*O desemprego*, 1935	€200,000
October 2005	PCV	Amadeu Souza Cardoso	*Pastor*	€200,000

LN: Leiria e Nascimento.
PCV: Palácio do Correio Velho.

Table 30.6 Record sales at auction – painting post-1945, 1996–2006

Date	Auction house	Artist	Work	Price
April 2001	LN	Maria Helena Vieira da Silva	*Biblioteque, 1952*	€300,000
November 2006	PCV	Paula Rego	*A Madrasta*	€220,000
October 2005	LN	Maria Helena Vieira da Silva	*Le Zoo, 1949*	€150,000
May 2005	LN	Maria Helena Vieira da Silva	*La Maison d'Hercule, 1965*	€135,000
July 2000	LN	Paula Rego	*Untitled, 1985*	€130,000
November 2006	LN	Paula Rego	*Untitled, c 1960*	€125,000

LN: Leiria e Nascimento.
PCV: Palácio do Correio Velho.

Delaunays, developed a unique idiom with approximations to cubism, expressionism and futurism. Works by the artist of greater importance to emerge on the market tend to be channelled through private sales.

Almada Negreiros (1893–1970), having lived through a greater part of the 20th century, is a seminal figure in Portuguese modernism. A painter, draughtsman, poet and writer, Negreiros left an extensive oeuvre, which circulates on the market with multiple formats and techniques. Other modernists – Mário Eloy (1900–1951), Eduardo Viana (1881–1967), Jorge Barradas (1894–1971), António Soares (1894–1978) and Carlos Botelho (1899–1982) – deserve reference for their quality and assiduous presence on the market.

Following this generation, contemporary work began to develop with a succession of names and registers. The name of Maria Helena Vieira da Silva (1908–1992), due to the international career she developed, deserves natural mention. Her vast body of work regularly appears on the local market with domestic prices sometimes exceeding those of the international market.

Equally situated within the international context, with an impressive career built in the United Kingdom, Paula Rego (b 1935) is indisputably Portugal's living artist with the greatest international profile and the highest quotation in auction sales.

Owing to their constant and solid presence over the past 40 years on the national market, Júlio Resende (b 1917), Júlio Pomar (b 1926) and Manuel Cargaleiro (b 1927) also deserve particular reference.

Within contemporary creation, the market is one that is robust, with a breadth of names that comprise a circuit of galleries and collectors, as mentioned below. Helena Almeida, Jorge Queiroz, Julião Sarmento, Pedro Cabrita Reis and Rui Chafes (with a price range broadly between €15–75,000) are established artists who have generated foreign interest in their work, all of them being also represented by international galleries. Bruno Pacheco, João Pedro Vale, João Onofre, Vasco Araújo and the collective João Maria Gusmão and Pedro Paiva (with a price range broadly between €3,500–15,000) on the other hand, prevail among a group of countless young artists to emerge over the past few years.

Market structure

Auction houses

The Portuguese auction market is growing and is concentrated in three firms, Cabral Moncada Leilões, Leiria e Nascimento and Palácio do Correio Velho, all of whom are established in the city of Lisbon. The weight of antiques dealers, who used to renovate stockpiles and generate stock flow, has diminished in this market over the past few years. In view of the fact that private bidders have taken on a leading role, auction houses have been forced to present fresher, better preserved, accurately catalogued items for sale.

Auctions however remain quite detached from the contemporary art scene. Sales are infrequent and rarely present works of major importance. There is nevertheless an effort being made by auction houses to attract art from recent years and take advantage of the existing enthusiasm around it. Galleries and the private sales circuit continue to control the market of art from the past 50 years.

Auctioneers by and large adopt generalist sales, making broad distinctions on their sales: antiques and Old Masters, modern and contemporary art. Cabral Moncada nonetheless holds sessions uniquely dedicated to silver, whereas other auctioneers hold thematic sales on occasion, namely within the specialized fields of porcelain and faience.

During 2007 four new auction houses appeared in the Lisbon market: Aqueduto, Renascimento, P4 (specialized in photography) and Sala Branca (specialized contemporary art).

Antiques dealers

Like the field of auction houses, antiques dealers are geographically concentrated in Lisbon, with a few isolated ones in Porto. Keeping up with the international reality, this activity has been moving towards specialization. As a professional body, antiques dealers stopped rejuvenating in the 1980s with the demand of more professionalism and expertise from buyers, dwindling levels of supply and the escalating price of property rents.

We must mention, however, the dealers who increasingly have chosen the path of greater expertise or, within the range of items on sale, have shown preference for certain areas: António Miranda (Galeria da Arcada) is an authority in religious art, Fernando Moncada (Arte Tribal) in primitive art, João and José Mário Andrade (J Andrade Antiguidades) in furniture, Jorge Welsh in Chinese porcelain and oriental works of art, Manuel Castilho in oriental art and Manuel Leitão (Solar das Antiguidades) in *azulejaria*.

Associates Sebastião Jorge Neves and João Teixeira (António Costa Antiguidades), Florindo dos Santos, Frederico Horta e Costa and Rui Quintela are other antiques specialists on the market. Within a more modern frame, Manuel Reis' Loja da Atalaia is an authority for anyone interested in vintage furniture. Guy Magalhães Pereira and Álvaro Roquette, on the other hand, are the current spearheads of a new generation of antiques dealers.

In Porto, a city with a tradition of eminent collectors, the panorama is currently one that is quite bleak, due increasingly to the loss of the region's economic power to Lisbon. Despite this rather desolate environment, Pedro Aguiar Branco (VOC Antiguidades) – working within the reach of the Portuguese Empire – and Luís Alegria – who has a special focus in Chinese porcelain – have gained a wider audience outside the city and are national authorities.

Contemporary art galleries

In the global context of the market, the sector of contemporary art galleries may be considered to be the one working in a more professional way. Currently, a small number of galleries are working like their international counterparts; endeavouring to produce quality exhibitions, to represent a coherent roster of artists, to promote and support their work and channel artist's creations to the right collections.

More recent art galleries like Baginski – Galeria Projectos, Galeria 24b and Agência Vera Cortês have progressively consolidated a position for themselves on the market through their focus on the work of emerging artists. Graça Brandão, Módulo, Lisboa 20, Pedro Oliveira, Quadrado Azul, Pedro Cera and Presença are examples of galleries with a relative amount of tradition and a mixed roster that ranges from distinguished, rising to emerging artists, and the occasional representation of an international name. These galleries are mostly frequented by national audiences.

Galeria Filomena Soares and Cristina Guerra Contemporary Art, on the other hand, have gone to enormous lengths to establish a presence in the international arena. Both strategically represent some of Portugal's most distinguished artists and their international counterparts in high-profile international art fairs, promoting their work on the global art circuit.

Certain other instances deserve equal mention in the local arena: the historic Galeria 111, founded in 1964, which is currently undergoing a process of renewal; the decisive measures of galeria Luís Serpa Projectos, which drew the international art scene to the market in the

1980s; and Mário Sequeira, located in Braga, who has mounted several prominent exhibitions by high-profile artists and hosted various interesting outdoor sculpture projects.

Art fairs

Like other markets, Portugal has its own art fair, a key event for the contemporary scene. Arte Lisboa is a growing fair of local accent, started in 2000, and which reflects the conservative and limited buying power. To date, it is still in search of its identity, due mainly to the lack of a strong cultural programme. Nevertheless, it is improving year on year. Growing interest in the contemporary art market and increased visibility raised visitor attendance from 15,000 in 2005 to over 19,000 in 2006.

FIL's Antiques Biennial, a point of reference for the antiques market, alternates with the biennial hosted by the Portuguese Antiques Dealers' Association. The latter fair possesses a vetting committee, which assures the quality and authenticity of all items on sale.

The art press

The Portuguese specialized art press, like the market, is limited. The monthly *L+Arte* is a magazine committed to contemporary art and antiques. Available on all local newsstands, the magazine offers a global perspective of this market and is geared towards the general public. *Dardo* is a four-monthly trilingual (Portuguese, Spanish and English) contemporary art magazine, catering to an international audience. The daily newspaper *Público* covers the major events on the art scene. Its weekly cultural supplement *Ipsilon*, as well as the supplement *Actual* from the weekly *Expresso*, offer limited reviews and articles on running exhibitions. In May 2006, www.artecapital.net was launched, offering a new vision of art to the net with its selection of headlines, articles, reviews and so on. In October 2007 a new art and antiques magazine was launched, *Artes e Leilões*.

Collectors

As Portugal is a country of limited resources, there are very few private collectors with the means of creating coherent and cohesive collections. The Portuguese collector is conservative and is subject to the influence of currents of opinion and taste. Although there may be a category of high-profile contemporary art collectors who exercise an important role, generally the Portuguese collector is reserved – especially within the field of antiques.

Two high-profile cases are João Rendeiro's Ellipse Foundation and the Berardo collection. Both of these privately owned collections focus on international art, with minor incursions into Portuguese art, and are on public display. Owing to the manner millionaire José Berardo forced his way around the Portuguese government to maintain his collection on public display in 2006, Berardo is, in all probability, today's most well-known art collector.

Francisco Capelo stands as an example of a Portuguese collector practising in the international arena with a variety of interests. He was responsible for conceiving the Berardo collection, as well as the recent Museu de Design e Moda (MUDE); his private collection sold in attractive conditions to the city of Lisbon for €6.6 million in 2002.

For many years, the collection of the Modern Art Centre of the Calouste Gulbenkian Foundation was the only institution to systematically acquire Portuguese contemporary art. In 2006, the budget for acquisitions was €900,000. The Serralves Museum, on the other hand, was given a one-year acquisition budget of €1 million.

Several private institutions are currently acquiring contemporary art as a part of their corporate social responsibility commitment. The finest example is the Banco Espírito Santo and its single-minded investment in photography. By funding two major awards and providing numerous other sponsorships, this bank has seriously contributed to photography in Portugal.

The bank Caixa Geral de Depósitos, with a central holding of contemporary Portuguese art and an annual acquisitions budget of €400,000, and the PLMJ Foundation, created by a prominent law firm, with a holding of emerging artists and recent acquisitions in the media of photography and video, are two other instances that deserve mention.

Sadly, acquisitions from institutions, public or private, have hardly any direct influence on the local market since most major-budget organisms – Ellipse, Berardo and Serralves – direct their acquisitions to the international market. This explains why private collectors maintain the contemporary art market. This blueprint of the market can also be applied to the field of antiques, where the number of institutions acquiring pieces is even smaller, and the state and its museums, by way of the Instituto Português de Museus, has been granted an infinitesimal part of its needs: €385,000 was the average amount spent per year between 1996 and 2006 on a total of 29 museums.

Final notes

With the exception of a small élite, the lack of patrimonial tradition amongst the Portuguese is a reflection of the country's low cultural level. Efforts have been made over the past few years to reverse this historical reality, but they seem to have been to no avail. This background, which is further complicated by weak buying power by European standards, comprises an unfavourable factor in achieving a highly competitive and vibrant art market. Despite this context, the market in Portugal has proceeded in its process of maturation, becoming increasingly more professional and selective.

This positive step forward reveals economic growth, which implies greater regulation, and will inevitably lead to greater financial transparency. In turn, this will enable academics to embark on the much-needed economic analysis of the market which will hopefully unveil its true situation.

The fact that private transactions are not declared means that tax evasion has opened the doors to a parallel market, which continues to exert a substantial influence on the global market. This in turn renders financial analysis an impossible endeavour.

In Portugal, value-added tax is applied to the sales of works of art at a rate of 20 per cent. Regarding acquisitions in auctions, the buyer and auction house's commission are equally liable for taxation, but not the hammer price.

Following the EU directive, the artist resale right was implemented in June of 2006 to ensure for visual artists or their representatives a percentage of the value of transactions. This law, like others prior to its existence, is most likely to have a limited application and impact on the market. Ultimately, EU legislation will benefit renowned artists with vibrant secondary markets. Auction houses, in the long run, will most likely be the hardest hit by this measure. Despite this downside, legislation will definitively help increase and broaden state regulation of the market. This, in turn, will help make the sale of art a more complex, but in equal measure, a more organized and transparent activity.

Articles are constantly being published in popular business news magazines about investing in art. Although reflecting the existing interest in the area, they are hardly ever informative or enlightening, and the preference in these pieces is usually given to the

financial potential of investing without an in-depth, prior analysis of the numbers or mention of the inherent risks. Being an insiders' market, it may be that certain buyers appreciate the nature of the risk and are able to maximize their investment. In fact, although there are quite a number of individual agents, most buyers still do not see art as an investment. Proof of this is the fact that there are still no institutions or firms in the country with the financial know-how and awareness of the market assisting buyers and their investments. To this effect, the Millennium BCP bank created an initiative which, although short-lived, provided investors and private art collectors with specialized consultancy.

In light of what has already been said, the exotic appeal of Portugal's heritage is certain to attract international buyers. The sheer quality and exceptionality of particular items, at very reasonable prices, should be the motive of some attention – as with furniture and silverwork of the 17th century and first half of the 18th century. As to paintings, names like Columbano Bordalo Pinheiro, Amadeo de Souza Cardoso and Almada Negreiros can equally come as a serious surprise to foreign audiences.

Portugal has paradoxically suffered from its participation in the international circuit. On the one hand, the country lacks the strength that is needed to rival the international élites; on the other, it is not sufficiently peripheral to produce a distinctive art and thus seems doomed to attempt to internationalize artists with only occasional successes.

The attraction of the Portuguese market lies not only in existing opportunities, but also in the fact that it is changing and headed in the direction of increased professionalism and expertise. Furthermore, the general public's interest signals this potential and capacity to grow. Following the international paradigm, art fairs will become increasingly important, antiques dealers will have to shrink in number and augment their expertise, auction houses will absorb a large portion of the market and contemporary art will become more of a commodity. The nationalist tendency of the market will certainly remain, even though collectors at the top end of the market will progressively pick more renowned, international names from the global market.

Knowing that all of the subjects addressed in this text beg further analysis, it is our hope that the ideas forwarded here will be developed, rejected or confirmed with the emergence of new data.

Acknowledgements

While writing this chapter we had the help of several people who generously shared their opinions with us and whom we sincerely thank: Alexandre Melo, Anísio Franco, Carlos Ramires, Ivânia Gallo, Hugo Xavier, João Pinto Ribeiro, José Paulo Chaves, José Pedro Rosa, Luís Serpa, Manuel Leitão, Mário Teixeira da Silva, Miguel Cabral de Moncada, Miguel Magalhães, Miguel Nabinho, Paula Brito, Pedro Ataíde, Pedro Serrenho, Pedro Maria de Alvim, Pedro Aguiar Branco, Rodrigo Ortigão de Oliveira and Sérgio Rau Silva.

For further information on the development of this particular art market, go to: www.koganpage.com/artmarkets.

Reference

Kusin and Company (2002) *The European Art Market 2002*, TEFAF, Maastricht.

Russia

Sergei Reviakin

The Russian art market has been shaped by Russia's long history but came into being mainly in the 1990s. It has quickly become one of the fastest growing in the world and at the beginning of the 21st century has the potential to expand and mature.

The art market today

Rebuilding or *perestroika* which started in the Soviet Union in 1985 led to the collapse of the Union in 1991 and disintegration of the old state system. The new Russian state was born and a new Russian art market slowly started to form. Its present shape and future growth is determined by the existence of international and national markets in Russian art, the regulatory framework inherited from Soviet days, and continuing state patronage and support of museums, artists and art education.

Figure 31.1 shows an impressive 397 per cent growth rate in the Russian art prices index from January 1976 to the present, with its peak of 4970 in November 2007. The index is based on prices of 25,422 paintings of 100 Russian leading painters sold.

The international market in Russian art was formed by several waves of emigration during the last century, extensive sales and auctions overseas of art treasures by the Soviet government in the 1920s and 1930s, sales of 'unofficial' art in the 1960s to 1980s to foreigners inside Russia, socialist realist art to mainly American collectors in the 1990s and 2000s and contemporary Russian art now.

In 1925 the Foreign Commerce Commissariat founded Antikvariat, an art and antique export–import agency. The State Hermitage alone gave 2,880 paintings to it to be sold privately to collectors like Calouste Gulbenkian, a famous oil magnate, and Andrew Mellon, the US Treasury Secretary, and at public auctions abroad in 1928–34 where foreign and Russian paintings and art objects were sold. So did other museums and state funds. More art treasure sales were organized by an American businessman, Armand Hammer, in the 1920s and 1930s.

In the 1960s and 1970s interest in Russian art abroad was confined to non-Russian art connoisseurs and to emigrants and their descendants, who were also very knowledgeable about the subject. There were a small number of galleries dedicated to Russian art. Sotheby's

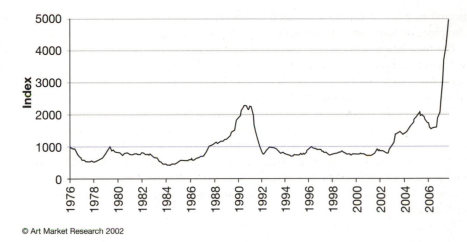

© Art Market Research 2002

Figure 31.1 Russian Art 100 index

had started its Diaghilev ballet material auctions from 1967 and Russian paintings, drawings and watercolours 1900–1925 auctions in London from 1970. Parke-Bernet Galleries (acquired by Sotheby's in 1964) had its first Russian works of art sale in New York in 1968.

Christie's sold Russian imperial jewellery in the 1920s and porcelain in the 1960s for the Soviet government in separate Russian sales. This auction house started with sales of Russian objects like Fabergé and jewellery in Geneva in the 1970s, either combined with other sales or stand-alone. It had a notable sale of Ambassador Jean Herbette's collection in Geneva in 1971, which mentioned Russian works of art in the title. In those days there were no auction sensations and the lots were sold for modest sums of money, often not exceeding several hundred pounds for a painting by Aleksandr Benois (1870–1960) to Russian art collectors living outside Russia. In New York, Christie's had a Russian works of art, Fabergé and icon sale in 1980, and from 1981 Russian items were included in silver and *objets d'art* sales with the word 'Russian' mentioned on the catalogue cover. In 1970s Sotheby's sold Russian items in several different sales, and in 1985 it held its first annual specialist Russian art sale. By the 1990s the international market for Russian art was well established and mature. Both auction houses now have dedicated art departments for Russian paintings and works of art with their own sales. The situation was very different inside Russia. Most if not all important pre-revolutionary art was in the state museums. The sale of art was confined to a few state-owned 'commission shops' selling everything including second-hand clothes, and to private sales. Private collectors were few, and registered with the state. They showed their collections to their fellow collectors and never displayed them publicly. The first Museum of Private Collections as a part of the Pushkin State Fine Art Museum was opened in 1994. The collections were formed from religious objects unwanted by the atheist state, works bought directly from the artists, their heirs or from a few collections that had escaped confiscation by the Bolsheviks.

The prices for art were low and affordable to the collectors, who came mainly from the Soviet ruling élite and were highly paid professionals: doctors, science academics and other intellectuals. In the 1960s and 1970s it was not unusual for exceptional works of the Russian avant-garde to cost no more than a few hundred roubles. In rare circumstances several

thousand roubles (1 rouble was equal to US$2) would be paid (for an early 20-century masterpiece by Konstantin Korovin (1861–1939), for example).

The foundation of the modern national art market was laid at the turn of the 1980s. The first Russian private art gallery, the First Gallery (Pervaia Galereia) and the first auction house, Gelos, were opened in Moscow in 1988. The first Russian art fair, ART-MIF, was held in Moscow and the Contemporary Art Centre opened in 1990.

The watershed event for both international and national parts of the Russian art market was the Sotheby's Russian avant-garde and Soviet contemporary art auction in Moscow in July 1988, when over £2 million worth of art was sold to mainly foreign buyers like Elton John, a wealthy pop singer, more than quadrupling the initial estimate. A work by the contemporary artist Grigory Bruskin (b 1945) was sold for £240,000. Other works fetched tens of thousands. This auction set a world precedent if not a trend for Russian art prices, and revealed the art market potential.

The immediate effect of privatization of the economy was the emergence of a class of wealthy individuals in Russia in the 1990s, which has been increasing ever since. The mammoth centralized economy of the Soviet Union collapsed and was sold off to the new Russian capitalists, who became the owners of oil and gas fields, oil refineries, coal mines and aluminium plants, gold and diamond deposits. Having built magnificent houses for themselves in Russia and acquired second and third homes in Europe or the United States, they became the buyers of Russian art in Russia and abroad. Some of them, like Viktor Vekselberg who acquired nine Imperial Fabergé eggs and 190 other items for over US$100 million from the Forbes family in February 2004, became avid collectors of Russian art and buy extensively from leading international auction houses and galleries. The 2000s brought stability and increased prosperity to Russia, helped by the skyrocketing oil prices. The number of 'official' Russian dollar millionaires was over 100,000 and there were several dozen billionaires in 2006. One can only guess what the real figure is, as most of the wealth reports can hardly reveal the true picture.

The members of the new rich élite have international lifestyles. The rise of their Russian national consciousness made them buy and/or collect Russian art. Their upbringing and education introduced them to easily comprehensible and recognizable classical and realist art of the 19th and 20th century, which is in scarce supply. The sellers are either collectors or their descendants who had had the paintings for years, their dealers or new Russian collectors who are for some reason disposing of some of their stock. The buyers are the members of the ever growing Russian well-to-do class. The growing demand and short supply greatly contribute to the high prices and increased turnover of the Russian art market.

Auction houses

In 2000 the combined annual revenue of the Russian departments of Sotheby's and Christies was just over £10 million (US$15 million). The growth of auctioned art continued in 2002 and 2003, and the combined two auction houses' Russian sales turnover exceeded US$100 million in 2004. In 2005 the leading auction houses, joined by Bonhams (London), Auktionsverk (Stockholm), MacDougall's (London), Tajan (Paris) and others, turned over well over £100 million (US$200 million). In 2006 all the art items of Russian origin sold by Christie's auctions alone made around £40 million (US$80 million). Seven Russian auctions made more than £80 million (US$150 million) at Sotheby's in the same year. Five auction houses (Auktionsverk, Bonhams, Christie's, MacDougall's and Sotheby's) made more than

£200 million (US$400 million) in sales of Russian art in 2007. Phillips de Pury and Company became a world leader in contemporary Russian art and photography and auctioned almost £10 million (US$20 million) worth of Russian art in London and New York in 2007. Another notable event in Russian collecting was the acquisition of the entire Rastropovich-Vishnevskaya collection for probably over £30 million (US$60 million) by a Russian businessman, Alisher Usmanov, through Sotheby's London in September 2007. The fact that many smaller European and American auction houses and galleries joined the 'Russian' race and started to have specialist Russian sales in 2007 suggested that the total international auction turnover had reached more than half a billion US$0.5 billion (£0.25 billion) by the year end. The first specialist Russian Contemporary Art auction held by Sotheby's in March 2008 brought over £4 million to the auction house with an average lot price of over £25,000.

The newly born art market in Russia has survived the turbulent 1990s and is fully developed and growing in the 2000s. There are more than 500 art and antique companies all over Russia, with at least 200 of them in Moscow. Moscow is the place to be for an art professional. There are 10–12 large and around 30 medium-sized galleries, many of them located in the Central House of Artists. Regular auctions are held at Albion Gallery, Gelos, Russian Coins and Sovkom. The number of dealers is estimated to be over 1,000.

Art fairs

The main semi-annual event for the Russian art and antiques business is the Russian Antique Salon. The first salon was held in 1996 (with 18 participants) and the 23rd in Moscow in April 2007, with 205 participants and only 25 galleries were selling art from abroad. The 24th Salon will have over 200 participants again in April 2008. There are two annual contemporary art fairs. The 12th Art Manege was held in December 2007. It featured 72 galleries and the total value of works sold was just below US$5 million. The 12th Art Moscow is expected to have over 80 exhibitors in May 2008. The Moscow World Fine Art Fair, set up in 2004 and held in May, is dominated by foreign galleries offering non-Russian art. In May 2007 it had 75 exhibitors and was attended by 50,000 visitors. The number of exhibitors and visitors is expected to be higher in May 2008.

Although all the main players of the art market are well known it is difficult to ascertain its size. Due to all-pervasive distrust of the state inherited from the Soviet days and 18 per cent value added tax, the art market participants make few of their records public and do not like to show their sales volumes and the names of their clients. According to government sources the undeclared art market turnover was US$300 million in 2006. The secretive nature of the art market in Russia, lack of transparency, provenance and exhibition records made it essentially a buyer's market due to the lack of confidence. Many potential buyers prefer to buy at the Russian sales of the international auction houses, where the sums paid are double or triple those paid for similar works in Russia.

Art and taxation

The growth of the art market was encouraged by some changes in the legal and tax framework. The compulsory licensing of art and antique businesses was abolished in 2000. The 30 per cent art and antique import duty was scraped in 2003. According to the United Nations Commodity Trade Statistics Database for 2003, the declared import of works of art,

collectors' pieces and antiques to Russia has been steadily increasing and far exceeding its export. The state however still retains its right to know about the ownership of art objects. Every art work imported to Russia must be registered with a Ministry of Culture representative at the port of entry. There have been over 60,000 pieces of art registered since 2003. There are no restrictions on taking art which is less than 50 years old out of Russia.

Education and expertise

The state continues to play the main role in art education, which has always been and still is on a good level. The main establishments for training artists, sculptors, architects and restorers are the Russian Academy (formerly the Moscow College) of Painting, Sculpture and Architecture, the Moscow State Surikov Academic Art Institute and Saint Petersburg State Repin Academic Institute of Painting, Sculpture and Architecture. Most of the Russian state universities offer art history and fine art degree courses, attended by thousands of students. In 2006 to meet the realities of the market economy the Moscow State University introduced a specialised MBA in art management, which includes legal, business and art subjects.

One highly sensitive area is professional art expertise. In Soviet times it was a prerogative of the state museum employees, although their knowledge and independent advice was hardly needed because of the lack of private buyers. A specialist's advice cost 1 rouble in the 1960s. The situation changed drastically in the 1990s. Unscrupulous dealers bought authenticity certificates from more than willing poorly paid museum 'experts'. A separate market in art certificates flourished. In January 2007 the government tried to forbid museum employees from issuing their opinions on museum letter-heads in an expert capacity but backed down on its decision in early 2008.

The other issue is the art works' provenance and authenticity. Although all major Russian museums have their collections catalogued and published, few individual artists have had *catalogues raisonnés* compiled. In fact only three artists and two sculptors were so marked during Soviet times. The first Russian *catalogue raisonné* (of Robert Falk (1886–1958) by D Sarabianov and Y Didenko) was published in 2006. The first Russian artist's foundation (for Petr Petrovich Konchalovsky (1884–1935)) was founded by the members of his family in 2006. It aims to preserve the legacy of the artist and confirm the authenticity of his paintings. The good news is that a number of *catalogues raisonnés* (Alexandra Exter, Oskar Rabin and others) are being prepared and due to be published in 2008–2009.

Contemporary art

A few galleries such as Guelman, Aidan, XL, Regina and other Moscow galleries opened from the beginning of the 1990s and now located in Winzavod, the new Centre of Contemporary Art in Moscow, are making great efforts to support and promote contemporary Russian art and artists. The gallery owners think that the contemporary art market is bound to grow, with prices already reaching tens of thousands of dollars and more, which is reflected in the prices achieved at Phillips de Pury and Sotheby's auctions in London and New York. Most of the buyers (who are not all Russians) prefer to buy art with well-known and easily established provenance coming from living artists.

Although most galleries collaborate with state organizations like the State Tretyakov Gallery and the State Contemporary Art Centre to organize exhibitions for their artists, the

contemporary art segment of the Russian art market still desperately needs state funding. Most Russian museums themselves are in need of cash injections from the state in order to expand their collections and acquire contemporary art works. Donations and bequests continue to be one of the major sources of new exhibits. The increasing role of the government bureaucrats creates a conflict of interest with the museum directors and curators on the choice and amount of money to be spent on new acquisitions.

The diversity of the contemporary art movement makes it difficult to establish popular artistic trends. Although there is continuing artists' and collectors' interest in abstract and conceptual art, many artists resort to classical and figurative art, which tends to appeal more to the public. Video and photography are becoming popular means of artistic expression.

Conclusion

The interest in art is as great as ever in today's Russia. Every Russian quality newspaper has a section on Russian and international art markets. The *Fine Art Gallery* and *Vernissage* newspapers cover art news and events. *Russian Art* and *Art Chronicle* magazines cater for a more sophisticated reader. A television Culture channel has a large number of committed viewers. The internet sites www.kultura-portal.ru and www.art-times.ru reach Russian-speaking audiences in every corner of the planet.

Russian art and the Russian art market have now spread far beyond Russia's borders. The early 20th-century Russian avant-garde influenced the development of international art and have been awarded a well-deserved place in the pantheon in the history of world art. Russian art exhibitions have been all over the world, including Russian landscape in the age of Tolstoy at the National Gallery in London in 2004, Quest for identity: Russian art in the second half of the 19th century at the Musée d'Orsay in Paris in 2005, Russia! at the Guggenheim Museums in New York in 2005 and Bilbao in 2006, Beyond the 60s: unofficial art in Russia in Pushkin House in London, Sots art: political art in Russia from 1972 to today in La Maison Rouge in Paris in 2007, and From Russia at the Royal Academy of Arts in London in 2008. The Hermitage Museum has opened permanent exhibition centres in Las Vegas, London, Amsterdam and Ferrara. Russian buyers are welcome at the TEFAF (Maastricht), Grosvenor (London) and Palm Beach (Florida) Art Fairs. Russian galleries have stands at Art Basel, Art Cologne, Armoury New York, Frieze London and other fairs where Russian art is now sold by international galleries. Sotheby's and Bonhams opened representative offices in Moscow in 2007. Russian art has become and is accessible and attractive for international art collectors, investors and simple art lovers.

For further information on the development of this particular art market, go to: www.koganpage.com/artmarkets.

Singapore

Lindy Poh

Introduction

The Singapore modern art market has been the subject of intense scrutiny since the signs of a significant market with global reach emerged in the early 1990s with the arrival of specialist art auction houses and a slew of new galleries. If we define the art market and industry broadly, we would include not just the primary channels in which sale transactions of art objects as commodities take place, but also encompass a much larger collective of institutions, agencies and sources (including art museums) that shape, fund and influence the fiscal value of art.

While there are only 20 galleries and institutions that are members of the Art Gallery Association (AGA, an organization formed in 1996 to broadly govern professional codes of practices) and less than 10 art auction houses operating in the city, a much denser network of 1,000 art-related businesses and agencies functions today, including art galleries (which are not registered with the AGA), art consultancies, conservators, writers, historians, appraisers, framers, art handlers, insurers, art security, design and printing (exhibition collaterals), public and private museums, art rental venues, food and beverage (for exhibition receptions). Of these, 211 are art companies and 52 are visual arts and photography societies. (Statistics provided by the National Arts Council, Singapore, where 'art companies' are defined as companies registered with the Accounting and Corporate Regulatory Authority and include commercial art galleries, art auctioneers, arts consultants and managers.)

A quick survey of public art exhibitions or initiatives in 2006 established that an unparalleled number of public exhibitions (see Table 32.1) as well as unprecedented number of art spaces had burgeoned.

An early market had already formed with some vigour during colonial times, which included the import of paintings, commissioned paintings and 'art statuaries', photographic portraits in commercial photo studios, framing and even evidence of the commercial production of pots and ceramics. Certainly a lively industry that involved the graphic and applied arts and architecture was developing as hotels, villas and iconic buildings burgeoned over the island, with advertisement posters, signage and graphic work produced for merchandise, cinema and other leisure pursuits.

Table 32.1 Visual art exhibitions in Singapore

Year	1993	1994	1995	1996	1997	1998	1999
No of exhibitions	150	208	255	273	346	399	406
No of days	1,441	2,135	3,265	3,270	4,115	6,164	7,654
Year	2000	2001	2002	2003	2004	2005	2006
No of exhibitions	520	518	551	537	542	568	660
No of days	8,376	8,515	9,459	11,380	13,627	12,875	14,838

Visual arts refers to public exhibitions of abstract or representational art objects such as paintings, sculpture, pottery, ceramics, creative photography, installation art and multi-media art. Applied arts such as film, video, graphic design, fashion design, jewellery design and handicrafts are excluded.

Source: National Arts Council, Singapore

'Luxury lifestyle' took off as tin and rubber prices soared during the mid-1920s, with evidence that there was familiarity with fashionable art trends, such as Art Nouveau (a decorative trend from the 1890s–1920s) in spaces such as the famous Eu Villa (built in the mid-1910s). Sculptors like the Italian Rodolfo Nolli set up a commercial studio in the 1920s, producing cast sculptures, ornamental bas-relief works and architecture-related projects. Nolli's famous studio at 47 Scotts Road, with its signage 'Arts and General Buildings Precasts', produced commissioned works for numerous projects and banks including the Supreme Court, City Hall, Fullerton, Bank of China and the Tanjong Pagar Railway. An interesting account of the emerging art market in the 1950s is featured in local art history chronicles by Kwok Kian Chow (1996). The account refers to the exhibition sales of pioneer artists and the influence of patron-collectors like the film magnate Datok Loke Wan Tho (1915–1964) and Dr Tan Tsze Chor (1911–1983).

Auction houses

Still, it was not until the 1990s, with the setting up of the international art auction houses in Singapore, that more analytical reports on the modern art market surfaced. Although auction houses had been established in Singapore earlier than the mid-1980s, these chiefly dealt with property or other assets and were not dedicated to fine art or artefacts. Christies' International (Singapore) launched its art auctions in 1993, while Sotheby's first auction took place in 1996 (following its setting-up of an office in Singapore in 1985).

While Christie's' strategic move to Hong Kong in 2002 for its auctions had fanned speculations about the viability and potential of Singapore as a base for developing a world art market, other market figures have presented much more positive forecasts (allowing for some market contractions after 11 September 2003 and post-SARs). Current figures show that more than six key art auction houses specializing in art works that have emerged in the last decade (this includes Sotheby's Singapore, Christie's International Singapore, Raffles Fine Arts and Auctioneers, Glerum and Bonhams, Larasati and Borobudur), and that while some have wound down or diversified, others like Larasati and Borobudur have entered the scene in the last two years. Recent auction results from Sotheby's showed the highest recorded sales by Sotheby's in two decades, with S$11 million worth of sales of south-east Asian paintings, kindling overseas media reports that the art market in Singapore continues to be burgeoning (Bianpoen, 2005).

There are particular problems endemic to high-volume or high-level auction activities that would inevitably impact on the 'ecology' or matrix of any art scene, including its art museums if these have active acquisitions programmes. As with everywhere else, allegations of fakes and flawed provenance have been recurrent and problematic. Other new problems that have been identified, with particular resonance in the south-east Asian art market, include the rapid 'vanishing' of 'masterpieces' that are being hunted down by the auction houses (Bianpoen, 2005).

The theatrics of art auctions have also drawn biting criticism from those who claim that dramatic price movements, whilst acting as crowd-pleasers, are not sound indicators of the general 'value' of an artist or their art works. Still, although final hammer prices have not always been predictable – as with the instance from Sotheby's in October 2005 where a painting by Lee Man Fong (1913–1988) fetched a record S$1 million (some way from its S$300,000 estimate) – the auction market is seen by some quarters as generally less volatile than the stock market, with average quarterly fluctuations smaller than the Dow Jones Industrial Average. It is thus considered as less sensitive than other assets to geopolitical and economic upheavals or crises.

Art fairs and infrastructure

The current ArtSingapore, a fair dedicated to modern and contemporary art, can be tracked to the roots of Trésors (1993), which marked the first time a fine art and antiques fair was hosted in Singapore. From this fairly modest inception, the annual art fair has evolved into a somewhat quirky barometer of the times, signalling overall art market sentiments in Singapore. The seventh edition of ArtSingapore in 2007 announced visitorship of 15,000, participation of 87 galleries from 16 countries, with the highest art piece sold for US$600,000 and gross takings of over $4.3 million (in 2006).

The deepening sense that the local market holds greater potential has been borne out by the increasing number of galleries that have extended business overseas (particularly in China and south-east Asia) and the rise of e-commerce for art since 2000. Still if we accept that the 'art market' encompasses a far broader collective of institutions and agencies (besides auction houses and fairs), it would be useful to assess how state initiatives have shaped public and market receptivity towards the visual arts. The oft-cited Renaissance City Report (March 2000) emerged with a vision that became pivotal for the conception and construction of infrastructural spaces for the arts, including the visual arts. (This report, published by the Ministry of Information and the Arts, Singapore had inter alia the aims of establishing Singapore as a global city of the arts and providing cultural ballast in nation-building efforts. Six key strategies were proposed, and the report was raised and accepted in Parliament on 9 March 2000.)

While the term was not new (other 'renaissance city' initiatives elsewhere were being developed, such as the paper *Revitalisation in the Renaissance City: Economic development in Detroit* (Stokes, 2000); also Tamagawa Renaissance City project, Japan), its contents were regarded as a landmark for Singapore culture in the breadth of its intent and the scale of its ambition. Its $50 million budget over five years was also a milestone in terms of state underwriting for an arts initiative. The report has been critiqued at various levels, but is largely accepted as the catalyst for numerous initiatives that have endeavoured to shape not just the infrastructure for the display or exhibition of the visual arts – but also its production and circulation.

There have also been other reports that have been pivotal to signal, launch or facilitate the tremendous changes over the last 15 years. These include the Report of the Advisory Council on Culture and the Arts (1989), which heralded the formation of the National Arts Council in September 1991 and the beginnings of the conception of art centres like the Esplanade: Theatres on the Bay. Other publications that reinforced the idea of a Global City of the Arts were released by agencies such as the Singapore Tourism Board (1995).

Tax and other incentives

It was also inevitable and critical that tax and other incentive schemes were launched that have boosted corporate and private sponsorship and funding of art. These include double tax incentives for cash donations, donations to the museums of the National Heritage Board as well as commissions for public sculptures. The Public Sculptures Donation Scheme was enhanced from its initial structure in 1988 to a more 'incentivizing' scheme in 2002, to include double tax deduction benefits and exemption from estate duties. Another recent incentive scheme by the Urban Renewal Authority (URA) offers additional gross floor area (GFA) over the maximum allowable under the Master Plan 2003 to property developers that integrate art works into their development in the city centre area (for details see www.ura.gov.sg).

A palpable shift in the last two decades can be found in the increasing support for the view of the visual arts not just as 'cultural ballast' but as material with significant potential for economic returns and with positive contributions towards national tourism. This approach has been reinforced by a number of research studies and papers coming from academic quarters (eg Markusen and King, nd). This stance has been most notably applied by the Arts House at Old Parliament in its recent collaborative and partnership schemes, in which art and commerce have been integrated.

There has also been new interest in the 'creative industries' and 'creative clusters', which extend not just to fashion or graphic arts but to photography, animation, film-making and new media. The Creative Industries Development Strategy spearheaded by the Ministry of Information, Communications and the Arts (MICA) in partnership with other state agencies is one of the keynote documents that signals the new emphasis on this sector. Details are featured in reports such as Economic Contributions of Singapore's Creative Industries (Ministry of Trade and Industry, 2003), and the Economic Review Committee Services Subcommittee Workgroup on Creative Industries (2002).

Art specialist skills and services

An interesting development in the Singapore art market has been the expanding interest in exploring areas of specialist art skills, services and research, and offering incentives for designated talents to set up in Singapore. Contact Singapore, a 'global network' service for employment and career opportunities in Singapore, has offices in Australia, China, United Kingdom, Europe, India and North America, and designates at least 10 categories of 'talent' in the visual arts that it seeks to attract.

The existing network in Singapore, though limited, has contributed an added dimension to the art market and art skills arena. These include areas of art conservation, art production, art publishing, and art as well as intellectual property laws. The Heritage Conservation Centre (HCC), for instance, leads one of the foremost conservation and care storage spaces in Asia. Its

distinguishing characteristics are its 'connectedness' with international conservation centres and practices, its professional contacts, knowledge and updated facilities and equipment.

In the area of intellectual property, a recent ground-breaking occurrence was the naming of a historic international trademark treaty after Singapore – bearing testament to the substantial investment Singapore has made in world efforts in the area of trademark law. (The name Singapore Treaty on the Law of Trademarks was adopted 28 March 2006, by the World Intellectual Property Organisation (WIPO): for details see www.wipo.int). It extends recognition of trademarks to 'sound-marks' and 'scent-marks' – the result of acknowledging a more 'multi-disciplinary' identity for what had been an area of 'visual art' protection.

Beyond the numbers, the art market in Singapore should be understood as a complex collective of agencies, institutions and entities that operate beyond the immediate platforms of auction houses and galleries. The art market in this sense has emerged as a dramatically 'expanded field' in its very scope, intentions and reach – extending to new players, new spaces and audiences or users in ways that compel a reconsideration of conventional industry and professional measures and gauges.

For further information on the development of this particular art market, go to: www.koganpage.com/artmarkets.

References

Bianpoen, C (2005) Singapore auctions show burgeoning art market, *Jakarta Post*, 16 October

Kwok, Kian Chow (1996) *Channels and Confluences: A history of Singapore*, Singapore Art Museum, Singapore

Markusen, A and King, D (nd) *The Artistic Dividend: The arts' hidden contributions to regional economic development*, Humphrey Institute of Public Affairs, University of Minnesota, USA

Singapore Tourist Promotion Board and Ministry of Information and the Arts (1995) *Global City of the Arts*

Stokes, C E (2000) *Revitalisation in the Renaissance City: Economic development in Detroit*

South Africa

Harriet Hedley

Introduction

For centuries South Africa, a strategically important outpost, was used as a port by various European countries, the first settlements being the Dutch in 1652. However prior to this date the Portuguese visited these shores and with its changing fortunes, it became part of the British Empire before it was taken back by the Afrikaners, descendants of the Dutch, in 1948. With the mining of the rich mineral deposits came people and influences from all over the globe who brought with them, arts and crafts from their various countries and also contributed to the rich tapestry of South African fine and decorative arts.

South Africa is home to some of the most ancient and beautiful art in the world today. Approximately 2,000 years ago the inhabitants of Southern Africa, the San or Bushmen, produced the first paintings of the region, referred to as rock art. These paintings reflected not only what was happening in their daily lives and the animals around them, but also the cosmology of their creators. Although many Europeans when they first encountered rock art considered it very primitive and crude, it has influenced many South African artists.

Today South African collectors tend to focus on either the early 18th and 19th century, classic 20th century or contemporary art. Fine paintings are rare and important pieces achieve prices in line with the world art trend. There are numerous artists, but in this chapter only nine have been chosen for discussion as they dominate the South African secondary market at present. Some of the artists have lived and worked abroad and had a foreign influence. For example, both Irma Stern and Maggie Laubser worked with the German expressionists and this can clearly be seen in their work.

Collectors are usually specific in the areas they collect. Africana collectors tend to collect 18th and 19th-century art, furniture, books, silver, brass and glass. The younger generation like the more vibrant 20th-century art. During the apartheid years in South Africa (1948–94), black artists were neglected; however in recent years this has changed. There is a burgeoning contemporary art market and it is interesting to note that during the last few years the confidence that local collectors have in South African art has increased significantly.

Key artists

John Thomas Baines (1820–1875)

Baines was a remarkable artist and a detailed observer who left us a rich legacy of his many trips around the globe. Born in November 1820 in Norfolk, England, Baines arrived in Cape Town in November 1842. He became South Africa's first official war artist, travelled the interior extensively as far as the Zambezi River and reported back what he saw through his art work. He is best remembered for his detailed paintings and sketches of numerous landscapes, nature studies, historic paintings and representations of people, which give a unique insight into colonial life in Southern Africa. In the 1980s his important paintings achieved top prices at auction. For example, his Victoria Falls paintings very rarely come on to the market and together with the group paintings, where he paints a portrait of each individual, are possibly the most sought after. His works can be seen in various collections in South Africa including the Africana Museum, now called Museum Africa, which holds the most extensive public collection of his works, the Albany Museum, the second oldest in South Africa, King George VI Art Gallery, now called the Nelson Mandela Art Gallery, and the Local History Museum in Durban, since the mid-19th century. Today many of his paintings are sold mostly in London and South Africa at auction, through dealers and by private treaty.

Frederick Timpson I'Ons (1802–1887)

I'Ons was born in 1802 in England and died in Grahamstown, South Africa in 1887. Before coming to South Africa in 1834 he owned an art school in Marylebone in London where he taught drawing, painting, handwriting and commercial subjects. Shortly after he arrived in South Africa he became a volunteer in the Sixth Frontier War. There he was commissioned by his military officers to do portraits of the chiefs of the region like Magoma and Khama. His depictions of local inhabitants such as the Khoikhoi and Africans are considered his best works. However the public at the time preferred his paintings of vast, dark landscapes and I'Ons started painting in this genre.

Good works by I'Ons rarely come onto the market. Sales usually take place both in South Africa and London, and it is interesting to note that regardless of the situation he depicted, political or not, there is no sway in the prices for this artist – he had a good eye and ability to report what he saw and translate it to canvas. The collectors of Africana are the main buyers. The Art Sales Index Database indicates that the highest price achieved for a painting by I'Ons was £120,567 in 1996. This was an unusually large painting depicting a very important subject and came directly from his family. A far smaller painting, *Canteen scene during the Frontier Wars*, was sold more recently through Christie's London for £34,000.

Irma Stern (1894–1966)

Stern was born in 1894 in the small South African town of Schwiezer-Reneke and died in Cape Town in 1966. In 1913 she studied art in Germany at the Weimar Academy, in 1914 at the Levin-Funcke Studio and notably from 1917 with Max Pechstein, one of the founders of the Novembergruppe. Stern was associated with the German expressionist painters of this period and she travelled extensively during her lifetime in both Africa and Europe.

It is fascinating to study the results and graphs of Irma Stern's paintings in the secondary market. Her rise in stature really appears to have begun in 1999, with the first sale of a painting by a South African artist achieving an excellent price. Her *Still life: fruit and dahlias*

sold for about £70,000. The following year *Cape girl with fruit* was sold for about £114,000. This was the start of new collectors coming on to the market and the beginnings of the rise in prices. Most recently a portrait of a Congolese woman was sold for £569,300 at Christie's in London, a world record price at auction for this artist.

Maggie Laubser (1886–1973)

Laubser was born in Malmesbury in 1886 and died in Cape Town in 1973. She studied in South Africa, London, Holland and Germany. Her works were strongly influenced by the German expressionists whose search for expressiveness of style was by means of exaggerations and distortion of line and colour; a deliberate abandonment of the naturalism implicit in impressionism, in favour of a simplified style which was expected to carry far greater emotional impact.

Until recently – November 2006, when a portrait achieved about £310,000 at auction – top paintings by Maggie Laubser were sold at auction for between £20,000 and £40,000. During the late 1990s a collector could find a good painting by Laubser at an auction for under £10,000. Any collector who appreciates her works, and wishes to purchase a painting on the secondary market must bear in mind that the subject is important and determines the estimate and price. For example her portraits tend to achieve higher prices than landscapes, and as with all the other artists, provenance, subject, condition and size are very important.

Jacob Hendrik Pierneef (1886–1957)

Pierneef was born in Pretoria in 1886. During the Boer War his family returned to Holland and it was here that he came into contact with the Old Master pictures, which had a lasting impression on him. He studied at the Rotterdamse Kusakademie and when he returned to South Africa, aged 18, he met with and was encouraged by established artists such as Frans Oerder, Anton van Wouw and Hugo Naude. He excelled at landscape portrayals of the highveld and these gave him a lifetime source of inspiration; however portrayals of people in his paintings are very rare.

Pierneef visited Europe again in 1925/26 where he met Anton Hendiks and also studied the theories of William van Konijnenburg. It was during this visit that he came into contact with contemporary art of the period and was also able to study recent styles such as impressionism, post-impressionism, cubism, cubo-futurism and fauvism.

It is interesting that collectors like different periods of Pierneef paintings. Until recently landscapes from the late 1920s/early 1930s were the most desirable because of the colours and technique used but a painting dated 1951, when his palette lightened, with an interesting provenance was sold at over £140,000. Some collectors liked the Transvaal landscapes that he painted between 1946 and 1948, and others prefer his less realistic paintings to his more realistic ones. The painting that was recently sold for £200,000 was larger than most, dated early 1928 and had a significant provenance.

Gerard Sekoto (1913–1993)

Unlike many contemporary black artists, Sekoto's work was recognized during his lifetime. He was born on 9 December 1913 at Botshabelo mission, near Middleberg, Mpumulanga and died in Paris in 1993. At the age of 25 he came to Johannesburg to become an artist. Sekoto used strong, bright colours and unusual perspectives to convey the lively vitality and spontaneity of urban street life despite the hardship of life.

He held his first solo exhibition in 1939. In 1940 the Johannesburg Art Gallery purchased one of his pictures, the first picture painted by a black artist to enter a museum collection. His ambition was to visit Paris, the centre of the art world, and in 1947 he left South Africa, a self-imposed exile, to live for the rest of his life in Paris.

During the 1970s Sekoto's paintings became political. In 1989 the Johannesburg Art Gallery honoured him with a retrospective exhibition and he received an honorary doctorate from the University of Witwatersrand. He is recognized as the pioneer of urban black art and social realism. He broke the convention of 'native' studies which had preceded his work. His work is highly sought after by collectors in both the corporate and private sectors. Gerard Sekoto commands high prices on the secondary market and indeed his self-portrait recently sold in London for a world record price for the artist at £120,000.

George Milwa Mnyaluza Pemba (1912–2001)

Pemba is without a doubt a great South African artist, whose talent was recognized only late in his life. He was born in 1912 in Port Elizabeth. He grew up in the Eastern Cape and as a young child he was encouraged to draw and paint. He illustrated many books on African customs and traditions. Some of Pemba's best work was in watercolour; however in the 1950s he also mastered oils. He was primarily a painter of portraits. His main source of inspiration was the life of the people who surrounded him in both rural areas and townships. Although a non-activist, he expressed his hatred in living under the apartheid regime by depicting the suffering and struggle of the black people.

He was also interested in indigenous cultures, the tribal life of the different regions and the impact of urbanization on his people. As an excellent portrait artist, he depicted his subjects with sensitivity, capturing not only their likeness but also their character. His paintings are noted for their excellent composition and their bold use of colour. By the end of the 1980s he had become one of South Africa's most revered black artists.

He gradually started to command good prices locally. Pemba is recognised as a pioneer of social realism in South Africa, taking his inspirations from the realities and struggles of urban black people's everyday life during the troubled times. At present his works are still affordable and one cannot go wrong in buying this artist's work. A book was written on him and his paintings have been exhibited in some of the top galleries. His better works range between £10–15,000 at auction.

Marlene Dumas (b 1953)

Dumas is one of the greatest living female artists, who achieved a dizzying price at auction for her painting *The teacher*: $3.3 million in 2005, the highest price ever for a female contemporary artist. Dumas was born and raised near Cape Town, South Africa but migrated to Holland after graduating from the Michaelis School of Art in Cape Town in 1975. Her works now reveal a constant theme; the relation between art and female beauty, art and pornography, female models and models of art. Her work recalls aspects of expressionism, and at the same time combines the critical distance of conceptual art with the pleasures of eroticism. She says: 'One person's nude is not another person's naked. I am not interested in shocking the world – it is already filled with shocking things. But I don't want to leave the viewers cold either.'

Many of her paintings often portray the formerly repressed years of apartheid South Africa, and her painting *The dance*, which was sold at Christie's London in June 2007 for £960,800, shows the integration of the races; two black girls with two white girls holding

hands. Although it is quite a haunting painting with a limited amount of information, the subject is evocative and arouses a sinister and suggestive atmosphere. Looking through recent records, her oil paintings very rarely come up for auction and when they do, they achieve huge prices. However, her watercolours and mixed media tend to come on to the market more regularly, and the subject very often is poignant portraits or sexually explicit.

Her work has been widely exhibited and her paintings are in many important collections including Tate Gallery, London, De Pont Foundation, Netherlands, Centre Pompidou, Paris, the Art Institute of Chicago and Iziko South African National Gallery, Cape Town.

William Kentridge (b 1955)

Kentridge is an exceptional artist and talented person who has achieved considerable international acclaim not only for his charcoal and pastel drawings but also for his work in theatre, opera and animated film. He is also a prolific printmaker, draughtsman and sculptor. He was born in Johannesburg in 1955 where he continues to work and live. He studied for a Bachelor in Politics and African studies in 1976 at the University of the Witwatersrand, in Johannesburg.

He had his first one-person exhibition of his paintings and sketches at the Market Gallery in Johannesburg in 1979, and since then has featured in numerous one-person and group exhibitions both in South Africa and abroad, in London, New York, Paris, New Mexico, Barcelona, China, San Diego and Sydney, although perhaps his largest exhibition to date was at the Musée d'art Contemporain in Montreal in 2005. The Goodman Gallery in Johannesburg and Cape Town is his primary dealer, where he has exhibited since 1986.

As Kentridge is one of the most exciting and innovative contemporary artists to emerge out of South Africa, prices keep on rising not only for his art work, but his animated films on laser disc or video which are also highly collectable. His originals are most sought after by collectors.

Conclusion

In the last few years, South African artists have gained more and more recognition both locally and internationally. It is important that the collector, when buying contemporary art, be advised by a reputable gallery that promotes contemporary art, as many gallery directors are highly qualified and have an excellent eye.

The artists that have been written about here can be considered some of the most popular and have good track records on the secondary market both locally and internationally. Without a doubt there are many other excellent South African artists, some well known and others less so, such as David Goldblatt, Penny Siopis, Berni Searle, Jane Alexander, Claudette Schreuders, Wim Botha, Guy Tillim, Willem Boshoff, Moshekwa Langa, Robert Hodgins, Louis Maqhubela, Ephraim Ngatane, Cecil Skotnes, Dianne Victor, Karel Nel, Joni Brenner, Marco Cianfanelli, Pat Mautloa, Sam Nhlenghethwa, and Zwelethu Mthethwa. These are some of the names one should keep an eye out for in years to come.

For many collectors art is seen as an investment. However, it is always recommended that collectors buy what they like and the best they can afford, and that financial gain should not be their primary motivation. A very useful guide to potential collectors is to study prices at auction. These of course only give a partial insight to the market but are nevertheless a good global guide. Estimates and prices at auction are influenced by many factors positively and negatively. Interestingly, prices achieved for the classic South African paintings by

well-known white artists, went through a period of lull immediately after the transfer of power from the apartheid government to democracy.

South African art has become sought after and in May 2007 the first sale focusing on South African art took place in London. It was attended by many, including local South Africans, and went remarkably well, placing South African art on the international arena.

For further information on the development of this particular art market, go to: www.koganpage.com/artmarkets.

Sub-Saharan Africa
A male Fang statue, Gabon, sold for €371,250,
June 2004 in Paris
© Christie's Images Limited

Argentina
Antonio Berni *La gallina ciega* (1973)
Collection Ms Amalia Fortabat, Buenos Aires

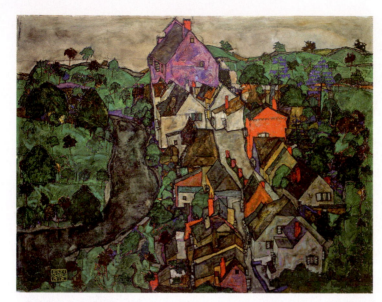

Austria
Egon Schiele (1890-1918)
*Krumauer Landschaft
(Stadt und Fluss)
(Krumau landscape:
town and river)*, signed
Egon Schiele and dated
1916 (lower left); signed
and inscribed Wien
`Landschaft' Privatbesitz on
the stretcher, oil, tempera
and coloured chalk on
canvas, 110.5 × 141cm
Courtesy of Sotheby's

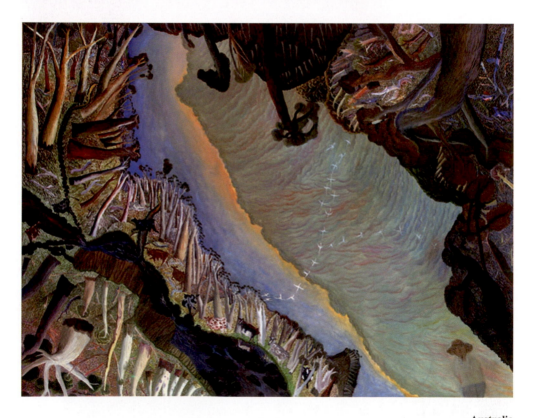

Australia
William Robinson *Landscape with sunset and self portrait* (1988), oil on canvas, 147.5 × 193cm
Private collection, Australia
Courtesy of the artist

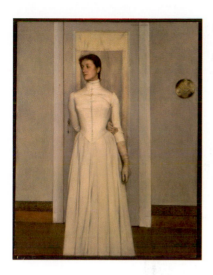

Belgium
Fernand Khnopff *Portrait of Marguerite, the sister of the artist*,
US$ 790.884 (Christie's New York, February 28,1991), on loan
from the Fondation Roi Baudouin/Koning Boudewijnstichting
(Belgium) at the Royal Museum of Fine Arts of Belgium (Brussels)
© Christie's Images Limited

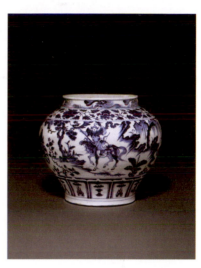

China
A blue and white
narrative porcelain
jar, Yuan dynasty
(1279-1368),
sold for
GBP 15,688,000
in July 2005
– the highest priced
Asian work of art
ever sold at auction
© Christie's
Images Limited

Czech Republic
Kristof Kintera *Talkman* (1999–2003), acoustic and
kinetic sculpture, metal construction, electro-installation,
polyurethane, clothes, 100 × 40 × 35cm
Courtesy of Jiri Svestka gallery

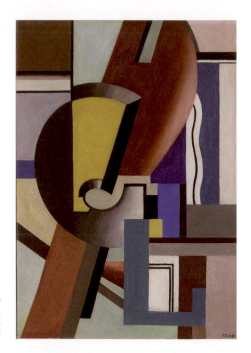

Denmark
Franciska Clausen *Contrastes des Formes* (1927),
oil on canvas, 65 × 45 cm
© Christie's Images Limited

Iceland
Johannes Kjarval *Landslag* (1935-40), oil on canvas, 85 × 115cm
Sold for GBP 35,000
© Christie's Images Limited

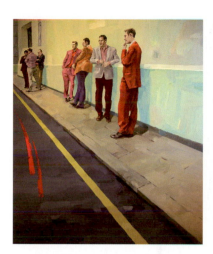

Finland
Topi Ruotsalainen
The Return of Pink Cadillac
Topi Ruotsalainen is one of the rising stars in Finland, as his exhibitions are quickly sold. He was just awarded The Young Artist of Taidekeskus Salmela 2008 Reproduced by kind permission of Taidekeskus Salmela/Topi Ruotsalainen

Finland
Ellen Thesleff *Skogsfeerspel (Metsänhaltijan leikki)*
(The Playing Fairies of the Forest), oil on canvas, 96 × 75.5cm
Ellen Thesleff was one of the most important female artists
in Finland in the 19th century
Reproduced by kind permission of Taidekeskus Salmela/Ellen Thesleff

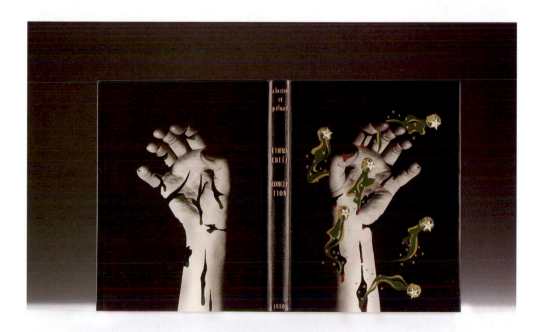

France
André Breton & Paul Eluard *L'Immaculée conception*, Paris, Editions Surréalistes, José Corti, 1930
© Sotheby's France

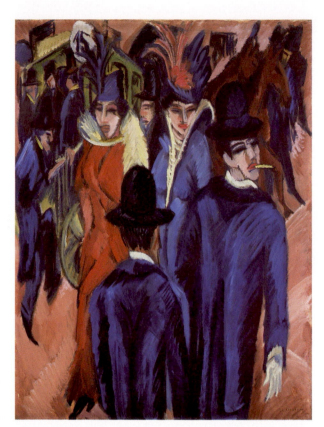

Germany
Ernst Ludwig Kirchner (1880-1938)
Berlin Street Scene
© Christie's Images Limited

Indonesia
S. Sudjojono *The indestructible desert* (1976), 100 × 300 cm
Estimate: HK$800,000-1,200,000, price: HK$3,032,000
Auction of Modern & Contemporary Southeast Asian Art, May 2006
© Christie's Images Limited

Greece
George Jakovides,
Motherly love (?),
oil on canvas,
90 × 66 cm
Sold for GBP
257.67
© Christie's
Images Limited

Greece
Kostis Velonis
Space Loneliness
(2005)
Copyright of the
artist

Ireland
Louis Le Brocquy *Image of Samuel Beckett*
© Christie's Images Limited

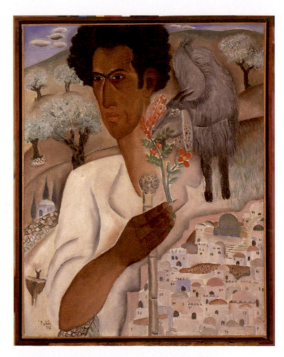

Israel
Reuven Rubin (1893-1974)
Self-Portrait in Jerusalem, signed and dated
'Rubin 925' (lower left), signed again, titled and
dated 'Self Portrait 1924/25' (on the stretcher),
oil on canvas, 82 × 64 cm
Estimate: US$ 200,000-300,000,
price: US$ 349,000
Sold at Christie's Tel Aviv, 10 April 1999
Sold to benefit the International Synagogue at the
John F. Kennedy International Airport, New York
© Christie's Images Limited

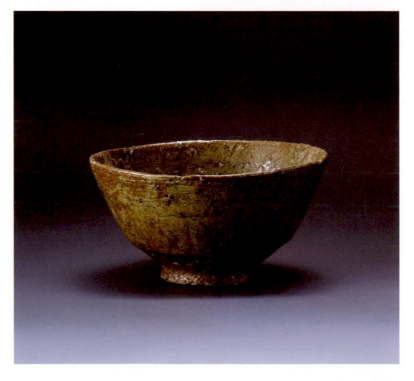

Japan
Kugibori Iraho tea bowl, 7.3 × 14.3cm, Edo Period
Image courtesy of Tanimatsuya Toda Shoten

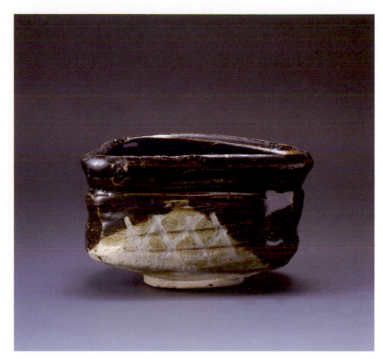

Japan
Black Oribe "Kutsu"
shaped tea bowl,
8.2 × 13.7cm, Edo Period
Image courtesy of
Tanimatsuya Toda Shoten

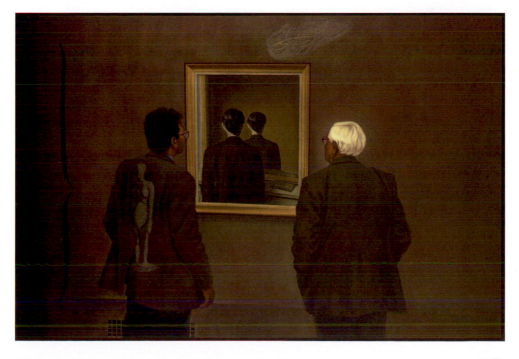

India
Atul Dodiya *Three Painters*, signed and inscribed, oil and acrylic on canvas, 122.3 × 183cm
Christie's New York: September 2007, South Asian Modern and Contemporary Art
© Christie's Images Limited

Malaysia
Dr. Jolly Koh *The Road Not Taken II* (2008), oil and acrylic on canvas, 145cm × 203cm
Reproduced by kind permission of Dr Jolly Koh

Mexico
Leonora
Carrington
(b.1917)
*The Temptation of
St Anthony* (1947),
oil on canvas
© Christie's
Images Limited

Middle East
Ahmed Moustafa (Egypt, b. 1943) *Qur'anic
Polyptych of Nine Panels* (1995), oil and
watercolour on Velin Arches hand made
paper (seven panels); on canvas (two panels)
Each panel 102 × 102cm
Estimate: US$ 300,000-350,00,
price: US$ 657,000/AED 2,411,190
World auction record for any painting by an
Arab artist, world auction record for the artist
Image courtesy of Ahmed Moustafa

Netherlands
Jan Sluijters
(1881-1957)
*Seated Nude
(Greet)*, signed,
oil on canvas,
50 by 40cm.
Painted circa
1909–10, sold for
€276,250 at the
sale of Modern &
Contemporary Art,
6 December 2007
© Sotheby's
Amsterdam

New Zealand
Charles Goldie *Te Aho, A Noted Waikato
Warrior* (1905), oil on canvas, 600 × 497mm
Signed and dated Auckland 1905
Private collection, permission arranged by
Webb's Auction House

Norway
Hans Fredrik Gude and Adolph Tidemand *Brudeferden i Hardanger* (1853)
Reproduced by kind permission of Grew Wedels Plass auksjoner

Portugal
Columbano Bordalo Pinheiro, *O Serão*
Sold at Palácio do Correio Velho in 2004 for €310,000
Courtesy Palácio do Correio Velho

Philippines
Geraldine Javier (b. The Philippines
1970) *The absurdity of being*
Sold in Hong Kong May 2007
© Christie's Images Limited

Spain
Juan Sánchez Cotán
(1560-1627)
*Bodegón with a cardoon
and francolin,*
oil on canvas,
73.3 × 62.2cm.
Christie's (King Street)
sale date: 8 December 2004
© Christie's Images Limited

Singapore
Russel Wong (b. 1961) *Bamboo Forest,* photographic Lambda print, 122 × 366cm
Christie's Hong Kong, May 29, 2005, Southeast Asian and Modern Indian Paintings (inc. Contemporary Art)
© Christie's Images Limited

South Korea
Kim Dongyoo *Marilyn vs Kennedy* (2007),
oil on canvas, 118 × 92cm
Private collection
Courtesy of the artist

South Africa
28 February 2007, New York, William Kentridge, Bronze, *Promenade II* (in 4 parts)
© Christie's Images Limited

Sweden
Anders Zorn *Naken på strand* (1907), oil on canvas,
73 × 54 cm
Sold for GBP160,000
© Christie's Images Limited

Switzerland
Fritz Glarner (1899-1972) *Relational Painting Nr. 5* (1951),
oil on hardboard, 124 × 66 cm
Sold at SWISS ART for 720,000 Swiss francs
© Christie's Images Limited

Thailand
Michael Shaowanasai *On the road to Nirvana,* 2003 photo and performance, Venice Biennale 2003
Reproduced by kind permission of Manit Sriwanichapum/Michael Shaowanasai

United States
Andrew Wyeth *Ericksons* (1973),
tempera on panel
Bought by Michael Altman Art
Advisory
© Christie's Images Limited

South Korea

Sunhee Choi and Byungsik Choi

The art market of today was formed after the Korean War (1950–53) when young artists who had worked abroad, mainly in France and the United States, came back to Korea. These artists were influenced by western art in terms of technique, often reflecting Korean sensibility and cultural background. The fundamental structure of the current Korean art market started to develop in the 1970s when commercial art galleries such as the Hyundai gallery and the Myoung-dong gallery opened in Seoul in 1970. The market continued to grow through the 1980s and 1990s when the country benefited from its economic development – gross national product per person reached $12,646 in 2003 from $1,598 in 1980. After the 1988 Olympic games, the market reached its peak and many people were seeking to buy art as an investment; 80 per cent of the commercial galleries in Seoul opened in this period. Foreign dealers became interested in the Korean art market after 1991, because the Korean government passed a new law to enable the import of western art. Regarding export, apart from a few galleries selling Korean art works at art fairs abroad, most demand remained within the country.

However, throughout the development of the art market, the lack of transparency and pricing system have remained the biggest problems. The price was controlled by the artists rather than by supply and demand. The artists decided on a price for their work which was often much higher than the actual market price. As a result, when galleries were selling these works there were two different prices, a selling price which was usually much lower than the official price. Then came the 1997 Asian currency meltdown, which was followed by International Monetary Fund restructuring. As a result of its weak and inadequate structure, the art market suffered from the economic crisis and all spending on art was on hold.

However, since the new millennium, the art market has been revitalizing as the country's economy is recovering from the crisis. Most of all, the Korean government is making an effort to stimulate the art market. Art and culture is becoming more accessible to the public through a number of exhibitions and various cultural events organized by public institutions as well as commercial organizations such as auction houses and galleries. Commercial galleries are trying to find a larger market abroad by opening branches, mainly in China, and by participating in international art fairs like Art Basel, Art Cologne, Freize, Arco and the Armory show. The demand for works by young Korean artists by the international market is

growing rapidly for several reasons. First, there is a huge interest in Asian contemporary art based on the booming Chinese contemporary art market. Second, the Korean domestic art market structure is changing rapidly in response to the nation's growing interest in art based on the economic growth of the country since 2000.

Art presently sold

The objects demanded and circulated in the Korean art market are ceramics, traditional Korean paintings, scrolls, calligraphy, old books, old furniture, objects of craftwork, modern and contemporary paintings, photography and sculpture. The biggest demand in the antiques sector is for antique ceramics such as celadons from the Goryeo dynasty (918–1392) and white porcelain from the Choson dynasty (1392–1910). Old Master paintings by artists like Chung Sun and calligraphy by Kim Junghee are selling at their highest price ever, making from $200,000 up to $350,000. However, modern and contemporary paintings have a stronger market than Korean Old Master paintings. This is a result of the change in lifestyle since 1970, when Koreans begun to be influenced by western housing systems like apartments. Also, many Koreans travelled to the west, especially to the United States, and decorated their houses in western style when they came back to Korea.

Korean artists were strongly influenced by western modern masters. Among them, Whanki Kim (1913–1970) who studied in New York has a strong market these days. Another artist of the same generation to Whanki Kim, Sookeun Park's (1914–1965) works are selling with record prices. He is highly appreciated for his unique painting style and subject matter which closely relates to Korean sensibility. Since 2004 artists from a younger generation, who are in their early and mid-30s, are gaining recognition from the international market, and foreign auction houses have begun to sell their work in Hong Kong and New York. A domestic demand is emerging for these young artists, who usually had struggled with establishing themselves in the Korean art market in the past.

There is a high demand for western works of art in Korea, notably postmodern and contemporary art since the late 1990s. Some wealthy collectors started to collect works by famous western masters of modern painting and contemporary artists like Pablo Picasso, Andy Warhol, Joan Miro, Gerard Lichter and Damien Hirst. British and French antique furniture is imported but the size of the market is not significant. When importing works of art bought from abroad, buyers do not need to pay import tax.

Private museums and galleries exert a strong influence on artists. But when those institutions plunged into a slump in the 1990s, artists were supported by a number of independent art space founders, notably Loop, Alternative space Pool, Insa and Ssamzie, and sometimes by government organizations like the Art Council of Korea and Korea Culture Foundation. Young artists from those alternative spaces such as Ham Jin, Jung Yeondoo and Kwon Osang are now establishing their career in Korea as well as in the international art scene.

There are around 80 art colleges in Korea. The area of teaching is divided into traditional Oriental paintings and western-style works such as oil painting, sculpture, photography and media art. Unlike the former generation of Korean artists who had experienced the upheaval of social, political and cultural changes through the 1960s to the 1990s, young artists today have been growing up with great optimism in their country, celebrating high technology and a huge wave of globalization. Full of creative energy and unique sensibility, these artists are more interested in expressing the issues of identity, criticism of the current society and culture

through experimental media and new techniques. There are around 30,000 artists registered by the Artists' Association but it is assumed that only 3,000 artists are working vigorously and making a living from their work.

Players

There are around 1,000 antique dealers in Korea. Among them 700 dealers have galleries, and most of them are concentrated in the Insa and Jangan districts of Seoul. The biggest antique galleries are Hakgoje, Dabosung and Yenar. The Korean Antiques Association is the trade association for the antique dealers, and was founded in 1971. The lack of information on buying and selling antiques makes it difficult to estimate the market size. It is estimated to be around $50 million.

Most collectors of Korean traditional art are known to be true amateurs rather than investors. Among international buyers, the Japanese were major collectors, especially of fine Korean porcelain. As a result of the Japanese colonial ruling of Korea from 1910 to 1945, many of the oldest and most significant Korean art pieces are held in private and public collections in Japan. The Tokyo National Museum displays or stores more than 1,000 gold, bronze and celadon pieces. As many as 35,000 Korean art objects, 30,000 rare books and 80 per cent of all Korean Buddhist paintings have been confirmed to be in Japan. Apart from museums in Japan, major museums like the Metropolitan Museum New York, the British Museum and the Guimet Museum in France have Korean galleries, presenting valuable opportunities to introduce Korean art to western audiences.

According to Seoul Auction, the average sale rate for antiques increased from 30 per cent in 2001 to 74 per cent in 2006. As the market is growing, the issue of authentication is becoming more important. The Development Committee for Korean Art Authentication (DCKAA) was founded and funded by the Korean Ministry of Culture and Tourism, and the Culture and Arts Committee. The Development Committee is conducting a comparative study of the current situation of the art authentication practices in different countries like France, the United Kingdom and Italy.

In the recent art market history, commercial art galleries were major players. However the lack of professionalism and transparency of the price system have remained big obstacles to converting a wider range of potential buyers into purchasing power. Many galleries have survived with a small number of collectors, dealing in works by around 30 established artists.

According to the Galleries Association of Korea, there are around 100 commercial galleries registered to the association and around 200 galleries which are not registered. Among these galleries, around 50 galleries are promoting contemporary art vigorously, most established ones being located in Seoul. The biggest players are gallery Hyundai, Gana, Kukje and Arario. Gana operates the Gana art centre in Chungdam-Dong and the Insa art centre in Insa-Dong. Gana also has a branch in Paris and owns a major auction house, Seoul Auction, which opened in 1998. The Hyundai gallery was one of the first commercial galleries to open in Korea and has represented the most prominent masters of modern and contemporary Korean art.

Arguably the most powerful name in the Korean art market is Arario. The founder of Arario Small City, containing shopping malls, multiplex cinemas and restaurants in Cheonan, Chang-Il Kim, opened a large gallery space in Beijing in 2005 and a third space in Seoul in 2006. He is to open the Another Museum, a non-profit public art museum designed by a

British architect David Adjaye, next to his Cheonan gallery. The museum will host much of his rapidly expanding collection of contemporary art. He is also planning to open a gallery in New York. Like Arario, some big galleries are opening branches in Beijing, now the biggest hub for Asian contemporary art dealers to meet international collectors. The Pyo, Mun, Ium and pkm galleries opened branches in Beijing in 2006.

The leading gallery for the primary market, Kukje, is a regular participant at Art Basel Miami, and once mentioned that it had 200 serious collectors for Kwang-Yong Chun (b 1944) in North America alone. Kukje has been also hosting exhibitions with very established international artists such as Bill Viola, Anish Kapoor, Joseph Beuys, Alexander Calder and Eva Hesse. There are no cultural similarities but these artists are important in the history of art and their works are appreciated by Koreans in a more universal context much as Americans or French people like their work. Pkm gallery sells works by Korean young artists such as Bae Joonsung (b 1967) and Ham Jin (b 1978) at the Frieze Art Fair.

Increasingly, Korean galleries are participating in international art fairs like Art Basel, Art Basel Miami, Art Cologne, Art Chicago, the Armory Show and the Arco art fair. Stimulated by the rising popularity of Asian contemporary art, many galleries are applying to established international art fairs. In response to the western buyers, especially Europeans who are making pilgrimages to China to find young and promising Asian artists, many Korean galleries are participating in Chinese art fairs like Art Beijing, the Beijing Chinese Art Exposition and the Shanghai Art Fair, aiming to sell local artists' works to overseas collectors. The Ministry of Culture supports part of the participation fee for the galleries attending foreign art fairs. It has spent $2 million for Korea's participation as a guest country at ARCO 2007.

The lack of collectors has been a major problem in Korea but it has been changing as a result of a new tax scheme. Personal transfers of art works are subject to few taxes in Korea, the only exceptions being taxes on donations or gifts to heirs since 2003. According to the National Tax Service, individuals who collect art work are not subject to tax because collecting art is regarded as purchase for private enjoyment, not investment. In contrast, in an attempt to curb property speculation, the South Korean government is proposing to put capital gains tax and higher property taxes on owners of substantial housing portfolios. As a result, surplus investment destined for the property market has been diverted into the art market since 2005.

Large numbers of potential collectors are turning to the art investors. Seoul Art Fund, Korea's first art fund, was founded by Good Morning Shinhan Securities and Pyo gallery in September 2006. The fund is investing $7.5 million in established Korean and Chinese artists such as Kim Hungsoo, Nam June Paik (1932–2006) and Zhang Xiaogang (b 1958). In January 2007, another private equity art fund, investing $10 million in Korean blue-chip artists such as Lee Ufan (b 1936), Kim Tschangyeul (b 1929) and Kim Kang Yong (b 1950) was created by five art galleries (Gallery Bhak, Park Ryusook gallery, Johyun gallery, Shilla gallery and Insa gallery) with Korea Art Invest Co. Both funds hold art works for three and a half years and they buy most works from artists directly. The galleries involved sell the works through exhibitions.

In the public sector, the Ministry of Culture has founded Art Bank'in 2005 with a plan to spend around $2.5 million buying works by living Korean artists, mostly young and established artists whose works are relatively less in demand. The aim is to support artists and stimulate the art market. In 2005 and 2006 it bought around 900 works and rented them to different governmental organizations. The average rental cost is varied but it is about 3–7 per cent of the price of the rented works. The budget for 2007 was increased to $2.7 million.

Art fairs in Korea

Art fairs have grown just as rapidly as auctions. The most important art fairs are KIAF (Korea International Art Fair), MANIF International Art Fair, Seoul Art Fair and SIPA (Seoul International Print, Photo & Edition Works Art Fair).

The largest one is KIAF, which takes place at Coex (Korea Convention and Exhibition Centre) in Seoul every year in May. In 2006, 150 galleries from 13 countries participated in the fair and 208 galleries including 92 foreign galleries were present in 2007. The Manif art fair, in which artists are direct participants, had a turnover of $650,000 in 2006, selling twice as many works as in 2005. Most significantly, these art fairs are representing affordable works alongside expensive blue-chip works, attracting small and medium-sized collectors.

Auctions

It was only in the late 1990s that auctions were firmly established in Korea, when Seoul Auction was launched in 1998 by one of the biggest galleries in Korea, Gana. After eight years of trial and error, Seoul Auction has developed into a major auction house in Korea, almost monopolizing the Korean auction market. However in October 2005 another big player, the Hyundai gallery, launched K-auction with Hana Bank, a publishing company Hakgoje and the former CEO of Seoul Auction, Kim Soonung. Since then, K-auction has grown dramatically. The launch of K-auction made a fundamental change not only in the auction market but also in the whole structure of the art market, creating an increasingly competitive environment between auction houses and galleries.

Over the five years from 2001 the Korean auction market grew rapidly. The average turnover was around $10 million in 2004 and doubled in 2005. In 2006, turnover at the two major auction houses (Seoul auction and K-auction) reached $63 million, two and a half times the amount they reported for 2005. There were 2,783 works presented and the average sale rate was up to 70–80 per cent. The auction record for the best-known Korean artist, Sookeun Park, was doubled in March 2007, when K-auction sold *On the road* (1962) for $2.5million. The previous record was $1.24 million for *Seated woman and a jar,* set at Christie's New York in 2004.

Although a critical issue of ownership by major galleries, the establishment of auctions and a transparent price system defined by buyers will eventually help to reform the Korean art market, it has been criticized for its lack of transparency. Seoul Auction charges a 10 per cent buyer's premium and commission on top of the hammer price, and K-auction charges 10 per cent for works sold for up to $100,000 and 8 per cent for works sold above $100,000, and 10 per cent of commissions.

Apart from Seoul and K-auction, Korea Fine Art Auction has hosted 33 auctions since its launch in 1996. Myungpoom auction, Dongseo auction and art market auction were newly launched in 2006, targeting collectors of middle and low-price range of Korean traditional art works and modern paintings.

The internet is turning numerous novices into art investors and vitalizing the Korean art market. There are 6,000 members of the art investment club run by the internet site daum (http://cafe.naver.com/artinvest). They update information on the art market every day, and most importantly these members, often called 'ant collectors', are creating demand in the art market. Both Seoul and K-auction hold online auctions. K-auction's second online sale, held in January 2007, totalled $550,000 and sold 86 works out of the 119 offered. Portal art

(www.porart.com) sells around 700 works (mainly North Korean and Chinese contemporary) monthly online with a much lower price range (between $100 and $3,000). As a result of the success of those online sales, it is estimated that the online art market will grow rapidly.

In Korea, by the law, foreign auction houses are unable to operate. Sotheby's was the first foreign auction to open a representative office in 1990 followed by Christie's in 1995. However, Sotheby's closed its office in 1996 but is expected to reopen the branch in the near future.

Korean art in the international auction market

The first auction of Korean art was held in 1986 at Christie's New York and since then there have been two auctions per year. The most expensive Korean work ever sold at auction was a rare iron-decorated dragon jar, which sold for $8,417,000 (Christie's New York, 1996). Sotheby's started to sell Korean art, alongside its Japanese and Chinese department, twice a year in London in 2002. In the area of contemporary art, Christie's was again a first challenger to sell works by Korean young artists. It started by selling eight Korean contemporary works in an Asian contemporary art sale in autumn 2004, and sales doubled in 2005. It created a huge international interest in Korean contemporary art within two years, and the total of Korean contemporary art works sold in May 2006 topped $1.5 million, almost 10 times higher than the inaugural sale. In that sale Kim Dong-Yoo's *Marilyn Monroe vs Chairman Mao* was sold for $335,920, over 25 times its estimate. Selling more than 95 per cent of the total lots in each sale, Christie's maintains its position as a market leader in this area. Sotheby's sold Korean contemporary art in March 2006 at a New York sale for the first time, intending to meet the growing demand for Asian contemporary art from collectors based in the United States. Twenty Koran works were among the 25 works presented in the sale, which totalled over $700,000, almost double the estimate.

The star artists in the international market like Kim Dong Yoo (b 1965) and So Young Choi (b 1980) merely had buyers in Korea before their works started to sell in foreign auctions. Prices for the work of So Young Choi, whose work became famous with use of pieces of blue jeans as a medium, have risen from $1,400 (*Anchang village*, 100×160 cm) in October 2004 at Christie's Hong Kong to $190,000 (*Kwang Ahn bridge*) in 2006.

Foreign auctions act as a primary market for these young Korean artists as many of these artists are directly represented in international auctions without having a stable primary price in Korea, but the highly satisfying sale result abroad suddenly awakes the domestic market. Galleries are looking for young artists and collectors are now buying cutting-edge Korean contemporary works. Seoul Auction sold 100 per cent of the Korean contemporary works presented in its Cutting-edge sale in June 2006.

Table 34.1 Christie's Hong Kong Korean contemporary auction results, 2004–06

Date	Number of works sold	Highest selling price	Sale total
October 2004	8 out of 8	$ 45,000	$ 140,000
May 2005	15 out of 15	$ 30,000	$ 170,000
November 2005	23 out of 25	$ 82,000	$ 590,000
May 2006	31 out of 32	$ 323,000	$ 1,560,000
November 2006	33 out of 33	$ 150,000	$ 969,000

Most of these artists have unique techniques and styles, free from international trends, mixing their Korean cultural background with innovative ideas coming from the optimistic environment that has benefited from globalization. The market based in Hong Kong still remains conservative, with more demands for works that contain Korean traditional elements and subject matter. However, works by young artists like Ham Jin (b 1978), who makes tiny sculptures with unconventional mediums like hairs, toothbrushes and rice grains, have an increasing number of collectors attracted by the originality of the work. Although some are concerned by the 'Bubble effect' for Asian contemporary art, prices for high-quality Korean contemporary works have remained much lower than for the Chinese contemporary stars. According to Christie's Korea, 95 per cent of buyers at the 2004 and 2005 Korean contemporary art sales were non-Korean.

For further information on the development of this particular art market, go to: www.koganpage.com/artmarkets.

Spain

Aina Truyols and Fernando Romero

Spanish art is increasingly sought after since it is a particularly attractive ground from both an investors' and collectors' point of view. Some periods, such as 19th-century Spanish painting and the works of accomplished Old Masters, have obviously attracted collectors for a long time.

International art experts agree that many high-quality art works from the 17th and 18th centuries have been rather overlooked until recently, and are thus still available for very attractive prices. Experts highlight the aesthetic quality and stark simplicity of these works – seemingly very much in tune with present-day international collectors. Likewise, collectors and investors alike have realized that they can get hold of major works by Spanish artists for a fraction what they would pay for the best-known names in the 19th century market. Speculators claim to sometimes treble the prices just by reselling works abroad, which reflects the disparity in prices between the local and international market.

The art market and legislation

In 1985 the Spanish Patrimony Law was introduced. This legislative reform has served well in protecting Spain's art from smuggling, yet its tightness still hampers full market expansion. It abolished the luxury tax and lowered VAT on works of art. The reform included the creation of the National Heritage Inventory, where all works of art over 100 years old (and approved by appointed official experts), of relevant living artists or those declared to be of cultural interest can be inscribed. This inscription exempts the works from wealth tax and up to 95 per cent of inheritance tax. However, certain conditions are attached: the works must be eligible to be shown in publicly organized exhibitions and of free access to researchers. Moreover, inscribing might complicate the obtaining of an export licence, and the state reserves the right to be the preferential purchaser if the work is proposed for sale. Indeed, the state has the right to pre-empt and to declare a work unexportable. This happened in 2003 with two important rediscovered works by Francisco de Goya (1746–1828), *Tobias and the Angel* and *Holy Family*, which were bought by the state for €1.75 million. The auction house selling them sued the government since it judged that the works would have been sold at a much higher price had they not been declared unexportable (*Art Newspaper*, June 2003, p 39). Exporting

Spanish works was very difficult 15 years ago. Nowadays any work of art over 100 years old and inscribed in the National Heritage Inventory needs an export licence to leave the territory. This partly explains why major collectors have preferred to buy outside Spain.

Indeed, where there is a possibility of sale abroad, the application for export means an irrevocable offer of sale to the state. Although export refusals are minimal compared with the annual volume of application (around 5 per cent according to the Patrimony Protection office), this allows the administration to acquire significant works of art.

Works bought abroad can be re-exported at any time within the first 10 years of entering the Spanish territory if declared and registered with a licence when imported. After this period, the owner needs to renew the licence, yet these works can neither be declared unexportable nor be pre-empted by the state.

Taxes

(Source for this information: *Art Newspaper* September 2006, p 17.) The definite export of a work of art to a non-EU state is subject to an export tax ranging from 5 per cent for works up to €6,000 to 30 per cent for works valued above €600,000. However, given that exports to EU countries are free, export tax can be avoided by exporting to another EU country first and thereafter to its final destination.

Original works of art and antiques over 100 years old are exempt of import taxes regardless of their value, but are subject to 7 per cent VAT. Objects less than 100 years old – including furniture – can be liable to the standard 16 per cent import VAT.

Sales by professional dealers, auctioneers and galleries are charged the standard 16 per cent VAT, whereas direct sales from the artist have a reduced VAT scheme of 7 per cent. In sales where VAT is not applicable (in a direct sale between private individuals for instance) the works may be subject to a transfer tax which currently stands at 4 per cent.

If a work is donated it may be liable for a donation tax which varies depending on various factors: the degree of kinship between donor and recipient, the value of the work of art and the geographical region (rules vary from region to region, and many regions are free of this tax). Also variable from region to region is inheritance tax, ranging from 0 per cent to 34 per cent, but lately this is being gradually abolished or highly reduced. As mentioned, works listed on the National Heritage Inventory are 95 per cent exempt from inheritance tax. Works of art can be donated to museums in lieu of personal income and inheritance tax as well as corporate taxes, which has been increasingly popular in recent years.

Droit de suite is collected by the independent body VEGAP, primarily from auction houses, for works over €1,800 at a variable rate starting at 3 per cent. In contrast with most other countries where *droit de suite* is collected, there is currently no maximum threshold on the amount applicable per work of art (source: VEGAP).

Investing in the Spanish art market

Between 1998 and 2001 the Spanish share of the global art market grew by 12.5 per cent to 0.91 per cent, an increase almost double that of the American market for the same period (Kusin, 2003: 22). In 2001 the total sales turnover for both dealers and auctioneers in Spain was an estimated €203.29 million. The optimism and extraordinary success of recent fairs and auctions in the Spanish market suggest that this growth rate might increase, as consecrated Spanish artists of all periods are gaining international recognition, 19th and 20th century art in particular.

Pablo Picasso (1881–1973) has been the top seller at auction for the past 10 years, and his market turnover rose by 112 per cent in 2006 (Art Market Trends 2006). Other modern top sellers include Joan Miró (1893–1983), who as seen below has remained in demand throughout the years, Salvador Dalí (1904–1989), Joaquín Sorolla (1863–1923), Antoni Tapies (b 1923), Manolo Millares (1926–1972), Antonio Clavé (b 1913), Óscar Domínguez (1906–1957), Eduardo Chillida (1924–2002), José María Sicilia (b 1954) and Miquel Barceló (b 1957).

However the Spanish art market remains quite local and regional, inasmuch as Spanish buyers still tend to buy Spanish art, and moreover, Catalans will favour Catalan art, Basques will buy Basque art and so forth. Yet this practice is increasingly changing, as Spanish art buyers are fully entering the international market scene.

Foreign appreciation of Spanish art is most obvious at the top end of the market, as the 60 per cent of buyers at specialized Spanish art auction sales are foreign collectors, many from the United States, who buy the finest and most expensive lots. Indeed, given the relatively weak tradition in collecting, Spanish art buyers have unfortunately not until recently appreciated their role of ensuring masterpieces remain on Spanish soil.

On the other hand, Spanish contemporary artists have been achieving very competitive prices in the national market, but it is still unknown whether these prices are sustainable in the international market. Indeed, very few contemporary Spanish artists enjoy international recognition, as reflected by the insignificant representation that they receive in reputed international galleries and by the absence of any Spanish artist in the Kunstkompass 2006 listing – which ranks living artists based on the frequency and prestige of their exhibitions. An exception is Barceló , who surpassed his auction record in April 2006, when a work sold at Christie's for over €1.1 million.

There still exists a difference in prices for important Spanish works of art, especially regarding Old Masters. As mentioned above, the relatively restrictive export legislation means that top-end works denied an export licence underperform significantly when sold at Spanish auctions. This has also greatly limited the participation of foreign buyers in the Spanish art market, and thus the prices achieved.

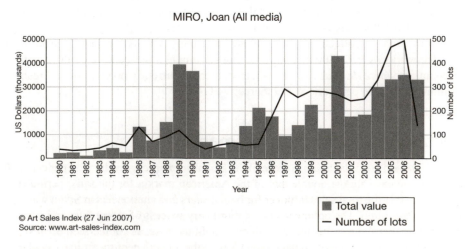

© Art Sales Index (27 Jun 2007)
Source: www.art-sales-index.com

Figure 35.1 Sales at auction of works by Joan Miró, 1980–2007

The Spanish art market: booming since the 1990s

Spain's art market has had a relatively late development; it was only after the country's move towards democracy following Franco's death in 1975 that galleries and fairs started to emerge. Until the mid-1980s the art market remained highly provincial and traditional, with a strong preference for Old Masters and 19th-century Spanish art. Moreover, strict legislative regulations (works of art were subject to luxury tax of over 25 per cent for instance) paralysed the development of collections while encouraging an illicit art market. The 1980s saw the growth of the market, with the opening of numerous regional art centres all over the country and the inauguration of the contemporary art fair ARCO in 1981.

Between 1987 and 1990 the Spanish economy boomed, with an annual growth averaging 5 per cent. These were glorious years for the local art market: auctions achieved excellent results in all categories and numerous artists reached record prices. As seen in Figure 35.2, sales for works by Picasso rocketed in those three years as his estimates multiplied by seven. However, as will be explored later, collecting remained a matter for national institutions and corporations rather than private individuals. Currently the Spanish art market continues to grow at a firm pace, and it was estimated that between 2002 and 2003 the local contemporary art market turned over €1.5 billion.

Galleries

Galleries hold considerable power given that Spanish buyers still favour them – together with buying directly from the artist – over auction houses. These are generally grouped under the national Union of Art Galleries Association, based in Madrid.

There exist various regional associations of contemporary art galleries – the regions of Madrid, Catalonia, Valencia and Galicia have the most powerful regional galleries associations. Spain has over 920 contemporary and modern art galleries. The regions with most galleries are Madrid and Catalonia, accounting for half of the total, with about 200 galleries and 190 respectively; there are 173 in the community of Valencia, 57 in the Balearic Islands and 40 in Galicia.

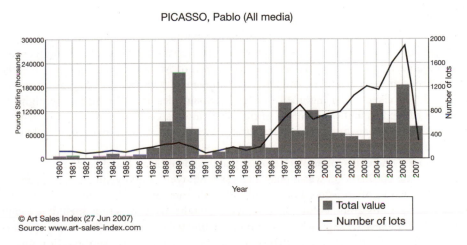

PICASSO, Pablo (All media)

© Art Sales Index (27 Jun 2007)
Source: www.art-sales-index.com

Total value
Number of lots

Figure 35.2 Sales at auction of works by Pablo Picasso, 1980–2007

In June 2007, the Federation of Modern and Contemporary Galleries Associations (Fagam) was founded with 95 member galleries. This represents 10 per cent of the national estimate of galleries, but 75 per cent of the galleries present at the 2007 ARCO fair.

The lack of internationalization of the art gallery sector is striking. Indeed with a few exceptions such as contemporary galleries like Aizpuru (Madrid), de Alvear (Madrid), Benítez (Madrid), González (Madrid), Lorenzo (Madrid), Polígrafa (Barcelona) – all of which attend Art Basel – as well as Javier López (Madrid) which recently opened a gallery in New York City, very few galleries attend major international art fairs. In 2001, a survey enquired about the number of international fairs attended by galleries in the previous year. Out of the meagre 57 respondents only a quarter had attended more than one. One gallery had attended more than five, ten went to more than three and 12 went to two (IFEMA, 2006). It also has to be noted that some international names such as Marlborough Fine Art and Maeght have galleries in Spain.

There are about 250 key antique dealers in the Spanish territory, and about 10 antiques dealers associations, led by the Spanish Federation of Antique Dealers, founded in 1981 and based in Madrid. Again, few attend international fairs with some exceptions such as Caylus and Luis Elvira. Anticuario and López de Aragón, both from Madrid, attend the Maastricht Art Fair.

The major contemporary art galleries are located in Madrid and Barcelona, as well as in Valencia, Bilbao, Seville and Palma de Mallorca. Indeed, Spain cannot be accused of being a centralized country in terms of art, since increasingly foundations and galleries are surfacing across the country. In the capital, we could highlight Juana de Aizpuru, Soledad Lorenzo, Elba Benítez, Helga de Alvear, Pepe Cobo, Javier López, Distrito Cu4tro and Vacío 9. These galleries are located in three major areas of the city: around the Justicia neighbourhood, to the south of the Alonso Martínez square; at the south of the city, in calle Doctor Fourquet around the Reina Sofía Museum; and to the north of the Retiro park, around the Calle Coello.

In Barcelona the scene is still generally more experimental, with top galleries including Toni Tàpies, Espai Ubú, Galeria Senda, Mito, Galeria Estrany-de la Mota, Galeria Antonio de Barnola, Carles Taché, Ignacio de Lassaletta, N2, Joan Gaspar, Joan Prats, Toni Tànd and Polígrafa but also Manuel Barbié who specializes in the avant-garde. In Valencia, the scene is headed by Luis Adelantado.

Art fairs

Antiques

After a few uncertain years, the Spanish market for antiques and works of art is reviving. The two major fairs covering the antiques sector are first, Feriarte the first art and antiques fair in Spain, organized by the Antique Dealers Association of Madrid. It takes place annually in Madrid between late November and early December. Its 30th fair (2006) was attended by around 33,000 visitors and included 177 galleries and dealers, of which only eight were foreign. It offered 18,000 works of art of the most varied styles and periods, of which 5,393 were sold (*El Economista,* 22 December 2006). Most of them were paintings, followed by books and decorative arts.

Antiquaris Barcelona takes place annually at the end of March and beginning of April in Barcelona. The 2007 edition was a huge success with over 23,000 visitors, more than 8,000 antiques and works of art offered and over 100 exhibitors, of which about 20 per cent were foreign dealers. Early 20th-century painting was again the main attraction, including a canvas by Joan Miró, *Femme Oiseau,* which sold for an estimated €2 million. The steady success of both these fairs reflects a growing interest in Old Master and modern painting, furniture – art

deco and modernist (art nouveau) styles in particular– and the decorative arts. Numerous other fairs take place around the country.

Contemporary art

Contemporary art is booming in Spain. Undoubtedly, ARCO is the major contemporary art fair of the country, taking place every February in Madrid. During its early years it involuntarily played a cultural role which hindered its commercial potential. This has now changed as ARCO reinforces its role as a mayor player in the increasingly competitive contemporary art market.

In 2007, the entrance fee was considerably raised, what has probably kept the number of visitors unchanged from previous years to 195,000. Also, the first two days and a half are now reserved for professionals and collectors only. In 2008, participation included 295 galleries, of which 222 were foreign and further internationalization is on the agenda. Every year the fair invites a guest country: Korea in 2007 and Brazil in 2008, thus strengthening Arco's profile in the emerging Asian and Latin American markets.

The 2007 edition saw an increase in total sales of 15 per cent over 2006, although no specific sales figures were revealed. The sales of the 2008 edition remained unchanged from the previous year, what was seen as a success given the recession in the economy.

Many exhibitors make healthy profits during the fair, sometimes accounting for 50 per cent of their annual profits. An important segment of buyers at ARCO are institutional and governmental investors – such as the Reina Sofía Museum (Madrid) which spent about €2 million in 2007 and over €1million in 2008. This plays a major role in the development of the local market.

Another important fair is the nascent yet promising Art Madrid. It takes place at the same time as ARCO, yet its organizers aim to focus on encouraging growth of national private collecting. The first fair in 2006 was attended by 15,000 visitors with sales of almost €7 million. In 2008 sales turnover more than tripled, reaching €25 million, the number of visitors was around 25,000, and it included almost 80 exhibitors, of which a quarter were foreign, with an important presence by Latin American galleries.

Smaller fairs take place throughout the country. In the last decade numerous contemporary art fairs have surfaced yet sometimes have not managed to get established in the market. Two recent initiatives that we could highlight are LOOP, a highly international video art fair taking place in early June in Barcelona and which in 2007 celebrated its fifth occasion, and SWAB – in Barcelona as well – which started in May 2007 with the participation of 42 galleries (of which only seven were Spanish), with the focus on emerging artists.

Auction houses

Traditionally Spanish buyers have been reluctant to buy at auction, to which they attributed higher prices. However, following an increase in interest in art and collectibles the auctioneering sector has been growing steadily in the last two decades. The biggest auctions take place mainly in Madrid and Barcelona, and auction houses have been created in Seville, Bilbao and Valencia.

Durán Subastas opened in Madrid in 1969 and is the oldest auction house in the country. Others in Madrid include Castellana Subastas, Fernando Durán, Alcalá Subastas, Subastas Segre and Ansorena. In Barcelona, Subastas Brok and Balcli's have to be mentioned as well as Arte, Información y Gestión in Seville and Subastas Gran Vía in Bilbao.

Christie's has had representative offices in Spain for over 30 years, yet ceased sales there between 1974 and 2004. In October 2004 it carried out its first annual Spanish art sale in Madrid, where 84 per cent of the lots were sold for a total €5.2 million. In 2005, Christie's

Spanish art sale recorded exceptional prices: two works by El Greco and his workshop, *San Lucas* sold for €1.3 million and *Santiago el Mayor* for €997,600 (both with estimates of €100–150,000). In 2006 the total sale amounted to €15 million, a record for the Spanish auction market, whereas in 2007, this figure was €14 million.

Sotheby's London has an annual sale in November of Spanish painting, concentrating on artists from the second half of the 19th century to the 1930s, including Joaquín Sorolla, Ramon Casas (1866–1932), Mariano Fortuny (1838–1874) and Santiago Rusiñol (1861–1931). From 2000 to 2006, Sotheby's sold over £27 million worth of art in this category. These impressive results clearly reflect the keen and increasing interest – and potential for capital appreciation – that Spanish art is receiving from both national and international collectors.

The online auction market has developed in the recent years. www.setdart.com is based in Barcelona and was founded in 2005 when it sold over 6,000 lots. It sells paintings, sculpture, drawings, furniture jewellery and other collectibles. www.arcesubastas.com, www.ansorena.com and www.subastascastellana.com also offer online auction services.

Challenges faced by the Spanish art market

Although the Spanish contemporary art market is experiencing a very prosperous and optimistic moment, it remains unexploited. This is partly because the number of private collectors remains relatively small. The concept of affluent young professional collectors has not really not taken off as it has elsewhere. Also, although institutional investments have played a major role in the dynamics of the market, the collections that these institutions create are all quite similar. They seem to focus on the same and often recognized artists. This limits both the spectrum of the contemporary art scene and the opportunities for emerging artists, only confirming the necessity for new private collectors to enter the art scene.

Although the export of works of art from Spain has been greatly eased in recent years, the country remains an importer rather than exporter in terms of art. During the first eight months of 2006 Spanish art imports amounted to €349.41 million while exports amounted to only €33.74 million (that is, 10 times less). As discussed above, the legislation is still too

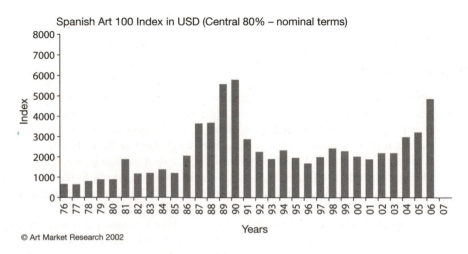

© Art Market Research 2002

Figure 35.3 Spanish Art 100 Index, 1976–2007 (US$)

protective, and further liberalization of exports of works of art is necessary to ensure the full growth of the Spanish art market.

A significant number of works of art are estimated to be undeclared and owners are generally disinclined to register their works. This has prevented the blossoming of a healthy art market, although habits and attitudes have improved substantially in recent years.

Finally, although the Spanish economy remains strong, significant downside risks could affect the development of the art market, including Spain's increasing loss of competitiveness, almost 40 per cent of GDP debt, the potential for a housing market collapse, the country's changing demographic profile and the decline in EU structural funds.

Museums, foundations, collectors, publishers and the art market

In 2002–03 the number of visitors to public museums was more than 15 million, and in 2006, the number of visitors to Spanish museums increased by 7 per cent.

In recent years Spain has hosted some of the top art exhibitions by number of visitors. In 2006 Picasso: tradition and avant-garde in its two venues at the Prado and the Reina Sofía in Madrid totalled 785,189 visitors, ranking as the world's most visited art exhibition. In 2005, two exhibitions at the Guggenheim Bilbao, The Aztec empire' and Art informel and Abstract Expressionism, ranked third and sixth total number of visitors (*Art Newspaper*).

Private and public-sector promotion of contemporary art

In the past decade, contemporary art has attracted the attention of Spain's autonomous and municipal governments, with many museums and institutions devoted to it having been created with public funds. There are 230 public exhibition centres and museums of contemporary art in Spain, the most important being in Valencia, Barcelona, Badajoz, Vitoria, Las Palmas de Gran Canaria, León and Palma de Mallorca. Acquisition policies – managed by respected professionals – from some of these new museums have an effect in the national art market and subsequently on the promotion of young talented artists. There are also forthcoming projects in San Sebastián, Santander and Vigo. Spain was also a starting point of the

Table 35.1 Top art museums in Spain by number of visitors, 2005 and 2006

Museum	2006	2005
Museo Nacional del Prado (Madrid)	2,165,581	1,966,496
Museo Nacional Centro de Arte Reina Sofía (Madrid)	1,418,032	1,590,099
Caixaforum (Barcelona)	1,265,380	1,081,886
Museu Picasso (Barcelona)	1,225,543	1,074,060
Museu Nacional d'Art de Catalunya (Barcelona)	1,068,814	769,914
Teatre-Museu Dalí (Figueres)	1,028,280	1,019,195
Museo Guggenheim (Bilbao)	1,008,744	965,082
Museo Thyssen-Bornemisza (Madrid)	736,713	643,784
Fundació Joan Miró (Barcelona)	579,926	529,013
Instituto Valenciano de Arte Moderno (Valencia)	429,661	275,761

Sources: *Eroski*, *El País* and others.

phenomenon of brand museums in the era of globalization, with the Basque government funding the Guggenheim Museum in Bilbao. Of all the Spanish national museums, the Museo Nacional C A Reina Sofía has the largest budget for acquisitions: €12 million in 2007.

While the vitality of the Spanish public sector as a promoter of contemporary art and its market is clear, corporate collecting has also contributed to the boom. The Fundación ARCO is one of the largest buyers of contemporary art and soon will be housing its collection in Madrid's old slaughterhouse, converted into a museum. Major companies such as Telefónica and Coca-Cola have set up foundations that are buyers of contemporary art, although the healthy Spanish savings bank sector is on top of the list. The La Caixa Foundation has the biggest private collection of contemporary art in Spain – from the 1980s onwards – with roughly 900 works by Spanish and international artists in all media. This does not come as a surprise as it has the largest budget of all the Spanish foundations for culture and art, €70 million in 2006. This powerful institution has many exhibition spaces all over the country with solid exhibition programmes covering traditional and contemporary art, and had a total of 1,825,000 visitors in 2005. The two most important are CaixaForum Barcelona – the third most visited museum/exhibition space in the country – and CaixaForum Madrid which opened in February 2008.

Caja Madrid also has a large budget for cultural and art purposes, and the list of other minor savings banks doing similarly in a more local basis is long, somehow compensating the shortage of funding from the public sector.

Pre-20th-century art

Every year there are notable acquisitions of important works by Spanish Old Masters and other relevant works of art and antiques by the Ministry of Culture for the Prado and other national museums, sometimes making use of its right of preemption at the auction market.

The promotion and active investment of the Spanish artistic heritage by the central, autonomous and municipal governments is still strong. This is reflected for instance by the state acquisition in 1993 of the Thyssen-Bornesmisza Collection for €254 million. Additionally, the Catholic Church of Spain has been displaying the wealth of its artistic patronage since the late 1980s in a series of major exhibitions with the title Las edades del hombre, showing works that had never been seen or exhibited out of their original context before. The decoration of a chapel at the Cathedral in Palma de Mallorca by Miquel Barceló – one of the top Spanish contemporary artists – was inaugurated in February 2007. Patrimonio Nacional is another institution managing the palaces, monasteries and collections owned by the Spanish monarchy in the past which are now property of the state, and has recently started the construction of the Museum of Royal Collections in Madrid, which will display its extraordinary and vast historical collection of works of art and tapestries.

Private collectors

The names of Abelló, Koplowitz, Arango, March, Várez-Fisa, Naseiro and Carmen Thyssen-Bornemisza – most of them over 60 – amongst others identify the wealthiest private collectors in Spain. Mainly related to the finance, industry, services, construction and banking sectors, they collect from Spanish and foreign Old Masters to 19th-century, early 20th-century and contemporary art. They all share an eclectic approach to art collecting, often without a speculative intention. While the figure of the art investment advisor is of growing importance for big collectors, it is also true that in most cases buying art for passion and the pleasure of collecting is still the main impulse.

Young collectors, either from affluent backgrounds – some with a tradition in collecting – or with recent fortunes, generally focus on contemporary art. They acquire works in galleries but also at fairs such as ARCO and other foreign ones. Generally speaking, young collectors are more open to speculation, they usually follow the market and are aware of prices, making use of the tools that the internet has to offer such as artprice.com.

The upper middle class also participates in the auction market, as was noted recently by one of Christie's representatives in Spain. They are mainly couples – from 40 to 50 years old – both working and receiving good salaries, with a sound knowledge and sensibility to art, who will have up to €3,000 to spend on a work to their taste.

Art publishing

The art book business in Spain has also experienced a transformation in recent years. Many institutions and museums publish art books and exhibition catalogues. Some publishing companies specialize in books on the fine and decorative arts, most of which have an international presence. The most relevant are Fundación de Apoyo a la Historia del Arte Hispánico, Lunwerg, Ediciones El Viso, Editorial Nerea, Grupo Antiquitas and Ediciones Polígrafa.

The most important and respected magazines and periodicals devoted to art are *Goya: Revista de arte* (art history), *Galería Antiqvaria* (art collecting and the market), *Lápiz: Revista Internacional del Arte* (contemporary art, Spanish/English edition), *Arte y Parte* (contemporary art), *Subastas Siglo XXI* (art market), *Exit EXPRESS* (contemporary art), *Art.es* (contemporary art) and *Minerva* (modern and contemporary art).

Major national and economical newspapers periodically have articles about the art market in its global dimension, and the most important art libraries are housed in national or major museums such as the Museo Nacional C A Reina Sofía, Museo Nacional del Prado and Museu Nacional d'Art de Catalunya, and the faculties of history of art around the country.

For further information on the development of this particular art market, go to: www.koganpage.com/artmarkets.

Bibliography

Cuadernos ICO (1996) *Mercado del Arte y Coleccionismo en España 1980–1995*,

Kusin, D (2002) *The European Art Market in 2002: A survey,* The European Art Foundation, Helvoirt, The Netherlands

Kusin *et al* (2005) *The Global Market for Modern and Contemporary Art*, The European Art Foundation, Helvoirt, The Netherlands

Other sources

Art Newspaper
Artprice, Art Market Trends 2006
El Confidencial
El Economista
El País
Eroski
IFEMA (2006) *El Mercado Español del Arte*, December, study by ARCO's Communication and Press Department
www.artfacts.net

Sweden

Kira Sjöberg

Introduction

This chapter gives a general view of the art scene and market in Sweden from an international perspective. I do not cover the busy antiquities market for lack of space.

Swedish art history, when considered from the western point of view, is a fairly young one despite the country's relatively long existence. Sweden was for a long time part of the Kalmar Union to which modern-day Denmark and Norway also belonged. It was ruled by Danish royalty which accounts for an overlap both in art historical and historical traditions between the two countries. Modern Sweden was founded in 1523 by Gustav Vasa and was ruled by the Vasa family for a long period after that. The current royal family, the Bernadottes, have a French affinity through a field marshal of Napoleon, and since the 1974 constitution have had only a ceremonial role (royalty.nu, royalcourt.se).

Patronage and collections, private and public

As Görel Cavalli-Björkman writes (nd), 1832 was the year when the Art Union or the Konstförening was formed in Stockholm, which led to the creation of other art societies that organized exhibitions and sales of contemporary art. The emergence of a group of wealthy Jewish collectors and patrons – including Pontus Fürstenberg, Carl Robert Lamm (1856–1938), Ernst Thiel and John Josephson (1866–1940) – helped support Swedish art in the late 19th century. In the 20th century, government funds were made available for the arts, including different types of scholarships. In 1937 the State Council of Art was established to pay for art for public institutions and places. The most notable project funded by this body was the underground railway in Stockholm with 37 stations, often called the 'longest museum in the world' (Wadell, nd).

The first important collectors of art in Sweden were members of the Vasa royal family. Gustav I formed an important collection, and so did Queen Christina, and her generals and aristocrats surrounding her. The tradition of collecting was continued in the 18th century by Carl Gustav Tessin, who bought particularly French contemporary art during a Grand Tour

and later as Swedish ambassador to Paris, including works by Nicolas and Jean-Baptiste Lancret, Boucher, including the *Triumph of Venus*, Chardin, Jean-Baptiste Oudry, and 17th-century Dutch artists. Tessin also assisted the Royal family including Princess Lovisa Ulrika, who built a very fine collection at Drottningholm that include works by Tiepolo and well-known Dutch artists.

Two significant collections were built up by Gustaf Adolf Sparre, whose collection in Vanås Castle in southern Sweden was intact until the 1980s. Paintings by Rembrandt and Chardin were part of it. The immigrant Dutch de Geer family also had a fine collection at Finspång Castle. Another notable collection was Galleriasamling, given as a gift from Napoleon to his step-daughter Josefina, later Queen of Sweden. Originating from Bologna, Italy, it included 16th and 17th-century works: 60 pieces are still in the Royal family's ownership.

An important figure in the early 20th century was J A Berg, who formed the picture collection of Stockholm University. His contemporaries included the Count and Countess von Hallwyl, whose collection consisted of several important works by Dutch masters. In the period between the World Wars, several private collectors concentrated on the art of the French impressionists, and many of these works have subsequently passed into the collection of the Nationalmuseum in Stockholm. Klas Fåhreu has a famous collection at Lidingö, which includes works by Cézanne and Renoir (Cavalli-Björkman, nd). Private collecting is not something openly discussed in Sweden but according to Per Öqvist (2007a, b), among the main contemporary collectors are Abba's Benny Andersson, music legend Per Gessle and the media family Bonnier.

Public museum collections at the Moderna Museet, Nationalmuseum and many other well-established museums are worth a visit, as they host an array of international art as well as much Swedish and Nordic art. The catalogue to the 2006 exhibition of Swedish art at Moderna Museet serves as a good starting point for familiarization with local artists' works (see http://www.modernamuseet.se/v4/templates/template3.asp?id=2780). Martin Gustavsson's discussion of state involvement in the art market in the mid-20th century (2003) is an interesting read.

Corporate collecting on a public level is relatively small-scale in Scandinavia. The Swedish and Finnish-owned Stora Enso collection is based mostly in Finland. Large Swedish-based companies such as Sony Ericsson and Skanska do not appear to have an art collecting history and do not have projects such as Nokia: for instance Nokia's Connect to Art programme enables mobile phone users to purchase limited editions of digital art by up-and-coming artists. Nordea Bank collects locally in Sweden (source: Merita Art Foundation).

The international marketplace for Swedish art

The toughest competition by buyers in Sweden is for 19th-century and early 20th-century pieces, as that is what the auction houses in Sweden as well as other Nordic countries mostly concentrate on. In recent years there have been an increase in sales of cutting-edge contemporary art, hence the competition on this level will become increasingly tough for international houses, particularly if the world's attention turns to this more local market.

The two major international auction houses dealing with Swedish art are Christie's and Sotheby's. The former started specialist sales in London in the late 1980s but stopped them in the 1990s due to the market crash. The sales started again in the late 1990s, but at Sotheby's. On 28 June 1999 Sotheby's sold 44 works of Scandinavian origin as part of a sale of 19th-century European art, which made £3.15 million (approx US$6.2 million) (sotheby's, 1999;

shareholder.com, 1999). This sale was naturally limited to artists of high value from the 19th century, and this emphasis continued until the 2006 sale. The auctions mostly take place in June, and Scandinavian items are also included in other sales such as design, impressionist and modern art sales.

For the past decade or so Christie's too has included Swedish pieces in its sales of 19th-century European art. It has tended to concentrate on the Nordic impressionists and early 20th-century modernists such as Carl Larsson (1853–1919) and Anders Zorn (1860–1920), whose works have made some world auction records.

Bonhams, the third major international auction house, does not specifically concentrate on Nordic artists. It did however sell a Zorn in a 19th-century sale in autumn 2006 for £250,000 (US$495,000), more than £100,000 over its pre-sale estimate. The work was discovered in the United States. Bonhams, like Christie's and Sotheby's, has a representative office in Sweden.

Sotheby's 2006 sale of Scandinavian 19th-century art realized £3,380,200 (shareholder.com, 2006). Estimates were exceeded by for instance Carl Larsson's *Decorating the tree*, pen and ink on paper, estimated at £120–180,000 and realizing £254,400 (including the buyer's premium).

In October 2006 Christie's inaugural Nordic Art & Design sale, a new concept on the international auction market outside the Nordic countries, offered art and design from the 19th and 20th centuries including postwar and contemporary art. Despite the interest and activity in the postwar and contemporary art scene in Sweden especially, works had rarely reached the auction market in the past in these countries. The Nordic sale established many new world auction records, perhaps partly for this reason.

Christie's sale included a piece by Öyvind Fahlstöm (1928–1976), *World trade monopoly* (B, Large) from 1970, which remained unsold. Perhaps one reason is that like concrete art, another area which has not been very successful on the national or international art market, it

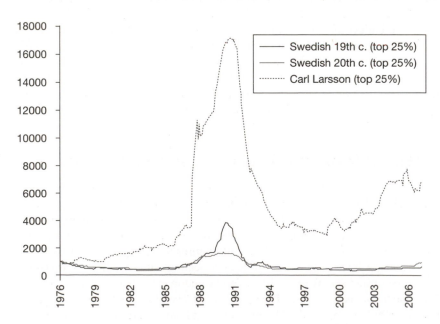

Figure 36.1 The top 25 per cent of Swedish fine art sales, 1976–2006 (in real terms, US$)

was intellectually demanding and not traditionally pleasing to the eye nor a brand to buy. Because these works fetch relatively low prices historically with a few exceptions in recent years in Stockholm, this could be an area of much investment potential in the future should the winds of taste on the market change to somewhat more intellectual pieces.

Bengt Lindström's (1925–2008) three pieces all sold above the top estimate, but work by Torsten Andersson (b 1926), who sells extremely well in galleries, remained unsold in the Nordic sale. The pre-sale estimate was £18–22,000, at the top end for Andersson (in Sweden his top hammer price was SEK370,000 (c £23,000) and second-highest price only c £8,000 – artnet, nd).

Other Swedish contemporary artists who are internationally known include Karin Mamma Andersson (b 1952) and Lena Cronqvist (b 1938) (neither appeared in the Christie's 06 sale). Andersson's auction prices listed on artnet range from €4–30,000. Lena Cronqvist has sold 146 pieces at auction (again, according to artnet); a sizeable number compared with Torsten Andersson's with 25 hits.

2007 sales continued the established routine, with Sotheby's Scandinavian sale offering for example modernists Nils von Dardel (1888–1943; estimate £50–80,000) and Sigrid Hjerten (1885–1948; estimate £8–12,000) and some contemporary pieces. However it mostly concentrated on the 19th and early 20th century, with the star lot – an August Strindberg (1849–1912) – estimated at £1–1.5 million. The sale concept has changed a little perhaps due to the Nordic art and design sale Christie's put together. Christie's had an even concentration on the different areas of art and design from 19th-century pieces to contemporary Nordic photography and visual arts. There were some interesting pieces, and it offered some artists whose pieces are not as extensively available on the local auction market. They do however reach an international marketplace through wide networks the galleries have globally and through representation in international art fairs.

Auctions

The best way to start familiarizing yourself with the market and what is available to a collector is by contacting Iaspis (International Artists' Studio Program in Sweden, www.iaspis.com) and the galleries mentioned in the 'Galleries' section. The three top auction houses with an international reach in Sweden are Stockholms Auktionsverk, Bukowski Auktioner and Uppsala Auktionskammare (http://www.auktionsverket.se/, http://www.bukowskis.se/, http://www.uppsalaauktion.se/). These sell top-range Swedish art as well as design and other household goods and are the leaders of specifically the local art market but remain the holders of many world auction records in Swedish art. Two others for the middle-range market selling everything for the house are Lilla Bukowski's and Auktions Kompaniet, both daughter companies of Bukowski Auktioner which is owned by the Lundin family who bought it in March 2007 (www.bukowskis.se). There are about 360 registered auction houses in Sweden today, of varying degrees selling a multitude of items, and a website focused on finding an auction in ones vicinity called auktion.se demonstrates how established this form of exchanging goods, whether highly valuable art or cutlery of little market value, is in the country's cultural life (www.auktion.se).

The Swedish 19th- and 20th-century painting index was discussed in the article 'Swedish painting' in the *Art Newspaper* in 1996. According to it the art market peaked in 1989 at US$15,814, which was about 1,500 per cent above the prices realised in 1975. The article discusses also how the four-year decrease after the crash that brought it down by 83 per cent to $2,637 affected the market as it did elsewhere in the world. The early 1990s depression

drove the art market to a practical standstill and since then, prices have been increasing slowly. With a mainstream of paintings offered for sale, one example of such could be an average sized mid-range painting by the relatively popular artist Bruno Liljefors (1860–1939) which at the top of the market made around $80,000, falling to $19,800 in 1994, and in 1996 estimated to reach around $21,000. In spring 2007 the going price or estimate in London for an average size and commercial subject matter for Liljefors appeared to range from £20–45,000 (http://www.sothebys.com, www.christies.com).

Galleries

The primary market in Sweden is very active, and the various offers include galleries focused on specific artists, print making, cutting-edge contemporary, net-based galleries, government-funded exhibition spaces and first-stage selling fairs for up-and-coming artists. The gallery scene in Sweden saw much upheaval in the 1990s, with galleries opening and closing, reinventing and restructuring themselves constantly (konsten, 2007). There are hundreds of galleries, with the largest concentration in Stockholm, Gothenburg, Malmö and Lund, as well as many others in cities around Sweden.

Perhaps the most internationally known Swedish gallery, concentrating on 19th-century as well as Old Master and 20th-century (Swedish and Nordic) art, is Åmells. Its reach on an international level includes the J Paul Getty Museum, the Kimbell Art Museum in Fort Worth, Texas, the National Museum in Stockholm and the Louvre in Paris (www.amells.com). Åmells exhibits at all the major art fairs in Europe and the United States, and has offices in London and Stockholm.

Mollbrinks Konst in Uppsala is an accessible gallery with a busy national exhibiting schedule, and shows internationally as well. For example in 2003 it showed Scandinavian masters at the Nordic Heritage Museum in Seattle, Washington (ww.mollbrinks.se). The best tool however, to find a gallery representing an artist of interest is to use artistfinder.com, which gives contact details for galleries representing particular artists.

Other internationally oriented contemporary art galleries in Sweden are Galleri Magnus Karlsson, Gallery Nordenhake (in Stockholm and Berlin), and the Wetterling Gallery in Stockholm. These galleries show at the Armory, Frieze, Art Basel and other international art fairs, and have an active exhibition schedule with national and international artists. They have very accessible websites in English and have very knowledgeable and helpful staff. In February 2006 Market, a new fair in Sweden, took place for the first time (see www.market-art.se), The next fair is planned for mid-February 2009.

Other galleries easily accessible to those outside Scandinavia are Galleri Lars Bohman, which represents contemporary Nordic artists such as Lena Cronqvist of Sweden and Bjarne Melgaard of Norway. Gallery Olsson represents young Swedish artists such as Johan Scott (b 1952), but has a website mostly in Swedish. Galleri Christer Fahl of Stockholm has an interesting exhibiting diary mixing international with Swedish artists, as do Gallery Andrehn Schiptjenko of Stockholm and Galerie Leger of Malmö. Others are Galleri Freden, Galleri Bel'Art, Södra Galleriet, Galleri Andersson Sandström, Brändström & Stene and Galleri 21 in Malmö. Among artists represented by these galleries are Karin Mamma Andersson, Torsten Andersson, Mats Leiderstam (b 1956), Sofie Tott, Agnes Cleve (1876–1951) and Johan Scott. Prices start from a few thousand Swedish crowns (SEK) and can reach several hundred thousand. For example Scott has a waiting list for his works according to Galleri Olsson. Christie's estimated his works in 2007 at £12–18,000 (US$20–35,000); in Stockholm's Auktionsverket their estimates have been SEK15–60,000 (c US$2–8,000).

Art awards

There are two Nordic-wide art awards, the Carnegie Art Award and Ars Fennica. The Carnegie, founded in 1998, is awarded biennially to support up-and-coming artists. It is one of the largest art prizes in the world, giving awards of SEK1,000,000, 600,000 and 400,000 (US$145,000, 87,000 and 58,000 as of April 2007) to three participating artists, and a scholarship of SEK100,000 (US$14,500) to a young artist.

The Finland-based foundation Ars Fennica gives its award yearly to one artist from the Nordic or Baltic region. The selection committee varies yearly and the final selection is made by an international expert. The prize is currently €34,000 (approx US$45,000) and the winning artist is given an exhibition with a printed catalogue. See page 123 for further details of both awards.

Taxation

Taxation of art in Sweden is in the form of VAT on sales, which artists have a duty to pay at approximately 25 per cent. There are limits before artists are liable for tax but there are problems in this field. As Compendium states:

> Tax deductions outlined by local tax authorities may sometimes be of great importance for the individual artist. Self-employed artists face a number of problems within the current tax system: for example, basic pensions are calculated on the income generated over their lifetime and as most scholarships or grants are not taxable, they are not included in the overall total of lifetime income.

(culturalpolicies.net)

Conclusion

As in other countries, artists' value increases when they win awards or have exhibitions in major venues. Shows in museums such as Moderna Museet, Liljevalchs Konsthall, Bonniers Konsthall and Magasin 3 Konsthall will drive the market upwards. Another important factor is representation and promotion by international galleries around the world as the increased contemporary sales on the secondary market. A good example is Karin Mamma Andersson, who won the Carnegie Art Award in 2006 and was exhibited in Moderna Museet over summer 2007. The price development of her work is evident. Other examples are Gunvor Nelson's retrospective in MoMA, New York in October 2006, Lena Cronqvist at Nancy Margolis Gallery in New York from October to December 2006 and one of Sweden's foremost sculptors, Pål Svensson (b 1950), at Jim Kempner Fine Art, October to November 2006.

Sweden's market is one that buzzes. The art life in the cities and larger towns is active, and artists produce interesting works with varied media and subjects. Arguably it is a good sign of the growth potential of this field when venture capital firms start to invest in art investment companies. An example is the investment by Verdane Capital in Konstbolaget.se in April 2007 (konstbolaget.se). The artists mentioned in this chapter are among the best known internationally, but the best way to become familiar with the different movements is through local galleries, auction houses and online artist searches. July and the few weeks before and afterwards each year are very quiet on the market due to the holiday season.

According to Mark Poltimore, chairman of Sotheby's UK and Scandinavia and one of the key people in bringing Scandinavian art on to the world art market by establishing the concept of Scandinavian sales internationally in the late 1980s, Nordic contemporary art is an area which will grow and become more available and increasingly evident on the international market in the next few years. Swedish art is certainly finding its space abroad through the international networks already in place (author interview, 2007). He believes the contemporary art of Sweden is relatively undervalued. As international collectors whom constantly look for new investments in art find these themed sales or representations on the UK and US auction and gallery level, prices are likely to rise. Swedish art is very accessible and aesthetic, and according to both Christie's and Sotheby's representatives, for these reasons it is very commercial.

For further information on the development of this particular art market, go to: www.koganpage.com/artmarkets.

Bibliography

Art Newspaper (1996) *Swedish Art*, vol 7 (May), p 32

Cavalli-Björkman, G (nd) Swedish art, patronage and collecting, Grove Art Online [online] http://www.groveart.com/ (accessed 12 January 2007)

Christie's (2006) Catalogue for Nordic Art and Design sale, 31 October

Christie's (2007a) Catalogue for Nordic Art and Design sale, 26 June

Christie's (2007b) Press release, Nordic Art and Design, 26 June [online] www.christies.com (accessed 12 May 2007)

Engblem, S (1999) Art in Sweden – leaving the empty cube. *Contemporary Swedish Art*, Swedish Institute

Gustavsson, M (2003) Political conflicts on the Swedish art market 1920–1960, *Economic Sociology* 5(1) (October)

Jyrama, A (1999) *Contemporary Art Markets; Structure and Practice*, Helsinki Business School, Helsinki

Laitinen-Laiho, P (2001) Kotimaiset taidemarkkinat 1980– ja 1990–luvulla, PhD thesis, Turku University, Finland

Luukkana-Hirvikoski, T (2007) *Taide yrityksissa*, University of Jyväsklä, PhD work in progress

Öqvist, P (2007a) Konst – den ultimata konsumtionen, *Ekonomi Nyheterna*, 28 August, [online] http://ekonominyheterna.se/va/magasin/2007/34/konst-den-ultimata-konsum/index.xml

Öqvist, P (2007b) Girighet och skönhet på fåfängans marknad, *Ekonomi Nyheterna*, 28 August, [online] http://ekonominyheterna.se/va/magasin/2007/34/konst-den-ultimata-konsum/index.xml

Statens Museum for Kunst (1993) *Leger og Norden*, exhibition catalogue, Statens Museum for Kunst, Copenhagen, 22 April–20 June 1993

Wadell, M (nd) Swedish art, patronage and collecting, Grove Art Online [online] http://www.groveart.com/ (accessed 12 January 2007)

Wadell, M-B and Zeitler, R (nd) Swedish art; art history c 1770–1900, Grove Art Online [online] http://www.groveart.com/ (accessed 12 January 2007)

Interviews

Sophie Hawkins, head of Nordic Art and Design sale, Christie's, 15 January 2006

Alexandra McMorrow, Head of 19th Century European Art, Christie's, 6th December 2006

Lord Poltimore, Sotheby's chairman, UK & Scandinavia, 19 February 2007

Websites and web articles

http://en.wikipedia.org/wiki/History_of_Sweden
http://sv.wikipedia.org/wiki/Konkret_konst
www.amells.com
www.arsfennica.fi/ehdokkaat.html
www.artnet.com/PDB/FAADSearch/FAADResults2.aspx?Page=1www.auktion.se
www.auktionsverket.se/
www.auktionsverket.se/press/eklund.htm, Stockholms Auktionsverk, press release, 7 March 2006
www.bonhams.com/cgi-bin/public.sh/pubweb/publicSite.r?sContinent=usa&screen=sweden
www.bukowskis.se/
www.carnegieartaward.com/
www.culturalpolicies.net/web/sweden.php?aid=515
www.dn.se/DNet/jsp/polopoly.jsp?a=585230&d=2206
www.iaspis.com
www.konsten.net/
www.konstbolaget.se/images/press/Konstbolaget20070425.pdf
www.konsten.net/narbild/claes.html, 1 January 2007, 4pm
www.market-art.se
www.modernamuseet.se/v4/templates/template3.asp?id=2780,
www.mollbrinks.se/previous_exhibitions.html, 21 January 2006
www.royalty.nu/Europe/Scandinavia/Sweden.html
www.royalcourt.se/royalcourt/themonarchytheroyalcourt/theswedishmonarchy/themonarchyinsweden.
 4.396160511584257f2180005799.html
www.shareholder.com/bid/news/19990629–9299.cfm. Sotheby's press release, 29 June 1999
www.shareholder.com/bid/downloads/news/20060613–200408.pdf, Sotheby's Scandinavian Sale press
 release, 13 June 2006.
www.sothebys.com, press release, 26 May 1999
www.uppsalaauktion.se/

Switzerland

Dirk Boll

Introduction

As Switzerland is divided into several linguistic and cultural regions, there is no such thing as a uniform Swiss culture. The individual language regions have traditionally been strongly influenced by their neighbouring countries, while the 20th century saw an increasingly strong US-American impact. In addition, the fine arts have also been affected by each canton's religious beliefs. Even though there is an overall balance between protestantism and catholicism, protestantism – characterized by the Zurich reformer Ulrich Zwingli's deferential view – has been more influential with regard to cultural innovation. With regard to the applied arts on the other hand, the products of the many Swiss porcelain factories, from Nyon to Kilchberg in Zurich, as well as the cabinetmakers' workshops such as the Bernese Funk dynasty, rather followed the styles of their feudalistic European peers.

It was only during the Enlightenment of the 18th century and the discovery of Switzerland as a romantic travel destination that a clearly distinguishable style of Swiss fine art was created – before this period one would rather find local adoptions of German, French or Italian styles. In today's art market however, 18th-century works such as those by the painter Angelika Kauffmann (1741–1807) are less important; instead, works of art from the late 19th and the early 20th century are much more significant and demanded.

Ferdinand Hodler (1853–1918) (world record 2007 at CHF11 million), Cuno Amiet (1868–1961) (world record 2007 at CHF1.2 million), Giovanni Segantini (1858–1899) (world record 2007 at CHF11.8 million), Augusto Giacometti (1877–1947) (world record 2007 at CHF1.6 million), his cousin Giovanni Giacometti (1868–1933) (world record 2007 at CHF3.2 million) and Giovanni's sons Diego (1902–1985) and Alberto Giacometti (1901–1966) (world record 2007 at CHF22.2 million) as well as Jean Tinguely (1925–1991) (world record 2007 at CHF830,000) stand at the vanguard of modernity and its artistic realization. This list of names may be continued right to the very present with artists like Peter Fischli (b 1952), David Weiss (b 1946) and Sylvie Fleury (b 1961).

The Swiss art market's structure corresponds to the model of western industrial nations and is divided into a primary market catered for by the galleries, as well as a secondary market served by the art trade and the auction houses.

The Swiss gallery scene

The primary fine arts market is characterized by a particularly strong presence of galleries in cities of the German-speaking part of Switzerland. In the field of contemporary art, Zurich is without a doubt the leading location. Many galleries were able to establish themselves in Zurich not least due to the development of the Löwenbrau premises, a converted industrial complex from the 19th century, which became a centre for the arts and culture. The centre incorporates both museum-quality institutions and exhibition halls such as the Migros Museum and the Kunsthalle Zürich; in addition, leading international galleries such as Hauser & Wirth, Bob van Orsow, de Pury & Luxembourg, Galerie Peter Kilchmann, Nicola von Senger and Eva Presenhuber – all of them galleries procuring contemporary art – are also located there. This new centre for the arts stands in addition to the traditional Zurich gallery scene with exponents such as Thomas Ammann Fine Arts, Bruno Bischofberger, Annemarie Verna, Jamileh Weber – all of these galleries emphasizing art of the postwar period – as well as the Mai 36 Galerie, which concentrates on Contemporary Art.

In addition to urban development measures, changes regarding the general conditions within the European Union, such as the political discussion concerning the rise of the value-added tax to the highest tax rate for works of art, had a bearing on the Swiss, and particularly the Zurich, art scene. As a result of this discussion, numerous international galleries which were based in the European Union opened branches in the German-speaking part of Switzerland. These include the Cologne Galerie Gmurzynska in Zurich and St Moritz, the London company Haunch of Venison and the Berlin Gallery Arndt & Partner, both of whom now have branches in Zurich, as well as the Cologne Gallery Karsten Greve and Salis & Vertes from Salzburg, now both represented in St Moritz.

Similar to Zurich, Geneva also has its gallery district, albeit in much smaller dimensions. It appears that, contrary to the deferential character of German-speaking Switzerland and its more profound engagement with the fine arts, in the French-speaking part of the country – with its less strict religious background allowing for a more relaxed way of dealing with luxurious objects – an emphasis on collecting Old Master paintings, works of art, silver, porcelain and cabinetmakers' furniture has developed. Nevertheless, the increasing awareness for contemporary art has led to the creation of a centre in Geneva called the Quartier des Bains, which houses galleries and exhibition halls. Here, the galleries are arranged around the Batiment d'Art Contemporain (BAC), which is home to various institutions such as the Centre d'Art Contemporain Genève, the Musée d'Art Moderne et Contemporain (MAMCO), and the Centre de la Photographie.

The leading fair for modern and contemporary art

ART Basel, an institution which is regularly praised by the media as 'the world's best fair for the classic modernity and for contemporary art', is simultaneously active in the primary and secondary markets, and also forms part of the national and international 20th-century art markets. The bi-yearly concurrency of ART Basel with the Venice Biennale in particular appears to be the reason for a rise in attendance; this seems to be even more the case since the Biennale – parallel to the Kassel Documenta – attempts to reflect the current international state of the output of art. An unequalled high level of quality regarding supply and display, as well as the participation of all internationally renowned galleries, provide a periodic climax to the art market season.

Elements such as a claim for museum-quality items and positive turnover are however not the only factors persuading both visitors and exhibitors to take part. Basel provides an environment which promotes media and objects of a difficult or cost-intensive nature, such as sculptures, video and other installations. This is done through the exhibition corporation providing special areas which are less costly (ART Unlimited). Spaces within the sector for the promotion of young talents are also offered at reduced space rates, a feature referred to as ART Statements. The fair has also become increasingly attractive since 1996, when a group of rejected applicants decided to establish their own exhibition programme in the immediate vicinity, the Liste. Its activities are understood not as a form of protest, but rather as a rehearsal facility with the long-term objective of participating in the ART. All these elements contribute to the overall range of choices and also, despite the high standards of the fair, lead to some of the works of art being offered at prices in the four-digit range.

The massive success of the fair led to the creation of a spin-off in Florida called ART Basel Miami Beach, which first took place in December 2002. ART Basel Miami Beach very successfully stood its ground against the US-American competition, whose fairs not least include ART Chicago, which is committed to modern and contemporary art. With the realization of this project, the participants of ART Basel have clearly succeeded in gaining more substantial access to the markets in the United States and South America.

The secondary market in Switzerland

While the galleries operate in both the primary and the secondary market, the situation regarding auction houses is unambiguously clear – regular auctions do not offer works coming directly from the artist, but only works that come on the market for at least the second time. The Swiss scene is dominated by the Zurich establishments of the international auction houses Christie's and Sotheby's, which not only provide contact points for vendors and buyers and organize imports and exports of works of art, but also, with their twice-yearly auctions of Swiss art, are in a position to set the highlights of the art season. In other words, in contrast to some other European countries such as Germany, Austria and Scandinavian countries, where the international auction houses export works of art to London (where they are offered in, for example, the German and Austrian sale or the Nordic sale), in Switzerland, works of art are instead put into auctions in the country of origin itself.

In the field of fine arts, the most significant Swiss competitor is certainly the traditional Bernese Kornfeld enterprise, with one auction per year; in the field of applied arts and Old Master paintings, the Zurich auction house Koller, with a broader range of offers and an accordingly higher number of auctions per year, merits mention. Further institutions active in the auction business operating on a more national or regional level are Fischer in Luzern, Schuler in Zurich, and Dobiaschofsky and Stuker, both of which are located in Bern.

Art businesses in the secondary market are also located predominantly in the German-speaking part of Switzerland; this is evident regarding Old Master paintings (Koetser in Zurich), and the works of classic modernity (Henze & Ketterer in Wittrach by Berne), post-war works (Galerie Lelong in Zurich), photography (Galerie Zur Stockeregg in Zurich), as well as in the antiques trade (Cahn in Basel and St Moritz). The arts of the 20th century are also equally represented in Geneva with the internationally renowned Galerie Jan Krugier. The Fondation Beyeler in Riehen by Basel is an exception in that it is a foundation with its own collection and a private museum structure designed by Renzo Piano, which originated out of the Ernst Beyeler Art Trade.

Jewels and wristwatches

Even though not part of fine art as such, watches and jewels constitute an important segment for enterprises active on the Swiss art market. The Swiss VAT rate is a mere 7.6 per cent and therefore corresponds to the lowest rate of the EC Member States. This, together with the country's high amount of external capital, are reasons for the most successful outcomes of watch and jewellery auctions in Geneva and Zurich – each year, about one quarter of global market turnover in these areas is earned in Switzerland alone.

Swiss impact on international art markets

Possibly the most important role of Switzerland regarding the international art market is providing interim storage facilities for works of art. Freeports in Basel, Zurich, Geneva and Chiasso specifically cater to the storage of foreign owners' works of art. Up to now, works of art stored in those locations are subject to neither VAT nor genuine custom duties. The freeports of the 21st century are service centres which can provide restoration facilities, and even galleries carrying out restorations or providing assistance with sales of the merchandise stored there. Sales within the freeports are equally not liable for VAT, at least not yet.

In addition, Swiss collectors and enterprises constitute an important clientele at international fairs and auctions. An estimated 10 per cent of international acquisitions at auction are made by this clientele, a number which not least reflects the traditionally outstanding state of the Swiss economy in the international environment.

This momentary picture is anything but fleeting, a fact which is reflected in the collectors' great tradition of wealth and education, and the exceptional collections of Swiss private collectors, as well as Swiss institutions such as trusts and private museums. Consequently, this clientele also constitutes an important group in the international art trade's buying market.

This situation and its tradition is mirrored by the huge number of important Swiss private collections with public access. To begin with those donated by their collectors, the Hahnloser Collection of Impressionist and Modern Art is on view at the Museum Villa Flora in Winterthur. In the same town Oskar Reinhart donated his collection of Old Master, 19th-century and impressionist works of art to the nation. Not only a Reinhart museum in town, but also his former private residence exhibit this important group. A Zürich highlight is the E G Bührle Foundation, also containing art works from the 15th to the early 20th century. Currently on view at a private villa, it will be moved into a new wing of the museum Kunsthaus Zürich, to be opened in 2014. Other Zürich collections are the Merzbacher collection of 20th-century art and the Ringier collection of postwar and contemporary art, both private, but accessible by appointment. Access is the key factor at Schaulager Basel, a private institution that has an exhibition programme, but opens its storage (housing a collection of 20th-century art) to everybody concerned, no matter whether this person is art historian, student or museum curator.

As well as paintings there are other important collections nationwide, such as the Bibliotheca Bodmeriana in Geneva, the Pauls-Wilz collection of 18th-century European porcelain in the museum Zum Rosengarten in Basel and the collection of classical photography given by the collector (and art dealer) Kaspar Fleischmann to Zürich University to form a study collection for the newly established Photography Institute, flanked by the Swiss Foundation of Photography and the Museum of Photography in Winterthur.

Legal framework

Legal frameworks traditionally have a significant impact on regional and national markets, as well as on international business relations. This relates in particular to fiscal aspects such as regulations regarding cultural property.

Protection of cultural property

From the Second World War until 2005, Switzerland had no regulations at all regarding the protection of cultural property. This had to do less with the number of sales into the country than with its role as a transit country and trans-shipment centre for the arts, which is also the reason that the legal system did not take cross-border trade into consideration. It was only in 2003 that the Swiss National Assembly adopted a law regarding the transfer of cultural property. In doing so, the UNESCO convention of 1970 – which is oriented along EC regulations – was adopted in Switzerland; it is referred to as the federal law relating to the international transfer of cultural property (Kulturgütertransfergesetz or KGTG), and was implemented on 1 June 2005.

The aim of this law is to prevent the theft, looting, as well as the illegal import or export of cultural property, which is supposed to contribute to the preservation of cultural assets. The term 'cultural property' has been defined in a UNESCO catalogue of criteria from 1970; briefly, every work of art dealt with on the art market is subject to the KGTG's, that is UNESCO's, criteria. Since the law's range and contents are however also supposed to be open to a process of transformation derived from professional discussions, the structure of the law allows for further amendments.

For the art market, this law is particularly relevant due to its impact on the export control of cultural assets, specific lists of which are included. Further important points include the regulation of restitution claims of cultural property that has been illegally exported from Switzerland, an extension of the period of time up to 30 years concerning the good faith acquisition of stolen cultural property, and, above all, the introduction of higher due diligence standards for art dealers and auctioneers. Regarding loan agreements in Switzerland, immunity from seizure legislation has been introduced.

The KGTG thus defines a central corpus of nationally important cultural property which prohibits any cultural assets listed therein from being acquired in good faith. The cantonal registers, which may be linked to the federal one, only incorporate private property upon approval by the owner. The state may pursue illegally exported cultural property if any of the items recorded in one of these lists are exported.

The higher due diligence standards in the art trade also obligate any professionals involved to ascertain the identity of their business partners, to inform them of the legal situation regarding the transfer laws of all nations concerned, and to keep an account of all their transactions on the art market. These accounts are to be kept for 30 years.

Taxes

When purchasing works of art, they are subject to the same VAT as any other goods. The VAT rate is 7.6 per cent, with a reduction to 2.4 per cent for books. Artists, as well as writers, producers and directors, do not need to pay VAT when selling their works. This tax exemption also applies to art photographers, but not to photographers active in advertising or the press.

Switzerland does not charge any customs duties on paintings, drawings and sculptures. Numbered copper engravings and lithographs that have been made using non-mechanical

methods are also tax exempt. In the case of unnumbered lithographs the customs duties are relatively modest, as the tax is calculated according to weight. If no customs duties are raised upon importing cultural property, then such items are subject to import tax, which corresponds to the VAT rate above. So an item is either subject to a custom duty or the import tax; only works imported by the artists themselves are tax exempt. With regard to acquisitions of Swiss collectors abroad this import tax can save a considerable amount of money, as a Swiss buyer who exports the piece does not pay any VAT in an EC country (currently up to 25 per cent), but only the import tax (of 7.6 per cent).

For procurement of works of art via galleries with rotating exhibitions, VAT is only levied on the gallery's commission. This also applies to sales via auction houses, except if the seller themselves is a dealer – the dealer may then transfer his own tax duty to the buyer at auction, who in turn pays VAT on the full sale price. On the secondary market, the intermediary may make use of differential taxation, which enables them – as long as the objects dealt with are older than 100 years – to pay tax only on the difference between the purchase price and the sale price.

When owning works of art, these count towards one's assets and are taxed according to each canton's different rates. Some cantons exclude households, including furniture, carpets, books, silver and paintings. The fiscal authorities' regulations are based on established criteria; for example, they determine whether a cultural object was bought for furnishing purposes or as an investment. Additionally, they take into consideration whether the object is included in the household insurance or whether it is covered by a special fine arts insurance. The higher the owner's net worth, the higher the tolerance for fixtures and works of art; the state considers that wealthy people are more likely than others to own precious objects. The property tax rates vary between 0.1 per cent and 1 per cent.

Generally speaking, when selling one's own works of art, no taxes are levied on the capital gain made by private individuals through the non-professional sale of cultural property. Assets which have been made by means of professional dealings with cultural property on the other hand are taxed on the cantonal level; income tax rates vary between 20 per cent and 42 per cent. Indications of professional sales activity may for example be determined by a certain number of sales during a particular time span, the period of time of ownership before a sale, as well as the professional level of the sales strategies involved.

Upon inheriting works of art, a cantonal capital transfer tax may be levied if the deceased's last domicile was located in a canton with capital transfer tax duty. Depending on the canton and the degree of kinship between the deceased and the beneficiary, the capital transfer tax varies between 0 per cent and 53 per cent.

Giving works of art away is not only tax-free, but may also be deducted from the taxable income as long as it does not exceed more than 20 per cent of said income. This regulation is not only valid for works of art, but applies equally to the transfer of legal positions such as copyrights.

The droit de suite

As a consequence of copyright, *droit de suite* refers to the right of an artist and their descendants to participate in the profits from resale of works of art. While the EC Member States have been obliged to introduce national *droit de suite* regulations after the harmonization of this law, Swiss law has up to now not introduced such regulations. All attempts by artists' unions and other lobbies to introduce a *droit de suite* within the framework of various legislative procedures in Switzerland have failed until now.

The introduction of the *droit de suite* has certainly been hindered by the goal of increasing the Swiss share in the international art market. The secondary market in art of the classical modernity affected by the *droit de suite* in Switzerland does not generate nearly as much return as it does in London; this also applies to the Swiss network of auction houses, dealers, and other service providers to the art market. Instead, the strength of Swiss art procurement lies rather in the field of contemporary art. The aforementioned establishment of several international galleries in Zurich may be considered a response to the EC harmonization of the *droit de suite*; the EC-wide introduction of the *droit de suite* in June 2006 has however, at least regarding the works of living artists, not yet provided the expected impulse. The balance between Switzerland and Great Britain – being the most important European art market place – or the United States – being the most important art market place worldwide – of import and export has not changed significantly yet.

Raubkunst, Fluchtkunst, Beutekunst – looted art

As a consequence of its neutrality, Switzerland was generally an important market during both world wars, which also included the fine arts. After several headlines regarding Nazi gold in Swiss numbered accounts and an increasing sensitization regarding looted works of art, Switzerland created an Independent Commission of Experts Switzerland – Second World War (ICE) in 1996, which also shed light on the role of Switzerland as a trans-shipment centre of looted art.

The examination report regarding the role of the country as a trans-shipment centre of works of art between 1933 and 1945 was published in 2001, which is also when the authors introduced the difference between Raubkunst (looted art) and Fluchtkunst (escape art); the term Fluchtgut, or escape goods, refers to objects which were transferred to Switzerland by their owners and then sold there. At least according to Swiss law, restitution claims for so-called Fluchtgut were not allowable. Restitution claims could therefore only be made with regard to looted art, which meant objects that had been looted – also referred to as spoils – by German troops based in European foreign countries, and thereupon brought to Switzerland and sold there. However, in order to protect the good faith status of the new buyers, any claims after 1948 are time-barred. After 1948 claims were no longer valid.

Even so, an international conference regarding the issue of looted art was held in Washington in 1998, where in a joint final declaration the member states were asked to locate, identify and publish details of looted works of art in order to arrive at a fair and just solution concerning the return of such works. Hence the Washington declaration forms an agreement which does not provide a binding basis from a legal point of view, but certainly does so from a moral standpoint. As a result, restitution claims may also be made in Switzerland, independent of the national legal situation. With this declaration, the due diligence which was demanded globally was also established as the basis for each art transfer, ultimately leading to its legal implementation via the law on the transfer of cultural property.

For further information on the development of this particular art market, go to:
www.koganpage.com/artmarkets.

Taiwan

Iain Robertson

Chinese contemporary art has been the hottest speculative commodity of the last decade. It has now been superseded by its Indian equivalent. There was a time in the mid-1990s when Taiwanese art was riding high in the market's affections, but Taiwanese contemporary art has now lost most of its value. That said, a close observation of Taiwan reveals that the island, its people, its market and its art are as resilient as ever. Having pruned its 1990s stars and developed extremely strong prices for Taiwanese and international Chinese moderns, local talent is being nurtured by cutting-edge dealers, innovative 'art spaces' and a mature public sector, underpinned by a young generation of Taiwanese collectors.

Taiwan's recent history and current art market performances

The Nationalist government on Taiwan was recognized as the legitimate government of China – the Republic of China on Taiwan – until 1971, when the United Nations General Assembly voted to expel Taipei and seat Peking. Taiwan became a constitutional democracy in 1991, shortly after the election of the eighth president of the Republic of China, Lee Teng-hui. A two-China situation has existed since that time and Taiwan is, officially, a de facto state recognized by no more than a handful of countries. In recent years, since it became a democracy in 1989, the territory (technically it is not a nation or country) has, under the current Democratic Progressive Party and President Chien Shui-bian, asserted its Taiwanese-ness over its Chinese-ness. I do not believe that this will change under the Kuomintang candidate and 12th president of the Republic, Mah Ying-jeou, who was elected to power in March 2008.

Taiwan's history and the current political reality have a huge influence on its culture and art market. First, Taiwan's culture is a potpourri of European, Japanese, southern Chinese, American, republican Chinese, quasi-imperial Chinese and aboriginal. Second, in addition to the 10 aboriginal tongues, the island is home to the Mandarin Chinese (*putong hua*), Taiwanese (Ho Lo – Fujian dialect) and Hakka dialects. The spoken Mandarin Chinese of Taiwan is, arguably the world's best, and the extraordinarily high levels of literacy are achieved in the full

characters, not the abbreviated form used on the mainland. Third, Taiwan relies on the protection of the United States, and the procurement of arms from the world's superpower – and the latter is expensive – to preserve its independence. Fourth, the island is home to the greatest collection of Chinese art in the world, housed in the recently refurbished National Palace Museum – the contents of which were sequestered from China by the retreating Nationalists.

By the 1990s, Taiwan's stock and art markets were booming and it was at this time – 1992 – that Sotheby's and Christie's made the decision to hold their first auctions in Taipei, and the international art world started to take an interest in Taiwan, christening it 'Island of Culture'. The Art Dealers Association of Taiwan, under the chairmanship of Lili Lee-Friedrich, set about attracting foreign galleries to its new art fair. At that time, Taipei was home to some 200 galleries and Taiwan boasted three local auction houses in addition to Sotheby's and Christie's.

Meanwhile, the Committee for Cultural Planning and Development (CCPD), now the National Culture & Arts Foundation and Council for Cultural Affairs, combined with city governments to open new museums all over the island; in the southern port city of Kaohsiung, a new museum under the Directorship of the affable Huang Tsai-lang and in Taichung the National Taiwan Museum of Fine Arts (NTMFA) were two of the most impressive projects. In 2001 a new museum of contemporary art was established in a renovated Japanese period school in Taipei, and a few years later a massive public/private initiative saw the evolution of an entire district of Taipei into an emporium for contemporary ceramics with a first-class museum of ceramics at its centre.

The Taiwan government is amongst the most generous in Asia, spending some $640 million a year on the island's arts and culture; funding some 93 art programmes and supporting 12 museums and 18 non-profit contemporary art spaces. The public sector's cultural edifices were joined by private initiatives; Dimensions, Eslite, Fuban and the Ju Ming open air culture museum as well as Tashin Bank's Arts Award, which provides outstanding individuals in the visual and performing arts with a $30,000 prize.

Mention should also be made of the financial power of Buddhist orders in Taiwan. The money behind the Yu Yu Yang sculpture foundation came from the sculptor's eldest daughter's religious foundation. The bizarre Museum of World Religions was also the product of a religious order – the Ling-jiou Mountain Wu Sheng Monastery. A worthy western art museum in the southern (temple) city of Tainan houses the impressive if eclectic collection of Chi Mei. But it was the Chang Foundation (now closed), built from the profits of the Hong Shi property corporation and curated by James Spencer, formerly of Christie's, that set the standard for quality of content and presentation. This subterranean space situated in the city's centre was a world-class repository for Chinese works of art. It was the Chang collection that led to the extensive improvements in the display and preservation of works of art in Taiwan's oldest museum, the National Museum of History. Bestriding the island's, indeed China's, culture like a colossus is the National Palace Museum, whose director enjoys ministerial status, home to the world's finest collection of Chinese art from pre-history to the Qing dynasty. Highlights of this collection are the Song dynasty paintings and ceramics, but the museum is superbly represented in every category of Chinese art.

Why did this first-rate cultural infrastructure and sophisticated commercial network fail Taiwan's 1980s and 1990s generation of artists? Hung Tung-Lu (b 1968) is one of the very few making waves on the international market. Out of the dozens of artists represented in Visions of pluralism – contemporary art in Taiwan 1989–1999, a seminal touring exhibition that even made it to Beijing, only Hung Tung-Lu seems to have taken off. Unfortunately there have been a lot of casualties from those riding high in the boom market of the 1990s. Huang Ming-chiang, whose intricately painted rice fields were a feature of most Sotheby's and Christie's

auctions in Taipei in the mid-1990s and whose paintings regularly made between US$50,000 and US$75,000, has disappeared. A work by J C Kuo (b 1949), who was sold in galleries throughout Taipei and exhibited in public institutions on the island a few years ago, was bought in at a recent sale at Sotheby's Hong Kong, despite a modest high estimate of HK$120,000 (US$15,500).Yang Mao-lin (b 1953), whose statements on Taiwanese identity appeared at major retrospectives in the Taipei Fine Art Museum and actually sold at Christie's premature auction of Asian art in London in 1998 for £5,060 (US$8,450) against a high estimate of £5,000 ($8,350), just £690 ($1,152) less than Zhang Xiao-gang's *Bloodline series no 54 & no 55*, has disappeared. Chen Chieh-jen (b 1960), who was represented by the powerful Lin & Keng gallery in the 1990s and created impossibly gory laser prints of mutilated bodies, is another forgotten artist from that period. Yang and Chen were a part of the 101 Modern Art Group and explored social and societal issues, and their emergence coincided with the establishment of the Taipei Fine Art Museum (1983) and SOCA (1986) – later ITPark, the most important 'experimental space' for new art in Taiwan over the last 20 years.

Then there were those Hanart/Taipei artists, who many would have backed for stardom today; Yu Peng's (b 1955) pseudo-Chinese brush paintings and Cheng Tsai-tung (b 1953) and Chiu Ya-tsai's (b 1949) well-worked oil paintings for example. Yu Peng has sunk without trace and Cheng's recent modest offerings at Sotheby's New York 2007 auction – *Resting the tune for the cool moon and lay down your world weary staff* – was bought in. The artist's *Landscape* sold for a mere HK$144,000 (US$18,720) at Sotheby's Hong Kong in April 2007. Chiu has fared slightly better, selling two Modigliani-style paintings titled *Portrait* for HK$192,000 (US$24,960) and HK$102,000 (US$13,260). The Yu Peng and Cheng Tsai-tung indices were controlled by Hanart, and there was every indication that by 1998 the market for both artists was set for further growth. This was certainly backed up by the tertiary market prices which were greatly in excess of those offered by dealers at the time (see Table 38.1).

The one artist who one would have thought capable of graduating to international stardom was Wu Tien-chang (b 1956). His work can best be described as stylized photo-studio portraits of people in fancy dress with their facial apertures covered by inanimate objects. *Wounded funeral I–IV* (1994) is perhaps the most memorable, a visual representation for the metaphor 'Hear not, smell not, see not, hear not'. Once again a very large – 180×225cm – work, *Companions for life* (2002) failed to sell at Sotheby's, New York in March 2007.

In an indication of the peculiar nature of this market, eight etchings by Hou Chun-ming (b 1963) sold for HK$480,000 (US$62,400) at the Sotheby's Hong Kong auction in April 2007. This was extraordinary, because Hou's work was one of only a smattering of flat image multiples in the auction – and multiples do not tend to attract Chinese buyers, who prefer the cachet of owning a unique masterpiece. The subject matter was also very challenging; the work representing, as it does, Hou's sexual obsessions disguised as ancient Chinese morality classics which are a commentary on duplicity amongst Taiwan's media. These particular images appeared in a touring exhibition – Art Taiwan: the contemporary art of Taiwan – in 1995 which was shown in the Taipei Fine Arts Museum and the Museum of Contemporary Art in Sydney. Hou was categorized as an evaluator by Victoria Lu in Hanart Taipei's seminal exhibition, New art, new tribes: Taiwan Art in the Nineties, in 1993 and a pair of his prints were set beside arguably the most emblematic Taiwanese work of art painted about Taiwan since Ch'en Ch'eng-po's 1931 depiction of *Sunset at Tamsui*. The work in question was Huang Jing-ho's oil painting *Fire*, a masterpiece of satire, humour and observation. In it, kitsch and seedy night life meet a veneer of traditionalism amidst a riot of disturbed foliage. But the work of the George Grosz of Taiwan is difficult to find today. It may be of course, that the artist's collectors just don't want to let his work go.

Table 38.1 Cheng Tsai-tung and Yu Peng price development 1990–98

Cheng Tsai-tung

Year	Size (cm)	HK$	US$	HK$ per sq cm
1995	31×59	15,000	1,948	8.2
1995	60×16	13,000	1,688	13.13
1998	19×24	7,500	974	16.45
1998	21×31	10,000	1,298	15.36

By auction

Year	Size (cm)	NT$	US$	Location	House
1992	130×96	352,000	13,750	Taipei	Christie's
1995	65×80	92,000	3,487	Taipei	Christie's
1996	79×109	184,000	6,660	Taipei	Sotheby's
1997	100×81	161,000	5,828	Taipei	Sotheby's

Yu Peng

Year	Size (cm)	HK$	US$	HK$ per sq cm
1991	133×64	3,000	389	0.35
1995	26×233	28,060	3,644	4.63
1998	100×27	15,000	1,948	5.56
1998	33×135	33,000	4,285	7.41

By auction

Year	Size(cm)	NT$	US$	Location	House
1997	110×79	115,000	4,163	Taipei	Christie's

Source: Hanart TZ

Only the sculptor Ju Ming (b 1938) has made the transition from local star to international celebrity. He has managed this through the range and quality of his work and through the brilliant and assiduous promotion of his dealer, Johnson Chang of Hanart TZ Gallery. Ju has performed well at the last four auctions at Sotheby's and has built a strong position for himself in the international market for contemporary art (see Table 38.2). His reputation has been enhanced by his open air museum and by the fact that enough of his work is positioned overseas for the *Taichi* series, at least, to be recognizable.

Had his mentor and teacher, Yu Yu Yang, been as ably guided and his fate not left to his family, we might today be trading in the work of two great international Taiwanese sculptors. Yang certainly had a greater range, if a little less aesthetic sense than Ju. Once again there was a time in the mid-1990s when one would have backed Yang to be a major international figure. He had an avid collecting base in Taiwan and in Japan, where the Hakone open air museum was a keen supporter. The erstwhile Hong Kong collector, T T Tsui, was also a fan of his work.

Taiwanese buyers do not, as yet, appear to have taken a view on Chinese contemporary painting. According to Sotheby's, only 6 per cent of the buyers at their Asian New York sale in 2006 and less than 5 per cent at the 2007 sale – which was dominated by mainland artists – were Taiwanese. Those Taiwanese attending the Hong Kong sale in 2007 were interested in the meagre Taiwanese offerings or had come just to marvel at the prices for Chinese art.

There are, as we see, lots of reasons why individual artists did not matriculate to the global stage, but equally it is inexplicable why some failed. I am left with a strong sense that many of those Taiwanese artists would have succeeded had it not been for the rise of contemporary Chinese art, which has swamped the arts community with a mass of immediately recognizable

Table 38.2 Ju Ming and his market development 1995–2007

Title	Edition	Size (cm)	Material	Estimate	Price(US$)	Location	House	Date
Taichi series Boxing (90)		42×100×53	bronze	202,500–253,150	587,000	HK	Christie's	May 2007
Taichi series (97)	9 of 9	23×21.5×15 (×2)	bronze	38,700–52,000	84,615	HK	Sotheby's	April 2007
Taichi series–Taichi arch (92)	1 of 1	28×55×27	wood	64,500–90,500	192,307	HK	Sotheby's	April 2007
Guanyin	1 of 1	57×35×25	wood	45,200–58,500	64,615	HK	Sotheby's	April 2007
Taichi series (84)	2 of 10	50.8×29.2×38.1	bronze	35,000–45,000	66,000	NY	Sotheby's	March 2007
Taichi series (84)	2 of 3	45.7×44.5×47.7	bronze	35,000–45,000	62,400	NY	Sotheby's	March 2007
Taichi series (95)	6 of 10	50.8×31.7×25.4 48.2×24.7×27.9	wood	60,000–80,000	BI	NY	Sotheby's	March 2007
Living World series (04)	1 of 1	65×30.4×25.4	wood	50,000–60,000	BI	NY	Sotheby's	March 2007
Living World series (06) (Story of the skirts)	1 of 1	70.2×44.2×70.2	wood	60,000–80,000	BI	NY	Sotheby's	March 2007
Taichi series (88)	1 of 1(×2)	65×58×36 71×54×41	wood	194,000–258,000	515,600	HK	Sotheby's	April 2006
Taichi series (95)	10 of 10	91×60×55	bronze	64,500–77,500	70,895	HK	Sotheby's	April 2006
Taichi single Whip (85)	8 of 10	43×77×33	bronze	120,000–180,000	130,000	NY	Sotheby's	March 2006
Taichi series (95)		34×40×23	bronze	25,625–29,687	49,472	Taipei	Ravenel	Dec 2006
Taichi series		36×43×56	bronze		14,195	Taipei	Caves	1999
		105×30×47	wood		43,533	Taipei	Caves	1999
		97×106×68	bronze		83,280	Taipei	Caves	1999
		40×33×33	bronze		11,987	Taipei	Caves	1999
		71×87×53	bronze		35,194	HK	Hanart	1998
		33×26×25	wood		18,545	HK	Hanart	1998
		37×38×20	bronze		15,324	HK	Hanart	1995
		91×63×59	bronze		32,142	HK	Hanart	1995

imagery ably promoted by key dealers and now the international auction houses, worldwide. What can a small island community, shorn of its diplomatic relations, do in the wake of this kind of market saturation?

The antique and Old Master markets

Elsewhere, the market is active across a number of traditional Chinese works of art categories. Jade is in great demand and can be purchased at open markets, in antique shops and at auction. There is a strong watch and jewellery market, with significant wealth stored in very pure gold trinkets and charms. Chinese Imperial ceramics (reign marks first appear on imperially commissioned items in the mid-15th century) are sought after, but the finest wares from the Song dynasty are more desirable. Bronze, cloisonné, lacquer and textiles form further strands to Taiwanese taste. Buddhist sculpture is acquired for its religious resonance rather than its sculptural, and headless torsos are not appreciated. Traditional pen and ink scroll paintings on paper and silk, in which the nuances of depth, shading and volume are created by gentle pressure on the brush, depicting landscape and other compositions, is highly appreciated in Taiwan. The accoutrements of the scholar's desk: brushes, brush rests, brush pots, ink cakes, ink stones, water droppers, small boxes for red seal paste, and seals form another important part of the collecting passions of the Taiwanese. Auspicious symbols, which appear on a number of items, most clearly define the passions of all Chinese collectors. A significant proportion of wealthy Taiwanese are *huachiao* (the offspring of the Nationalists) and still regard the works of art created in China pre-communism as the highpoint of world culture.

In the 1990s a number of Taiwanese collectors were persuaded to buy Impressionist art, and demand for these works took hold of the market for most of the decade, although Sotheby's and Christie's held disastrous modern sales on the island in 1996, selling just over 20 per cent of the stock. Geoffrey Gu (the chairman of China Trust) was a significant player in this market. Buying in this area has slackened in recent years, although a foundation in Tainan – the Chi-mei – is still actively collecting western works of art (also musical instruments) – largely for educational purposes, exhibiting the collection in a purpose-built museum adjoining the company's factory. Fine wine forms another relatively bullish commodity on the island, with oenophiles either buying from London and New York merchants or on the secondary market at local auction houses like Ravenel. Finally, there is a small market in aboriginal art, both old and new, on sale in the reservations in the island's hinterland.

Conclusion

The future for Taiwan's artists today lies in ensuring that they are not merely considered to be Taiwanese. If they were to maintain a base in Shanghai or New York this would persuade collectors that the fate of their purchase did not depend on Taiwan's indigenous art market. That market is showing clear signs of recovery but it will always be small and under-represented internationally. One can only hope that those distinctive, Taiwanese qualities that make the art from the island so arresting are salvaged in the artists' efforts to homogenize their offerings for an international audience.

For further information on the development of this particular art market, go to: www.koganpage.com/artmarkets.

Thailand

Brian Curtin

Introduction

In his forward to *Modern Art in Thailand* (1992), a definitive study by the pre-eminent historian, critic and curator Apinan Poshyananda, Stanley J O'Connor writes of the introduction of the museum system to Siam during the late 19th century. Art, he claims, was consequently defined as a specialized activity with its own functions and values, to be viewed and interpreted distinctly. The notion of art, in other words, took on a life of its own.

Two important points underline this new definition. First, the history of art in Siam, dating from the 13th century with the first Tai [sic] kingdoms of Sukhothai and Ayuttahaya, was predominantly one of Buddhist art, serving the purpose of religious worship. (Siam became Thailand ('Land of the Free') in 1949, further to a bloodless coup which installed a constitutional democracy.) Second, the entire art history of Siam/Thailand is marked by a curious negotiation of foreign influence: from the stylistic legacies of the Khmer civilization and trade routes with China and India through to the idiosyncrasies of the modern period. The museum system was introduced to Siam/Thailand during the reign of King Chulalongkorn (1868–1910). Chulalongkorn is considered the godfather of modernization for this country and his efforts and reforms are held to signal the fact that Siam resisted colonization. Poshyananda goes on to write of the traditional responsiveness of Thai culture to external influences, without the systematic impositions of colonial powers, and remarks that Thai artists throughout the modern period have faced the tension of a desire to be modern while also preserving a sense of national identity.

This tension continues to mark art production, and its various representations, in Thailand. A number of the kingdom's most significant contemporary artists work with issues of national and cultural identity, traditional and neo-traditional Buddhist art continues to thrive, and the gallery and market system in Bangkok is marked, with varying degrees of significance, in terms of national/international.

However, the contemporary Thai art scene is diverse and increasingly expanded by the presence of foreigners. While local concerns and contexts may provide interesting understandings of much of what is produced here, this should not suggest a homogeneity of output.

Galleries: an introduction

The long-standing web resource Rama IX Museum Foundation currently lists 80 art galleries in Bangkok. The Bangkok Art Map (BAM), which began in 2007, lists 40 venues. These numbers may be broken down in terms of not-for-profit spaces (including universities and museums), galleries that have become defunct since their listing, galleries pandering to exceptionally commercial interests (for example, copies of canonical Buddhist art, or just copies generally), cafes and restaurants which double as exhibition spaces, and galleries which are focused on notions of contemporary art.

The reason for a difference in the number of venues between the resources lists is unclear, and BAM does not charge galleries to be listed. However, the Bangkok art gallery scene is idiosyncratic and unpredictable. Strict categories of differentiation between galleries, in terms of form or style of art, do not exist in the media and at the level of practice they usually do not last. For example, galleries such as Number 1 (founded 2006), specializing in what is claimed to be spiritually aligned neo-traditional subject matter, will be listed alongside the exceptionally hip Gallery Ver (founded 2006). Ver was founded by the internationally renowned artist Rirkrit Tiravanija (b 1961), and has hosted shows by the equally renowned Udomsak Krisanamis (b 1966) and Achim Kubinsky. Tang Contemporary Art (founded 2000) began as a gallery showcasing Chinese art but since 2006 has included Thai and other Asian artists in its programme. Catherine Schubert Fine Art opened in 2007 with a remit to show Chinese and western artists but is now considering an exhibition by a Thai artist. Gallery Soulflower opened in 2007 with a focus on contemporary Indian art but is planning two group shows with both Thai and Indian artists for 2008.

Thai artists feature prominently across Bangkok's art gallery scene. While 100 Tonson Gallery has hosted shows by Damian Hirst and Orlan, and Conference of Birds gallery showed Ryan Trecartin during 2007, named international artists rarely figure in gallery programmes. However, many galleries report that while their programmes are dominated by Thai artists this is not the consequence of an agenda. Thavibu Gallery (founded 1998) is one notable gallery that explicitly advertises itself in terms of the artists' national identity: Thavibu is derived from Th[ailand], Vi[etnam] and Bu[rma].

H Gallery (founded 2002) initially built its reputation on the promotion of contemporary Thai artists but occasionally exhibited non-Thai artists and during 2007 explicitly shifted its programme to international artists, while still including Thai artists in the mix.

The art market

The following is a partial view. Language problems, among other issues, limited the scope of my research. Information on galleries is based on questionnaires I sent to what I believe to be the most credible galleries in Bangkok, based on a perception of a relatively focused programme of exhibitions in terms of contemporary art and international contacts.

Sotheby's and Christie's both have offices in Bangkok. Sotheby's was founded there in 1997 by the collector Rika Dila (see below), who has since left, and specialized in the sale of jewellery. Bangkok Art Auction began in January 2006, and held two auctions in that year. River City shopping complex runs monthly auctions of art and antiquities, with the exception of January.

As yet there are no art fairs in Bangkok. At the time of writing, however, meetings have begun between galleries to form a Thailand Art Galleries Association and one of the current aims of this Association is to establish an art fair for Bangkok.

A high amount of sales across galleries are to collectors, ranging from 50 per cent to 70 per cent annually. Walk-in buyers account for, on average, 5–10 per cent of annual buyers. However, Thavibu Gallery claims 70 per cent of its sales are through the internet, though this gallery began life as an internet-based enterprise.

Prices for art works are, as one might expect, variable. H Gallery reports that for young Thai artists a small art work would cost approximately 60,000 Thai baht (US$2,000). A prominent Asian artist could sell for upwards of 2,000,000 Thai baht (approximately $67,500). The price range for 100 Tonson Gallery, which is the main Bangkok gallery for relatively difficult-to-sell artworks such as video and installation, is between 8,000 and 6 million Thai baht (approximately $270–203,000). On average Tonson sells individual pieces for 150,000 Thai baht (approximately $5,000). Thavibu Gallery report a ceiling of 593,000 Thai baht (approximately $20,000) and charges an average of approximately 119,000 Thai baht ($4,000) for 'medium sized quality works by young, good artists'. Galerie N's range is 50,000–150,000 Thai baht ($1,687–5,000). Paintings/works on paper are the highest sellers.

The nationality of buyers can be linked to the particular contacts of the gallerists. There is no consistency across different galleries. Tang Contemporary Art sells mostly to Chinese buyers. 100 Tonson Gallery lists Thai as their top buyers and Teo + Namfah Gallery lists Americans. Gallery N sells mostly to Thai buyers. Less than half of H Gallery's buyers are Thai. Japanese, Singaporeans and Europeans otherwise feature in the top three nationalities that Bangkok galleries sell to.

Auction house sales are generally low, though galleries report being approached regularly by auction houses. Josef Ng, curator for Tang Contemporary Art, commented that his gallery does not often sell through auction houses because 'We want to release our works to collectors and cultural organizations first. That's our priority.' Museums sales, however, figure low.

Appearances at international art fairs are not regular, though this is possibly about to change. Over the last seven years, one-off appearances by Thai galleries have been at San Francisco Art Expo (2000), Art Singapore (2001), Art Taipei 2006, ARCO (2006), Shcontemporary (Shanghai 2007) and Art Beijing (2007). 100 Tonson Gallery will take part in the Dubai Art Fair during 2008.

The reasons for setting up a gallery or otherwise dealing in art in Bangkok typically include a sense of 'early days'. Competition is relatively mild and there is a large pool of high-quality art to draw from. The Thai middle class is growing and 'old money' wealth is conspicuous. Moreover, one can speculate on the potential effects of the art booms in China, India and Korea for the region generally. However, most galleries suggest a somewhat idealistic agenda as they aim to respond to the following: Thai art is undervalued locally and internationally, high-quality exhibition programmes in this city were sporadic and opportunities for foreign artists, major or otherwise, to show here is slight. Thailand's first contemporary art museum, the Bangkok Art and Culture Centre, will open early 2008, adding further interest.

A high import tax on artworks and zero government support are the biggest bugbears for galleries. Otherwise, galleries report that the legal situation for dealing art in Thailand is 'flexible' and 'nothing special'.

Collectors

Forbes.com lists Petch and Surat Osathanugrah, Sermkhum Kunawong, Sivapron Dardarananda and Boonchai Bencharongkul as major art collectors in Thailand. Petch Osathanugrah owns the biggest private collection of Thai art in the world and the

Osathanugrah family own Bangkok University, alongside a variety of business interests. The city campus of Bangkok University opened BUG (Bangkok University Gallery) in 2006, an enormous two-storey white cube space which has consistently maintained an interesting and well-produced programme of shows. Only one gallery, Galerie N, responded to my request for the names of collectors and included Sermkhun Kunawong.

Reinhardt Frais is a Pattaya-based 'collector' whose practice serves well the idiosyncrasies of the local art scene. Refusing the label of collector, Frais builds his collection through supporting noteworthy artists early in their careers. An early supporter of Franz West (when, to quote, 'You couldn't give away his work for free'), Frais is currently associated with the remarkable outputs of Mit Jaiin and Nim Kruasaeng (b 1973).

Another Pattaya-based collector is Liam Ayudhkij, an Irish-born naturalized Thai who has lived in Thailand for 44 years. Beginning his collection in 1967, Ayudhkij buys on average 33 art works a year, which he describes as 'contemporary, mainly abstract, paintings' and the highest he has paid is 1.1 million Thai baht. Ayudhkij buys mostly from galleries and while 80 per cent of his collection is of Thai artists he lists Ireland as the main country he buys from (followed by Thailand and Malaysia).

Rika Dila founded Bulgari and Sotheby's in Bangkok. Collecting for so long she cannot remember when she began, Dila has amassed a collection of early work by notable Thai artists, including Chatchai Puipia (b 1964), Pinaree Santipak (b 1961), Thaweesak Srithongdee (b 1970) and Natee Utarit (b 1970). As to be expected, given a lack of local infrastructure and sustained international interest, Dila's collection is largely showcased in her home or otherwise held in storage.

Jean Yves Le Moal has lived in Bangkok for two years, and began collecting in 1976. He does not characterize the type of art he collects but mainly collects paintings. The highest he has paid is 3.5–4 million baht.

Media

Thailand has two national bilingual art magazines, published monthly. *Art 4D* is primarily focused on design while *Fine Art* primarily covers fine art. There are many, many, lifestyle and culture Thai-language magazines. National television stations cover exhibitions of news interest. For example, Gallery Soulflower, which specializes in contemporary art from India, received much media attention for a show of contemporary Indian art during 2007.

2007 saw the monthly publication of BAM (*Bangkok Art Map*) and TA&DG (*Thailand Art and Design Guide*), both offering comprehensive listings and advertising space.

For further information on the development of this particular art market, go to: www.koganpage.com/artmarkets.

Bibliography

Poshyananda, A (1992) *Modern Art in Thailand*, Oxford University Press Singapore, Oxford and New York

Rama IX Art Museum Foundation: www.rama9art.org

Forbes magazine: www.forbes.com

Turkey

Zeynep Kayhan

Art in the museum-bound, non-craftsmanship, commoditized western sense is a fairly recent concept in Turkey, which was thriving with diverse artisan industries before the advent of mass production. The arts that prevailed within the current geography of Turkey during the lofty Ottoman reign (1299–1922) are, for practical purposes, crammed under title of 'Islamic art' and encompass calligraphy, manuscripts, ceramics and metalwork. Painting made its entrance to the Ottoman court in the 15th century, under the patronage of Fatih Sultan Mehmet. However, a serious art institution based on the European model came along only in 1875 (Mühendishane-i Berrii-i Hümayun) after a considerable increase of momentum in relations with the western world. An enduring result was the modernization of the state institutions, and the foundation of an art school was, in all certainty, a byproduct of the reorganization of the military structure. Officers and military school students were sent anywhere from Vienna to London to supplement their art education, and the Ottoman government established a private art school in Paris, called Mektebi Osmani.

The first painting exhibition was opened in 1873 by Şeker Ahmet Paşa (1841–1907), who studied in the workshop of Boulanger in Paris, and this was soon followed by the foundation of the more influential school Sanayii Nefise Mektebi Alisi by Osman Hamdi Bey (1842–1910), himself a student of the Boulanger and Gerome workshops.

Among this first generation of painters were Hoca Ali Rıza (1864–1939), Halil Paşa (1860–1939) and Süleyman Seyid (1842–1913).

By 1914, new blood was gushing forth, whirling down an impressionistic path, determined to discover an authentic course. Through portraiture and landscape painting, artists such as İbrahim Çallı (1882–1960), Ruhi Arel (1880–1931), Hikmet Onat (1982–1977), Nazmi Ziya (1881–1937) and Namık İsmail (1890–1935) strove to recover a link with nature, rather rusty after centuries of avoiding direct representation.

The 11th Galatasaray exhibition in 1927 revealed the modernist reverberations of Cezanne through the hands of Ali Çelebi (1904–1993) and Zeki Kocamemi (1900–1959), both graduates of Hans Hofmann's workshop. In 1929 these two artists led the unveiling of the first artist initiative of the newly founded Turkish Republic. Other members included Şeref Akdik (1899–1972), Mahmud Cuda (1904–1987) and Hale Asaf (1905–1938), who were united

under the theme of exploring village life and incorporating folkloric elements into modern painting in a highly conscious effort to update and embrace Anatolian heritage.

The 1940s saw the turn towards more political art, digging into themes of community and city life, and the following three decades were characterized by discussions of daily life and local aesthetics through stabs at shifting formalisms. Abstract expressionism and geometric abstraction also started to gain ground in the 1950s as well as disagreements over what modern is, particularly in the context of Turkey where an authoritarian and militaristic flavour of modernity was experienced in the form of painful, frequent and very literal punches in the gut. Important painters of this period are Ferruh Basaga (b 1914), Adnan Turani (b 1925), Nuri İyem (1915–2005) and sculptors Ali Hadi Bara (1906–1971) and Zühtü Müridoğlu (1906–1992), followed by İlhan Koman (1921–1991).

After the Second World War, a flock of artists fled to Paris to better absorb the budding movements, among them are Nejad Devrim (1923–1995), Fahrelnissa Zeid, Adnan Varınca (b 1918), Abidin Dino and Avni Arbaş (1919–2003).

The 1970s and 1980s are more difficult to pin down in terms of overriding themes as the primary concern became the artist, his/her identity politics, gender troubles, psychoanalytic concerns, in brief a more individualized approach towards art. Artists such as Erol Akyavaş (1932–1999), Burhan Dogançay (b 1929), Ömer Uluç (b 1931), Mehmet Güleryüz (b 1938), Burhan Uygur (1940–1992), and Neşe Erdok (b 1940) made their mark during this time, and most of them continue to work today.

What is contemporary in this limiting, categorizing, simplifying art historical chronology is art from the 1970s onwards, which leans towards a conceptual framework and a thorough examination of the discourse of art production, exhibition and preservation. Contemporary art hopes to include new technologies, alternative means of production and engagement with the viewer, thus acting the part of interdisciplinary media. From this diverse batch we can count Füsun Onur (b 1938), Sarkis (b 1938), Nil Yalter (b 1938), Balkan Naci İslimyeli (b 1947), Sükrü Aysan (b 1945), Serhat Kiraz (b 1954), Ayşe Erkmen (b 1949), Gülsün Karamustafa (b 1946), and Hüseyin B Alptekin (b 1957).

The groundbreaking development in Turkish contemporary art has been the International Istanbul Biennial, which celebrated its 10th run in 2007. It has contributed immensely to Istanbul's potential as an international contemporary art centre or preferably a proud periphery, bringing in as well as spawning renowned curators and encouraging and connecting both local and international artists. Owing to this internationalist wave of contemporary art, a good number of Turkish artists are in fact better known abroad. A few examples are Kutlug Ataman (b 1961), Hale Tenger (b 1960) and Haluk Akakçe (b 1970).

The Turkish art market

Contemporary art: galleries

The Art Gallery Association of Turkey declares itself to have around 100 members, but speculates that there are perhaps 500 art galleries in Turkey, the majority of which are located in Istanbul with sporadic interest in Izmir and Ankara. Among those with international claims are Galeri Nev (representing Abidin Dino, Canan Tolon, Ergin İnan, Erol Akyavaş, İlhan Koman, İnci Eviner, Nejad Devrim) and Galerist (Ayşe Erkmen, Haluk Akakçe, Taner Ceylan, Hussein Chalayan) and up and coming X-ist, Galeri Apel, Mac Art Gallery, and Evin Art Gallery (Neşe Erdok, Hakan Gürsoytrak, Mustafa Horosan).

Art fairs

The longest running art fair, Artist, is now in its 17th year and claimed a mind-boggling 343,000 visitors in 2007. In 2006, it spawned a fledging yet ambitious Contemporary Istanbul, which strives to be more selective and edgier through focusing solely on contemporary art, and preparing for international participation. The second instalment in 2007, hosting 70 galleries from 16 countries, expected around 50,000 visitors. The youngest fair, ArtBosphorus, was first produced in 2007.

The secondary market – auctioneers and dealers

Istanbul is replete with auction houses of varying sizes and specialties. They hold frequent and mixed themed auctions where paintings are sold next to furniture, jewellery and Islamic art. Most prominent of these are Antik Palace (which has sold Osman Hamdi (1842–1910) for 5,000,000 ytl, Nazmi Ziya (1881–1937) for 560,000 ytl and Fabius Brest (1823–1900) for 694,000 ytl), Alif Art (Ivan Ayvazovski for 900,000 ytl), Artium (Halife Abdulmecit Efendi (1868–1944) for 650,000 ytl, Hoca Ali Riza (1858–1930) for 300,000 ytl), Bali Muzayede Evi, Macka Mezat and Portakal Sanat Evi. (At the time of writing £1 equals 2.47 Turkish lira (ytl).)

Works of Orientalist artists (such as Brest, Fausto Zonaro (1854–1929) and Amadeo Presiozi (1816–1882) frequently appear and are quickly picked up in auctions, which lack the melodious helter-skelter and theatrical air of their counterparts overseas.

Christie's has representation in Istanbul, and organizes annual tour exhibitions and lectures. It does not hold auctions on location but directs vendors and buyers to sale destinations in New York, London, Paris or Geneva. Experts often make scheduled visits for valuations and maintain close relationships with their client base.

With a few exceptions the market in Turkey is isolated, prone to seasonal bubbles and consecutive bursts. The most searched after works – those of national hero painters almost exclusively and rather fittingly from the military tradition – are hard to come by, and the middle market consistently turns towards modern and contemporary Turkish art.

Collectors

Owing to the diversity of influences and civilizations that traced through and grew within the current geography of Turkey, one may come across a surprising array of collections, some of which remain unknown for long periods of time. Ancient Greek and Roman sculptures, artefacts and coins are collected widely, and some world-class collections have been published and exhibited, though they are decidedly out of international circulation due to cultural heritage laws forbidding their travel. Similar circumstances apply to Islamic art collections, with particular focus on Iznik pottery, calligraphy, silverwares, textiles, rugs, carpets, handwritten Qur'ans and miniatures.

There is a yearning among painting collectors to build a chronology of Turkish art, perhaps due to the lack of state institutions rising up to the task. Some delve more thoroughly into 19th century, riding mostly on the back of the Orientalists with peeks into the Italian school or Barbizon. There are some remarkable impressionist/modern collections and few but noteworthy excursions to the dark terrain of contemporary art. The younger generation of collectors go after photographs and prints, more affordable and hipper areas which differentiate them from their parents.

There is hardly a sense of collective philanthropy (donations are not tax deductible) and a number of individual initiatives have sprung up throughout Istanbul, showcasing wholly or in part the collections of their founders. While any such cultural investment is most gratefully received, the critics, frustrated with the lack of more strenuous exhibition and education programmes, regard this ardent museum-building activity as a prestigious and dare one say tax-deductible publicity vehicle.

There are some firms with notable art collections, Yapi Kredi Bank being one of the pioneers. Its large holdings include an extensive Turkish art collection – including classic and contemporary, an ethnographic collection and numismatic collection that comes equipped with a library. Is Bankasi, Garanti Bankasi, Akbank and Merkez Bankasi are some other firms which have corporate collections.

Public collections and museums

The state-sponsored Museum of Painting and Sculpture is basically defunct, without sufficient funds to provide even the most rudimentary maintenance and exhibition programming. A lot of supporting acts have appeared. First, Elgiz Museum, or Proje 4L in 2001, a boutique establishment boosting the owner's contemporary collection, then in 2004 Istanbul Modern, working towards establishing a cohesive historicity with monograph exhibitions, later in 2005 the expanded and improved Sabanci Museum (it was initially opened in 2001), an effort by the family of the same name, showcasing the late Sakip Sabanci's considerable calligraphy collection, while educating the masses and busting the block with Picasso and Rodin shows. Pera museum, crowning the revival of the Pera neighbourhood, was endowed by the Suna and Inan Kirac Foundation in 2005 and encompasses the collector's Orientalist art collection, Kutahya tile and ceramics, Anatolian weights and measures, and has temporary galleries showing anything from Dubuffet to Koudelka. Santral Istanbul, affiliated with the privately owned Bilgi University, is the most recent effort (on the location of an old power plant) to pin down or perhaps just trace the journey of Turkish modernism and contemporary art.

There are a few non-profit spaces as well as artist initiatives. Garanti Platform Contemporary Art Center is perhaps the most influential, complete with a library and an international residency programme. Aksanat features among other things a contemporary art workshop, a gallery, a music studio, and now, despite the protests of many, the patron company's tech equipment shop. Yapi Kredi Culture and Arts Center, after years of curating pieces from the bank's collection with loans from private sources, has now started a new series of contemporary artist exhibitions, each accompanied by a well-formulated catalogue. Some promising new spaces are Pist, K2, Yama and Nomad.

Taxation

All transactions, including imports, are subject to 18 per cent VAT, which is discouraging. Donations are not tax deductible. *Droit de suite* is not practised. Inheritance tax at 20 per cent is only applicable to registered items, meaning antiquities and early Ottoman artifacts. Collectors' organizations are lobbying vehemently against this.

For further information on the development of this particular art market, go to:
www.koganpage.com/artmarkets.

Bibliography

Akay, A (2005) *Sanatin Durumlari*, Baglam Yayinlari, Istanbul

Erdemci, F, Germaner, S, Kocak, O and Rona, Z (2007) *Modern ve Ötesi*, Bilgi Universitesi Yayinlari, Istanbul

Tansug, S (1996) *Cagdas Turk Sanati,* Remzi Kitabevi, Istanbul

The United Kingdom

Godfrey Barker

London is the centre of the international art market when measured by volume of sales at auction and by the strength and depth of its art trade. It leads all other cities in its concentration of art dealing expertise, located in the square mile of Mayfair and St James's.

It is surpassed by New York in share of picture sales at auction, when measured by value; London in the 21st century has taken 31–35 per cent, New York 42–46 per cent of the world's fine art auction business, the latter gaining from heavy American buying of the French impressionists, Vincent van Gogh, Pablo Picasso and US contemporary art. By volume, London leads. Other cities fall far behind these two. In auction sales of the decorative arts, London is world number one by volume and by value, although finer individual sales have been seen since 1995 in Hong Kong of Chinese ceramics, in New York of antiquities and in Geneva of jewellery.

For most of the 20th century, London was the undisputed centre of the international art business, for the gloomy reason that the United Kingdom was both the world's treasure house of art and at the same time the art world's biggest seller.

Paris was its major rival but London routinely achieved higher prices, in part through the vast wealth of British industrialists, in part from the rising invasion of American dollars after 1880. Great Britain was the world's richest country, first from trade, then from industry and then from empire from 1715 to 1914; its aristocracy, its landed gentry and its merchant middle class paid huge prices for art on the Grand Tour and filled Britain's country houses with the trophies of Italy and Germany, most of all in the Napoleonic Wars as the French forced distress sales across the continent. But after 1870 the economy of the English landed estates came under attack from corn exported at near-zero prices from the American mid-west and from Argentina. The domestic price of British corn collapsed by 40 per cent in the decade after 1875. Tenant farmers went out of business and were unable to pay rents. Only the hill-farming Scottish escaped. The owners of England's great houses survived for the next 60 years by repeated sales of paintings, drawings, works of art and books, mostly to the new economic powers of the United States and Germany.

London was the city where the world now came to buy. Although much was sold – there was a ceaseless haemorrhage abroad between the Hamilton Palace auction in 1882 and the Duke of Northumberland's sales from Alnwick in 1928 – much great art was retained. It is a

remarkable fact that in wealth of great paintings and art objects created before 1870, Britain's country houses keep more in private hands than the private owners of the rest of the world put together.

The auction market

Sotheby's, Christie's and Bonhams are, at the start of the 21st century, the world's three largest auction houses by value of sales. All sell heavily in London and all were, 20 years ago, under British control. Now Sotheby's (founded 1745) has passed to public ownership after a two-decade reign by A Alfred Taubman, a property developer from Michigan; Christie's (founded 1768) fell to a French luxury goods entrepreneur, Francois Pinault, in 1998; while Bonhams (founded 1793) passed into Joint Anglo-Dutch ownership in 2006. Sotheby's is headquartered in New York, although in law it is based in London under the terms of the UK Monopolies Board's consent to Alfred Taubman's takeover in 1983. Christie's and Bonhams are headquartered in London.

Phillips, founded in 1796 and for a short period – 1811 to 1840 – the world leader among auction houses, met financial problems in the mid-1990s and was sold twice. It revived its former glory in a magnificent era of extravagance between 2000 and 2002 under the direction of the former chairman of Sotheby's Europe, Simon de Pury, and the art dealer Daniella Luxembourg. Record-breaking sales, mostly in New York but some in London, were made with the backing of the French-owned luxury goods group Louis Vuitton Moet Hennessy (LVMH). LVMH exited as quickly as it entered, however, in late 2002 but not before Phillips threatened to dislodge Christie's and Sotheby's from their 250 years of worldwide auction eminence. De Pury has since resumed a handful of auctions a year in London, concentrating on contemporary art since 1980.

With art fairs, London has lost the pole position it held from 1934 to the late 1980s with the Grosvenor House Fine Art Fair. The world's most wide-ranging fair is now the European Fine Art Fair at Maastricht, Holland, finely situated on the borders of Belgium, France, Germany and the Netherlands. But London retains specialist art fairs of world importance in Asian art and porcelain while Grosvenor House, limited only by the too small size of the hotel which houses it, retains much if not all of its previous significance.

London's position as an art centre is strengthening again overall at the start of the 21st century. The high value of sterling against the US dollar and euro makes it attractive to sellers, its geographical position and easy access from the main cities of Europe and the United States bring in buyers in large numbers, and the preference of Russians and Germans in particular to sell in London rather than at home in their own countries is growing rather than diminishing. Art is imported from 40 countries around the globe for sale in London. Although New York, Geneva, Hong Kong and Paris play major and distinctive roles in the international art world, the general pre-eminence of London in auction sales and art dealing seems set to continue for at least the decade ahead.

The market for British art

In 1917 Henry Huntington, the American builder of the Southern Pacific Railway, sailed the Atlantic in the SS *United States* accompanied by Thomas Gainsborough's (1727–1788) portrait of *The Blue Boy* in his stateroom. It was a reproduction on the wall but Huntington

was sufficiently entranced that when in 1921 the real painting appeared on the London market in an emergency sale by the Duke of Westminster, he gave £148,000 for it.

That price was not just an artist record for Gainsborough. It was the highest price for art that the world had ever seen, exceeding the £103,500 for Rembrandt's *Mill* in 1911 and the £113,500 for the *Smaller Cowper Madonna* in 1913 paid by Huntington's rival at the top of the art market, P A B Widener of Philadelphia.

The record price of *The Blue Boy* also crowned the summit scaled by 18th-century British painting, between 1911 and 1925, to become the most expensive school of art the world had ever known – an eminence it retained until it was displaced by French impressionism in the 1980s. Gainsborough was not the only stellar British artist in this unprecedented rise, though with the Huntington *Blue Boy* and his full-length of *The Hon Frances Duncombe* bought at £82,500 by the Pittsburgh steelman Henry Clay Frick, he was undoubtedly the most expensive. But Sir Joshua Reynolds (1723–1792) was lifted on high to £73,500 by Huntington for *Sarah Siddons as the tragic muse;* George Romney (1734–1802) to £70,000 by the Pittsburgh banker Andrew Mellon for his portrait of *Mrs Davenport;* John Hoppner (1758–1810) to £72,300 by the Philadelphia banker and horse breeder E T Stotesbury for *The tambourine girl* and Sir Thomas Lawrence (1769–1830) to £90,000 by Huntington for *Pinkie (Miss Mary Moulton Barrett).* In a separate reverence to Sir Anthony Van Dyck, a full-length portrait of King Charles I's Queen, the coolly arrogant *Henrietta Maria*, was lifted to £77,500. These record sums valued Reynolds and Lawrence in particular at levels known only to Rembrandt and Titian. The price of Gainsborough, for six impossible years, exceeded that even of the divine Raphael. It was the apotheosis of English painting on the art market.

Eighty years on from the 1920s, English 18th-century painting is the bargain basement of the art market. That description may sadly be extended to British art in most forms. The reason is simple. It was America that lifted British 18th-century art on high; and its fall follows the near-total withdrawal, after 1945, of American interest. This vast change in fashion is simply explained. All the attractions of 18th-century British society to America's rich before the War – its aloofness, its aristocratic mien, its disdain – were a world apart from America's new national mood after 1945. British art seemed simply 'wrong': it was, above all, undemocratic in the new radical democracy of the postwar United States.

Thirty years before, men of wealth but dirty hands like the railwaymen Huntington, Widener and Vanderbilt, the retail magnates Altman, Kress and Kresge, the steel barons Carnegie and Frick, the money men Morgan and Mellon, had unabashedly turned to art to assert social status against the fierce resistance of Mrs Astor's Dutch Knickerbocker society in New York. The new industrial rich bought British art because portraits of the 18th-century British aristocracy on their walls 'validated' them in some post-colonial sense, just as marrying their rich daughters to financially troubled British dukes and earls vaulted them at one stroke to Old World social eminence. Henry James's *Portrait of a Lady,* with its irresistible fortune-hunter Isabel Archer, and his novel *The Europeans* gave Americans the necessary instructions. The expressions radiated by the English grandees painted by Reynolds and Lawrence and, sometimes, by the smarter faces of Gainsborough were the superiority the new rich sought: 'I am a very splendid fellow'; 'I own this park'; 'I love my dogs'; 'This is my wife'; and, to the artist, 'Down on your knees.' Self-admiring swagger of this sort, plus discreet advertisement of prices paid, did much to lift the men of toil from New York social obscurity after 1914. After the Second World War, all was changed. Men of money no longer needed such social assistance.

What also forced down the price of British art after the War was the supply of major pictures to the market. It dried up. The records of the early 20th century were paid for

masterpieces multiply forced out in 50 years' distress sales from the English country houses. Distress began in the 1870s with the arrival at Britain's Atlantic ports of cut-price corn from the American prairies and from Argentina – corn so cheap that, even after transport, it forced down the cost of British wheat from 56 to 31 shillings the quarter and ruined the tenant farmers of arable land. Rents paid to landlords plunged. Survival came from major sales of art, immeasurably gathered by the British in Europe across 200 years of the Grand Tour. Paintings and books were freely sold by the Dukes of Hamilton (1882 and 1919), Marlborough (1885), Norfolk (1909), Devonshire (1912), Sutherland (1913), Northumberland (1915 and 1929) and Westminster (1921) and by major owners such as the Earls of Dudley (1885), Radnor (1890), Warwick (1896), Cowper (1913 and 1927), Pembroke (1917 and 1928), Carnarvon and Fitzwilliam (1919) and Spencer (1925). Behind those names lay Britain's wealth in art in famed country houses. It is thanks only to the far greater American interest, 1900 to 1940, in buying native British pictures rather than Old Masters that houses such as Chatsworth, Blenheim, Longleat, Wilton, Althorp and Arundel retain in private hands in the 21st century a still miraculous array of paintings and works of art. Private British wealth in art created before 1900 exceeds the private wealth of the rest of the world put together.

After 1929 and the Wall Street Crash, and certainly after 1945, American money for British art largely vanished. (The great exception was for sporting art.) Prices fell and supply with it. Snobbery is still alive and kicking in New York, Boston and Philadelphia – its country club culture and its gated communities are the obvious evidence – but America has radically cut its cultural dependency on Europe and on Britain in particular. Only two forms of British loyalty strongly survived. On the English furniture market, the finest Georgian mahogany tables, chairs, desks and cabinets are priced to awesome levels on an analysis which says that new money in New York in the 21st century must choose as new money did in the 1920s: to go 'brown' (English) or to go 'gold' (French Louis XV or XVI). The convention is that brown furniture goes to those who wish to make a social understatement, one suggestive of family age, good manners, descent and connection; gilt French furniture is bought by those making an 'in your face' announcement of new financial triumph. The other loyalty to Britain is that Kentucky racehorse owners have kept British sporting art seriously expensive over the last 50 years – so expensive, in fact, that horses painted by Sir Alfred Munnings (1878–1959) now cost more than their owners painted by Gainsborough. But horses are the only British snobbery in paint still wanted by Americans; portraits of their owners are disdained.

There appears at present not to be a price-lifting single American 'big buyer' for British art of the stature of Frick, Huntington or, from 1950 to 1990, Paul Mellon of Virginia, the discriminating patron of equine pictures. A brief flurry was made at lower price levels by W M B 'Bill' Berger of Denver, Colorado from 1991–96, but he has since died and his family's interest has apparently deceased with him.

The market price of British painting has depended for three centuries mainly on the British themselves, but for important shorter passages, on the support of Americans. The rest of the world has not engaged. The French, in particular, have scorned British painting as 'horses and portraits'; the Louvre saw the work of the most innovative of British artists, J M W Turner (1775–1851), as unimportant until 1967 when it bought the only work he painted in France, *Landscape with a river and a distant bay*. This is still its only oil by Turner. The Louvre catalogue placed him, reasonably enough, 'in the tradition of Claude Lorrain' (Turner was much moved by Claude and Poussin on visiting France in 1802). The museum has not been disposed to add further works even after Turner became the most expensive painter in the world in 1980 (*Juliet and her nurse*, £3.08 million) and again in 1984 (*Seascape, Folkestone*, £7.36 million).

The reason for French detachment is not just xenophobia but one that raises the problem of British painting for several Continental cultures: it is too painterly. The French gaze appears to put highest value on exactitude. French money has for two centuries fallen heavily on French native painting and on the Dutch and Flemish schools, which offer near-photographic realism under the magnifying glass. Sweeping brushstrokes – of the type to which Sir Joshua Reynolds objected in Gainsborough – are to many French eyes a lower art. British painting raised also a deeper problem for the French: its subject matter. The academic tastes in paint of France, visible in 19th-century exhibitions at the Paris Salon, esteemed the mythological 'subject picture' far above the portrait (merely commercial) and the sporting picture (vulgar). These were and are French reasons for low interest in British painting, 1700–2007, but explanations of related sorts arise for other countries: the Mauritshuis in The Hague, for example, owns no Gainsborough, Reynolds, Romney, Stubbs, Turner or Constable, nor does the Kunsthistorisches Museum in Vienna. The Prado in Madrid owns only a Spanish sitter of Gainsborough, the Uffizi in Florence has one Reynolds. British art display is only fractionally more generous in the Gemaldegalerie in Berlin and in the Pinakotheks in Munich. The Louvre shows trios of Lawrence and Gainsborough, two pictures by Constable and a single Reynolds. This enthusiasm contrasts, for example, with the presentation of 25 works by Poussin and Claude in the National Gallery in London.

Against the background of hostile regard British art has struggled for recognition in all countries except on the island itself, and in Australia, Canada and the United States. This limited appeal, however, did no damage to the price of British art until the 1960s. The United Kingdom was the world's richest country for 200 years until 1914; the United States has been thereafter.

British buying alone lifted the price of British living artists between 1850 and 1900 to awesome levels. Thirteen British painters then passed the £2,000 paid for Michelangelo by the National Gallery in London in 1868 and again in 1870. Although Sir Lawrence Alma-Tadema (1836–1912), Sir Edward Burne-Jones (1833–1898), William Powell Frith (1819–1909), William Holman Hunt (1827–1910), Sir Edward Landseer (1802–1873), Frederick Leighton (1830–1896), Edwin Long (1829–1891), John Everett Millais (1829–1896), Sir Edward Poynter (1839–1919), Dante Gabriel Rossetti (1828–1882), Clarkson Stanfield (1793–1867) and John William Waterhouse (1849–1917) remained a purely native love, interest in Turner was wider; a dramatic intervention came from America when Cornelius Vanderbilt paid £20,000 in 1885 for *Venice from the porch of Madonna della Salute*. The price was a 19th-century record for any British picture.

The London market in Victorian painting was a Wild West affair from 1863 to 1895, with values rising higher in real terms than on any contemporary art market at any time on any continent, excepting the excesses of Paris in the late 1880s and of New York and Los Angeles in our own time. Like several contemporary art booms in the last 400 years based on speculation and on the philosophy of 'buy it cheap and sell it dear', the Victorian art price explosion was not destined to last. Fashion changed sharply on the market in the freer airs of the 20th century and the price of Victorian living artists plunged so steeply after 1900 that as late as 1975, for example, the 1875 record price for Frith (£4,872 for *Supper at Boswell's lodgings*) had not been exceeded. There has been a decisive Victorian recovery since 1980 as the London auction houses have directed funds from the United Kingdom, the United States and Australia to fill the vacuum, but it remains true of Victorian art as it does of the British 18th century: British pictures are the bargain basement of the art market.

In the 21st century, British painting appears to be creeping faintly back into fashion. This is a large and risky statement but evidence for it is supplied by the art market's leading statistician, Robin Duthy. Duthy's Art Market Research Index – the former *Daily Telegraph* Art

Index – shows that the astonishing world art boom of 2005–08 includes especial growth in British art. 2006 (Duthy's indices are extracted from 130,000 worldwide auction prices per annum) was an *annus tremendens* for 17th to 19th-century British portraits and an *annus mirabilis* for British sporting pictures. It is across the five years 2002–07, however, that a surge appeared in British art to compensate for the sluggish prices of the last quarter of the 20th century. Using only the central 80 per cent of all auction prices to remove the distortion of the very high and very low, Victorian pictures have risen 61 per cent, sporting pictures by 260 per cent, portraits by 95 per cent and the British 20th century (Lowry, Munnings, Sutherland etc) by 130 per cent. The British Art 100 Index, taking in artists from Sir Peter Lely (1618–1680) to Damien Hirst (b 1965), rose 71 per cent since 2002. Irish paintings, which doubled in value in the 1990s, added 50 per cent at auction since 2000 in a slightly cooler market. In most British categories the top 10 per cent of paintings outgrew the central 80 per cent. The exception is Victorian pictures, which has unexpectedly shown its strongest surge in the middle market.

It might be claimed that British art has nowhere to go except up. It has lagged behind all other sectors of the world picture market at auction for 30 years (excepting only Scandinavian paintings) and it has much ground to make up. Thus British art did significantly better in 2005–06 than French impressionists (a flat line, July to July) and contemporary art (marginally down, for the central 80 per cent, after a stupendous rise in 2004–05). The market in the spotlight, Modern European painting, Picasso, Matisse, Modigliani and friends, rose 38 per cent from July to July.

Leading British artists

If Price is any guide to international taste, then five British artists matter more than all the others. The list below of records set for British art at auction excludes Hans Holbein and Sir Anthony Van Dyck, who have historically been judged the supreme talents at work in the British Isles and who are painters whose creations cross all borders. Among 400 years of British-born artists, however, the highest sums at auction have been paid for these:

■ Francis Bacon (1909–1992), *Study from Innocent X* (£26.4 million) $52.7 million, Sotheby's New York, May 2007;

■ J M W Turner, *Giudecca, La Donna della Salute e San Giorgio* (£20.5 million) $35.85 million, Christie's New York, April 2006;

■ John Constable (1776–1837), *The lock*, £10.78 million ($21.2 million), Sotheby's London, November 1990;

■ Sir Joshua Reynolds, *Portrait of Mr Omai*, £10.3 million ($14.7 million), Sotheby's London, November 2001;

■ Damien Hirst, *Lullaby spring*, £9.7 million ($19.45 million), Sotheby's London, June 2007.

This list is offered with an obvious caution. It reflects the availability for sale of masterpieces. No supreme Gainsborough, for example, has come on the public or private market since *Mr and Mrs Andrews* in 1960. But the list otherwise says much about those British artists who enjoy international recognition – and appeal – in the 21st century.

The main conclusion to be drawn, I believe, is that mere 'Britishness' no longer commands a high-priced market. After the inflation to unsurpassed levels of the British portrait and the British genre picture in London in the 19th century and in Pittsburgh and New York in the early

20th century, the 'British image' has sunk in international interest. The one exception in this list is the luminous Suffolk landscape at Dedham by Constable, *The lock on the River Stour.* The only reason why the once-immense Reynolds appears in this company is because his portrait of *Mr Omai* is a full-length study of a more fashionable 21st-century subject – a Tahitian tribal chief brought to London in 1774 by the explorer Captain Cook, a chief who captivated London society with his graceful South Seas nobility of manner. There is no reason to believe that a full-length Reynolds of a more traditional British aristocrat at home or in his park would begin to soar to such levels of expense.

Historically, the list points to a large consensus among art historians that Turner is the innovative genius of British art. While the British 18th-century portrait painters owe obvious debts to Van Dyck, Lely and many predecessors, while the 18th-century British landscapers owe even greater debts to classicism in Italy and France, and while the 19th-century rural painters depend on Gainsborough and further back through him on Ruisdael and the Dutch, Turner after 1840 is a revolution in art of his own making. He took giant steps at the outset of photography to free the painting from all obligation to 'document' the visual scene or be a mirror to nature; and he fathered impressionism and expressionism at the same time in a decade of convulsion in paint, producing images like *Rain steam and speed* which had not before been conceived in art. It suited French critics like the Goncourt brothers and Taine to denounce him as a hallucinatory alcoholic whose eye was distorted by four pints of gin and milk a day but the truth is that Turner changed the face of art and made possible a true French impressionism, for Monet and Pissarro analysed his work intensely when exiled in London, 1870 to 1872. The 1830s Venetian *View of the Giudecca* which made $35 million in 2006 is far from the most expensive Turner that can come to market. Lord Clark's 1844 *Seascape Folkestone,* which made £7.36 million at Sotheby's London in 1984, went to Canada around 1990 with an export valuation of £20 million and would now, should it reappear at auction in the 21st century, expect to sell for over £30 million (or $60 million), perhaps for more.

Equally the market is now certain that Constable is an innovator in mood and brushstroke in British landscape who owes little to predecessors. It took 70 years after his death for Constable to become a high-priced performer on the art market – *Salisbury Cathedral* sold for £8,190 in 1908 – and he dipped again in value between 1920 and 1945. But he became the star of the art market landscape revival that calmed souls after the Second World War, although he was oddly overlooked in the 1860s British landscape revival amid the urban anguish of the Industrial Revolution, despite being another forerunner to impressionism. Constable's place in the firmament of art genius now seems to have international support.

In the 21st century, however, the British art that sells highest in the world is of a very different and not overly British sort: the paintings of Francis Bacon, Lucian Freud (b 1922) and David Hockney (b 1937) from the 1940s to the present day, and the inventions of Damien Hirst and the 'Young British Artists' since 1990.

Bacon is seen, notably in America, as the most powerful response in art from any country to the evil of the Second World War. His 16-year series of snarling, screaming popes trapped in invisible cages encapsulates the 20th century's most painful discovery – that humanity is so deeply flawed that corruption has entered the soul of the most sacred people on earth. A half-dozen sketches and finished pictures of the popes are still in private hands to fuel the market, as are the sado-masochistic portraits of Bacon's large sexual entourage. Less easily absorbed because less comfortable on the wall are these diptychs and triptychs of the artist's homosexual friends and partners, made in the louche environs of London's Soho in the 1960s and 1970s, but in 2008 these raised prices between $50 million and $70 million in London and New York.

Bacon is for many the supreme 20th-century exponent of British genius at the psychological portrait, but so also for many is Freud. His pictures have climbed to $13 million in private sales, their prices unaffected by a 64-year lifetime of production. Freud exposes the soul in no less brutal painting of the body than that of Bacon but with a more classical, realist handling of paint; his portraiture is in significant quantity nude portraiture and his torsos are typically more expressive of emotion and stress than are his faces. Some of his finest work has been done with his own family; many of his portraits are anonymous.

David Hockney is a more decisive draughtsman than either Bacon or Freud but his highly recognizable portraits command a lower-priced market, at values up to $5 million. His style is probably too delicate and nervous and British in feeling to gratify fully the taste for big-brush violence in art in modern America, but he remains popular on both sides of the Atlantic.

The British artist, however, who enjoys unparalleled acclaim in both Europe and America and enjoys it on a scale not before known is Hirst, the king of the London 'Bratpak' of 'Young British Artists'. Hirst credits himself with a personal fortune of around £100 million, and he is only 43; his sweeping round-figure judgment on his wealth is however endorsed by the editors of the *Sunday Times* Rich List in London. He is the richest artist in British history and exceeds the equivalent real earnings of Van Dyck, Reynolds or Benjamin West. He can only get richer. In mid-2007 Hirst demonstrated his extraordinary skill in manipulating the art market by producing at his London art dealer White Cube a platinum skull affixed (by a professional jeweller) with 8,601 diamonds, some of them D flawless. Hirst in turn affixed to the skull the title *For the love of god* – a nod to its celestial gleam, as if defying death – and affixed also a price of £50 million ($104 million). The skull thus became the most expensive 'work of art' on sale in the world, the net jewel value being around £7 million and the added art value £43 million, and in September 2007 it was bought by a UK–US syndicate of financiers of whom just one was identified: Damien Hirst. Asked why he was buying what he himself was selling, Hirst revealed that he hoped to sell the skull for an even higher price. The art market was duly astonished.

The effect of hanging a £50 million price over Hirst like a star in the sky was immediate. It made all other works for sale by Hirst look cheap. One of an ambitious series of pill cabinets mocking human trust in medicine, *Lullaby spring*, promptly quadrupled estimate at Sotheby's London to fetch a record price for Hirst of £9.7 million, a reward for British art at auction exceeded only by the four paintings cited on the list above. Hirst's ability to control his price on sale raised questions whether his creations were driven by the love of art or the love of money. His wealth was enlarged by sales to the London advertising agent Charles Saatchi, his chief patron, and to his dealer, Jay Jopling at White Cube, which were followed by later repurchase and resale by Hirst. Devices like these ensured that the market was regularly starved of Hirsts for sale, with consequent rises in value. Yet Hirst has made ingenious art with his company Science Ltd which, either by accident or by design, now stands among the most significant of its time.

Consciously or not, Hirst has emerged as spokesman for 21st-century human beings who ask, baffled at their own existence, 'Why the hell am I here?' (The question was first worded as such by the British sculptor Antony Gormley.) Hirst has cut open sheep and cows to stare at the silent miracle of life, exposed the wombs of pregnant women and produced a metaphor for a seemingly purposeless life, the *Insectocutor*, in which a million flies in a large glass tank feed on a rotting cow's head, reproduce and eventually die from incineration by a live radiator bar on the ceiling of the tank. Hirst has created another vivid metaphor for an age that has lost God with his tank of formaldehyde containing a menacing shark. Humanity, told by astronomers scanning the vasts of space that we are an accidental species living on a planet of

one star amid billions of stars scattered in many multiverses, may well conclude that to be human is to swim in darkened waters in the company of sharks alongside. The shark, bought by Charles Saatchi for less than £50,000 in the early 1990s, was sold by him for $12 million to an American hedge fund manager in 2006.

Hirst bids to rise higher in price with his genius at invention, self-publicity and money management; the possibility of his reaching Warhol-level records in the $70 millions or even the records in the $130 millions of the American art heroes Willem de Kooning and Jackson Pollock is not to be ruled out. His art, however, raises alarming issues of survival and conservation. The deteriorating shark was replaced in 2007. Several other of his science-based creations are self-destructing. It may well be that the Hirsts destined to rise highest and longest in value will be the paintings and bronzes to which he increasingly turns his hand.

The issues in Hirst's art are not British issues but universal ones. It is likely to be on this basis that British art revives and flourishes on the art market in the 21st century, not, as a century ago, on its 'Britishness' alone.

For further information on the development of this particular art market, go to: www.koganpage.com/artmarkets.

The United States

Brook S Mason

New York

The art market for American art as well as antiques remains supreme in the United States even though the mighty Dow Jones Industrial Average occasionally stumbles, consumer spending slows and housing sales suddenly plummet. Indicators range from the tony evening auctions at Sotheby's and Christie's in New York to the booming growth of art and antiques fairs nationwide and especially the vibrant Chelsea art gallery scene.

Without question, money is the new mantra of the feverish art market. The roaring global economy is fuelling the spate of newly-minted millionaires and billionaires, with many fast turning to collecting while driving prices of both art and antiques as never before. Now new world record prices are routinely struck at auctions and privately as well.

Sticker shock prices were the norm for 2007, and Sotheby's New York sale of contemporary art held in May rung up a record $254,874,000 making that its highest total for such a speciality sale ever. Among the high-flying lots was Mark Rothko's (1903–1970) 1950 *White center (yellow, pink and lavender on rose)* from the collection of the banker and philanthropist David Rockefeller, which sold for $72,800,000. Five bidders chased that iconic painting, which the auction house expected to surpass $40 million. New world record prices were set for Jean-Michel Basquiat (1960–1988), Robert Rauschenberg (b 1925), Richard Prince (b 1949), Tom Wesselman (1931–2004), Dan Flavin (1933–1996) and John Baldessari (b 1931), among others. 'It was an historic sale with 15 new world price records,' said Tobias Meyer, Sotheby's worldwide head of contemporary art. Close to 70 per cent of the material sold for prices exceeding their high estimates. The sale doubled the previous record total for contemporary art, $128 million made only a single year earlier.

Those results confirm the sudden ascendancy in value of American postwar and contemporary art. But there is another shift going on in the fast-paced American market, and the sale of Gustav Klimt's spectacular *Portrait of Adele Bloch-Bauer II* for a stupendous $87,936,000 at Christie's impressionist and modern art sale on 7 November 2006 demonstrates a powerful change. 'The results are a new historical marker,' said Christopher Burge, Christie's auctioneer. That evening he hammered down $491,472,000, their highest total realized for any sale and established new world price records for Klimt, Schiele and Balthus, to name just a few.

Also of historical note was the profile of the winning bidders, indicating a far more decidedly international cast, which was unprecedented on these shores. So buyers taking art home from Christie's were heavily European, and Americans only came in second place in terms of the percentage of buyers. Asians, Russians and Latin Americans made up the balance. As in prior seasons, Americans took home the bulk of the material, this is a major shift.

Of course, rumours are swirling that the top buyers at both Christie's and Sotheby's spate of evening sales held in November were heavily Russian and Chinese. Still one thing is certain, there is a glut of brand new faces to the art and antiques collecting world. 'One of the driving forces is buyers from outside America,' says Brett Gorvey, Christie's specialist. Buyers are now coming not from a single nation or even one part of the world but rather they are global, and this is a new shift.

'These days, there are more buyers who have less than five years of collecting,' says David Norman, Sotheby's impressionist and modern co-chair. So say goodbye to that now hackneyed image of collectors who built their art holdings over generations. The over-whelming majority of those old-style collections held by a single family have been increasingly sold off in recent years.

What's sparking the big spending? Well, for starters Wall Street bonuses were expected to be as high as ever. With some traders making as much as $100 million in a single year, many in the financial world are flush with cash, and newly minted billionaires are commonplace. They do not just reside in Manhattan. Greenwich, Connecticut alone is home to more than 100 hedge funds.

That kind of money even spills over into the museum world. For example, Los Angeleno Eli Broad recently announced his enormous collection will be housed at the Los Angeles County Museum of Art (LACMA) in the Broad Contemporary Art Museum (BCAM) which will open in early 2009. Broad forked over a cool $50 million for the new annex which will be designed by Italian architect Renzo Piano. One index to the mega scale Broad collects on is his 1,800-piece collection with pivotal works by Jasper Johns (b 1930) and Ed Ruscha (b 1937), big enough to fill far more than a single museum. Broad was spotted on a shopping spree at Art Basel in June.

Then in Miami, there is practically a bevy of private museums, including the Rubell Family Art Collection. Other examples of private museum founders include Emily Fisher Landau with a museum of contemporary art in Queens and Ronald Lauder. Wal-Mart heiress Alice Walton is yet another collector with a private museum on her plate. She focuses on American painting for her Bentonville, Arkansas-based Crystal Bridges Museum. Just this past November, the Washington, DC National Gallery of Art and her Crystal Bridges Museum of American Art had agreed to purchase a prize American painting for a whopping $68 million. It is Thomas Eakins's (1844–1916) 1875 *The Gross Clinic*, which cost a mere $200 originally and is owned by the Philadelphia-based Thomas Jefferson University in Philadelphia. Interestingly, this pivotal oil when submitted for entry in the 1879 Centennial Exhibition in Philadelphia was rejected.

While at the very last minute the Philadelphia Museum of Art and the Pennsylvania Academy of the Fine Arts managed to raise $30 million to retain the painting jointly, the picture's sudden ascendancy in value is a key indicator of the feverish American paintings market. Clearly, to buy iconic American paintings by major artists today requires deep pockets like never before.

Ms Walton is a prime mover in the American paintings market but she is hardly alone in seeking patriotic fare. In fact, Christie's American painting expert, Eric Widing reports that his speciality now commands the second-highest percentage of new buyers in the entire

auction house. Photography scores the largest group of new buyers, though. 'Younger collectors who are new to the market are initially drawn to photography,' says Howard Greenberg, a prominent Manhattan photography dealer.

Another measure of this market is the growth of sales at Sotheby's American paintings department. Back in 1996, that firm hammered down 299 lots totalling $56,563,000 and the average lot value was $189,174. Fast forward to 2006 and 350 lots were on the block with total annual sales of $142,834,800, while the average lot value climbed to $408,099.

Now, paintings by Norman Rockwell (1894–1978), long derided as a mere illustrator (he created umpteen *Saturday Evening Post* covers for the publication, which was considered then a totally downmarket magazine) are fetching French impressionist-like prices. Rockwell's *Breaking home ties*, which received the second-highest number of votes for most popular magazine cover by *Post* readers, made a similar surprisingly steep price record. Sotheby's scored $15.4 million for the picture of a farm boy about to leave home at its November sale, and that price dwarfs the former record which was achieved only in the prior spring, indicating the hunger for illustration.

But what is amazing is that now even work by living artists, who some see as illustrators, are topping the price charts. The latest sign of this new shift can be spotted in the recent sale of a painting by Andrew Wyeth (b 1917), who although nearing the age of 90, still paints scenes of both Chadd's Ford, Pennsylvania and Cushing, Maine. In May, Michael Altman Art Advisory paid the stupendous sum of $10,344,000 for Wyeth's 1973 tempera on panel *Ericksons*, a grim portrait of a Maine neighbour in his kitchen, far outstripping its $4–6 million estimate.

'With a growing scarcity of prime American paintings, more collectors are turning towards illustration, which in many cases is emblematic of patriotism,' says Alan Fausel, Fine Art department head with Bonhams New York. He sold a Rockwell painting for a common coffee advertisement for over $300,000 in November.

Now the increased demand for American paintings is affecting the market for works on paper. Christie's spring 2007 sale of American art perfectly demonstrates this new shift. Then Georgia O'Keeffe's (1887–1986) 1916 watercolour *Blue I* flew past its $400–600,000 estimate and sold for a vigorous $3,008,000, making a world record for a work on paper by the artist.

Another shift in the market is the sudden racing prices for artists like the African-American Jacob Lawrence (1917–2000). At Christie's this spring, the artist's 1947 tempera on board, *The builders,* made a historic $2,504,000, or more than four times its high estimate.

One important measure of the American paintings market can be gleaned from Sotheby's. In 2001, the average lot at its American paintings sales went for $88,721, and by 2003 that amount had inched up to $128,604. Then in 2006 the figure was a whooping $768,613, or more than eight times the cost of the average lot five years before, according to a Sotheby's spokesperson.

The entire area of 20th-century design is a relative newcomer to the auction world. While Tiffany glass has long made top prices, furniture by American designers created in the 20th century is now fetching prices related to those for colonial antiques. The star designer is Japanese-American George Nakashima (1905–1990), whose furniture barely crossed New York City salesroom floors a decade ago. 'Now everyone wants Nakashima,' says James Zemaitis, Sotheby's 20th-century design department head. To a great degree, Nakashima fits right in with the zeitgeist of today with an emphasis on natural materials along with a certain Zen harmony.

Proof of just how coveted such seemingly rustic furniture, with tabletop edges left in their raw, unfinished states, can be found in Sotheby's 15 December 2006 sales. Then Nakashima's

exceedingly large 1988 Arlyn table sold for a record $822,400 against a $300–500,000 estimate, to Floridian collector Rudy Ciccarello. 'I really felt that this table, the most important piece that Nakashima ever built, should be part of the collection,' said Ciccarello, referring to his holdings. Now even the less important furniture by Nakashima is fast ascending in value, according to Philadelphia dealer Bob Aibel who owns Moderne Gallery. 'Seven years ago, I turned down a 1989 Nakashima desk for $25,000 as no one wanted to spend that much,' recalls Aibel. 'I appraised that piece of furniture for $150,000 for the Minguren Museum in California.'

Hordes of novice collectors are contributing to those price hikes. Jose Antonio Lorbon, who serves as director of the Sebastian + Barquet gallery with considerable holdings of 20th-century design in Chelsea, NY, is seeing an increasing number of clients who are totally new to the field. 'The younger clients are driving the prices,' says Lorbon. 'Over 60 per cent of them already have built art collections and now they are adding 20th-century design to complement their paintings.'

Now not so very old antiques like those made in the 20th century are also commanding attention. A case in point is the phenomenal growth of the Chicago auction house, Wright. In a brief period of time, it has achieved significant prices. Most notable is $630,000 realized for an Isamu Noguchi (1904–1988) 1948 table in birch, marble and steel. Wright sold a similar Noguchi table nine years earlier for a mere $9,000. Manhattan private dealer Cristina Grajales purchased the table for a client. In fact, it was the exact same client for whom she snapped up a Carlo Mollino table at Christie's in 2004 for a staggering $3.8 million. Five clients vied for the table up to the $2.1 million mark, according to a Christie's expert.

'There are more and more new collectors seeking 20th-century furniture,' says Grajales from her downtown loft. Her clients think nothing of forking out over $1 million-plus for a single piece of furniture. One could almost say 20th-century design is the new French *dix-huitéime* gilt furniture. 'Many of my collectors also own vast holdings of contemporary art and they see French 20th century by designers like Jean Prouvé and Charlotte Perriand as compatible visually,' says Grajales.

One measure of the sheer number of major 20th-century design collectors can be gleaned from Joshua Holderman, Christie's 20th-century design expert. He cites an architect and a consultant who frequently bid on behalf of as many as six different clients.

The entire area of contemporary decorative arts, including glass, fibre, clay and metal is also booming. A case in point are William Morris (b 1957) hand-blown glass vessels rich in Native American, Indian and Greco-Roman design motifs. 'When first introduced, they went for $25,000 each,' says Manhattan private dealer Donna Schneier. By 1994, his work went for in the $30,000 to $40,000 range. Today, a single one can go for $250,000 and up. With Morris just announcing his retirement, prices for his work will further rise. 'More mainstream museums like the Boston Museum of Fine Arts and the Minneapolis Institute of Art collecting in this area are validating the field for an entire generation of collectors,' says Mark Lyman, who created the annual International Exposition of Sculpture Objects and Functional Art with venues in both Chicago and New York.

Other shifts can be detected in 20th-century art. These days, works by the Dutch-born but New York City-based Willem de Kooning are stirring up yet more record prices. His 1977 landscape abstraction oddly titled *Untitled XXV* steamed ahead to a record $27 million at Christie's November evening sale. Look back 15 years ago and the American market was hampered by a recession. Then a de Kooning was inexpensive, says Christie's Gorvey. Plus, then there were no Russians buying and very few from Hong Kong were players.

The presence of Hong Kong buyers was apparent at Christie's sale in November 2006, and Hong Kong real estate titan Joseph Lau snared Andy Warhol's (1928–1978) 1972 *Mao* for a

record-making $17.4 million. In all, Christie's totted up a staggering $60 million plus for its Warhols on the block. Of note, Warhol prices only topped the $1 million level back in 1988.

Of course, the contemporary art market could not be more heated. A single painting, Elizabeth Peyton's (b 1965) 1999 *Princes William and Harry,* indicates the rush for this area of art. Phillips, de Pury & Company sold the double portrait for the equivalent of $806,000 in London. When the picture was first painted, it went for a $20,000 range. That shows how contemporary art is the new cash cow. There is another wrinkle to the contemporary art market. 'Many of the buyers are in their 30s and early 40s,' says Gorvey. And the overwhelming majority of them make their money in the fast-paced financial world. Several decades ago, novice collectors first got their feet wet buying decorative pictures and then moved on. That is no longer the case.

Another massive change in auctions is the heavy preponderance of private individuals buying at the 20th-century, postwar and contemporary art sales. 'Now, it's 95 percent privates with dealers acting as advisors,' says Gorvey. At Art Basel this summer, dealers spoke of a constant influx of art advisers, some leading their American clients by the hand.

Another facet to the high prices is the enormous amount of material coming to market. 'The strong market persuades people to sell,' says Gorvey, meaning that the high prices achieved indicate that it is a great time to unload art.

But there is a decided shift to contemporary art collectors' acquisition habits. Michel Witmer, the European Fine Art Fair director and private consultant, observed this new change close up at the Maastricht, Holland fair best known for Old Masters paintings last March.

Of the Americans buying, Witmer witnessed a husband and wife snapping up a Damien Hirst work to add to their 17th and 18th-century European paintings collection, both Dutch and French. 'It is the first contemporary work they have bought,' says Witmer. 'They have a New York apartment and a house in London.' He also noticed a young female collector from Florida, who had focused solely on contemporary art, buying a classical antiquity at TEFAF for the first time, which she felt was the perfect compliment to her collection.

This kind of collecting across multiple categories is hardly restricted to Americans.

'Clearly, this new eclecticism on the part of Americans will further heat up the market,' says Witmer. Call this the new, new Gilded Age with Americans on a buying spree, and one thing is certain: the pace of their shopping is far more accelerated than that of their 19th-century ancestors.

Art shows and fairs

Everyone knows that art and antiques fairs seem pumped up by growth hormones, with yet another fair on the roster all the time. 'Five years ago, even though many of the major international fairs were in place, the show calendar was sparse compared to today,' says Walter Robinson, editor of the New York-based art net.com online magazine which has been tracking fairs for close to a decade. 'Now, well over 100 fairs are on the calendar with new ones popping up practically weekly.'

Serious shoppers are not alone in tackling fairs. Numerous others see hitting the show circuit as akin to auditing art and antiques appreciation courses. 'Yet lately, more people are strolling fairs than ever for investment opportunities,' says Thea Westreich, who heads up the Manhattan-based Thea Westreich Art Advisory. With some Warhol paintings tripling in value in just over a few years, financial industry figures in unprecedented numbers have been zeroing in on this niche market.

The Florida city of Miami best epitomizes the ballooning growth of fairs. Only six years ago, Samuel Keller, the energetic organizer of the Swiss-based Art Basel, launched its sister event: Art Basel Miami Beach. What a difference a few years makes. For its December 2006 version, the city has morphed into fair central with eight ancillary art events which are staged at the exact same time. They include NADA, SCOPE, PULSE, Design Basel Miami, Aqua Art, Photo Miami, Ink Miami, Frisbee Fair and Flow Miami International Art Fair. Each one has its own identity, so NADA which is the brainchild of the New Art Dealers Alliances showcases emerging artists, while Ink Miami focuses on works on paper.

Now the talk is of yet more fairs in Miami, with some saying 20 art shows will take place. The latest entrant is Art Miami, a long-time contemporary art fair which had taken place during January. Now the event owned by SB Media is planning on setting up in a tent with 100 dealers. There is a new entity on the horizon, a boat, no less and this vessel may just change the fair scene nationally and internationally. Called Grand Luxe, this travelling art fair filled with only top-tier international galleries is the brain child of Floridian fair organizer David Lester. His new venture SeaFair is a bevy of boats, including a $20 million, 228 foot yacht complete with restaurants and cappuccino bars which will ply the Eastern seaboard and focus on newly rich markets like Charleston, South Carolina where the number of million-aires far surpasses that in Palm Beach on the Floridian Gold Coast. That millionaires figure is no figment of the imagination; it comes from the Wachovia Wealth Management Unit.

'It's essential for dealers to reach new markets and my ship provides them with that oppor-tunity,' says Lester. His ship debuted in Oyster Bay, Long Island in spring 2007 before moving on to Greenwich, Connecticut, home to 100 hedge funds and major collectors like Steven Cohen. One sign of how flush Greenwich is for dealers: the Greenwich Gallery there sold some 300 European and American paintings annually, reports Vincent Vallerino, who previously worked at the Greenwich establishment but has recently joined hands with the Schiller & Bodo Gallery in Manhattan. 'Just look at vast estates in Greenwich,' says London dealer Michael Playford, who heads up Two Zero C Applied Art Ltd and intends to sign for Lester's voyages.

Already 100 dealers have signed on, putting down from $10,000 to $30,000 for a week's cruise. Most in demand was the moneyed West coast of Florida trip in January 2008. That particular route includes St Petersburg, Tampa, Sarasota and Naples, and that area is now dubbed the Platinum coast for the enormous number of high rollers residing there. With Lester's Grand Luxe debuting in September 2007 and the fair environment broadening with ever more ancillary fairs, the show calendar is bound to swell even more.

The New York gallery scene

Fast-spiralling art auction results and world record prices struck within the blinking of an eye in the auction houses are not the sole measure of the ballooning art market. The gallery scene must also be considered.

Simply consider the gallery scene right after Labor Day. The Chelsea art season kicked off with a stunning 141 shows debuting in a single week alone, and more than 80 shows opened on one particular evening, 7 September, in 2006. Scoot back a decade, and Chelsea, bounded by the Hudson River, was a warren of scruffy auto mechanic shops and taxi garages. Matthew Marks was among the very first galleries to open. Now, this contemporary art dealer commands five gallery spaces.

Galleries in Chelsea have multiplied exponentially, with over 300 separate galleries in that neighbourhood alone, and now the latest twist indicating the enormous wealth and

growth of galleries is individual dealers taking on yet more pricey real estate to better showcase their holdings.

Chelsea is becoming an increasingly international gallery scene, with participants from Germany, France and even India. Now Chelsea is marked by greater and greater diversification in terms of galleries. For example, the Singapore-based Bodhi Art Gallery opened an enormous Chelsea space, 5,000 sq ft to be exact. Bodhi founder Amit Judge also has galleries in Mumbai and New Delhi. 'There is a growing market for contemporary Indian art,' says Bodhi. Now there are six galleries devoted to that specialty in New York.

The art scene is happening so fast in New York that I can think of no other economy marked by that speed.' Bodhi's comment could not be more on target.

For further information on the development of this particular art market, go to: www.koganpage.com/artmarkets.

Venezuela

Diana Boccardo

The Venezuelan art market should be seen in the light of the country's history. This chapter aims to give the reader a general idea of some of the artists that have nourished the culture of Venezuela and have captured the interest of scholars and collectors.

The colonial era

The beginnings of the art market in Venezuela date from the 17th and 18th century, when the country was still under the power of Spain. Works of art were commissioned to decorate churches, and the artists were paid small amounts of money for their work. Religious devotion and art were closely related, and soon the most important families in the city of Caracas began the precious activity of collecting. The nobility and wealthy families imported works from Mexico and Europe, and ordered family portraits from Spanish artists who were known in the new colonies.

One of the most important and prolific artists of the period was Juan Pedro López (1724–1787). His market, as in the case of other colonial paintings, is very difficult to judge. It would be impossible to establish any valid statistics since its pricing is very subjective. For instance, in May 2005, Sotheby's New York offered *La Virgen, Reina y Pastora de la Iglesia* (The Virgin, Queen and Shepherdess of the Church, 1780) with an estimate of US$50–70,000; it reached the record price of US$144,000 (all auction prices given including buyer's premium) (exchange rate 1,920 Bolívars = US$1). Two Venezuelan bidders competed for the piece and both expressed the 'need' to own the beautiful painting depicting their favourite image of the Virgin Mary.

Travellers to the New World

In 1810, the Venezuelan rebellion against the Spanish Crown began. The wars and destruction lasted until 1821, when independence was sealed with the triumph of the Battle of Carabobo. The consequences of these events and the sense of nationalism could easily be felt among the people and the artistic creations. Painters became the 'writers' of Venezuelan history.

Once the Independence wars were over, the small nation had to struggle with a complicated political process and extreme poverty. Its doors were open to the world, and many scientists, painters and naturalists, motivated by Humboldt, travelled to South America to witness the beauties of the exotic paradise. Among the travellers, the best known visitors were Robert Ker Porter (1777–1842), who was probably the first to draw the city of Caracas, Jean Baptiste de Gros (1793–1870), Ferdinand Bellerman (1814–1889), Anton Goering (1836–1935), Camille Pissarro (1830–1903) and Fritz Melbye (1826–1896).

Pissarro was very prolific during a short visit of two years in Venezuela. At a very early age, he became acquainted with the Danish painter Melbye, and both chose to visit Venezuela in 1852. Under Melbye's direction, Pissarro executed paintings, watercolours and drawings, representing market scenes and peasants around the Plaza Mayor (Main Square), and, although he worked mainly in the city of Caracas, there are also coastal and rural life scenes, forests and his favourite subject, women washing clothes in the rivers. Pissarro's works depicting Venezuelan scenes are very strong in the local market. The main institutions that house his early works in Venezuela are the Museum of Fine Arts, the National Art Gallery and the Central Bank, all located in Caracas.

The 19th century

With Venezuela now an independent country, a new academic style appeared. Artists were commissioned to represent scenes of the emblematic battles and portraits of the leaders of the independence for the decoration of the new government premises. From 1870 until 1887 the Venezuelan government was led by General Antonio Guzman Blanco, and, in 1849, he created the Academy of Fine Arts in Caracas. During the second half of the 19th century, painting in Venezuela was finally reaching its maturity. Cristóbal Rojas (1857–1890), Arturo Michelena (1863–1898), Martin Tovar y Tovar (1827–1902), Emilio Mauri (1855–1908), Antonio Herrera Toro (1889–1954) and Carlos Rivero Sanabria (1864–1915) are some of the names that enlightened the period.

Michelena was considered an outstanding artist well before the end of his short life, and he still remains among the most acclaimed of all Venezuelan painters. In 1885 he travelled to Paris and enrolled at the Académie Julian, guided by Jean Paul Laurens. Michelena achieved his first success at the Salon des Artistes Francaises in 1887 at the age of 24, when he was awarded the Gold Medal, second class, the highest honour that a foreign artist could receive at the salon, with his painting L'enfant malade, executed in 1887. The story of this painting is particularly interesting and I am especially proud of the outcome. The whereabouts of this magnificent painting were unknown since it was sold in 1926 in the Vincent Astor Sale in New York. After several months of amazing research, Sotheby's located the painting in the storage of the Ringling Museum in Sarasota, Florida, where it had been kept for more than 60 years.

In November 2004, Sotheby's included L'enfant malade in the Latin American art auction with estimates of $150–200,000. Venezuelan collectors and scholars were keen to have the opportunity to have the masterpiece on home soil for the first time. However, this was not the intention of the national institutions, which left the bidding in private hands. I had the honour of executing the winning phone bid; I will always treasure the moment when the hammer fell at $1,200,000, a record price for the artist.

The 20th century

In 1908 Juan Vicente Gomez overthrew the authoritarian government of his predecessor, Cipriano Castro, who had ruled since 1899. Gomez installed a dictatorial and military regime in Venezuela that lasted 27 years. The time was particularly difficult for young artists. In spite of the regime and restrictions in the country's development, they still had the Academy of Fine Arts to attend. One of these young artists was Manuel Cabré (1890–1984), who, with other students, participated in the first artistic rebellion against the Academy. Cabré painted a series of landscapes strongly charged with the spirit of impressionism, such as *A fragment of the Avila* (1914). He is considered 'the painter of the Avila', a mountain to the north of the valley of Caracas. In the auction market the record price for Manuel Cabré is for *Vista del Valle de Caracas from El Calvario*, a very early painting (1927) offered by Sotheby's in May 2001, with estimates of $100–150,000, sold for $148,750.

In recent years, the emigration of Venezuelans has increased. The nostalgia of many 'caraqueños' has somehow favoured the market of Manuel Cabré: they want to have a piece of the Avila in their new homes.

After the artistic rebellion, some artists were expelled and others left the Academy in protest. It was a new generation of painters who were eager to develop an aesthetic that reflected the excitement of the new era. They worked and studied on their own, and in 1912 they created the Circle of Fine Arts. The national landscape was interpreted following the innovative style of French impressionists artists.

The oeuvre of Armando Reverón (1889–1954) is a great example of this new trend. The 'painter of light,' as he is usually remembered, achieved his original style after 1921, when he moved to El Castillete (tiny castle) a very simple construction he built by the sea, where he captured the striking brightness of the tropical sun. Among his most acclaimed paintings is *Portrait of Casilda,* a small canvas that held the record price in Reveron's international market for 11 years. The painting was offered in November 1997 at Sotheby's with estimates of $70–90,000 and made $332,500. Reveron's most recent painting offered at auction was *Paisaje* (1930). Estimated at $300–400,000, it reached $456,000 at Sotheby's in May 2007, setting a new record.

After the death of Gomez in 1935, Venezuela witnessed a new light in the fields of art. The inauguration of the Museo de Bellas Artes (Museum of Fine Arts) in 1938 and the construction of the Ciudad Universitaria (Central University, Caracas) in 1944–45, both by the Venezuelan architect Carlos Raul Villanueva (1900–1975), were the definitive steps towards modernism.

Alejandro Otero (1921–1990) was a key artist from this period. In his series of *Cafeteras*, from 1947 to 1950, the subject matter, the coffee pot, undergoes a process of transformation into lines floating in the space. Later in 1955, he changed his subject to his famous *Coloritmos*, which can be described as elongated wood panels, crossed from side to side by white and dark parallel lines in which spaces the artist added forms of pure and brilliant colours. An example of Otero's works offered in the international market is *Cafetera azul fondo pintado* (1947), offered at Sotheby's in 1998 with estimates of $50–70,000 and making $63,000. *Coloritmo 23* (1957) was offered at Sotheby's in 2005, estimated at $40–60,000 and making $162,000.

The 1950s

The Salones Oficiales (official salons) encouraged artistic production by granting prizes to the best creations and offered the public the opportunity to admire and discuss the latest trends in art. In keeping with this atmosphere of art appreciation and business, the first

public auction in Venezuela was organized by the Gallery Sala Mendoza in 1957. The auctions facilitated interaction among the already important collectors and provided an essential mechanism for a dynamic art market. Many names were brought to the rostrum: Marcos Castillo, Luis Guevara Moreno, Arturo Michelena, Héctor Poleo, Pascual Navarro, Oswaldo Vigas, Emilio Boggio and Armando Reverón. From the group in this first auction, *Los tres comisarios* (1941) by Poleo (1918–1989) achieved the highest price. The Sala Mendoza has just celebrated 50 years organizing exhibitions and auctions, including international and local artists.

The 1960s

The decade was dominated by political struggles which divided Venezuelan society. It was a time of commotion, guerrilla assaults and riots. Some artists used their canvases, panels and papers as a means to express their feelings, creating a sort of revolutionary art, in which the matter and the image transmitted the violence of the moment. According to the registry of galleries and the Sala Mendoza, the interest of collectors was mainly centred on Venezuelan artists, especially those who belonged to the Circle of Fine Arts, and the preferred subject matter was landscape. The references of the Caracas market by the 1960s were Reveron, Boggio, Cabré, Bárbaro Rivas (1893–1967) and Poleo.

In spite of this 'traditional' taste, an innovative style was developing in the hands of Gego, an abbreviation of the name Gertrud Goldschmidt (1912–1994), whose wire sculptures were already drawing the attention of collectors. She experimented with parallel lines in drawings and prints at the beginning of her career and later developed a system of nets in which the parallel lines were still present. These works are known as *Reticuláreas*, fine articulated lines of wire and other materials that seem to float in the space.

Gego's record price achieved at a public auction was set with a *Reticulárea* dated 1972, offered at Sotheby's in November 2004, with estimates of $100–150,000 and making $411,200. In 2005, another *Reticulárea* was sold at Sotheby's for $340,800, exceeding its estimates of $125–175,000.

By the end of the decade, Venezuelan collectors broadened their selections towards Latin American and European modern and contemporary art, thanks to the professional advice of two new galleries in the city, Estudio Actual (Clara Diament Sujo) and Conkright (Rachel Adler).

Informal, kinetic, and figurative art were present during the 1960s, with works rich in colour and texture. Jesus Soto (1923–2005) is the most acclaimed among kinetic artists in Venezuela. He surpassed the geometric abstraction and experimented with movement and vibration, overlapping surface and colours. He used matter, combined textures and added objects to his works creating extraordinary pieces that have been highly praised worldwide, mainly in Venezuela, the United States, United Kingdom, France, Germany, Italy and Brazil. His earliest works dating from the late 1950s to the early 1960s, have reached the highest prices in the international market. His record price achieved at an international auction was for *Vibración*, a kinetic work (1959), offered at Sotheby's in November 2005, with estimates of $90–120,000, sold for $419,200.

The 1960s were also the years when the so-called 'naïve art' found recognition and success. The Venezuelan artist who has achieved the highest prices in the market is Rivas. He was an untutored painter with his own vision of the world. His paintings were charged with simplicity and a religious message. His auction record was set with *Autorretrato con Santa Barbara*, offered at Sotheby's in 1998, estimated at $20–25,000 and making $43,125.

The 1970s

The decade was marked by a plurality of trends. Kinetic, figurative, optic and abstract art were in vogue. The Venezuelan economy experienced a significant growth which was echoed in the art market. During 1974 and 1975, oil prices and public expenditure increased to a point that the country was referred to as the 'Venezuela Saudi'. The Sala Mendoza performed two auctions per year instead of the habitual annual auction during the 1960s, due to the increasing number of collectors attending the event.

Venezuelan collectors showed strong interest in paintings executed by local artists, and the favourite subject matter remained the landscape. Reveron, Poleo, Rafael Monasterios and Otero achieved the highest prices at auction. In 1977 at the Sala Mendoza auction, Poleo's *Maternidad* was sold for $44,190 (at that time the exchange rate was 4.30 Bolivars per US$) and in 1979, also at the Sala Mendoza, Reveron's *Mujer desnuda con sombrero* was sold for $37,210. In 1960 a painting by Poleo, *De la tierra a la tierra*, sold at auction for the equivalent of $930 and in the same year *El patio* (1914) by Reveron sold for the equivalent of $1,130.

In 1975 the Galeria de Arte Nacional (National Art Gallery) was founded. It was designed to host all the Venezuelan art that was previously shown at the Museum of Fine Arts under the brilliant and professional direction of Miguel Arroyo, who, during his 10 years of dedication at the museum, played a remarkable role in the country's art history. At the same time, the Museum of Contemporary Art was inaugurated by the journalist Sofia Imber. The new museum offered a space for contemporary paintings, sculptures, photography and video, executed by Venezuelan artists such as Soto, Cabré, Francisco Narvaez, Gego, Zitman and Reverón, as well as by international artists such as Paul Klee, Fernando Botero, Pablo Picasso, Henri Matisse, Fernand Leger and Victor Vasarely.

The 1980s

Venezuelan modern and contemporary art was supported and triggered mainly by two galleries, the Sala Mendoza, directed by Axel Stein, and Galeria Sotavento, directed by Zuleiva Vivas and Ruth Auerback. The conceptual paintings of the 1980s are one of the most important chapters in Venezuelan 20th-century art. There is no longer a political dialogue. Artists worked with textures and colours in large canvases combining abstract and figural art, following the steps of transvarguardism led by Sandro Chia and Francesco Clemente in Italy.

Two of the most acclaimed painters at that moment were Ernesto Leon and Carlos Zerpa, followed by Eugenio Espinoza, Jorge Pizani, Miguel von Dangel, Oscar Pellegrino, Susana Amundarain, Felix Perdomo, Onofre Frías, Victor Hugo Irazabal, Carlos Sosa, Patricia Van Dalen, Luis Lizardo and Antonio Lazo. Among the most praised sculptors of the decade were Rafael Barrios, Harry Abend, Miguel Boreli, Oscar Machado, Carlos Medina, Jorge Stever and Max Pedemonte.

By the end of the 1980s a group of young artists decided to innovate with electronics and installations: José Gabriel Fernández, Sammy Cucher, Oscar León Jiménez, Oscar Molinari, Nela Ochoa, Ali González and José Antonio Hernández Diez. Hernández Diez is one of the most active artists in the country and his prices have increased significantly. His works are offered at auctions, the most attractive pieces being his installations with skateboards *Experience* (1995), a group of three skateboards of three different sizes, was sold by Christie's in 1999 for $17,250.

The 1990s

The Iberoamerican Art Fair opened its doors in Caracas for the first time in 1992. The fair is cele-brated annually in June in Caracas. During the weeks of the fair, people can view the latest and traditional trends of art and it is one of the most dynamic moments of the Venezuelan market.

In 1994, Odalys Sánchez de Saravo opened the Casa de Subastas Odalys (Odalys auction house). She organizes numerous auctions each year and has become a reference for the local art market. Some have argued that the elevated number of auctions of works by local artists, approximately 10 per year, have lowered the prices of artists that had already achieved a name and a place in the market. However, it is undeniable that her auctions have provided great enthusiasm to the art market as well as an up to date reference of prices.

2000 to the present

Although recent economic activity has been robust thanks to the rising prices of oil, which remains at the centre of the Venezuelan economy, business carries major risks and often discourages private investment. Venezuela has been ranked number 82 out of 102 countries by the World Economic Forum on a measure of how favourable investment is for institutions.

In spite of the unclear political situation in Venezuela, the activities of its art market remain very dynamic and offer the public the opportunity to participate in auctions, exhibits, seminars and workshops. The drivers of this dynamism are the national and private museums, foundations, cultural centres, public and private exhibition places, art galleries, and a very important group of art critics who have dedicated their lives to research and transmit their knowledge through amazing publications that are essential on our bookshelves: Alfredo Boulton, Carlos Duarte, Juan Calzadilla, Juan Carlos Palenzuela, Miguel Arroyo, Roberto Guevara, Perán Erminy, Rafael Pineda, Inocente Palacios, Francisco D'Antonio, Luis Enrique Perez Oramas, Ariel Jimenez and William Niño.

National museums have been recently grouped under the figure of Fundación Museos Nacionales (National Museums Foundation), with most of its members in Caracas: the Galeria de Arte Nacional (National Art Gallery), Museo de Bellas Artes (Fine Arts Museum), Museo Arturo Michelena, Museo de la Estampa y el Diseño Carlos Cruz Diez (Stamps and Design Museum Carlos Cruz Diez), Museo Alejandro Otero, Museo de Arte Contemporáneo (Contemporary Art Museum), and Museo Jacobo Borges.

Private foundations have played a major role in consolidating several of the most important collections in the country: the Fundación Coleccion Mercantil (Banco Mercantil Foundation), Fundacion Banco de Venezuela, Fundación Provincial, Fundación Gustavo y Patricia Cisneros, Fundación Daniela Chappard, Fundación Gego, Fundación Polar, Fundación Previsora, Fundación Provincial, Museo de Arte Colonial (Colonial Art Museum), Proyecto Armando Reverón and Fundación Museo de Arte Moderno Jesús Soto.

Some of the most active exhibition spaces are the Universidad Central de Venezuela, Corporación Andina de Fomento, Sala Mendoza, Sala Trasnocho Arte Contacto (TAC), and the network of galleries, Galería 39, Alternativa, San Francisco, Acquavella, Ascaso, Blasini, Díaz Mancini, Dimaca, D'Museo, Durban, Félix, Freites, La Cuadra, Medicci, Minotauro, Muci, Grupo Li, Spativm, Trazos, Graphic Art, Okyo, Fernando Zubillaga, Carmelo Fernández, Edición Limitada, A. Siete and Clave.

Venezuelans' attendance at international art-related events is increasing every day. Collectors show a strong interest in acquiring and supporting local artists whose works are

offered abroad mainly in the United States, France and the United Kingdom. It is common to see Venezuelans competing at international auctions for works by Reverón, Soto, Gego, Cruz Diez, Otero, Cabré, Michelena, Narvaez, 19th-century travellers, and leading their prices to the highest records.

Venezuelan art has been recognized internationally, not only by auction houses but also by institutions such as the Museum of Fine Arts Houston, thanks to the effort of curator Mari Carmen Ramirez, who organized the amazing exhibits of Soto, Otero, Carlos Cruz Diez and Gego. At the present time, Venezuelan art can be acquired at international galleries such as Clara Diament Sujo Gallery and Faria Fine Arts in New York and Sicardy Gallery in Houston.

Expectations continue to grow around what the international and local auctions will bring each season. Venezuelan collectors are showing strong interest and commercial potential and we can hope that sensibility and good taste will prevail in order to continue building the incredible collections that continue to enrich Venezuela's art history.

For further information on the development of this particular art market, go to: www.koganpage.com/artmarkets.

Index

(italics indicate a figure or table in the text)